# WORLD IMPRESSIONISM:
## The International Movement, 1860-1920

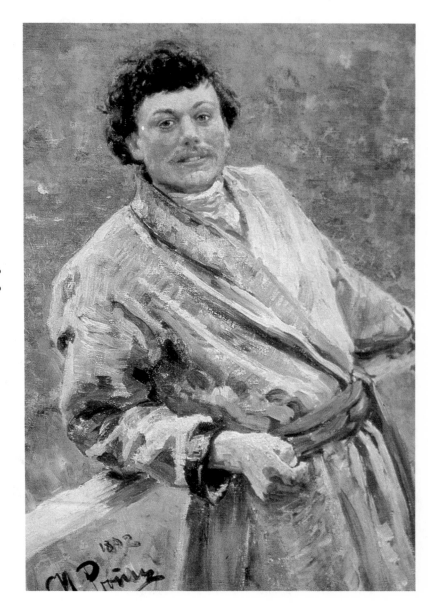

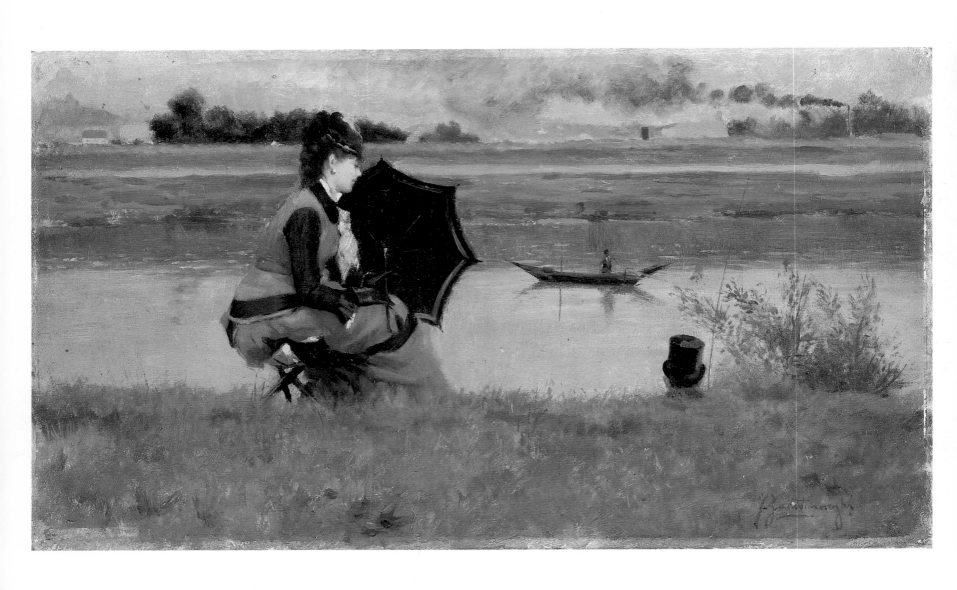

# WORLD IMPRESSIONISM: The International Movement, 1860-1920

Edited by Norma Broude

Harry N. Abrams, Inc., Publishers, New York

The publisher gratefully acknowledges Donald Holden,
painter and writer on art, who proposed the idea for this book
and generously inspired us to pursue it.

EDITOR: Charles Miers
DESIGNER: Darilyn Lowe
RIGHTS, REPRODUCTIONS, AND PHOTO RESEARCH: Lauren Boucher

Page 1: Ilia Efimovich Repin, *White Russian* (plate 498)
Page 2: Federico Zandomeneghi, *Along the Seine* (plate 245)
Page 7: Joaquín Sorolla, *María Painting at El Pardo* (plate 266)

Library of Congress Cataloging-in-Publication Data

World Impressionism: the International Movement, 1860–1920/ Norma
  Broude, general editor; essays by Eleanor Tufts . . . [et al.].
        p.        cm.
  Includes bibliographical references.
  ISBN 0–8109–1774–2
  1. Impressionism (Art) 2. Painting, Modern—19th century.
  3. Painting, Modern—20th century.   I. Broude, Norma.
ND192.I4W67   1990
759.05′4—dc20                                           90–218
                                                        CIP

Printed and bound in Japan

# CONTENTS

# PREFACE

AS AN ART historian who has studied and written about the work of the Macchiaioli, I have long wrestled with defining the relationship between those nineteenth-century Italian painters and their better-known contemporaries, the French Impressionists. "They are *not* 'Italian Impressionists,'" I have frequently insisted, as friends try valiantly to find a familiar context for these fascinating artists with the unfamiliar name. Like many of my colleagues who work with the other, so-called non-French schools of the nineteenth century, I have been reluctant until now to accept the attractive and easy label of Impressionism. That reluctance has reflected a desire to insist upon the uniqueness of nineteenth-century Italian painting as well as a refusal to relegate it to the position of a planet that revolves dependently around the sun of the much-acclaimed French Impressionist movement.

But the same postmodern impulse that has led us in recent decades to explore the independent identities of a wide variety of national schools of nineteenth-century painting and to savor their diversity must also lead us, inevitably, to question the narrowness of the prevailing model of Impressionism itself—to wonder, in other words, whether Impressionism, despite the French origins of that term, was uniquely a French invention and achievement or whether this notion is in fact just another of the old conceptual frameworks of art history that will need to be reexamined and to some extent dismantled in the wake of postmodern revisionism.

It is my hope that the exciting revelations provided by this book can begin to change the public's perception of Impressionist innovation as an exclusively French phenomenon and may also help to expand our understanding of the global and interactive nature of late nineteenth-century art in general. Though broad in scope, the book is selective rather than encyclopedic in design and intention, and its twelve essays introduce us to representative manifestations of the Impressionist impulse and influence in a variety of places around the world during the late nineteenth century. The essays have been arranged loosely in cultural and geographical clusters rather than in a chronological sequence. The first group of four deals with Impressionism in the English-speaking world; the second with Impressionism in countries whose own native traditions influenced art in France during the Impressionist era; the third with Impressionism in a selection of countries in northern, central, and eastern Europe and in Russia.

In these essays, we have showcased the works of scores of little-known artists, some of whom enjoyed considerable and well-deserved international reputations in their own day, but who have now, at the end of the twentieth century, been almost entirely forgotten outside of their native countries. These artists are being presented and evaluated here for the first time not as forerunners or imitators of the French Impressionists but as part of a larger international movement whose vitality,

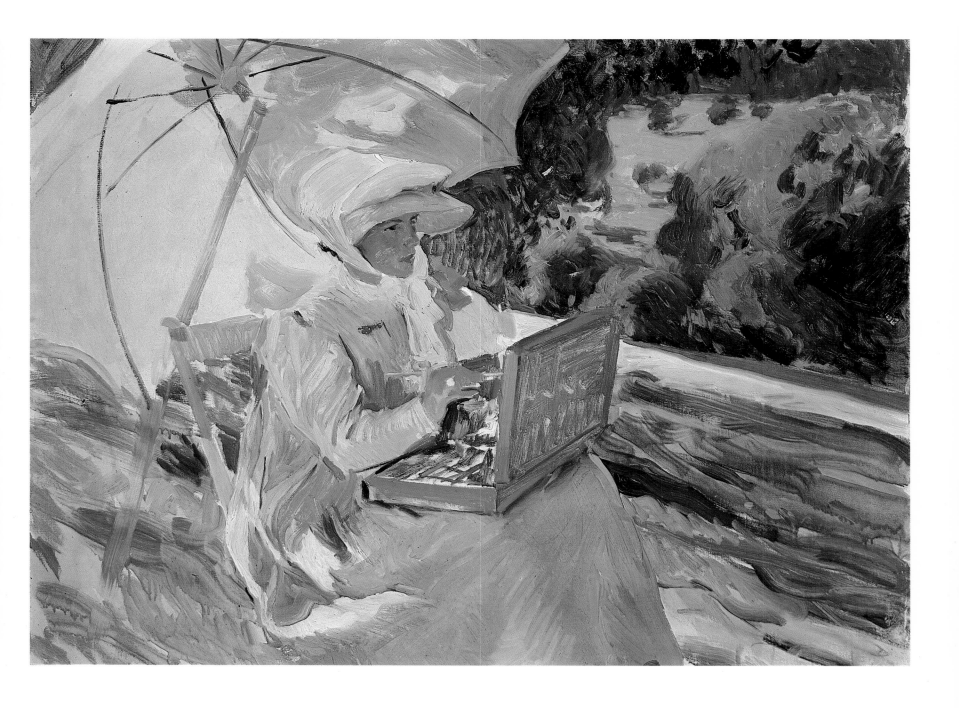

scope, and longevity demand at last to be fully recognized and appreciated.

Many people are owed thanks for their contributions to a project of this magnitude, first and foremost among them the distinguished authors, without whose specialized expertise a book of this ambitious scope and authority could never have been realized. I am grateful to all of them for their cooperation and for the discussions and exchanges that made my task as general editor of this volume an exceptionally enjoyable and stimulating one. The dedication and enthusiasm of the authors for the project were fully matched by the professional staff at Harry N. Abrams, Inc., who lent us invaluable support at every stage in the development and production of the book. Special thanks are due Paul Gottlieb, president of Abrams, who gave us all the freedom to develop the "World Impressionism" concept into a meaningful book. Warm appreciation goes also to our patient and indefatigable photograph researcher, Lauren Boucher; our gifted designer, Darilyn Lowe; and most of all to Charles Miers, who, in his dual role in acquisitions and editing, displayed a sympathetic understanding of the book's purpose and intellectual design that contributed in many important ways to its evolution.

Norma Broude
Washington, D.C.
January 1, 1990

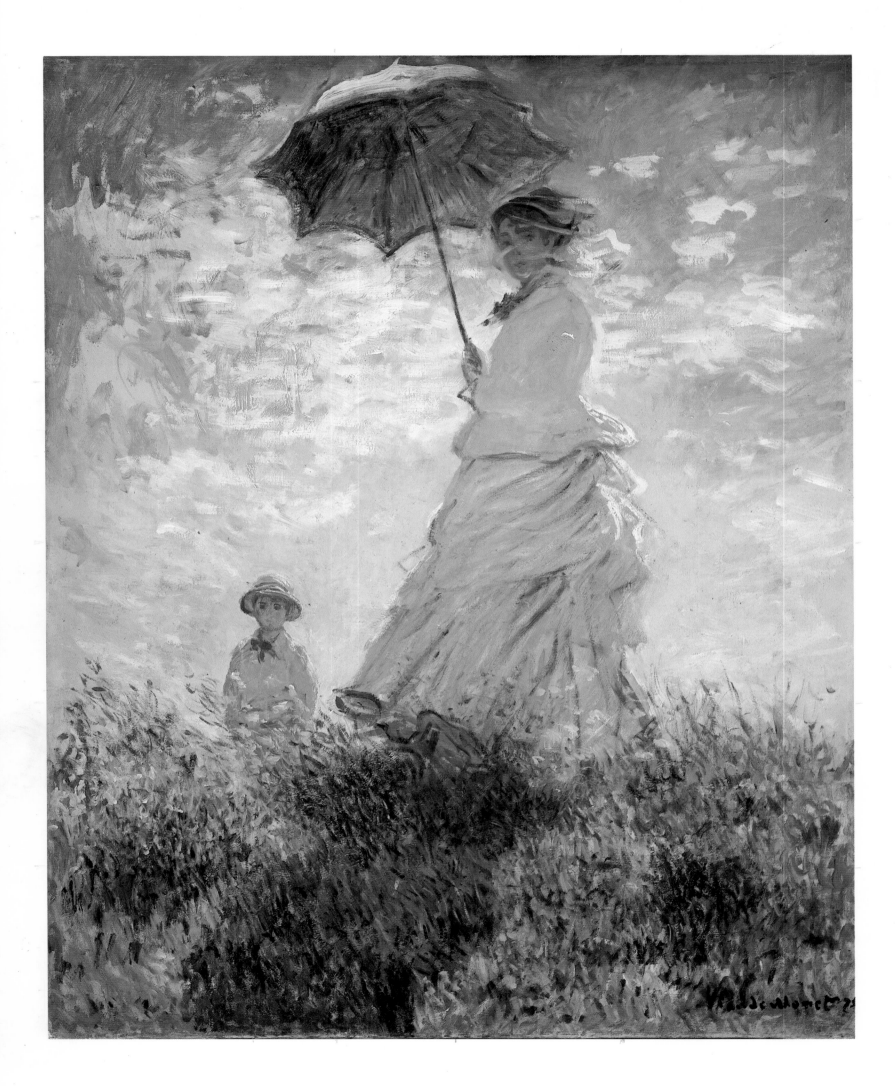

# A World in Light: France and the International Impressionist Movement 1860–1920

*Norma Broude*

Like the art of the Renaissance, the Impressionist movement of the late nineteenth century brought about far-reaching changes in the way that artists image the world. It marked a conclusive dividing line between past and present and opened the way for much of the art, even the abstract art, that was to follow it in the "modern" period. With its luminous and high-keyed palette, its loose and apparently spontaneous brushwork, and its thematic engagement with an outdoor world of middle-class leisure and pleasure, Impressionism was a watershed that permanently changed vision and redefined the nature of visual expression in modern culture. And it was a style that spread rapidly from its presumed cradle in France to other countries in Europe, America, and even the Far East, where it was sometimes imitated but more often substantially transformed by local artists in response to indigenous tastes and traditions.

While such cultural diffusion of an artistic style is not unprecedented in the history of art (one thinks, for example, of the way in which the Gothic style spread outward from the Île-de-France or of the spread of the Renaissance style and attitude from Italy), the global nature of the Impressionist phenomenon and its vitality well into the early decades of the twentieth century, even in the face of competing avant-garde styles, are extraordinary. Its universal appeal and rapid proliferation were noted by the American critic Christian Brinton in his discussion of the Panama-Pacific Exposition in San Francisco in 1915:

> Paris of course proved the spot from whence radiated this new gospel, just as, a generation later, it was from Paris that was launched the propaganda of the Expressionists, who today represent the inevitable reaction against Impressionism. Simultaneously there sprang up over the face of Europe, and also America, countless acquisitive apostles of light who soon changed the complexion of modern painting from black and brown to blonde, mauve, and violet. The movement seemed spontaneous. In Spain it was Sorolla and Rusinol who popularized the prismatic palette among the vineyards of Valencia, along the plage of Cabanal, or in the gardens of Andalucia. Far up among the peaks of the Engadine, Giovanni Segantini, the solitary, heroic-souled Italian-Swiss painter perished in endeavouring to apply the principles of Divisionism, as he termed it, to simple and austere mountain scenes. Darkness was everywhere dissipated. Under the direct inspiration of Degas, Max Liebermann undertook the task of injecting purity of tone and swiftness of touch into the Gothic obscurity and linear severity of Teutonic painting. Claus and Van Rysselberghe in Belgium, Thaulow in Norway, Krøyer in Denmark, and a dozen or more talented Swedes witness the widening acceptance of the Impressionist programme.

1. Claude Monet. *Woman with a Parasol—Madame Monet and Her Son.* 1875. Oil on canvas, 39⅜ × 31⅞". National Gallery of Art, Washington, D.C. Bequest of Mr. and Mrs. Paul Mellon

Brinton went on to characterize the phenomenon in England, Scotland, and the United States and to caution his audience, in the case of the last, not to assume "that American Impressionism and French Impressionism are identical." Emphasizing the uniqueness of the national style and the importance of adaptation to "local taste and conditions," he asserted that "the American painter accepted the spirit, not the letter of the new doctrine."[1]

In his precocious recognition of these varied manifestations of "World Impressionism," as we may now be inclined to call it, Brinton displayed an international point of view that was fairly unusual for an art critic but not unique during the teens of the twentieth century, a point of view that was certainly consonant with the developing concerns and political outlook of a decade that produced not only World War I but also the League of Nations. As an art historical construct, however, Brinton's view of an international Impressionist movement was destined to remain undeveloped; and as a result the phenomenon that inspired his remarks in 1915 has now, by the end of the twentieth century, been virtually forgotten. For even by the next decade, and certainly by the 1930s, the international movement he described was being submerged and its reality denied by a falsely linear and chronological view of the development of modern art, one that was prepared to recognize successive new movements such as Post-Impressionism, Fauvism, Expressionism, and Cubism as the new avant-garde and to confine Impressionist "innovation" to a relatively brief period in the history of French—and only French—art.

The prevailing view of the relationship between French Impressionism and other national or "regional" schools (as they have come to be hierarchically designated in relation to the French "center") has gone through two distinct stages in twentieth-century art historical and critical writing, and is now, I would propose, in our postmodern era, ready to enter a third.

During the first half of the twentieth century, particularly from the 1920s on, a monolithic and partially mythic French Impressionism, defined as an art that was created spontaneously and exclusively before nature and in direct response to nature's light, was increasingly held up as the standard of excellence against which other schools of late nineteenth-century painting were to be measured. When outdoor study of contemporary life and landscape led to studio-finished paintings, which was true of much of the art produced in Europe and America during the second half of the nineteenth century (and true, to some extent, even of French Impressionism itself), this involvement with open-air painting was often described as inconclusive and abortive—"an 'Early Renaissance' that was not followed by any 'High Renaissance,'" as Fritz Novotny wrote in 1960 when he set out to describe the work of the Italian Macchiaioli[2]—because it did not normally lead to the production of pictures with diffused drawing and flecked brushwork, pictures that looked like those of the French Impressionists. Or when national schools of painting that

were in fact directly inspired by the stylistic characteristics of French Impressionism began to grow, thrive, and survive into the early twentieth century, they were—and sometimes continue to be—dismissed as mere "variants" of French Impressionism, "a diluted form" of the real thing.[3]

Thus, during this first phase of art historical thinking, all "regional" activity was in one way or another defined in relation to an avant-garde standard thought to be exemplified by the French school and was almost invariably judged inferior or in some respect lacking according to that standard. Since the 1960s and through the 1970s and 1980s, however, there has emerged a gradual, postmodernist revision of this Francocentric attitude, spearheaded by the efforts of art historians on a local level to redefine and reevaluate their national schools of painting strictly on their own terms—which is to say, in terms of purely local traditions and contexts, both artistic and social—rather than as precursors to or as offshoots of an avant-garde "flowering" of nineteenth-century painting that was always presumed to have taken place elsewhere. This reassessment, which has gradually revealed the unique character and quality of the various national schools, has been achieved in many cases at the cost of artificially isolating these schools from a broader international context. And to reinsert them back into that context remains an uncomfortable problem as long as the position of French Impressionism as the universal standard of excellence—rather than as one among many national schools—goes unchallenged. It is in part the purpose of this book to issue such a challenge, thereby opening the way to a third, less Francocentric and more truly universal, phase in the critical discourse about Impressionism.

In this third phase, a fresh vision of the total picture with the specific characteristics of the various national schools taken into account can help us to understand French Impressionism as part of a larger movement—as one specific manifestation of a larger Impressionist impulse. Impressionism in France was of course unique, as indeed it had to be because of its specific social and cultural context. But among artists all over the world in the nineteenth century there was an impulse to paint contemporary life and experience directly from nature, to study the effects of nature's light, and to use a lighter palette and looser brushwork to proclaim the artist's individuality and sincerity and the immediacy of the experiences that the canvas mediated for the viewer. This impulse was at times entirely independent of what was then happening—or was still to happen—in France, taking its character, instead, from what was indigenous to the tastes, concerns, and traditions of each region. It is this universality of what I call the "Impressionist impulse" in the nineteenth century, as well as the unique forms it took in each country, that the essays in this book reveal. At the same time, the Impressionist movement in France had a direct impact and influence, often at a considerably later date, on what was happening in other countries, where it was self-

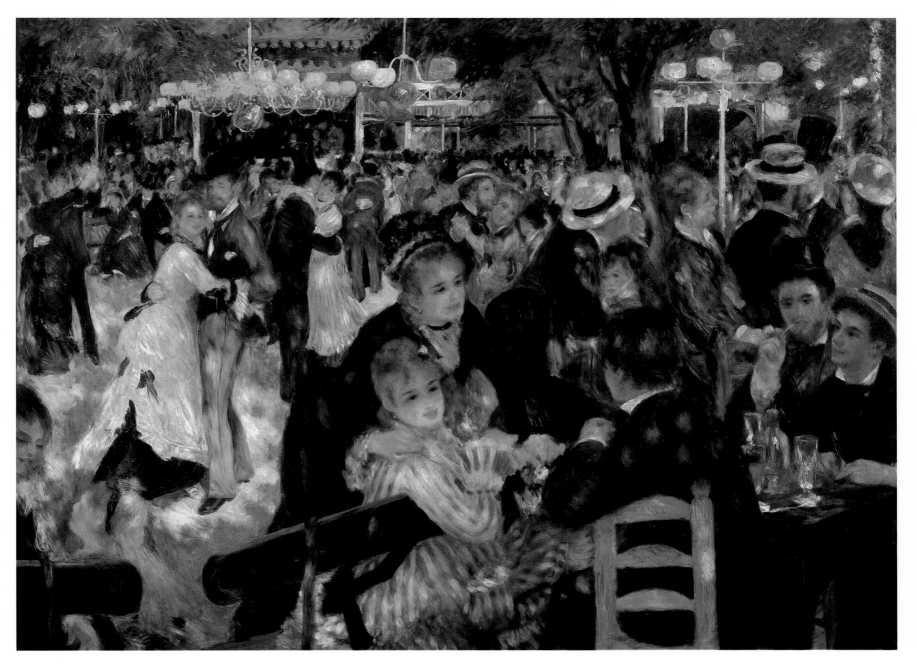

2. Pierre-Auguste Renoir. *Dance at the Moulin de la
Galette.* 1876. Oil on canvas, 51½×69″. Musée d'Orsay, Paris.
Bequest of Gustave Caillebotte, 1894

consciously imitated or transformed by local artists in specific ways. The history of this interaction and what it produced is also a major part of what this book explores.

What these essays and this book as a whole might also suggest is a new, postmodernist model for reconstructing the history of modern art in general, a model that is centrifugal and interactive rather than linear and revolutionary. The mainstream account of modernism to which we are accustomed will often begin with French Impressionism and tell the story of a succession of innovative, avant-garde movements that inexorably succeed one another in a steady progression toward the goal of formalist abstraction. An alternative model might see not French Impressionism of the 1870s but World Im-

pressionism, from about 1860 to 1920 and beyond, as a major event that was center stage in our visual culture for more than half a century, overlapping with other movements that were derived from it and that were at first marginal to it in terms of real influence but that have since come to be regarded as more central to the telling of the modernist story. Although Impressionism was joined in the early twentieth century by Cubism, that other major visual language of international modernism, it was never entirely replaced by it, as the essays and paintings in this book begin to show.

The new thesis presented by this book, then, might be stated as follows: we cannot fully understand the art of the late nineteenth century until we stop priv-

3. JEAN-FRANÇOIS RAFFAËLLI. *Mayor and Town Counselor.* c.1879. Oil on canvas, 21 × 28¾". Private collection

ileging the French school; and we will not stop privileging the French school until the international movement, in all of its depth and variety, has become better known and is more familiar to us. It is hoped that the twelve essays in this book, each by a scholar who has worked long and closely with the art of one of the non-French schools of the nineteenth century, can provide a foundation and a framework for this exciting voyage of rediscovery.

## The Diversity of French Impressionism: The Eight Group Exhibitions and Their Impact

It is now more than a century since the painters whom we know as "The Impressionists" first banded together to bypass the Salon jury system and the academic establishment in France in order to show their art directly to the public. In the interim, that art has become one of the most beloved and written about of any period, its popularity resting in part on the many well-known and widely reproduced icons of the movement, such sunlit scenes of the good life among the middle classes as Monet's *Woman with a Parasol* of 1875 or Renoir's *Dance at the Moulin de la Galette* of 1876 (plates 1 and 2). Until recently, our selective focus on such paintings helped to sustain an overly simplified and popularized notion of what, in stylistic as well as thematic terms, avant-garde painting during this period was supposed to be like—a carefree and colorful, rapidly executed, outdoor art of "impressions," in which the firmly drawn contours of older painting were made to dissolve under a barrage of stenographic brushwork and sparkling natural light.

This narrow vision of a monolithic French Impressionism began to crumble in 1986, when an important exhibition, *The New Painting: Impressionism 1874–1886*, provided, at last, a key to recovering the full reality and complexity of the new art that emerged in Paris during this period.[4] A selective re-creation of the eight historic exhibitions organized and sponsored by the artists themselves between 1874 and 1886, this show and its catalog presented a dazzling variety of painting styles and pictures. They made it possible for us to reexperience something of the experimental diversity of the original Impressionist exhibitions, thereby broadening our frame of reference and opening a path to new ways of thinking about French Impressionism and its influence.

The painters who are today enshrined in the public imagination as the archetypal heroes of the Impressionist movement are less than a dozen in number. But as this exhibition reminded us, no fewer than fifty-seven artists painted the more than seventeen hundred works that were shown at the eight Impressionist group exhibitions. And the majority of these artists—artists such as Jean-François Raffaëlli (plate 3), Giuseppe De Nittis, Zacharie Astruc, Alphonse Legros, Marcellin Desboutin, Ludovic Piette, and many others—painted pictures that are not normally thought of today in the context of "Impressionism." Yet many of them were admired by the critics who responded to the Impressionist phenomenon, and their works appeared in sufficient numbers at these exhibitions to have a serious impact on the public's notion of what "the new painting" was all about (the catalog of the 1880 exhibition, for example, lists twelve works by Degas but more than forty by his friend, the now lesser-known but then critically acclaimed Raffaëlli).

The term "the new painting" comes from the title of a pamphlet, *La Nouvelle peinture*, which was written in 1876 by Edmond Duranty in response to the second Impressionist group show. Duranty was a novelist and critic whose interest in the modern school embraced genre and figure painting as well as landscape; and his essay was the first of its kind to be devoted at any length to a consideration of all of these currents in the new art of the time.[5] In it, significantly, Duranty did not use the words "Impressionist" or "Impressionism." Nor did those terms gain real currency at first as a group description among the artists, who acknowledged their own diversity and did not want to be labeled by a single style or concept. Degas, for example, preferred to be called a "Realist," and the only all-encompassing term that the group as a whole ever really agreed upon was "Independents."

"Impressionist" was a term picked up and popularized—first by hostile critics and then by friendly ones—from the title given by Monet to one of his pictures in the 1874 show, *Impression, Sunrise* (plate 4). By the time of the third group show in 1877, it had come to be accepted and promoted by the artists themselves as a preferable and more positive alternative to "Intransigent," a term with connotations of the politically radi-

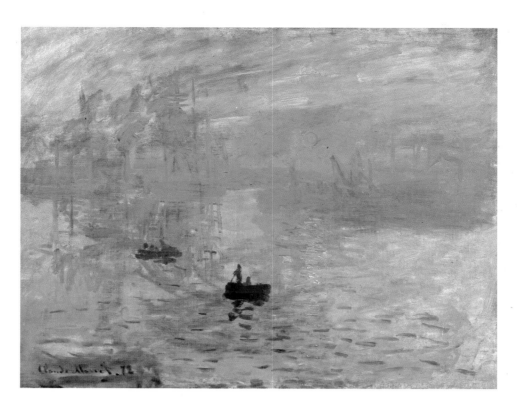

4. CLAUDE MONET. *Impression, Sunrise.* 1873. Oil on canvas,
19 × 24⅜″. Musée Marmottan, Paris

5. CLAUDE MONET. *Sunset on the Seine, Winter Effect.* 1880.
Oil on canvas, 33⅜ × 59⅞″. Musée du Petit Palais, Paris

cal and subversive that had been gaining currency in the press.[6] But the more perspicacious writers of the period quickly recognized how unsuitable "Impressionism" was as a blanket term for all of this art and were moved to make finer distinctions. In a lecture of 1879, for example, the Italian critic Diego Martelli distinguished between the peculiar, thematic modernity of artists such as Manet (who, in fact, never showed with the group) and Degas (who was one of its principle organizers and guiding spirits), and the mode of vision that characterized the artists whom he called "the real Impressionists."[7]

Monet, according to Théodore Duret in 1878, was "the Impressionist, *par excellence.*" And a quick review of the pictures that appeared at the eight original group shows would indeed suggest that it is the landscape school, represented principally by Monet but also by Pissarro, Sisley, and others, in which we come closest to finding the kinds of paintings—those plein-air recordings of natural luminary phenomena—on which our idea and ideal of Impressionism have been largely based.

Paradoxically, of the new modes of painting that were being presented at these exhibitions, it was the landscape school that was the least radical and revolutionary—in spirit and intention, if not always in style. "The Impressionists," wrote Duret in 1878, "did not come of nothing, they are the products of a steady evolution of the modern French school."[8] And the landscapes that Monet chose for these exhibitions clearly reflect that heritage, which in the French tradition can be traced back to Claude Lorrain. From *Impression, Sunrise* in the exhibition of 1874 to *Sunset on the Seine, Winter Effect* (plate 5) of 1880 from the seventh exhibition in 1882 (the last in which Monet participated), these paintings are expressions through light of a moment felt before nature. They were not designed to teach us about contemporary politics or industry.[9] Rather, they are poetic projections of the artist's most subjective and personal experiences in nature, and as such they are brilliant extensions of an earlier nineteenth-century European Romantic tradition of landscape painting, which in England was represented by Turner and Constable and in France by Rousseau, Corot, Daubigny, and others. It was this European Romantic tradition—which Monet's pure Impressionism perpetuated well into the first decades of the twentieth century—that created an affinity of spirit and sometimes of style between Impressionism in France and contemporary schools of landscape painting in Germany, Switzerland, Scandinavia, and Russia, countries where subjective and expressive traditions of landscape painting were both long-standing and still influential during the Impressionist period.

The expressive intentions of the Impressionists, when dealing with urban as well as rural landscapes and themes, were often acknowledged by their closest friends and critics, including Georges Rivière who responded to Monet's *Gare Saint-Lazare* (plate 6) at the third group show of 1877 in just such terms. "Looking at this magnificent painting," he said, "one is seized by the same emotion as before nature, and this emotion is perhaps

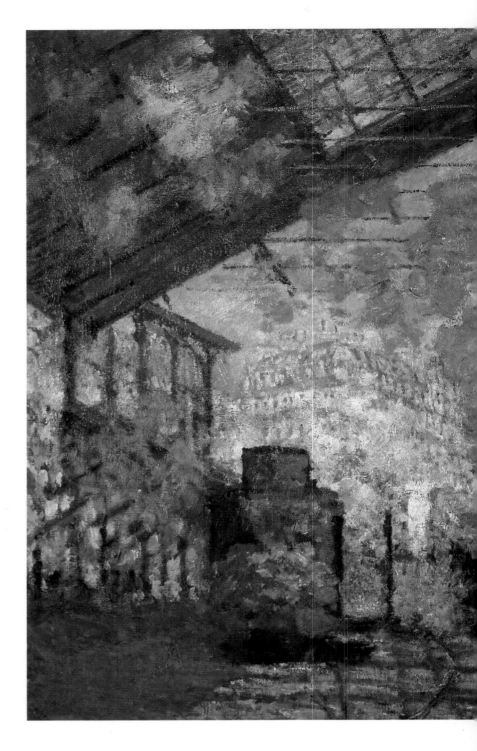

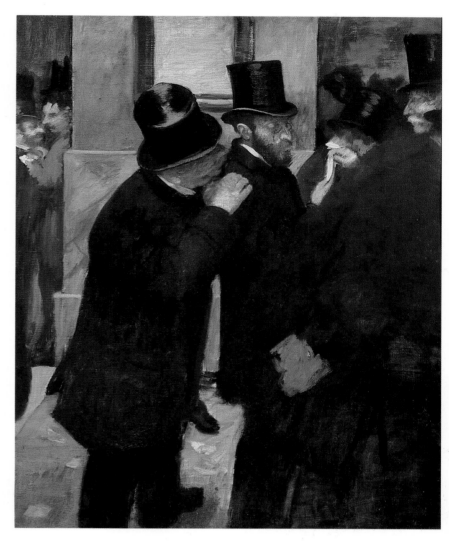

6. CLAUDE MONET. *Gare Saint-Lazare, Paris.* 1877. Oil on canvas, 29¾ × 41″. Musée d'Orsay, Paris

(above right) 7. EDGAR DEGAS. *Portraits at the Stock Exchange.* c.1879. Oil on canvas, 39⅜ × 32¼″. Musée d'Orsay, Paris

stronger still, for in the painting there is that of the artist as well."[10] Of the viewer of the Impressionists' works in general, Rivière wrote: "This painting addresses itself to his heart; if he is moved, the objective is fulfilled."[11] In thus describing the Impressionists as artists who feel and experience deeply before nature (used here broadly to signify the environment, whether rural or urban) and in his understanding of them as artists who strive to convey their personal and individual emotional experiences through their paintings, Rivière was not alone. In 1874, for example, in response to paintings at the first group show, the critic Jules Castagnary wrote of these artists: "They are 'impressionists' in the sense that they render not the landscape, but the sensations produced by the landscape."[12]

Distinct from the "real" Impressionists in these group exhibitions were the artists whose major focus was the human figure, and through it, the depiction of contemporary life. While the painters of landscape, who derived from the Romantic tradition, were usually bent on communicating their *own* experiences in nature and in the urban or suburban landscape, these artists, who were represented principally by Degas and his followers

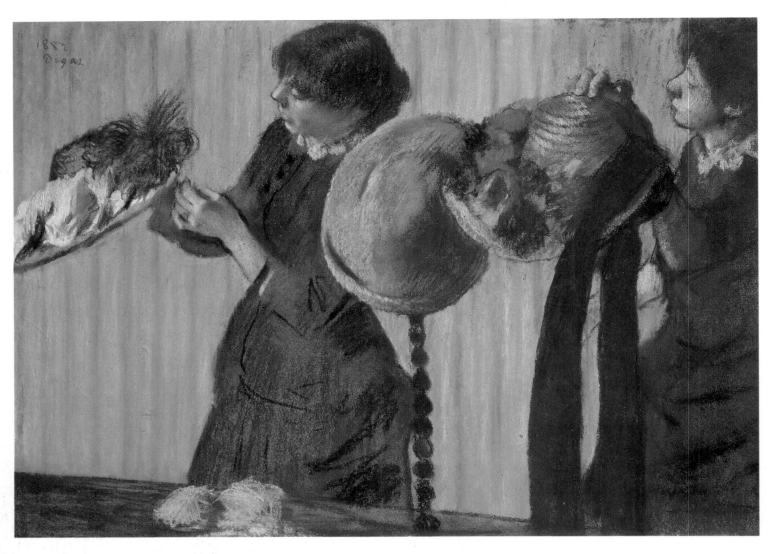

8. EDGAR DEGAS. *Milliners.* 1882. Pastel on paper, 19 × 27″.
The Nelson–Atkins Museum of Art, Kansas City, Missouri.
Acquired through the generosity of an anonymous donor

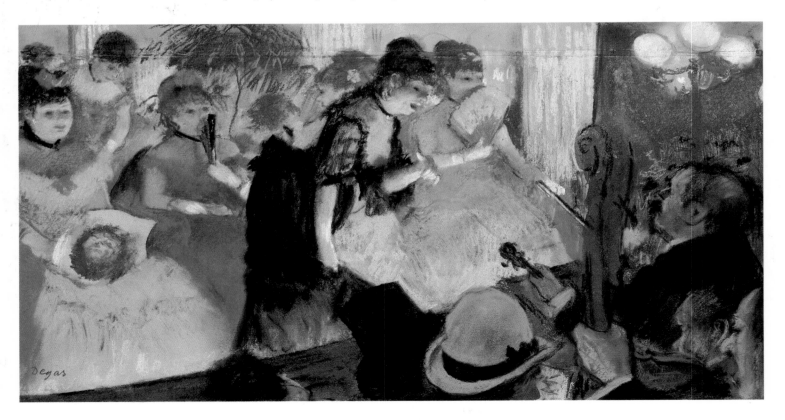

9. EDGAR DEGAS. *Cabaret.* c.1877. Pastel over monotype on
paper, 9½ × 17½″. In the collection of The Corcoran Gallery of
Art, Washington, D.C. Clark Collection

and were more nearly aligned with Realist and Naturalist currents in French art, were more concerned with understanding and communicating the experiences of their subjects in modern society. Hence their many carefully drawn pictures of contemporary men and women set against the background and in the context of their daily life experiences, with every detail of their settings as well as their actions indicating, as Duranty put it, "their financial position, class, and profession." "The individual," Duranty continued, "will be at a piano, examining a sample of cotton in an office, or waiting in the wings for the moment to go onstage, or ironing on a makeshift table."[13] Among the works from the 1876 exhibition that inspired Duranty to these comments are Degas's *Portraits in an Office (New Orleans)* and his *Dance Class* (Musée Municipal de Pau and Musée d'Orsay, Paris, respectively). These, along with many other works in this vein by Degas, such as *Portraits at the Stock Exchange* from the fourth group show of 1879 (plate 7), and the artist's many familiar representations of laun-

dresses and milliners (plate 8) are not only images of individuals set in life, but they are also striking statements of the separate worlds of men and women in the nineteenth century, seen here in their gender-stratified arenas of work and friendship. Another theme developed by Degas and taken up by many of the artists who followed him was the world of urban entertainment—scenes of the fluid interaction between spectators and spectacle at the racetracks, theaters, and café-concerts of modern Paris (plate 9).

Also in the camp of the "Realists," as Degas would have called them, was Gustave Caillebotte. Invited by Degas to participate in the second group show of 1876, Caillebotte became a principle organizer and financial supporter of the later group exhibitions, and as artist and collector he exerted a major influence, both directly and indirectly, on the international Impressionist movement. A man of independent means, Caillebotte became an important patron for many of his financially less fortunate friends. His extensive collection of their work, be-

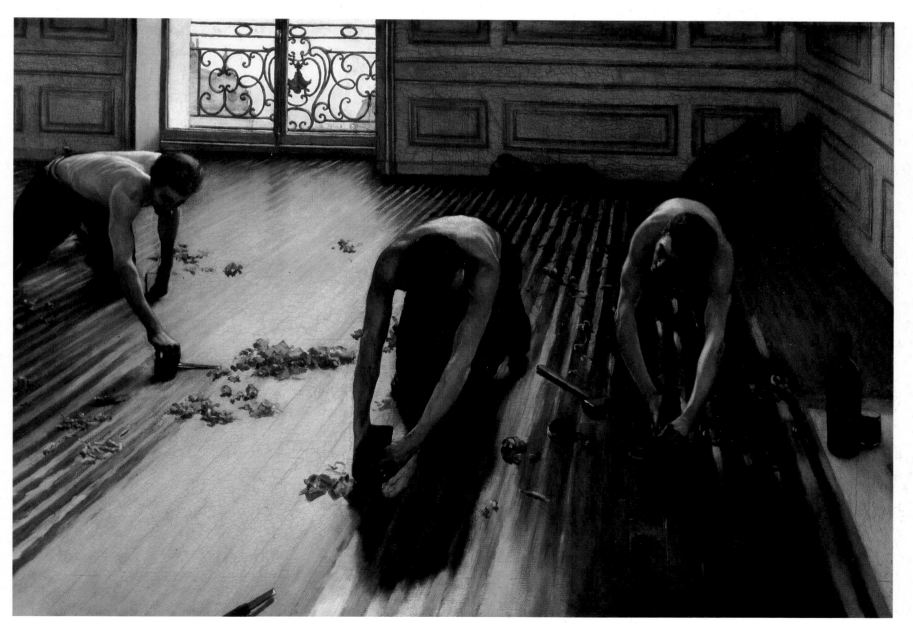

10. GUSTAVE CAILLEBOTTE. *The Floor Scrapers.* 1875. Oil on canvas, 40⅛ × 57⅝″. Musée d'Orsay, Paris

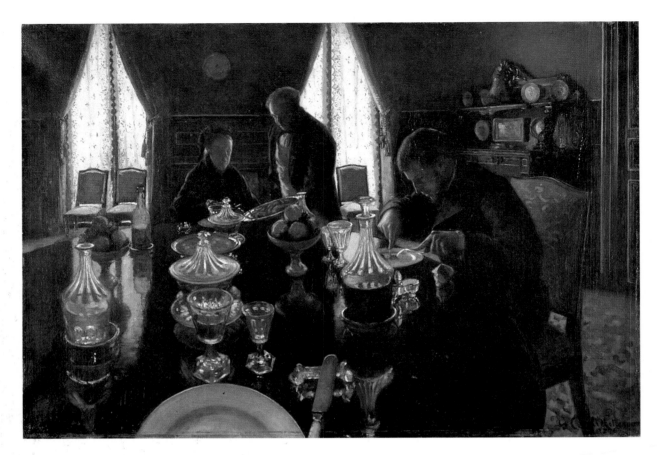

11. GUSTAVE CAILLEBOTTE. *Luncheon.* 1876. Oil on canvas,
20½ × 29½″. Private collection

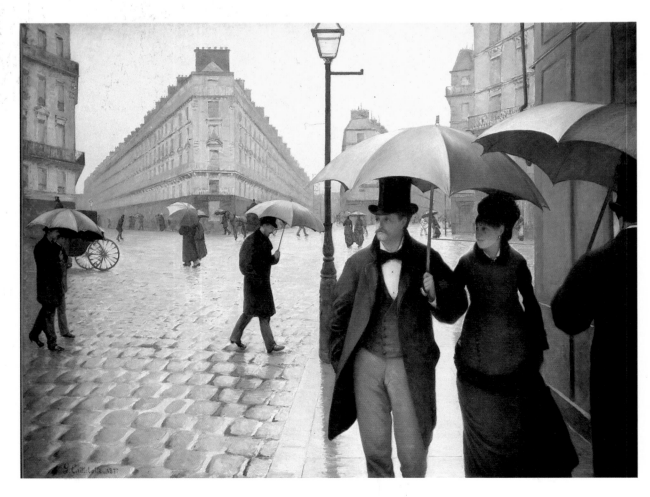

12. GUSTAVE CAILLEBOTTE. *Paris. A Rainy Day.* 1877. Oil on
canvas, 83½ × 180¾″. Charles H. and Mary F. S. Worcester Collection,
1964.336. © 1990 The Art Institute of Chicago. All Rights Reserved

queathed to the state upon his death in 1893 (but only partially accepted), formed the basis for the public collections in France of Impressionist art. His own stature and reputation as a major French Impressionist painter, long submerged by critical emphasis on the more canonical work of his colleagues, have been fully and firmly reestablished in the recent literature, where his contributions have come as an impressive revelation.[14]

In his paintings that were shown at the Impressionist exhibitions we can see the enormous range and power of Caillebotte's subject matter and style, from the incisive realism of *The Floor Scrapers* in the 1876 show to the visual wit and urban sophistication of *Le Pont de l'Europe* (1876; Petit Palais, Geneva), shown in 1877, and the quiet intimacy of *Luncheon*, painted and exhibited in 1876 (plates 10 and 11). These are works that poignantly reflect the changing manners and modes of public and private life in the urban metropolis. *Luncheon*, for example, presents the private space of the upper-middle-class home. Its setting, in fact, is the apartment that the artist shared with his mother and brother, who are depicted in this surprisingly intimate but also strangely claustrophobic scene of *haute bourgeois* family life. The character of this and other private interior spaces painted by Caillebotte contrasts vividly with his images of the broad and open public spaces of contemporary Paris, where men and women move about and interact casually and with a new, exhilarating freedom (plates 12 and 14). The recently redesigned boulevards and public spaces of the great city (part of the modernization project undertaken in the 1850s and 1860s by Baron Haussmann, prefect of the Seine under Napoleon III) now seemed to set the tempo of modern life.[15] These public spaces themselves become a spectacle of endless fascination for the men—and less frequently the women—in Caillebotte's paintings. These figures often look down in silent meditation from their windows upon fragmented vistas created by the complex intersection of the boulevards below (plate 13); or they regard the passing parade from the balconies of their apartments, spaces that seem both literally and symbolically to mediate these private and public worlds (plate 14).

Caillebotte's style, like his vision of bourgeois life in the modern city, combines the new and the old in thoroughly modern ways. His pictures are carefully drawn, hard-edged, and compelling in their illusionism, and they were painted in a relatively traditional way. They were not spontaneous, plein-air productions, but were normally based on a complex series of drawings and oil sketches in which the perspective layout of the spaces and the positions of the figures within those spaces were carefully constructed. Even more than in the work of Degas, perspective—exaggerated and used as a tool of both objective spatial organization and dramatic subjective expression—is integral to the effect that these paintings have on us. Caillebotte's subjective manipulations of the science of perspective were partially inspired, as in the case of Degas, by Japanese prints and by the parallel stimulus of photography. But the far more radical exag-

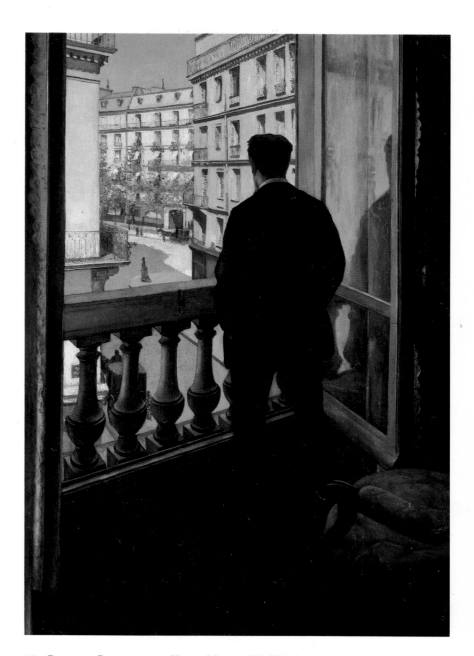

13. Gustave Caillebotte. *Young Man at His Window.* 1876. Oil on canvas, 45¾ × 31⅞″. Private Collection

geration of Caillebotte's handling of perspective also finds parallels in the work of contemporary Italian painters such as Giuseppe De Nittis and Telemaco Signorini and may even have taken some inspiration from these sources.[16] Caillebotte's brand of Impressionism was certainly congenial to the point of view of a surprising number of foreign artists who visited Paris and who were impressed by "the new painting," as comparisons between his works and those of such artists as the American Childe Hassam (plate 59), the Norwegian Christian Krohg (plate 380), and even Edvard Munch (plate 15) will attest. Indeed, Munch's Impressionist and later works, as Kirk Varnedoe has shown, may owe much to the example and the influence of Caillebotte.[17]

In the 1930s, in a ground-breaking and influential essay, Meyer Schapiro linked the new, random, fluid, and open style of Impressionist painting with the charac-

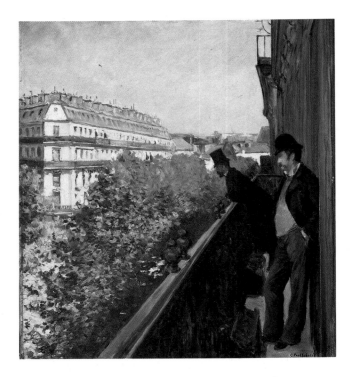

14. GUSTAVE CAILLEBOTTE. *A Balcony, Boulevard Haussmann.* 1880. Oil on canvas, 26¾ × 24″. Private collection

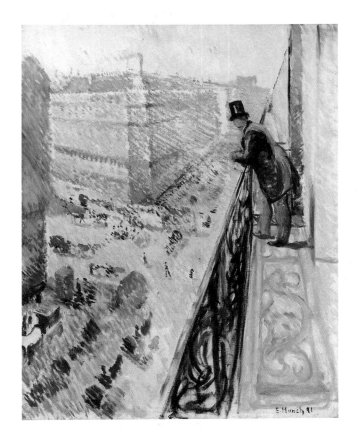

15. EDVARD MUNCH. *Rue Lafayette.* 1891. Oil on canvas, 36¼ × 28¾″. Nasjonalgalleriet, Oslo

ter of the subject matter that the style supports, pointing in particular to the random movement and fluidity of social interaction to be found in Impressionist scenes of middle-class urban and suburban leisure and recreation in outdoor settings.[18] Since then, Impressionist painting has become almost exclusively associated in the public mind with this thematic realm. But in recent years, art historians have begun to recognize and to stress the very important role that the theme of work plays in Impressionist art—not only in the paintings of Camille Pissarro, who, among these artists, most conspicuously continued the Barbizon school tradition of painting rural peasants and laborers (plates 16 and 17), but also in the work of Degas and Caillebotte, whose paintings of laundresses and milliners, floor scrapers and house painters at work extended and developed the Naturalist theme of urban labor as a subject for contemporary art. As Linda Nochlin has observed, even the ballet dancers, café singers, prostitutes, and barmaids painted by Degas and Manet are workers, female workers who labor to make possible the leisure time and recreational activities of others (plate 9).[19] Berthe Morisot's images of a wet nurse and washerwomen outdoors are also images of contemporary labor (plate 18); but their identity as such has long been masked by society's tendency to subsume such labor by women into the realm of domesticity.[20]

Berthe Morisot was one of three women who exhibited on a fairly regular basis with the group of independent artists. She participated in all of the shows except the seventh; the American Mary Cassatt (discussed below; chapter 1), participated in the fourth through the eighth; and Marie Bracquemond (less well known until recently) in the fourth, fifth, and eighth. Although their works were on the whole relatively well received by contemporary critics, their art often played an important role in helping to define what was most aggressively "new" about "the new painting." In the fifth show of 1880 in particular, where all three of the women artists were represented, their work alone carried (in the face of the defections of Monet and Renoir) the bravura painterliness associated with the group. But even within the context of avant-garde Impressionism, the extreme lightness of palette and brushwork that already characterized Morisot's style by the mid-1870s was extraordinarily daring and innovative at this early date, as the juxtaposition of her work with that of Pissarro confirms.

In the late 1870s, Marie Bracquemond's fascination with the coloristic effects of sunlight on white gave rise to paintings such as the *Woman in White* (plate 20) and the more fully realized *On the Terrace at Sèvres* (plate 19), both of which appeared in the 1880 exhibition.[21] Although inspired to paint ambitious canvases like these outdoors by the example of Monet and Renoir (plates 1 and 2), Bracquemond was an artist who approached the interpretation of her human subjects with far greater empathy for their individuality than is normally found in the work of either of her plein-air mentors. The "woman in white," seen outdoors in a garden or at the seashore, soon became an archetypal Impressionist

A WORLD IN LIGHT

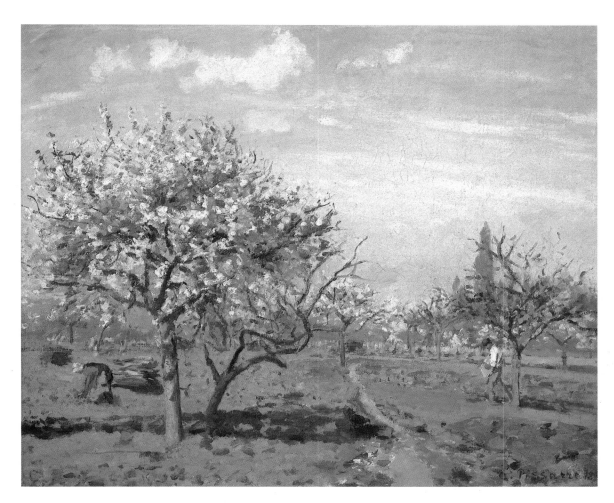

16. CAMILLE PISSARRO. *Orchard in Bloom, Louveciennes.*
1872. Oil on canvas, 17¾ × 21⅝″. National Gallery of Art,
Washington, D.C. Ailsa Mellon Bruce Collection

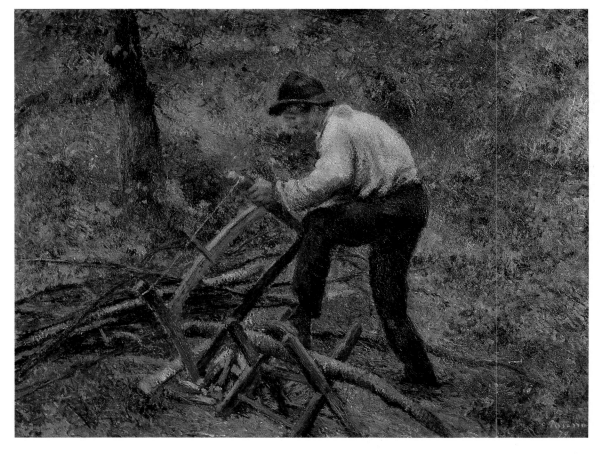

17. CAMILLE PISSARRO. *Père Melon Sawing Wood, Pontoise.*
1879. Oil on canvas, 35 × 45¾″. The Robert Holmes à Court
Collection, Perth, Western Australia

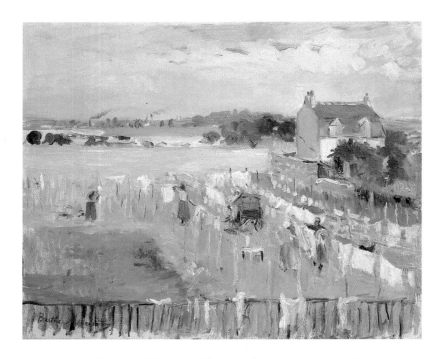

18. BERTHE MORISOT. *Hanging the Laundry out to Dry*.
1875. Oil on canvas, 13 × 16″. National Gallery of Art,
Washington, D.C. Collection of Mr. and Mrs. Paul Mellon

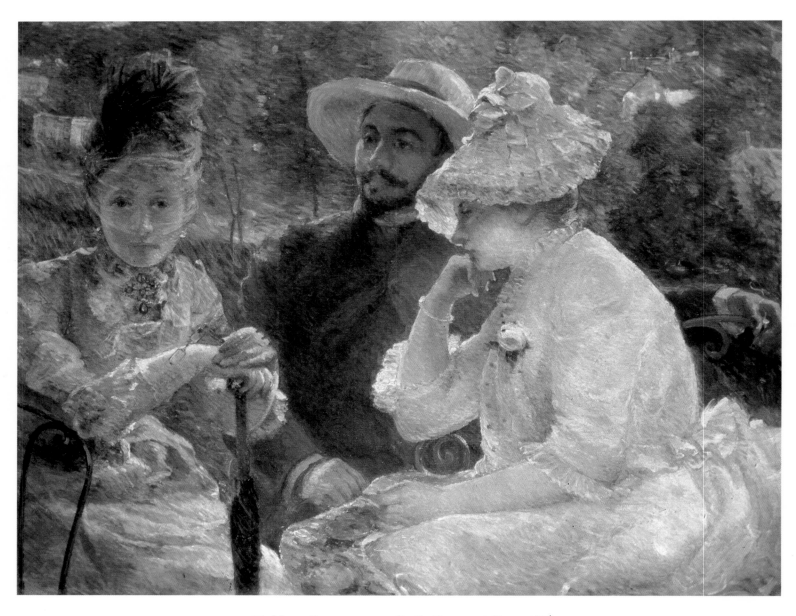

19. MARIE BRACQUEMOND. *On the Terrace at Sèvres*. 1880.
Oil on canvas, 35⅝ × 45¼″. Petit Palais, Geneva

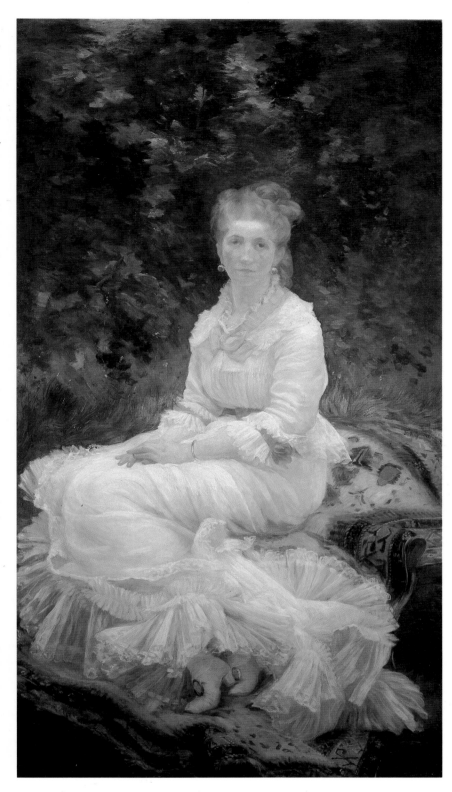

20. MARIE BRACQUEMOND. *The Woman in White*. 1880. Oil on canvas 70⅞ × 39⅜". Musée de Cambrai

motif around the world. It was attractive to artists who found in it the perfect vehicle for investigations of the formal properties of reflected light and color, and it found favor among patrons who sought in its display of the upper-middle-class ideal of passive femininity an affirmation of their social aspirations and status.

The artists who were most active as organizers and sponsors of the eight original group shows are among those who have become most familiar to us today as "The Impressionists." The politics among them and their sometimes conflicting goals for their association helped to determine the composition and character of each of the original exhibitions. Pissarro was the only artist who showed at all eight of the exhibitions. In 1879 Renoir defected when Degas introduced the rule that none of the exhibitors could send works to the Salon, and in 1880 Renoir was joined by Monet. In 1881 Renoir, Monet, and Sisley submitted paintings to the Salon, and they as well as Caillebotte (who disapproved of many of the artists whom Degas was bringing to the group) did not participate in the Impressionist show. But in 1882 Caillebotte and Renoir returned, and it was Degas and his friends (Cassatt, Raffaëlli, Forain, and Zandomeneghi) who were absent from the show. In 1886, at the insistence of Pissarro, the last group show remained a forum for the new and admitted the works of Georges Seurat and his followers (plate 251). But considerable dissension resulted, and Monet, Renoir, and Sisley (whom Pissarro began to refer to, disparagingly, as "the romantic impressionists"), left the group, distressed by the scientific proclivities of the newcomers and the apparent impersonality of their style.

Although Édouard Manet never exhibited with the Impressionists at their independent exhibitions, he was widely regarded by the critics, the public, and many artists to be the titular head of the new group and the symbolic representative of the new values that it represented.[22] Henri Fantin-Latour's *A Studio in the Batignolles Quarter* of 1870 (plate 21) is in essence a homage to Manet, who is presented as a dignified and elegant figure, seated at his easel and surrounded by such critical supporters as Zacharie Astruc and Émile Zola, as well as by younger followers, including the German painter Otto Scholderer (a friend of Fantin's, standing in the background to Manet's left), Renoir (standing to his right), Monet (the shadowy figure at the far right), and Frédéric Bazille (the tall figure who stands in profile in the right foreground). And in Bazille's far more casual and informal rendering of friends gathered in his own studio, painted in the same year, it is once again Manet who is given the place of honor and authority, flanked by Monet to the left and Bazille to the right, as he observes and perhaps critiques the work that is being displayed for him upon the easel (plate 22).

With his pioneering and influential painting of 1862, *Music in the Tuileries* (plate 23), it was Manet who had finally fulfilled Charles Baudelaire's long-standing quest for the true "painter of contemporary life," an artist who could interpret the very essence of modernity,

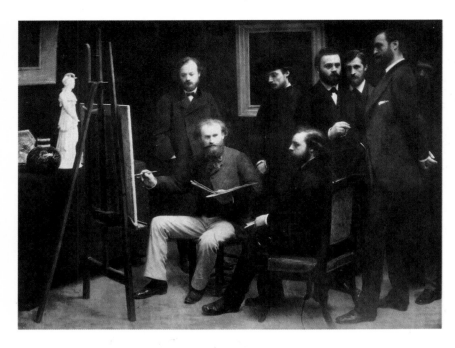

21. HENRI FANTIN-LATOUR. *A Studio in the Batignolles Quarter.* 1870. Oil on canvas, 80¼ × 107⅝″. Musée d'Orsay, Paris

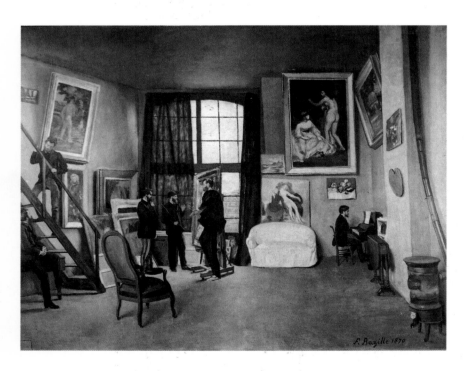

22. FRÉDÉRIC BAZILLE. *The Artist's Studio.* 1870. Oil on canvas, 38½ × 50½″ Musée d'Orsay, Paris

conceived, in Baudelairian terms, as "the transitory, the fugitive, the contingent."[23] Unlike earlier paintings by Courbet, Millet, and Daumier that are based on contemporary life, Manet's picture takes as its subject the world of fashionable Parisian society. This is Manet's own social milieu, into which he sets himself (at the far left), along with such friends as Baudelaire, Antonin Proust, the writer Théophile Gautier, and the composer Jacques Offenbach, members of an elegant crowd of people who sit or stroll about and converse with animation as they listen to an afternoon concert in the public gardens of Paris. The realism explored here was of a new kind. It is the realism of an artist who assumes the position of the Baudelairian flaneur, the urbane and uninvolved boulevard stroller, who casually observes and portrays contemporary Parisian life with a fresh eye for those things that are momentary and episodic in the passing parade. While such subjects and point of view had their precedents in eighteenth-century engravings as well as in nineteenth-century newspaper illustrations (for example, the drawings of Baudelaire's favorite, the popular illustrator Constantin Guys), never before Manet's painting had the sensations of the contemporary flaneur experience been given such immediacy and force, its character virtually heroicized on the scale of an official Salon painting.

Displayed for the first time in 1863 at the private exhibition that was Manet's first one-person show and seen on that occasion by Monet and Bazille, *Music in the Tuileries* was an important and prophetic picture for the next generation of painters, not only because of its new subject and attitude, but also because of its style, a style that flattened forms, suppressed halftones, and emphasized linear silhouettes, partly in response to the seventeenth-century Dutch and Spanish painters whom Manet admired, but also as an early response on his part to the Japanese print.[24] Although Manet is reported to have made studies for his work in the Tuileries Gardens,[25] his large canvas was composed and painted in the studio, structured traditionally on a tonal armature, without regard for the atmospheric and luminary verisimilitude that would soon preoccupy his younger admirers, including Claude Monet.

Monet's ambitious project to paint a contemporary *Déjeuner sur l'herbe* on a monumental scale, undertaken in 1865–1866, must have been conceived, at least in part, as a challenge to and extension of Manet's earlier work. While Monet's twenty-foot-wide, studio-painted canvas survives only in fragmentary form, a smaller-scale compositional study (plate 24), itself based on studies of figures and landscape settings made outdoors in the Forest of Fontainebleau, suffices to show what Monet was now trying to accomplish.[26] In this scene of contemporary leisure, with flickering patterns of sunlight and shadow filtering down through a canopy of trees overhead and with its light-drenched atmosphere and bright colors applied everywhere in irregular, patchlike formations, Monet was attempting to translate the direct optical experience of nature and its unifying light, via plein-

A WORLD IN LIGHT

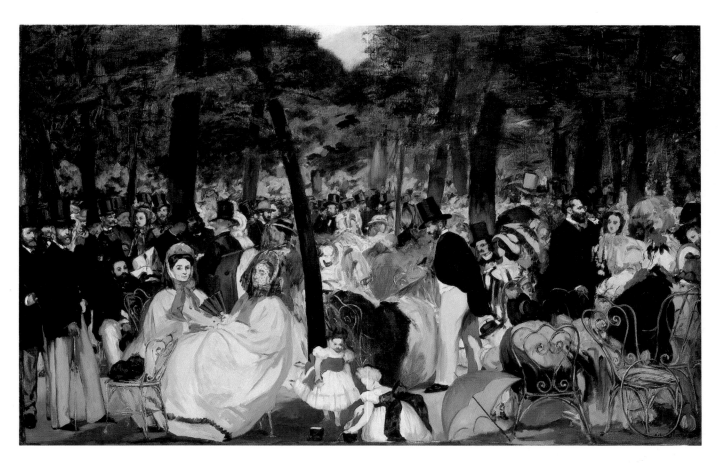

23. ÉDOUARD MANET. *Music in the Tuileries.* 1862. Oil on canvas, 30 × 46½″. The National Gallery, London

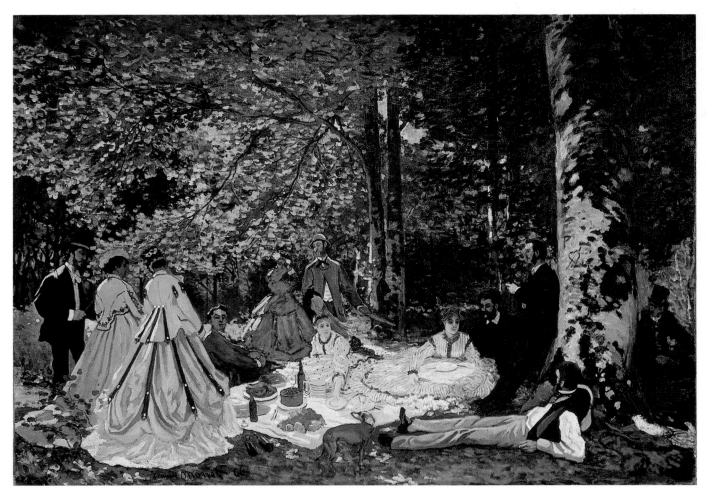

24. CLAUDE MONET. *Déjeuner sur l'herbe (Study).* 1865. Oil on canvas, 51 × 71¼″. Pushkin Museum, Moscow

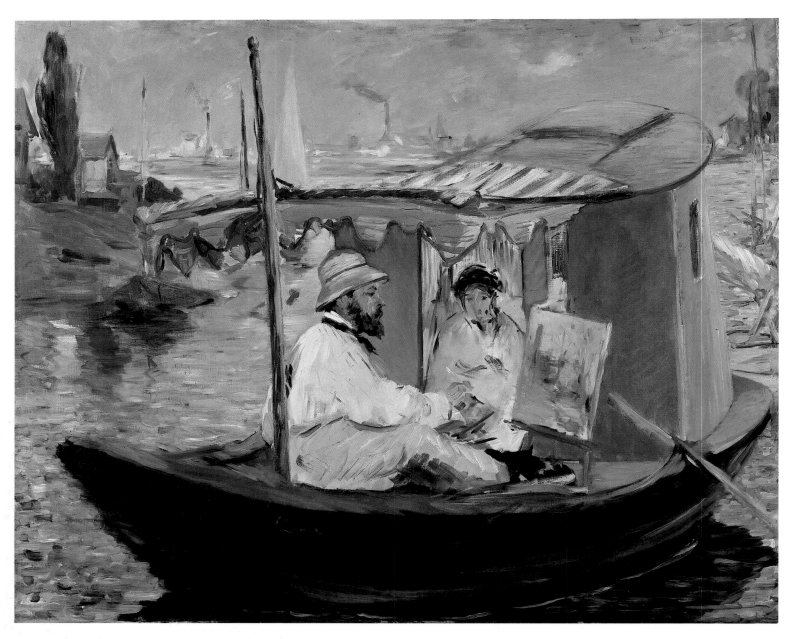

25. Édouard Manet. *Monet Painting in his Studio Boat.*
1874. Oil on canvas, 32½ × 39½″. Bayerische Staatsgemälde-
sammlungen, Munich

air studies, into a huge finished canvas, a canvas that by
virtue of its very size would proclaim the aesthetic valid-
ity of the plein-air experience for the making of serious
art. Already incipient here is the mode of visual atten-
tiveness that Monet later made the basis for his mature
plein-air practice and that he described many years later
to the American painter Lilla Cabot Perry in the follow-
ing terms: "When you go out to paint," he said, "try to
forget what objects you have before you—a tree, a house, a
field, or whatever. Merely think, here is a little square of
blue, here an oblong of pink, here a streak of yellow, and
paint it just as it looks to you, the exact shape and color,
until it gives your own naive impression of the scene
before you."[27]

Throughout the 1860s, nevertheless, Monet
showed considerable ambivalence over the proper dis-
tinction to be made between a sketch done in a single
sitting before nature and a finished work of art, a prob-
lem that was a central one for artists throughout the
world in the nineteenth century. And it was not until the
mid-1870s that he began to formalize the practice that
would become his answer to this dilemma: the practice of
returning to a site repeatedly, sometimes over a long
period of time, in order to continue work there on a
painting—but only when he encountered the closest pos-
sible recurrence of the atmospheric and luminary condi-
tions under which he had begun the picture. This was a
procedure that allowed Monet to be true to the luminary
moment, the effect, that had inspired his initial
response—his impression—and at the same time to cre-
ate, in a surprisingly traditional sense, a balanced and
finished work of art.[28]

A WORLD IN LIGHT

Thus, pictures begun and usually finished out-of-doors after many sessions were considered to be complete by Monet. But there is ample evidence, at least from the early 1880s on, that Monet would put finishing touches on his canvases back in the studio.[29] This practice became particularly important for his later works, which were often exhibited as "series" and therefore retouched by the artist in order to provide them with coherence and unity as a group. But despite this important aspect of his practice, by the turn of the century Monet's identity as an Impressionist had already become very much bound up in the public mind with the purity of his plein-air practice, so much so that when he was accused of using photographs rather than nature as the source for some of his works, he wrote to his dealer Durand-Ruel in 1905 to deny the charge, adding angrily: ". . . whether my cathedrals, my Londons and other paintings were made from nature or not is nobody's business and is not important. I know many painters who paint from nature and who do only horrible things. That is what your son should tell those men. The result is everything."[30]

Nevertheless, by 1874, the year of the first Impressionist group exhibition, Monet, Renoir, Pissarro, and Sisley had become firmly committed, in the broadest sense, to the outdoor painting of landscape; and it was the strength of this commitment that set them clearly apart from the more figure-oriented and still studio-focused practice of their admired friend Manet. Although Manet chose to exhibit at the Salon and not with the Independents in the spring of 1874, he visited Monet at Argenteuil that summer and documented the latter's procedures in an unusual plein-air work of his own, a study that shows Monet painting outdoors on his studio boat, anchored in the middle of the river (plate 25). Open here to recording the sparkling reflections of sunlight on the water's surface, Manet paints with a lighter and brighter palette and with a comparatively more broken and flickering brush stroke than had formerly been his practice.

And the impact of such plein-air experience did indeed make itself felt in Manet's style of the 1870s. But it did not alter the essential character of his normally

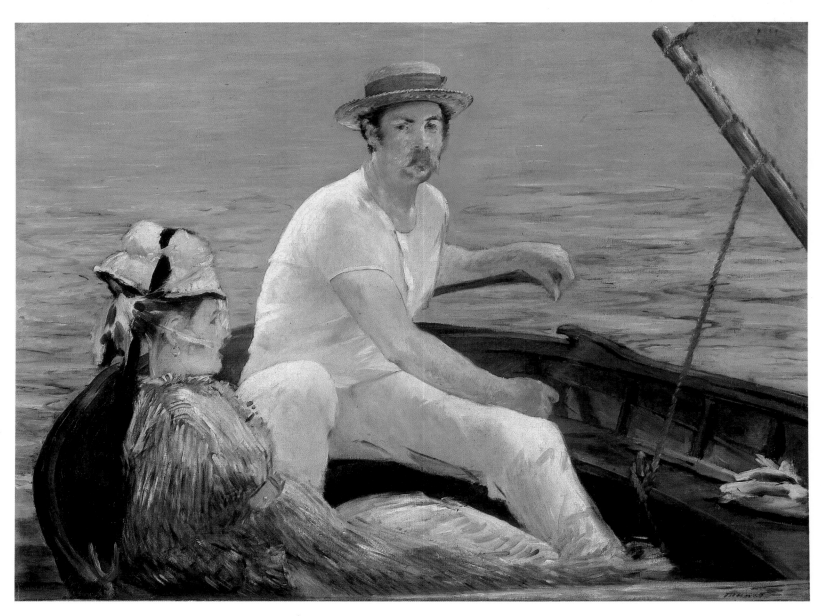

26. ÉDOUARD MANET. *Boating.* 1874. Oil on canvas, 38¼ × 51¼". The Metropolitan Museum of Art, New York City. Bequest of Mrs. H.O. Havemeyer, 1929. The H.O. Havemeyer Collection (29.100.15)

studio-painted and larger finished works. In *Boating* of 1874—a painting that was exhibited in 1879 at the Salon, where Manet continued to seek a traditional forum for his work (plate 26)—Manet adopts the outdoor river setting and tonalities of the Impressionists for a contemporary scene. His focus is neither the light nor the landscape, however, but rather the figures, clearly drawn and silhouetted against the broad expanse of the water behind them. The local colors of water and wood are painted in broad tonal oppositions and as relatively unmodulated hues, without the infinite variety of color that one of the "real" Impressionists might have been inclined to observe and record. But the natural movement of contemporary life is nevertheless here—the "slice-of-life" captured, monumentalized, and contrived to appear uncontrived, as the boat and its passengers, viewed up close and radically cropped by the frame in the manner of the Japanese print, threaten to drift away beyond our field of vision. Through such unique combinations of the traditional and the vanguard, both Manet and Degas were able to present "the new painting" from Paris in a form accessible to those artists who, like themselves, had received traditional training and remained studio-focused.

## The Experience of Foreign Artists in Paris: The Influence and the Afterlife of French Impressionism

The Impressionist movement emerged in Paris in the early 1870s, during the years immediately following the traumatic events of the Franco-Prussian War and the Paris Commune. Ignominiously defeated in 1871 by the Prussians, who had marched through Paris and subsequently annexed Alsace-Lorraine, and then torn apart by the bloody events of the Commune, France experienced a conservative political backlash in the 1870s, marked by a renewed alliance between church and state, an exaggerated fear of the loss and destruction of traditional values, and a middle-class determination to suppress revolutions of all kinds. The art of the French Impressionists of course cannot be construed as "political art," in the sense that the work of David or Daumier may be said to be political in theme and intention. What in fact is striking is the extent to which French Impressionism seems at every turn to deny and ignore the tension-ridden spirit of the postwar culture in which it first found its public voice. But the political climate of that period does help us to understand the overreactions that attended upon the reception of the new movement—the vehement resistance and exaggerated ridicule with which these so-called "Intransigents" and their art were initially met in conservative quarters.

The general xenophobia that persisted in France in the aftermath of the Franco-Prussian War also provides an important context for understanding the experiences of many of the foreign artists who flocked to Paris in increasing numbers during the last decades of the century in order to seek wider markets for their work and to imbibe the principles of "the new painting" at its source. Bitterness against the Germans as well as the Prussians led, understandably, to their virtual exclusion from both conservative and avant-garde artistic circles in France after the war, as Horst Uhr explains below (chapter 11). Yet surprisingly few foreign artists of any nationality had direct contact with the French avant-garde. There were exceptions to the rule. In the 1870s and 1880s, the Italian painters Zandomeneghi and De Nittis, recruited by Degas, who had strong ties with Italy, participated in some of the original Impressionist group exhibitions; but they had very little support and even experienced direct hostility from their other French colleagues. The American Mary Cassatt, also a protégée of Degas, was a staple member of the group throughout this period. After 1885, Degas became an important friend and influence for the English painter Walter Sickert. In the late 1880s and 1890s, the American painters John Singer Sargent, Lilla Cabot Perry, and Theodore Robinson worked with Monet at Giverny. And in the first decade of the twentieth century the Japanese painter Umehara Ryuzaburo, who had gone to France to study, met and struck up a close friendship with Renoir.

More typically, as the essays that follow will show, many of the foreign artists who would go on to develop Impressionist styles in their homelands came to Paris initially with the hope of studying at the École des Beaux-Arts or with conservative painters whose styles had been affected to a limited extent by Realism and Impressionism—painters such as Jules Bastien-Lepage, Léon Bonnat, Jean-Léon Gérôme, Émile-Auguste Carolus-Duran, Raphaël Collin, and Jean-Paul Laurens, all of whom enjoyed considerable international reputations during these decades. Many of these foreign artists had studied first in Munich and had been exposed to the Realist subjects and dark palettes popularized by the Munich School earlier in the century. In Paris, they enrolled in great numbers at the Académie Julian, a private academy staffed by well-known academic painters, which offered a popular, more open, and flexible alternative to the state-run École. As foreigners in France, most tended to band together socially and professionally in national groups, both in Paris and at the increasingly popular artists' colonies outside of Paris where they would go to escape their academic studios and to make plein-air studies (a practice that had become an established one for art students in France ever since the Barbizon era)—the Russians at Veules in Normandy, the Scandinavians and later the Japanese at Grèz-sur-Loing, and the Americans and Canadians at Grèz and Giverny.

While many were aware of the Impressionists and their work, which they admired for its innovative spirit and the lively immediacy of its brushwork, those who came from native traditions that stressed drawing and the integrity of expressive forms were often ambivalent

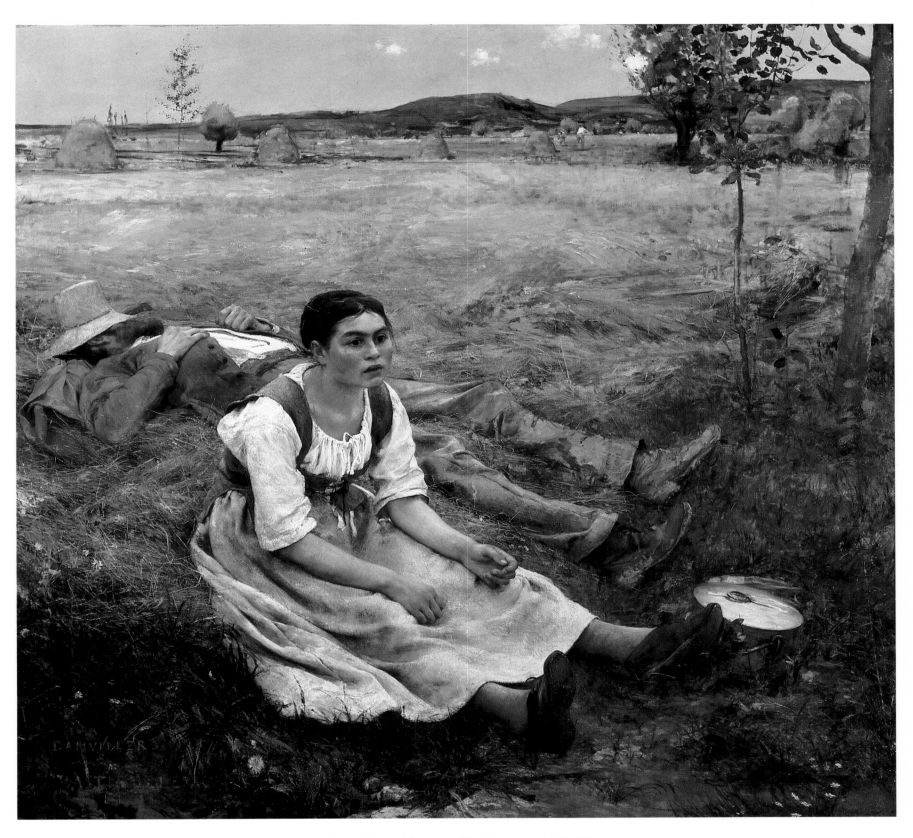

27. JULES BASTIEN-LEPAGE. *The Harvesters.* 1877. Oil on
canvas, 70⅞ × 76¾″. Musée d'Orsay, Paris

about the stylistic "excesses" and unorthodoxies of the new French style. These artists often found an acceptable and inspirational alternative in the work of Jules Bastien-Lepage (1848–1884), a painter whom Degas deprecatingly referred to as "the Bouguereau of the Naturalists."[31] Trained under Cabanel at the École des Beaux-Arts, Bastien appreciated and was influenced in various ways by the work of Millet, Courbet, and Manet. He became widely known and acclaimed for his peasant subjects, which he often set against the open landscapes of northeastern France, where he was born and where he worked for most of his life. *The Harvesters*, shown at the Salon of 1878, marked the beginning of his meteoric rise and is representative of his style (plate 27). Bastien typically treated his peasant subjects with a selective optical realism that brought portions of foreground figures and foliage into exceptionally sharp focus but treated background landscape elements in a more summary manner. Although he usually avoided bright colors, his surprisingly convincing illusions of ambient light and his emphasis on painting the landscapes of his own region *en plein air* appeared to align him with the avant-garde, while the clarity of his drawing and the expressive pathos of his figures satisfied more conservative tastes as well. Similarly, the vivid brushwork and emphatic tonalities of Bastien's *Little Bootblack in London* of 1882 (Musée des Arts Décoratifs, Paris) would seem to owe much to Manet (for example, *The Fifer* of 1866; Musée d'Orsay). But the engaging and sentimental interpretation of the figure made Bastien's painting far more accessible and appealing than Manet's works for most viewers at the time. Although admired worldwide in the late nineteenth century, Bastien had a particularly strong impact on Russian, Scandinavian, and British painters. They responded to the expressive poetry with which he treated his often stark themes of peasant life, as in the much-admired *Poor Fauvette* (1881; Glasgow Art Gallery and Museum) exhibited in London in 1882 and reputed to be Bastien's best-known and most influential work in Britain.

In surprising numbers, foreign artists in Paris exhibited at the Salon and won medals and prizes for their efforts.[32] Few, however, could be described as genuine expatriates. For even though they might elect to stay in Paris, in some cases for almost a decade or more—like the Japanese painter Kuroda Seiki or the Norwegian Harriet Backer—most eventually returned home, fired in many instances by an almost moral need to bring back to their native countries what they had learned and to use it, for different reasons and in different ways, in the service of a national identity and a national art. Often they established artists' colonies on the models of their French experience to promote the practice of plein-air painting—for example, the Danish artists at Skagen, the Belgian Luminists at Astène, the English painters at Bosham and Amberley, the Australians at Box Hill and Eaglemont, the Americans at Old Lyme and Cos Cob in Connecticut and at Shinnecock on Long Island. Invariably, they faced a problem of adaptation and often found

themselves working simultaneously both within and against established plein-air traditions in their native countries. And in exceptional cases, like the Japanese, as J. Thomas Rimer explains (chapter 5), the task for these Paris-trained artists of reintegrating themselves both aesthetically and socially within the cultural traditions that prevailed in their homeland was not only extremely difficult but often traumatic.

It is remarkable to see in the following essays how often the development of an Impressionist style or attitude—Impressionism here being defined in the broadest sense as painting that emphasizes contemporary life, light, and color, whether influenced directly by the French or growing independently out of indigenous sources—was tied to or coincided with nationalist aspirations and the formation of national identities in many parts of the world in the late nineteenth century. For artists in emerging nations—for example, Italian artists in the decades following national unification in 1861, Australians in the years leading up to their independence from Britain in 1901, Belgians celebrating in the 1880s their fiftieth anniversary of independent statehood during a decade of social unrest and crisis, Finns ardently supporting the pro-Finlandia movement of the late nineteenth century after centuries of Swedish and, since 1809, Russian rule, Norwegians chafing under Swedish control, and the Swiss, politically unified as a nation in 1815 but continuing to struggle throughout the century with inherited cultural and linguistic disparities—for these artists, to record directly out-of-doors the unique and particularized light of the homeland, to articulate in painting the special character of its landscapes, both rural and urban, was to celebrate and to affirm their country's national identity in specifically and often self-consciously political ways.

For these artists and for others, what the style of Impressionism (now taken in its avant-garde French form) meant principally was freedom, a freedom that was personal as well as political; and herein lay its remarkable appeal to artists who came from a wide variety of cultures in the late nineteenth century. For those who had been trained in the European tradition, the individualistic and responsive style of French Impressionism could signify, most obviously and in the broadest sense, a new freedom from academic constraint. This newfound freedom had a special and extended meaning in Japan, where Impressionism, as an art that could convey individual personality and the sensations of the moment, confronted an ancient and diametrically opposed tradition and opened up new avenues of expression for artists who returned from Paris to work in this mode. Even though these artists might experiment with a variety of styles and techniques later on in their careers, the enduring legacy of Impressionism in Japan, as Rimer describes it, was to encourage independence and to empower artists there to pursue an individual vision of the world, and from this course, he says, they never wavered. Freedom in another specialized sense was a pivotal part of the meaning of Impressionism for British artists, given the

high priority of convention and the strictures of social class in their culture. In Impressionism's thematic celebration of urban life and freedom, these artists, as Gruetzner Robins explains (chapter 2), found liberation from the anecdotal and moralizing norms of Pre-Raphaelite and Victorian painting, as the boundary between conventionally acceptable and unacceptable subject matter suddenly shifted with the influence of French Impressionism.

Influences during the Impressionist era, of course, did not flow only from one source and in one direction—that is to say, only from France out to the rest of the world. French Impressionism, in fact, might never have come into being as we know it without the cumulative impact that the art of Holland, England, Spain, Italy, and Japan had on the development of painting in France during the nineteenth century. Seventeenth-century Dutch landscape and genre painting was enormously popular among artists and collectors in France in the nineteenth century and provided an important precedent and inspiration for the work of the Barbizon painters, the Realists, and the Impressionists (Troyon, Daubigny, Courbet, Manet, Monet, and Pissarro all made pilgrimages to the Lowlands).[33] Early nineteenth-century English landscape painting, itself partly dependent on the Dutch tradition, was another formative influence on the developing French landscape school; and the art of Constable and Turner had a direct impact on Monet and Pissarro when these artists took refuge in London during the Franco-Prussian War.[34] Seventeenth-century Spanish painting, well represented in public and private collections in France during the nineteenth century, was a decisive stylistic influence for many French painters during this period, most notably Manet.[35] Italian art and the classical tradition were of critical importance for Degas. And from the 1860s on, the impact of the Japanese color-block print on artists first in England and France and then all over Europe was responsible for sweeping renovations of traditional modes of Western pictorial design and spatial organization.[36] Therefore, it is important to keep in mind that artists from these countries who were attracted to French painting during the Impressionist era were responding to an art that already reflected, to a very great extent, significant aspects of their own cultural heritage and taste. If Kuroda Seiki's *Chrysanthemums and European Ladies* (plate 178) reminds us of Degas's *Woman with Vase of Flowers* (traditionally known as *Woman with Chrysanthemums*; plate 28), it is not necessarily because Kuroda's asymmetrical composition was derived from Degas's, but because Degas's daring and unconventional composition had in its turn been inspired by a Japanese aesthetic, one that Degas as a Western artist adapted to the needs of an expressive and psychologically probing portrait, as did the German Impressionist painter Lovis Corinth when he painted the portrait of his daughter *Wilhelmine with Flowers* in 1920 (plate 461). (The long-standing and otherwise mystifying misidentification of the flowers in Degas's picture as chrysanthemums—the imperial flower of Japan—must in some way reflect an acknowledgment on the part of Western observers of this cultural debt.)

Given the complexity of the cultural interactions that shaped art during the Impressionist era, we are left to wonder why it was that Paris was so universally perceived as the center of the art world during this period. And given the widespread impulse among artists in the late nineteenth century toward an art that emphasized contemporary life, light, and color, why was it that the French school—and the French school alone—achieved and maintained international preeminence as the ideal and uniquely authentic embodiment of the Impressionist attitude? The role of the French as stylistic innovators is of course not to be denied. But answers to these questions may also be sought productively in other realms, in particular in the changing market forces and systems that affected the production, dissemination, and evaluation of art during this period. For it was during the course of the nineteenth century that long-established, state-controlled systems of patronage and support for artists in Europe were replaced by the activities of commercial dealers, independent businessmen who gradually assumed the traditional role of the patron and functioned as intermediaries between artists and collectors. And it was in France that these important changes were pioneered. Durand-Ruel, remembered today as the primary dealer for the Impressionists, and other Paris-based firms such as Petit, Goupil, Reitlinger, and Boussod, Valadon represented French artists abroad, establishing branches in major foreign cities, including New York, London, and The Hague. Through their commercial activities, they helped to build international reputations for French artists, first the Barbizon painters and then the Impressionists, making them visible to critics and the public as identifiable cultural commodities through well-publicized, dealer-sponsored exhibitions and group shows that stimulated and helped to feed a rapidly expanding international market.[37]

The early and successful development of the dealer system in France was not only extraordinarily effective in promoting French art around the world, it also attracted artists from other countries to Paris. Increasingly during the second half of the nineteenth century, it was the dealers as well as the established Salon system that made Paris a mecca for artists who sought wider markets for their work and the financial rewards that international recognition could bring. In particular, such artists as De Nittis, Boldini, and Fortuny, who were à la mode in the French manner, were able to achieve international success by functioning commercially through the French system. An important part of that new French system, which pioneered a modern identity for art as a consumer commodity, was the series of Expositions Universelles that was held in Paris throughout the second half of the nineteenth century. Collaborations between art and industry, they helped to establish France's reputation as a producer and merchandiser of luxury products and reinforced the position of Paris as

the acknowledged arbiter of taste and culture in the modern world.[38]

Another important factor that contributed in the late nineteenth century to the apotheosis of French Impressionism first in France and then around the world was the emergence and the role of a new entrepreneurial class of collector-patron, for whom the art of the Impressionists—an art that depicted a changing, dynamic, modern world of affluence and well-being—struck an immediate responsive chord. As Albert Boime has pointed out, for the self-made industrialists, financiers, railroad developers, and department-store magnates in France who collected Impressionist paintings at a surprisingly early date, this was a vanguard art that affirmed the freedom of entrepreneurial creativity and the fluidity of a modern world that they had helped to shape—a world upon which they too had acted creatively.[39] It is in all likelihood a similar process of identification that has supported a taste for French Impressionism and prompted the formation of large collections of these paintings in other industrialized countries as well, earliest and most notably in the United States and most recently in Japan. And it has been predictably from this same entrepreneurial class in countries around the world that support and patronage for the developing national schools of Impressionist-style painting have also principally come.[40]

A striking phenomenon that emerges from the essays in this book is the unusual number of women artists who came to the fore as part of the Impressionist movement in France and the proliferation of their professional activity in countries all over the world as the Impressionist style spread. This increase in the professional aspirations and opportunities for women artists must of course be correlated with the general effects of the feminist and suffragist movements in Europe and America in the late nineteenth and early twentieth centuries.[41] But this phenomenon is also one that may be explained in large part by Impressionism's liberation of subject matter and its legitimization in particular of a domestic iconography that had formerly occupied a subordinate position in the hierarchies of the high art tradition. For during the centuries when high art had been defined as history painting and its production had depended on life drawing and conventional training at the academies—access to which women were denied until late in the nineteenth century—the presence of women in the art world had been marginalized. In the nineteenth century they made their appearance at official exhibitions in considerable numbers, but nevertheless almost exclusively as the quasi-amateur painters of still lifes, flower pieces, and portraits.[42] When the subject matter of daily contemporary life, including domestic life—the experiences to which women did have access—became legitimized by Impressionism as the raw material for an art that was in the vanguard, the floodgates were opened, more fully and completely than they had been in any period with the possible exception of the Rococo, for the active participation of women artists in the professional realm of high art. Moreover, as the twentieth-century progressed, the style and aesthetic of Impressionism continued to offer women artists a socially acceptable and personally congenial sphere of expression in the face of the increasingly male-focused attitudes and issues of later avant-garde styles.[43] The extraordinary accessibility of the Impressionist style and attitude for this large and hitherto disenfranchised group of creative people may also in part explain the longevity and continuing creative force of the international Impressionist movement throughout so much of the twentieth century, even though its publicly most prominent and visible exponents were men.

Among the latter, the most internationally successful in their own period around the turn of the century were such artists as the Swede Anders Zorn, the American John Singer Sargent, the Russian Ilya Repin, and the Spanish painter Joaquín Sorolla y Bastida. In Rome and Paris in the mid-1880s, Sorolla was influenced by the work of Bastien-Lepage and Adolf von Menzel, and he did not develop the bravura brushwork, plein-air procedures, and lighter palette for which he became famous until late in the century. But, as Eleanor Tufts observes, within a very few years, his virtuoso technique, his scenes of sun-drenched Spanish landscapes and beaches had won for him tremendous popularity and acclaim not only in Spain but also in France, Germany, England, and the United States (chapter 7). In New York, for several weeks during the winter of 1909, more than 150,000 people lined up in the cold to see an exhibition of the Spanish Impressionist's work at The Hispanic Society of America. And his continuing popularity over the next decade overlapped with such events as the Armory Show, which introduced into the United States a new and very different kind of avant-garde.

Late developments in international Impressionism like the work of Sorolla can be thought of in chronological terms as an "afterlife" of the Impressionist movement. Impressionism had an afterlife in France as well, in the form of the Intimist movement of the 1890s, which survived through the first several decades of the twentieth century in the works of Édouard Vuillard and Pierre Bonnard (plates 29 and 30). In particular, the exquisite later paintings of these artists, which appear to perpetuate anachronistically the themes, moods, and techniques of nineteenth-century Impressionism, have raised problems in evaluation for art historians. Formerly relegated to the position of minor masters vis-à-vis such twentieth-century "innovators" as Picasso or Kandinskii, Bonnard and Vuillard are artists who have in fact only begun to come into their own as major figures in the art historical pantheon during the postmodern era. Their case, as well as that of the other late Impressionists whose work will be encountered in this book, raises the issue of how art historical and aesthetic value have been determined during the modern period and reveals the extent to which "originality"—understood in the twentieth century as innovation—has overridden personalized forms of continuity as the single most important modern-

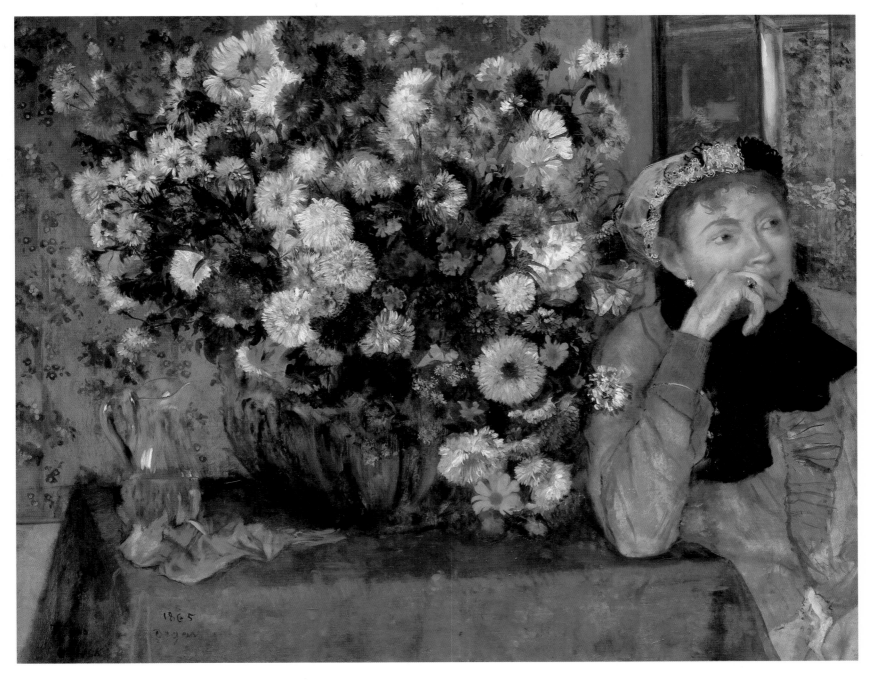

28. EDGAR DEGAS. *Woman with Vase of Flowers (Mme. Paul Valpinçon?)*
or *Woman with Chrysanthemums.* 1865. Oil on canvas, 29 × 36½". The
Metropolitan Museum of Art, New York City. Bequest of Mrs. H.O.
Havemeyer, 1929. The H.O. Havemeyer Collection 29.100.128

ist standard of greatness and achievement in the visual arts. That this should be so is ironic. For it was Romanticism that began and Impressionism that codified the modern period's emphasis on the artist's originality and personal style, defined in the nineteenth century, however, as the unique response of the artist to his or her own visual and emotional experiences in nature. While it was the nineteenth century's conception of "originality" and authentic artistic expression that motivated and gave life to the international Impressionist movement, it was the twentieth century's very different understanding of the concept that led to the international movement's later critical neglect.

Taken as a group, the images in this book present a world in light, but a light of many different kinds, from the transparent clarity of Norwegian light to the diffused and golden light of Australia to the intense contrasts of sunlight and shadow that are more typical of the Italian experience. Some are painted with vivid and broken brushwork, in an apparently rapid and spontaneous manner; others appear to be more linear and restrained, their compositions more slowly developed. And their variety is after all not so very different from the variety to be found within the French school itself. What they all have in common is a preoccupation with nature's light, light captured on the site as a unifying and expressive force. Despite the sometimes differing look of the results, we should nevertheless keep in mind that it was the same

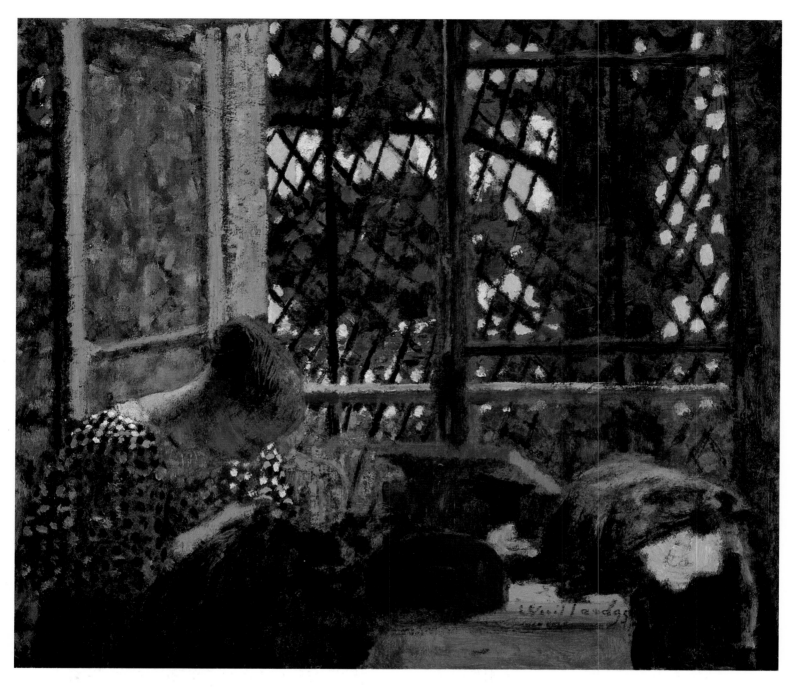

29. Édouard Vuillard. *Woman Sewing Before a Garden.*
1895. Oil on paper mounted on canvas, mounted on panel,
12¼ × 14⅝″. Bequest of John T. Spaulding. Courtesy Museum
of Fine Arts, Boston

plein-air devotion to natural light that prompted Monet in the 1880s to lash his easel to the wind-battered rocks at Belle-Île and also prompted the Swedish artist Carl Larsson to paint outdoors in the freezing cold and snow, swathed in his fur coat and rush shoes (*The Open Air Painter;* plate 384) and the Danish artist Frits Thaulow to use oil paints treated to withstand bitter cold in freezing winter temperatures. In *Hip, Hip, Hurrah!*, by the Paris-trained Peder Severin Krøyer (plate 352), a group of Scandinavian artists gather out-of-doors to celebrate with a champagne toast the return of the sun in the Danish artists' colony of Skagen. And while we are greeted here not by the temperate climate and the lush environment celebrated in analogous French pictures by Renoir (plate 2), as Alessandra Comini points out, "the colors and light-filled wandering shadows" are those that we associate with French Impressionism, "the illumination and brushwork, while not broken, are elegant, buoyant, and scintillating" (chapter 9). In this and the other essays that follow, we will see highlighted and developed the complex issue of the meeting and interchange between national sensibilities during the Impressionist era, helping us to appreciate Impressionism anew, not as an isolated and regional French movement but as a truly international phenomenon.

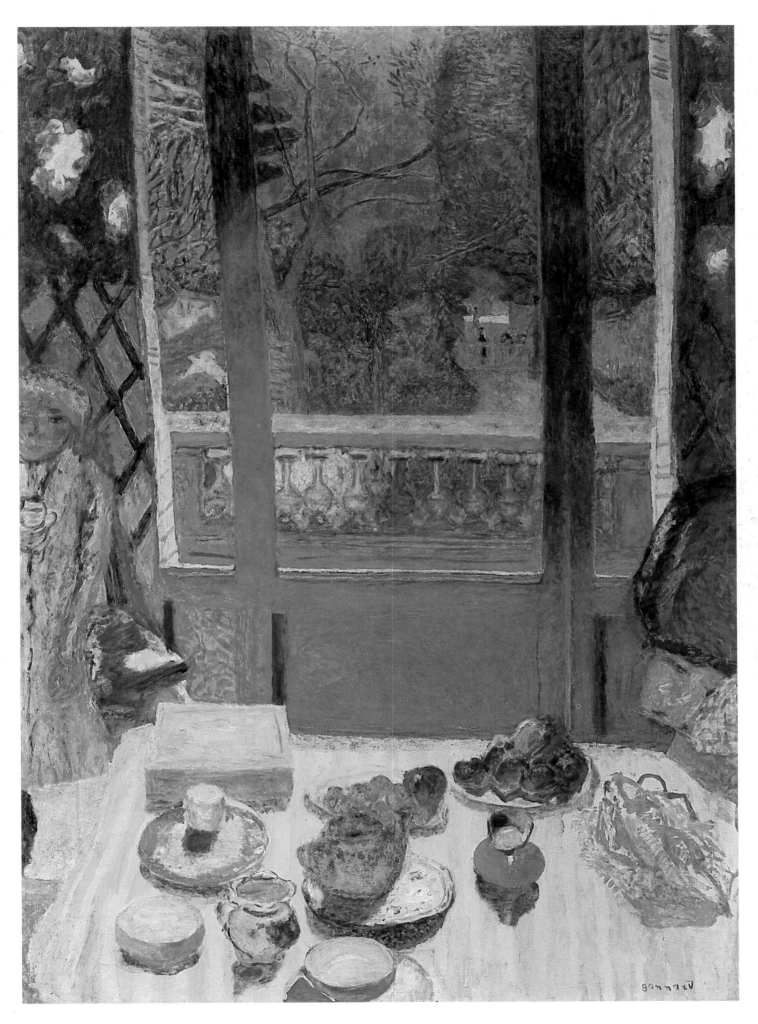

30. PIERRE BONNARD. *The Breakfast Room.* 1930–1931. Oil
on canvas, 62⅞ × 44⅞″. Collection, The Museum of Modern
Art, New York City. Given anonymously

# IMPRESSIONISM IN THE UNITED STATES

*William H. Gerdts*

31. MARY CASSATT. *Woman with a Pearl Necklace in a Loge (Lydia in a Loge, Wearing a Pearl Necklace).* 1879. Oil on canvas, 31⅝ × 23″. Philadelphia Museum of Art. Bequest of Charlotte Dorrance Wright

WITHIN TEN YEARS of the Boston opening in 1883 of the *Foreign Exhibition*, the first major appearance of French Impressionist painting to be seen in the United States, the work of Monet, especially, and his colleagues had been on view in a score of American art galleries, private club exhibitions, and museums. In addition, Impressionism had become the primary critical issue to be discussed in American periodicals and had attracted many of the major collectors of modern art in this country. Most significantly, growing numbers of young American artists who had studied in French ateliers had adopted some or all of the strategies of Impressionism with which they were becoming increasingly familiar, either in France or back home in the United States.

Until recently, it has been customary to distinguish between French Impressionism and the American interpretation of the movement by insisting upon a native Realist tradition that modified the willingness of American artists to abandon linear conceptualism for full immersion into Impressionist light and color. Modifications of Impressionist practice can, indeed, be found in the work of many American painters, but this is due, as we shall see, not to the need, conscious or unconscious, to maintain links with the American artistic past, but rather to achievements recently attained by these American artists in Parisian ateliers, where traditional academic standards were maintained in opposition to the growing innovations embodied in Impressionism. Modifications were due, also, to the strong Tonal presence in much contemporaneous American landscape painting, itself a reflection of the great popularity of French Barbizon art in the United States.

There were, however, other significant differences between the French and the American versions of the movement. One was the practically total aversion of American Impressionist painters both to concerns of alienation and isolation that are present in so many French urban scenes of the period and to reflections of class distinctions. This is due, at least in part, to American perceptions of French Impressionist landscape work as opposed to figural subjects, a distinction critically underscored in the reaction to the first great presentation of such French painting in this country, which took place in New York City in 1886. One writer, referring to the art of Manet, Degas, Renoir, Caillebotte, and Seurat, found the "masculine principle" embodied in their figural paintings and the "feminine" in the landscapes of Boudin, Sisley, Pissarro, and above all, Monet. The writer further noted that "the tenderness and grace of impressionism are reserved for its landscapes; for humanity there is only the hard brutality of naked truth."[1] American Impressionists, for the most part, reflecting either their own predisposition or that of their patrons, rejected the "brutality of naked truth" and concentrated either upon tender landscapes or upon figural work that centered on graceful living and, above all, upon children and the ideal American woman. This last theme was hardly lim-

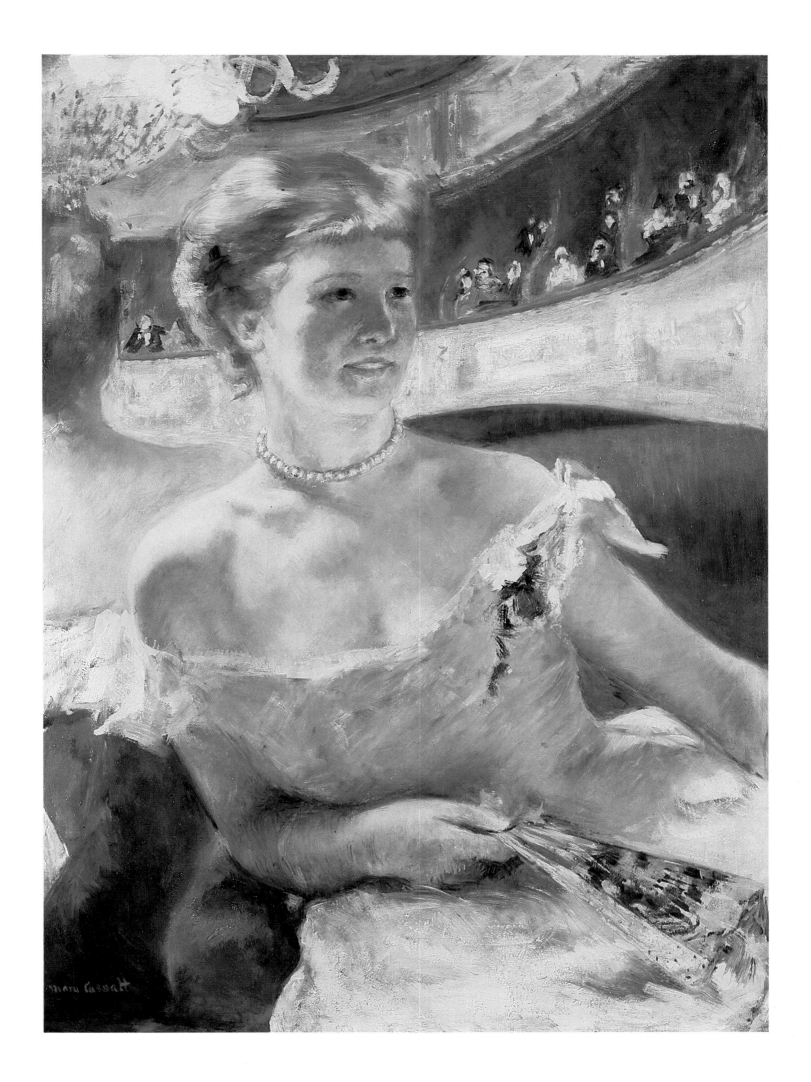

32. CHILDE HASSAM. *Rainy Day, Columbus Avenue, Boston.*
1885. Oil on canvas, 26⅛ × 48″. The Toledo Museum of Art,
Toledo, Ohio. Gift of Florence Scott Libbey

ited to the Impressionist painter; it had become a domi-
nant pictorial conception in the wake of the vast economic
development following the Civil War, reflecting the so-
cial disjuncture within the new wealthy elite. The male
was a figure of active participation in mercantile ven-
tures, while the female was identified and even venerated
for her passive role as no more than supervisor of home
and hearth. Thus her image in that guise, quiet, inactive,
and contemplative, not only reflected the actual state of
upper-class American womanhood but may have acted
as an instrument of reinforcement. These same women
and their husbands were often the patrons of the artists
who created such images.[2]

Probably the American Impressionist who came
closest to reflecting the French concern with the contem-
porary urban scene was Childe Hassam, but it is argu-
able that his most trenchant observations of this theme
can be found in his early Tonal pictures of Boston,
painted in the mid-1880s before his exposure to Impres-
sionism, and above all in his early masterwork *Rainy
Day, Columbus Avenue, Boston* (plate 32). But this pre-
Impressionist interest was true, actually, for many of the
leading Americans; both John Twachtman and J. Alden
Weir also displayed far greater awareness of social dy-
namics in the paintings they created before they began to
investigate the principles of Impressionism. Impression-
ism, however, provided these artists not only the pos-
sibility of exploring radical new formal strategies but was
eminently suitable for the interpretation of subjects that
had an appeal for patrons far broader than did concerns
for social and urban realism; it may be, too, that the
artists themselves, as they matured, favored less probing
themes.

The concept of "Impressionism" was familiar to
Americans as early as the 1870s, but for the most part,
the term was adopted to describe work of a very different
sort from that with which it is presently associated or, for
that matter, that which was correctly identified in the
critical press after the crucial date of 1886. Before the
New York exhibition of Impressionism there were iso-

lated artists, critics, and patrons who were familiar with
the French Impressionist movement, but Impressionism
was identified primarily with sketchy, seemingly incom-
plete works of art, often painted with strong contrasts of
light and shade and displaying little coloristic or atmo-
spheric concern. American artists variously referred to as
Impressionist by critics in the 1870s and early 1880s
included Winslow Homer (1836–1910), Robert Blum
(1857–1903), James Whistler (1835–1903), and J.
Frank Currier (1843–1909), none of whom today would
be viewed as working in relationship to Monet, Degas, or
Renoir.[3] Currier, in fact, was one of the principal expo-
nents of the radical phase of Munich avant-garde paint-
ing; in America, Impressionism was also initially
identified with the art produced in the Bavarian capital
by American painters that seemed to dominate the early
exhibitions of the Society of American Artists (itself
newly founded in 1877 in opposition to the traditional
and nativist National Academy of Design).

To be sure, there were isolated American painters
and writers who were fully aware of French Impression-
ism as it developed during the 1870s, but almost all of
them reacted extremely negatively to the innovative aes-
thetic. Lucy Hooper, the Paris correspondent for the
American edition of *The Art Journal*, succinctly sum-
marized these attitudes in 1880 when she wrote of
Manet that "it must be said that he is less mad than the
other maniacs of Impressionism."[4] Well-established
painters such as George Inness, who resided in Paris for a
year beginning in the spring of 1874, as well as younger
neophytes studying in the Parisian ateliers such as Weir,
also vented their distaste for Impressionism, but when all
is said and done, it remains surprising how few of the
hundreds of American artists in Paris during the 1870s
appear to have taken any notice at all of the new
movement.

The most striking exception to this was Mary
Cassatt (1844–1926), the first American Impressionist,
who, after initial study at the Pennsylvania Academy of
the Fine Arts, went abroad in 1866.[5] She studied with
such excellent traditional masters in Paris as Jean-Léon
Gérôme and Charles Chaplin and with Paul Soyer and
Thomas Couture out in the French countryside at Éco-
uen and nearby Villiers-le-Bel, but after returning to
Philadelphia at the time of the Franco-Prussian War in
1870, Cassatt was back in Europe at the end of the
following year. She went to Italy, where she studied and
worked in Parma in 1872, and then traveled to Spain,
visiting Madrid and painting figural subjects distinctive
of contemporary Spain in Seville. These Spanish pictures
were Cassatt's earliest mature and independent works, in
which vibrant brushwork and strong, dramatic color ef-
fectively carve out fully three-dimensional figures,
themselves expressing the immediacy of daily Spanish
life as palpably as her rich handling of the medium.
Though paintings of "modern" life, with their dark tones
and solidly rendered forms, these works are by no means
Impressionist, but in both subject and handling they
reflect the early art of Manet.

Settling in Paris in 1873, Cassatt began her long and productive association with Edgar Degas in 1877. Two years later, refusing to submit further work to the Paris Salon juries due to previous rejections, she began instead to exhibit her paintings with the Impressionists. Her *Lydia in a Loge, Wearing a Pearl Necklace* (plate 31) appeared in the 1879 display, the group's fourth joint exhibition. In the combination of bright colorism and flickering interior light with the still effective corporeality of form, the work reflects not only the artist's subscription to the Impressionist aesthetic but especially the impact of Degas's art. Degas-like, too, is both the theatrical setting itself and the spatial ambiguity created by posing the sitter against a mirror reflecting the sweep of distant boxes across the vast space. Cassatt's sister, Lydia, the presumed subject of the painting—there is some doubt about the identification[6]—is presented very simply but fashionably gowned, quite décolleté for a proper American lady, her sensuousness enhanced by the pink tonality of her dress and the deeper reds of the plush armchair in which she sits, which, together with the mirrored background, confirms both the elegance of the theater and the expensive price of the seat that Lydia enjoys. She appears very relaxed and is voluptuously posed, the artist presenting a tantalizing ambiguity in the distant spectators, who may be focusing their gaze on a performance or upon the subject of the painting; Lydia thus becomes an element of theater herself.

*Lydia in a Loge* may be the earliest Impressionist painting by an American artist and the earliest such work reviewed by an American critic, the writer for *The New York Times* noting Cassatt's nationality and commenting on the "dirty-faced female, in variegated raiment, who, in real life, would never have been admitted in any decent society until she had washed her face and shoulders."[7] Although Cassatt remained affiliated with Degas and the Impressionists, she, like many of her French colleagues, turned away from the full colorism and dissolution of form that had characterized so much Impressionist painting during the 1870s, and by 1886 she had returned to depicting strongly defined shapes reinforced by a heightened sense of linear design, emphatic patterning, and flattened and cutoff forms, a style adapted from her growing awareness of Japanese art. These qualities may be found in many of her pictures. In *Woman with a Red Zinnia* (plate 33), for example, the strong, dark, and flat horizontal of the bench is balanced by the upright figure, the subject's verticality repeated both in the flower she holds and the trunks of the trees in the park behind her. The woman's contemplative and slightly melancholy countenance may reflect the nineteenth-century symbolic interpretation of the zinnia as an expression of absence.

Though hailed in France as one of the major Impressionists, with whom she exhibited again in 1880, 1881, and 1886, Cassatt's impact on the development of Impressionism in her native country was limited, for few of her Impressionist paintings were shown here until the 1890s. Indeed, in her sole early exhibition with the So-

33. MARY CASSATT. *Woman with a Red Zinnia*. 1891. Oil on canvas, 29 × 23¾". National Gallery of Art, Washington, D.C. Chester Dale Collection

34. MARY CASSATT. *Reading the Figaro*. 1878. Oil on canvas, 39¾ × 32". Private collection

35. John Singer Sargent. *Carnation, Lily, Lily, Rose.*
1885–1886. Oil on canvas, 68½ × 60½". Tate Gallery, London

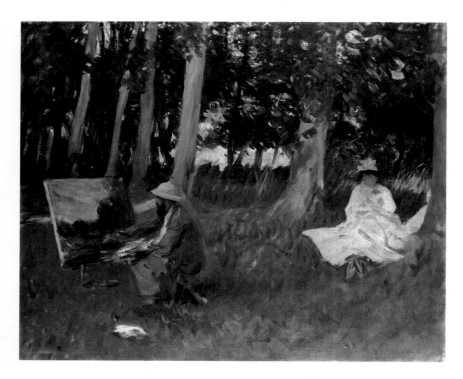

36. John Singer Sargent. *Claude Monet Painting at the Edge of a Wood.* c.1887. Oil on canvas, 21¼ × 25½". Tate Gallery, London

ciety of American Artists in 1879—the same year she first showed with the French Impressionists—her major contribution was the great portrait of her mother *Reading the Figaro* (plate 34), painted in 1878; though a powerfully dramatic rendering, the work is not at all Impressionist. It was as if she carefully chose a relatively more conservative example to represent her art in New York. Though still a casual scene of modern and intimate daily life, the work not only eschews the colorism of *Lydia in a Loge*, but substitutes a mature, no-nonsense subject for the graceful Lydia in a composition well anchored with strongly geometric forms. Cassatt's impact in America lay more in her guidance of collectors, including her brother Alexander and her close friend Louisine Elder (later Mrs. Horace Havemeyer), who, under her influence, were the first American patrons of the Impressionists.

Cassatt had persuaded Elder to purchase Degas's *A Ballet* (now *Ballet Rehearsal*) in 1875, a pastel exhibited at the American Water Color Society annual in 1878, probably the first authentically Impressionist painting on public display in the United States, and one greeted critically with surprising tolerance.[8] Subsequently, isolated examples of paintings by the French Impressionists appeared on view in New York and Boston, notably the display of arts and manufactures from abroad organized in the latter city by the Foreign Exhibition Association, which included Manet's *Entombment* and six paintings by Pissarro, four each by Renoir and Sisley, and three Monets. American awareness of French Impressionism reached its culmination in the great exhibition of French painting arranged by the French dealer Paul Durand-Ruel and held at the American Art Association in New York in the spring of 1886. This, too, was instigated by Cassatt, attempting to assist Durand-Ruel in recouping his failing fortunes. A show of approximately two hundred and ninety works was on view from April 10, the group of more academic works totally overshadowed by the twenty-three canvases by Degas, seventeen Manets, fifteen Sisleys, thirty-eight Renoirs, seven Morisots, forty-two Pissarros, and forty-eight Monets. This was a landmark exhibition for the American art world, generating a vast amount of critical controversy but also stimulating a great deal of patronage, and so popular among the public was the show that it was extended in late May at the National Academy of Design with additional loans from American collectors, including two pictures by Cassatt lent by her brother. Many may have come to scoff and to echo the sentiments of the more hostile reviewers, but quite a few New York and Boston art patrons acquired paintings from the show, replacing their collections of Barbizon art with works by Monet and other Impressionists. The exhibit was sufficiently successful that Durand-Ruel opened a New York branch two years later, and the French firm of Boussod, Valadon & Company did likewise. Never again would the nature of Impressionism be misunderstood in this country, and soon the aesthetics of the movement would be adopted by other native artists

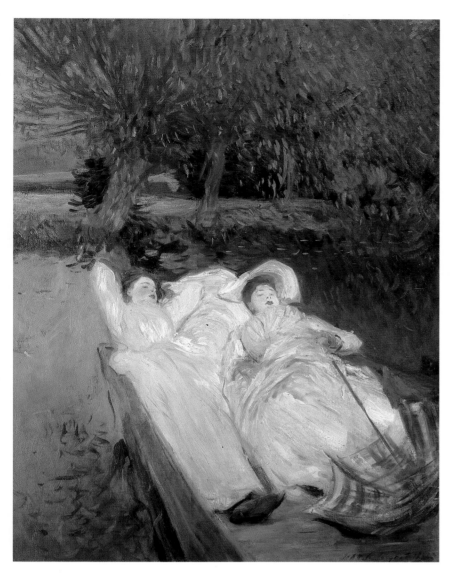

37. JOHN SINGER SARGENT. *Saint Martin's Summer.* 1888.
Oil on canvas, 36 × 27″. Private collection

with their works displayed in annual exhibitions and commercial galleries.[9]

It was not Cassatt but rather another of America's most famous expatriates, John Singer Sargent (1856–1925), who had a more direct impact upon the transference of Impressionism from Europe to America.[10] After studying in Paris with Carolus-Duran, Sargent established himself in the French capital as a fashionable portraitist, but the controversy over the exhibition of his *Madame X* (1884; The Metropolitan Museum of Art, New York City) at the Paris Salon in 1884, criticized both for its cold and arrogant interpretation of the subject as well as for her décolletage, led the American to direct his attention across the Channel to England. While he continued to paint portraits, Sargent's summers were spent successively in Broadway, Henley-on-Thames, Calcot, and Fladbury, and it was in his summer work of 1885–1889 that Sargent explored the tenets of Impressionism. The majority of these paintings were small landscapes and depictions of his friends, fellow artists, and family. Painted out-of-doors but also created in a relatively broad and colorist manner was his major exhibition picture of the period, *Carnation, Lily, Lily, Rose* (plate 35). Sargent worked on this painting at Broadway during the summers and autumns of 1885–1886, taking the large canvas outdoors for about twenty minutes each evening to catch the constant glow of the late afternoon light, each time posing the two young girls in white lighting Japanese lanterns amidst the flowers. Despite the selective nature of Sargent's Impressionism—the flowers and lanterns are far more freely painted than the carefully delineated models—and the subdued light and colorism of evening, the picture was extremely avant-garde for the traditionally minded British art establishment. Yet, although the work earned Sargent the title of the "arch-apostle of the dab and spot school,"[11] it was well received when shown at the Royal Academy in 1887, though more for its decorative and sentimental appeal than for its radical aesthetics.

Sargent had known Claude Monet personally, probably meeting him as early as 1876, and by 1887 he had begun to acquire examples of Monet's painting. On trips to France he also visited Monet at his home in Giverny, and evidence to that effect can be found in his depiction of *Claude Monet Painting at the Edge of a Wood* (plate 36). The picture, the date of which is controversial but would appear to be most likely 1887, is not only a testimonial to the friendship of the two artists but also to the new strategies of plein-air painting, for it is obvious that Sargent is engaged in the same pictorial act as is Monet—that is, Sargent, too, is painting outdoors at the edge of a wood at Giverny. Yet again, the selectivity of Sargent's Impressionism must be acknowledged, given his abundant use of neutral tones and black. This work, in fact, may have occasioned the exchange between the two artists recorded many years later by the French art dealer René Gimpel, who reported that Monet told him that on a visit to Giverny Sargent had joined him in an outdoor painting excursion. Sargent had borrowed colors from Monet and asked the Frenchman for black: "I gave him my colors and he wanted black, and I told him, 'But I haven't any.' 'Then I can't paint,' he cried, and added, 'How do you do it?'"[12]

It was in the summer of 1888 in Calcot that Sargent most completely adopted the full range of Impressionist light and color, seen with particular effect in *Saint Martin's Summer* (plate 37), the most monumental of Sargent's several depictions of women resting in a boat. Sargent emphasizes here a mood of *dolce fa niente*, while creating a dynamic pictorial construct, the strong diagonal axis of the figures pulled forward by the parasol in the lower-right corner and the boat abruptly cut off in the foreground. The heavy clothing of the women suggests the lateness of the season (Saint Martin's Day is November 11), but the warmth of the sunlight is found in the myriad touches of warm colors that dapple the white garments of the two women. A similar Impressionist work of the same year, *A Morning Walk* (plate 38), depicting Sargent's sister, Violet, most completely identified the artist with the Impressionist movement in America;

it was seen in 1890 successively in Boston, New York, Chicago, and Philadelphia.

The inspiration for Sargent's depiction of *Claude Monet Painting* almost surely lies in part with the series of pictures that the French Impressionists had previously painted of one another in the act of painting, perhaps specifically Monet's own *In the Woods at Giverny* (1884; Los Angeles County Museum of Art), in which the French master's future stepdaughter Blanche Hoschedé is depicted painting at an easel outdoors. In turn, *Claude Monet Painting* initiated a whole series of pictures of fellow artists at work *en plein air* by Sargent. Especially significant here is his rendering of *Dennis Miller Bunker Painting at Calcot* (plate 39) of 1888. Bunker (1861–1890) was a popular young Boston artist, who had trained with Gérôme in Paris and established himself as an able painter of attractive academic portraits and Tonal landscapes.[13] Sargent met him during the winter of 1887–1888, when he was in America and had conquered Boston with his fashionable portraiture. He invited Bunker to spend the ensuing summer with him at Calcot, and it was during this visit that Bunker, inspired by Sargent's own partial and temporary conversion to Impressionism, followed the older artist's lead.

Bunker's perturbation over the radical change of aesthetic stance from the academic to the avant-garde is implied in Sargent's painting; unlike Monet, who dashingly paints away at full speed in Sargent's depiction of him, Bunker is shown standing away from his canvas, musing rather than active, while the viewer sees only the back of Bunker's canvas. Yet Bunker's own conversion was ultimately swiftly effected, as confirmed in his glorious, vividly chromatic depiction of *Chrysanthemums* (plate 40), painted back in Mrs. Jack Gardner's Boston conservatory later in 1888, and in the many pictures of open fields and meadows in nearby Medfield recorded by Bunker in the summers of 1889 and 1890 (such as *The Pool, Medfield;* plate 41). In such works, Bunker has adopted not only the casual, seemingly disorganized, and cutoff compositional structure of Sargent but also his long and distinctive "quill-like" brush stroke, as well as the variegated high color key of Impressionism.

Though Bunker died tragically young at the end of 1890, he was an influential artist and teacher, and he paved the way for the quick acceptance and development of Impressionism in Boston. Artists associated with Boston were also among the large contingent of Americans who arrived in Giverny in the summer of 1887, the first of several generations of Americans to establish Giverny as their painting ground and to develop there an Impressionist stance in their interpretation of nature. The seven artists who went to Giverny in 1887 were six Americans—Theodore Robinson (1852–1896), Theodore Wendel (1857–1932), John Leslie Breck (1860–1899), Willard Metcalf (1858–1925), Louis Ritter (1854–1892), and Henry Fitch Taylor (1853–1925)—and the Canadian William Blair Bruce (1857/9–1906). For the most part, they were students at traditional ateliers in Paris, though Robinson was somewhat older

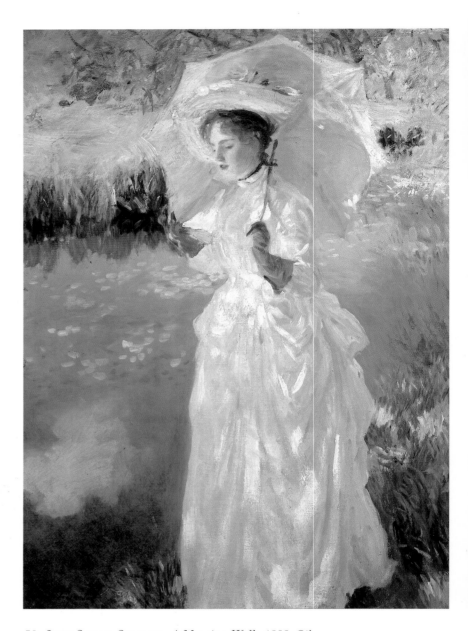

38. JOHN SINGER SARGENT. *A Morning Walk.* 1888. Oil on canvas, 26⅜ × 19¾". Private collection

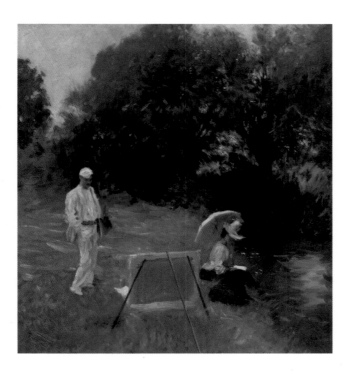

39. JOHN SINGER SARGENT. *Dennis Miller Bunker Painting at Calcot.* c.1888. Oil on canvas, 26¾ × 25″. © Daniel J. Terra Collection. Terra Museum of American Art, Chicago

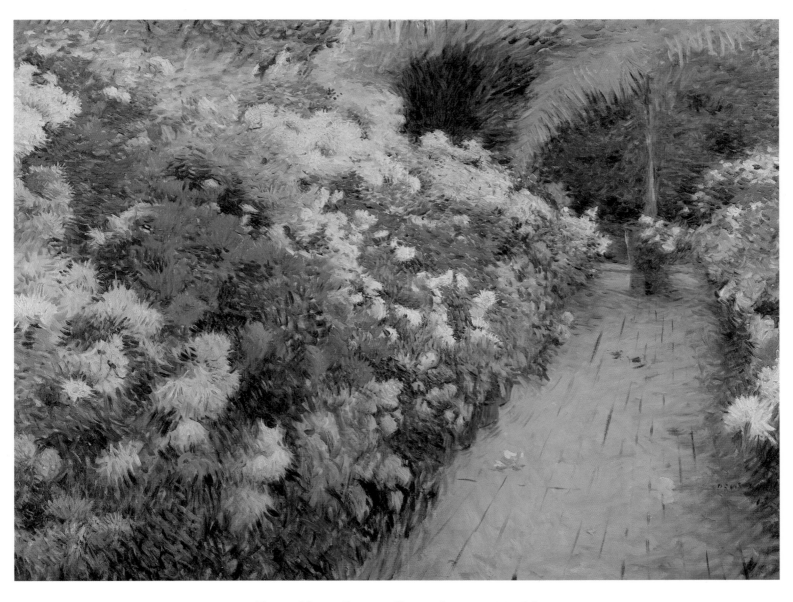

40. DENNIS MILLER BUNKER. *Chrysanthemums.* 1888. Oil on canvas, 35⁷/₁₆ × 47⅝″. Isabella Stewart Gardner Museum, Boston

41. Dennis Miller Bunker. *The Pool, Medfield.* 1889. Oil
on canvas, 18 × 24″. Emily L. Ainsley Fund. Courtesy Museum
of Fine Arts, Boston

42. JOHN LESLIE BRECK. *Willows.* 1888. Oil on canvas,
18×22″. Private collection

43. LILLA CABOT PERRY. *Giverny Landscape, in Monet's
Garden.* c.1897. Oil on canvas, 26×32″. R.H. Love Galleries,
Inc., Chicago

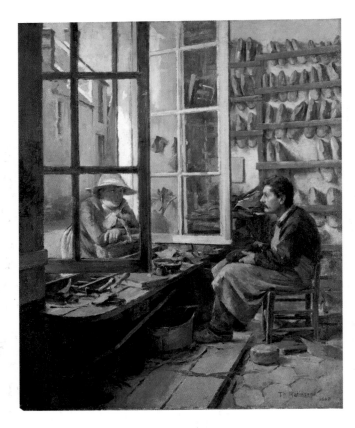

44. THEODORE ROBINSON. *A Cobbler of Old Paris*. 1885. Oil on canvas, 25½ × 20¾″. Smith College Museum of Art, Northampton, Massachusetts. Bequest of Mrs. Lewis Larned Coburn, 1934

45. THEODORE ROBINSON. *La Vachère*. 1888. Oil on canvas, 86⅜ × 59⅝″. Baltimore Museum of Art. Given in Memory of Joseph Katz by his children, BMA 1966.46

than the rest and had studied with Carolus-Duran and Gérôme a decade earlier. Their descent upon Giverny was organized more as a summer outing than as a search for artistic innovation or inspiration.[14]

Although there is some documentation that a number of these painters—Robinson, Wendel, and Metcalf—had each been to Giverny earlier, the summer of 1887 was crucial for the exposure of these artists and their companions to the tenets of Impressionism through the presence of Claude Monet, who had settled there four years earlier. One can follow their development, year by year, seeing the gradual adoption of broken brushwork and increasingly high colorism and the abandonment of neutral tones, strong tonal contrasts, and solidly depicted forms. In turn, these artists attracted other American students studying in Parisian studios to Giverny, which developed as a major art colony to the increasing displeasure of Monet himself. Philip Leslie Hale (1865–1931), Theodore Butler (1861–1936), and the Englishman Dawson Dawson-Watson (1864–1939; later to establish himself as the leading Impressionist painter in Saint Louis), arrived in 1888, Lilla Cabot Perry (1848–1933) in 1889, and Guy Rose (1867–1925) from California in 1890.

It should be emphasized that only a few of these artists were close to Monet, and probably many of them had only the slightest acquaintance with him. Indeed, the impact of these Americans upon each other was probably in the long run greater and more significant than that of the French master himself in terms of their gradual acceptance of Impressionist strategies. Certainly, they all shared not only a common aesthetic, but also similar motifs—views of the valleys from the hills above the town and especially scenes along the Epte River, with the pollarded willows enframing its embankment.

Such a typical Giverny picture is *Willows* (plate 42) by Breck, painted in 1888 and perhaps one of the group of works brought back to Boston the following year by Lilla Perry, who showed them to friends. Among her acquaintances was Hamlin Garland, who noted the works as "a group of vivid canvases . . . each with its flare of primitive colors—reds, blues, yellows, presenting 'Impressionism' the latest word from Paris."[15] Encouraged by Monet himself, Breck may have been the first of the Americans in Giverny to adopt fully the principles of Impressionism, but Monet discouraged the young American's romantic attachment to Blanche Hoschedé, and Breck left France for good in 1891. The previous year, however, Breck had the first of a series of one-man shows of his work in Boston, this at the Saint Botolph Club, which further established Boston as a bastion of avant-garde artistic developments, though not without provoking some critical controversy.[16]

The artist who most completely identified with Monet's own methodology and one of those who became closest to the French master was Lilla Perry, whose *Giverny Landscape, in Monet's Garden* (plate 43) paraphrases the master's techniques. Perry spent ten sum-

46. THEODORE ROBINSON. *From the Hill, Giverny.* c.1889.
Oil on canvas, 16 × 25½″. © Daniel J. Terra Collection. Terra
Museum of American Art, Chicago

mers in Giverny between 1889 and 1909 and wrote one of the most perceptive "Recollections" of Monet to be published by an American. In 1898 her husband, the educator Thomas Sargeant Perry, accepted a chair in English literature in Tokyo, and while there with him for three years, Lilla Perry introduced the full range of Impressionism into her Japanese landscapes.[17]

Theodore Butler was the one artist of this early group actually to remain in Giverny, having married Suzanne Hoschedé in July of 1892 and thus becoming part of Monet's own family. But a more significant artist and one of the most influential of all the American Impressionists, was Theodore Robinson, who of all the early "Givernyites" appears to have been most intimately associated with Monet and his art during his years in Giverny.[18] Robinson had studied first with Carolus-Duran and then with Gérôme, and the combination of a painterly technique derived from Carolus and the sound draftsmanship of Gérôme is evident in *A Cobbler of Old Paris* (plate 44), which Robinson painted in 1885, just prior to his association with Monet in Giverny. The neutral tonalities and careful spatial definitions of the picture gave way by 1888 to the dappled sunlight and brighter colorism of *La Vachère* (plate 45), one of Robin-

son's few large, Salon-size Impressionist pictures. Yet the format and the peasant genre subject, favored among more academically oriented painters, suggest Robinson was never to abandon the traditional academic strategies as completely as Perry or other contemporaries such as Childe Hassam. This was true of the great majority of American Impressionists, but it was due, not, as some historians would suggest, to an innate American "Realist" tradition but rather to the impact of their academic—usually French—training. Simply put, the post–Civil War generation of American artists who spent years studying abroad had invested too much of their time and energy and had drunk too deeply and too recently at the fountain of academic tradition to abandon it completely for a radical new aesthetic, however much it beckoned them. Robinson's diaries confirm his vacillation between greater spontaneity and the maintenance of academic standards. He would write in May 1892 that "things are spotty. I must look out—and they fall to pieces in important places—not enough feeling of construction. . . . I must try for more largeness and grasp completeness at the same time getting vibration and brilliant color." And in April 1894 he noted that "my painting stops too soon and I am too satisfied with the appearance (surface)

without going on and giving that special effort of attention."[19]

One should note, however, the growing freedom and informality in Robinson's work during his years at Giverny. This is true both of his figures painted outdoors and his pure landscapes, such as his *From the Hill, Giverny* (plate 46) of about 1889. Typical of Robinson's compositions is the high vantage point, looking over a valley and out to a high horizon line. In between, the landscape and buildings are layered along a series of contrasting diagonals, the slabs of building roofs and walls confirming a strong compositional construct, created in painterly terms and not totally unrelated to similar strategies adopted by Paul Cézanne. Robinson would undoubtedly have been aware of Cézanne's work through Monet; the structural strategies of the French master would have had obvious appeal to an academically trained American who was constantly questioning his attraction to sketchiness and reminding himself of the need for greater control and design.

By 1891 Robinson had developed a far looser technique and a richer palette, as evidenced in his *Gathering Plums* (plate 47), in which he continued to investigate peasant subject matter, thereby relating his work actually more to the art of Pissarro than to Monet; the structure here is far less formal than the staid imagery of *La Vachère*. It would seem that a number of American artists working in Giverny strived to effect a consolidation of traditional peasant imagery with the new aesthetic strategies of Impressionism. Robinson took the lead here, but similar themes were painted in Giverny by Dawson Dawson-Watson, and the concern with agrarian themes is also evidenced in the haystack pictures painted by Lilla Perry and John Breck.

Another factor to be considered in *Gathering Plums* is Robinson's use of photography. The painting is actually derived from a photograph, but while some emphases in light-dark contrasts and certain areas of blurring are retained from the photograph, Robinson utilized pigment splotches to produce a truly painterly image. This increased chromatic concern is seen at its broadest and most beautiful in the small, jewellike *La Débâcle* (plate 48). The title refers not to an unseen narrative event but to the book held by the seated woman, which was Zola's latest novel, published that year, and therefore further identifies the work as a painting of modern times.

These pictures were all created in Giverny, where Robinson lived for much of each year from 1888 to 1892. He would go back each year to New York in the late autumn and remain into the spring for the major annual art exhibitions; then he would return to France. And in those exhibitions at the Society of American Artists and the National Academy, Robinson, beginning in 1889, exhibited his Impressionist works, becoming one of the first American artists to be critically identified with the Impressionist movement. (Cassatt's involvement with the movement was identified by Parisian correspondents of New York newspapers as early as 1879, and Sargent was

47. THEODORE ROBINSON. *Gathering Plums.* 1891. Oil on canvas, 22 × 18″. Georgia Museum of Art, The University of Georgia. Eva Underhill Holbrook Memorial Collection of American Art. Gift of Alfred H. Holbrook

so recognized in London by 1887, but his Impressionist paintings did not appear in America until 1890). Furthermore, Robinson's work met with professional acclaim, winning prizes at the Society of American Artists in 1891 and 1892 for a landscape and figure painting, respectively.

In the spring of 1892, on Robinson's return to Giverny for what would prove to be his last season there, Monet discussed with the American his latest project, the series of canvases he had begun in February of the façade of Rouen Cathedral depicted in different conditions of light and atmosphere at different times of day. That summer, in emulation of his mentor, Robinson created a number of series of his own, notably the "Valley of the Seine" (1892; Addison Gallery of American Art, Andover, Massachusetts), three paintings of a typically high hillside view with the river and the town of Vernon beyond. One canvas depicted the scene in bright sunlight; another with stronger cloud patterns in the valley; and the third, totally overcast. Breck had earlier, in 1891, emulated Monet even more closely, with a series of fifteen paintings of haystacks depicted at different times of

IMPRESSIONISM IN THE UNITED STATES

48. THEODORE ROBINSON. *La Débâcle.* 1892. Oil on canvas,
18×22″. Scripps College, Claremont, California. Gift of
General and Mrs. Edward Clinton Young, 1946

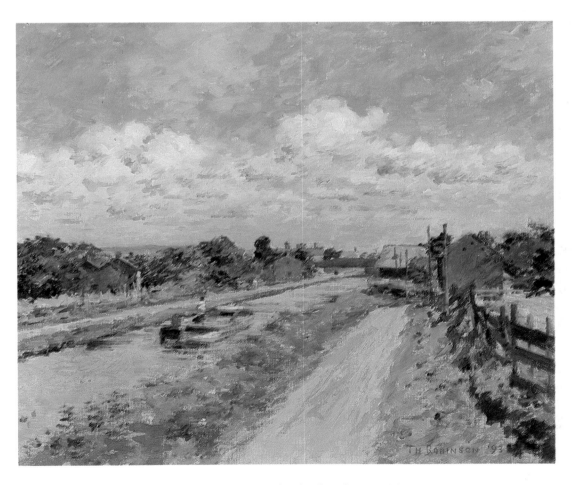

49. THEODORE ROBINSON. *On the Canal.* 1893. Oil on
canvas, 18×22″. Collection Ann M. and Thomas W. Barwick

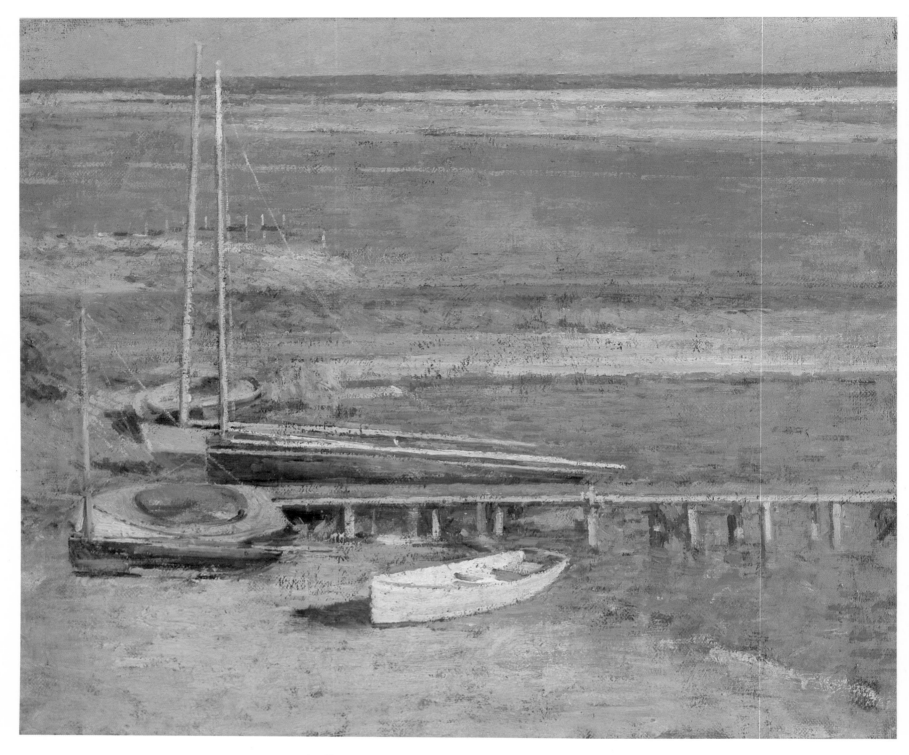

50. THEODORE ROBINSON. *Boats at a Landing.* 1894. Oil on
canvas, 18½ × 22″. Collection Mr. and Mrs. Meyer P. Potamkin

day, but Robinson's smaller series was a more independent conception, while still documenting the pictorial implications of transitory conditions of climate and light.

Robinson stayed in France until December 1892 and then returned to New York, remaining in America for the last four years of his short life. He continued to work in the Impressionist manner he had developed in Giverny, including the exploration of serial images, the most prominent example being his several views of Port Ben, on the Delaware and Hudson Canal (plate 49). This series was painted in 1893, while he was teaching summer classes for the Brooklyn Art School at Napanoch, New York. He taught these classes again the following summer, this time at Evelyn College in Princeton, New Jersey, though he found less inspiration in the local landscape that season for his own painting than he had at Napanoch the previous year. In June 1894, however, Robinson had visited his colleague John Twachtman at Cos Cob in Connecticut, and there he also painted a series of views at the Riverside Yacht Club, such as *Boats at a Landing* (plate 50), which are among his most boldly colored and abstracted paintings. They are dominated by a new sense of formal design that testifies to the impact Japanese prints had made on a number of American Impressionists in the early 1890s.

By then, John Twachtman (1853–1902), too, had become identified as one of the more significant and most original American adherents to the Impressionist aesthetic.[20] Born and trained in Cincinnati, Twachtman, like many of his Midwestern colleagues, had gone abroad to study first in Munich, rather than Paris, traveling there in 1875 with the already well-established Cincinnati artist Frank Duveneck (1848–1919). Twachtman was one of a group known as the "Duveneck Boys," following their mentor in adopting the strong Realist aesthetic introduced into Munich art by Wilhelm Leibl in 1869 and immediately adopted by Duveneck and other Americans who came to study in Munich in the early and mid-1870s, a heritage of the impact in Germany of the art of Gustave Courbet. Twachtman went with Duveneck to Venice in 1877 and spent the next five years moving back and forth between Europe and America, at first adopting the radical Munich strategies of strong tonal contrasts and rich blacks set down with bravura paint application, as seen in a series of vivid harbor and wharf scenes he painted in New York. These strong, gritty pictures of urban activity established Twachtman as a leading exponent of Realism within an American context, as was noted by the art writer W. Mackay Laffan. In an article devoted to Twachtman (though the artist was not named) Laffan concluded, "There shall be more joy over one honest and sincere American horse-pond, over one truthful and dirty tenement, over one unaffected sugar-refinery, or over one vulgar but unostentatious coal-wharf, than there shall be over ninety and nine Mosques of St. Sophia, Golden Horns, Normandy Cathedrals, and all the rest of the holy conventionalities and orthodox bosh."[21]

By 1882, however, Twachtman decided that he

had carried the Munich manner as far as he could and subsequently returned to Europe, this time to study in Paris. For the "black" manner of Munich, he substituted the "gray" palette of French artists of the "juste milieu" such as Jules Bastien-Lepage, though he rejected the Naturalism of that master in favor of a concern for abstraction, reflecting the influence of both Whistler and oriental art. Twachtman's most monumental canvas painted in his "second manner" is *Arques-la-Bataille* (plate 51), where the emphasis upon pure design presages his mature Impressionist work.

Once back in the United States in 1886, Twachtman began to explore southwestern Connecticut, and in 1890 he purchased a farm on Round Hill Road in Greenwich; by the following year he had established a summer school at the Holley House in neighboring Cos Cob.[22] Through the 1890s, in paintings such as *Winter Harmony* (plate 52), Twachtman adopted a distinctively lighter color range and a thick, gritty paint application that were especially effective in winter scenes he painted on his Greenwich property and at the Holley House (and in which there was an emphasis upon sinuous outlines that at times foretold the rhythms of Art Nouveau). The critics recognized not only Twachtman's Impressionist adherence but also his individuality, his very poetic interpretation of the landscape through the adoption of close Tonal values, and his propensity for simplification in abstracting the essence of a scene. Unlike his contemporaries, Twachtman was seldom concerned with divisionist brushwork or with the full color range associated with Impressionism.

Although critics identified Twachtman as a convert to Impressionism, he incorporated into his paintings many of the characteristics of the contemporary Tonalist movement associated with the art of such painters as Henry Ward Ranger (1858–1916), J. Francis Murphy (1853–1921), Dwight Tryon (1849–1925), and George Inness (1825–1894). For Twachtman this consisted not only of the formal strategies of a dominant single tone and a softly muted palette but also an identification with spiritual values rather than the materialism to which critics of Impressionism so objected. This constitutes the explanation as to why so many writers greatly admired Twachtman's art and identified him as a poet-painter.[23]

For the most part, Twachtman's subject matter remained the gentle hill country, the flowing streams, and the small waterfalls and quiet pools on his property, though he did paint a series of views of Niagara Falls in 1894 and essayed even more spectacular scenery at Yellowstone the following year. But in general his concerns in rendering nature were intimate and subjective, and he avoided the scientific analysis of nature that characterized much of the work of Monet and even of his friend Robinson. Those same motivations led him to paint in both oils and pastel a series of still lifes of flowers, weeds, and wild herbs (plate 53), where nature is seen close up but still living and growing; in general, he shunned formal arrangements in favor of the casual and natural. At the same time, his floral and other nature subjects

51. JOHN HENRY TWACHTMAN. *Arques-la-Bataille.* 1885. Oil
on canvas, 60 × 78⅞″. The Metropolitan Museum of Art, New
York City. Morris K. Jesup Fund, 1968 (68.52)

52. JOHN HENRY TWACHTMAN. *Winter Harmony.* c.1890–
1900. Oil on canvas, 25¾ × 32″. National Gallery of Art,
Washington, D.C. Gift of the Avalon Foundation

53. JOHN TWACHTMAN. *The Flower Garden.* c.1900. Oil on canvas, 27⅛ × 22³⁄₁₆″. Courtesy of Brigham Young University Museum of Fine Arts, Provo, Utah. All Rights Reserved

French Impressionists, his repugnance was stated in a letter to his parents: "They do not observe drawing nor form but give you an impression of what they call nature. It was worse than the Chamber of Horrors."[25]

Weir settled in New York late in 1877. It would be a good many years before he overcame his distaste for the radical aesthetic, but even while in France he was moving in a more modern direction, away from a complete concern for academic finish and becoming a close friend of Bastien-Lepage's and of Whistler's. Though he deplored the lack of finish in Whistler's work, he nevertheless subscribed to the dark tonalities and strong sense of design inherent in that master's "harmonies" and "nocturnes." Indeed, Weir's *Against the Window* (plate 54) is a partial paraphrase of the portrait of Whistler's portrait of his mother, which had been seen in this country only two years earlier.

During the 1880s Weir resided in rural Connecticut, with homes at both Branchville and Windham, which surely accounts to some degree for the attraction of the area held for his friend Twachtman, with whom Weir shared several significant two-artist shows in 1889 and 1893. As with Twachtman, the Connecticut environment provided Weir with the subject matter and backgrounds of his increasingly Impressionist work— landscapes and figures posed out-of-doors, a development noted by the critics at his first significant one-man show held in New York in 1891. The masterpiece of Weir's scenic work is *The Red Bridge* (plate 55), in which he contrasted the varied rich greens of nature with the newly painted, functional iron span that had replaced an older bridge near Windham. Again, as with Twachtman's earlier New York harbor scenes, the stress on the modernity of the red bridge was an important component of Weir's picture. *The Red Bridge* is also informed by the new enthusiasm for the aesthetic of the Japanese print, which had overtaken Weir, Twachtman, and Robinson about 1893, seen here in the decorative planarity of the design and especially in the introduction of the cutoff forms of the trees pressed against the picture plane in the foreground. Actually, these artists were late in succumbing to such oriental influence, which had first appeared in American art in the 1860s with painters such as John La Farge and was hardly confined to the Impressionists. As with many American artists, Weir utilized Impressionist strategies first in landscape work; it took longer for him to accommodate figure work to the new aesthetic, due to the rigorous academic training he had undergone in Paris.

Giverny was not the only art colony in France where Americans began their subscription to Impressionism, but it was certainly the most prominent. American artists also flocked in the summers to Pont-Aven and Concarneau in distant, primitive Brittany and to a group of villages ringing the Forest of Fontainebleau— Marlotte, Montigny, and particularly Grez-Sur-Loing. Scottish, Irish, and Scandinavian artists especially joined Americans in Grez, painting landscape and peasant pictures in the manner of Bastien-Lepage. Impres-

were an integral part of his Connecticut property, the totality of which constituted the basis for almost all of his mature art. Of all the American artists associated with Impressionism, Twachtman was the one most appreciated both by the critics and his fellow painters, and his influence was further implemented through his teaching both at Cos Cob and at New York's Art Students' League. When he died in Gloucester, Massachusetts, during the summer of 1902, American art lost one of its finest and most distinctive resources.

During his lifetime, Twachtman's art was often linked with that of his closest friend and colleague, Julian Alden Weir (1852–1919).[24] Weir was the son of the instructor of drawing at West Point and thus had grown up in an artistic environment. After studying at the National Academy of Design in New York, Weir went to Paris in 1873 and became a pupil of Gérôme's at the École des Beaux Arts. His adherence to and achievement of academic standards can be seen in his *Study of a Male Nude Leaning on a Staff,* (Yale University Art Gallery, New Haven), painted in Gérôme's class in 1876, and although that same year he visited the show of the

54. JULIAN ALDEN WEIR. *Against the Window.* 1884.
Oil on canvas, 36⅛ × 29½". Private collection

55. JULIAN ALDEN WEIR. *The Red Bridge.* 1895. Oil on
canvas, 24¼ × 33¾". The Metropolitan Museum of Art, New
York City. Gift of Mrs. John A. Rutherford, 1914 (14.141)

56. ROBERT VONNOH. *Poppies in France*. 1888. Oil on canvas,
12¾ × 22⅞″. © Terra Museum of American Art, Chicago

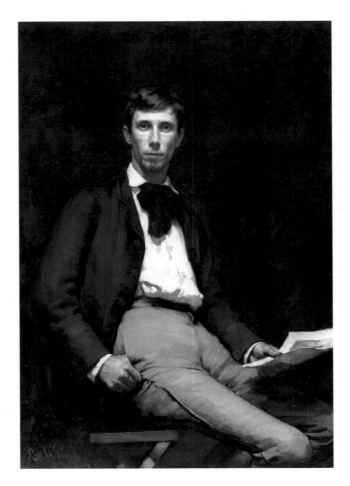

57. ROBERT VONNOH. *Companion of the Studio*. 1888. Oil on
canvas, 51½ × 26¼″. Courtesy of the Pennsylvania Academy of
the Fine Arts, Philadelphia

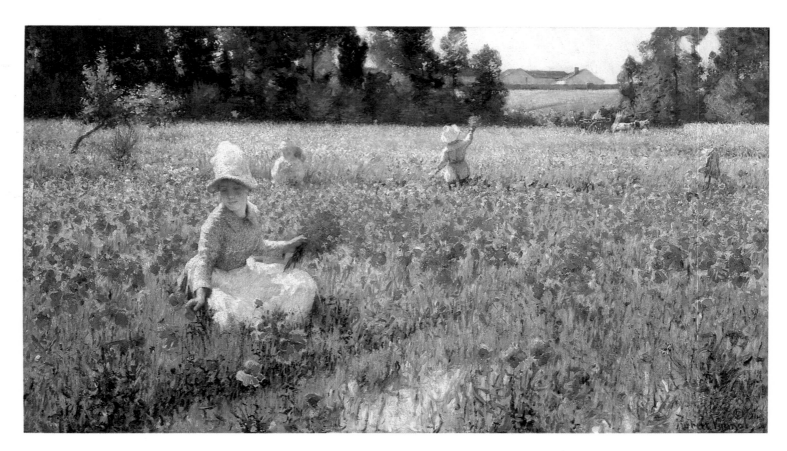

58. ROBERT VONNOH. *Coquelicots (In Flanders Field)*. 1890.
Oil on canvas, 58×104″. The Butler Institute of American Art,
Youngstown, Ohio

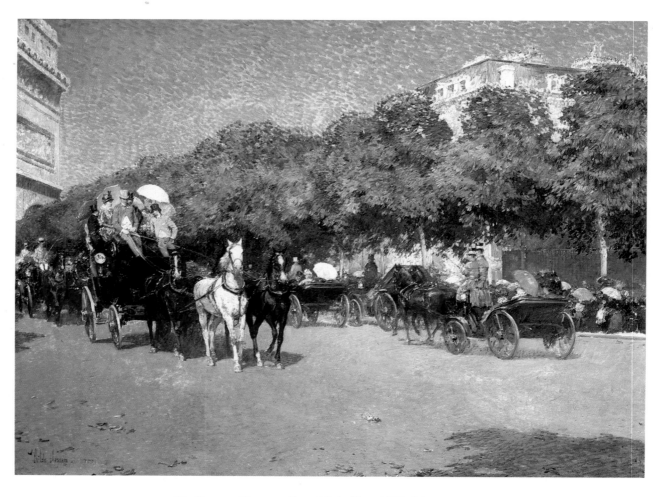

59. CHILDE HASSAM. *Grand Prix Day*. 1887. Oil on canvas,
36×48″. From the collection of the New Britain Museum of
American Art, Connecticut. Grace Judd Landers Fund

sionism would seem to have been introduced there by the Irishman Roderic O'Conor, who had arrived in Grez about 1884 and who was painting landscapes in bright, unmixed hues by 1886. He in turn had a decisive influence on the Boston-born and -trained Robert Vonnoh (1858–1933), who began working in an Impressionist manner in Grez by 1888.[26]

Vonnoh is still one of the least appreciated among the major early American Impressionists, but his "conversion" illustrates the dichotomy present in the work of almost all the early painters of the movement. Vonnoh's *Poppies in France* (plate 56) of 1888, with the rich colors of the unmodulated and unoutlined flowers laid on with a palette knife, appears almost Fauvist in its freedom and spontaneity. Yet, that same year he painted his *Companion of the Studio* (plate 57), a depiction of the Canadian art student John C. Pinhey in a solid, tonal manner, all in neutral tones. Thus, in Paris Vonnoh responded in a studio painting of a figure in an interior with all the academic strategies he had learned; in the countryside, free from academic restrictions, he explored the theme of landscape, embracing the most radical aesthetic of the day with great enthusiasm. And when he came to paint a major exhibition picture of a sunlit, outdoor modern-life subject, his large *Coquelicots* (plate 58), he effected a compromise by painting the landscape and the poppy field with great freedom and verve and rendering the figures in a more carefully drawn and modeled manner, though still in sunlit and colorful terms. Vonnoh, in turn, influenced the Impressionist direction taken by the Cincinnati painter Edward Potthast (1857–1927), who was also in Grez in the late 1880s; Vonnoh was later an influential instructor at the Pennsylvania Academy in Philadelphia in the early 1890s, encouraging students such as Robert Henri (1865–1929) to investigate Impressionist strategies.

Rather than his colleagues Robinson, Twachtman, Weir, or Vonnoh, it was Childe Hassam (1859–1935) who became identified as the quintessential American Impressionist painter and the one who would seem to have had the greatest influence in the propagation of the aesthetic from New England to California.[27] This was not, however, Hassam's original identification; after beginning his career in Boston as an illustrator of newspapers, magazines, and books, he emerged as a fine artist first in the medium of watercolor and then as a painter in oils of Tonal urban landscapes, often majestically somber works such as *Rainy Day, Columbus Avenue, Boston*. Though a magnificent paean to urban contemporaneity, Hassam's painting also reflects the oppressiveness and the anonymity of modern street life in its formal symmetry, in the rigid gridwork of the avenues, and in the careful positioning of the dark figures and carriages, which all carefully adhere to the geometric compositional structure. The painting bears comparison with the contemporaneous Parisian street scenes of such European Realist masters as Jean Béraud, Luigi Loir, and Giuseppe De Nittis; De Nittis's work especially was much admired and collected in America in the

60. CHILDE HASSAM. *Mrs. Hassam in Her Garden.* 1889. Oil on canvas, 34 × 52″. Collection of Mrs. Norman B. Woolworth

1870s and 1880s, and his *Place de la Concorde* was shown in New York at the Pedestal Fund Art Loan Exhibition in 1883. Furthermore, Hassam would have had the opportunity to see De Nittis's city scenes, which were on view in several exhibitions when he visited Paris in 1883.[28] Also, Hassam's picture, in its combination of rainy weather conditions and the looming central building, offers an especially startling comparison with Gustave Caillebotte's *Paris, A Rainy Day* (plate 12) of 1877. But while the similarity is not only one of motif, as the two paintings both utilize similar wide-angle spatial techniques and deeply receding diagonals to create and heighten an oppressive tension plunging the foreground figures toward the picture plane, there appears little possibility that Hassam could have seen the French painting or even reproductions of it.

The following year Hassam went abroad again, this time to study and work in Paris, and both there and after his return to this country in 1889, when he settled in New York City, he became known primarily for his city scenes and especially for his paintings of rainy days—one critic even advised him to "come in out of the rain."[29] Nevertheless, Hassam's French experience was a liberating one; in his *Grand Prix Day* (plate 59) of 1887, the artist abandoned his previous dark tonal mode for the full glare of bright sunshine, introducing the spotted colors of the parasols and replacing the tight drawing of his earlier Boston street scene with the swift, broken brushwork of Impressionism. Hassam's Impressionism is still selective at this stage; the horses and carriages are far more precisely rendered than the rich painterliness of the sky and the avenue of trees. Though celebrating the day of the Grand Prix at the racetrack at Longchamp in the Bois de Boulogne, Hassam is unconcerned with the races themselves but celebrates instead the fashionable procession of carriages, occupied with an easy, informal mix of men and women. His scene is situated in the heart of Paris (as identified by the Arc de Triomphe, cut off at the left side

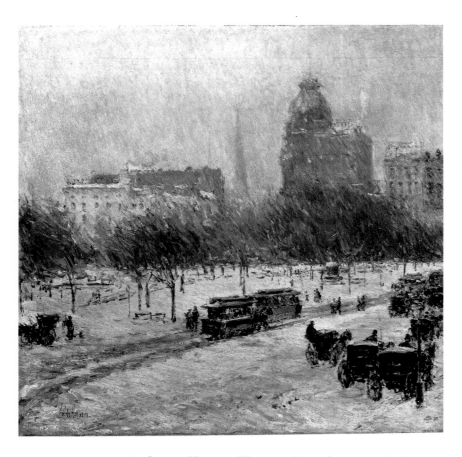

61. CHILDE HASSAM. *Winter in Union Square*. 1889. Oil on canvas, 18¼ × 18″. The Metropolitan Museum of Art, New York City. Gift of Miss Ethelyn McKinney, 1943, in memory of her brother, Glen Ford McKinney (43.116.2)

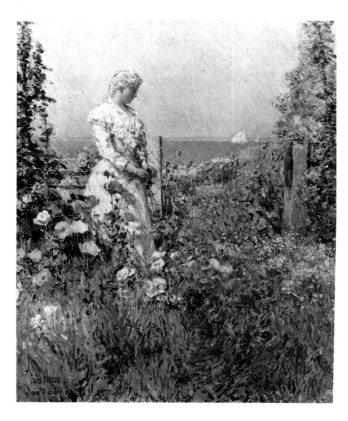

62. CHILDE HASSAM. *Celia Thaxter in Her Garden*. 1892. Oil on canvas, 22⅛ × 18⅛″. National Museum of American Art, Smithsonian Institution, Washington, D.C. Gift of John Gellatly

of his composition) and balanced by a tall building at the right on the Avenue des Champs Elysées. Still the picture is not about the monuments of Paris, but rather the vivacious activity among upper-class society, which he renders in a sparkling manner through Impressionist strategies of light and color. While the picture brings to mind especially the outdoor scenes of Degas and the cityscapes of Manet, it is perhaps unwise in the absence of documentation to speculate on what French Impressionist pictures Hassam might have seen in Paris during the first six months of his stay. Alternatively, he may well have seen one of Manet's racetrack pictures that was shown in New York at the Durand-Ruel exhibition in the spring of 1886, prior to Hassam's departure for Europe that autumn; but Hassam's picture is more calculated and lacks the spontaneity of Manet's art.

The streets of Paris offered Hassam myriad opportunities to paint active city life, and he savored the colorful wares of the flower sellers along the Seine, street merchants who thus brought elements of the country into the lives of the busy city dwellers. In his summers spent in Villiers-le-Bel, on the outskirts of the city, Hassam painted quieter but still very colorful garden scenes. Such a picture represents Mrs. Hassam in her garden (plate 60), a work painted in 1889. As in his Paris scene of two years earlier, Hassam contrasts a broad expanse of empty ground plane with the busy pattern of colorful, flecked brush strokes that define the figure and the floral setting. Interestingly, while the nominal subject of the painting is his wife, Hassam presents her in the shadows, manikinlike and lured away from her earlier position on the more comfortable bench on which her hat and knitting still lie; it is the garden and the bright red and pink flowers that are revealed in full sunlight.

When Hassam settled in New York, soon after his return to this country late in 1889, he immediately became identified as the modernist painter of the city.[30] Theodore Robinson, as usual spending the winter and early spring in the city, was a painter of country subjects, and most of the other emerging Impressionists in the New York region were primarily devoted to landscape. But in such works as *Winter in Union Square* (plate 61), Hassam applied the full range of Impressionist techniques to a typical scene of modern life in the urban metropolis. Indeed, it would be fair to say that Hassam's paintings during the 1890s mark the most complete demonstration of classic Impressionism in America.

Hassam did not confine this mode, however, to his residence in New York, and, in fact, what may be his most beautiful paintings are those created during the summer months in New England, especially the works he produced on the island of Appledore, one of the Isles of Shoals off the coast of New Hampshire and Maine. There, the poet and essayist Celia Thaxter presided over an informal salon of talented writers and painters, of whom Hassam emerged as the most renowned. Over a period of many years, but especially from 1890 to 1894, some of Hassam's greatest works were inspired by the riotous abandon he perceived and recorded in Thaxter's

IMPRESSIONISM IN THE UNITED STATES

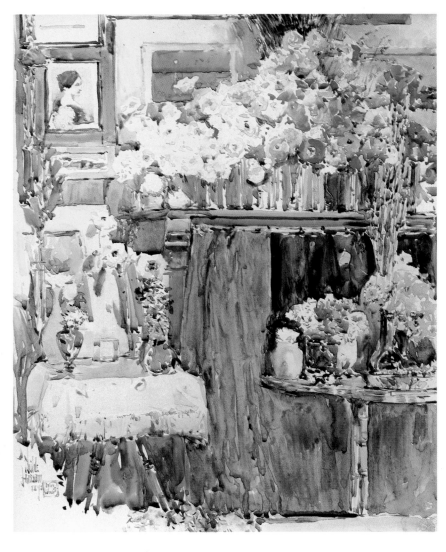

63. CHILDE HASSAM. *Celia Thaxter's Sitting Room, Isle of Shoals (The Altar and the Shrine)*. 1892. Oil on canvas, 15½ × 12¼". The Pfeil Collection

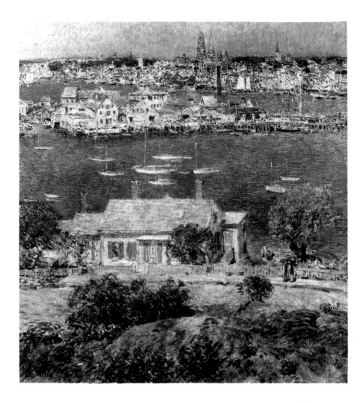

64. CHILDE HASSAM. *Gloucester Harbor*. 1899. Oil on canvas, 24½ × 22½". The Pfeil Collection

natural garden. Paintings such as *Poppies on Shoal Island* (private collection), ablaze with poppies and other flowers, are pictorial paeans to nature and to Thaxter, mirroring Thaxter's own writings and poetry. It was thus only appropriate that twenty-two of Hassam's watercolors adorned Thaxter's last book, *An Island Garden*, published just prior to her death in 1894.

Hassam's Appledore paintings are primarily landscapes without figures, with only a few exceptions. One of these is his representation of *Celia Thaxter in Her Garden* (plate 62), where the subject, in a brilliant white dress covered with purple shadows from the surrounding blooms, is placed knee-deep in the rich abundance of blossoms and silhouetted against a calm, sunlit seascape. The picture is portrait, still life, landscape, all in one. Hassam's most eloquent tribute to Thaxter is a larger, square painting, *Celia Thaxter's Sitting Room* (plate 63), in which a portrait of a younger woman is almost lost in the informal and comfortable profusion of summer furniture, books, pictures, stuffs, and bouquets fashioned by Thaxter from her garden. The work is an eloquent tribute to the hospitable environment Thaxter created for her guests and to her commitment to art and nature.

After Thaxter's death in the summer of 1894, Hassam did not cease visiting the island, but his summer travels often took him to other New England coastal towns, including Newport, Gloucester, and Old Lyme. The paintings done in these venerable communities are true tributes to Hassam's respect for Puritan New England traditions, as noted by a number of his critics[31]; but he interpreted these values in the most modern and most celebratory of aesthetics. His *Gloucester Harbor* of 1899 (plate 64) is a strongly structured and richly colored view of the town seen from the near shore and beyond a series of small boats, the masts of which lead the eye back to the white church spires breaking the high horizon line in the distance. The bright, pure colors illuminated in brilliant, beneficent light suggest Hassam's admiration for—almost veneration of—the hallowed, unsullied town.

Hassam's most significant summer stay was his first visit to Old Lyme, Connecticut, in 1903. That town had already developed an art colony of painters who worked in the alternative Tonalist aesthetic that had been initiated in the late 1880s by George Inness. They painted landscapes, rural farm activities, and farm animals and achieved a poetic interpretation through the prevalence of a single, harmonizing tone, applied in broad, painterly terms. By the late 1890s Tonalism's misty poetics were championed against the growing prevalence of Impressionism by those critics and collectors who found the rawness and immediacy of the new aesthetic inimical. Henry Ward Ranger was the dominant figure among the artists at Old Lyme at the turn of the century, but Hassam's appearance in 1903 and successive summers turned Old Lyme into an important regional center for Impressionist painting, and Ranger moved up the coast to Noank. Hassam's most famous images painted at Old Lyme were his several views of the

Congregational church, painted between 1903 and 1906. In these works, again, Hassam interprets a venerable, traditional, and spiritual structure in modern, painterly, and light-filled terms.[32]

Hassam's tremendous pictorial output is characterized by the greatest thematic diversity of any American Impressionist. Labor and industry, subjects not usually associated with the joyous holiday spirit of Impressionism, were undertaken by him in paintings of shipbuilding done at Gloucester and Provincetown as well as in his paintings of the urban environment, too, such as *The Hovel and the Skyscraper* (Mr. and Mrs. Meyer Potamkin Collection, Philadelphia), a New York scene of 1904. This is the most elaborate of a number of construction and industrial scenes painted by Hassam, who remained fascinated with the dynamics of urban life. This very American concern with the skyscraper would be developed during the following decade in his New York "Window" series, where views of the urban skyscraper landscape are visible beyond the curtained interiors with which they are pointedly contrasted. The art of many American Impressionists in the 1900s witnessed an increasing overlay of Post-Impressionist strategies, decorative patterning, and other nonnaturalistic concerns, and some of Hassam's paintings even verge on pure abstraction, the extreme of which was reached in a group of seascapes, such as his *Sunset at Sea* (plate 65) of 1911. Here, Hassam utilizes a minimalist approach by laying on a series of horizontal bands of broken color; the lower two-thirds of the picture are dominated by green and yellow to indicate water, and the upper third is a yellow, blue, and red combination to distinguish the sky, with only a small boat on the separating horizon to identify the nature of the scene.

During the second decade of the century, Hassam developed two series of images that brought him exceptional attention. His "Window" series consists of paintings of the figure in an interior, sometimes a country bungalow but more often an upper floor of a New York building, as in his *Tanagra* (National Museum of American Art, Washington, D.C.) of 1918. Of more enduring fame was Hassam's "Flag" series.[33] These pictures directly reflected Hassam's patriotic stance during World War I. From the Preparedness Day parade of 1916 through America's entry into the conflict in 1917 to the victory the following year, Fifth Avenue was the site of numerous parades and was decorated with the flags of the United States and its allies. In works such as Hassam's *Avenue of the Allies, Great Britain* (plate 66), the giant banners serve as great foils of color, while below, ideographs of masses of humanity surge through the streets. Just as Hassam's New England scenes bear witness to his genuine respect for the nation's colonial heritage, so the flag series testifies to his strong love of country and was recognized as such by the critics and public. The series is richly celebratory and was enthusiastically greeted when exhibited at Durand-Ruel's New York gallery in 1918. Indeed, the pictures spawned numerous imitations by other artists around the nation.

65. Childe Hassam. *Sunset at Sea*. 1911. Oil on canvas, 34 × 34". Rose Art Museum, Brandeis University, Waltham, Massachusetts. Gift of Mr. and Mrs. Monroe Geller

Works by early American adherents to the Impressionist aesthetic had been on view in increasing numbers from 1890 on in exhibitions held by artists' organizations in New York and Boston, as well as in commercial galleries in these cities. French Impressionist paintings were also being collected and displayed frequently elsewhere. Chicago was initially exposed to Impressionism with several examples by Monet and Renoir included by Durand-Ruel in a show he mounted at Thurber's Art Galleries in 1888. A more substantial loan collection was also sent there by Durand-Ruel for inclusion in the art gallery of the Inter-State Industrial Exposition annual of 1890. This was the last of the annual fairs that had started up to boost Chicago's commerce and prestige following the disastrous fire in 1871; the art sections constituted the most important exhibitions held in the city until the Art Institute of Chicago inaugurated its annual shows of contemporary American art in 1888. That same year, 1890, a group of French Impressionist works was on view in the art gallery of the annual Saint Louis Exposition and Music Hall Association, and in 1891 a collection of thirty-nine of Hassam's paintings was shown there. Paintings by Monet and Pissarro were first on view in San Francisco in a loan exhibit held in 1891. Critical reaction was increasingly receptive to Impressionism, though some writers, such as Alfred Trumble, the editor of *The Collector*, continued to lament

66. CHILDE HASSAM. *Avenue of the Allies, Great Britain.*
1918. Oil on canvas, 36 × 28⅝″. The Metropolitan Museum of
Art, New York City. Bequest of Miss Adelaide Milton de Groot
(1876–1967), 1967. (67.187.127)

the materialistic nature of the aesthetic, championing still the poetic subjectivity of practitioners of the Barbizon mode. Even when voicing guarded and limited enthusiasm for the work of Monet, Trumble remained disturbed by the conversion of American artists to Impressionism.[34]

Nevertheless, by the time of the great Columbian Exposition held in Chicago in 1893, the triumph of Impressionism in America was all but complete. The official French art section was devoid of the work of the Impressionists, but the major French Impressionists were well represented in a section entitled "Loan Collection of Foreign Works from Private Galleries in the United States." Likewise, a good many of the American artists involved with that modern aesthetic had paintings on view; Childe Hassam exhibited his *Grand Prix Day*, for example. While the art display at the exposition ran the gamut of styles—including academic, Barbizon, and plein-air—and of subjects—from poetic figural work to earthy peasant genre—and Impressionist works were much in the minority, it was Impressionist paintings by artists of many nationalities that appeared, in their color and light, to attract critical attention. And it was at the exposition that Impressionism found its first major American critical champion in the person of Hamlin Garland.[35] Garland was especially attracted to Scandinavian paintings that today would be judged only tentatively Impressionist, but he pointed to them as a model on which to build a distinctly American modernism, at once contemporary, yet very national and independent of French prototypes.

Four years later, "The Ten American Painters" was formed, which has been referred to as an academy of American Impressionism.[36] This was not strictly true, for some of the artists involved with The Ten adhered to Tonalist preferences and others really turned to Impressionism only after they began to show with the group. But "The Ten" was founded by Hassam, Weir, and Twachtman (Robinson having died in 1896), and Impressionism tended to dominate their annual shows. The artists involved had been active exhibitors with the Society of American Artists, but by 1897 many found that society's shows too heterogeneous, too varied in quality, and not terribly distinguishable from the annuals of the older National Academy of Design. So ten artists decided to secede from the society, not so much to found a new organization but rather, finding their work mutually harmonious and compatible, to exhibit together in small, select exhibitions held annually in New York City and in surroundings that would allow each work the most advantageous exposure.

Willard Metcalf, one of the original "Givernyites" of 1887, had been working increasingly in an Impressionist manner by the mid-1890s, but it was only in the years after he began his association with The Ten that he gained great prominence.[37] He joined the Old Lyme art colony in the summer of 1905, and the following year painted there his *May Night* (plate 67), a nocturnal view of the Florence Griswold House, which was

67. WILLARD LEROY METCALF. *May Night.* 1906. Oil on canvas, 39½ × 36⅝". In the collection of The Corcoran Gallery of Art, Washington, D.C. Museum Purchase

where the artists boarded and the art center of the village. Metcalf's picture won a gold medal at the *Corcoran Gallery Biennial* in Washington that year and spawned numerous imitations. Based in New York City, Metcalf did not stay in one art center, however, but became known as the painter of New England, working in many other places, including Cornish, New Hampshire, and Chester, Vermont. While Metcalf interpreted the landscape in all seasons of the year, he became especially known for his late autumn and winter scenes.

Another New York artist-member of The Ten was Robert Reid (1862–1929), primarily a figure painter rather than a landscape specialist.[38] Even in his earlier academic representations of peasant genre painted in France from 1885 to 1889, during his years of training there, Reid was drawn to experimentation with light and color, and by the mid-1890s he was critically associated with the Impressionist movement. At about that time, he began to concentrate upon the theme that would preoccupy him—the monumental depiction of lovely women outdoors, usually accompanied by flowers with which they would have an empathetic relationship and which would identify the painting itself. Probably the best-known of these is his *Fleur-de-Lis* (plate 68) of about 1899, in which the young model is almost engulfed in the mass of swaying flowers. Reid's paintings are very consciously decorative, with vivid overlaying of patterns

68. ROBERT LEWIS REID. *Fleur de Lis.* c.1899. Oil on canvas, 44⅛ × 42¾". The Metropolitan Museum of Art, New York City. George A. Hearn Fund, 1907. (07.140)

and with a sense of motion imparted by rhythmic lines and ribbonlike brush strokes. Later, about 1910, Reid began to prefer a more controlled indoor setting, usually the boudoir, with the high coloration often transferred to the dressing gowns of his subjects and repeated in flowers and in the decorative detailing of his room interiors.

Though The Ten was primarily New York-based, three of its members were Boston artists: Edmund Tarbell (1862–1938), Frank Benson (1862–1951), and Joseph DeCamp (1858–1923). Like Reid, they also were primarily figure painters; despite the active presence of John Leslie Breck, Theodore Wendel, and other Impressionist landscape painters on the Boston scene, Impressionism there became primarily identified with a distinctive approach to figurative art during the 1890s that stressed the elegant ambience of the upper-class woman. Edmund Tarbell was the earliest of these three, returning from his training abroad in 1886, and three years later he began his long and influential association with the Boston Museum School.[39] In 1890 Tarbell displayed his commitment to Impressionism in his *Three Sisters—A Study in June Sunlight* (plate 69). The casual and sparkling rendering of upper-class women leisurely enjoying themselves outdoors is characteristic of the first phase of Boston Impressionism, and Tarbell here adopts the full chromaticism of the movement, even adding the scintillation of a flickering pattern of colored light over

the figures. The painting represents the hallmark of Boston figurative Impressionism, idyllic views of attractive and fashionable women totally at leisure; an "aristocratic" art form that appealed to wealthy Boston collectors.[40]

Though not a member of The Ten, the Boston artist who took Impressionist figure painting to the extreme of dissolution in the early 1890s was the still little-known Philip Leslie Hale.[41] Hale began to paint in Giverny in 1888, and by 1890 he had started to adopt a rather individual form of decorative divisionism, or Pointillism, painting during the summers both in Giverny and at the home of his aunt, Susan Hale, at Matunuck, Rhode Island. Hale posed his models, garbed in thin white costumes, in bright, sunlit gardens, in fields, and along the banks of a river and depicted these scenes in sharp keys of color with an emphasis upon yellow, applied in long, thin brush strokes and combined with dots of pure color. The results of such a method may be seen in *The Water's Edge* (plate 70). The very artificiality of elegantly dressed women engaged in fishing adds to the sense of decorative unreality; it is a theme addressed nonetheless by a number of American artists of the period, including Sargent and Thomas Wilmer Dewing.

In 1893 Hale began teaching at the Boston Museum School along with Tarbell and Frank Benson. Benson, like Hale, Joseph DeCamp, and others, was identified as one of the "Tarbellites," critics noting a similarity in method and subject matter among the Boston figure painters and viewing the group as following the lead of Tarbell.[42] In fact, however, during most of the decade of the 1890s, Benson had shown little interest in Impressionist light and color, after an initial experimentation with out-of-doors painting in his *In Summer* (cut down, private collection) of 1887, which even preceded Tarbell's outdoor work.[43] Following that, Benson reverted to painting solidly modeled, sometimes allegorical images of women and especially to contemporary renderings of the figure indoors, seen in the glow of light from lamps and fires, works that attracted a good deal of critical acclaim. It was only beginning in 1899, painting initially at New Castle, New Hampshire, and then at his summer home on the island of North Haven, Maine, that Benson began to subscribe fully to the tenets of Impressionism as in *Calm Morning* (plate 71) of 1904; these are light-filled and vividly coloristic images of his own children, painted outdoors.

The second phase of Boston Impressionism was initiated through the revival of interest in the work of the seventeenth-century Dutch painter Jan Vermeer.[44] Vermeer's art was rediscovered in France in the 1860s, but the American conjunction with that revival is usually pinpointed to the year 1904. It was then that the earliest American monograph on Vermeer was published in the important "Masters of Art" series, thought to have been written by Philip Hale, who later also published a full-length book about Vermeer,[45] and it was that year also that Tarbell produced his *Girl Crocheting* (plate 72),

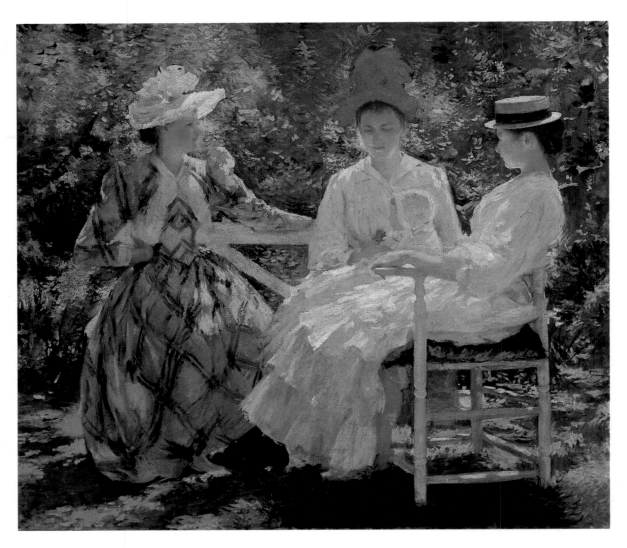

69. EDMUND C. TARBELL. *Three Sisters—A Study in June Sunlight.* 1890. Oil on canvas, 35⅛ × 40⅛". Milwaukee Art Museum. Gift of Mrs. Montgomery Sears

70. PHILIP LESLIE HALE. *Girls in Sunlight.* c.1897. Oil on canvas, 29 × 39". Gift of Lilian Wescott Hale. Courtesy Museum of Fine Arts, Boston

71. FRANK BENSON. *Calm Morning.* 1904. Oil on canvas,
44×36. Gift of the Charles A. Coolidge Family. Courtesy
Museum of Fine Arts, Boston

which emulates the color, light, and subject matter of
Vermeer. From then on, some of the Boston figure paint-
ers, such as Tarbell, DeCamp, and William Paxton, more
often than others, such as Benson, turned increasingly to
indoor scenes informed by Vermeer's aesthetic.

Joseph DeCamp was the third Boston member of
The Ten.[46] The figure paintings that he first exhibited in
their annual exhibitions were dark academic studies of
the nude; he first explored Impressionist color in his
landscape work at the beginning of the present century,
surely stimulated by his association with the other artists
of the group. Unfortunately, a great part of DeCamp's
earlier production was lost late in 1904 in a fire in the
Harcourt Building in Boston where he had his studio;
subsequently, he was one of the painters who adopted the
Vermeer aesthetic in paintings such as *The Guitar Player*
(plate 73). In works such as this and Tarbell's *Girl
Crocheting*, the lovely young women take their places
among elegant furniture and objets d'art; they sit en-
gaged in emphatically "womanly" tasks or play musical
instruments. As such, these pictures have been inter-
preted in a feminist context, as conforming to a male

ideal of the time, upholding the social value of passive
domesticity.[47]

The Ten exhibited together annually for twenty
years, 1898 to 1917, with occasional displays also in
Boston, Philadelphia, Providence, and a final retrospec-
tive showing at the Corcoran Gallery in Washington,
D.C., in 1919. After John Twachtman's death in 1902,
examples of his art continued to figure in the next two
annuals, but he was absent from the roster in 1905, and
that year his place was taken by William Merritt Chase
(1849–1916), who began to exhibit with The Ten in
1906.[48] Chase had been one of the principal Americans
to study in Munich during the 1870s, where he associ-
ated with Frank Duveneck and later also with Twacht-
man; on his return to New York in 1878, he became a
leading figure in the newly founded Society of American
Artists, and, appointed that year at the Art Students'
League, he quickly established himself as one of the
leading art teachers in the nation. Though he worked
first in the dark, tonal style of Munich, he came in the
1880s to admire the art of Édouard Manet. He lived in
Brooklyn after his marriage in 1886 and painted scenes
in Prospect Park and, later, in Manhattan's Central Park.
Chase's Impressionist inclination first emerged in these
well-received park pictures, bits of urbanized nature
painted with light and air and color, sparkling examples
of leisure activity.[49]

Chase's park scenes of the 1880s paved the way for
his further explorations of nature and life outdoors, cre-
ated at Shinnecock on Long Island, beginning in 1891.
These were painted while he was running the Shin-
necock School of Art, which continued operation through
1902. But while Chase taught oil and pastel painting at
the school and reviewed each student's work, he was also
busily engaged in his own painting; as John Gilmer
Speed noted of Chase, "Summer vacation is his busiest
and his happiest time, and upon the work then done he
not infrequently finds his inspiration for the remainder of
the year."[50] Chase was strongly drawn to the low-lying
dunes and beaches of Long Island, the blue of sea and sky
acting as a foil for the rich green of the bayberry bushes,
with the pictures often animated with sparkling repre-
sentations of his wife with a parasol and his children in
pinafores. Works such as *The Fairy Tale* (private collec-
tion) of 1892 are filled with the casual enjoyment of
summer and are painted in an Impressionist technique.
Like Benson on North Haven later, many of Chase's finest
paintings are depictions of and reflect his devotion to his
own family.

Chase's Shinnecock School was only the most fa-
mous and one of the longest-lasting of the many outdoor
summer schools that sprang up in this country in the
1880s and 1890s;[51] we have already noted Twachtman's
activity at the Holley House in Cos Cob and Robinson's
teaching for the Brooklyn Art School. By the last decade
of the century, such outdoor teaching had become a vital
aspect of American art instruction and was extremely
significant for the dissemination of Impressionism.[52]
Summer teaching, of course, need not have led neces-

72. EDMUND C. TARBELL. *Girl Crocheting.* 1904. Oil on canvas, 30 × 25″. Permanent Collection. Canajoharie Library & Art Gallery, New York

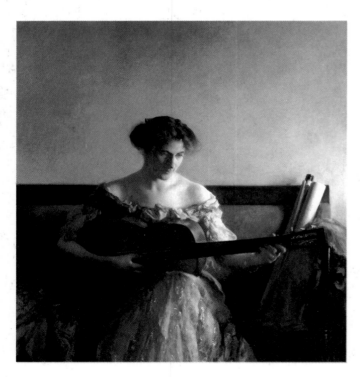

73. JOSEPH RODEFER DeCAMP. *The Guitar Player.* 1908. Oil on canvas, 50⅜ × 46½″. Hayden Collection. Courtesy Museum of Fine Arts, Boston

sarily to the adoption of Impressionist strategies, and in fact some summer art schools, such as that established by Walter Satterlee at Bellport, Long Island, in 1895, was not even geared primarily to landscape, but rather to the painting of exotic and picturesque figural themes, painted in the outdoors. Yet such outdoor training almost inevitably produced greater appreciation of and concern for effects of light and bright color and for the recording of an "impression," often captured in a single session. In turn, while many of the students at these schools retained an amateur status, others developed into serious professionals and carried both the methodology and the results of their instruction to all parts of the country. As one critic noted in 1894:

> A decade ago such schools were unknown. . . . That these Summer schools have exerted a powerful influence on the character of our painting will be seen by any one who studies the exhibitions. . . . We no longer have any doubt that the modern eye has been developed to see color, movement, light and atmosphere unknown and undreamed of in [John F.] Kensett's day. . . . out of this enlarged vision and abler technique of the Summer schools, will come the geniuses of the next period in our art.[53]

It was these dynamics that partially accounted for the universality of Impressionist-related modes of painting throughout the United States by the early years of the present century and the enshrinement of Impressionism in one of the last of the great international fairs, the Panama-Pacific Exposition held in San Francisco in 1915. There, Impressionist painters from Old Lyme to San Diego were out in force, and some artists, such as Hassam, Twachtman, Tarbell, and Chase, were given whole rooms to themselves. By this time Impressionism was the dominant mode throughout the country, though more so in some areas, such as much of the Northeast, the Midwest, Utah, and California, than in the South or the Northwest. Regional distinctions would seem to be based on subject matter rather than style, the formal strategies of Impressionism applied to winter landscapes among the Pennsylvania painters centered near New Hope, to agrarian scenes in Utah, and to the coastal landscape by northern California painters working at Monterey, and those farther south painting at Laguna Beach and around San Diego. There were outstanding artists among these regional artists, such as Edward Rook in Old Lyme, Guy Rose in Los Angeles, and Maurice Braun in San Diego.

The artist who won the grand prize in painting at the Panama-Pacific Exposition was Frederick Frieseke (1874–1939), the best-known of the generation of American artists who were active in Giverny in France in the early twentieth century. Although many of the initial group of American Givernyites had returned to this country by the early 1890s, a few, such as Theodore Butler, continued to reside there, and others, such as

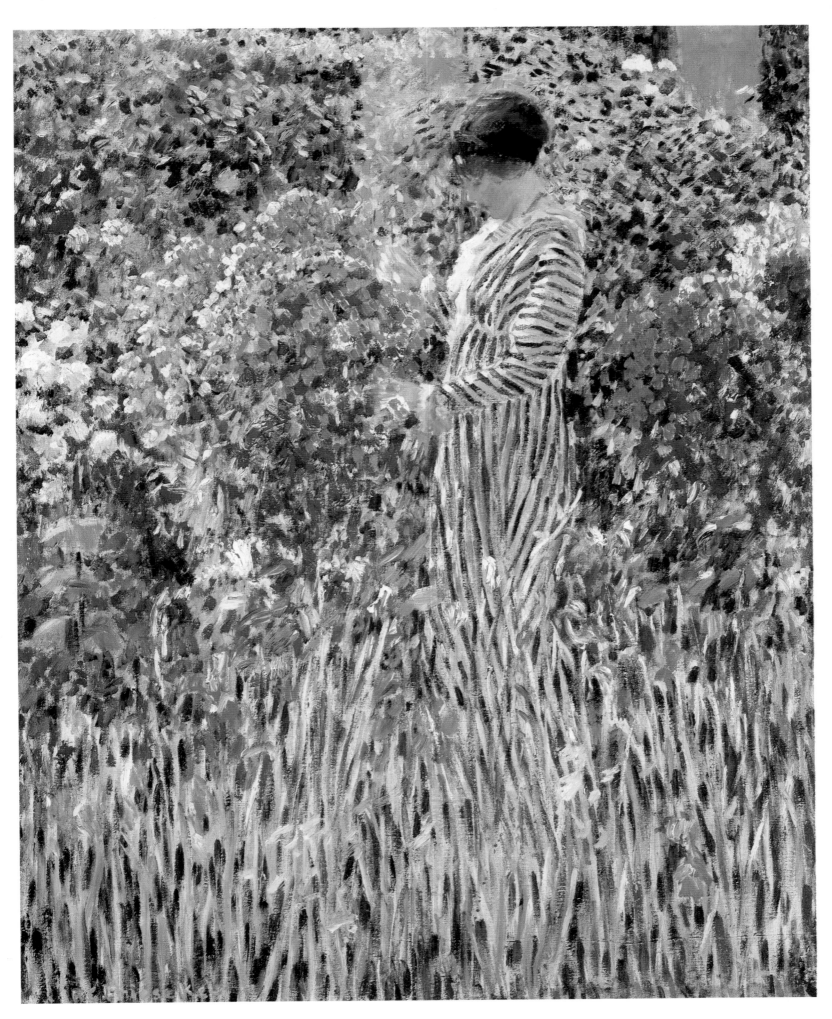

74. FREDERICK CARL FRIESEKE. *Woman in a Garden.*
c.1912. Oil on canvas, 31 × 26½″. © Daniel J. Terra Collection.
Terra Museum of American Art, Chicago

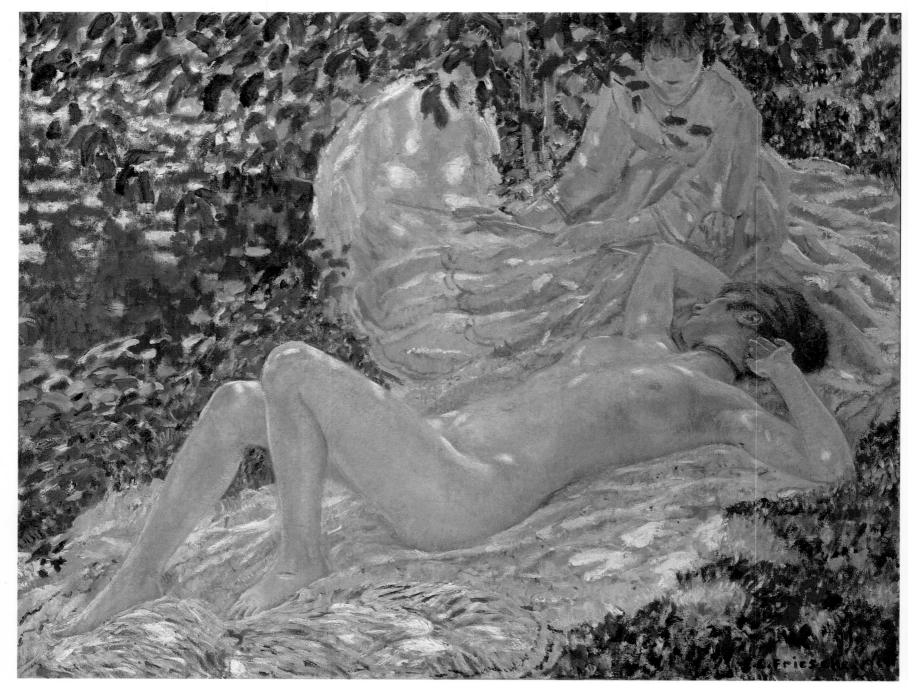

75. FREDERICK CARL FRIESEKE. *Summer*. 1914. Oil on
canvas, 45 × 57¾". The Metropolitan Museum of Art, New York
City. George A. Hearn Fund, 1966. (66.171)

Lilla Perry and Philip Hale, continued to visit. Further-
more, a new influx of Americans came in the 1890s,
gathering around the painter-sculptor Frederick Mac-
Monnies (1863–1937) and his artist-wife, the former
Mary Fairchild (1858–1946). This group of artists was
not especially inclined toward Impressionism but had
been attracted to Giverny by the confraternity of Ameri-
can painters that was already ensconced there and by its
pleasant rural atmosphere still within an easy commute
of Paris. They introduced into the artistic repertory there
the themes of the garden and the nude, which became
prominent, in turn, in the work of their successors such
as Frederick Frieseke, Lawton Parker (1868–1954), and
Louis Ritman (1889–1963).

Frieseke was probably the earliest of the third
"generation" of Americans to settle in Giverny.[54] He was
born in Michigan and studied at the school of the Art
Institute of Chicago, and his Midwestern background
appears to have led many other Chicago-trained painters
to follow him to Monet's hometown. While Frieseke had
undergone the usual academic training in Paris and is
said to have had some instruction from Whistler, he
moved rather quickly from Tonalist indoor figure paint-
ing to an emphasis upon outdoor subjects. However,
unlike Robinson and Breck, Frieseke seems not to have
associated much with Monet, acknowledging instead the
influence of Auguste Renoir. Unlike many of the earlier
American Givernyites, Frieseke and those of his genera-

IMPRESSIONISM IN THE UNITED STATES

tion were often primarily involved in figure painting, creating an art that was extremely feminine-oriented; in the case of Frieseke himself, his large, rounded figures resemble the monumental images of Renoir. They are often posed in lush, colorful flower gardens, the multi-colored profusion of which is contrasted with the flamboyant designs of large garden umbrellas and the patterned gowns of his models, as in his *Woman in a Garden* (plate 74) of about 1912. And for Frieseke, the nude outdoors was another favored subject, one far more related to the work of French artists such as Renoir and Pierre Bonnard than to American traditions, and one that he felt he could paint in France with greater freedom than back in America. In pictures such as *Summer* (plate 75) of 1914, Frieseke projects a casual sensuality, the unclad figure caressed by the light-dappled shadow patterns cast by the foliate enframement. The artist, in fact, claimed that light was his primary concern: "It is sunshine, flowers in sunshine, girls in sunshine, the nude in sunshine, which I have been principally interested in."[55]

The feminine theme also dominated the art of Frieseke's contemporary in Giverny, Richard Miller (1875–1943), an artist from Saint Louis.[56] The two painters were often critically associated, and each was given a room for his work at the 1909 Venice *Biennale*. Color and light were also important to Miller, but he often maintained stronger academic strategies, and his images, more often painted indoors, are generally presented in a mood of pensive reverie, as in *The Toilette* (plate 76). Miller returned to America during World War I, and in 1916 he associated with the Stickney School of Art in Pasadena, where his much-admired painting helped further the strong current of Impressionism that developed in southern California during the 1910s.[57] Guy Rose, who had previously painted in Giverny along with Frieseke and Miller and was an instructor and later director of the Stickney School, was the area's principal Impressionist landscape painter; other painters whose work suggests a relationship with Miller's include Jean Mannheim (1863–1945), another teacher at Stickney, and William Cahill (?–1924). Alson Clark (1876–1949) and Clarence Hinkle (1880–1960) were two other leading southern California Impressionists, along with Donna Schuster (1883–1953), the outstanding woman artist working in this mode, some of whose work again bears affinity with Miller's.

Miller had been invited to teach at Pasadena by Guy Rose, a native California artist who had lived and worked in Giverny until 1912. These two, along with Frieseke, Edmund Greacen (1877–1949), Lawton Parker, and Karl Anderson (1874–1956), were known as "The Giverny Group" and as "Luminists," and their work was shown together in exhibitions in 1910. Although Impressionism was now endemic in America, this group of painters constituted about the last major original manifestation of the aesthetic, one that would soon be regarded as irrelevant in the artistic turmoil generated by the Armory Show, held in New York City early in 1913.

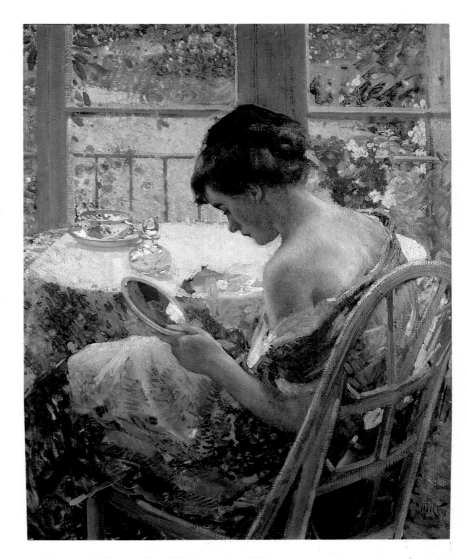

76. RICHARD MILLER. *The Toilette*. c.1914. Oil on canvas, 40 × 32½". The Columbus Museum, Columbus, Georgia

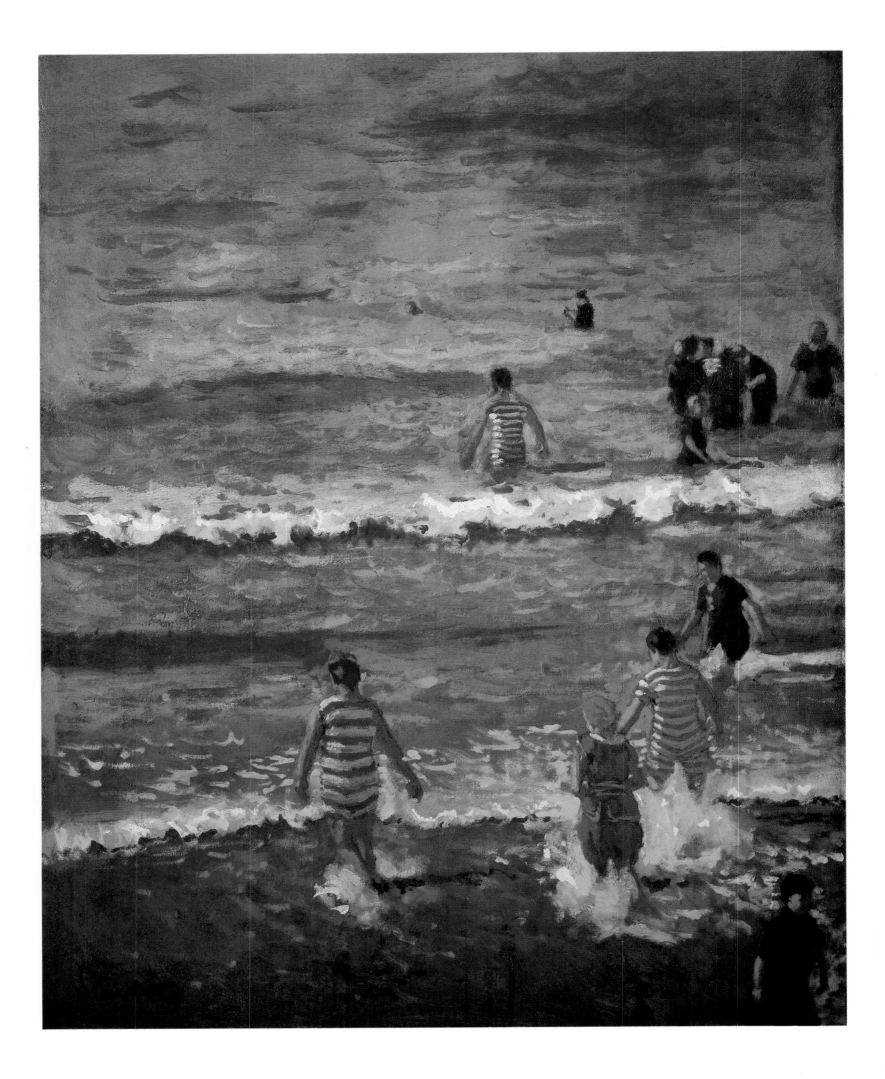

"IMPRESSIONISM" HAS BEEN used as a descriptive term for much of the new British painting of the late nineteenth century when it showed the influence of recent French art. Some British artists knew about Degas and Monet and the other painters who showed in the Independent exhibitions in France; others regarded the *juste milieu* Salon painters such as Bastien-Lepage as Impressionist. Whistler was also considered to be an Impressionist. Impressionism, therefore, gained critical currency as a catchword for any painting with a loosely worked technique, a plein-air element, or an interest in modern life.

Such "Impressionist" pictures did not conform to an established Victorian mode of picture making as represented at the Royal Academy. Its president, Lord Leighton, painted highly finished, idealized classical themes that typified the art of one faction at the academy. Detailed anecdotal subject pictures with a didactic element represented another. "Foolish praise was lavished on Sir Frederick (Leighton's) silliness, Poynter's stupidity, and Tadema's dullness," moaned George Moore, the novelist, critic, and friend to Degas and Manet.[1] However, many British artists were happy to cast off Victorian conventions and search for greater freedom in Paris. It was not only that they were dissatisfied with the restrictions placed on them by their own culture. The artistic preeminence of Paris had a magnetic attraction. Yet once in Paris, the majority of British artists studied at the École des Beaux Arts or the Académie Julian and looked no further than the Salon for inspiration. By doing so they were replacing one set of values and conventions with another. For example, John Lavery's *The Tennis Party* (plate 78), which was shown at the Royal Academy and the Salon, uses an abrupt change of space between the two players to create a sense of motion, a convention Lavery (1856–1941) learned from Bastien-Lepage. Another British group was more radical. The London Impressionists, which was the name they chose for a show at the London branch of Goupil's in December 1889, adopted Degas, Monet, and Whistler as their mentors. The London Impressionists comprised ten artists: Walter Sickert (1860–1942), their acknowledged leader, his brother Bernhard (1862–1932), Philip Wilson Steer (1860–1942), Sidney Starr (1857–1925), Theodore Roussel (1847–1926), Paul Maitland (1863–1909), Francis Bate (1853–1950), Frederick Brown (1851–1941), Francis James (1849–1920), and George Thomson (1860–1939). Sickert, Starr, and Roussel had been part of the growing entourage of Whistler supporters. Whistler personally selected them to support his counterattack against the British art establishment in the early 1880s, following the humiliating defeat of his libel suit against Ruskin in 1879, for which Whistler was awarded a farthing in damages. The suit had been precipitated when Ruskin, after seeing Whistler's *Nocturne in Black and Gold: The Falling Rocket* at the newly opened Grosvenor Gallery in 1877, had said that he "never expected to hear a coxcomb ask two hundred guineas for flinging a pot of paint in the public's face."[2]

# BRITISH IMPRESSIONISM: THE MAGIC AND POETRY OF LIFE AROUND THEM

*Anna Gruetzner Robins*

77. WALTER RICHARD SICKERT. *Bathers—Dieppe*. c.1902. Oil on canvas, 51¾ × 41⅛". Walker Art Gallery, Liverpool. National Museums and Galleries on Merseyside

Sickert, Starr, and Roussel were comparatively unknown artists who adopted Whistler's style and thus boosted the importance of Whistler's own pictures when they showed together at the Society of British Artists. (The society added "Royal" to its name in 1887, the year after Whistler became its president.) In return for their devotion, Whistler taught the strategies of the avant-garde to his "impressionist school," as it was known to British critics. In catalog prefaces, in letters to the press, and in his increasingly ostentatious manner when in the company of his followers, parading past the dealers' galleries on Bond Street or posing in the Café Royal, Whistler executed a carefully planned and calculated attack on the status quo of British art.

Whistler's crowning achievement was his "Ten O'Clock" lecture, which he delivered to an audience in Prince's Hall, London, in February 1885 and repeated on several occasions in the following months. Theodore Duret, friend and critic of the French Impressionists, was in the audience for the first rendition, and he immediately pointed out to Starr that Whistler was describing himself when he preached that the new independent artist must defy convention to create truly original art.[3] Whistler's lecture was an attack on the "philistinism" of Victorian art and its strong emphasis on narrative and anecdote. Whistler assigned a more abstract function to painting, saying that the original artist should ignore storytelling in favor of rearranging the shapes and colors of the natural world into new forms.

Whistler's views had an indisputable effect on his followers, but they were also eager to emerge from under his mantle and to achieve their own independence. In 1888 they formed their own Impressionist clique at another exhibiting institution, the New English Art Club. The club had been started in 1886 by French-trained British artists whose pictures were being rejected by the Royal Academy. The first New English Art Club exhibition had been a catholic mixture of French-influenced pictures, with the rustic paintings of Cornish fisherfolk by the Newlyn School in the majority. The first exhibitors decided that the club should be run democratically and that the annual exhibitions should be selected by a committee of fifteen artists elected by the previous year's exhibitors. (The five artists with the most votes then formed a hanging committee. Any artist could submit two works for approval if invited to do so by two members.) After the arrival of the Impressionists, there had been friction, however. Steer's French Impressionist–influenced picture Chatterboxes (untraced) had not found favor with the Newlyn element in 1887, and Steer joined forces with Whistler's Impressionist group. The Newlyn faction almost immediately fell out with the Impressionists. More ill-feeling followed after the Impressionists gained a stronghold on the committee in 1888 and dominated the club's spring show by giving large pictures by Steer and Sickert places of honor. At this time Sickert was writing art criticism for the London edition of The New York Herald, The Art Weekly (a magazine started by Francis Bate and another British Impres-

78. Sir John Lavery. The Tennis Party. 1885. Oil on canvas, 30⁵⁄₁₆ × 72¼". Aberdeen Art Gallery and Museums, Scotland

sionist, Arthur Tomson), and the Impressionist journal The Whirlwind (founded by Stuart Erskine and Herbert Vivian in 1890), and he rarely missed an opportunity to take a swipe at the Newlyn painters. By the time of the 1890 exhibition, which was held in a rented apartment so that the pictures could be seen in a domestic setting, the London Impressionists, as they were now known, had managed to oust the Newlyners and other conservative elements and make the club the headquarters for British Impressionism.

Sickert and his nine cohorts sent seventy pictures to the London Impressionist exhibition in 1889. Asked in an interview "What is an Impressionist?" Sickert, who masterminded the gallery show and wrote the accompanying catalog, flippantly replied, "It is a name they will give us in the newspapers."[4] Sickert strongly denied that theirs was like the eighth and last Impressionist exhibition in France, which he had seen, for he was well aware that Impressionist art should be culled from experience, not example, and he repeatedly stressed the local geography of the group's pictures, emphasizing the key role played by their presence in the metropolis. Sickert said, "For those who live in the most wonderful and complex city in the world, the most fruitful course of study lies in a persistent effort to render the magic and poetry which they daily see around them."[5]

In this respect "London" qualified "Impressionist" by stressing the group's local origins and detracting from its French affiliations. It also encapsulates the group's dilemma. For they had a deep interest in French

Impressionism, in particular the pictures of Degas and Monet, yet they recognized that they had to work within their own cultural milieu to produce original art. Moreover, these British artists had little interest in plein-air Impressionist landscape of the 1870s. In fact, Sickert's friendship with Degas and Sargent's with Monet had made them most familiar with Degas and Monet's more complexly worked pictures of the 1880s. Sickert made frequent visits to Degas's studio, bought three pictures, told the others about his working methods, distributed prints and photographs of his art, and praised him in his art criticism. Sargent, who was in the British group's circle, had painted with Monet at Giverny and had bought four of his recent pictures, including one from the London show in 1889. Seeing Monet's one-man exhibition at the London branch of Goupil's in 1889 was an invaluable experience for the London Impressionists. Yet when asked who in their group were Impressionists Sickert responded by stressing the group's independence from France and refusing to establish specific temporal or causal links between the London Impressionists and their French predecessors. He named only Velázquez, the English illustrator John Leech, and Holbein. The English landscape artists Constable, Turner, Gainsborough, Wilson, Crome, Whistler, and another illustrator Charles Keene, were soon added to this list.[6]

In retrospect, this was ironic, since the ongoing difficulty faced by British Impressionists was how to marry British scenes to an approach to picture making that was French in origin. Sickert depicted his country's

capital city, and he actively encouraged the others to search for areas and aspects of the metropolis that had not been portrayed by Victorian artists. Yet the French Impressionists' depictions of modern life had impressed the critic Frederick Wedmore, who wrote an appreciative review of Durand-Ruel's Impressionist exhibition held in London in 1882, which included works by Degas, Monet, Renoir, Sisley, and Mary Cassatt, and it was this aspect of the London Impressionists' pictures that Wedmore repeatedly praised when reviewing the Goupil show. Indeed, George Moore lamented that there had been no suitable pictures of modern London life to draw from when he had written *A Modern Lover* (1883), a novel about imaginary modern British artists, so he had used French Impressionist pictures instead, and given them British authorship.

Sickert's preoccupation was how to create an original perception of modern life. In 1887 the critic of the *Artist*, an influential magazine edited by Charles Kains Jackson, was undoubtedly coached by Sickert when he said that Sickert's aim was to reproduce the first impression made by an object on the retina with a "succession of patches of colour" that at "some arbitrary distance resolve themselves into the impression."[7] Later Sickert repeated the view that Impressionism was the painting of "what we actually see." He elaborated on this by comparing the Impressionist vision with that of the Victorian artist William Powell Frith, who also painted contemporary life but spoke disparagingly about Impressionism, which he thought had "tainted" the country.[8] "You ask how Frith's *Derby Day* differs from our pictures," Sickert said, referring to his own perception in an urban milieu, "simply because it is a panorama. The eye could not possibly see all he depicts."[9] Unlike the detailed figures of Frith's crowds, Sickert's *Theatre of the Young Artists, Dieppe* (plate 79) is a conglomerate mass with amoebalike blobs of color applied in fluid patches that suggest movement and changeability as the crowd waits in front of the more permanent structure of the sharply defined façade.

When Sickert first saw a work by Degas, *Le Baisser du rideau* (Lemoisne 575), a pastel of two dancers curtseying as the stage curtain falls, he was standing next to one of the giants of English Aesthetic painting, Edward Burne-Jones, who angrily reprimanded him for admiring "a fag end of a ballet."[10] Burne-Jones had consciously rejected his own encounters with modern life to construct medieval fantasies of Arthurian and Chaucerian subjects. For Sickert, this first sighting, in 1882, sparked a lifelong interest that was to be fueled three years later in 1885, when he visited Degas in Paris and was sent to various galleries and Degas collectors to learn firsthand the repertoire of compositional devices of Degas's modernity. Nevertheless, Sickert knew that his version of modern life had to be derived from a local set of specifications.

The English music hall had been the hub of working-class metropolitan forms of entertainment. By the 1880s the composition of its audience reflected the

79. Walter Richard Sickert. *Theatre of the Young Artists, Dieppe*. 1890. Oil on canvas, 22 × 26″. Atkinson Art Gallery, Southport, Merseyside

80. Walter Richard Sickert. *Gatti's Hungerford Palace of Varieties: Second Turn of Katie Lawrence*. c.1887–1888. Oil on canvas mounted on hardboard, 33¼ × 39⅛″. Purchased Watson Bequest Fund 1946. Art Gallery of New South Wales, Sydney

81. THEODORE ROUSSEL. *Blue Thames, End of a Summer Afternoon.* 1889. Oil on canvas, 33 × 47½″. Courtesy David Messum Gallery, London

82. PAUL MAITLAND. *Three Public Houses, Morning Sunlight.* 1889. Oil on canvas, 30 × 27¾″. Tate Gallery, London

(right) 83. PAUL MAITLAND. *The Hollywood Arms.* c.1891. Pastel, 30 1/16 × 24¾″. Victoria & Albert Museum, London

mingling of the classes that characterized modern urban London. To the conventional Victorian middle class this was an unacceptable and threatening development. Bound by a rigid class code, they disliked frivolous entertainment, especially when it came in the form of fanciful dress and elaborate costume. Yet Sickert was prompted to portray the English music hall by Degas's café concerts (he bought the pastel and lithograph *Mlle Bécat at the Café des Ambassadeurs:* 1885; Thaw Collection, New York City), but he also insisted that his music-hall pictures were inspired by his own experience. Sickert made nightly excursions to the halls to make directly observed sketches of the performers and the audiences. *Gatti's Hungerford Palace of Varieties, Second Turn of Katie Lawrence* (plate 80) belongs to a group of his works that explore the relationship between audience and performer. It portrays one of the most notorious halls in London where "mashers," fashionable in their bowler hats, affluent middle-class "swells," workers, and prostitutes, one of whom is recognizable by her "monstrous red hat," gathered.

Sickert's music-hall paintings were viewed with distaste and horror by his opponents, while his supporters disregarded their social contentiousness to praise their more formal qualities. By the 1890s the English music hall became a cult form for British intellectuals and writers, including Arthur Symons and Max Beerbohm, who praised the artistic quality of the performances and disregarded any disquieting social message. Sickert's later paintings show a similar shift of attention.

Sickert's first music-hall paintings tested conventional standards about suitable subject matter, but even Sickert was hesitant to test the moral climate further. Painting and drawing from the nude was still frowned upon in England. Any nude presented outside a mythological or idealized context was considered suspect. Roussel's *The Reading Girl* (1887; private collection), had been harshly criticized because the nude girl's nonchalant absorption in her journal and the ordinary deck chair she sat in made her recognizably modern. Yet Roussel's model, Hettie Pettigrew, had clearly posed in the painter's studio not in a domestic context. At the same time the merits of Degas's pastel studies of the nude in more "natural" poses and more domestic surroundings were being hotly debated within London Impressionist circles.[11] Sickert, however, did not paint a comparable group of modern nudes until after 1900. Was it fear of another hostile backlash or his own timidity that prevented him?

Other London Impressionist pictures also challenged Victorian codes of taste and respectability. Roussel and Maitland were influenced by Whistler's industrial views of the Thames, although their pictures were in sharper focus and peopled with the local residents. Whistler consciously avoided the picturesque Chelsea sites so praised by Victorian guidebooks. "Whistler's Chelsea shops will tell the discoverers exactly what London 'was' like at the end of the nineteenth century," said Sickert.[12] Roussel's *Blue Thames End of a Summer Afternoon* (plate 81) depicts the ugly modern aspects of

84. SIR JOHN LAVERY. *Woman on a Safety Tricycle.* 1885. Oil on canvas, 13¾ × 20½". Government Art Collection, London

85. SIDNEY STARR. *At the Café Royal.* 1888. Pastel on linen, 24 × 20". Fine Art Society, London

86. SIDNEY STARR. *A City Atlas*. 1889. Oil on canvas,
24 × 20¹/₁₆″. National Gallery of Canada, Ottawa. Gift of the
Massey Collection of English Painting, 1946

87. JAMES GUTHRIE. *The Morning Paper.* 1890. Pastel on gray paper, 20½ × 24½". Fine Art Society, London

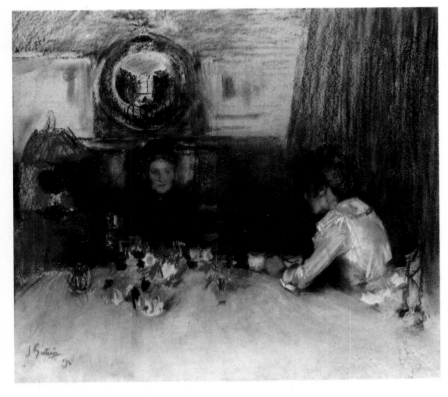

88. JAMES GUTHRIE. *Causerie.* c.1890. Oil on canvas, 19⅞ × 22½". Hunterian Art Gallery, University of Glasgow

the river on the Battersea side, opposite Chelsea—the railway bridge, the barges that transported waste and raw materials, the warehouses and factories. Public houses and the attendant problems of drunkenness and alcoholism were subjected to vigorous moral scrutiny by Victorian artists, but Maitland had the modern artists's air of detachment. The King's Arms, with its advertising sign for Combe's Ales, and the two beer retailers in *Three Public Houses* (plate 82) were part of local Chelsea life, as were the conversing couple by the fence, the morning crowd in the beer retailers, the waiting cab in front, and the nurse with two young children and perambulator. In *The Hollywood Arms* (plate 83), another picture of a Chelsea public house, the dark, monochromatic thickly worked pastel and the glaring light on the crowd, which includes a waiting child, heightens the versimilitude of the urban night scene. As D. S. MacColl wrote: "He has learned the lesson of sensitiveness to . . . beauty . . . that may be got from ugly things."[13]

The other London Impressionists also viewed the city with a Baudelairian sense of detachment. Their London scenes had none of the moralizing sentiment found in Victorian art. It was reported that they looked for subjects from the tops of hansom cabs. Starr had the strongest sense of London as an urban sprawl, and he concentrated on depicting busy railway stations, crowded shopping streets, popular restaurants (plate 85), theaters, and shops. He also explored London's suburbs and portrayed fashionable St. Johns Wood in north London, with its spacious villas and gardens, empty wide streets, and society crowds. We glimpse one of these suburban views at dusk from the top of a city atlas, a type of omnibus (plate 86). Sickert said that Millet, too, would have painted these suburban streets had he lived in London in 1889, "instead of the threadbare formulas which were vital in 1830."[14] Who is the solitary female passenger unaccompanied and unchaperoned? Possibly she is a servant since the cheaper seats on an omnibus were on the unsheltered roof of the cab.

Lavery also portrayed modern young women, who might be riding a safety tricycle (plate 84) or playing an energetic game of tennis. Sport for women was a highly controversial development, and his images of athleticism contrasted sharply with those of cloistered, subdued women in Victorian pictures. James Guthrie (1859–1930) took up the theme of contemporary, middle-class women in a series of pastels of 1890, depicting them in Helensburgh, a commuter town near Glasgow. His pictures encompassed a range of activities, including those of the intensely absorbed young woman in *The Morning Paper* and the idle gossips of *Causerie* (plates 87 and 88).

Steer was also disenchanted with Victorian art. At an evening symposium on Impressionism at the Art Workers Guild at which Starr and Sickert also lectured, Steer spoke of his admiration for the compositional unity in Impressionist painting that he thought was sadly lacking in most British art. Victorian subject pictures are "like worms," Steer said. "If you cut them up into half a dozen pieces, each bit lives and wriggles."[15] When Steer

saw Sargent's *Carnation, Lily, Lily Rose* (plate 35) at the Royal Academy in 1887, he said, "The only thing that one can care about is Sargent's picture."[16] Sargent's portrayal of the young girls as the poetic embodiment of the garden in a twilight atmosphere also appealed to Monet, who renewed his interest in outdoor figure painting in the late 1880s, at a time when Sargent was a regular visitor to Monet's house in Giverny. Sargent was clearly fascinated by Monet's bravura handling and bold colors. The complex variety of color and brushwork that typifies Monet's pictures from the 1880s and 1890s was also a revelation and a great liberation for Steer. Unlike Monet, Steer did not depend entirely on his sensations in front of nature. "Art is the expression," said Steer, "of an impression seen through a personality."[17] Steer sketched London scenes, sent two memorable pictures of the London ballet to the New English Art Club, and painted portraits that are recognizably urban; however, his seascapes were his most experimental pictures.

Walberswick on the Suffolk coast, where Steer painted for a number of years, was a favorite picturesque sketching spot for British artists after the railway line opened in 1879. But Steer ignored its picturesque views and painted the sea and atmosphere of the windswept coast with a variety of expressive forms. His observation of these natural effects was a starting point, but his more complex seascapes, such as *Children Paddling, Walberswick* (plate 89), were composed from sketches and memory and often reworked over a number of years. The brushwork in *Children Paddling* is highly schematic; the arabesque impasto of the whitish yellow for reflected sunlight is repeated in the decorative undulating shore and the flat billowing sails, while the scratchy long lines of paint hieratically emphasize the children's innocence and fragility. Steer's more spontaneously composed seascapes were painted on panels with long, translucent streaks of color. They depict fashionable seaside crowds with vivid immediacy. Steer had a decided preference for a range of pastellike blues, purples, and pinks, with palish yellow for highlights (plates 90 and 91). Monet

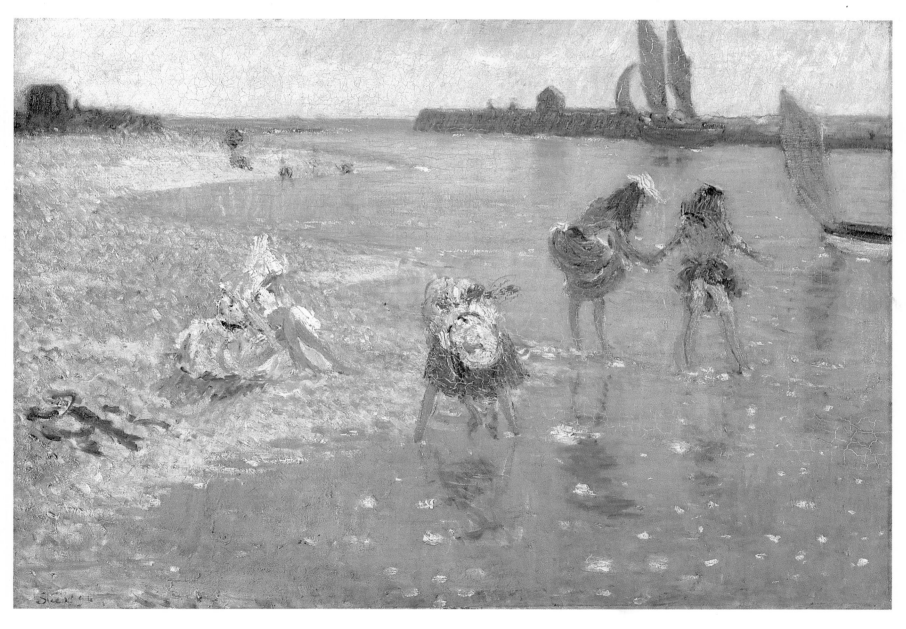

89. PHILIP WILSON STEER. *Children Paddling, Walberswick.* c.1889–1894. Oil on canvas, 25¼ × 36⅜″. The Fitzwilliam Museum, University of Cambridge

also used such delicate nuances of color to suggest the luminous atmosphere of the south of France. For Steer they evoked the soft English summer light, which he modulated by varying the intensity of key. A blue, purple, and pink palette became Steer's hallmark for his sea-scapes and was frequently also used by the other London Impressionists (such as in Roussel's *Blue Thames* and Starr's *A City Atlas*).

Maitland was also inspired by Monet's palette. He created complex harmonies of color in the blue, pink, and purple ranges by distilling and abstracting the architectural forms of the Chelsea streets where he lived (plate 92). This palette, with the addition of a sharp green, was also used by Sickert for his sea studies (plate 77) and later became the characteristic palette of Spencer Gore.

The London Impressionists rarely painted sunlight effects per se, but they did share a noticeable preoccupation with artificial light. Whistler had extolled its magical qualities in the "Ten O'Clock" lecture, and his portrait of his wife *Harmony in Red: Lamplight* (1886; Hunterian Museum and Art Gallery, University of Glasgow) showed how artificial light falsified colors compared with their appearance in natural light. This was surely the British group's reaction against the chromatic color practices of the plein-air Impressionists, who used bright color contrasts to suggest sunlight. In the hands of the London Impressionists, artificial light took on a more symbolic function as a particularly potent symbol of modern life. Roussel, Starr, Sickert, and Steer all painted portraits under gaslight, while Starr, Maitland, and Thomson portrayed London night scenes by gas and electricity. Roussel made meticulous color notes to study the effect of artificial light on local color for his two portraits of Mortimer Menpes in evening dress. In another study in lamplight, *Portrait of a Little Girl*, a pastel, there is a stark tonal contrast between the delicate pink-frocked figure of Roussel's daughter Jeanne and the flat black background behind her (plate 93). Sickert used gaslight to heighten and intensify the artificiality of the music-hall performances, employing exaggerated bands of light that the critics thought made his performers look like marionettes.

Whistler also encouraged his followers to participate in the technical experiments in printmaking, watercolor, and pastel that he actively pursued in the 1880s. Both Sickert and Roussel were notable printmakers. Roussel also worked in watercolor, while Starr preferred watercolor and pastel. Whistler was acutely aware of the technical possibilities and limitations of pastel. Unlike Degas, who pushed the medium to new limits to create color effects more commonly associated with oil painting, Whistler used delicate, deft touches of pastel and made full use of a single stroke of texture and color for fleeting effects.

Sickert was impressed by Degas's pastels of the nude, which he saw in Degas's studio in 1885 and again at the last Impressionist exhibition in 1886, and he was a well-informed source about them. The first Degas work to be shown at the New English Art Club was the pastel

90. PHILIP WILSON STEER. *Figures on the Beach, Walberswick.* 1888–1889. Oil on canvas, 23½ × 23½". Tate Gallery, London

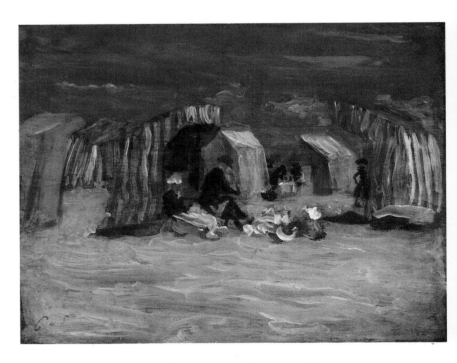

91. PHILIP WILSON STEER. *Bathing Tents, Boulogne.* 1891. Oil on canvas, 8 × 10¼". Private collection

*Danseuse Verte* (Lemoisne 572) from Sickert's collection. Seeing it undoubtedly helped Starr to create the textures and colors of *At the Café Royal* (plate 85). Its tight structure of strokes and the densely worked surface of rich contrasts between the dark blue and the vibrant yellow low-hanging lights create a vivid image of bohemian nightlife. Starr understood that the short, quick strokes that Degas used in his pastels heightened the modernity of the images, and he praised James Guthrie for sharing his views about the function of pastel. Guthrie's *The Morning Paper* (plate 87) has a delicate modulation of dark gray pastel on lighter gray paper with touches of pink. The play of the crayon against the textured paper and the Arts and Crafts pattern of the upholstery create an arresting vision of modernity. In response to the vogue for pastel in France and Britain, the Grosvenor Gallery instigated annual pastel exhibitions in 1888 and invited Helleu, Jacques-Émile Blanche, Besnard, Roussel, Starr, and Steer, among others, to exhibit. In 1890 Steer's *The Sprigged Frock* (plate 95) was included in the newly formed British Society of Pastellists show at the Grosvenor Gallery. The hatched sweeping strokes in vivid green and blue and the summary handling of the discarded papers show that Steer was equally receptive to Degas's methods. Steer also used different scales and media for other scenes of modern life. For instance, *Rose and Lily at a Piano* (plate 94) has a relaxed, informal quality compared to his more formal portraits.

The London Impressionists signaled their continuing interest in Degas and Monet by showing the French artists' pictures at the New English Art Club several times throughout the 1890s. D. S. MacColl praised the French artists as "a kind of gravity for the floating theories, the undefined enthusiasm, the very defined distaste, the word 'impressionism' excites."[18] Steer's sympathy for Monet was too firmly established to ignore. MacColl suggested quite rightly that Steer's art was naive, but others said that his pictures were manqué and pastiches of the real thing. Steer was forced into a corner, further exacerbated by George Moore and MacColl's diminishing interest in Monet.

From the 1880s onward, Impressionism was hotly debated by Royal Academicians and other art establishment stalwarts who raged against the pernicious effect it was having on a native tradition. The conservative art journals gave this issue extensive coverage. In the 1890s the London Impressionists looked again at their proclaimed list of English predecessors. When Steer lost touch with the stimulus that Monet originally provided (prompted, no doubt by Moore and MacColl's lack of interest, since they were his staunchest allies), he experimented with several different modes, including portraiture and landscapes in the manner of Gainsborough, Reynolds, and Constable. Wedmore thought this was part of Steer's originality, but a receptiveness to so many influences is also symptomatic of a restlessness that was to be a recurrent dilemma for British artists in the twentieth century who felt a strong sense of dislocation from their own culture.

92. Paul Maitland. *The Flower Walk, Kensington Gardens.* c.1897. Oil on canvas, 50 × 70″. Tate Gallery, London

Around 1890 there was another shift in attitude when Impressionism became synonymous with Symbolism and Decadence in English literary circles. Arthur Symons, the critic, poet, and friend of Sickert's who later wrote *The Symbolist Movement in Literature* (1899), explained: "Taken frankly as epithets which express their own meaning, both Impressionism and Symbolism convey some notion of the new kind of literature which is perhaps more broadly characterized by the word Decadence."[19] The present writer suggests that to define London Impressionist painting by the 1890s is similarly confusing. In simple terms it can be said that London Impressionist pictures were closer in meaning to avant-garde French painting of the late 1880s than the naturalist painting of French Impressionism in the 1870s. London Impressionist pictures could therefore be described as "Decadent" and were considered to be so by British critics. Thus Steer's fractured diversification when he adopted many different styles simultaneously and at random is symptomatic of English Decadence.

The London Impressionists had a seminal influence on several British landscapists, including George Clausen (1852–1944), Edward Stott (1859–1918), James Charles (1851–1906), and H. H. La Thangue (1859–1929). All four had painted rural themes since the 1880s, using palettes and techniques derived from the French Naturalist paintings—such as those of Bastien Lepage—they had seen at the Salon while students in Paris. Clausen, Charles, and Stott were part of the Impressionist circle at the New English Art Club. The London Impressionists' own pictures, their enthusiastic support of Monet and Degas, and their strongly voiced contempt for painting in the Bastien Lepage mode had a persuasive effect on them. They still painted rural scenes in the 1890s, but their pictures are distinctly different from those of the previous decade, showing a greater

(left) 93. THEODORE ROUSSEL. *Portrait of a Little Girl*.
c.1890. Pastel, 18×14″. Collection Philip Lyon Roussel

(above) 94. PHILIP WILSON STEER. *Rose and Lily at a Piano*.
1893. Oil on panel, 8×10″. Private collection

(below) 95. PHILIP WILSON STEER. *The Sprigged Frock*.
1890. Pastel, 23½×23½″. The William Morris Gallery,
Walthamstow, London

concentration on light and atmospheric effects, a brighter palette, and a less monumental treatment of the figure. These "English luminists" all lived in the south of England. Charles and La Thangue resided at Bosham, a fishing village on the Chichester harbor in Sussex. Edward Stott was also in Sussex, at Amberley, while Clausen was to the east at Widdington in Essex. One English critic suggested that they were creating an English Barbizon in these rural pastorals. Indeed Millet's pictures of French rural life were highly regarded by Clausen and Stott, and they borrowed extensively from Millet's themes and compositions. (Sickert also appreciated Millet's capacity for vivid expression in his draftsmanship.) London was in easy reach by train for meetings with dealers, exhibitions, and artistic companionship. Away from London these artists consciously sought a life of rural simplicity.

P. G. Hamerton, in his influential book *Landscape* (1885), had criticized the new mechanized agriculture, which he thought had spoiled the countryside. And he complained that the tree-lined hedgerows had been cut down by modern farmers and replaced by tidy fences, fields divided by movable iron fences, and steam engines, which had made plowing obsolete: "The old poetical work of the reaper is accomplished by a man sitting on a strange cast iron invention."[20] But the British Impressionist landscapists avoided these issues, preferring rural scenes where there was no evidence of change. For example, Charles and La Thangue chose Bosham because the surrounding countryside was farmed by simple means, with no trace of the steam plow or threshing machine (plates 101 and 102). Stott was strongly attached to the age-old charm of Amberley. He deplored the advent of telephone lines and bought up old cottages as they fell vacant to save them from demolition. Clausen found it cheaper living in the country. He also saw the advantage of living away from the politicking of artistic cliques, so that he could concentrate on simple forms. (It does not seem to have occurred to him that these rural scenes could convey a political message.)

The landscapists shared their love of rural life with Thomas Hardy, to whom they were frequently compared. But there was one difference. Hardy returned to Dorset to rediscover his roots, while for the artists this was a novel experience of rural paradise. Clausen and La Thangue had come from comfortable London middle-class backgrounds; Stott and Charles from industrial towns in the north of England. Their collectors were the self-made industrialists who also bought Barbizon pictures from the London dealers.

Clausen's *The Mowers* (plate 96) is one of a group of paintings of agricultural laborers working the land in the old way. Clausen used these pastoral forms to express an increasingly sophisticated interest in Degas and Monet. He shared the London Impressionists' admiration for Degas's pastels and actually purchased a fan painted by Degas. As Starr had done in *A City Atlas*, Clausen translated the freely expressed strokes of bright contrasting color of his own pastel studies into oil. This was but one aspect of an amalgam of approaches in *The Mowers*. The figures in motion point to Millet's *The Sower* and to Degas's studies of dancers, which Clausen would have seen at the New English Art Club, while Monet's influence accounts for the brightly colored sunlight effects. This list of influences shows how quickly Clausen absorbed and adapted the interests of the British Impressionist avant-garde. Clausen worked from sketches and drawings, rarely painting from directly observed landscape. When asked to define Impressionism, he explained that he thought it regrettable that Impressionism should only refer to "the rendering of effects of light," because he also thought it meant "the impression or emotion which nature gives to the painter,"[21] thus saying that for him painting from nature was a synthesis of his observations of light effects and felt experience.

Stott also stressed the role of the artist's temperament, saying that Impressionism was "a recording of the impression of the painter's nature."[22] Stott adapted an Impressionist technique and used long, thin, loosely expressed brush strokes and touches of bright color for flickering light effects. He did not paint directly from nature but instead had a complicated working method. Color relationships were established with pastel landscape sketches done from memory, and he made countless figure studies in pencil and chalk before composing his pictures in the studio. (He also kept a studio in London for use before the spring shows.) Stott's friend Laurence Housman said that by working from memory Stott combined the synthetic, the allusive, and the reminiscent so that the most salient details expressed the true spirit of the landscape. Stott's landscapes are usually peopled by rural children and youths. But there is little reference to the poverty and hardship, the bad housing and lack of sufficient food and clothing that was frequently the lot of the children of agricultural workers (plate 97). (Stott's figures are passive and submissive, their rounded forms grow out of the Sussex earth. Housman explained: "They are essentially of the earth . . . too clodlike to be discontented, comfortable because they are so vegetable."[23]) Sickert was the first to describe Stott as a poet painter who bore out Whistler's axiom that "painting is the poetry of sight." Whistler's view that the artist should exercise a selective process in front of nature is well known: "Nature contains the elements, in colour and form, of all pictures . . . but the artist is born to pick and choose." This view also influenced Steer, who was a personal friend of Stott's and explains Steer's statement that "two men paint the same model: one creates a poem, the other is satisfied with recording facts."[24]

In 1888 a substantial collection of Constable's paintings and oil sketches went on show at the Victoria and Albert Museum in London, and as a result there was a significant upsurge in his popularity in the 1890s. British critics saw a link between Constable's open-air studies and those of the French Impressionists and chauvinistically promoted Constable as an important precursor of the movement. Constable's strong attachment to the

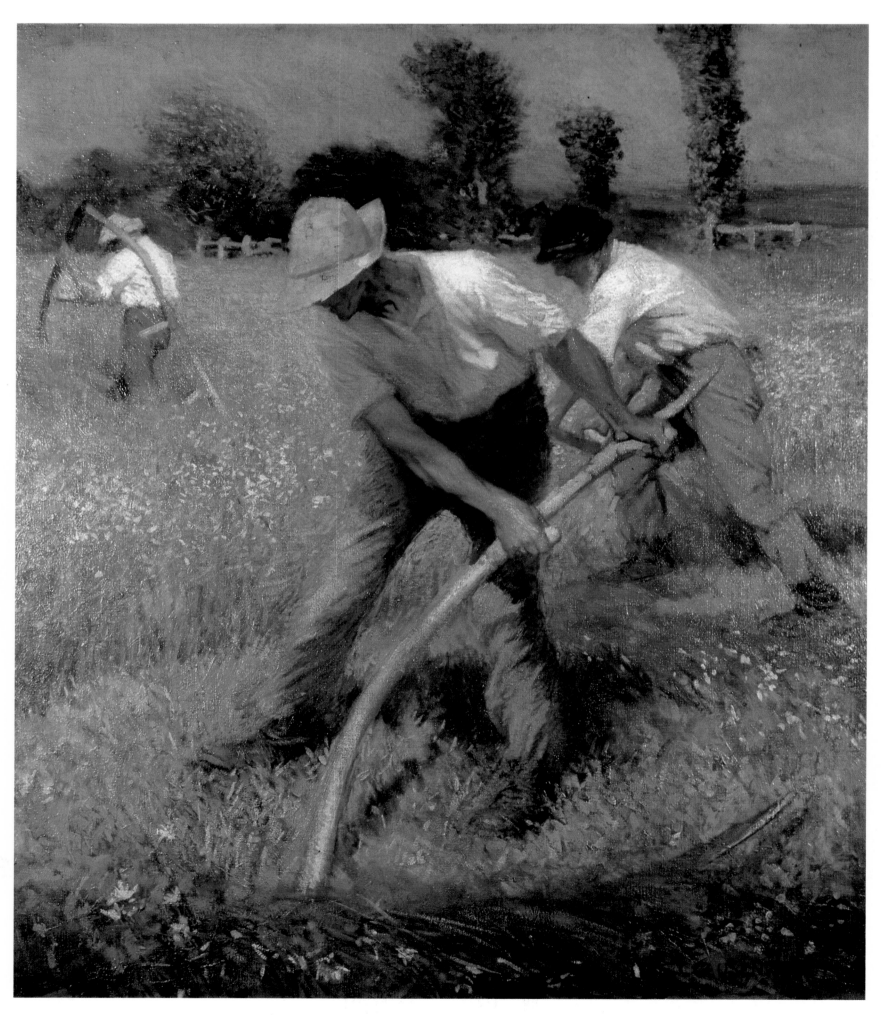

96. GEORGE CLAUSEN. *The Mowers*. 1892. Oil on canvas,
38¼ × 30″. Lincolnshire County Council Recreational Services.
Usher Gallery, Lincoln

97. EDWARD STOTT. *The Old Gate*. 1890s. Oil on canvas, 23 × 29⁵⁄₁₆". City Art Gallery, Manchester

claim La Thangue also made, saying that he never kept a studio after leaving London. (A photograph shows him working resolutely outdoors in front of *In the Orchard;* plate 98.) Like Charles, La Thangue used a cool, tonal palette with high contrast for sunlight effects. In Sussex, La Thangue depicted a range of farming activities, gleaning, harrowing, and tucking, and a nostalgic series about the fruit harvest. After 1900 he traveled south to Liguria and Provence in search of the nostalgia of the past and the simple life. Working in Mediterranean light he produced strongly lit pictures in bright colors, whose sweeping diagonal brush strokes have a strikingly physical quality (plate 99).

A humanistic tendency emerged within British Impressionism in the 1890s, and paintings of large-scale figures in domestic settings formed a significant proportion of works shown at the New English Art Club exhibitions until well after 1900. This new departure, which had a pervasive effect on the next generation of British art students, can also be traced back to the London Impressionists. In 1892 Fred Brown, one of their original members, was appointed to the prestigious post of professor of art at the Slade School. He immediately asked Steer and Henry Tonks (1862–1937; plate 100), an anatomical illustrator at a London hospital and amateur painter who attended Brown's night classes, to join the teaching staff at the Slade, where Brown and Tonks made drawing and painting from the nude the mainstay of the curriculum. Tonk's New English Art Club combined an interest in the figure with Impressionist tech-

English countryside and his atmospheric simple views of English scenes appealed to those seeking an English rural arcadia. Frederick Wedmore, for instance, who had been "a Constable lover for many years" went out walking near Colchester and "found" Constable in the countryside that had inspired him.[25] Several painters working in Britain at the end of the nineteenth century were compared to him. Steer was congratulated when he gave up "things in spots and stripes" and looked to "the manner and standpoint of Constable." C. J. Holmes's *Constable and His Influence on Landscape Painting* (1902) stressed the connections among Constable, Monet, Steer, and the English luminists, but he admitted that Monet was an important link in the chain and that he had directly influenced the British Impressionists.[26]

The American Mark Fisher (1841–1923), who settled in England in the 1870s after studying in Paris with Sisley and Monet, painted views of the English countryside similar to those by Constable, but with a luminosity and handling comparable to Sisley's. Fisher was admired by the London Impressionists, who elected him to the New English Art Club in 1892. Fisher was a close friend and neighbor of Clausen's at Widdington; however, his pictures are closer to those of Charles, who was also Clausen's friend. Charles had painted large anecdotal pictures of Sussex village life; one, *Christening Sunday* (1887; Manchester City Art Gallery), was admired by Degas at the Paris Exposition Universelle in 1889.[27] His smaller, more informal family groups at play or relaxing in the open air are rural idylls of middle-class family life. They have a cool, tonal palette in a light key and are worked with a heavily loaded brush in short, flickering strokes.

Charles painted on the spot in the open air, a

98. HENRY HERBERT LA THANGUE. *In the Orchard*. c.1893. Oil on canvas, 32⁵⁄₈ × 28½". Cartwright Hall, Bradford Museum and Art Gallery

nique. As a student in London, Brown had worked from casts, and it was not until he went to Paris to study under Bouguereau that he was able to draw from life. By French standards, Brown and the hundreds of foreign students like him were learning an academic method. However, Brown thought it should be an essential element in the new British art. "Real drawing," he said, "can be cultivated by a system of incessant and repeated studies by ignoring the mere surface, and endeavouring to express those qualities of character, proportion and movement."[28] Brown did praise students who filled sketchbooks with directly observed London scenes, but classroom time was devoted to the figure.

Sickert, Moore, and MacColl had praised Steer's figure pictures, which had a greater sense of corporal form than the naively drawn figures of his seascapes. They had no difficulty reconciling painting that had a structure of form and sensations of light expressed through color. Indeed the British Impressionists shared an underlying prejudice against painting based primarily on color! MacColl, rather lacking in prescience, regretted that "all Monet's handling goes to build up colour,"[29] and he thought that a recent painting of a grain stack by Monet had a "wooley" look. Wynford Dewhurst, in his influential *Impressionist Painting: Its Genesis and Development* (1904), suggested that the British Impressionists' role was to reintroduce form into Impressionist painting.[30] At the same time Moore and MacColl mounted a campaign against other recent tendencies in French art where experimental handling took precedence over traditional forms of draftsmanship. They especially disliked the Pointillist technique of Seurat and the Neo-Impressionists (which made it particularly difficult for Steer, whose increasing use of variety, textured handling, and broken color can be compared to Pointillism). Both Moore and MacColl liked the loose even brushwork that typifies French Impressionist painting of the 1870s. Moore became increasingly nostalgic about these pictures, which he saw when he first lived in Paris, while dismissing the more recent pictures he saw on his trips there in the 1880s. Pictures by Monet, Degas, Renoir, Pissarro, and Morisot from Moore's favorite period were shown at the New English Art Club, other independent exhibitions, and in dealer's galleries in the 1890s. As a result, British artists had a more educated awareness of this earlier phase.

Brown's enlightened attitude toward women art students at the Westminster School of Art, where they had been allowed to study from the nude, earned him a faithful band of followers at the Slade. Like other talented Slade students, Ethel Walker (1861–1951) was encouraged to exhibit at the New English Art Club. *The Garden* (plate 103) is typical of a number of pictures with plein-air effects that she sent to the club. It can be compared to *Summertime* (plate 104) by Walter Osborne (1859–1902), who renewed his associations with the club around 1900 and used it as a venue for his new Impressionist pictures. Both *The Garden* and *Summertime* have an affinity with the relaxed outdoor groups

99. Henry Herbert La Thangue. *A Provençal Spring.* c.1903. Oil on canvas, 30 × 34″. Cartwright Hall, Bradford Museum and Art Gallery

100. Henry Tonks. *The Crystal Gazers.* 1906. Oil on canvas, 30½ × 24½″. Birmingham Museum and Art Gallery

101. JAMES CHARLES. *The Picnic.* 1904. Oil on canvas,
14¾ × 21″. Warrington Museum and Art Gallery, Cheshire

102. JAMES CHARLES. *Disturbing the Fishers.* c.1905. Oil on
canvas, 15½ × 21½″. Warrington Museum and Art Gallery,
Cheshire

103. ETHEL WALKER. *The Garden.* 1899. Oil on canvas,
30½ × 25″. Cartwright Hall, Bradford Museum and Art Gallery

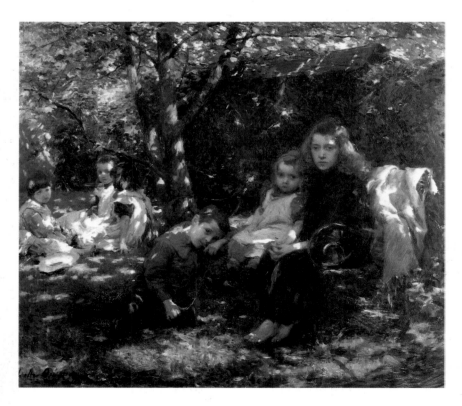

104. WALTER OSBORNE. *Summertime.* 1901. Oil on canvas,
42 × 48″. Reproduced by kind permission of the Harris Museum
and Art Gallery, Preston

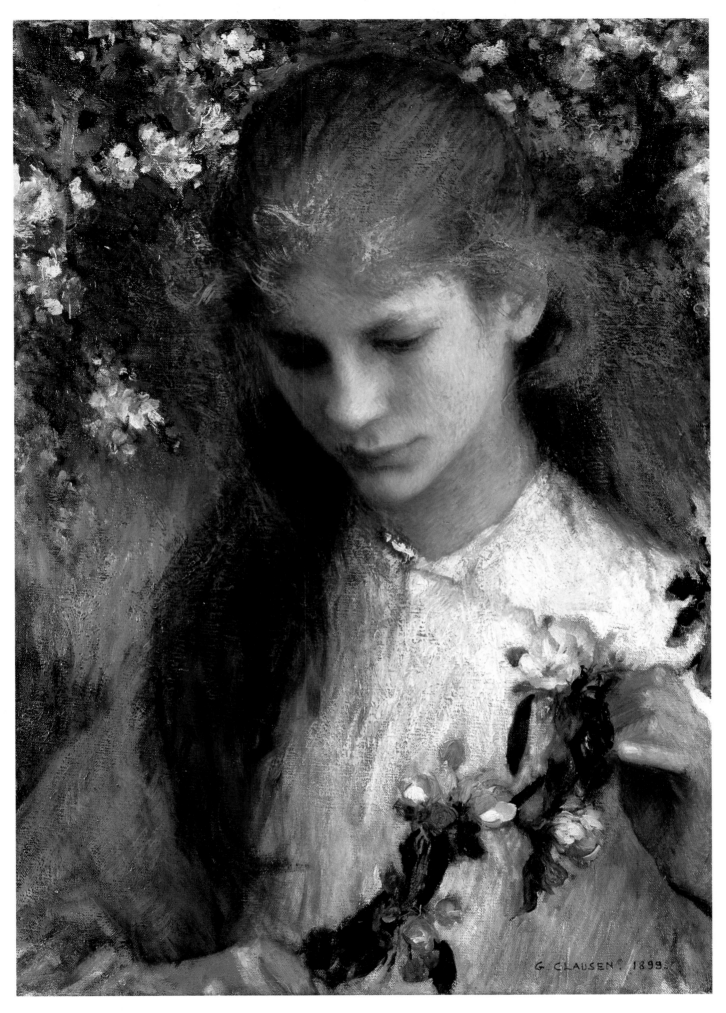

105. GEORGE CLAUSEN. *Apple Blossom*. 1899. Oil on canvas,
24¼ × 16". Private collection

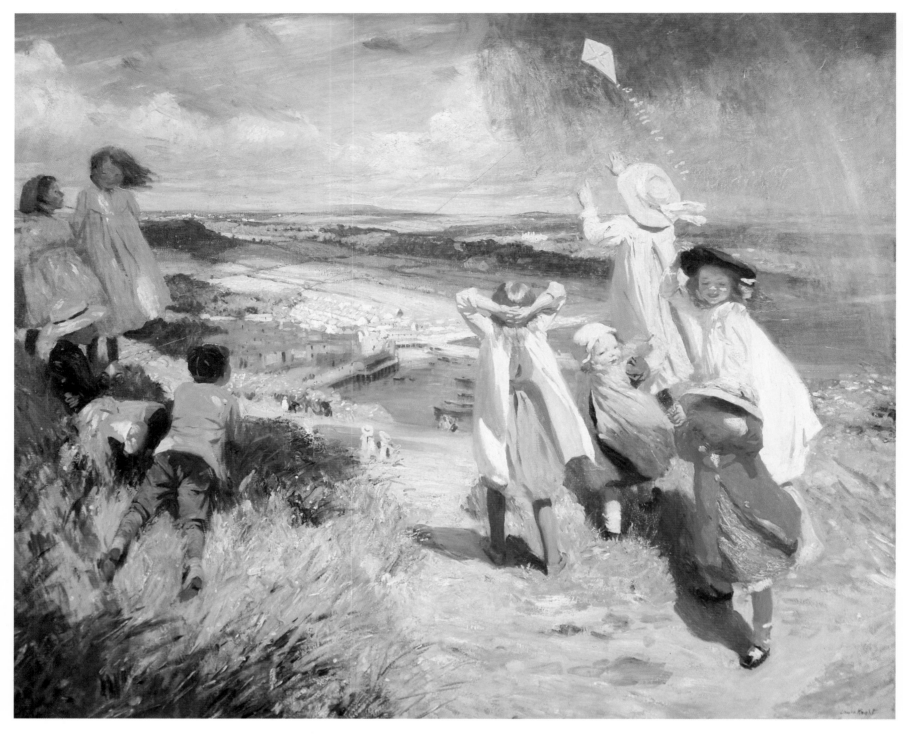

106. DAME LAURA KNIGHT. *Flying a Kite.* 1910. Oil on
canvas, 59 × 70⅞″. South African National Gallery, Cape Town

that Monet and Renoir painted at the end of the 1870s. They show how British artists took the dappled light effects and the broken color of plein-air Impressionism and grafted them on to a structural treatment of the figure. Clausen's *Apple Blossom* (plate 105) is another example. In spite of an insistence on modeled form, color has been applied in patches in a high key for the effects of sunlight and shadow. In this later phase of British Impressionism, light could play across surface textures, but it was never allowed to dissolve the forms beneath. Interestingly, when MacColl was asked to define the new vision in British art, he said it was one that "sees the world as a mosaic of patches of colour."[31] There is a link here with Sickert's earlier explanation of Impressionism, which also stressed that the Impressionist vision saw objects as patches of color. This thinking was a quiet revolution against the minute, precise detail of the Pre-Raphaelites, and it influenced British painting for many years to come.

In spite of the older academicians' misgivings, the British Impressionist landscape painters were welcomed by the Royal Academy in the 1890s. Clausen and La Thangue were elected associates of the Royal Academy in 1895 and 1898, respectively, and Edward Stott followed in 1906. A number of other landscape painters at the academy, such as Bertram Priestman and Fred Hall, were using a looser, more spontaneous technique and the smaller-sized canvases that characterize one aspect of Impressionism. A glance through the illustrated Royal Academy guides of the 1890s shows that British Impressionist landscapes vied for places with the Victorian pictures that had dominated the exhibitions of the previous decade. The Royal Academy was also quick to welcome Sargent (1856–1925). He was elected an associate in 1894 and an academician in 1897. Sargent had many imitators, such as Wilfred De Glehn (1870–1951), who copied his bravura handling of society portraits and outdoor figure pictures. In 1903 Clausen was appointed professor of painting at the Royal Academy Schools. Clausen's lectures (published in 1904 and 1906 and in a collected edition in 1913) appealed to a large audience because he referred to a broad spectrum of painters, including the old masters and the French Impressionists. In 1908 Clausen joined the ranks of the Royal Academicians, followed, in 1912, by La Thangue, which shows that the Royal Academy also had a sympathetic interest in their Impressionist style. Pictures in an Impressionist mode by relatively unknown artists such as Laura Knight (1877–1970) were also readily accepted (plate 106). Indeed, Impressionism was a favored style at the Royal Academy exhibitions well into the twentieth century, having been further boosted when W.W. Russell, a pupil of Fred Brown's who subsequently taught at the Slade, became keeper of the Royal Academy Schools in 1927. The society figures and middle-class professionals who patronized the Royal Academy exhibitions accepted this aspect of British Impressionism because the painters portrayed them as they saw themselves: comfortable and confident in a domestic, leisurely, uncomplicated world.

107. FREDERICK SPENCER GORE. *The Cricket Match.* c.1908–1909. Oil on canvas, 30 × 34″. Wakefield Art Gallery, West Yorkshire

With the exception of Guthrie and Lavery, Scottish artists had little interest in French Impressionism. "The Glasgow Boys," as they were known, were influenced by Bastien-Lepage in the 1880s. Many of them, including George Henry and E.A. Walton, had turned to a flat decorative style of painting in bright colors. A large number of Irish artists had also studied in France, but few of them adopted the techniques of the French Impressionists. This may explain why the Irish artist Walter Osborne, who had followed French Impressionism, went to the New English Art Club when looking for a venue for his Impressionist pictures.

In 1905 Sickert returned to London after a seven-year absence abroad, and almost immediately a new group of young painters gathered around him. Under Sickert's tutelage they painted ordinary scenes and people in Camden Town. Spencer Gore (1878–1914) was a member of the Camden Town Group, as it became known. Gore acquired a considerable knowledge of Impressionist color theory through his friendship with another member of the group, Lucien Pissarro (1863–1944), Camille's son, who had settled in London in 1890. At first Lucien had had little interest in the British Impressionists except for Steer. But he found kindred spirits in Sickert's new group. The broken touches of vibrant color seen in Gore's *The Cricket Match* (plate 107) show a sophisticated understanding that won Gore the respect of many European Neo-Impressionists. This marks a new phase of artistic development, when British painters looked to the Neo-Impressionists, Van Gogh, Gauguin, and Cézanne, before inventing their own brand of Post-Impressionism.

IMPRESSIONISM WAS THE subject of an article in the short-lived Toronto arts magazine *The Arion* as early as September 1881, although the term was used only to describe the "suggestive art" of some young Americans impulsively pursuing a new artistic fashion, likely the followers of Whistler and the Munich-trained modernists who recently had begun to attract attention in the exhibitions of the new Society of American Artists in New York. There is no mention of those French painters who had first exhibited together in Paris seven years earlier.[1] It would be yet another fifteen years before the term gained any real currency in Canada, by which time it was used to designate not only the work of Monet, Renoir, and their associates but also that of Canadian painters who were perceived to be under their influence, a course of development that roughly parallels the reception of the movement elsewhere in the English-speaking world.

In 1881 Canadian art was dominated by artists in the two principal cities of Montreal and Toronto who, following confederation some fifteen years before, had been systematically exploring the new national landscape. Their detailed, heroically scaled pictures, inspired by the work of recent British artists in the thrall of John Ruskin's dictum of truth to nature and influenced as well by some luminist painters and Albert Bierstadt in the United States, embodied the optimistic expansionism of the age. Their popularity peaked in the years following the opening of the transcontinental railway in 1886—more than a third of the Art Association of Montreal's annual spring exhibition of 1888 consisted of scenes of the newly accessible Rocky Mountains and West Coast—but already a succeeding generation of artists had turned its back on the Canadian landscape to gaze fixedly east on Paris. Graduates of art schools established in Montreal and Toronto during the 1870s, these emerging artists were attracted to the French capital by a sophisticated artistic system based on the study of the human figure and secured in centuries of European tradition, one that included large, open schools, the hugely popular annual Salon, and an artistic scene that was both competitive and diverse. Every serious young artist in Canada aspired to study in Paris, and by the early 1890s they all did.

The effect on Canadian painting was swift and decisive. By 1895 monumental figure painting in the French manner essentially replaced the national landscape in the exhibitions. But progressive aspects of Parisian painting were also felt; a concern for personal expression, for the sensitive, poetic approach of both the radical Frenchmen and those foreigners, epitomized by Whistler, who were forging a new international style. This broadly based "Aestheticism" had taken hold in Canada by the end of the century, and under its aegis landscape once again had become a sufficient—indeed a desirable—subject of art.

As much as a devotion to the visual culture of France was shared by young painters of many nationalities in Paris, language dictated their social and

# IMPRESSIONISM IN CANADA

*Dennis Reid*

108. WILLIAM BLAIR BRUCE. *Landscape with Poppies*. 1887. Oil on canvas, 10¾ × 13¹⁵⁄₁₆″. Art Gallery of Ontario, Toronto. Purchase with Assistance from Wintario. 1977

even their professional associations. English-speaking Canadians inevitably found themselves in the company of other British subjects or Americans, for instance, while those whose mother tongue was French enjoyed easier access to the life of the city. On the other hand French Canada was still a profoundly Roman Catholic society, unlike Paris, a fact that, at least initially, dictated different and generally more conservative artistic goals for francophone Canadians. To the degree that Impressionism in Canada can be separated in its early stages from the larger involvement with the French academic system or that it can be distinguished from the eclectic Aestheticism that had emerged by the 1890s, it will be seen to have been advanced most effectively by English-speaking artists in tandem with painters of similar interests from Britain and the United States.

There was a Canadian with those painters in Giverny in 1887 who were among the first Americans to emulate the Impressionists, an ambitious young man for whom the pursuit of success in the highly competitive, diverse artistic world of Paris of the 1880s was a driving, all-consuming force. While the paintings of William Blair Bruce (1859–1906) are the earliest by a Canadian to show the influence of Impressionism, his involvement with the style was desultory and had little impact on his compatriots. His experience in Paris and among the numerous artists' colonies of the period, repeated by many of those who followed him, nonetheless serves as a useful background to the general phenomenon.

Bruce was born and raised in Hamilton, at the head of Lake Ontario and just west of Toronto, and following rudimentary art studies there, he left for Paris early in the summer of 1881. Aspiring from the beginning to master large-scale figure painting of the sort that dominated the Salon he enrolled that fall for classes taught by Tony Robert-Fleury at the Académie Julian. The following April he had a painting accepted for the Salon. As one of "*les élèves de chez Julian*," as Lucien Pissarro would later somewhat contemptuously describe the foreign students who were then filling Paris, he had already discovered painting *en plein air* at Barbizon, where, living in the well-known establishment run by Madame Siron, he came under the influence of English and Scottish artists (his father was Scottish), among them William Stott of Oldham and Alfred East. While espousing the naturalism that was the goal of outdoor painting, Bruce specialized in moonlight studies in tones of gray and blue with silver and gold highlights that he would sometimes call "impressions" but that clearly bobbed in the broad wake of Aestheticism flowing from the success of Whistler.

Fame, he was convinced, would come only with figure work, however, and so he devised a sentimental canvas in the manner of the current popular favorite, Jules Bastien-Lepage: a large figure of an old woman posed in a landscape that won a medal at the Salon in 1884.[2] This new success simply spurred Bruce's ambition, and the pressure to work and anxiety concerning his progress led to a nervous breakdown. By the spring of 1885 he had decided to return home. After passing the summer at Grèz, another artists' colony near Barbizon favored particularly by Stott and other Glasgow painters, he left for Hamilton and what would be almost a year and a half of recuperation.

Bruce was back in Barbizon the first week of January 1887 with the American painter Theodore Robinson, whom he probably had met in the summer of 1885 at Grèz. Early in May he wrote to his mother from Paris that he intended "going to the seashore in a few days with a small party of Americans,"[3] but seven weeks later he wrote again from a small village northwest of Paris where the Epte joins the Seine: Giverny. This time he was precise both about his companions and their domestic arrangements, which had already been in place for a while. In the large furnished house they had rented, his five companions were Robinson, the painters Willard Metcalf (who Bruce also probably met at Grèz in the summer of 1885), Theodore Wendel, and Henry Fitch Taylor, and—expected only in mid-August—the wealthy Arthur Astor Carey.[4] All were Americans, and it seems that at least two of them, Wendel and Metcalf, had first discovered Giverny the year before.[5] While it is a moot point whether the presence of Claude Monet, who had settled at Giverny in 1883, was the real attraction the village held for the Americans, Bruce, by the evidence of his letters at least, seems to have been indifferent to the French master's existence. Although he cites the numerous amenities the place afforded, the Canadian never once in his letters from Giverny mentions either Monet or Impressionism.

Its association with the French master nonetheless soon became the distinguishing characteristic of this newest artists' colony, and if "the blue green color of Monet's impressionism"[6] that one American commentator as early as that fall reported had permeated Bruce's housemates' pictures never spread to his, we can still see ample evidence in his work at Giverny of new attitudes toward composition, color, and light. The change was not radical (neither was it, at first, in the work of his friends). His most ambitious picture of 1887 is a relatively loosely brushed, large figure of a woman sewing in the outdoors against a foliage screen; a work similar to Robinson's canvases of the time.[7] Small plein-air canvases are typical of his output in Giverny, however, and in most of his surviving examples, the horizon line, already rising in his paintings of the previous five years, has moved higher and the foreground has been treated more broadly, flattening the composition and bringing attention to the texture and conformation of the brushwork. He essayed Monet-like subjects, as in *Landscape with Poppies* (plate 108), and put aside, for the time being, concern for moody atmospheres of tone to pursue those qualities of intense summer light that can give substantial body to forms or dissolve them in shimmering pools of color.

There is no apparent sequence to Bruce's work at Giverny in 1887. *Landscape with Poppies* is obviously of the poppy season, probably late May or early June, but was the more naturalistic *Sur l'Epte, Giverny* (plate 109)

109. WILLIAM BLAIR BRUCE. *Sur l'Epte, Giverny.* 1887. Oil on canvas, 13¹⁵⁄₁₆ × 10¾″. Art Gallery of Hamilton, Canada Bruce Memorial, 1914

110. MAURICE CULLEN. *Biskra.* c.1894. Oil on canvas, 12⅝ × 21¼″. National Gallery of Canada, Ottawa, purchased 1981

painted earlier in the spring, before the leaves had come out, or in the fall, sometime before the end of October when he left for Stockholm with his fiancée, a well-to-do Swedish sculptor? It is an academic question because such naturalism was not only highly developed in his work before Giverny but also recurred after. Bruce never embraced the careful analysis of color in light and the broken brush strokes that some of his American friends learned to employ so effectively in emulation of Monet and his associates, although he later applied elements of Impressionism to his painting from time to time. However, as he demonstrated in his Salon submission of 1888, *The Phantom Hunter*[8]—a large, pathetic figure posed in a studio-contrived snowy landscape illustrating a Canadian legend—his values as an artist and his strategy for success had been essentially set during his brief but intense term at the Académie Julian. Although he maintained some contact with Robinson until the American's death in 1896, Bruce appears never to have worked at Giverny following his marriage in 1888, he and his wife preferring to pass the summers at Grèz and the winters in Italy.

It is unlikely that William Blair Bruce's brief sojourn in Giverny and his relationship with American Impressionists helped in any direct way to bring knowledge of the movement to Canada. Only three of his French paintings were shown publicly there before 1900, lent to exhibitions in Toronto by one of his Hamilton teachers, and he returned home again only once, for the summer and fall of 1895. Those interested in advanced art ideas already knew of Impressionism by then, and the following spring Canadian Impressionists were exhibiting in both Toronto and Montreal. It was only in Montreal, however, at that time Canada's largest city and the dynamic center of culture for both anglophone and francophone, that the movement would achieve prominence.

## Impressionism in Montreal

The ground was relatively well prepared in Montreal. In addition to the occasional item from Paris in a local newspaper of the activities of hometown artists involved with Impressionism, there was for an eleven-month period between May 1892 and the following March a regular report from the French capital in which Impressionism was frequently and intelligently discussed within the context of current Parisian artistic activity. A feature of *Arcadia*, a twice-monthly journal of the arts published in Montreal, the "Art in Paris" column was the work of Philip Hale, a Boston-born painter who was a prominent member of the American colony at Giverny in the years following Bruce's stay there.[9] *Arcadia* also reported in December 1892 on what appear to have been the first Impressionist pictures shown publicly in Montreal, "good and characteristic examples" by Monet, Sisley, Pissarro, and Renoir, at the gallery of William Scott, work that the unidentified commentator

understood to be representative of "the latest phase of French artistic life."[10] While Montrealers had some familiarity with "the artists who are midway between the Romanticists and the Impressionists [Bosboom, Vollon, Bonvin, Jongkind, Ribot, and Monticelli are all mentioned as examples] . . . of the genuine Impressionists we have, hitherto, seen little, and the Association might do worse than give us a New Year's exhibition, in the small gallery, of the works of this school presently available in Montreal."

It was to be two and a half years, until May 1895, before the Art Association of Montreal gave any appearance of a response to this challenge, sponsoring an uninformative talk on Impressionism by the French painter Jean-François Raffaëlli during one of his frequent American speaking tours.[11] Finally, in November of that year the annual loan exhibition of the association did include four locally owned French Impressionist paintings: a Monet *Poppy Field*, lent by the prominent Montreal banker George Drummond, and a Pissarro and two Renoirs, the property of Sir William Cornelius Van Horne, president of the Canadian Pacific Railway and Canada's best-known collector-connoisseur. The presence of such pictures—which doubtless resulted from the close involvement of both Drummond and Van Horne with wealthy New Yorkers of progressive taste— stimulated further discussion and a public lecture on the subject the following March by William Brymner, a respected Montreal figure painter and for the past decade Master of the Art Association school.[12] Brymner had spent altogether close to five years in Paris between 1878 and 1885, partly at Julian's, and his art, like Bruce's, was firmly grounded both in academic principles and in painting from nature. While never himself an Impressionist, he was sympathetic to the movement, and calling upon his own experience of the work of Manet and Monet he stressed in his lecture their conviction and the authenticity of their painting, while cautioning against those who followed their manner with little understanding of the direct response to nature that was its foundation. Brymner's point was not simply rhetorical, for Montreal was by then enjoying its own resident Impressionist, Maurice Cullen (1866–1934), a friend, although some eleven years Brymner's junior, and the one painter in Canada who would remain throughout the period committed to the style.

Born in Saint John's, Newfoundland, Cullen was brought to Montreal about 1870, where he later received some art training. Living in Paris by the late fall of 1888, he studied first at the Académie Colarossi, then at Julian's, and in November 1890 also enrolled at the École des Beaux-Arts. News of Cullen's progress in Paris reached Montreal, or at least the readers of *Courier du Canada*, first in January 1891:

> Mr. Cullen inclines somewhat towards the impressionist school, and this is certainly not meant to be a reproach, for this tendency proves the artist's horror of banality, which we can hardly encourage too much. He has just completed two landscapes in this vein now on view at the American Student Association, boulevard Montparnasse; two very personal and promising works.[13]

While an integral part of the anglophone student community, Cullen also met occasionally with a group of French-Canadian artists who had formed a monthly eating club called la Boucane. He seems to have sought out most of the expatriate Canadians, including the Bruces, whom he visited regularly at Grèz beginning in 1892. Working during the outdoor seasons at Moret, nearby, he also traveled to Venice and Milan, and, probably in 1894, to Algeria. Unlike Bruce, Brymner, or most of the other Canadians in Paris at the time, he did not exhibit figure subjects. Cullen had landscapes accepted in the salon of the new Société Nationale des Beaux-Arts in the spring of 1894 and again in 1895, when he was elected an associate and the French government purchased one of his pictures. Perhaps intending to capitalize on this impressive validation, he returned home to Montreal shortly after.

Cullen waited until October to exhibit, submitting two North African pictures to a kermesse in support of the Hôpital Notre-Dame. One of these, *An African River*, is probably the canvas we know today as *Biskra* (plate 110). While its steady, even light and crisply contrasted tones derive directly from the sort of plein-air naturalism that we would expect of an habitué of Julian's, it reveals a bold ability to describe the fraying fragmentation of forms as observed under the intense southern sunlight that suggests an affinity to the closer analysis of the Impressionists. This connection was noticed when, in January 1896, Cullen rented a storefront in the Art Association of Montreal building to exhibit his work. The scenes of Moret, Algeria, and paintings of the previous summer and fall done around Quebec City that he displayed, *The Gazette* reported (remarkably, right after the Drummond Monet and Van Horne Renoirs and Pissarro had been shown), "will give some a better idea of the Impressionist School than anything else seen here."[14]

Within a month of his first Montreal exhibition, Cullen was back in Paris, perhaps financed by copying commissions, if not by sales. (He registered at the Louvre to copy a Greuze at the beginning of April and a Velázquez at the end of that month.) He returned to Canada in the early summer and immediately set out for Sainte-Anne-de-Beaupré opposite the Île d'Orléans and downriver from Quebec City, a town, famous for its pilgrimage church, that reminded him of the peasant villages he had known in France. It was his principal painting spot for the next few months. In December he held another exhibition in Montreal, again with French work, but emphasizing his new Canadian pictures (no Canadian ones of the year before seem to have survived): "summer work done on the lower St. Lawrence" and "snow effects" captured there more recently.[15]

Among the latter is *Logging in Winter, Beaupré*

111. MAURICE CULLEN. *Logging in Winter, Beaupré.* 1896.
Oil on canvas, 25⅛ × 31⁷⁄₁₆″. Art Gallery of Hamilton, Canada.
Gift of the Women's Committee, 1956

112. MAURICE CULLEN. *Moret, Winter.* 1895. Oil on canvas,
23⅝ × 36¼″. Art Gallery of Ontario, Toronto. Gift from the
J.S. McLean Canadian Fund, 1957

(plate 111), a scene of early winter that has rightly be-
come one of his best-known paintings. As much as
Cullen's French canvases of 1895 show a sensitive regard
for the analysis of color effects in light—particularly
impressive in *Moret, Winter* (plate 112)—they also dis-
play a stylishness in the paint handling and color rela-
tionships that approaches the mannered self-
consciousness against which Brymner had warned in his
lecture of March 1896. *Logging in Winter*, on the other
hand, in its accurate rendering of the crystal clear air of a
sunny but cold Canadian winter day, in its rich array of
colors within the narrow range of hues dictated by dor-
mant foliage, and in its impressive combination of
broadly applied and scumbled paint in the depiction of
snow shadows fulfills Brymner's condition for Impres-
sionism's basis in a direct and deep response to nature.
The slight coarseness and touch of awkwardness, the
inevitable rawness of the painting are entirely appropri-
ate to the experience it encompasses and underline its
authenticity.

As difficult and uncomfortable as it is to paint
outdoors in subzero weather (the paint stiffens as do the
hands) Cullen was back to the Beaupré region early in
January and painted there and around Quebec City at
least through February with another Montrealer he may
have met in Paris, James Wilson Morrice. Work done
then, such as *Shipyard at Lévis* (plate 113), painted
across the Saint Lawrence from Quebec City, is, like
*Logging in Winter*, boldly direct, with the brushwork
reinforcing the observed color relationships, which in
turn reflect the particularly clear, cold light. These
paintings of the winter of 1896–1897 are the most evi-
dently Canadian and also the most thoroughly Impres-
sionist of his career.

Cullen exhibited his Canadian landscapes
widely, and despite their innovative nature they were
always singled out for praise. All of the reviews in French
and English described him as an Impressionist. The
comments of "Françoise" in *La Patrie* are not untypical:

> Mr. Cullen is a conscientious impressionist of the
> modern French school. I could never convey the
> extraordinary effect of his paintings. The winter
> scenes have an astonishing strength of color; one
> feels that he paints what he sees and how he sees
> it, with the sole concern to render nature
> sincerely.[16]

Despite such critical approval, Cullen did not win
the material success of patronage. After another long
season at Quebec City and Beaupré he rented a hall in
early December 1897 to exhibit the new work, but there
were no sales again, and in desperation he put every-
thing up for auction. The paintings sold but mainly to
artist-friends and at what the *Montreal Star* described as
"ridiculously trivial" prices.[17] While Montreal critics,
particularly those who wrote in French, were aware of
the fact that Impressionism was by then a general and
widely accepted influence in Paris, the number of collec-

113. MAURICE CULLEN. *Shipyard at Lévis*. 1897. Oil on
canvas, 16¼ × 18⅛". Private collection

tors who shared this understanding was negligible. Ex-
cept those of Van Horne and perhaps one or two others,
the collections of the day were formed of the more conser-
vative late Barbizon and The Hague School painters and
their followers who worked in moody grays.

Cullen continued in Canada with a routine that
closely approximated his time in Paris: long seasons of
plein-air painting in an attractively rustic and inexpen-
sive setting punctuated by regular exhibitions and doses
of the more concentrated artistic life of Montreal. While
he lived from hand-to-mouth, his work, as we can see in
*Summer near Beaupré* (plate 114), remained securely
based in the direct experience of nature. He traveled to
Europe again in the spring of 1900, visiting Brittany,
Venice twice, Giverny, and other well-known artists' re-
sorts, often in the company of Brymner and Morrice,
returning to Canada in the early winter of 1902 with a
more highly developed sense of color as a distinct entity, a
greater concern for scale, for pervasive mood, and for
clever, often isolated painterly "effects." *Lévis from
Quebec* (plate 115) of 1906 is a good example of his new
style. Impressive in its own right, it nonetheless resides
too much in the idealizing realms of the imagination to
be called Impressionism. His continuing presence in
Montreal (bolstered by that of Brymner, who remained
principal of the School of the Art Association of Montreal
until 1921, the one serious art school in the city) encour-
aged at least two subsequent generations of young
Montreal artists to seek advanced study in Paris. None,
however, developed the deep commitment to Impres-

114. MAURICE CULLEN. *Summer near Beaupré.* c.1898. Oil on canvas, 17¼ × 21¹⁵⁄₁₆″. Art Gallery of Ontario, Toronto. Purchased with funds from the Richard and Jean Ivey Fund, London, Ontario, 1980

115. MAURICE CULLEN. *Lévis from Quebec.* 1906. Oil on canvas, 30⁵⁄₁₆ × 40⅛″. Art Gallery of Ontario, Toronto. Gift from the Albert H. Robson Memorial Subscription Fund, 1946

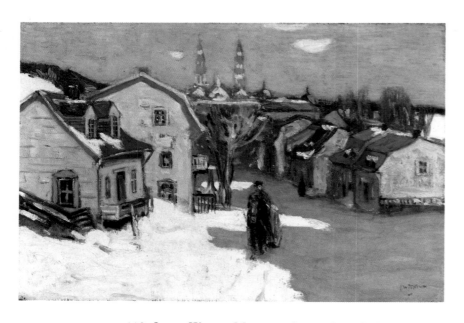

116. James Wilson Morrice. *Sainte-Anne-de-Beaupré.*
1897. Oil on canvas, 17½ × 25⁵⁄₁₆″. Gift of William J. Morrice.
The Montreal Museum of Fine Arts' Collection, 943.785

sionism that Cullen sustained during the 1890s, although, as we will see later, it touched and helped form a number of them in significant ways.

Cullen's example was also important to his contemporary James Wilson Morrice (1865–1924), who worked with him at Beaupré in January and February 1897. Although Montreal-born, Morrice was from a wealthier background than Cullen and had studied law in Toronto for seven years as a young man, so they did not know one another in Canada. Morrice settled in Paris in the fall of 1891 and briefly attended the Académie Julian, where the two might have met. He did meet another ex-Newfoundlander there, Maurice Prendergast of Boston, and they became close friends.

Over the next two or three years Morrice frequented the popular artists' spots on the Channel coast—Dieppe and the Breton ports of Saint-Malo, Dinard, and Cancale—often with Prendergast and sometimes with another friend from Julian's, an Australian, Charles Conder. There Morrice painted out-of-doors on small canvases, employing an open, airy quality that suggests some interest in Impressionism but that could have derived from lessons that he is purported to have taken from Henri Harpignies, a follower of the atmospheric late manner of Corot, after he left Julian's. By 1895, when Prendergast returned to Boston, Morrice was painting in the Channel ports and on the streets of Paris, using brighter, patterned colors for scenes that were intimate in scale and subject, and similar to the work of the then emerging Nabis.

That same year, following Prendergast's departure, Morrice made friends with three more Americans, Robert Henri, William Glackens, and Robert Henry Logan. Henri, with whom he became particularly close, encouraged the turn to more deliberate painting Morrice had taken and introduced him to the practice of field sketching on small wooden panels and later working up choice subjects on canvas in the privacy of the studio. This method distanced Morrice even farther from the spontaneous handling and essentially objective analysis of color in light that underlay Impressionism, and the moody tonalism and deliberate compositional structuring of Whistler began to interest him. Working at Brolles in the Forest of Fontainebleau early in 1896 with an artist from Toronto, Curtis Williamson, reinforced this tendency, but that summer alone at Saint-Malo and Cancale he turned to painting out-of-doors on canvas again, delighting in the light. The images he made there, however, are the most Nabis-like of his career.

Perhaps it was the change of environment, the alluring clarity of the atmosphere, that wrought the marked transformation in the work of his next significant painting trip, which he took six months later in frozen, far-distant Canada, working with Maurice Cullen at Sainte-Anne-de-Beaupré. As he wrote in February to Edmund Morris in Toronto, another Canadian painter friend from Paris, he had decided to forgo returning to France in order to stay in Beaupré "some more weeks."[18] He intended painting a Canadian snow subject for the Salon.

In spite of the cold, Morrice's working method that winter followed that in Cancale the summer before: painting directly on canvas *en plein air*. He would have been encouraged in this by Cullen, of course, and it is probably to the influence of Cullen, as well as to the Canadian climate, that we can attribute certain of the other remarkable qualities of the canvases he painted then. These include the startling clarity of the atmosphere—so compelling a feature of the best-known painting of the trip, *Sainte-Anne-de-Beaupré* (plate 116)—the rough, urgent way in which the paint has been applied, and the raw, slightly awkward quality overall. It is Morrice's extraordinary sensitivity to color, however, that is most impressive in *Sainte-Anne-de-Beaupré*. The rich, boldly worked whites in the brilliant light, the wonderfully palpable blue grays of the shadows, the steady, even blue of the sky, are all convincing as closely observed local color but are juxtaposed in an exquisitely strained, yet assured harmony. It is, however, the initial impression of spontaneity, of the whole picture being defined in terms of light and shade, and of the colors created as they dance and mingle that makes this painting and a few others of that winter the most Impressionist of his career.

Morrice was back in Montreal by April 1 for the opening of the Art Association's spring exhibition, which included two of his paintings, a Canadian winter scene (probably *Sainte-Anne-de-Beaupré*) and a Paris subject. While Cullen's Impressionist Canadian winter scenes attracted the approval of virtually every reviewer, Morrice's paintings passed unnoticed. Morrice left for Paris in May and was soon involved again with Henri. Their creative relationship remained close (until the American's return home in the summer of 1900), evidenced by their shared interest in the clearly structured yet decora-

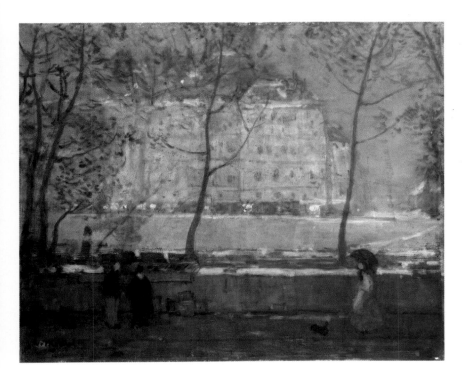

117. JAMES WILSON MORRICE. *Quai des Grands-Augustins, Paris.* c.1905. Oil on canvas, 19¼ × 23¼″. National Gallery of Canada, Ottawa, purchased 1909

tive painting of Whistler and in nocturnes in particular. While such work seems to us at some remove from Impressionism, in praising Morrice's submissions to the 1899 Salon of the Société Nationale des Beaux-Arts the critic for *La Révue des deux Frances* described them as "good impressionism, made without research but conscientious and meaning exactly what it says."[19]

Morrice achieved a position of some prominence in Paris before World War I, forging a personal style that was sensitively in tune with many of the advanced artistic concerns of the day. While his work of the period, such as *Quai des Grands-Augustins, Paris* (plate 117) of about 1905, might appear to us to reflect the influence both of Whistler and the Nabis, at closer proximity it was primarily associated with Impressionism. Clive Bell, for instance, who was a friend of Morrice's in Paris in 1904 and who considered Morrice to be "an excellent painter whose work . . . is . . . still insufficiently admired," described him as "an Impressionist of the second generation."[20] Writing in 1913, Charles Louis Borgmeyer, another admirer, tried to situate the Canadian's talent even more precisely:

> While he is not a Master Impressionist, he is a legitimate successor of theirs. Not that he decomposes his tones, or uses the "comma" of Claude Monet, or the superposed touches of Cézanne. He is too personal for that. He is one of the few who know where to stop and still hold to the essentials.[21]

Morrice—by then involved with Matisse and other Fauves in associations that stimulated continuing

creative growth and artistic development—was in fact the only Canadian of his generation for whom Impressionism was but a stage in an evolution toward a more radical approach to painting.

Cullen, of course, launched his career in Canada and produced his most exciting work as an Impressionist but then modified his approach in later years in response both to international fashion and the conservative tastes of Canadian collectors. Other Montreal painters born in the 1860s who were involved at all with Impressionism either, like Bruce, turned to it upon occasion as an alternative pictorial mode to the large-scale academic figure painting that consumed their ambition or at a relatively late point in their careers, when Impressionism was widely accepted, adapted something of its manner to what was still essentially academic figure painting. There were a number of painters who fall into the first category. All, including Ludger Larose, Joseph Franchére, Joseph Saint-Charles, and Henri Beau, were pupils of the Institut National des Beaux-Arts, founded in Montreal in 1870 by the Abbé Joseph Chabert, a French priest who had studied at the École des Beaux-Arts in Paris. All were trained to fill the demand in Quebec for church decorators and religious muralists, and all, with the encouragement of Chabert, managed to pursue further studies in Paris. Henri Beau (1863–1949), who cultivated the closest connections with the French capital, had the most significant involvement with Impressionism, although it consisted essentially of two interludes in a career otherwise directed to the painting of academic murals.

Born in Montreal, Beau began his studies with Chabert about 1881 and first made it to Paris seven years later. As early as 1891 his easel paintings display discrete dabs of color in the backgrounds and other distant reflections of Impressionist practice, but then suddenly in the summer of 1897 he produced a series of landscapes around Boguen and Lannion in the Léguer River estuary of Brittany that are in subject, style, and handling full-blown French Impressionist paintings. That year he also painted Impressionist street scenes in Paris and the attractive *Woman with a Parasol* (plate 118), which, while close to Monet in composition, paint handling and quality of light, conveys a strong sense of the moment, an element of personal conviction that gives it authority.

Beau continued to seek commissions of grand-scale figure paintings, the most important a huge mural depicting the arrival of Champlain at Québec awarded in 1902 in a competition to decorate the Palais Législatif in Quebec City. Once *The Arrival of Champlain* was finished (it was installed in October 1903), he turned again to what appears essentially to have been holiday painting *en plein air:* these works are in the manner of Monet or Pissarro with a strong emphasis on color analysis and the study of broken sunlight. Some, possibly including *The Picnic* (plate 119), were painted in the region of Montreal, where Beau lived from at least July 1904 until the fall of 1906, and a work of that title in the Art Association of Montreal's spring exhibition of 1905

was singled out for praise: "The effects of light through the foliage denote a master."[22]

The following February, Montreal had its first comprehensive exhibition of French Impressionism when the Art Association borrowed twenty-nine paintings from Durand-Ruel: works of the six acknowledged masters and of Mary Cassatt, Georges D'Espagnat, Albert André, Henri Moret, Maxime Maufra, and Gustave Loiseau. Surprisingly, the *Montreal Witness* insisted that local taste was not yet ready:

> If the pictures now on the walls of the Art Gallery were submitted to the committee of judges at the forthcoming Montreal Spring Exhibition, as the work of local aspirants, it is safe to say that most of it would be rejected with scorn.[23]

That was not the case, of course. Informed opinion in Montreal had accepted Impressionism as a historical fact, as one more "movement" in the inexorable evolution of art, a movement, as was explained in the lengthy introduction to the catalog of the Art Association show, that had already been superseded by Neo-Impressionism. Although the *Witness* reporter fulfilled his own prophecy by attacking one of Henri Beau's canvases in the spring exhibition in March, other critics praised it.

Beau quit Montreal for Paris later in 1906, never to return. Cullen remained prominent, of course; Morrice sent work from Paris regularly, and during the next few years evidence of Impressionism spread steadily through the Art Association spring exhibitions. Even established painters, such as the prominent society portraitist and one-time president (1893–1906) of the Royal Canadian Academy of Arts Robert Harris (1849–1919), felt its influence. While Harris had trained in Paris (1877–1878 and 1881–1882) and returned there briefly for the summer of 1887, when he self-consciously painted a model in the same pose twice, once in his usual and once in an "impressionist" style, it was only following the Art Association show in 1906 that elements of Impressionism began to creep into some of his portraits.[24] *The Skipper's Daughter* (plate 120), which he exhibited at the Art Association in April 1909, with its subject of summer recreation, its informal, tightly cropped composition, loose brushwork, and dominating play of brilliant light and shadow, is his most thoroughly Impressionist painting. It was not, of course, a commissioned portrait.

Another, younger man then also prominent in Montreal artistic circles embraced Impressionism more enthusiastically at this time, though no more thoroughly. This was Marc-Aurèle de Foy Suzor-Coté (1869–1937), a talented, facile painter who is reported to have studied at Chabert's Institut National about 1886 and then worked with a traditional religious painter for three years before leaving for Paris in March 1891. Like Beau and most of the others who started with Chabert, Suzor-Coté beat a steady path between Paris and Montreal over the

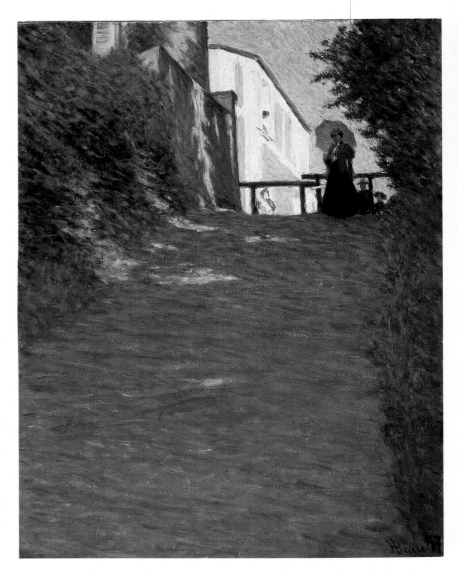

118. Henri Beau. *Woman with a Parasol.* 1897. Oil on canvas, 16⅛ × 12⅝". Purchase, Horsley and Annie Townsend Bequest. The Montreal Museum of Fine Arts' Collection, 1986.1

next few years, fulfilling church commissions in Canada and copying commissions in Paris, while studying and otherwise advancing himself in the Parisian art world. A student of Léon Bonnat's, he produced large paintings of figures in landscapes but also specialized in trompe l'oeil still lifes and Barbizon-influenced landscapes that are strikingly naturalistic. He occasionally essayed historical subjects and competed eagerly in 1902 for the commission to decorate the Palais Législatif in Quebec City.

On a painting trip in Brittany in the summer of 1906, Suzor-Coté, like Beau a decade earlier, quite suddenly produced landscapes—*Port-Blanc-en-Bretagne* (plate 121) is one—in a classic Impressionist style. He never painted any like them again, but they presage a distinct change in his landscape painting once he finally settled in Montreal in the summer of 1907. While still attempting large-scale figure subjects on a regular basis and occasional mural work (none religious anymore, however), he began to specialize in winter landscapes,

developing a characteristic composition of a gentle S-curved stream in the snow as a vehicle for the impressive light, color, and pure painterly effects he was able to command. As in *Stream in Winter* (plate 122), there is often an emphasis upon a dominant hue, a deliberately decorative element in common with the later work of Cullen and many others who by the beginning of the second decade of the century were straying from the plein-air painting that underlay Impressionism. Nor does the self-consciously rich texture of the paint, achieved by virtuoso feats of scumbling and delicate palette-knife work, have much to do with Impressionism. Elements of Impressionist paint handling did persist in Suzor-Coté's figure pieces for a few more years,

and, after about 1915, of Neo-Impressionist handling, but as no more than a skin over traditional academic subject and composition. Very rarely, as in *Youth and Sunlight* (National Gallery of Canada, Ottawa) of 1913, one of these large canvases evokes a more substantial relationship to classic Impressionism, but they are studio creations entirely, with none of the immediacy of the real thing.

By 1913 Impressionism was no longer a new and controversial issue in Montreal, a fact underlined by the attack certain critics mounted against the first evidence of local Post-Impressionists at the Art Association that spring. Before then, however, another distinct group of Impressionists had emerged, a second generation. All

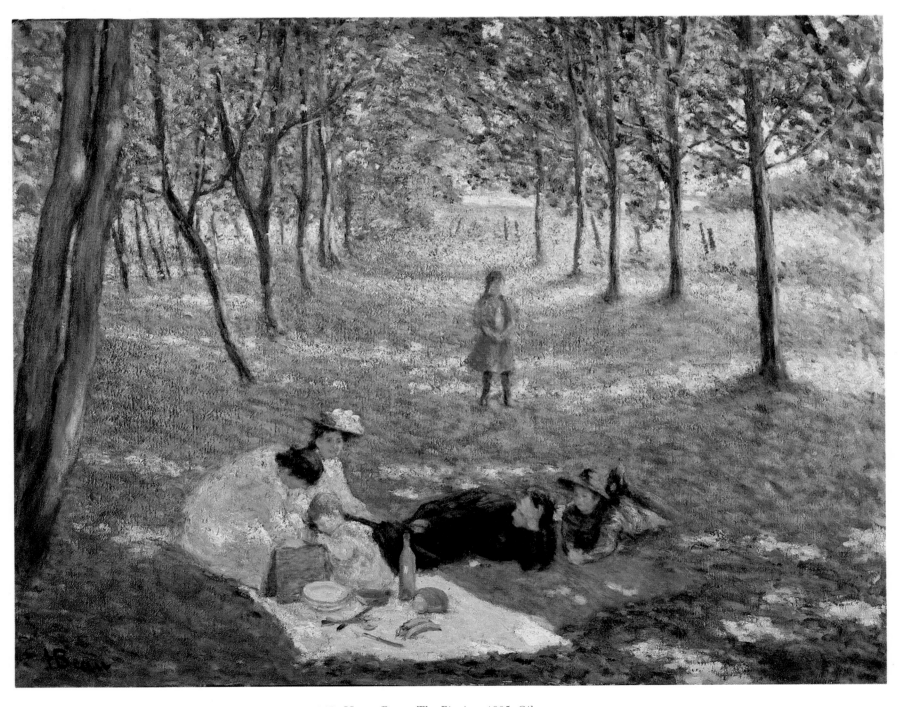

119. HENRI BEAU. *The Picnic.* c.1905. Oil on canvas,
28½ × 36⅜″. Collection, Musée du Québec, 86.43

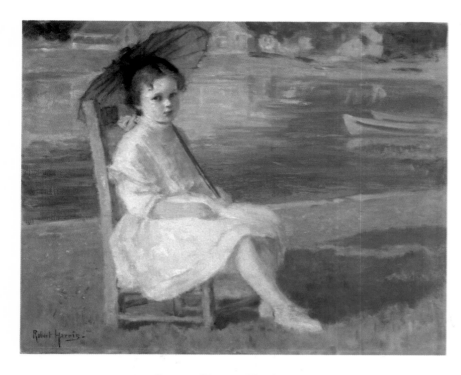

120. ROBERT HARRIS. *The Skipper's Daughter.* 1908. Oil on canvas, 24 × 30″. Private collection

121. MARC-AURÈLE DE FOY SUZOR-COTÉ. *Port-Blanc-en-Bretagne.* 1906. Oil on canvas, 25⅝ × 32″. National Gallery of Canada, Ottawa, purchased 1962

roughly fifteen years younger than Cullen and the others who came into contact with Impressionism in the nineteenth century, they were students of William Brymner at the School of the Art Association of Montreal, and all practiced painting out-of-doors well before first traveling to France. Clarence Gagnon (1881–1942) and William H. Clapp (1879–1954), for instance, painted together during the summers of 1902 and 1903 in the Beaupré region and farther along the north shore of the Saint Lawrence in more remote Charlevoix County.

Horatio Walker, the most prominent and successful Canadian painter of the day (much more prominent than Cullen), who specialized in peasant scenes modeled on the work of the Barbizon masters Millet and Troyon and who maintained a dealer and studio in New York City, had an extensive summer home and studio on the Île d'Orléans, just off the Beaupré coast, and his presence dominated the consciousness of those painters who were attracted in increasing numbers to the painterly possibilities of the region. Gagnon and Clapp called on Walker on more than one occasion. The pictures Morrice sent home to Montreal for exhibition and sale every year were also important to them. But above all there was the example of Cullen, of whom another of these Brymner students, A. Y. Jackson, later asserted: "To us he was a hero. His paintings of Quebec City, from Lévis, and along the river, are among the most distinguished works produced in Canada."[25] When the new generation inevitably moved on to Paris and the Académie Julian (Gagnon in January 1904, Clapp joining him, another Brymner student, Edward Boyd, and the young sculptor Henri Hébert in a Montparnasse apartment in the fall), they were ready for Impressionism.

While both Gagnon and Clapp lingered in Paris (Gagnon maintained a full-time studio there from 1907), they achieved a certain presence in Montreal before the war. Gagnon, who had a dealer before he left for Paris, sent a steady stream of paintings back for exhibition. The earliest reveal the influence of Horatio Walker in subject, composition, and color, evident in *Autumn, Pont de l'Arche* (plate 123) of 1905, exhibited with the Royal Canadian Academy in 1906. However, the blond tonality, the broad, loose brushwork, and the tendency to draw out decorative aspects, such as the rhythm of the brilliantly lit row of trees, reveal new concerns. Brymner encouraged Gagnon to contact James Morrice, and the two became friends. Morrice introduced Gagnon to sketching on small wooden pochades and turned his attention from rustic subjects to the delights of seaside resorts. The canvas *Summer Breeze at Dinard* (plate 124), while based on a sketch done probably in the summer of 1908, was itself probably painted in Montreal, where Gagnon set up a studio during a stay in 1909. Bright and airy and suitably Impressionist in subject, it is composed with such sensitivity to the placement of figures and the relationships of colors as to be on balance more Post-Impressionist. An important one-man show at the Galerie Reitlinger in Paris in 1913 featuring Canadian snow scenes confirmed this ten-

122. MARC-AURÈLE DE FOY SUZOR-COTÉ. *Stream in Winter.*
c.1911. Oil on canvas, 23⅞ × 28⅞″. Art Gallery of Ontario.
Gift of Moffat Dunlap from the Estate of his mother, Mrs. R.A.
Dunlap, 1947

123. CLARENCE A. GAGNON. *Autumn, Pont de l'Arche.* 1905.
Oil on canvas, 25½ × 36⅓″. Gift of Mr. James Morgan. The
Montreal Museum of Fine Arts' Collection, 909.56. © Estate of
Clarence A. Gagnon 1990/VIS★ART Copyright Inc.

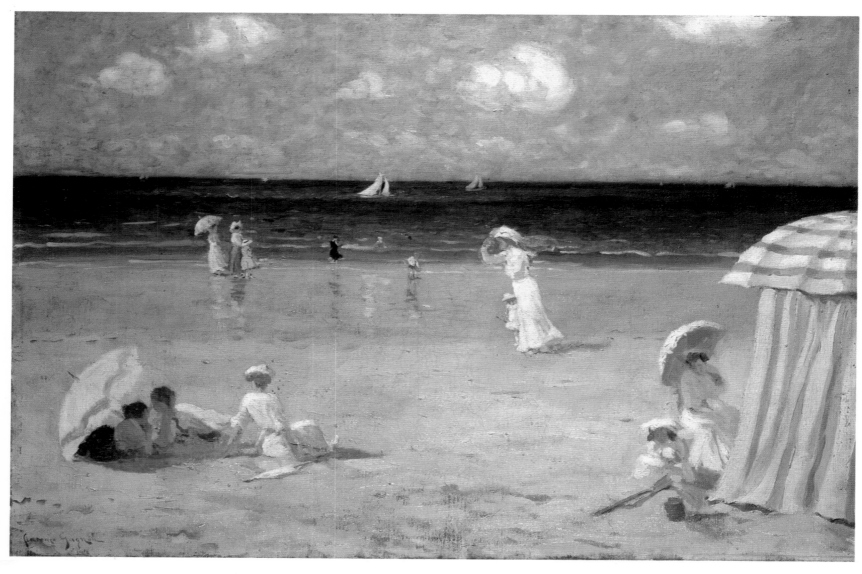

124. Clarence A. Gagnon. *Summer Breeze at Dinard.* 1909.
Oil on canvas, 21⅝ × 32⅞″. Collection, Musée du Québec, 37.01.
© Estate of Clarence A. Gagnon 1990/VIS•ART Copyright Inc.

125. William Henry Clapp. *A Road in Spain.* 1907. Oil on
canvas, 30½ × 36″. Gift of Mr. Henry Morgan and Co. The
Montreal Museum of Fine Arts' Collection, 913.25

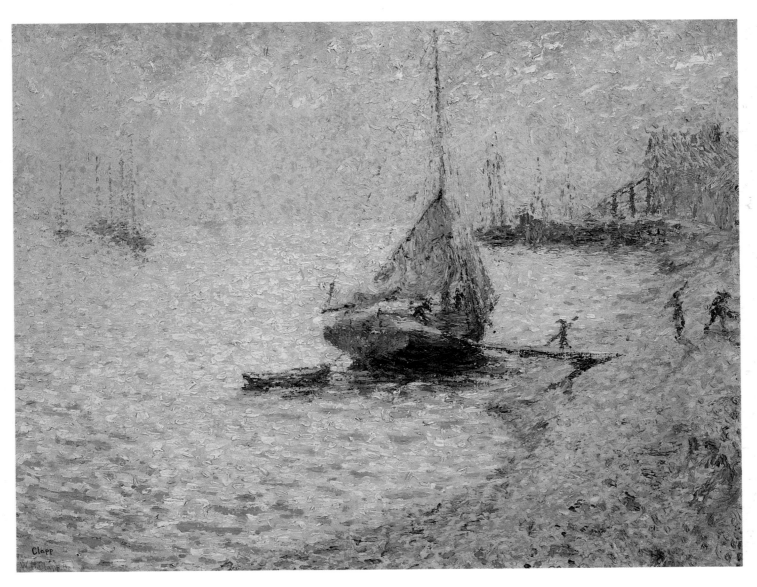

126. WILLIAM HENRY CLAPP. *Loading Lumber.* c.1909. Oil
on canvas, 28⅜ × 36¹⁵/₁₆″. Art Gallery of Hamilton, Canada

127. ALEXANDER YOUNG JACKSON. *Canal du Loing Near
Episy.* 1909. Oil on canvas, 25⅝ × 27⅜″. National Gallery of
Canada, Ottawa. Gift of Naomi Jackson Groves, Ottawa, 1979.
© Alexander Young Jackson 1990

128. ALEXANDER YOUNG JACKSON. *Sand Dunes at Cucq.* 1912. Oil on canvas, 20⅝ × 25¼". National Gallery of Canada, Ottawa. © Alexander Young Jackson 1990, purchased 1913

129. HELEN MCNICOLL. *The Little Worker.* c.1907. Oil on canvas, 24 × 20³/₁₆". Art Gallery of Ontario, Toronto. Purchase, 1983

dency, while also revealing a strong narrative element in his work—qualities he used to advantage in later years in a set of illustrations he prepared for *Maria Chapdelaine,* the classic novel of French-Canadian rural life that is his best-known and in many ways most characteristic body of work.

William Clapp embraced Impressionism with enthusiasm soon after his arrival in Paris. With too much enthusiasm, Brymner thought, writing to Gagnon late in 1906 that his friend should be told "that Monet is often good but that there are others."[26] Certainly, his *A Road in Spain* (plate 125), which he would have brought to Montreal with him early in 1908, is suggestive in handling, color, and evocative imagery of the mature Monet. *Loading Lumber* (plate 126), a Canadian subject shown with the Royal Canadian Academy in 1909, maintains that allegiance in a shimmering, scintillating fusion of air and water. The close analysis of color in light effects that we see here soon led Clapp to a kind of radical divisionism, and most of his later Canadian pictures, as well as those painted in Cuba after 1914, and in Oakland, California, where he settled about 1916, are in the manner of Pointillism.

A. Y. Jackson (1882–1974) was able to study with Brymner only on a part-time basis while he supported himself working in various lithographic shops. He still made it to Paris, traveling to France on a cattle boat in the early summer of 1905, and during the week he had there he looked up Gagnon and Boyd. Returning to Paris in September 1907 for two years, he enrolled at Julian's and visited some of the painters' spots. On a third trip (September 1911–January 1913), he avoided Paris almost entirely, working first in Brittany and then at Etaples. *Canal du Loing Near Episy* (plate 127), which dates from Jackson's second trip, is a classic, Sisley-like Impressionist picture of one of Sisley's favorite haunts. It is far from a mannered replica, though, as Jackson has understood the occasion to be an essentially retinal event. The canvas radiates serene objectivity while revealing delight in countless visual incidents. It is, however, a creation almost entirely of tone. *Sand Dunes at Cucq* (plate 128), on the other hand, which was painted while Jackson was staying at Etaples in 1912, is a glorious record of brilliant local color, the yellow autumn leaves and shadows of varying intensities of violet mauve fusing at the center of the canvas like smoldering embers. Painted *en plein air,* this canvas nonetheless suggests how both his love of color and a sense of the symbolic force of certain land forms would direct his art in the future.

While Jackson, Clapp, and Gagnon all moved quickly through an Impressionist phase in their early work, many others of their generation in Montreal, such as Randolph Hewton, Albert Robinson, John Lyman, and Emily Coonan, jumped that step entirely, emerging around 1913 in the Post-Impressionist camp. The one notable exception was Helen McNicoll (1879–1915), whose decision to study in England rather than France and whose early death precluded the rapid transition from Impressionism we see in the work of her colleagues.

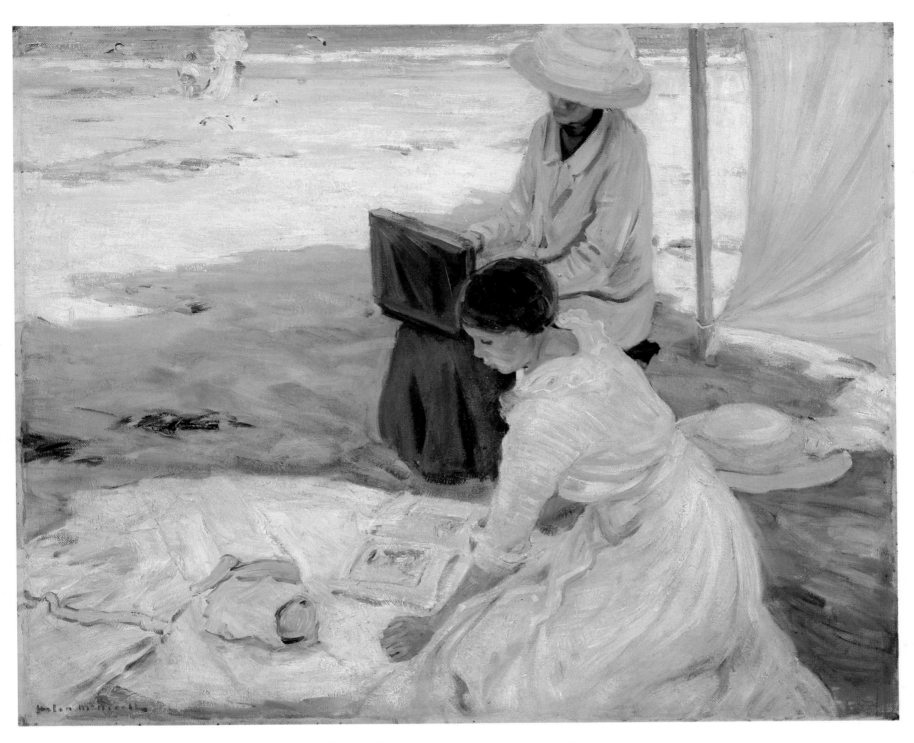

130. HELEN McNICOLL. *Under the Shadow of the Tent.*
1914. Oil on canvas, 32 × 40″. The Montreal Museum of Fine
Arts' Collection, 915.122

Little has been published concerning her life or art, but the impressive group of paintings kept largely by her family since her death demands attention.

McNicoll, who was born in Toronto but later moved with her family to Montreal, was one of many women to study with Brymner at the Art Association—over 90 percent of the students were female—but unlike most she later studied abroad. Deaf as the result of scarlet fever as a child and with her absorption in her art coupled with evident talent and her limited social potential due to her handicap, she could hardly be denied. Her father, who was first vice-president of the Canadian Pacific Railway, also had business connections in London and could afford to send her. She chose to study at the Slade School of Art, but, probably in the fall of 1905, enrolled in classes given by Algernon Talmage at Saint Ives in Cornwall, where she met the English painter Dorothea Sharp. The two painted together, mainly in Yorkshire but also on travels in France and Italy, until McNicoll's death in June 1915.

McNicoll maintained close connections with Montreal and exhibited there steadily from 1906 on, showing pictures painted in Canada in 1907 and again in 1912. Her paintings of the year or two following her move to England, such as *The Little Worker* (plate 129) of about 1907, conform to the tenets of classic French Impressionism in choice of subject, in the relationship of the brushwork to the analysis of color in light, and in scale. Her works from after 1912 or so, such as *Under the Shadow of the Tent* (plate 130) of 1914, are still conceived largely on the analysis of light but are more elaborately and precisely structured and more smoothly worked, revealing intimate views of cultivated recreation in the manner of those English painters—Talmage among them—who had developed a distinctive Edwardian mode from the examples of the French Impressionists, Whistler, and John Singer Sargent.

## Impressionism in Toronto

The period during which Impressionism appeared on the Toronto art scene coincides almost exactly with that in Montreal, the mid-1890s to just before World War I. While Impressionism's principal practitioners in Montreal achieved prominence, however, and significant aspects of the style ultimately touched most of the leading painters of the day, in Toronto it was hardly more than a peripheral issue, a relatively minor current among many that contributed to the development of a modern idiom in that city. It was introduced in Toronto not, as in Montreal, by a painter who had matured in the style and embraced it fully, but by slightly older artists who had established themselves on the basis of work grounded in some variant of Realist figure painting and only occasionally turned to Impressionism. George Reid (1860–1947) and Farquhar McGillivray Knowles (1859–1932) are two examples. Reid's *Idling* (plate 131) was among the first pictures to display Impressionist characteristics.

131. GEORGE REID. *Idling.* 1895. Oil on canvas, 18 × 16". Private collection. © George Reid 1990/VIS*ART Copyright Inc.

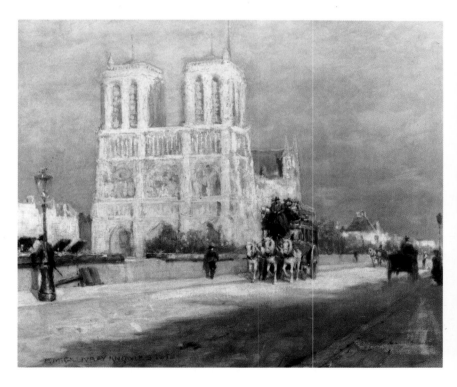

132. FARQUHAR MCGILLIVRAY KNOWLES. *Notre-Dame, Paris.* 1895. Oil on canvas, 23 × 25". The Government of Ontario Art Collection, Toronto, Canada

Originally about a third wider, and thereby somewhat less Impressionistic in composition than at present, it nonetheless stands virtually alone in his oeuvre. Unclearly dated—it could read 1892 but is likely 1895, the year it was published[27]—there is no evidence that it was exhibited in Toronto at the time. In Paris on his third visit for two months in 1896, Reid is reported to have studied the paintings of the Impressionists, although they appear to have had little effect on his work until his later years when he produced landscapes that are broadly handled studies of form-enhancing light. McGillivray Knowles's *Notre-Dame, Paris* (plate 132), another painting that emulates classic French Impressionism, was exhibited at the annual exhibition of the Ontario Society of Artists in Toronto in March 1896, at which time it was purchased by the Ontario government. McGillivray Knowles spent four years in Paris, centering his activities around Julian's, but *Notre-Dame, Paris*, painted there in 1895 not long before his return to Toronto, relates to the general body of his work much as does *Idling* to that of Reid's.

Not only was the appearance of Impressionist painting by Toronto artists sporadic and isolated during the late 1890s, there is no evidence that French Impressionist pictures were owned or publicly exhibited locally. Toronto collectors were neither as wealthy nor as bold as the most prominent Montrealers (late Barbizon and The Hague School painting was the limit of local taste). There were no dealers like William Scott to encourage them, and although the Art Museum of Toronto was established in 1900, its first picture galleries were opened only in 1918. It is hardly surprising that, unlike in Montreal at the time, there is no sense in exhibition reviews or articles on art in Toronto of an awareness of Impressionism. E. F. B. Johnston, a lawyer, collector, and one of the best-informed art commentators in the city, in reviewing the exhibition that included McGillivray Knowles's *Notre-Dame, Paris*, not only failed to notice it, but remarked on the advanced nature of much of the painting in the exhibition without once mentioning Impressionism.[28] Indeed, the progressive artists of the day in Toronto—painters such as McGillivray Knowles's second wife, Elizabeth, Reid's wife, Mary Hiester, Sidney Strickland Tully, and Clara Hagarty—while they might employ impressionistic "effects" in their work, saw their artistic modernity in a more broadly based Aestheticism.

There was one exception to this general circumstance, Ernest Lawson (1873–1939), who more properly might belong in essays devoted to the United States, the country where he pursued his career as a painter and where he himself claimed to have been born. He was in fact born in Canada, at Halifax, where he lived for ten years before moving to Kingston, Ontario, to live for five years with his aunt and his uncle, the Reverend George Munro Grant, principal of Queen's University and one of the most highly respected Canadian intellectuals of the day. In 1896, when Lawson was broke from a year-and-a-half stay in France and with a new baby (he had married just before leaving for Paris), he stopped in

133. ERNEST LAWSON. *Winter.* c.1907. Oil on canvas, 24¾ × 29¾". National Gallery of Canada, Ottawa, purchased 1914

Toronto and Grant arranged three portrait commissions for him at Queen's, all still there. One is undistinguished, but the other two, *Hon. William Morris, Founder and Trustee* and *Prof. H. J. Saunders, Faculty of Medicine*, are handsomely Manet-like in their directness, color, and breadth of handling. There is no evidence that Lawson showed work in Toronto that year, and he did not stay long in Canada, but he ultimately returned to exhibit with the Canadian Art Club in 1911 and participated in their annual exhibitions until the demise of the club in 1915.

The Canadian Art Club was a private exhibiting association organized in Toronto in 1907 by Edmund Morris and Curtis Williamson as an alternative to the established societies and an attractive local venue for those younger, more experimental painters who were pursuing their careers abroad. In terms of the range of taste presented there, it approximated the London-based International Society of Sculptors, Painters and 'Gravers. The paintings of Morris and Williamson are dark and moody in the style of the Barbizon-influenced work of some of their Dutch contemporaries (both had worked in Holland as well as France), and the other Toronto members reflected a similar taste, as did Horatio Walker and Homer Watson, the two senior members. Cullen and Morrice were also exhibitors from the beginning, in 1908, however, and others of the Impressionist-influenced Montrealers were involved: Gagnon from 1909, Clapp from 1912, and Suzor-Coté from 1913. Ernest Lawson was one of a small handful of members who represented tenuous Canadian connections but who reinforced the Impressionist contingent. His *Winter*

134. Arthur Lismer. *The Guide's Home, Algonquin.* 1914. Oil on canvas, 39½ × 44½″. National Gallery of Canada, Ottawa, purchased 1915

135. James E.H. MacDonald. *Tracks and Traffic.* 1912. Oil on canvas, 28 × 40″. Art Gallery of Ontario, Toronto. Gift of Walter C. Laidlaw, Toronto, 1937

(plate 133) was purchased from the 1914 exhibition by the National Gallery of Canada.

The annual exhibitions of the Canadian Art Club between 1908 and 1915 offered the only regular opportunity to see some form of Impressionism in Toronto in relatively congenial surroundings (the first French Impressionist painting to be shown in Toronto, a Monet from Durand-Ruel, was shown at the *Canadian National Exhibition* in September 1910). The club encouraged a small group of painters then forming in the city who paralleled Gagnon, Clapp, and Jackson in passing briefly through an Impressionist phase to a more formal approach to color and composition. Jackson, in fact, moved to Toronto in the fall of 1913 to join them. Immediately following the war they exhibited together as the "Group of Seven" and during the 1920s achieved fame as aggressive nationalists, their art, they claimed, a direct response to the rugged beauty of the Canadian wilderness. That it in fact was nurtured by the particular mix of modern idioms offered in the annual exhibitions of the Canadian Art Club is evident from immediately before the war, and Impressionism was an essential part of that mix.

Arthur Lismer (1885–1969), in his *Guide's Home, Algonquin* (plate 134) of 1914, for instance, employed broken brushwork to reveal the color components of both sun and shade in a classic Impressionist style. J. E. H. MacDonald (1873–1932), in his wonderfully atmospheric *Tracks and Traffic* (plate 135) of 1912, used broken brushwork to produce the scintillating effect of light on well-trampled snow, although it is painted mainly in the grays and ochers more characteristic of the Toronto members of the Canadian Art Club. *Houses, Richmond Street* (plate 136) of 1911, by Lawren Harris (1885–1970), in the breadth of its brushwork and its saturated colors evoking both the bright autumn hues and the staccato pattern of reflected light, also relates to Impressionist concerns yet is but a few short steps to the emphatic composition and broad, heightened color areas characteristic of the Group of Seven's first Toronto exhibition of May 1920.

Viewed in the most general terms, Impressionism was but one hue in the polychrome coat of international modernity worn by Canadian artists at the turn of the century, a stylish garment invented almost entirely abroad, albeit largely by expatriates and for export. Defined narrowly, however, and in relation to its specific application in Canada, Impressionism provided remarkable access to the Canadian landscape for two painters, Maurice Cullen and James Wilson Morrice. Their example encouraged a generation of Montreal artists, bridging the "truth to nature" tenets that gave life to the work of those nationalist landscape painters who preceded them and the wilderness-based nationalism of the Group of Seven in Toronto who followed. It was in Canada a crucial link.

Impressionism in Canada

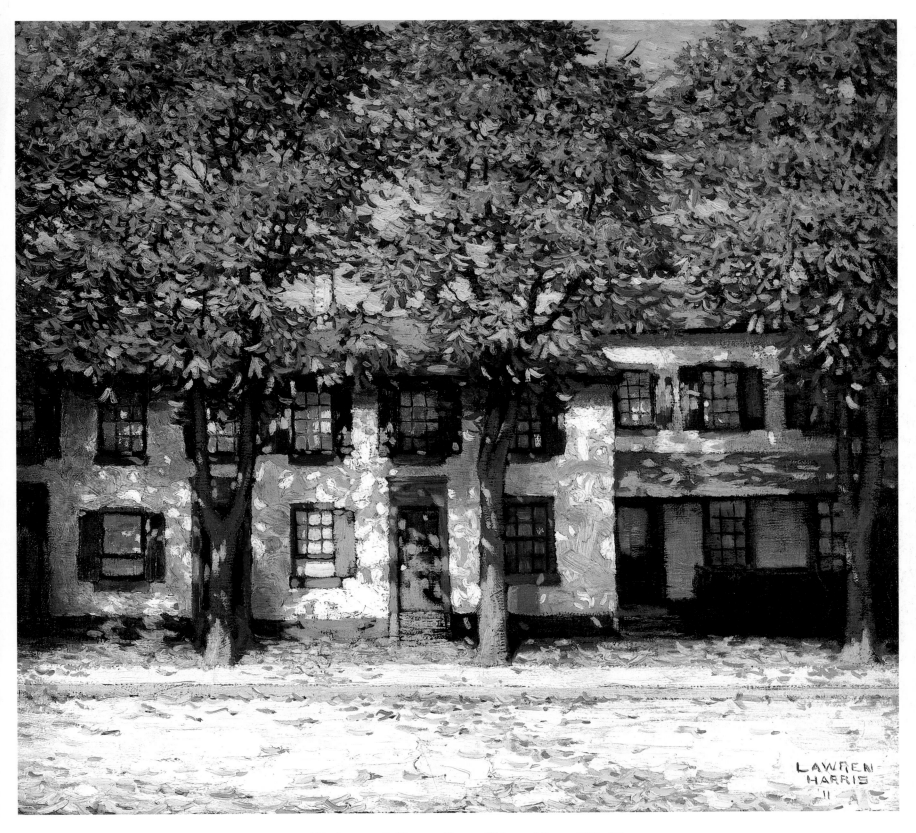

136. Lawren S. Harris. *Houses, Richmond Street.* 1911. Oil
on canvas, 30 × 32″. Collection of the Arts and Letters Club,
Toronto. © Lawren S. Harris 1990/VIS\*ART Copyright Inc.

# THE SUNNY SOUTH: AUSTRALIAN IMPRESSIONISM

*Virginia Spate*

137. TOM ROBERTS. *Bourke Street, Melbourne (Allegro con brio).* c.1886. Oil on canvas, 20⅛ × 30¼″. National Library of Australia, Canberra

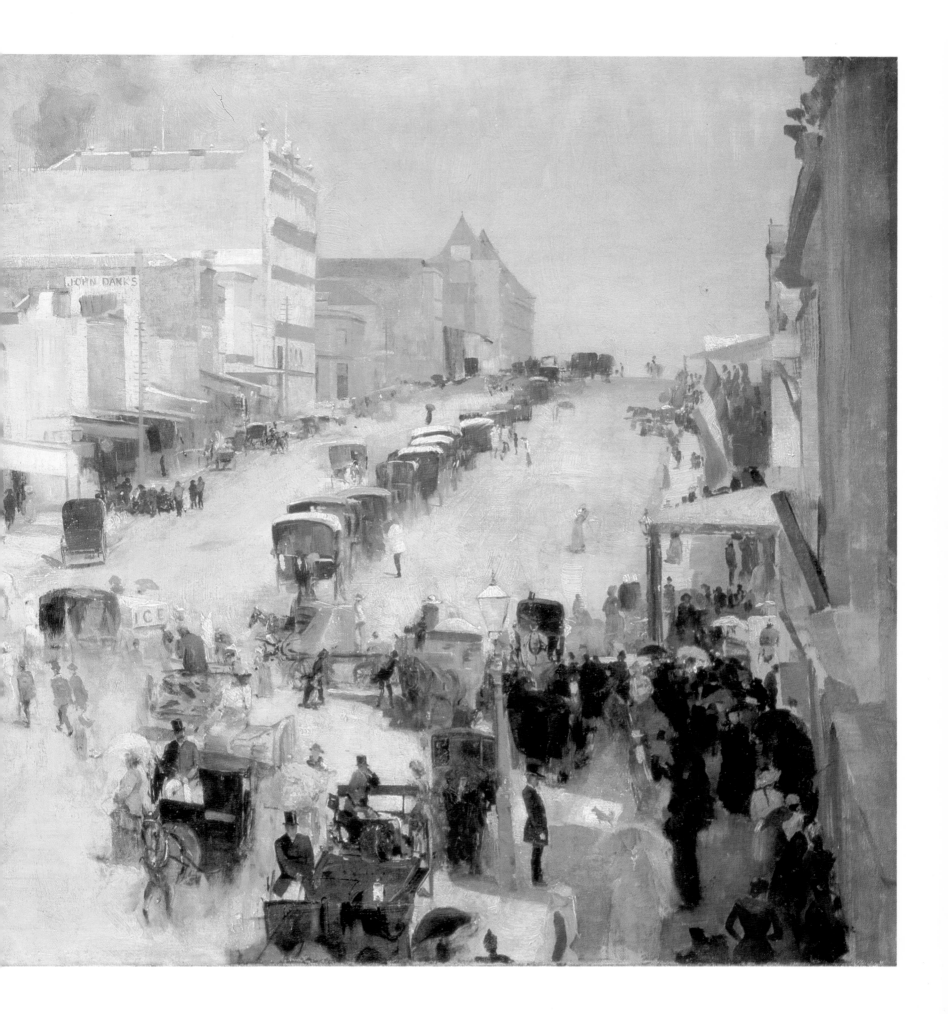

138. TOM ROBERTS. *Impression*. 1888. Oil on cedar panel,
4⁵⁄₁₆ × 17¼″. National Gallery of Victoria, Melbourne.
Purchased 1955

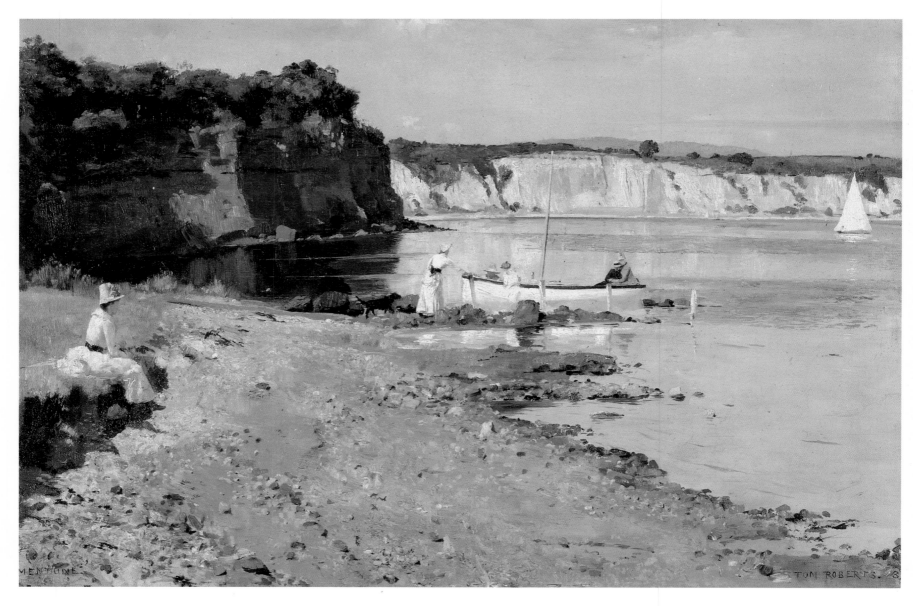

139. TOM ROBERTS. *Mentone*. 1887. Oil on canvas mounted
on board, 20 × 30⅛″. National Gallery of Victoria, Melbourne.
Purchased with the assistance of a special grant from the
Government of Victoria, 1979

140. TOM ROBERTS. *The Artists' Camp, Box Hill.* c.1886. Oil on canvas, 18⅛ × 24″. National Gallery of Victoria, Melbourne. Felton Bequest 1943

I N MELBOURNE IN 1889 a group of artists, including the three painters commonly recognized as the leaders of Australian Impressionism, Tom Roberts (1856–1931), Charles Conder (1868–1909), and Arthur Streeton (1867–1943), held a group show, the *9 × 5 Exhibition of Impressions.* They defined their aims in an accompanying manifesto:

> An effect is only momentary: so an impressionist tries to take his place. Two half hours are never alike, and he who tries to paint a sunset on two successive evenings, must be more or less painting from memory. So in these works, it has been the object of the artists to render faithfully, and thus obtain first records of effects widely differing and often of very fleeting character.[1]

The "nine-by-five" Impressions were painted on small panels—mostly nine-by-five-inch cigar-box lids—as quickly executed fragments of fleeting effects, and their creators insisted on their significance as paintings, rather than as studies for larger, more finished works (see Roberts's *Impression* and Conder's *How We Lost Poor Flossie;* plates 138 and 146). The presentation of the exhibition, artfully arranged with Liberty fabrics, vases full of spring flowers, and Japanese screens and fans—and the opening, at which "Miss Fanny Bristow sang" and "non-impressionist tea was served" (it was somewhat weak)—indicate that this was as much a social event directed at Melbourne's tiny cultural and social elite as a challenge to an established system.[2]

There was not in fact much of a system to challenge. Australia, which had no independent status as a nation, being composed of six British colonies, had just celebrated the first centenary of white settlement. As the centenary approached there had been considerable discussion as to whether there was—or ever could be—an Australian school of painting. Because most artists had been recent immigrants and there were no entrenched art institutions or academy, there was no unified tradition of Australian painting. There could, then, scarcely be an avant-garde, and there was no history of deliberate provocation of the bourgeoisie. Yet, by means of the *9 × 5 Exhibition,* Roberts, Conder, and Streeton tried to set these practices in place. The exhibition, modest though it was, makes clear the perennially double-sided nature of white Australian culture: in the manifesto and a subsequent letter, Roberts, Streeton, and Conder claimed to be laying the foundation for an Australian school by being true to their perceptions of Australian nature, but they did so through cultural forms generated half a world away. They gave Melbourne an avant-garde, invented a local form of exhibition *de scandale,* and demonstrated a clear understanding of some of the central concepts of Impressionism: truth to the perception of a fleeting moment, reliance on the immediacy of personal sensation, and distrust of convention and memory. These notions were compatible with the modernizing aspirations of the urban bourgeoisie to which the paintings were addressed, but were made ambivalent by the fact that Australians tended to define themselves in terms of a mythicized relationship to the bush.[3] A crucial aspect of the double nature of Australian Impressionism lies in the fact that while the painters sought to be true to their perception of a momentary effect of light, for them, as for an increasing number of their contemporaries in the years leading towards Australia's nominal independence from Britain in 1901, light—*golden* light—symbolized the desires clustering around the notion of Australia as a new land, a land of abundance, health, and happiness.

The first phase of Australian Impressionism dated essentially from of the summer of 1885–1886 to the end of the 1890s.[4] It was in 1885 that Tom Roberts returned to Melbourne after studying at the ultraconservative Royal Academy School in London and working at the conservative Académie Julian during a brief visit to Paris. He found that during his absence artists had begun the practice of painting *en plein air* in the bush around Melbourne, a practice probably initiated by recent immigrants such as Julian Ashton (1851–1942) and E. J. Daplyn (1844–1926), who, like Roberts, would have had ample opportunity to see plein-airist paintings by artists of the Barbizon school and by Bastien-Lepage and his English followers. Late in 1885 Roberts and Frederick McCubbin (1855–1917) set up a plein-air painting camp at Box Hill (depicted in *The Artists' Camp;* plate 140). Roberts and McCubbin were joined by Streeton at Mentone on the coast in 1886–1887 and then by Conder, with whom Roberts had painted on a quick trip to Sydney in 1888. Conder had already been painting on the plein-air expeditions probably initiated by Ashton and Daplyn after they had moved to Sydney in the early mid-1880s. In the summer of 1888–1889,

Roberts, Streeton, and Conder camped in an empty house in an overgrown formal garden looking over the valley of the Yarra river at Eaglemont—a village far enough from Melbourne to allow close communion with nature as they evolved new ways of representing the landscape. They were also visited by other artists, namely McCubbin, Jane Sutherland (1855–1928), Clara Southern (1854–1928), and Walter Withers (1854–1914). Australian Impressionism, like the French version, was largely the creation of friends who painted together in nature and developed their theories from its empirical study. As a place of discussion, the camp fire functioned as an equivalent of the Parisian café! As Roberts remembered of Box Hill:

> The evenings after work—the chops perfect from the fire of gum-twigs—the "good night" of the jackies as the soft darkness fell—then talks around the fire . . . we forgot everything but the peace of it.[5]

The women painters seem to have been less restricted by decorum than their French counterparts, and they too painted at Box Hill and Eaglemont, though doubtless they did not camp there (they also had city studios, as opposed to ones in the home).

By the summer of 1886–1887, an increasing number of pictures painted in fluid strokes of high-toned color (as in Roberts's Mentone paintings; plate 139) confirmed the critics' sense of the arrival of a new kind of Impressionism, one different from the low-toned plein-airism to which they had previously given the name and influenced more strongly by the most recent French art, which almost undoubtedly they had only read about. This early phase of Impressionism culminated in the public gesture of the *9 × 5 Exhibition* and in the paintings done at Eaglemont. In 1890 Conder left for Europe, after which Roberts and Streeton moved to Sydney, where they established an artists' camp on the harbor, a ferry ride from the city (where they also had studios for more formal painting, such as the portrait commissions on which Roberts's livelihood depended). In Sydney, however, perhaps because of the adverse effects of the economic depression of the early 1890s on artistic production, Impressionism never amounted to a group style as it had in Melbourne. In the late 1880s and 1890s an increasing number of Melbourne artists, including Emanuel Phillips Fox (1865–1915), Tudor St. George Tucker (1862–1906), and David Davies (1864–1939), studied in Paris rather than London and thus had more direct knowledge of French Impressionism than did Roberts and his group. Fox, Tucker, and Davies returned to Melbourne in the early 1890s, and the former two set up another "camp" near Eaglemont. Around the turn of the century, however, most of these artists, including Streeton, Roberts, Fox, Davies, Tucker, and Withers, perhaps disillusioned by the inability of Australia to sustain "a great school of painting," left for Europe and

141. TOM ROBERTS. *Summer Morning Tiff.* 1886. Oil on canvas, 30¼ × 20¼". Martha K. Pinkerton Bequest. Collection City of Ballarat Fine Art Center

AUSTRALIAN IMPRESSIONISM

142. FREDERICK McCUBBIN. *Moyes Bay, Beaumaris.* 1888. Oil on canvas, 23 × 36". The Art Gallery of Western Australia, Perth

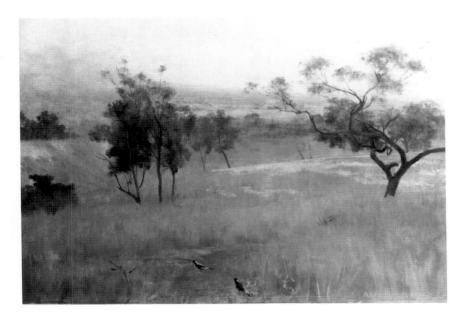

143. ARTHUR LOUREIRO. *An Autumn Morning.* 1893. Oil on canvas, 28 × 40". Collection Joseph Brown

thus spelled the end of Australian Impressionism as a movement.

It has been customary to evaluate Australian Impressionism in terms of its relationship to that of Paris. Even if this relationship is traced through English painting, through Whistlerism or impressionistic naturalism, the central obsession remains the French Impressionist connection—or its absence. The underlying assumption is always that Australian art comes from somewhere else, from somewhere so far away—a sea voyage of at least six weeks—that there can be no relationship but one of provincialism. Certainly geographical isolation meant that the relationship could not be one of slow assimilation or mutual exchange, but this model of dependency allows no consideration of a shared style that would acquire meaning in terms of its adaptation to local conditions. The model is, however, so strong that some art historians have even denied the existence of Australian Impressionism because the group did not use the broken colors of Monet, Renoir, Morisot, Pissarro, and Sisley.[6] Of course, by this criterion, a number of Paris Impressionists would be disqualified. Indeed, the standard notion of French Impressionism not only denies essential stylistic and ideological differences within the group, but also excludes other local variants.

In the early to mid-1880s Tom Roberts was probably the only one of the Australian group who might have seen Impressionist painting overseas, and there is no certainty that he did. A few French Impressionist paintings were exhibited in London in 1882 and 1883, but when Roberts visited Paris in 1884 or 1885, although impressionistic color, execution, and subject matter were recognized to have influenced Salon painting, Impressionism did not yet occupy the dominant position it has since been given by history. Some English students working in Paris in the 1880s never saw any examples of it,[7] and while Roberts was there the only exhibitions containing Impressionist paintings were the posthumous exhibition and sale of Manet's works in January and February 1884. If Durand-Ruel made his stock accessible to students, Roberts could have studied the entire history of the movement, but, apart from interesting relationships between some of his compositions and those of Monet, there is nothing to suggest that he did. The only evidence that Roberts may have seen the French master's work is in a little phrase written by Conder when in Paris in 1891: "Monet still paints with divided colours. . . ."[8] Apart from Whistler—whom an Australian critic was to call "the first of the English Impressionists," and whose 1884 exhibition Roberts almost undoubtedly visited—there is little evidence that he saw anything in England that would have shaped his Impressionism. In Australia itself there do not seem to have been any recent French paintings, let alone any Impressionist ones; there were no color reproductions of Impressionist works in overseas journals and very few, if any, black-and-white illustrations. If Roberts brought anything of French Impressionism back to Australia, it was in his memory, perhaps to be summoned up by similar mo-

ments of light or by scenes similar to those seen in such paintings. In more general terms, he had probably acquired a sense of the significance of the "impression," of modernity, and of the avant-garde. He was never dogmatic about style, and he used markedly different styles for different subjects. He was probably open to the words of his friend, the painter John Russell, who told him as he left for Australia: "Go and forget style and tackle our stuff for love."[9]

Australian Impressionism has been explained in terms of an evolution from the plein-airist "impression" and even as a derivation of the academic étude,[10] but it was quite different from the tonal structures of both. There is not a necessary evolution from naturalist plein-airism to Impressionism (in France, for example, Manet's paintings and Japanese prints created an essential fracture between the two). Australian critics used the term "Impressionism" to characterize three not always distinct stylistic tendencies: plein-air naturalism painted in muted tones, plein-air naturalism transposed into a higher key, and Impressionism proper, which used color as the primary constructive agent. For example, works such as Roberts's *The Artists' Camp* — painted a year after his return from Europe — with its closely related tones in blue greens and ochers and its combination of generalized suggestive masses and sharp-focus foreground detail is related to the plein-airism of Bastien-Lepage and of his English followers. Like much of that work it represents an unpretentious moment in a scene made more intimate by the closure of deep space. Similarly, paintings by McCubbin, Davies, Sutherland, and Southern (plates 142 and 163) representing the small farms around Melbourne suggest the transposition of the grays and blue greens of European plein-airism into the delicate ochers, olives, and pinks that convey certain aspects of the cultivated landscape around Melbourne, while the *Summer Morning Tiff* (plate 141) can be seen as a form of plein-airism transposed into a high key, with the grays, greens, and blues characteristic of the European movement translated into gold, articulated by olive green and warm grays, and accentuated by dazzling white. However, Roberts's *Bourke Street* (plate 137), painted *earlier* than *The Artists' Camp*, and Streeton's *Golden Summer* (plate 155), painted two years later, suggest a radical departure from tonal plein-airism in that color was used to construct the image, rather than as a skin over a tonally conceived painting. This form of Australian Impressionism takes its place in an international movement of which Parisian Impressionism was a specialized variant. Thus, comparisons between Australian and French Impressionism in this essay are not meant to suggest influence but to define relationships.

In the early 1880s, Australian critics described in their reviews landscapes painted with muted tones and an almost photographic oscillation between soft focus and high definition — seen particularly in the works of recently arrived immigrants such as the Englishman Julian Ashton and Arthur Loureiro, a Portuguese who had worked at Barbizon — as being "painted in low tones after the French method and in the style of the Impressionists." The technique of such paintings (plate 143), broad in comparison with that of artists who had been longer in the colony, was criticized "as resembling the productions of the Continental 'Impressionists' as they call themselves" and "accurate as hasty memoranda" but not sufficiently developed to be considered as pictures.[11] The criticism was of the same kind as that directed at the Paris Impressionists, and it makes it clear that an impression is as much in the eyes of the beholder as in the execution of the painting. Accusations as to the sinister influence of French art — in a colony that clung to its Britishness — were to become more prevalent but were also to attach themselves to a characteristic more commonly associated with Impressionism: high-keyed color embodying brilliantly clear light. Inspired by a growing concern with defining Australian national identity there was a demand for the expression of bright light even before artists began to paint it. In a letter to the *Argus* in 1883, an "Amateur" complained that "one looks in vain for the representation of Australian foliage and Australian light." When an "Artist" emphasized the necessity of learning from the past and of selling local works "for their value as artistic works and not from the motive of protecting a local industry," Amateur replied:

> I do not undervalue the opinions of those who have learnt in the great schools, but some of them saw Australian scenery with English eyes. . .and [criticized] young painters who were going direct to nature for subjects and colours. . . . Nearly all the landscapes in the National Gallery are of northern latitudes where the sun shines through a coloured atmospheric veil and Australians in trying to copy their merits have introduced [it] into a climate where it does not exist. . . . This may please an Englishman, but I was born in the sunny south. . . .[12]

Two years later an Englishman expressed doubts about the possibility of a local school of painting because in Victoria "the scenery, costumes, manners and customs which call forth the highest artistic faculties are almost nonexistent":

> To make presentable in pictorial form scenery whose colouring is dominated by the sombre and seedy gum-tree, the fullest artistic licence in colouring is scarcely adequate. [Its] atmospheric conditions. . .are fatal to picturesque effects. Distant mountains which in a more humid atmosphere would excite the mind with vague suggestions of space and mystery appear . . . like forms out of cardboard.

His condescending judgment goaded "A Landscape Painter" to defend "our pearl and opal coloured skies and the exquisite graceful forms of the gum-trees [are] calculated to call forth the highest faculties of the

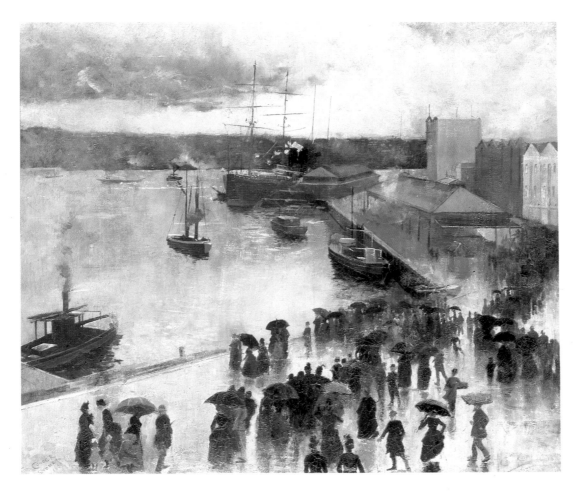

144. CHARLES CONDER. *Departure of the Orient, Circular
Quay.* 1888. Oil on canvas, 17¾ × 19¾″. Purchased 1888. Art
Gallery of New South Wales, Sydney

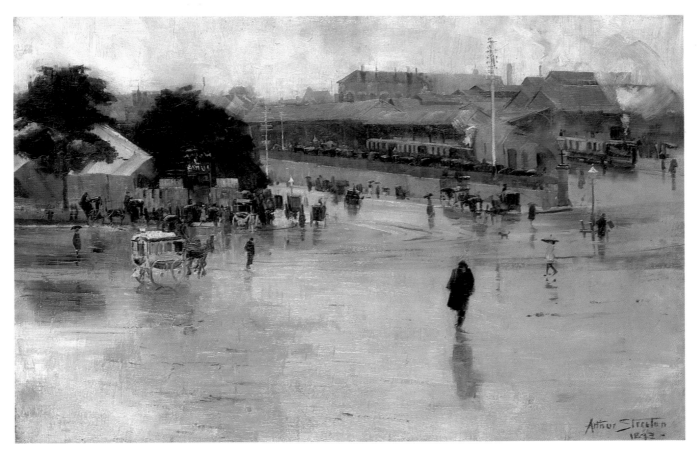

145. ARTHUR STREETON. *Redfern Station.* 1893. Oil on
canvas, 16¹⁄₁₆ × 24″. Gift of Lady Denison, 1942. Art Gallery of
New South Wales, Sydney

146. CHARLES CONDER. *How We Lost Poor Flossie*. 1889. Oil on wood, 9⅞ × 3⅝". Art Gallery of South Australia, Adelaide. Elder Bequest Fund 1899

artist."[13] This exchange took place almost immediately after Roberts had arrived back in Australia and two and a half years before Australia celebrated its first centenary—its first national event—in a climate of intense speculation as to what it was to be Australian. Central to the debate was the question of the role of Australia's unique landscape in the formation of a new society. The landscape was conceived as flooded with light, transparent; it was a landscape of fruitfulness, of health; a landscape whose great spaces encouraged freedom and initiative; a landscape lending itself to a society that would inherit the benefits but not the evils of European culture, which was seen increasingly, whatever its lures, as decadent, hypocritical, unhealthy, opaque.

The works that Roberts painted soon after his return to Australia were rather somber studies of prosaic scenes near Melbourne, painted in grays, ochers, and dull greens, and it was probably not until the summer of 1885–1886 that he painted his first unequivocal Impressionist work, *Bourke Street*. He depicted one of the main commercial thoroughfares of Melbourne as an untidy straggle of buildings—some the single-story buildings of early settlement, others beginning to acquire city scale—in marked contrast to the broad street so confidently laid out by Melbourne's founders. Roberts shows the characteristic way the street rises to a horizon, which seems to open onto emptiness, into the vast spaces beyond the city.

Roberts had brought back from England a street scene he had painted that was clearly inspired by Whistler, as well as tiny studies of the Thames employing delicate scales of pink and mauve-tinted grays suggestive of Whistler's *Nocturnes*—except for Roberts's use of strong robust tonal contrasts to break the delicate chromatic web. Roberts employed these scales of color in a more complex way in *Bourke Street*, but the painting indicates a crucial difference: Whistler insisted that no real artist would paint directly from nature, for art was a matter of asserting man's mastery over nature with the mind transforming it through the abstracting power of memory. By contrast, Roberts's varied brush strokes convey a sense of his fascinated scrutiny of the jumble of buildings, with their varied textures, heights, materials, fenestration, signs, and awnings, of the lampposts, telegraph poles, and hansom cabs, and of the bustling crowds in which can be discerned the contrasting clothing and stances of middle- and working-class people. This detailing acts as a sign of Roberts's presence at the scene, as do the abstracted but searching scales of ochers, pinks, and mauves he used to represent both the unity and variety of the streetscape. The paint invites the spectator to experience the picture in terms of the painter's responsiveness to a particular scene, captured in a "moment" that embraces many individual human moments.

Responsiveness to particular effects of light may explain one of the peculiarities of the painting. The absence of a "coloured atmospheric veil" means sunlight so brilliant that every detail is so sharp that the painting fragments into a number of visual "fixes." Thus, the dusty street and the violet shadows immediately below

AUSTRALIAN IMPRESSIONISM

147. ARTHUR STREETON. *Musgrave Street Wharf.* 1893. Oil on canvas, 15 × 10″. Private collection

the balcony on which the painter worked cannot be seen together, any more than can the brilliantly lit hill and the more opaque shadow beneath the awnings. The pictorial unity derives not so much from an artfully composed composition—as in Whistler's images of streets or wharves seen from above—but from the spectator's willingness to connect objects as one might in looking idly at a disorganized city scene. Monet's *Boulevard des Capucines* (Pushkin Museum, Moscow) of 1873 has something of this character, but in it the separate incidents of vision are bound together by tiny palpitating strokes of color that evoke an atmospheric haze absent from the Melbourne summer. Roberts probably could not have seen Monet's painting—though I like to speculate that the tricolor flag on the lower right might have been an acknowledgment of radical French painting. The two paintings do have one significant thing in common: they are both paintings of the new. Monet's painting was of a streetscape a little over ten years old, created by Haussmann's radical transformation of Paris. Bourke Street was somewhat older, one of the major streets laid out fifty years earlier when Melbourne was founded, though many buildings were virtual shanties until the town was made wealthy by the gold rushes of the 1860s and the subsequent "Long Boom" that lasted until the late 1880s. New though Monet's motif was, its cliffs of buildings suggest the possibility of permanence, while Roberts's implies an improvisatory, constantly changing environment. *Bourke Street* is indeed an exemplar of Baudelaire's dictum that "modernity is the random, the fugitive, the accidental."[14]

Before the 1880s there was little significant painting of urban themes in Australia, despite the fact that—contrary to myth—it was a highly urbanized society. Roberts's *Bourke Street*, Conder's *Departure of the Orient, Circular Quay* of 1888 (plate 144), and Streeton's *Redfern Station* of 1893 (plate 145)—with their unstable space and precarious, shifting relationship between individual and crowd, individual and city—suggest a determined attempt to express a modernizing process different from but related to those occurring in the European capitals. The uncertain relationship of the artist/spectator to the spaces of these paintings perhaps expresses the contradictions of the Australian Impressionists' introduction of a modernizing style without a dense tradition to work against, in paintings of cities so recently carved out of the untended bush, whose founders were determined to emulate the cultural forms of a civilization half the globe away. There was in Melbourne, a few minutes' walk from Bourke Street, a grandiose public library and art gallery (inspired by the British Museum) in a dirt street lined with cottages and shanties.

While avoiding mechanistic explanations, one might ask whether there were certain conditions that created a need for Impressionism. For one hundred years European-derived art in Australia had been almost exclusively focused on landscape painting—topographic, picturesque, sublime, romantic, plein-airist—and except for the topographic, such paintings had presented the

148. TOM ROBERTS. *The Sunny South.* c.1887. Oil on canvas, 12⅛ × 24³⁄₁₆″.
National Gallery of Victoria, Melbourne. Felton Bequest 1940

149. CHARLES CONDER. *Holiday at Mentone.* 1888. Oil on canvas, 18¼ × 24″.
Art Gallery of South Australia, Adelaide. South Australian Government Grant
with the assistance of Bond Corporation Holdings Limited through the Art
Gallery of South Australia Foundation to mark the Gallery's Centenary 1981

country as a realm essentially distinct from the city, often as something strange, alien, vast, and even menacing. Early plein-airism focused on more homely, familiar scenes, but although such scenes were generally of places near the cities they were still presented as if in a timeless realm, unquickened and unaffected by modernization. Impressionism allowed a new relationship between city and bush. Like the French movement in the 1870s, it depicted a modern urban relationship to the landscape in which the excitements of city life find their corollary in a modernizing, recreational countryside in which middle-class figures are depicted enjoying simple pleasures in a secure, protective, intensely pleasurable environment.

The fact that there could be a relationship—that is not merely one of imitation—between the Impressionisms that evolved in countries with strong artistic traditions (manifested in figure painting, complex and enriching rival styles, and powerful institutional structures) and the Impressionism developed in Melbourne, a colonial outpost half a century old, emphasizes the significance of Impressionism's tendency to deny the past in the moment depicted in paint. As an international movement, Impressionism tended to develop in countries in the process of national self-definition, in modernizing democratic or democratizing societies whose relationship to the past—which had to be superseded in the modernizing process—was ambivalent. In Australian Impressionism this denial of the past was particularly uneasy. Boom Melbourne, its economy swollen with gold, wool, wheat, and, more recently, property speculation, was developing a confident bourgeoisie, conscious of its need to distinguish itself from an increasingly organized working class, and in such a context Impressionism could be seen as an artificial import destined to serve the need of the new bourgeoisie for cultural signs that would confirm its status. The rhetoric of nationhood that was growing in Australia in the years around the centenary promoted the idea of a nation created by heroic pioneers but retained a profound unease about its history. What was being celebrated in 1888 was in fact the centenary of *convict* settlement at Sydney; the hundred years were, of course, marked by individual toil but not by any grand collective sentiment, and the colonies were enriched not only by that toil but by the gold rushes and all that implied of the individual greed and faith in luck that fueled the financial speculations and shaped the moral attitudes of the 1880s.

The Australian Impressionists constructed an image of a country bearing the traces of its creation—in terms of cleared land, cut trees, streetscapes that gave witness to different stages of development, construction, destruction, and reconstruction—but simultaneously their acceptance of the moment denied that past. One can thus discriminate between the centenary's rhetoric of progress, growth, and the heroism of discovery and pioneering and what contemporaries perceived as Impressionism's amorality (or worse). The Impressionists' insistence that "two half hours are never alike, and [that] he who tries to paint a sunset on two successive evenings,

150. Tom Roberts. *Mosman's Bay.* 1894. Oil on canvas, 25 × 76". Gift of Howard Hinton, 1933. The Howard Hinton Collection. New England Regional Art Museum, Armidale, New South Wales

must be more or less painting from memory" implied an existence made up of separate moments, which—however pleasurable—had no meaning beyond that moment (crossing a street, standing in the hot shade by the beach, glancing at light on water, lifting chops from the fire, pausing in a game of football . . .). Furthermore in response to criticism of the *9 X 5 Exhibition*, Roberts, Streeton, and Conder claimed that they would "do our best to put only the truth down and only so much as we feel sure of seeing [but] the question comes, how much do we see and how much are our ideas and judgements of work made up by comparison with those we have already known. . . ."[15]

In this context, one may see that *Bourke Street* is not a historical painting: it can have no past, for it captures a moment that in its intensity excises all previous time, just as the demolition and rebuilding of the city will destroy the past. The threat of losing reassuring historical continuities may explain the excess of an editorial in which it was insisted that the Impressionists' influence would be "misleading and pernicious" if they claimed their works were more than "mere sketches and memoranda in colour."[16] Acceptance of that claim would indeed negate the generalized moral significance that Victorians found essential in art, in favor of the enjoyment of the moment of individual self-realization.

Equally significant was the fact that Melbourne and Sydney Impressionists, like those of Paris and London, drew on alternatives to the high arts. A number of them earned their livings as photographers and supplemented meager incomes from painting by doing graphic illustrations (most importantly for the huge *Picturesque Atlas of Australia*, a compendium of illustrations of Australian history and urban and rural life published between 1883 and 1889). They drew on the conventions of graphic illustration and photography, emulating these processes' modern speed of execution, and they were also

influenced by populist illustrations of everyday life in the mass media, thus denying the contemplative and elevated moral values of more formal painting.[17] It was modern to show the city as dynamic and exciting rather than as the locus for the corrupt and corrupting; modern to take up the imagery of the flaneur, the carefree, morally detached connoisseur of the urban spectacle, who might enjoy, for example, the moment when Flossie was tempted and fell (plate 146); modern to enjoy crowded streets, trains, trams, omnibuses, and steam ferries. The Australian Impressionists depicted the city center, recreational sites around it, and the bush, rather than suburban or industrial sprawl, although some of their city paintings show skies stained by smoke. Roberts, for example, depicted Sydney Harbour with a dusky atmosphere, which reminded a critic "that this is a city consuming fossil coal and not charcoal").[18] Such depictions suggest, however, straightforward pleasure in the atmospheric spectacles created by the modern city. Indeed, in Sydney—as Streeton's *Musgrave Street Wharf* (plate 147), representing a commuter ferry, suggests—the sites of pleasurable recreation and of work are seen to interpenetrate.

When the Australian Impressionists painted the recreational countryside in the Yarra valley and on Melbourne's bay and Sydney's harbor, they painted together, camping in a cottage at Mentone or in a deserted house at Eaglemont and even in tents at Little Sirius Cove on Sydney Harbour when the economic depression precluded living in the city for a time. In these places they could share the pleasures they depicted since they were close enough to the city to be visited by friends, fellow painters, families, and girls "in their lovely pure muslins" for days of picnics, sketching, and impromptu dances.[19] Roberts, Streeton, and McCubbin painted the pleasures of boating, "skinny dipping" (despite the fact that this was illegal between 8 A.M. and 7 P.M.), sauntering along a beach or through paddocks, promenading along the waterfront, watching the yachts, or being rowed under an elegant parasol.

Conder's *Holiday at Mentone* (plate 149) is a witty comment on the transformation of nature into artifice through fashion, decorum, and painting. The freedom of the waves, the untidy lines of seaweed, and the straggling line of strollers are disciplined by the rigid grid of the jetty and its shadow, echoed by the nearest gentleman and the one tidy enough to align himself with the horizontal of the grid.[20] In subject and even character the work recalls Monet's paintings of modern beach life, while the pier and the lettering on the bathing establishment recall the walkways and lettering in Monet's *La Grenouillère* (1869: The Metropolitan Museum of Art, New York), a picture that Conder could not have seen. Painting in blinding sunlight extinguishes all but the brightest colors, suppresses halftones, and requires structuring devices such as the linear grid. Conder, like Monet, could have been influenced by the bright, flat areas of color and the linear skeleton of Japanese prints, which could be found in Melbourne studios, as in those of

151. TOM HUMPHREY. *The Way to School.* c.1888. Oil on canvas, 40⅛ × 24⅛″. Collection of the Warrnambool Art Gallery. Acquired 1888

Paris and London.[21] Even Conder's theme—figures promenading and enjoying the natural spectacle—was one of the central themes of Ukiyo-e art. The representation of middle-class recreation in the countryside is combined with a new delight in bright sunlight and presupposes a kind of painting whose pleasures the painter shared with his subject. Such subjects are depicted matter-of-factly, as if they were quite natural rather than new to art. There is no irony here, no mockery of middle-class pretensions or of petit-bourgeois contamination of the countryside with urban values, with litter, crowds, and vulgar intrusion into nature.[22] Instead, the painting seems to assume equal access to a nature whose modernization is taken for granted.

In painting, the nature immediately around Melbourne was the sphere of women and children, of lovers, artists, and an occasional gentleman; beyond was the realm of "strong masculine labour."[23] As elsewhere, children played a particular role in Impressionist landscape iconography in Australia. The colonial

152. CHARLES CONDER. *Springtime*. 1888. Oil on canvas,
17⅜ × 23¼". National Gallery of Victoria, Melbourne. Felton
Bequest 1941

nightmare of the child lost in the bush (depicted as late as 1886 by McCubbin) was perhaps a metaphor for European fears of an untamed, alien nature, but no longer had a hold on painters of the sun, who rendered nature transparent and familiar.[24] Thus Tom Humphrey's (1858–1922) little girls making their way through the bush in the *Way to School* (plate 151) are shown enjoying themselves in the golden grass of cleared land, while the gap in the trees indicates the continuity of the path and suggests that the children are at risk only of being late. From the painting one might infer that book education is transforming the meanings of the bush. Ladies and children domesticate the landscape and act as intermediaries between the artist and an increasingly intimate nature, but the landscape is never so clearly transformed into an ideal, protective garden as in Monet's paintings, and the landscape still conveys a sense of recent clearing. Even in Conder's pretty *Springtime* (plate 152), painted in the area first settled by Europeans ninety years before, the paddocks with their recently established, alien vegetation are patchy

and unformed. The little children in Humphreys's painting may be the counterparts of those walking in the suburban countryside of Monet's *Poppies, Argenteuil* (1874; Musée d'Orsay), but in Australia they play amidst thin, scratchy grasses instead of a field of flowers. Similarly the elegant lady in the *Summer Morning Tiff* seems out of place in the half-cleared paddock, and the dense eucalypt forest behind her has none of the familiarity and softness of the trees in Monet's painting. Even Streeton's lyrical landscapes, which are softer and more sensuous—perhaps because he was native-born and knew no other landscape—still retain a sense of scrawny incompleteness.

A number of Australian Impressionist paintings had a narrative structure deriving from Victorian anecdotal genre, and this temporal device could also help to make the landscape familiar. Roberts's *Summer Morning Tiff* is straightforwardly narrative in that it invites speculation on the before and after of the story (he did indeed follow it with a work entitled *Reconciliation*), and even his rapid sketch of a fleeting effect, the *Impression* (plate

153. CHARLES CONDER. *Yarding Sheep*. 1890. Oil on canvas,
14 × 22¹⁄₁₆″. National Gallery of Victoria, Melbourne.
Bequeathed by Mrs. Mary Helen Keep, 1944

138), suggests a sentimental incident. Other paintings—
Conder's *Yarding Sheep* (plate 153), for example—are
closer to the notion of an unmediated moment snatched
from time, having no connection with past and future,
and hence unstable and even disturbing—but many have
what one could call narrative vision. In Roberts's *Mentone*, the viewer is invited to pause on intersecting moments of perception: the descriptive detail of the pebbles
in the foreground leads to the girl and invites the viewer
to follow her gaze across to the boat; like her, the viewer
may focus on the heavy wall of the nearest cliff, move to
the white glimmer of those beyond, or pause on the glassy
smooth or wind-ruffled water and its reflections of sky,
cliffs, and yacht. Roberts's *Mosman's Bay* (plate 150) and
*Bourke Street*, Streeton's *Golden Summer* and *Fire's On*,
(plate 159), and Conder's *Departure of the Orient* are also
experienced in terms of a succession of moments, which
means that they can never be complete. Of course, eye
movement is necessary to experience any pictorial space,
but in French Impressionism the fusion of tiny strokes of
color draw these phases of perception into an ever-
deepening consciousness of the artist's processes, while
in Australian Impressionism they stand separate in the
transparent light and have no more to reveal beyond their
presence in the moment—the moment they depict, as
well as the moment the spectator experiences them.

Alongside these paintings of brilliantly colored
light were more poetic twilight paintings in which the
artists looked not to the sunset but to its afterglow in the
east. Streeton's *Twilight Pastoral* (plate 154), painted at
Eaglemont, shows a pair of lovers watching the valley and
distant hills as the colors become more intense in the
light of the setting sun. It is a fragile moment of departing light, but with none of the melancholy of the European fin de siècle, for the clear skies promise yet another
golden day in an eternity of golden days like those of
Streeton's *Golden Summer*.

The *Impression for "Golden Summer"* (plate

154. ARTHUR STREETON. *Above Us the Great Grave Sky
(Twilight Pastorale)*. c.1889. Oil on canvas, 28³⁄₄ × 14¹⁄₂″.
Australian National Gallery, Canberra

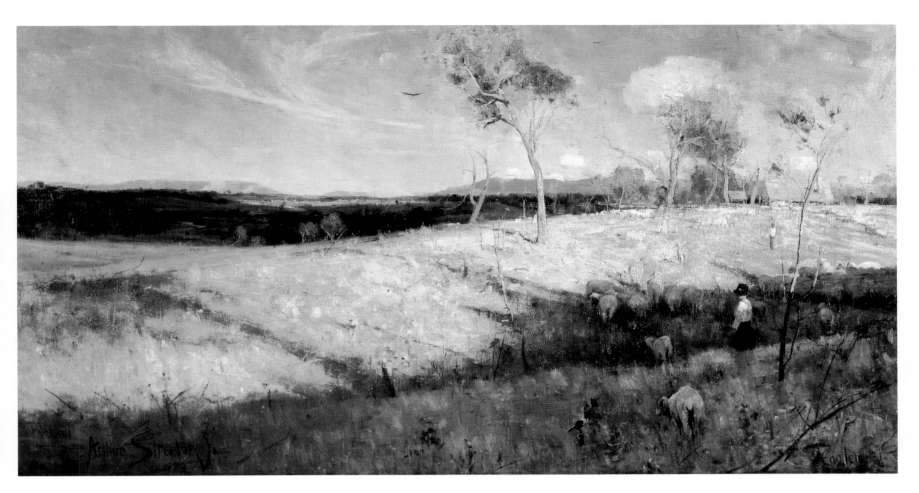

155. ARTHUR STREETON. *Golden Summer, Eaglemont.* 1889.
Oil on canvas, 32 × 60″. Collection W. J. Hughes, Perth

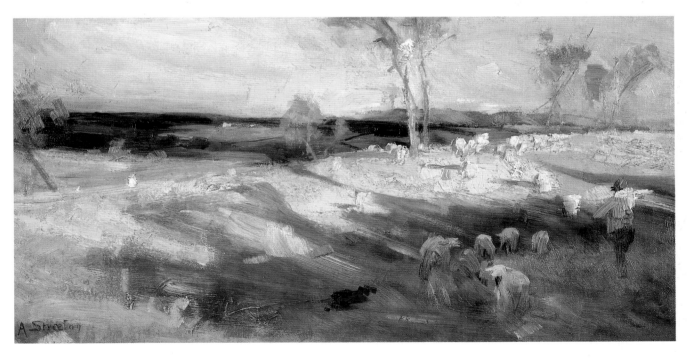

156. ARTHUR STREETON. *Impression for "Golden Summer."*
c.1888. Oil on canvas on board, 11⅝ × 23⅛″. Benalla Art
Gallery, Ledger Collection

156)—exhibited in the *9 × 5 Exhibition* (although larger than most)—is a brilliant study of late afternoon light captured in thick, smeared strokes of gold, red gold, and violet. *Golden Summer* is a larger and slightly more formal painting, probably also painted on the spot.[25] Streeton wrote about his experience:

> Oh, the long hot day . . . I sit on our hill of gold . . . the wind seems sunburnt and fiery . . . north-east the very long divide is beautiful, warm blue . . . all dreaming and remote. . . . Yes, here I sit in the upper circle surrounded by copper and gold, and smile joy under my fly net as all the light, glory and quivering brightness passes slowly and freely before my eyes.[26]

The painting depicts the coppery shadows of late afternoon creeping over the luminosity of the butter yellow grasses in the distant valley. Scattered houses, willows, and the slow bend of the Yarra are already tinted with mauvish shadows before a final line of gold draws the eye to the luminous blue hills. The slender eucalypts are caught by the sinking sun in a red gold blaze and stand out against the dusky valley and the still bright sky with its wispy clouds. This was an intensely personal response to a particular scene, but also one infused by a wider optimism, the confidence in Australia as a new arcadia. It was painted at Eaglemont (an hour by train and a long walk from Melbourne, while Argenteuil is a quarter-of-an-hour's train ride from Paris) on land cleared within the recent past—visibly so to those who knew—and the fairly substantial farmhouse indicates that those who owned it had done well. Neither house nor fences appear in the *Impression*, which suggests the complete freedom of the pastoral idyll, whereas in the larger work Streeton made it clear that the land was actively farmed. He included in the sketch a shepherd dressed in prosaic contemporary work clothes, but the scene is nevertheless invested with all the associations of the pastoral idyll, including the shepherd with his sheep grazing in a bountiful countryside, so secure they need no fences. Sheep, of course, produced one of the country's primary sources of wealth, but the painting scarcely refers to the industry, and one feels that all the shepherd lacks is a pipe and perhaps a nymph to make the reference to the happy land of simple, pleasurable labor, a land in which the only change was that of the passage of light from dawn to dusk.[27]

A contemporary critic observed that Streeton saw nature in "vivid light, a lucid and dry atmosphere, and colour in masses."[28] His comment provides a succinct characterization of the first phase of Australian Impressionism. Paintings were constructed by color, either in closely related harmonies or by brilliant contrasts; they were broadly painted with a loaded brush, though often with linear detail, which tends to lie on the surface of the painting rather than articulate depth. In a literal sense, they were more impressionistic than the French, being more immediate and less densely worked. Like all the

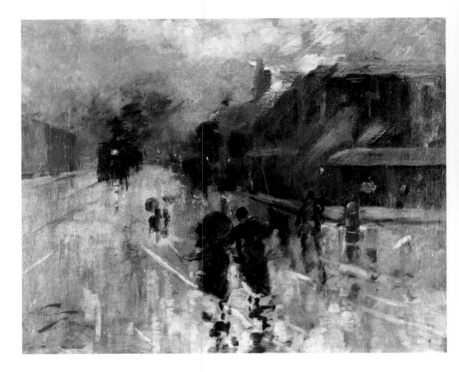

157. Girolamo Pieri Nerli. *Wet Evening*. 1888. Oil on canvas, 12¾ × 15⅞". Gift of Howard Hinton, 1935. The Howard Hinton Collection. New England Regional Art Museum, Armidale, New South Wales

Impressionists, the Australians represented the forms of the objective world as patches of color, not bounded by contours, that suggested less the specific form than the color sensation it evoked. The Australian Impressionists did not employ the framing devices of traditional plein-airism, such as the coulisse of trees or the fairly densely shadowed foreground, partly because the eucalypt provides no deep shade or soft massing of foliage. Instead smeared color empties out of the bases of their paintings, simultaneously insisting on its reality as paint and on its continuity with the spectator's space. Many of these characteristics evolved in response to the transparency and brightness of Australian summer light, which sometimes makes color so blinding that neither French Impressionism's broken strokes nor Whistler's elegant nuances nor plein-airist modulated tones could render it. A recurrent feature was the slender trunk of a eucalypt used to give tenuous stability to fluid and luminous planes of color. The foreground plane was often articulated with thin grasses, perhaps deriving from Bastien-Lepage's naturalism, but again responsive to specific conditions, such as the spiky linearity of native grasses. Many of these characteristics were seen as specifically French, as one critic claimed of Roberts, McCubbin, and Streeton:

> [They are] falling more and more under the influence of the French Impressionists, leaving so much unexpressed . . . and avoiding lucidity of statement and definition of detail . . . they have, however, an independent way of looking at nature which is to be commended as a sign of individuality. . . . But as nature never leaves anything unfinished; gives us more than amorphous objects

and blotches of colour and never confuses us by leaving us in doubt as to whether what we are looking at is a blade of grass or a twig of a tree . . . so we look for a reasonable approach to her accuracy of statement and scrupulous definition of form, colour and substance in that which purports to be a transcript of her handiwork.[29] Impressionism was found wanting:

> Colour and light are . . . the mere flesh covering of the painter's art . . . There is no distinct treatment of different objects . . . colour applied in this way is mere surface rendering.[30]

Strongly influenced by Ruskinian moral criteria, many Australian critics believed that, in its neglect of finish and of visibly hard work, French painting lacked moral seriousness in technique and in subject matter. French "illegibility" was contrasted with English "lucidity of language, eloquence of expression," and it was felt that the English school's "loving interpretation of nature will outlive all the eccentricities of the faddists and colour blind."[31] Although English and French schools were played against one another—the implicit assumption being that a new Australian style must always derive from somewhere else—some critics were beginning to assert that this style was acquiring its own character in response to local imperatives. One wrote that although the new mode of interpreting nature "owes its first impulse to French example . . . the evidence is that a distinct Australian school is in process of formation [with] an entire departure from English methods, traditions and precedents."[32]

Conder's *Departure of the Orient* and *How We Lost Poor Flossie*, Streeton's *Redfern Station*, and Nerli's *Wet Evening* (plate 157) show that it might frequently rain in the city, but in the country the golden light was never clouded. For the Impressionists, light was as much symbolic as it was realistic. It stood for all that was implicit in the notion of the sunny south, and because their pictures were painted in nature they could claim that they represented authentic experience. This light was, then, real. It was Australia. In one sense, their painting accorded with official rhetoric, expressed, for example, in the centenary ode to "Australia, Fair Land of the Sunny South," but they were saved from platitude by their determination to paint "only so much as we feel sure of seeing," and to avoid the "already known," seeking, indeed, to see nature as if it had never been represented before.

Remembering his last summer at Eaglemont, Conder wrote to Roberts from Paris in 1890: "I fancy all of us lost the 'Ego' somewhat of our nature in looking at what was Nature's best art and Ideality," while Streeton wrote in the same year, also recalling Eaglemont:

> Fancy if you could grasp all you feel and condense your thoughts into a scheme which would embrace sweet sound, great colour and all the slow soft movement.[33]

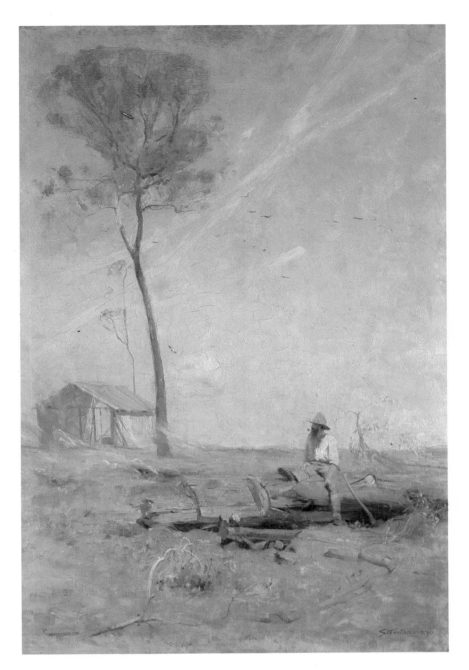

158. ARTHUR STREETON. *The Selector's Hut: Whelan on the Log.* 1890. Oil on canvas, 30¼ × 20⅛". Australian National Gallery, Canberra

"Its suggestion," he added, "is a large harmony, musical, rose." He was clearly influenced by Aestheticist language, but his practice was not confined by the abstractions of art for art's sake, and his excited litany of sense impressions as well as the very handling of his paints indicate that his experience lay in the discovery of the "otherness" of nature, not in the closed world of art. Conder's notion of the loss of "the Ego" implies consciousness of this otherness, attained through the self-forgetting observation of nature, made concentrated through the act of painting. There is, I believe, a significant relationship between the bodily experience of nature—that suggested, for example, in the representation of the boys in the hot light under the ti-trees beside the dazzling sea in the *Sunny South*—and the experience of painting. Something of the tension between homely

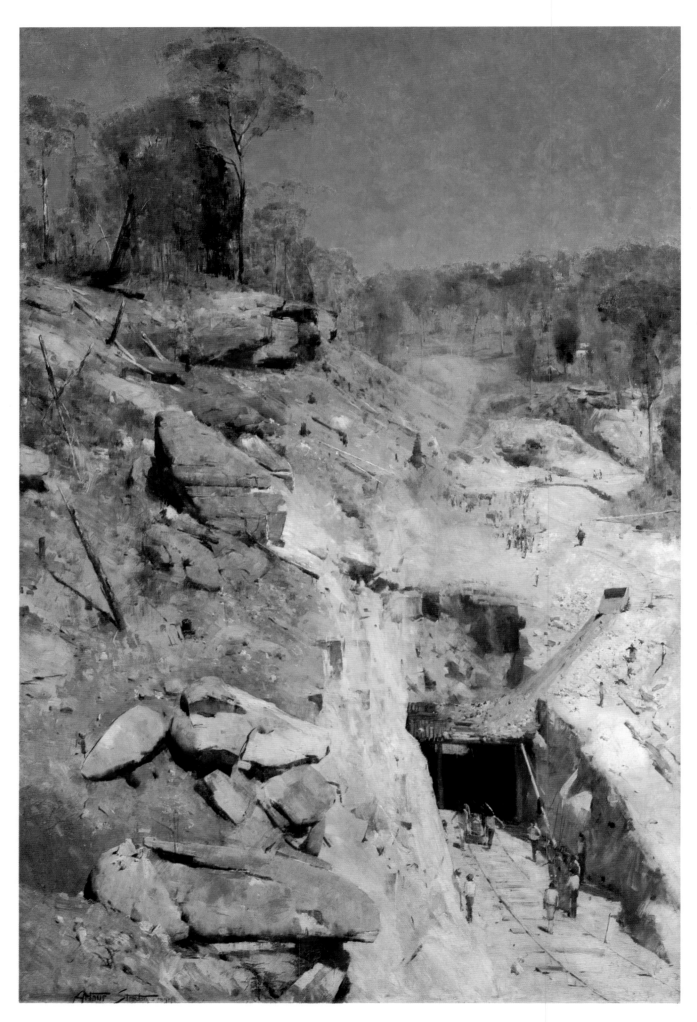

159. ARTHUR STREETON. *Fire's On (Lapstone Tunnel)*. 1891.
Oil on canvas, 72⅜ × 48¼″. Purchased 1893. Art Gallery of
New South Wales, Sydney

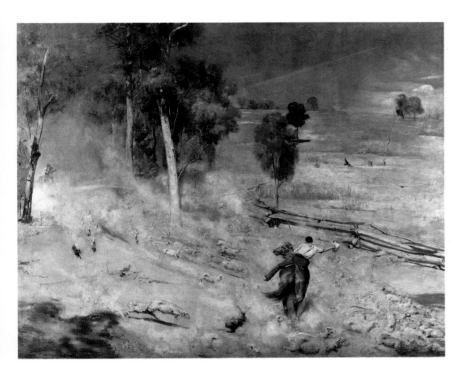

160. Tom Roberts. *The Breakaway.* 1891. Oil on canvas, 54 × 66⅛″. Art Gallery of South Australia, Adelaide. Elder Bequest Fund, 1899

experience and physical transcendence is suggested in another of Streeton's letters in which he writes of returning to breakfast in his "bright striped pyjamas" after having gone swimming in the early morning: "the sun . . . is very intimate with me as I step through all the wondrous wild flowers. Birds chirp and whistle as I bare my white limbs to the first pure morning sunlight."[34]

Although some critics praised the Impressionists' use of brilliant saturated color (one wrote that Streeton "paints summer effects as if he loved them"), the emphasis on brilliant light did not go unchallenged, and there was criticism of the "hard, lustreless and opaque yellows" of the landscape and "the impression of the glare and heat and dust . . . by the profuse use of yellow" in paintings by Streeton, Conder, and Humphrey.[35] These critiques were, however, written in 1890 and may have been influenced by recent devastating droughts, which, with a severe depression and widespread and bitter strikes, made it difficult to sustain the dream of a modern arcadia. Conder returned to Europe, while Streeton and Roberts began to paint pictures in which they sought to embody notions of history at variance with the Impressionist moment. Thus Streeton's *Still glides the stream, and shall for ever glide* (1890; Art Gallery of New South Wales, Sydney), another painting of the Yarra valley at twilight, could easily be seen as a grand expression of a particular effect of light were it not for the title, taken from the "Afterthought" of Wordsworth's sonnet of 1820 and introducing a very unmodern sense of the permanence of Nature: which "was, and is, and will abide." The poem suggests that the artist might transcend the moment in which his transient consciousness penetrates the enduring being of Nature through the creation of something that has the capacity to "live, and act, and serve the future hour."[36]

Other paintings express the processes of exploiting the land. In the same year he created *Still glides the stream,* Streeton painted *The Selector's Hut* (plate 158), showing a poor farmer in country far beyond Melbourne in the backbreaking process of clearing the land and of scratching a living from thin soil. A year later, in *Fire's On* (plate 159), a big picture probably largely painted on the spot, Streeton represented the heroic process of cutting a tunnel on the railway over the Blue Mountains near Sydney. Streeton gave his landscape a narrative structure that only gradually reveals the body of a man killed in the blast being carried out of the tunnel. Although Streeton depicted a human tragedy in the conquest of mastering nature, he constructed the painting to embody the randomness of experience, and the cloud of dust rising from the explosion isolates this as an unrepeatable moment. Roberts did something similar in *The Breakaway* (plate 160), a painting that cannot be called Impressionist, although the landscape was probably largely painted on the spot. It shows what Roberts had derived from his Impressionism—the ability to represent a number of intersecting events as if captured in the moment: the moment the sheep break for water and the stock rider attempts to head them off and the moment the huge cloud of dust takes specific form as if snatched out of the dynamic movement of light. Withers did paintings of gold mining in which the harsh sunlight exposes the scarred landscape and the stark staccato verticals of trees, machines, and man express the alienation of the scene from the pastoral countryside. There were pictures of what Roberts called "strong masculine labour," and they confirm the polarity between the male and female spheres: the outback is the sphere of the heroic male worker (plate 160); the area around the city that of woman, either workers on small farms (plate 163) or bourgeois ladies and girls secure in their gardens or in the domesticated bush (plates 161 and 162). Roberts and Streeton never represented the hard labor of pioneer women and always depicted women at leisure, and it was women artists such as Sutherland and Southern and artists close to traditional plein-airism such as McCubbin who depicted women at work in the countryside near the city. These spheres of work or of work and leisure were created in a society that saw its mission as one of conquering nature and thus rendering it fertile—and nature was, of course, female—"the one mistress, nature only," as one of Roberts's friends wrote.[37]

The first phase of Australian Impressionism lasted a few short years and was succeeded in the twentieth century by more naturalistic landscapes that drew on their discoveries but that deployed their golden grass, bright blue skies, transparent light, eucalypts, and long gold grasses with such insistence that they assumed the quality of symbols that lack the searching, fresh observation that characterized the earlier works. In the past few decades, early Impressionism has, however, come to be

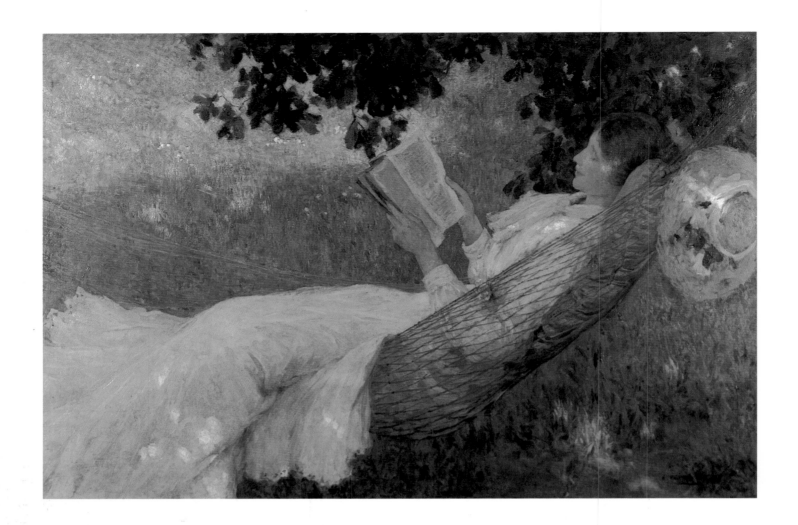

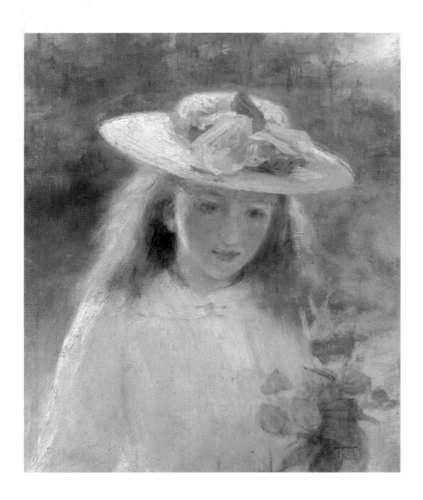

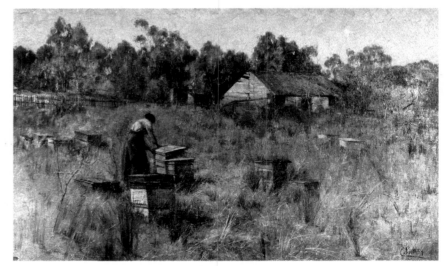

(top) 161. EMANUEL PHILLIPS FOX. *The Love Story*. 1903.
Oil on canvas, 40⅛ × 60⅛″. Martha Pinkerton Bequest, 1944.
City of Ballarat Fine Art Gallery

(left) 162. TUDOR ST. GEORGE TUCKER. *Young Girl in a
Garden with Gum Leaves*. c.1896. Oil on canvas,
20½ × 17½″. The Robert Holmes à Court Collection, Perth

(above) 163. CLARA SOUTHERN. *An Old Bee Farm*. c.1900.
Oil on canvas, 26 × 44″. National Gallery of Victoria,
Melbourne. Felton Bequest, 1942

thought the essential form of Australian art, and its creators have been celebrated as the first artists able to paint Australian light and the Australian icon, the gum tree. Early Impressionism was the first movement to express an intimate relationship between the landscape and its new inhabitants through casual, everyday subject matter, intensely familiar local landscapes, and a technique that frankly declares itself, revealing the means by which it creates the illusion and inviting the spectator to participate in the process. Initial reactions to Impressionism—in all countries—centered on its incomprehensibility, for audiences accustomed to "finished" paintings simply could not see an image emerging from smears and dabs of paint. The educated elites who bought Impressionist work—professionals, politicians, businessmen—may have enjoyed discovering the relationship between image and paint, and it was not long before Impressionism began to acquire popularity. Known to be painted before the motif, it appeared direct, spontaneous, unmediated, and ultimately became everyone's idea of what art should be. Australian Impressionist paintings have thus become immensely popular as images of a desired Australia, images whose visible technique guarantees them as representations of the real. This would be a golden land of eternal summer in which ordinary people could all participate in simple pleasures: an arcadia, heir to European culture, without poverty or civil strife; a land cleared by human exertion, but blessedly free of any scars which the exploitation of the earth might make. It would be a world where such labor as there was was found in the heroism of the outback pastoral imagery or the pleasurable labor of the small farms around Sydney or Melbourne, where the figures might be unpretentious, but were not peasants. This was the Sunny South in which the only inflection of the gold of the day was its modulation into heart-catching twilight skies, when color deepens and intensifies. Only in one painting—done far away in the exotic north, Tom Roberts's *Corroboree* (plate 164)—did any Impressionist depict the Aborigines, the spiritual owners of the so-recently cleared land, *in* the landscape.[38] There could be no shadows in sunny Australia.

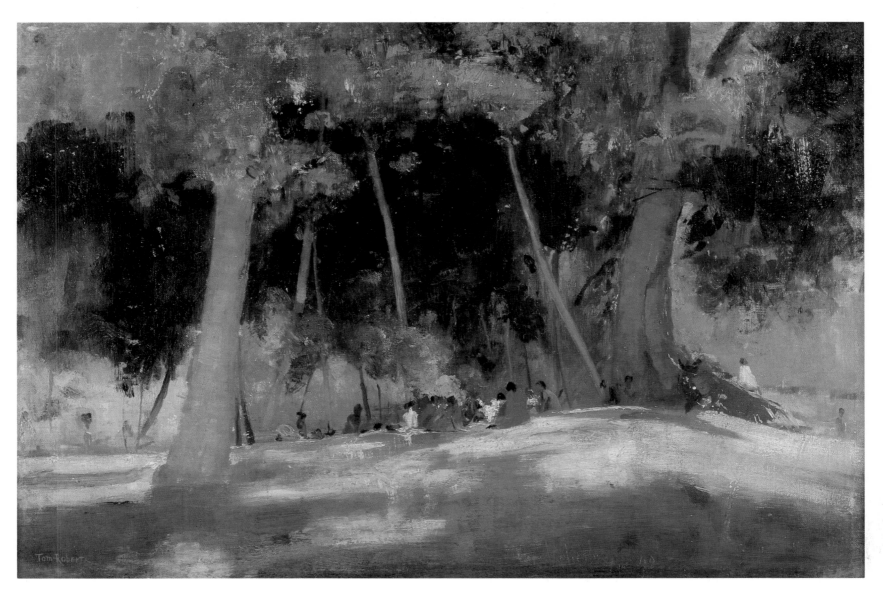

164. TOM ROBERTS. *Corroboree, Murray Island.* 1892. Oil on canvas, 14½ × 21½″. Elders IXL Collection

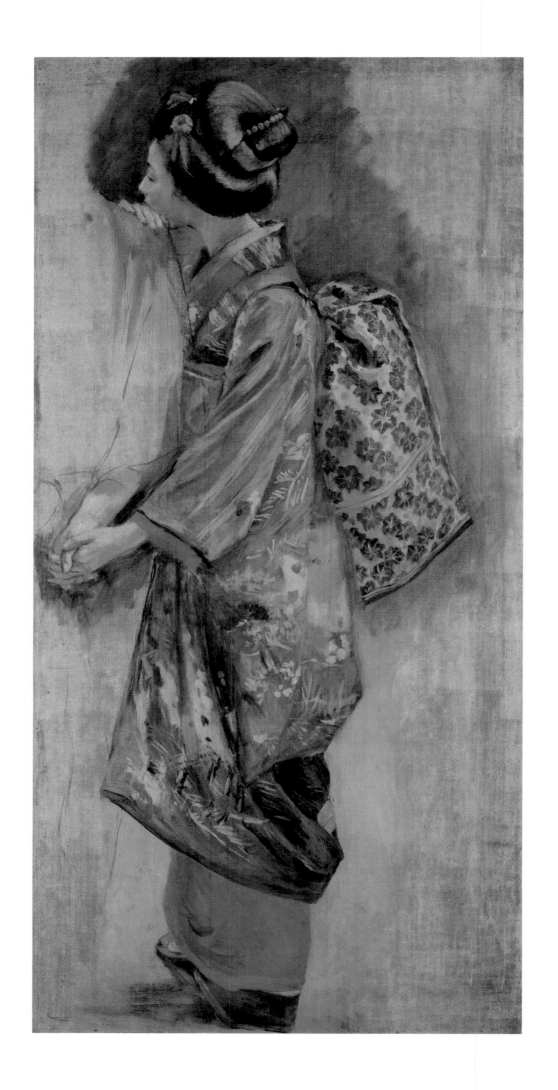

LOOKING AT THE striking reproductions that provide the visual pleasures of this chapter will be a new experience for most Western art lovers. There is a shock—to some degree a shock of recognition—involved in the discovery of these elegant images, and the questions as to where they are from and what role they play in Asian art come immediately to the fore. (A second look reveals that virtually all of them are Japanese; there is, strictly speaking, no Chinese Impressionism, although later international styles were adopted in that country by the late 1920s and after.) The paintings themselves certainly reveal the high level of artistic skill commanded by their creators. Yet what these pictures cannot suggest by themselves is the cultural freight they carry. When these works of art were painted, they were looked on in their own societies as avant-garde and iconoclastic works that pioneered new areas of visual expression. They provided a potent new source of inspiration for artists trained for a millennium in traditional Asian styles that bore little resemblance, either in aesthetics or in technique, to this new and liberating style of painting.

Japan opened herself to outside influences at the beginning of the Meiji period in 1868, after more than two hundred years of isolation and cultural solitude. The reasons for this isolation were largely political. In 1600 the formidable general Tokugawa Ieyasu, who was to become the first Tokugawa shogun, unified the country after many decades of civil war. He soon, quite justifiably, became alarmed at the dangerous incursions of the Spanish and Portuguese merchants and missionaries. He outlawed Christianity and all contact with Europeans, except for a trickle of commerce he permitted to continue in Nagasaki with the Protestant Dutch. By about 1800, however, Westerners (this time the Russians and the Americans), usually on their way to China, had begun to appear near the shores of the island kingdom again. By the middle of the nineteenth century, the shogunate was forced to sign treaties with various Western countries that promoted trade, travel, and commerce. By this time, the Tokugawa social structure, with its rigid hierarchies, was losing its ability to respond to political and social circumstances. When the system was set up early in the seventeenth century, the samurai were placed at the top of the social ladder and merchants at the bottom. Yet by the nineteenth century the merchants had long since come to hold the real economic power of the nation, while the samurai were in many cases reduced to the status of bureaucrats. Now, with so many outside pressures being brought to bear on this rickety structure, the foundations could no longer hold. Fatally slow to respond to the complexities of the political and social crisis that Japan continued to face, the shogunate itself fell in 1868. It was then that the young Emperor Meiji took back the reins of power from the Tokugawa family and redirected the nation towards the outer world.

As the Japanese themselves began to travel abroad, they began quite understandably to feel themselves lacking in terms of Western developments in in-

# THE IMPRESSIONIST IMPULSE IN JAPAN AND THE FAR EAST

*J. Thomas Rimer*

165. KURODA SEIKI. Study sketch for *Telling an Ancient Romance.* 1896. Oil on canvas, 36⅜ × 18⅛". Tokyo National Institute of Cultural Properties

Japanese names in this chapter are listed in the traditional fashion; family names first, followed by personal names.

166. UTAMARO. *Woman at Her Toilet.* 1795. Woodblock, 13¾ × 9⅞". The Metropolitan Museum of Art, New York City. Rogers Fund, 1914

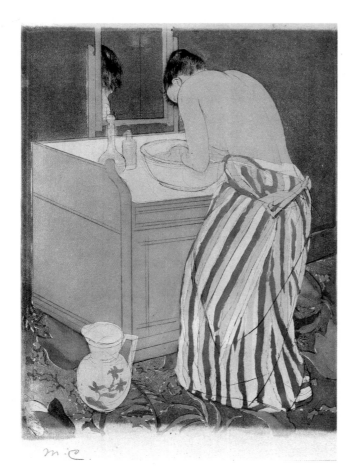

167. MARY CASSATT. *Woman Bathing.* 1890–1891. Color print, drypoint, soft-ground etching, and aquatint, 14⅛ × 10⅛". Gift of William Emerson and Charles Henry Hayden Fund, 1941. Courtesy Museum of Fine Arts, Boston

dustry, technology, and culture. Japan was by no definition an "underdeveloped" country, but her traditions were quite different from those of the Europeans who soon came to be so respected. The Japanese were quick to attempt to amalgamate aspects of Western culture that appeared either useful or attractive. Trains, bridges, and modern factories seemed necessary for progress and for political safety in what was then a dangerous world of Western imperialism and Asian colonialism. By extension, works of European literature, art, and culture, from Shakespeare and Goethe to Baudelaire and Mozart, were soon to be considered by Japanese visiting Europe as suggestive of exciting new possibilities for Japanese contemporary artistic expression. In the late decades of the nineteenth century, however, Japanese artists and intellectuals exposed to European influences felt themselves on the periphery of world culture, a culture that for them, as for most others, was centered in Europe.

Japan had, of course, a brilliant tradition in literature and the visual arts. In many ways those two modes had always been closely entwined. In the long history of the Japanese arts, poetry was regarded as the most significant form of expression, either in the form of thirty-one-syllable waka poetry or in the seventeen-syllable haiku form, which developed to its peak in the Tokugawa period. In these brief poetic forms, meaning was often conveyed through the use of images of nature that could suggest, even in a few words, a larger symbolic significance. In a similar manner, much of traditional Japanese art, which used ink and wash colors rather than oil, was developed to suggest rather than to express directly the object being rendered. In this aesthetic, the use of conventionalized yet resonant imagery was mirrored in the art of painting as well as literature. Indeed, throughout the Far East, painting was traditionally regarded as a sister art to poetry and calligraphy, existing as part of a larger whole. By the eighteenth century, some knowledge of the principles of Western painting had filtered (mainly through Dutch books) into the Japanese artistic consciousness, but the great tradition still prevailed. Art remained a superb means to suggest, rather than functioning as a medium in which to record.

In 1868, when Japan officially opened her doors to Western technology and culture, the traditional mechanisms for the support and sustenance of the visual arts were still in place. In many ways the system functioned in terms of the rigid class distinctions so important during the preceding Tokugawa period. For example, gifted wood-block printmakers in the traditional modes, such as Kiyochika (1847–1915) and Kiyokata (1878–1973), remained active, but their work was considered suitable only for a less-educated public. It was, on the whole, the highly trained and motivated sons of the samurai class who went to Europe to learn new ideas of high art and culture in order to bring them back to Japan. Indeed, some of these European-trained Japanese artists were themselves to begin a new, modern print movement in the early years of the twentieth century; but the impetus

that produced such superb works came from a modern mentality quite different from that of the old popular craft traditions. Those old systems continued on, but the educated public wanted something new. Something new, in this case, meant something authentic, yet Western at the same time.

Disruptions in society soon brought changes, some of which, such as the abolition of the traditional social classes, were undertaken directly by the state. Traditional schools of painting found patrons abandoning them, since some important families lost their money and status in the social reorganization. In this ambiguous milieu, efforts to encourage the arts taken by the new and powerful central Meiji government were to become crucial during the thirty-odd years before the turn of the century.

Yet the government's philosophy was inconsistent. In the early 1870s efforts were focused on providing instruction in Western-style drawing and sculpting as a means to develop a corps of well-trained artisans. By the 1880s a new nationalistic reaction to the increasing flood of Westernization caused the government, in setting up the Tokyo School of Fine Arts, to attempt to buttress more traditional views of Japanese painting. By 1900, however, there were enough Western-style artists and sufficient general public enthusiasm for their work to sustain the new movement; so much so, in fact, that Western painting was added to the curriculum of the by-now prestigious Tokyo institution. By 1908 the Meiji government returned to sponsoring annual art exhibitions, based on the French salon model, that showed Western-style as well as modern Japanese-style painting. Thus, traditional artists were not displaced, although they too found themselves altering their styles in consonance with the new possibilities.

Given this complex milieu, the work of the Japanese Impressionists must always be examined against a historical background of intense artistic activity in a bewildering variety of styles and genres. This period in Japanese history was as filled with false starts, contradictions, and confusions in the field of art as it was in the areas of politics, social relations, and international diplomacy. In painting, the Impressionist impulse was one among many. By the same token, all Western-style works, juxtaposed against traditional styles, were regarded in some sense as new, even avant-garde. However conservative some of these paintings may now appear to us, their cultural role at the time was considerably sharper. These paintings forced distinctions.

Many artists in the generation that came of age in the early Meiji period were willing to put aside traditional ideas of art, at least for a time, while they became avid students of the West. In this regard, Japanese attitudes show certain parallels with those of Americans and others, who, while acknowledging the authenticity of their own cultural traditions, sought high standards of excellence elsewhere. For those on the periphery, looking to Europe, and, in the case of painting, to Paris, seemed altogether natural. Young artists became fascinated by

168. OKADA SABURŌSUKE. *Iris Robe.* 1927. Oil on paper, 31½ × 20⅞". Fukutomi Tarō Collection

the possibilities of rendering their subject matter in a more specific and naturalistic way. Some learned of the possibilities through study with Western artists resident in Japan or by pouring over books of reproductions. Others lucky enough to make the long and expensive trip to Europe learned by visiting museums and galleries. Many were also fascinated by the new sense of the tangible world made possible through photography, which had become important in Japan by the 1860s.

The play of Eastern and Western visual values left virtually nothing unchanged in the Japanese tradition. Even the older painting techniques, which, incidentally, still continue in use even to this day, slowly absorbed and adopted certain Western concepts, including shading, perspective, and more naturalistic methods used to reproduce the human figure. On the other hand, some artists firmly committed to the Western style of painting occasionally experimented for their own pleasure in the traditional styles, but the basic differences in medium

169. Maruyama Ōkyo. *Bank of the Yodo River* (detail). 1765. Handscroll, ink and color on silk, 15⅞ × 617⅝″. Arc-en-Ciel Foundation, Tokyo

and philosophy made a truly close rapprochement difficult. Most artists chose to go one way or the other.

There were several special factors that complicated—and rendered more intricate—the appeal of Impressionism for the Japanese. In the first place, while young Western painters might be struck by the ideals and possibilities of the Impressionist aesthetic and seek to respond to it in their own work, aspiring Japanese artists of the same period were not merely participating in the creation of a new vision. They were also attempting to learn the rudiments of the new medium they had chosen, from sketching and the use of perspective to issues of palette and the potentials of oil paints. Even more complicated was the fact that the choice of an appropriate subject matter too was altogether new. Furthermore, in some senses at least, the play between East and West in the world of art was already occurring. The fascination shown by Manet, Monet, Van Gogh, and many others for Japanese prints, with their flat decorative surfaces, unusual perspectives, and bold coloring, had already begun to help change the look of nineteenth-century European art. The aspiring Japanese Western-style artists thus arrived on the scene at a moment when they were able to respond, even if unconsciously, with a certain emotional intimacy to the contemporary art they found being created in Paris and elsewhere. It is no wonder that a painter such as Umehara became a friend of Renoir's. There was a tacit recognition that, in a sense, both shared certain aesthetic values. The juxtaposition of three works of art illustrated below (plates 166–168) shows, like a series of reflecting mirrors, the effect of

170. Maruyama Ōkyo. *Sketches of Lake Biwa* (detail). 1770. Handscroll, ink on paper, 9 × 236¼″. Kyoto National Museum

Japanese prints on Western art, in the case of Mary Cassatt, and then the effect of such painting on Japanese painters in the Western style. Indeed, Okada Saburōsuke, who painted *Iris Robe* in 1927, took no special interest at this time in the traditional Japanese arts. His artistic mentors were European. But they, in turn, had already been influenced by the culture from which he came.

In order to explicate these issues in a way that will show the significance of the paintings illustrated here, it may be useful to examine them and the painters who created them in terms of three larger issues that helped shape the work of these gifted artists. The first involves a conscious understanding among the artists and their public alike of certain artistic polarities between East and West. The second was the need for these Western-style painters to come to terms with their careers in Japan. The third concerns problems of the artist as individual creator. By examining such questions, we can arrive at some tentative judgments concerning the nature of the Japanese contributions to world Impressionism. The nature of these polarities will also help indicate why, on the whole, the Chinese art community followed a different trajectory.

## Artistic Polarities Between East and West

Even though Japanese painters did not go abroad until the 1880s, artists in that country had not been isolated completely from developments in Western art. During the long period of seclusion, imported books, mostly from Holland, allowed artists to develop their considerable interest in Western methods of capturing space and perspective as well as in depicting more realistic subject matter. In the eighteenth century, for example, Maruyama Ōkyo (1733–1795) was able to incorporate into his art certain elements of Western realism. Ōkyo's enthusiasms, first learned through books and mastered through his own experiments, gave his work a surprisingly fresh and vigorous look to his contemporaries (plates 169–170). The work of Ōkyo and his colleagues, while considered high art by his contemporaries, had a considerable influence in other, less prestigious areas of Japanese artistic expression. These experiments may well have made possible the kind of relatively realistic depiction of landscapes found in the wood-block prints of later artists such as Hiroshige (1797–1858) and Hokusai (1760–1849), who often traveled to famous spots and then used their visual memory as well as occasional incidental sketches done at the site as useful elements in the production of the final drawings followed by artisans for the carving of the wood-blocks.

Other more socially respected artists in the generations following Ōkyo, such as Shiba Kōkan (1747–1818) and Watanabe Kazan (1793–1841), continued with what they tended to regard as "scientific experiments" until the opening of Japan in mid-century. While

not at the center of the traditional Japanese art world, these innovators were respected and appreciated for their unusual contributions. For the sophisticated viewer, at least, Western art did not come as a total surprise.

With the advent of the Meiji period in 1868, the Japanese government recognized that Western artistic methods permitted the rendering of volumes and space in a more "scientific" manner than their own artists produced and therefore determined that a training institute should be established in order to teach young students potentially gifted in the area of the visual arts. The Technical Art School was created in 1876. Its directors reported to the Ministry of Industry and Technology, which indicates, from the point of view of the Meiji government at least, what the purposes of the school were to be.

The goal of this training was to create a generation of visual artists able to render objects "scientifically." Training in the techniques of the traditional arts was not initially provided with government support. For many centuries individual teachers had provided an environment for these lengthy preparations. Young artists apprenticed themselves to master teachers and spent many years learning ink and brush techniques and then copying as accurately as possible the work of their predecessors so that they could internalize the classical principles involved. The social upheavals of the Meiji period eventually caused this old, personalized training system to break down. It was only at this point that the government set up the Tokyo School of Fine Arts in 1887, which paid for the teaching of the traditional visual arts in a new, state-subsidized studio atmosphere. Not until 1896 would Western-style painting be granted the same privilege.

Before the founding of the school, a few aspiring Japanese artists were able to study with the handful of European artists resident in Japan, many of whom were employed by Western editors as journalists in the days before the ascendancy of news photographs. The first of the gifted Japanese painters in the Western style, Takahashi Yuichi (1828–1894), for example, began his studies with Charles Wirgman (1834–1891), a British artist living in Tokyo who was assigned to create illustrations for the London *Illustrated News* and other similar publications (plate 171). Kawamura Kiyoo (1852–1934), on the other hand, studied with the Japanese painter Kawakami Tōgai, who had learned cartography and Western methods of sketching in order to serve his own government. Kawamura was sent abroad officially in 1871, five years before the establishment of the Technical Art School, to study in Venice. His work shows the level of technical accomplishment possible within a decade or two of the opening of the country (plate 172).

Nevertheless, it was the opening of the Technical Art School that established Western-style painting as a real possibility for contemporary expression. Perhaps of most importance, the foreign faculty hired by the school provided the first instruction in Western techniques conducted on a truly professional basis. The school's early

students were particularly fortunate in that the painting teacher hired to train them in art was a fine artist and a personal inspiration to many of them. Antonio Fontanesi (1812–1882) was already quite a noted painter in Italy when he responded to a circular issued by the Italian government seeking a painter to be sent to Japan. Despite the fact that his health was already in decline, he accepted the commission when it was offered and spent two years in Tokyo, from 1876 to 1878. Fontanesi's work, still widely known and highly regarded in Italy, is most often described as a kind of Barbizon landscape painting: romantic scenes usually rendered with a dark palette (plate 173). Yet the painter's subjective responses to nature possessed an authentic poetry all their own. Fontanesi's frail health kept him from remaining long in Japan, and, indeed, for both budgetary and increasingly conservative political motives, the government decided to close the school several years later, in 1883. Still, in the short time that he remained in Tokyo, Fontanesi managed to inspire a number of young Japanese artists, among them two gifted painters, Asai Chū and Goseda Yoshimatsu. For those lucky enough to attend the school, therefore, it was possible to learn the craft of oil painting as it was practiced in contemporary European terms.

Still, those aspiring artists who could find the funds, either through government scholarship or private means, to make the lengthy and expensive trip to Europe attempted to go to the sources of art to learn directly. A generation of young artists scattered around the world, to New York, London, Paris, Berlin, and Munich. They added new skills to their enthusiasm and talent and returned to Japan to teach and create a new kind of art that quickly began to stimulate interest among members of the public anxious to learn about world culture. Probably the most gifted of this early generation were the painters Harada Naojirō (1863–1899) and Goseda Yoshimatsu (1855–1915). Harada studied with the German painter Gabriel Max in Munich from 1884 to 1887, where he also came in contact with the great Meiji writer and intellectual Mori Ōgai (1862–1922), who was to do much to introduce German art, literature, and culture into turn-of-the century Japan. Harada and Ōgai became lifelong friends, and Ōgai did much to help his colleague's career in what, as far as the general public was concerned in those early years, was essentially a highly unorthodox art form. *Shoemaker* (plate 174), painted in 1886 while Harada was still a student in Munich, shows something of the kind of dark-palette realism that was typical of the Munich School and was generally in favor in Europe before the advent of Impressionism; a picture such as his charming *Landscape* (plate 175), created during the same year, already suggests something of an individual style and the artist's personal response to effects of light and atmosphere.

Goseda, who was a pupil in Tokyo of Wirgman's and Fontanesi's, went to France in 1880. He studied for several years with J. L. Bonnat, a highly respected academic painter. Little touched by emerging Impressionist ideals, Goseda's work shows in a painting such as *Mar-*

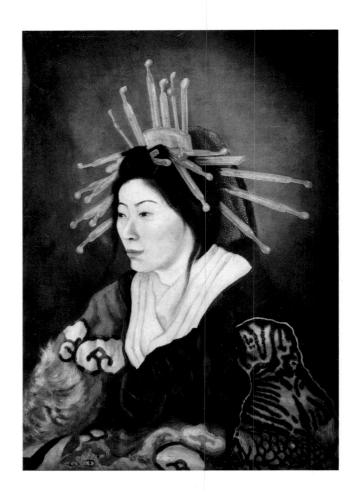

171. TAKAHASHI YUICHI. *Oiran.* 1872. Oil on canvas, 30½ × 21⅝″. Tokyo University of Fine Arts

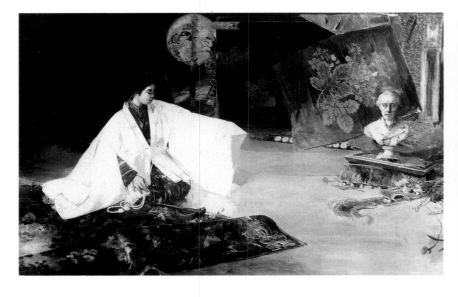

172. KAWAMURA KIYOO. *The Late Count Katsu's Court Dress.* 1899–1911. Oil on canvas, 43 × 68″. Tokyo National Museum

THE IMPRESSIONIST IMPULSE IN JAPAN

*ionette Show* (plate 176), an unusual subject that revealed something of Goseda's own personal sensibilities. In artistic technique, however, the painting remains within the kind of competent academic style of which painters of his generation in Japan were capable. It is no wonder that a painter such as Goseda was well-regarded in Europe as well as in Japan.

The development of a style of painting that might be regarded as a Japanese form of Impressionism, however, began when Paris became the focus of study for Japanese artists. In this regard, the activities and ideals of Kuroda Seiki (1866–1924), the first and one of the greatest of the painters who chose the Impressionist mode of expression, were highly important, as he became a mentor, teacher, and confidant to the generation of younger Western-style Japanese painters who learned from him.

As a young man, Kuroda showed some interest in art, but his main interest was in languages. He studied French at the rigorous Tokyo School of Foreign Languages, originally established by the Meiji government to train needed interpreters and diplomatic personnel. At the suggestion of his family, he went to Paris in 1884 to study law. Kuroda became friends with the young Japanese painter Fuji Masazō, who, diffident about speaking French, asked Kuroda to accompany him as an informal interpreter on a visit in 1885 to the painter Raphaël Collin, with whom Fuji wished to study.[1] This chance meeting with the French master eventually led Kuroda to make the decision to give up his law studies and become a painter himself. Studying and working in France for the next nine years, Kuroda learned to appreciate the kind of lighter palette by then adopted in more advanced artistic circles, and the youthful works he produced show both considerable technical skill and a sympathy for a variety of subject matter.

His *Woman Sewing* (plate 177), painted in 1890, when he was twenty-four, was conceived as a life study, and his *Chrysanthemums and European Ladies* (plate 178), painted two years later, shows an increasing mastery of design, color, and elegant surface texture. Because of his talent and character, Kuroda soon became an important figure among the young Japanese artists then in Paris, and from the point of view of his French colleagues and teachers, he was regarded as an extremely gifted artist. Kuroda became particular friends with Kume Keiichirō (1866–1934), and the painting entitled *Mr. Kume in His Atelier* (plate 179), painted in 1889, shows Kuroda's skill at capturing in a fresh and agile manner the excitement of a moment of creation. Paintings on similar subjects had long been familiar in French art, and nineteenth-century painters from Courbet onwards had rendered similar subjects. Kuroda and Kume seem equally at home in this kind of informal milieu. In such a moment, painter and sitter alike were expressing European, rather than Japanese values, as the artist's personality was seldom considered a subject appropriate for a work of art in the traditional Japanese canon of expression. The sense of personality and spontaneity as ex-

173. ANTONIO FONTANESI. *Spring Sun*. 1875. Oil on canvas, 28 × 19¾". Giacomo and Ida Jucker Collection

174. HARADA NAOJIRŌ. *Shoemaker*. 1886. Oil on canvas, 23¾ × 18¼". Tokyo University of Fine Arts

175. Harada Naojirō. *Landscape: The Backyard of a Farmhouse*. 1886. Oil on canvas, 29⅛ × 41⅛″. Private collection

176. Goseda Yoshimatsu. *Marionette Show*. 1883. Oil on canvas, 34⅝ × 46½″. Tokyo University of Fine Arts

177. KURODA SEIKI. *Woman Sewing*. 1890. Oil on canvas,
32 × 25⅝″. Ishibashi Museum of Art, Ishibashi Foundation,
Kurume

178. KURODA SEIKI. *Chrysanthemums and European Ladies*.
1892. Oil on canvas, 21¼ × 31⅜″. Private collection

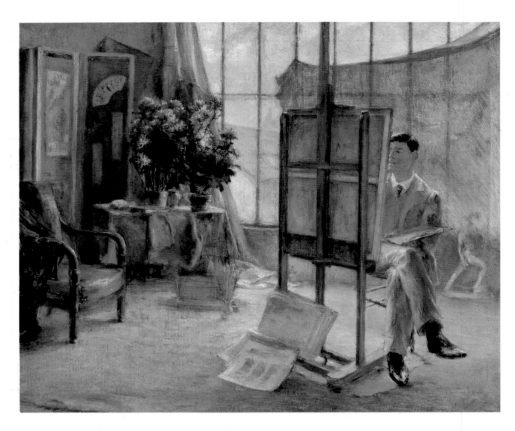

179. KURODA SEIKI. *Mr. Kume in His Atelier.* 1889. Oil on canvas, 15⁹/₁₆ × 18⅜″. Kume Museum, Tokyo

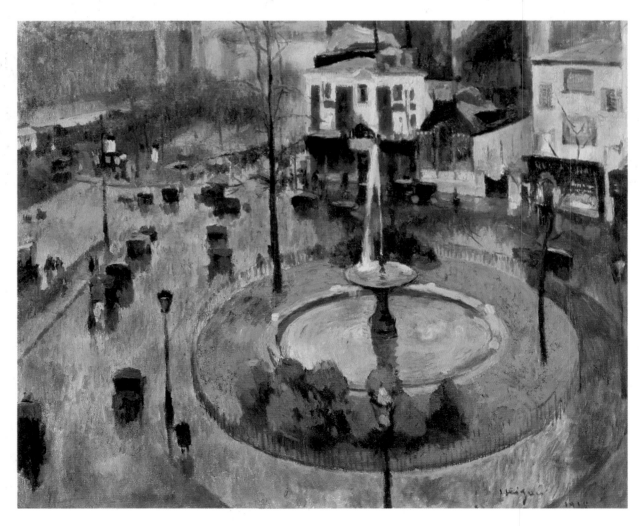

180. KANAYAMA HEIZŌ. *Place Pigalle in the Rain.* 1915. Oil on canvas, 24 × 28⅜″. Hyogo Prefectural Museum of Modern Art, Kobe

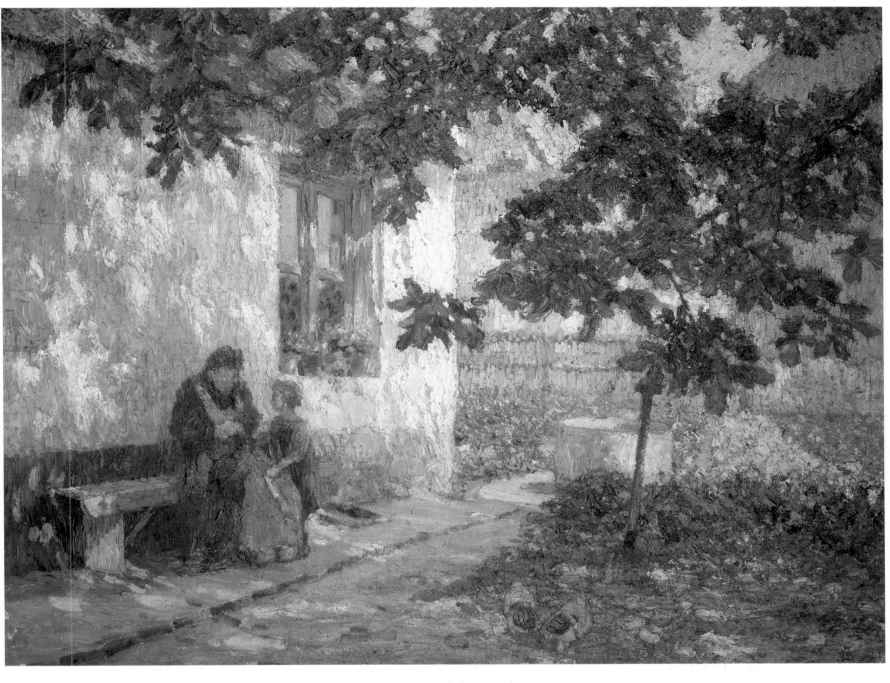

181. KOJIMA TORAJIRŌ. *Begonia Field*. 1910. Oil on canvas,
35¾ × 46½″. Ohara Museum, Kurashiki

pressed by Kuroda was seen, and rightly so, as presenting a whole new range of possibilities for Japanese painters.

Europe in general and France in particular thus provided a fresh milieu in which Japanese artists could discover much that was new in themselves and in the world around them. Kuroda set an example for a number of gifted artists who sought a sense of discovery in their Western artistic pilgrimages.

Kanayama Heizō (1883–1964) was one such visitor who went to Paris in 1912 and reveled in the atmosphere of France. Many of the paintings he did in Paris, such as the lovely *Place Pigalle in the Rain* (plate 180), capture his personal reactions to a view that he saw from his window; reportage is softened by his quiet and lyrical response to the scene. Kojima Torajirō (1881–1929), who studied with Kuroda, traveled in Europe for five years, and his *Begonia Field* of 1910 (plate 181) suggests some of his enthusiasms for the kind of subject matter and the quality of light that he observed in the art he saw in Paris and elsewhere.

Artists such as Kanayama and Kojima worked in France while still in their formative years. The highly respected Asai Chū (1856–1907), who had studied with Fontanesi, was a fully mature painter in the Western style when he finally made the trip to Paris in 1900. At Kuroda's suggestion, he traveled in the French coun-

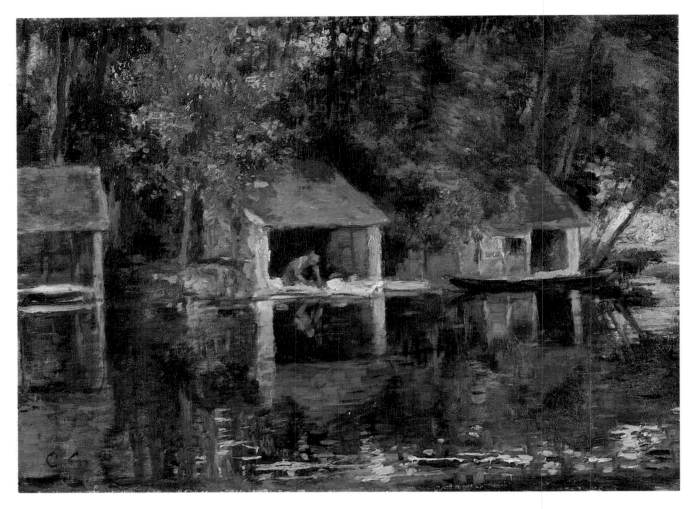

182. Asai Chū. *Washing Place at Grez-sur-Loing.* 1901. Oil
on canvas, 13⅛ × 17⅞". Bridgestone Museum of Art, Ishibashi
Foundation, Tokyo

183. Asai Chū. *Bridge at Grez-sur-Loing.* 1902. Oil on
canvas, 11³/₁₆ × 17⅛". Bridgestone Museum of Art, Ishibashi
Foundation, Tokyo

tryside, often painting and sketching near Grez, a village not far from the Fontainebleau forests much appreciated by the Barbizon school and an area where Kuroda himself had often worked. Asai's formed palette was darker than Kuroda's, as his *Washing Place at Grez-sur-Loing* indicates (plate 182), but he too was captivated by the light he found in France. Particularly in his watercolors, such as *Bridge at Grez* (plate 183), he revealed a new and delicate luminescence.

Fujishima Takeji (1867–1943) was another painter who had first developed his talents in Japan, often working in a decorative and Romantic style that suggests an amalgamation of a number of diverse Western influences. A painting such as *Butterflies* (plate 184) is typical of the charm and elegance of his work at this stage in his career. Admired by Kuroda Seiki, he became an important teacher and was sent by the Japanese government to France in 1905, where he remained for five years. The trip to France changed his artistic perspective considerably and brought him much closer to a truly individual style. Works such as *Yacht* (plate 185), painted in 1908, or *Pond (Villa d'Este)* (plate 186), finished a year later, show in their looser and more spontaneous style a fresh understanding of how to capture light as it plays over surfaces. In such pictures Fujishima learned to create effects unknown in earlier Japanese art and seldom exploited in the paintings of the earlier generation of Hareda and Goseda, whose pictures emphasized shape and volume. *Pond* also shows, perhaps unconsciously, the effect of Japanese prints on European painting of the time; the hanging branch only became a likely possibility after the cropping familiar from Japanese prints had entered the visual lexicon. The reflecting mirrors of East and West were again in play.

How did these painters, young or old, learn to appreciate and then carry out what were for them such surprising new approaches? Virtually all the Japanese artists going to Europe felt the need for formal study, although a few abandoned atelier lessons after a few months. The techniques of painting with oils were still not widely understood in Japan at the end of the century, or even after. Basic schooling in the medium was thus far more important for them than for artists from European countries or the United States, where adequate training in the technicalities of painting was usually available. The great painters of the Impressionist period, whom the Japanese most admired, however, gave no lessons and took no pupils. Japanese students in Paris at the turn of the century might look with excitement on the works of Monet, Degas, and Pissarro, and they would soon discover Cézanne through the first great retrospective of his work held in 1907. Of necessity, however, they studied with the academicians. Only Renoir, who late in his life befriended the young painter Umehara Ryūzaburō, took an interest in Japanese painters. It was thus to men such as Jean-Paul Laurens (1838–1921), whose interests lay in history painting, Raphaël Collin (1850–1916), who combined certain Impressionist techniques with an academic rendering of figure forms (plate 187) and C. E. A.

184. Fujishima Takeji. *Butterflies.* 1906. Oil on canvas, 17½ × 17½". Private collection

185. Fujishima Takeji. *Yacht.* 1908. Oil on canvas, 13 × 9¼". Tokyo School of Fine Arts

186. Fujishima Takeji. *Pond, Villa d'Este*. 1908–1909. Oil
on canvas, 18½ × 21¼″. Tokyo School of Fine Arts

Carolus-Duran (1837–1917; plate 188), the elegant portrait painter and teacher of John Singer Sargent, to whom the aspiring painters turned. We need to be reminded, too, from our vantage point of almost a hundred years later, that the names of these teachers were at the time by no means obscure ones. All three had considerable reputations and were universally regarded as among the most gifted artists of their time, until the shock of artistic change after World War I set their work aside. Indeed, the Japanese painters sought out, insofar as they were able, the best teachers available to them.

Nevertheless, the work of the Japanese painters in Paris shows immediately that much of what they learned and took to heart bore only a glancing relationship to the kind of academic work that their teachers represented. As they saw for themselves the newest art that was being created around them in Paris, so far removed from the principles of the academy, they, like so many other foreign artists living in France, moved to develop their own talents in this fresher, freer milieu.

From a larger perspective, too, it is clear that for most of the Japanese painters of this period, a European trip was regarded as an opportunity to explore artistic character, to experience another visual culture, and to master an expanding array of technical painterly possibilities. Few painters, however, contemplated staying on. Some during the period certainly might have done so; Kuroda Seiki in particular was highly regarded as an up-and-coming talent whose work was much admired by his French colleagues and mentors. Yet Kuroda himself had set the pattern for most of these artists, who, after their European sojourns, returned home and dedicated them-

THE IMPRESSIONIST IMPULSE IN JAPAN

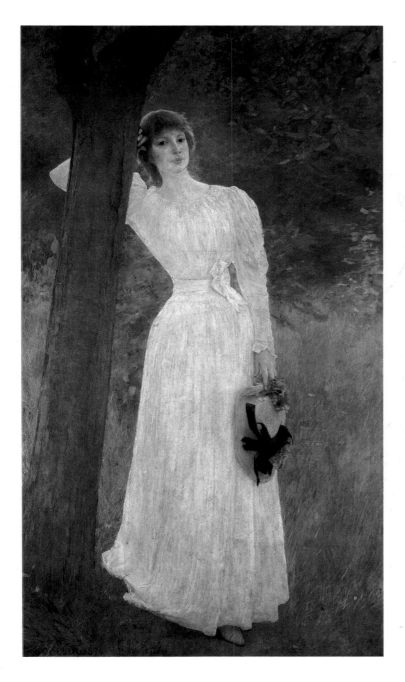

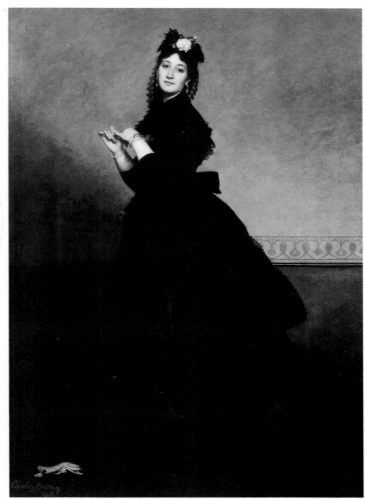

(left) 187. Louis-Joseph-Raphaël Collin. *Woman Carrying a Hat.* 1894. Oil on canvas, 76⅜ × 44⅛". Fukuoka Art Museum

(above) 188. C.E.A. Carolus-Duran. *Woman with a Glove.* 1869. Oil on canvas, 89¾ × 64½". Musée d'Orsay, Paris

selves to showing through their own works the newest trends in European painting to a growing and interested Japanese public. Part of their self-conceived duties, too, was to teach others what they had learned.

Kuroda returned to Tokyo in 1893 and taught privately. At that moment, there was no government-sponsored employment available to him, since the Tokyo School of Fine Arts still resisted providing instruction in Western-style painting. By 1896, however, public pressures and a change of bureaucratic leadership permitted the establishment of the school's Western Painting Section, which Kuroda was hired to organize and run. The first Japanese Impressionist now had a national forum to display his talents. Kuroda was influential as well in the establishment of the prestigious yearly government art exhibitions in 1907 (which, usually referred to as

*Bunten,* still continue today). He brought painters such as Fujishima to work at the school with him. This dedication to passing on acquired knowledge made it possible, in turn, for those painters who, for reasons of health, money, or personal inclination, could not travel to Europe, to learn both the techniques and the ideals of Western art. These painters took their role as teachers seriously, and through the efforts of Kuroda and the generation that followed him, the principles of Western oil painting were domesticated into a new Japanese tradition in which artists and the public alike were to take pride.

By the early years of the century, an ambience had been created that permitted Western-style painting to develop in a consistent and constructive way. Artists found support in both private and government-sponsored

exhibitions. Some commissions for their work became available, and journalists wrote extensively on the new developments seen in the work of artists returning from Europe. A number of influential small art magazines began to circulate;[2] these in particular helped educate the public, as they included not only essays on contemporary Japanese and European painters but photographic reproductions of important historical and contemporary works of European art as well.

Such an ambience soon made it possible for young artists with potential to learn the essentials of their craft in Japan. One example of the development of such a talent can be seen, and in a poignant fashion, in the work of Nakamura Tsune (1887–1924), who began his studies with Kuroda. Poor and unable to afford a trip to Europe, Nakamura poured over magazine illustrations and art reproductions in books in order to learn some-

thing of the history and theories of Western painting. His successive enthusiasms ranged from Cézanne and Renoir to his greatest source of inspiration, Rembrandt. For him, these painters did not represent (indeed could not represent) historical figures, as he, like most of his contemporaries, as yet had little sense of the chronological progression of styles in European painting. Rather, the muddy reproductions of the works he was able to find served as direct inspirations to his restless spirit. Dead at thirty-seven from tuberculosis, Nakamura remains a romantic figure from his period. However disparate individual examples of his style might be, an authentic persona lay behind them. A relatively early picture, such as his 1910 *Seaside Village* (plate 189), while owing much to the work of Kuroda and his other Tokyo mentors, reveals his skill at observing nature and his sophisticated grasp of design. His *Self-Portrait with a Straw Hat* (plate

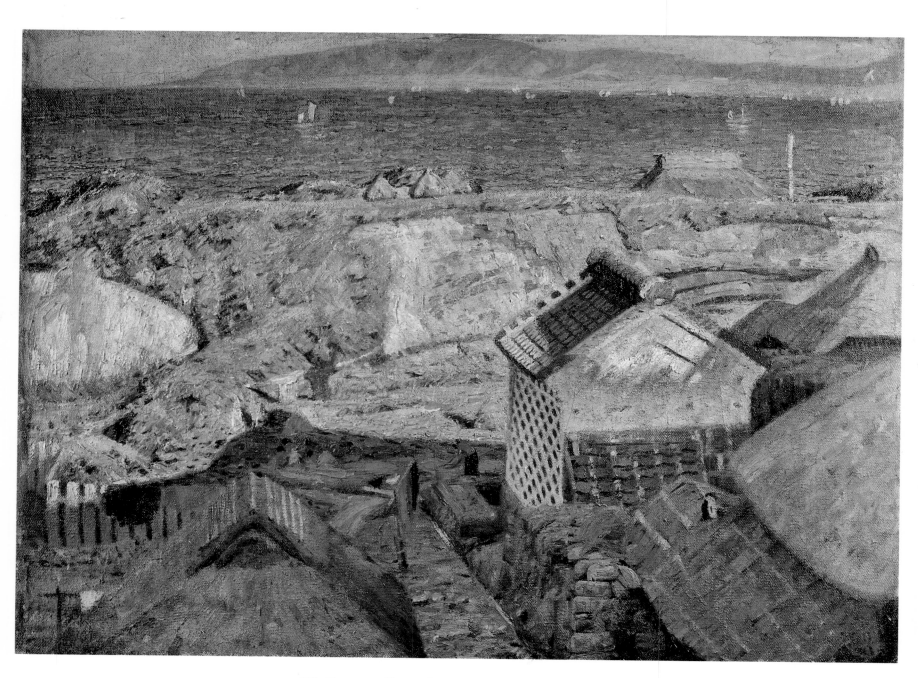

189. NAKAMURA TSUNE. *Seaside Village.* 1910. Oil on canvas,
24 × 32¼″. Tokyo National Museum

190. NAKAMURA TSUNE. *Self-Portrait with a Straw Hat.*
1911. Oil on canvas, 16⅜ × 12⅝″. Collection Nakamura-ya

191. NAKAMURA TSUNE. *Still Life with Wrapping Paper from a Bottle of Calpis.* 1923. Oil on canvas, 23⅞ × 19¾″. The Museum of Modern Art, Ibaraki

190), finished the following year, with its bold color surfaces and rapid brushwork, suggests the energy of new directions. His *Still Life with Wrapping Paper from a Bottle of Calpis* (plate 191), painted twelve years later, seems to inhabit still another stylistic world altogether, the monumentality of its shapes suggested by, but not slavishly suggestive of, Cézanne. It is remarkable to think that an artist capable of Western-style work of this quality could be at work in Japan less than twenty years after the return of Kuroda from France. And there were many others.

## Modern Painting in China at the Turn of the Century

For a thousand years, Chinese art and artistic ideals held hegemony over all of East Asia. Artists in such diverse regions as Korea, Japan, and Vietnam felt themselves part of this larger cultural matrix. It is thus no wonder that historically the Chinese took relatively less interest in Western art than the Japanese, who, on the periphery of the Chinese cultural orbit, felt themselves quite free to experiment. Strictly speaking, the Impressionist impulse had no direct effect on the work of Chinese artists at the turn of the century, even in such sophisticated cities as Beijing and Shanghai. European modern art was to have a powerful effect on Chinese painters in later decades, when the art of Matisse, in particular, became influential. Then the adoption of such European principles took on an overtly political significance, chosen as they were to serve as visual statements calling for more personal and artistic freedom.

In the Ming dynasty (1368–1644), Chinese artists and connoisseurs had learned something of Western painting through the activities of the Jesuits living in the capital. By the nineteenth century, however, these early contacts had for all practical purposes been forgotten. As late as the 1880s, when Kuroda was in Paris, the majority of Chinese intellectuals and artists were still largely self-absorbed and uninterested in Western culture. Yet incursions from the West continued to batter down the

192. LI SHUTONG. *Head of a Girl*. Before 1918. Charcoal, dimensions unknown. Whereabouts unknown

(right) 193. GAO JIANFU. *Pumpkin*. n.d. Ink and color on paper, 38 × 18½″. Hong Kong Museum of Art, the Urban Council

194. XU BEIHONG. *The Five Hundred Retainers of Tian Heng*. 1928–1930. Oil on canvas, 78 × 139¾″. Xu Beihong Memorial Museum, Beijing

defenses, both literally and spiritually, of the Quing dynasty (1644–1912), and some interest grew, if sporadically, in the Western arts. Little was undertaken in terms of learning from the West in detail, however, until the beginning of the twentieth century and after, when the dynasty was on the verge of final collapse. The historical process that had so changed Japan at the end of the Tokugawa period prior to 1868 was to take place in its own fashion in China as well, but some fifty years later.

The first sustained activities needed to renew Chinese art came during the period that produced the final collapse of the Quing dynasty in 1912. After the failure of the Boxer Rebellion in 1900 to expel the foreign presence in China—a revolt the dowager empress had encouraged—the Chinese republicans in exile under Sun Yat-sen helped to bring about the abdication of the young emperor and the establishment of the Republic of China. Many of these republican exiles during this troubled period had found a safe home in Japan, which represented for them a progressive civilization from which they stood to learn much.

Indeed, in the arts, much of the impetus for new activity came from the work of Chinese students in Japan. Attracted by the high standards of instruction at the Tokyo School of Fine Arts, a number of gifted Chinese enrolled there, either in classes to learn Western painting with Kuroda Seiki and his colleagues, or, more commonly, to study with teachers active in the Japanese Painting Section, which, while preserving elements of the more traditional Asian styles, still provided for more experimental and Western-influenced techniques than could be found in China at the same period. During the early decades of the century, the Japanese thus exerted a potentially strong influence over young Chinese artists, who apparently deeply admired their Japanese teachers. Yet by and large the gap was too great. Most of the best Chinese painters of the period turned their mature efforts towards older traditions, although those Chinese who grasped the new aesthetic ideals often returned to take up academic posts at home. Through schools and academies, Western-style drawing began to be taught as part of the Chinese curriculum, often by Japanese artists hired for the purpose, but few in the more general public were able to understand or sympathize with such experiments. During the troubled years that spanned the establishment of the Republic in 1912 and the consolidation of the Nationalist government under Chiang Kai-shek in 1928, the political turmoil and dislocations throughout China remained severe; few efforts could be undertaken to reform the arts in a country torn apart by the armies of contending warlords. Artists, isolated from any general movement, felt uncertain of their goals. As they usually had been trained in the great traditions of Chinese painting, they were tentative in their commitments to what still seemed an alien style. By contrast, young Japanese artists at the end of the Tokugawa and beginning of the Meiji periods were fascinated by Western precision, realism, and subject matter. Chinese artists, scholars, and patrons alike, who had never been in the habit of looking beyond their own styles for inspiration, were to some extent intrigued by these alien developments but were determined to adapt them into a Chinese aesthetic framework rather than to embrace them altogether.

An example of the tensions created by such early exposure can be seen in the career of one of the earliest and most revered Chinese artists who took an interest in Western art, Li Shutong (1880–1942). At age twenty-five he traveled to Tokyo and became a student of Kuroda's at the Tokyo School of Fine Arts. From the accounts that remain of his work, he was extremely gifted and mastered fully the Western academic techniques that inspired him, as his charcoal sketch *Head of a Girl* (plate 192) reveals. Returning to China at a time when, under the Republic, new ideas were finding greater acceptance, he began to propagate his theories of art and literature in Nanjing and elsewhere; his use, learned from the academic courses he took in Tokyo, of plaster casts and direct observation from nature in the painting of still lifes and live models was considered particularly remarkable. Yet in 1918, Li suddenly abandoned his new course of action and became a Buddhist monk, reverting altogether to traditional styles of painting.

Another highly gifted painter of this period, Gao Jianfu (1899–1951), also traveled to Tokyo in 1906 and worked there on and off until his return to China in 1916. Gao had some interest in Western realism, but, in studying the more traditional styles of painting in Tokyo, he became convinced that the best way to put Chinese art in touch with the contemporary world was to mix traditional techniques with modern subject matter. The results of his philosophy, as seen in a handsome work such as his *Pumpkin* (plate 193), produced highly accomplished paintings that, although perhaps in some ways startling to his contemporaries, to a Western eye owe far more to traditional Chinese values than to any inspirations from Impressionism or Post-Impressionism that may have come to Kao during his Tokyo years.

The painter Xu Beihong (1895–1953), at one point a younger disciple of Gao's, was completely taken as a young man with what he understood to be the objective realism of Western painting, which he first learned about in Shanghai. He began his studies in Tokyo in 1917. Then, like so many of his Japanese contemporaries, he went on to study in Paris, where he remained for eight years. Xu felt that ideals of Western realism might serve as a means to revivify the older Chinese traditions, and his works produced in the 1920s, such as *The Five Hundred Retainers of Tian Heng* (plate 194), reveal his use of historical themes, an approach suggestive of European styles that preceded Impressionism, and his meticulous draftsmanship. Yet Xu, like Li, would eventually turn away from such realism, to produce works much more closely bound to the possibilities of traditional Chinese brushwork and subject matter.

By the 1930s quite a number of Chinese painters had been to Paris and elsewhere in Europe, and they began to establish the kinds of contacts with contempo-

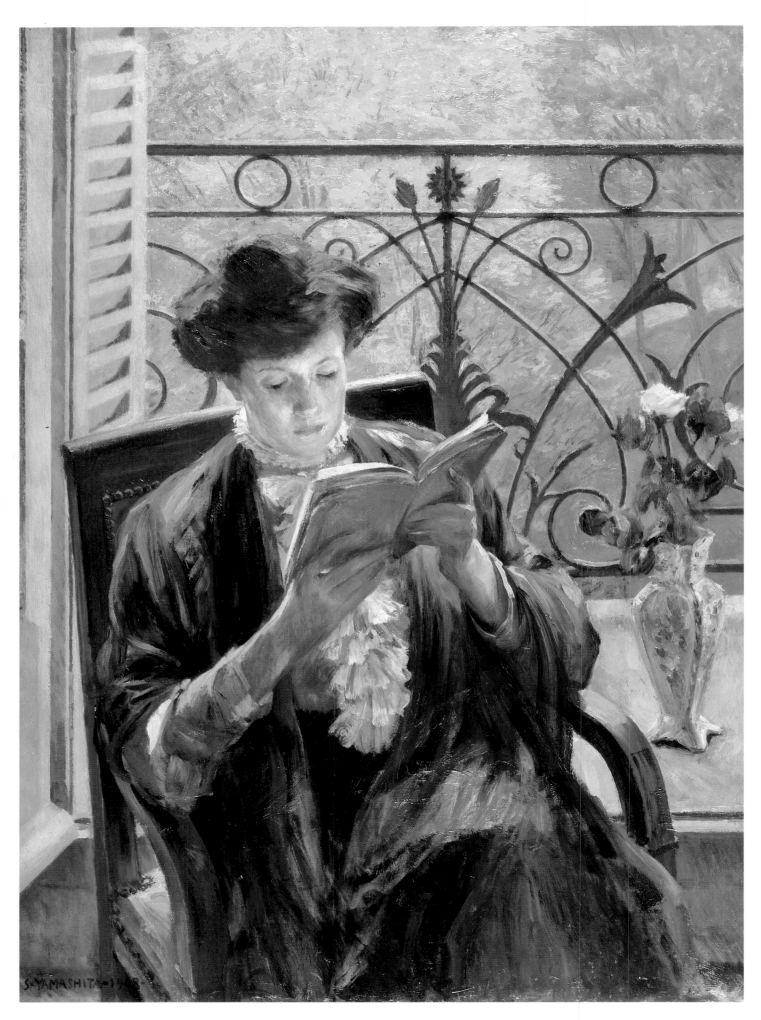

195. YAMASHITA SHINTARŌ. *Woman Reading.* 1907. Oil on
canvas, 39⅜ × 28¾". Bridgestone Museum of Art, Ishibashi
Foundation, Tokyo

rary European art that the Japanese had established over half a century before. These contacts eventually produced the mixture of Eastern and Western techniques that became a hallmark of the Maoist years. In Taiwan and elsewhere, real avant-garde works were produced as well, some of the highest standards.

In sum, it can surely be said that the confrontations and amalgamations between Chinese and Western art were important and produced fascinating results. Nevertheless Impressionism, with its elegant palette and sophisticated play of shapes and light, potentially of such significance to China's artists, who had taken such interest in earlier phases of Western art, was to have little direct or lasting effect.

## Coming Home: Painters in Japan

In the trajectory of the careers of those Japanese painters who devoted themselves to the Impressionist vision, a number of difficult stages needed to be mastered. The first of them involved the very process of learning. Traditionally, painters in the East and the West alike served long apprenticeships while they slowly mastered the details of their craft. Such a process was particularly crucial for the Western-style Japanese painters, who had almost no heritage of oil-painting technique and, at least during most of the period covered in this chapter, almost no opportunity to study at leisure in Japan original works of European oil painting.[3] For those who were lucky enough to go to Europe, they could examine such works in museums; others had to satisfy themselves with copying from photographic reproductions. In either case, copying became an important means for them to master technique. Again, until the last decades of the nineteenth century, such methods would have been regarded as unexceptional in Europe as well as in Japan, yet in the avant-garde atmosphere of Paris, where one style after another was to be overthrown, copying put these Japanese artists in the rear guard. A gifted painter like Morita Tsunetomo (1881–1933), for example, was fascinated by the techniques of Cézanne, and he set out in his early work to attempt to internalize the French master's methods by closely adopting them himself. A painting such as his 1910 *Landscape at Aizu* (plate 197), may now appear as overly derivative, yet this work, constructed as it is with rigor and enthusiasm, should instead be regarded both as a kind of étude and homage to the painter Morita most admired.

For most of the Japanese Impressionists, finding an individual style required a stage in which personal inclinations were put aside in an attempt to reproduce, in both spirit and form, insofar as possible, the kind of European works admired by beginning painters. In this regard, the remarks made by Shimazaki Tōson (1872–1943), one of the great novelists of modern Japan who lived in Paris for several years just before World War I, are worth repeating. Tōson loved art as well as literature, and he took a lively interest in the work of the Japanese

196. YAMASHITA SHINTARŌ. *Offering*. 1915. Oil on canvas, 21¾ × 18⅛". Bridgestone Museum of Art, Ishibashi Foundation, Tokyo

197. MORITA TSUNETOMO. *Landscape at Aizu*. 1916. Oil on canvas, 25⅝ × 31⅝". Museum of Modern Art, Saitama

painters he met in Paris. In observing their attempts to master these new styles, he wrote:

> What is a copy? Here in Paris there are many copies of things that have been made in Asia. Whatever could be collected from all over the world has been brought here, and copied, in order to make life richer and more abundant. Annam, India, Egypt, all these civilizations are copied a great deal. Yet these countries do not have the strength themselves to copy. Indeed, multiplicity is no cause for grief when choosing a model. The source of concern is rather that the strength to copy will be unequal to the task. If that strength is not sufficiently resolute, if the copy is indifferent, or halfhearted, then the real thing that is being copied can never truly become one's own.[4]

Once the copying phase was over, however, an artist then faced the problem of trying to create a personal style. Yet, few artists remained in Europe after what they considered their period of training. Returning to Japan, they had to face the considerable problem of using what they felt they had learned and internalized in order to treat fresh techniques and new subject matter in light of their own altered subjectivity. Many of the Japanese painters of the Impressionist period came to consider the works that they created in Europe, however accomplished, as student works. The hard labor of personal and social assimilation were to come later.

The art of Yamashita Shintarō (1881–1966) suggests some of the shifts involved. A gifted painter who studied with both Fujishima and Kuroda at the Tokyo School of Fine Arts, Yamashita left for Paris in 1904. His highly accomplished *Woman Reading* (plate 195), painted three years later, won a prize in the Paris Salon, and, indeed, seems to sum up the painterly virtues admired by the conservative side of the French art world at that time. Back in Japan eight years later, he painted *Offering* (plate 196), which shows him moving away from the Salon aesthetic in an attempt to develop his own mature style, which is related at least in part to his personal attraction for the work of Renoir. Yamashita was able to meet the elderly French painter through the good offices of Umehara Ryūzaburō and was given an opportunity to watch the master painting, an occasion that taught him, he later wrote, about the tremendous energy needed on the part of any painter in order to create a work of genuine charm and grace. Watching Renoir, he suggested, was like observing a demon; he saw the painter pouring forth his energies while maintaining at the same time his prodigious abilities of concentration.

Some artists created works of real accomplishment during their student days, then went on to work in wholly different styles. Sakamoto Hanjirō (1882–1969), for example, painted his early, Degas-like *Cloth Drying* (plate 198) virtually a decade before his departure for France; the style he chose was based on his own early Impressionistic experiments, which he made after seeing

198. Sakamoto Hanjirō. *Cloth Drying.* 1910. Oil on canvas, 45⅞ × 28″. Private collection

reproductions of European art and, at firsthand, the work of Umehara and others. After Sakamoto's return from France in 1924, however, the artist retired to the country-side in the south of Japan, where, altogether conscious of the problems involved in forging a personal and authentic means of self-expression, he worked alone for a decade or more before evolving a style that, although it owed virtually nothing to the Impressionist impulse, was to make him a revered artist in the postwar period. *Cloth Drying*, for all its pleasures, was a step, rather than a goal.

Another aspect of the difficulties the Japanese painters faced can be seen in the work of Kume Keiichirō (1866–1934), a close friend of Kuroda Seiki's. Both studied with Raphaël Collin, developed an interest in plein-air painting, and hoped to introduce the systematic teaching of contemporary Western painting styles to Japan. They returned to Tokyo in 1893. Kume's talents were considerable, but he professed great difficulties in adapting what he had learned to what he saw in Japan; indeed, Japanese subject matter was altogether new to him, as he had spent the formative years of his life in Paris. Visiting Kyoto for the first time in 1893, Kume tried as an experiment to capture in his *Autumn Land-scape at Kiyomizu Temple* (plate 199) the look of a famous Japanese temple site using the color tones and brush techniques he had learned to master in France. Tokyo, now fast becoming a modern city, contained few such traditional sites. The sight of such ancient architecture, and the atmosphere it conveyed, was thus as exotic to him as it might have been to a traveling European. As a result, certain of his contemporaries found the conception—and the execution—of the works he did in Kyoto somehow false; they objected to the transposition of Japanese shapes and the quality of light that surrounded them into an arbitrary visual design. Kume's *Village Girl* (plate 200), created a year later, while also painted outside, reveals certain characteristics, such as the flat and decorated surfaces of the wall behind the figure that suggest the beginnings of a more personal style, one that owes something to traditional Japanese patterns of design. Yet he was not to develop fully in his mature phase. By the end of the nineteenth century, once the plein-air style that Kume championed became better appreciated in Japan, Kume's experiments were vindicated; but by that time, he had more or less abandoned painting, perhaps, as some critics suggest, because of a sense that he felt himself somehow inadequate to bridge this gap in sensibilities. Kuroda tried to persuade him to continue developing his impressive talents, but Kume refused and became instead an administrator at the Tokyo School of Fine Arts, helping Kuroda to prepare and guide the talents of the next generation.

Another glimpse of the kind of changes required to capture a new milieu can be seen in a painting by Asai Chū. While his work in Grez lightened his palette, he arrived after his return to Japan at a much more somber tonality, such as that seen in his 1907 *Morning Sun* (plate 201). The sky shows a new sense of the use of light in landscape painting, but the dark trees and mountains provide a visual record of the way in which Asai responded to the landscape in his own countryside.

Such dichotomies were particularly acute for those artists who traveled to Europe and who thus had direct experience with the beauties of the French countryside, in particular the special quality of light that painters from every country have long remarked on. Some made the transition to their own environment relatively easily; some worked hard for many years, even decades, to recreate in Japanese terms what they had once grasped in a different environment. For those painters who were not able to travel abroad, the need to come to terms with their careers as Western-style painters in Japan was in a sense more complex, since they were forced to use as their objects of study either inevitably indifferent reproductions of European works or pictures done by their Japanese contemporaries in Europe and then brought back to Tokyo, Kyoto, and elsewhere. The struggle was subtle and endless.

## The Artist as Creator

Back from Paris in 1909 and intensely involved in an attempt to create an authentic modern Japanese art, the sculptor, critic, and soon to be acclaimed poet Takamura Kōtarō wrote:

> If another man paints a picture of a green sun, I have no intention to say that I will deny him. For it may be that I will see things that way myself. Nor can I merely continue on, missing the value of the painting just because "the sun is green." For the quality of the work will not depend on whether the sun depicted is either green or red. What I wish to experience, to savor, as I said before, is the flavor of the work in which the sun is green.[5]

Thus the call for authentic creativity was sounded, bringing forth a set of heroic responses from more than one generation of artists. Two issues helped shape the nature of this dynamic.

The first of them concerned the complex relationships among artists, patrons, and the public in Japan. Whatever their private visions, these artists needed to interact with the growing number of enthusiasts for Western painting in Tokyo and elsewhere. In this regard, these painters often saw themselves as teachers, anxious to educate the larger public to what was, indeed, a totally new means of perceiving the world through the visual arts. Western-style artists often earned their livings from teaching, infrequent public commissions for new government buildings, and occasional sales to patrons. Until after World War II, few Japanese homes, with their sliding panels and paper doors, had the kinds of Western rooms that could accommodate oil paintings. Art exhibitions, such as the yearly shows sponsored by the govern-

199. KUME KEIICHIRŌ. *Autumn Landscape at Kiyomizu Temple.* 1893. Oil on canvas, 21⅝ × 18″. Nara Prefectural Museum of Art

(right) 200. KUME KEIICHIRŌ. *Village Girl.* 1894. Oil on canvas, 21½ × 14¹⁵⁄₁₆″. Nakano Museum of Art, Nara

ment, exhibitions in fashionable department stores, or shows in small galleries in the larger cities, provided the chief means by which the public was to be exposed to modern Japanese art. Thus, the relationships among a government that tended to support through its patronage the more conservative Western-style painters, a growing but still ill-educated public, and the artists struggling for both recognition and authenticity constitute the shifting elements through which the dynamics of the period were established.

Resulting was a tangle between the public aspirations and private mentalities of the painters. Kuroda himself was perhaps the first to feel the brunt of these differences shortly after his return from Paris in 1893. During his last years in Paris, he had created a painting he called *Morning Toilette* (plate 202), which was highly regarded by his French contemporaries. He displayed the painting with understandable pride in Tokyo, first to a group of artists, who very much appreciated what he

had accomplished, then to the general public. At that point, there was a tremendous outcry at the display of a female naked body, a subject wholly new to Japanese art and regarded by many as pornographic, far worse than the figures, always at least partially clothed, visible even in traditional erotic wood-block prints, which, in any case, were never considered as worthy of any artistic consideration by the educated upper classes. The controversy over the suitability of such images in Western-style painting continued on for much of the decade.

Kuroda had other difficulties as well. As he learned about the role of painting from French academicians in the latter part of the nineteenth century, it was perhaps inevitable for him to become convinced that the most important genre of painting was that of history painting. Until that period, historical subjects had a distinguished pedigree in the West and were long considered as the most noble possibility among the genres of subject matter available. Kuroda tried valiantly to inter-

THE IMPRESSIONIST IMPULSE IN JAPAN

est the Japanese public in large canvases that dealt with various events in the Japanese past, but he found no success.

It is ironic that Kuroda's large historical canvas entitled *Telling an Ancient Romance*, which chronicled the chanted performance of a famous Japanese medieval tale, was not a success with the public, while the preliminary sketches he did for the larger work (plate 165) have long remained among his most treasured legacies. Traditionally in Japan, the majority of sketches created were retained as preparatory drawings; they were not generally regarded until the modern period as works of art in and of themselves. In modern Japan, however, as in the West, the sketch has sometimes attained, because of its freshness and its suggestiveness, more value than the finished work, which seems to reach closure and so dampen the viewer's visual imagination. In certain of his late works, painted privately for himself, such as his 1924 *Garden of Plum Trees* (plate 204), Kuroda was able to enter into a looser and suggestive exploratory style that apparently represented for him a whole new realm of visual speculation. Such, however, were not the works

that the public knew or was perhaps ready to appreciate.

The same division can be seen in the work of one of the most romantic and provocative painters of the period, Aoki Shigeru (1882–1911), whose short, intense, and stormy life has made him something of a romantic hero in modern Japanese culture. Aoki studied with several painters, including Kuroda, and also did a certain amount of accomplished painting directly from nature, as his painting *The Sea* (plate 205) indicates. The work suggests a strong debt to the art of Monet, whose paintings Aoki may have known through photographic reproductions by that time available in Japan. Aoki felt works such as these to be experiments, however. Possibly at Kuroda's urging, Aoki spent much of his time reading Japanese mythology in order to create such "important" historical canvases as his imaginative rendering of an incident in the life of a legendary prince named Onamuchi no mikoto (plate 203) and a dozen others, which were (and are) appreciated for the artist's stylistic advances rather than for his choice of subject matter. Aoki's effective use of color, line, and atmosphere, drawing on his enthusiasm for reproductions he saw of the

201. ASAI CHŪ. *Morning Sun.* 1907. Oil on canvas,
126 × 165⅜″. Kuma Museum of Art, Ehime Prefecture

203. AOKI SHIGERU. *Prince Onamuchi-no-mikoto*. 1905. Oil on canvas, 29½ × 50″. Bridgestone Museum, Ishibashi Foundation, Tokyo

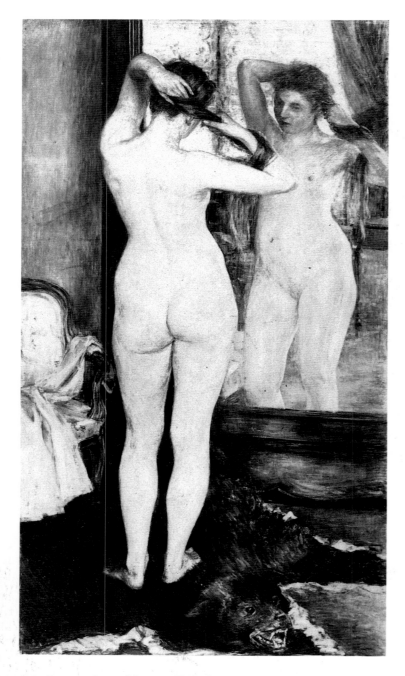

202. KURODA SEIKI. *Morning Toilette*, 1893. Oil on canvas, 70¼ × 38⅝″. No longer extant

work of the Pre-Raphaelites, has given some of his paintings the status of modern masterpieces, yet in strict historical terms, any visions of ancient Japanese life he conjured up are more arbitrary than historically suggestive.

There is perhaps no better example of the kind of freshness possible at the time than the charming sketch by Kanokogi Takeshirō (1874–1941), an artist who studied in France and spent his career creating paintings in an established and not particularly satisfying academic mode. For himself, however, he was capable of producing a work of strong appeal, such as his oil sketch of his young wife, entitled *Tsu Station (Haruko)* (plate 206). The combination of the figure and the pattern of the elegant fabric in the foreground, coupled with the images of the train in the rear, may call up visual memories of certain works by Caillebotte and Manet; yet Kanokogi, who painted the sketch two years before he went to Paris, doubtless knew little or nothing of their work when he created this striking image. In one sense, it might be claimed that Kanokogi painted what he saw, creating a juxtaposition that suggests both artistic and ideological tensions between East and West, old and new, man and machine. Had he continued to pursue this kind of private vision, he might have become one of the great modern Japanese painters. Such a personal response was to remain a private one, however. Indeed, the picture was not publicly shown until 1934. The public life and private visions of these artists remained apart, sometimes too far apart, for many decades.

Considering the variety of artists who worked from 1890 to 1920, when the Impressionist impulse was most important in the development of Western-style art in Japan, there were many influences that were brought to bear on the art of the period. One of the most important, strictly speaking, remained invisible in the works of art created. It was the inspiration provided by the exam-

204. KURODA SEIKI. *Garden of Plum Trees.* 1924. Oil on board, 10³⁄₁₆ × 13¾". Tokyo National Institute of Cultural Properties

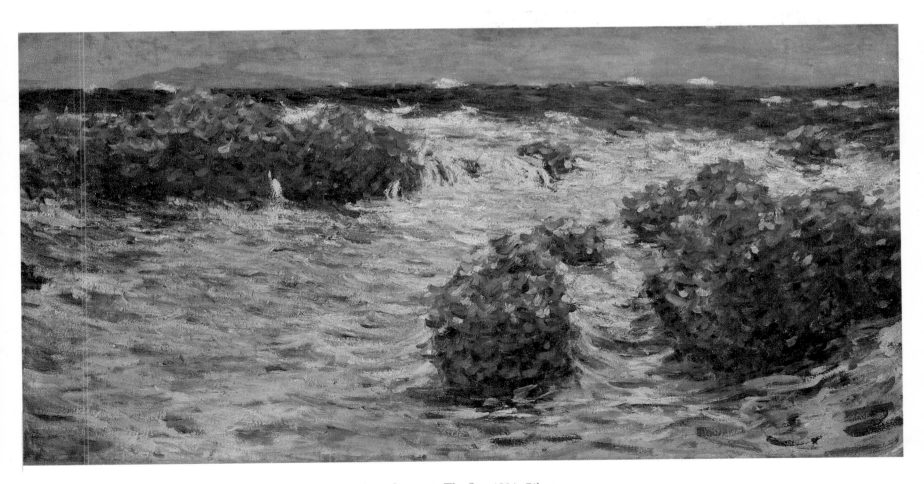

205. AOKI SHIGERU. *The Sea.* 1904. Oil on canvas, 14⅜ × 28⅝". Fujii Gallery, Tokyo

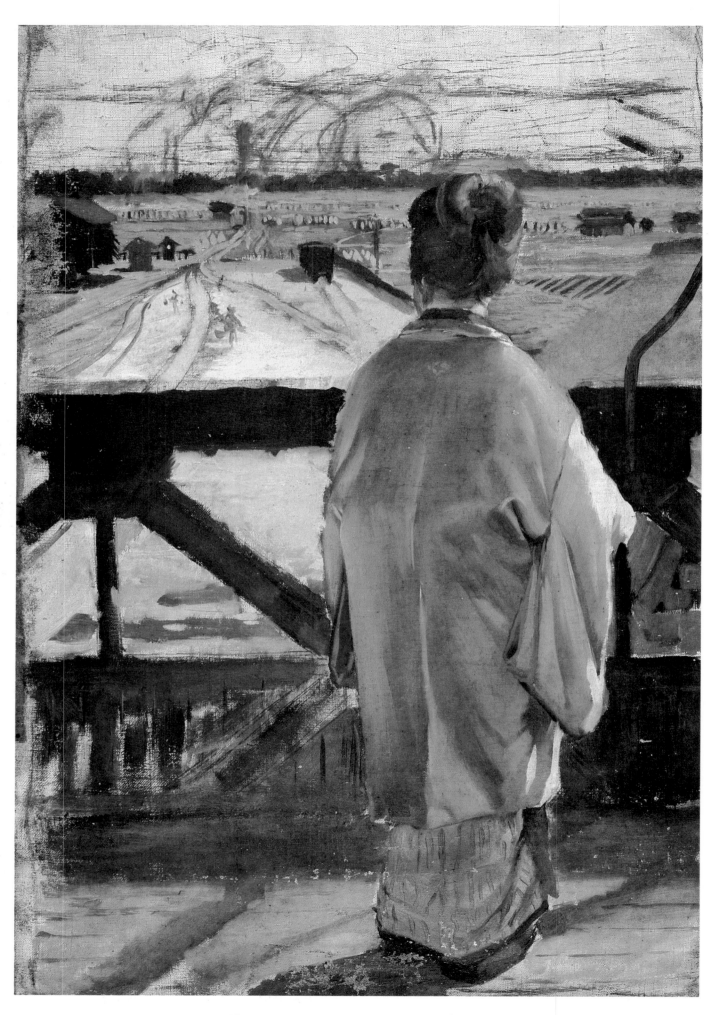

206. Kanokgo Takeshirō. *Tsu Station (Haruko)*. 1898. Oil
on canvas, 22⅝ × 15⅝". Private collection

ple of European artists who had the courage of conviction to go against the taste of the times in order to pursue their own vision. Such artists as Monet, Van Gogh, and Cézanne were valued as supreme figures, not so much for the fact that they incorporated some elements of Japanese art into their own work (although that fact may have created a certain unarticulated predisposition toward their art on the part of a number of Japanese artists), but because they possessed the energy and spiritual strength to work out their ideas without deference to reigning conceptions of art in their society. The appeal of such attitudes seems obvious now, as it is clear from our vantage point that the Japanese Western-style artists were battling, in their own view, both a lack of comprehension and an innate conservatism within their own culture. The Japanese Western-style painters of this period had some difficulties in maintaining a dialogue with their patrons and their public; and the strength to put aside the need to respond with mere agility to the tastes of others called for a special degree of independence never before so central to the Japanese artistic vocation. The stance required was a heroic one. Some fulfilled it only fitfully; others maintained this course throughout their long careers.

Thus, the ultimate and perhaps most valuable legacy of Impressionism in Japan was to provide a model of spiritual courage. Many painters, quoting their admiration for European Impressionist and Post-Impressionist painters, said that, even though they, as Japanese painters might wrestle with a number of styles and techniques, their dedication to the path they chose never varied, however many styles they might experiment with as a means to express their own vision of the world. The Impressionist impulse therefore came to represent in the work of many of the best artists of this period a phase in a longer trajectory, one that might have begun elsewhere and that would finish in a very different place. Two of the most respected, indeed revered, of modern Japanese artists illustrate this interplay very well.

Kishida Ryūsei (1891–1929) never went to Europe, although he had long planned to do so. Much inspired by the humanism of Takamura Kōtarō and his "Green Sun" essay, quoted above, Kishida set out to express his own vision of what was for him the visual surface of a deeper spiritual reality. His early style shows a considerable resemblance to the kinds of works seen elsewhere in this chapter, with their vivid play of color and light. In this regard, Kishida's 1913 *Portrait of Bernard Leach* (plate 207)—the famous British artist and ceramicist was then living and teaching in Japan—is both typical and highly successful. Yet by 1915, Kishida, who by that time had come into contact, through reproductions, with northern Renaissance art and was much taken with its spiritual qualities, and with Dürer in particular, turned to more realistic and emotionally freighted artistic mechanisms. It is the restless spirit of the artist, and his relentless quest, that tie them together. In that regard, the legacy of Impressionism and what it stood for in Japan were crucial.

207. KISHIDA RYŪSEI. *Portrait of Bernard Leach.* 1913. Oil on canvas, 24³⁄₁₆ × 18⅛″. National Museum of Modern Art, Tokyo

It is perhaps altogether appropriate to close this brief view of the Japanese experience with a few remarks concerning Umehara Ryūzaburō (1888–1986), one of the most important Japanese artists to study in France in the early years of this century and, until his death a few years ago, long the doyen of Western-style painters in Japan. His *Nude with Fans* (plate 208) shows at once his essential qualities of fluency, elegance, and charm. The picture may include a series of references and quotations related to European art, but this exchange of signs and symbols remains fresh, provocative, and genuine, the homage of a fine painter to much that he loves. The picture is to its European sources what, in music, Ravel's *Tombeau de Couperin* is to the seventeenth-century originals by the French baroque master: at once old and new, Couperin and Ravel. Yet, in the case of the composer, he was working within his own national tradition; Umehara was working with another. The ease and assurance of the results are therefore all the more astonishing.

208. Umehara Ryūzaburō. *Nude with Fans.* 1938. Oil on canvas, 31⅞ × 24". Ohara Museum, Kurashiki

209. UMEHARA RYŪZABURŌ. *North of Kyoto: Yase.* 1906. Oil on canvas, 12¹⁵⁄₁₆ × 9¼″. Private collection

(above right) 210. UMEHARA RYŪZABURŌ. *Notre Dame.* 1921. Oil on canvas, 21⁵⁄₈ × 17⁷⁄₈″. Kiyoharu Shirakaba Museum, Yamanashi

(right) 211. UMEHARA RYŪZABURŌ. *Haruna Lake.* n.d. Oil on canvas, 23⁷⁄₈ × 28⁵⁄₈″. Private collection

Umehara began his study of Western painting in 1906 with Asai Chū, who had returned to teach in Kyoto after his sojourn in Paris. Fired with an ambition to go to France, Umehara left two years later. His encounter in 1909 with the aged Renoir, which Umehara chronicled in a charming memoir,[6] represented the beginning not only of a close friendship with the Renoir family, but with a lifelong attachment to France. Throughout his long, prolific, and highly successful career, Umehara charted his way through French and Japanese culture, combining and distilling with fluency and confidence the various stimuli that came his way, both from art and from nature itself. Impressionism was perhaps the beginning of his road. Yet without the excitement and shock of that early rapprochement, the course he chose might have been a very different one.

Umehara painted a wide variety of subject matter, ranging from portraits to still lifes and occasional genre scenes. He is most appreciated for his landscape paintings, both urban and rural. The juxtaposition of five of these works, from various periods, helps reveal the developing options to the painter made possible by Impressionism. The date of the last picture included (1940) lies far beyond the parameters set by Impressionism, but it is useful to see the playing out of the long-lived painter's early impulses.

The first of the five is a picture entitled *North of Kyoto: Yase* (plate 209), which was finished two years before Umehara's first visit to France and was evidently painted on the spot. The fluency of his brushwork is already visible, but his style was, in light of what was to follow, as yet relatively unformed. His 1921 *Notre Dame* (plate 210), painted in Paris, shows the results of his work with Renoir and his subsequent interest in Post-Impressionism and the work of Matisse. The contrast between the light on the bridge and the dark towers is a strategy unlike any employed in his early works. Back in Japan by 1924, he painted his *Haruna Lake* (plate 211), a scene of a popular resort area in the central Japan Alps area. Umehara went on to apply Fauvist coloring and broad brush strokes to a locale in his own culture. At the time of Kume's paintings, done in Kyoto two decades before, the public was not prepared to see actual Japanese landscapes recreated in such juxtapositions of color and texture. Now Umehara could meet with great success, using to good advantage his superb sense of color, texture, and easy fluency. Eleven years later, in 1935, in his much admired *Tropical Scenery* (plate 212), he used with equal assurance a more subdued palette in order to capture the lush scenery on the warm Izu peninsula, south of Tokyo, an area that at certain seasons reminded him of the south of France. On this occasion, there was no difficulty in moving from Europe to Japan. Changes in light, vegetation, and land contour posed no artistic problems for the painter.

From 1939 to 1942 Umehara worked several months each year in Beijing and found himself enchanted with the look of the city. "The Japanese sense of color lies in the beauty of subtle tonalities," he later

212. Umehara Ryūzaburō. *Tropical Scenery, Atami.* 1935. Oil on canvas, 29 × 24″. Menard Art Museum, Komaki

wrote. "But the Chinese sense of color lies in the beauty of the combination of primary colors. Both worlds are beautiful of course, but I have a yearning to paint in the world of such strong colors." Nothing could capture this cosmopolitan gesture more than his *Beijing* (plate 213). At home in Europe, Japan, and the Far East, Umehara showed in his talent and suppleness the domestication and the transcendence of the European models of painting that began to enter Japan with the coming of Impressionism. Those early contacts produced not only the kinds of paintings shown in this chapter, many of which owe much, directly or indirectly, to Impressionism, but also a liberation of Japanese tradition that has allowed a redefining in the visual arts to continue on to this day. Perhaps it is the importance to contemporary Japan of that sense of liberation for the arts provided by Impressionism that fuels even now the craze among Japanese patrons of the arts to purchase, at seemingly any price, European Impressionist works of art. They serve as icons, implicit symbols of the forces that brought about the whole opening up of Japan, in the arts and in every other sphere of life as well, during the last hundred years.

213. UMEHARA RYŪZABURŌ. *Beijing, The Forbidden City.*
1940. Oil on canvas, 45¼ × 89″. Eisei Bunko Foundation, Tokyo

# ITALIAN PAINTING DURING THE IMPRESSIONIST ERA

*Norma Broude*

ITALIAN PAINTING DURING the second half of the nineteenth century presents a diversity of style and direction that does not readily conform to the more familiar French art historical model for this period. It did not emerge from the cultural context of a single capital city; nor did it coalesce around a more or less unified national identity and cultural tradition. Instead, it developed in a number of major regional centers, such as Florence, Rome, Naples, Venice, and Milan. And it reflected the influences of a variety of distinct regional schools of painting—from the constructive linearism that marked Tuscany's heritage and sensibility to the painterliness and poetry of the northern Italian tradition—schools whose characteristic differences and rivalries can be traced back in some cases as far as the Middle Ages and the Renaissance.

At the same time, nineteenth-century Italian painters shared with their European contemporaries, including the French Impressionists, tastes and tendencies that are fully characteristic of their period. These included a preference for painting the life of their own time, a concern for sincere, personal expression, and a commitment to working in nature and responding to nature's light through studies made directly outdoors. Italian painters were also exposed to many of the same stimuli—for example, photography and Japanese prints—that affected the development of their colleagues in France and elsewhere in Europe.

While it may thus be said that Italian painters shared the broader Impressionist impulse of their period, they were for the most part uninfluenced by the particular stylistic form that this impulse took in France. A few Italian expatriate artists, such as Federico Zandomeneghi, Giovanni Boldini, and Giuseppe De Nittis, worked closely with the Impressionist group in Paris; and a few Italian critics, most notably Diego Martelli, were enthusiastic about the movement and even tried to promote it in Italy at an early date. Nevertheless, French Impressionist paintings were not widely known in Italy until the turn of the century, when the critic Vittorio Pica began to write about them and they began to appear with some regularity, albeit in small numbers, at the internationally oriented exhibitions of the Venice Biennale. Few Italian artists who traveled abroad during the last three decades of the nineteenth century seem to have been interested in or influenced by the French movement, and many of those who were exposed to it during these years, either at home or abroad, were openly hostile to it.[1]

An essential context for understanding some of the directions taken by Italian painters during this period is to be found in their country's social and political history. Throughout the first two-thirds of the nineteenth century, the Italian peninsula, which had long been factionalized and dominated by foreign powers, underwent a process of political and military struggle known as the Risorgimento (a word derived from the verb *risorgere*, "to rise again"), a process that finally culminated in political unification and the birth of the modern Italian state. After successful military campaigns led by

214. GIOVANNI BOLDINI. *Diego Martelli at Castiglioncello.* c.1869. Oil on wood, 8⅝ × 7¼″. Private collection

Giuseppe Garibaldi in 1859 against Austria, which controlled principalities in the northern and central parts of the peninsula, the New Kingdom of Italy was proclaimed in 1861, with Vittorio Emanuele II of Piedmont as its constitutional monarch and Turin as its first capital. Venice was regained from Austria in 1866 and Rome from the papacy in 1870, to become in the following year the capital of a fully united Italy. But the new nation remained culturally divided by ancient regional traditions that were not so easily swept away. Massimo d'Azeglio, a Piedmontese statesman, expressed the challenge of social and cultural fusion now faced by the new nation: "Italy is made," he said. "We have still to make the Italians."[2]

For the artists of Italy in the years before and after unification, this was indeed the challenge to be met. Encouraged by the state to assist in the process of defining and shaping their nation's cultural identity, many artists did so by entering into a dialogue, on distinctly modern terms, with the spirit and the forms of Italy's substantial and diverse artistic heritage (the taste among many Florentine artists of this period for the art of the Tuscan trecento and quattrocento is one example). Although designed to overcome regional differences, this process was one that in fact contributed, at least initially, to their perpetuation. Subjects for painting that had been popular ones earlier in the century, grandiose or sentimentalized depictions of scenes from Italian medieval history that often carried with them political messages relevant to the present, continued to be popular among academic artists in the years immediately following unification. But in the 1860s a growing demand for paintings to commemorate the recent battles and events of the Risorgimento began to give official sanction to what had already become a growing trend among more progressive Italian painters: the turning of art to the subject matter of contemporary life. Even conservative artists were now provided with the impetus to study nature and the world around them as a source of material for these paintings of contemporary "history." But among younger artists, the new political and cultural ambience stimulated widespread rejection of traditional values in favor of a dedication to studying nature and contemporary life outdoors—the key issues that had emerged for progressive painters in many parts of Italy by 1860.

Even though painting in late nineteenth-century Italy developed independently out of a variety of local artistic traditions and in response to a specific set of social and political concerns, Italian painters of this period have nevertheless frequently been compared with and likened to the French Impressionists. In particular, the Macchiaioli, a group of Tuscan painters who were active in and around Florence from the late 1850s on (and who are today perhaps the best-known group of nineteenth-century Italian painters outside of Italy), were for a long time described misleadingly as proto-Impressionistic "patch" painters and as an early group of plein-air artists whose work both anticipated and paralleled that of their better known and slightly younger

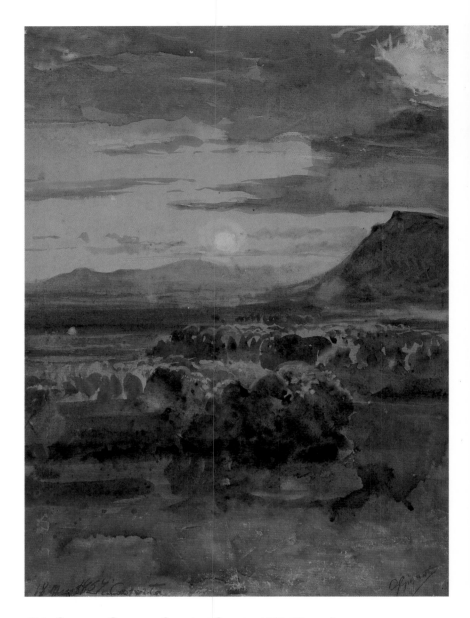

215. GIACINTO GIGANTE. *Sunset at Caserta*. 1857. Watercolor and gouache on paper, 13⅜ × 9⅞″. Museo di San Martino, Naples

French contemporaries. The style of French Impressionism, however, and the manner of seeing upon which that style was based, were never really congenial to these Italian painters, who had a fundamental attachment to the language of drawing. Although they were aware of the style by the late 1870s, the Florentines, on the whole, did not respond favorably to it. The major exceptions were the critics Diego Martelli and Adriano Cecioni, whose international interests prompted them, as early as the late 1870s and early 1880s, to try to put the Macchiaioli ("or *impressionists*, if we prefer to call them that," wrote Cecioni[3]) in the mainstream by relating their earlier activities to the current ones of the French Impressionists. Martelli and Cecioni's approach was eagerly adopted during the first half of the twentieth century by a host of Italian critics, dealers, and collectors, who, already beleaguered by the hegemony of French Impressionism, attempted to deliver the Macchiaioli from the

stigma of provincialism by claiming for them a prominent avant-garde position as Italian forerunners of the French school.

Ensuing efforts to measure the achievements of the Macchiaioli according to the foreign and artificial standard of French Impressionism led inevitably (given the early twentieth-century's bias in favor of the French style) to invidious comparisons. Such efforts gave way during the second half of the twentieth century, first to ostensibly more objective attempts to juxtapose the Italians and the French (attempts that nevertheless still took as a given the superior avant-garde position of the French movement[4]), and then, more recently, to a reluctance on the part of many Italian scholars to deal with the relationship between nineteenth-century Italian and French painting at all—apparently from a well-founded fear of perpetuating false comparisons and thereby obscuring the independent character and quality of the Italian school.[5] On a more positive note, the new attitude that has increasingly characterized Macchiaioli scholarship during the last two decades has been marked by the recognition that these artists lived and worked in Florence not Paris, by a concern for defining what was unique to their art and sensibilities because of that fact, and by the realization that their art, rather than "lacking" certain of the qualities of French Impressionism, offers us—precisely because of its national character and its indigenous roots—something else and something more. It is in these terms, as well as in an international context, that I propose to examine here the unique contributions of these and other Italian painters to the art of the Impressionist era.

## The "Macchia" in Naples and Florence

The ground for the development of *all'aperto* or outdoor painting in Italy during the second half of the nineteenth century was in part prepared in the regional academies where most Italian painters received their training. The strongest continuous traditions of landscape painting in early nineteenth-century Italy, for example, were fostered by the Austrian academies of Venice and Milan, where classes in landscape painting had been established as early as 1838, but most particularly in Naples. There, the local tradition of "view painting," initiated in the seventeenth century by the mythologized landscapes of Salvator Rosa, was reinvigorated in the early nineteenth century by the teachings of Antonio Sminck van Pitloo (1790–1837), a Dutch artist who became professor of landscape painting at the Neapolitan Academy in 1816, and by Gabriele Smargiassi (1796–1882), who followed him in that post in 1837. Both teachers encouraged their students to do landscape studies outdoors, in the countryside; and from the approach that they fostered, there emerged between 1820 and 1855 a generation of local landscape painters who joined together and became known as the School of Posillipo (after a site where they often painted). Giacinto Gigante (1806–

1876) is the best known of this group. In his work, landscape ceased to be the picturesque recording of local scenery and became instead, in the Romantic manner, a personal and poetic vision of nature's light and atmosphere (plate 215).

Also connected with the School of Posillipo were the Palizzi brothers, Giuseppe (1812–1888) and Filippo (1818–1899). In 1844 Giuseppe emigrated to Paris, where he was influenced by the Barbizon school artists. Filippo remained in Naples, and from the 1840s on, he became that city's best-known and most influential painter of animals and peasants. His work was based on *all'aperto* studies, which are scrupulously observed but also remarkably fresh recordings of the light, color, forms, and textures of nature (plate 216). His finished works, done in the studio, feature striking and poetically evocative "effects"—what Italian artists had for centuries referred to as "the *macchia*" of the picture, the tonal armature on which the picture is compositionally constructed. Unlike his predecessors, however, Palizzi did not invent his effects in the studio. Instead, he discovered them in the luminary effects of nature. Seeking out dramatic contrasts and expressive patterns of light and shadow outdoors, he recorded these effects of light *all'aperto* and then preserved them as the expressive bases of his studio-finished pictures.[6]

In 1868 the *macchia* was defined by the Neapolitan aesthetician and critic Vittorio Imbriani (a close friend of Filippo Palizzi and other progressive Neapolitan artists) as "a harmony of tones, that is, of light and shadow, capable of reawakening some feeling in the soul, of stirring the imagination to productivity." "The *macchia*," he wrote, "is the result of the first, remote impression either of an object or a scene; the first and characteristic effect, which imprints itself upon the eye of the artist."[7] The tonal *macchia* was extremely influential among Italian painters, particularly in Naples and Florence, during the second third of the nineteenth century. Conceived as the necessary expressive and structural ingredient in a finished painting, where it should be visible despite the addition of descriptive "finish," it remains most readily apparent to the twentieth-century eye, however, in studies and sketches.

A striking example is the *Piazza San Marco* (plate 217), painted in 1869 by the Neapolitan artist Michele Cammarano (1835–1920) during a sojourn in Venice, one year before he made his first trip to Paris. An image of urban modernity, it presents a scene of the upper middle-class at leisure in a crowded and fashionable public setting, and as such it is an unusual work for a nineteenth-century Italian painter. On grounds of both theme and style, it would seem to invite comparison with Édouard Manet's *Music in the Tuileries Gardens*, painted several years earlier, in 1862 (plate 23). But unlike Manet's work, painted from the point of view of the flaneur/participant in this world, Cammarano's quick and scintillating impression carries within it an element of moralizing social satire that is not uncommon in the work of this artist; and it is typical as well of eighteenth-

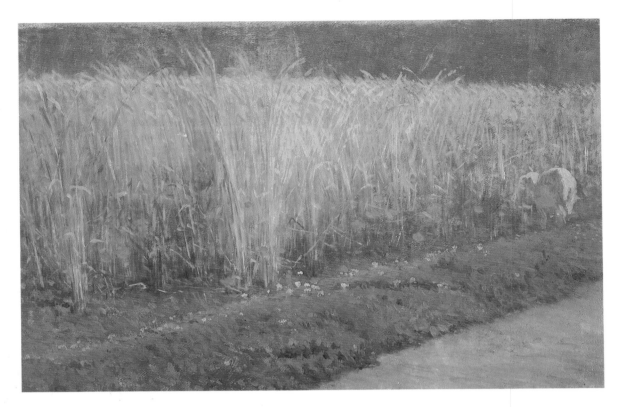

216. Filippo Palizzi. *Ripe Grain.* c.1850. Oil on canvas,
6¼ × 9⅝″. Galleria d'Arte Moderna, Palazzo Pitti, Florence

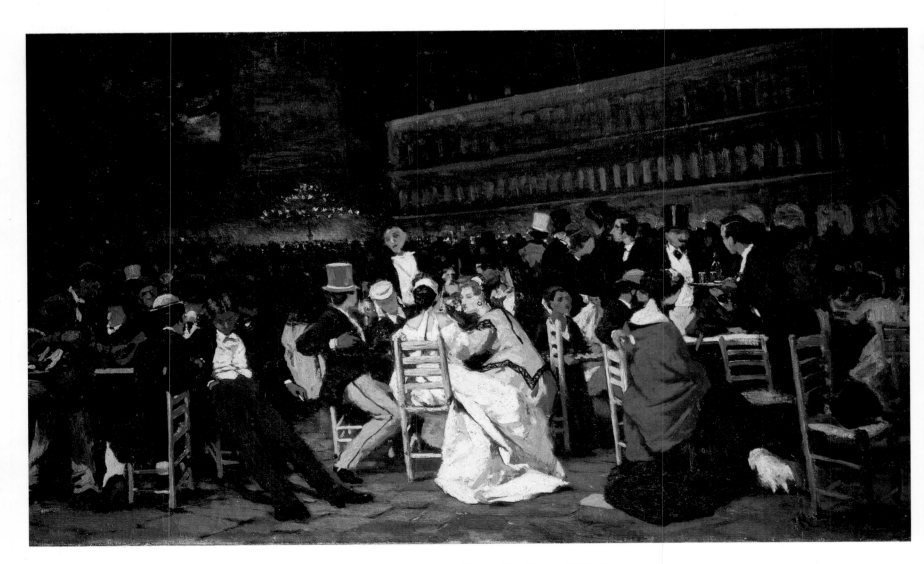

217. Michele Cammarano. *Piazza San Marco.* 1869. Oil on
canvas, 10⅝ × 17⅜″. Galleria Nazionale d'Arte Moderna, Rome

century Venetian painting—for example, the work of Pietro Longhi—a tradition to which Cammarano's study also appropriately relates. Painted in a rich range of blacks, whites, and grays, with occasional touches and areas of red and yellow ocher, this tiny sketch is executed with a bravura directness of touch and a taste for dramatic contrast that are exaggerated by its *bozzetto* format, but that nevertheless relate it stylistically to Manet's slightly earlier work—a relationship that is to be explained in this instance not by direct influence, but by the common sources in seventeenth-century Italian and Spanish painting that inspired both artists.

The Neapolitan concern for the relationship between effect and expression spread north to Florence in the 1850s, taken there by artists such as Domenico Morelli and Saverio Altamura, who had been forced to leave Naples and take refuge in Florence after the abortive political uprisings of 1848 (a series of largely unsuccessful rebellions that is sometimes referred to as Italy's "First War of Independence"). One of the politically and culturally most progressive areas in preunification Italy, Florence had become a haven for exiles and refugees from more repressive states, and the famous Caffè Michelangiolo on via Larga (today via Cavour) became a meeting place for artists from all over Italy as well as for those visiting from abroad. As a result of contacts made and ideas exchanged in this way, several of the younger Florentine painters were inspired to make their first attempts to study nature outdoors in the years between 1855 and 1860, and they soon began to use the vigorous light and dark contrasts, or "effects," discovered in nature through sketching, as the structural and expressive bases of their finished works. Given to pictorially constructive uses of light and shadow, as distinct from the more dramatic and painterly tonal oppositions generally preferred by the Neapolitans, the emerging Florentine school was originally described by the local press in the late 1850s as the "*Effettisti*"—artists who overemphasized effect. They received their more familiar name, the Macchiaioli, in 1862, when a hostile critic jokingly seized on the multiple meanings of *macchia*, a word that can mean "rebel," "sketch," and "patch" as well as "effect." The Macchiaioli were thereby branded as rebels against academic discipline and criticized for daring to display paintings that seemed, to conservative eyes at the time, to be mere unfinished sketches.[8]

The violent and exaggerated chiaroscuro that had characterized the earliest efforts of many of these artists soon gave way, by the early 1860s, to more mellow and poetic uses of light. Traditional literary and historical subjects were now abandoned as these artists who worked in Tuscany began to paint out-of-doors more consistently. In response to the postunification call for an Italian art, they turned for their subjects to the local landscape, the activities of workers and animals in the fields, and the life of the city streets and rural villages of their region. The Neapolitan-born painter Giuseppe Abbati (1836–1868), who settled in Florence in 1860, reached artistic maturity over the next few years in this

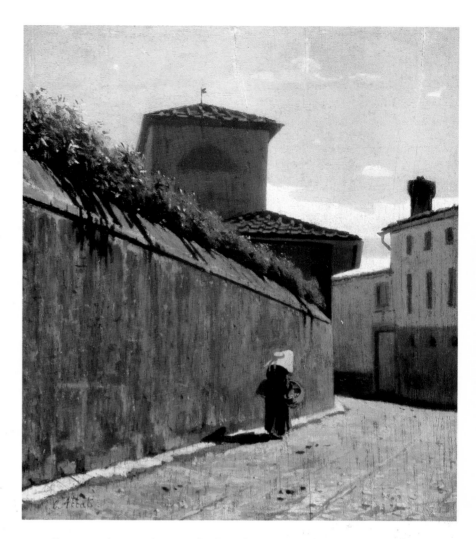

218. Giuseppe Abbati. *Street in Sunlight.* 1863. Oil on wood, 10¼ × 9″. Giacomo and Ida Jucker Collection

ambient as he came to grips with the *macchia* and the painting of contemporary life *all'aperto*. Attracted to architectural motifs and fascinated by the challenge of translating with his pigments both intense and subtle contrasts of sunlight and shadow, Abbati, who died in 1868 at the age of thirty-two, developed into a brilliant painter of the poetry of light. Typical of his work is *Street in Sunlight* of 1863 (plate 218), an archetypal image of a sun-drenched and silent Florentine street, in which are explored the effects of intense sunlight on color and architectural form.[9]

A coloristically distinctive variant on this tonal mode of outdoor study is offered by the work of the equally brilliant and promising Raffaello Sernesi (1838–1866). Born in Florence, Sernesi responded in his youth to the inclinations of his Purist teachers at the academy by studying and copying the works of such quattrocento masters as Masaccio, Fra Filippo Lippi, and Botticelli. About 1860 he began to paint studies in the open air, and, like his friends at the Caffè Michelangiolo, he was attracted to motifs that offered bold tonal contrasts of sunlight and shadow. But he added to their essentially tonal approach a responsiveness to strong, clear color,

219. RAFFAELLO SERNESI. *Roofs in Sunlight.* c.1860–1861.
Oil on cardboard, 4⅞ × 7½″. Galleria Nazionale d'Arte
Moderna, Rome

220. GIOVANNI FATTORI. *French Soldiers of '59.* 1859. Oil on
wood, 6⅛ × 12⅝″. Private collection

221. GIOVANNI FATTORI. *Woman in Sunlight*. c.1866. Oil on wood, 11 × 4¾". Giacomo and Ida Jucker Collection

and in particular to the azure and terra-cotta hues that are associated not only with Tuscany's landscape but also with its fresco tradition. Sernesi's startlingly simplified rendition of the motif of roofs in sunlight (plate 219), painted in Florence between 1860 and 1861, is typical of his jewellike studies, which are small in size but broadly painted and intrinsically monumental in their proportions. With its firm drawing and the rectilinear clarity of its spatial and compositional organization, it reflects the strength of Sernesi's attachment to his Tuscan Renaissance heritage.

For the Livornese painter Giovanni Fattori (1825–1908), the experience of working outdoors also brought with it, at an early date, a lightening and expansion of the palette to include the clear and intense local colors characteristic of the Tuscan environment.[10] Among the earliest of his outdoor studies is *French Soldiers of '59* (plate 220), a rapidly and vividly painted little panel done in the spring of 1859 from the artist's observations of the French soldiers who were quartered at the Cascine on the outskirts of Florence. Going far beyond the anecdotal reportage then normally associated with the treatment of such subjects, Fattori explores and communicates, through subtle spatial manipulations, the psychic distances that separate these figures, who are randomly observed in their ordinary activities. Also apparent in this early work is Fattori's taste for the flattening and patterning of forms in a narrow space, a predisposition that helps to explain his precocious openness to and creative assimilation of the lessons of the Japanese print. The influence of Japanese prints was widespread among Italian artists by the mid-1870s. But their impact on Fattori can already be observed in the early 1860s, in studies such as *Woman in Sunlight* (plate 221), painted around 1866, in which the flattening and silhouetting of the form, along with the extraordinary delicacy of its drawing and placement, suggest the influence of an orientalizing mode of vision.[11]

*Woman in Sunlight* is one of a small group of dazzling outdoor studies painted by Fattori in the mid-1860s, scenes in which his wife and his artist friends are observed as they sit, stroll, or paint, in garden settings, on the rocks, or in the bathing establishments along the seacoast just outside Livorno. Because of the thematic area into which Fattori ventured with these small-scale studies—the casual sociability of the middle-class vacationer and stroller out-of-doors—these are works that have often invited comparison with French Impressionism. But they are not typical of Fattori's thematic interests; nor do these images of middle-class leisure appear to have satisfied this artist's need to make significant social statements about contemporary life through his art, for he never chose to develop large-scale compositions from these outdoor studies, as was otherwise his practice.

The classes of people with whom Fattori himself most readily identified were the rural laborers, peasants, and soldiers in the new Italian state; and it is their life and lot that are presented and often monumentalized in

the majority of his studio-painted works. For these images, which depict for the most part soldiers and cowboys on horseback and peasants working in the fields, Fattori amassed an extensive body of outdoor studies, studies of animals, individual figures, and landscape motifs (plate 222). Most were painted on tiny panels of unprimed wood, frequently the panels of dismantled cigar boxes. Thinly and rapidly painted, with a limited palette and with the warm brown color of the wooden support showing through, they often depend, in the traditional manner, on the medium ground tone of the wood to help establish the value scale of the picture, thus aiding in the quick notation of the *macchia*, the effect of nature's light. These studies provided Fattori throughout his career with a repertoire of stock images, and he depended on them in his studio practice for the "truthfulness" of his luminary effects and documentary details. But even though they were central to his practice, as well as to his conception of himself as a "realist" and a progressive Macchiaiolo painter, these *macchie*, these impressions from nature, were not sold or exhibited during Fattori's lifetime; nor did he intend them to be judged or valued in themselves as completed works of art.

A similar attitude toward the value of the outdoor study and its relationship to the studio-finished painting can be found in the work of Silvestro Lega (1826–1895), another major artist who emerged from the *macchia* movement in Florence in the early 1860s.[12] Unlike Fattori, however, Lega is best known for his paintings of the quiet and traditional aspects of everyday bourgeois life in Tuscany, the domestic life and family values of the rural villas, in which women and children are the main protagonists. In the 1860s Lega lived and worked at Piagentina, in the countryside along the Arno outside of Florence. Here, in 1868, inspired by the lives of the people around him, he painted *The Pergola* (plate 224), in which a group of women (identifiable as members of the Batelli family, with whom Lega lived, and their friends the Cecchinis) are served their after-dinner coffee as they sit together in the shade of an outdoor arbor. With its harmonious and reserved composition, tidy and rectilinear spatial organization, careful drawing, and figures placed in frontal and profile postures, *The Pergola* conveys an air of solemnity and quiet simplicity, a gentle formality that recalls, not accidentally, the artist's Italian Renaissance heritage.

Although *The Pergola* is a carefully constructed and studio-finished painting, it nevertheless exemplifies, both thematically and stylistically, what Lega meant when he talked during these years about "*il vero*" and a work "done from nature." And it also perfectly exemplifies what a painting constructed according to the *macchia* principle was supposed to be like. For it was conceived in terms of a basic *macchia*, a strong luminary effect that structures the composition and that had first been discovered and recorded by the artist in separate studies from nature (such as plate 223). As a record of real people in nature, assembled in the studio from disparate studies, *The Pergola* is comparable both in theme

222. GIOVANNI FATTORI. *Haystacks.* c.1867–1870. Oil on wood, 6¾ × 5⅛". Private collection

223. SILVESTRO LEGA. Study for *The Pergola.* 1864. Oil on wood, 10 × 6¼". Private collection

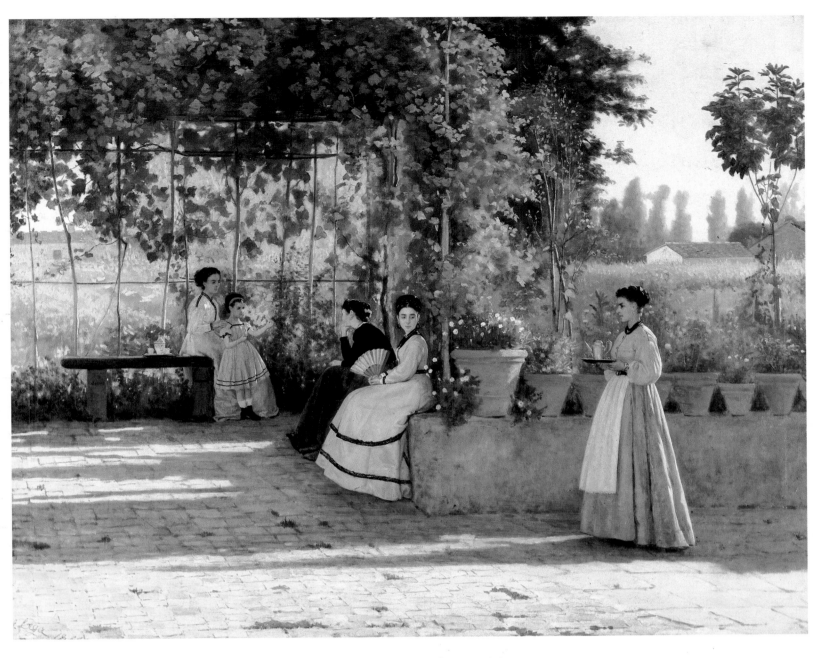

224. SILVESTRO LEGA. *The Pergola.* 1868. Oil on canvas,
29½ × 36⅞″. Pinacoteca di Brera, Milan

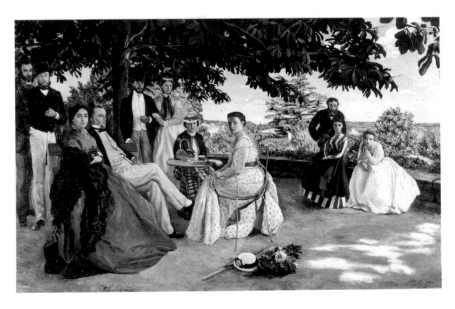

225. FRÉDÉRIC BAZILLE. *The Artist's Family on a Terrace
Near Montpellier.* 1867. Oil on canvas, 59⅞ × 90½″. Musée
d'Orsay, Paris

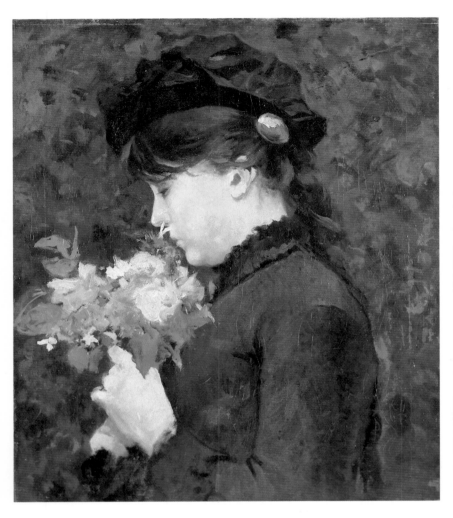

226. SILVESTRO LEGA. *Portrait of Eleonora Tommasi.* c.1884.
Oil on canvas, 18⅞ × 15¾″. Ojetti Collection

rence for several years, Martelli was introduced to the artists who gathered at the Café Nouvelle-Athènes (which he likened to the Caffè Michelangiolo), and he became especially well acquainted over the course of his stay in 1878–1879 with Manet, Degas, and Pissarro. An alert and receptive art-world observer, Martelli developed a positive taste and enthusiasm for the work of the Impressionists during this year in Paris, and, apparently believing that there would be a natural affinity between these artists and the Macchiaioli, he made every effort to share this new enthusiasm with his friends at home. In September 1878 he persuaded Camille Pissarro to send two canvases to Florence to be shown at the next annual exhibition (1879) of the local Society for the Promotion of the Arts.[14] Despite the letters that Martelli wrote to prepare his friends for Pissarro's paintings, they were accorded a cool and even hostile reception by the majority of these artists, who, like Fattori, were dismayed by their lack of conventional drawing and tonal modeling.[15] Upon his return to Tuscany in 1879, Martelli gave a public lecture on Impressionism at the Circolo filologico in Livorno, in which he used the findings of physiological optics to defend as natural the Impressionists' mode of achieving their effects with flecks of color instead of with drawn contours.[16] But among local painters, except for artists such as the well-traveled and cosmopolitan Telemaco Signorini, who was already among the converted, few responded positively to Martelli's sophisticated and precocious efforts to proselytize for the Impressionists and their work.[17]

An exception was Silvestro Lega, who had expressed admiration for the paintings sent by Pissarro[18] and who also appears to have had a positive response to the work of Edouard Manet, whose more studio-focused practice, even during the years of high Impressionism, would have made him a more congenial and accessible figure for the Italians. In a series of portraits that Lega painted in the early 1880s, including the *Portrait of Eleonora Tommasi* of about 1884 (plate 226), his work displays a tonal vivacity, a bravura directness of touch, and a virtually shadowless illumination of the figure in an outdoor setting that recall similar strategies and techniques in the work of Manet. Also relevant to Lega's work during this period was a major painting by Manet, *The Laundress* (c.1874; The Barnes Foundation, Merion, Pennsylvania), which was on display in Florence at the exhibition of the Donatello Society from September through March of 1881 and which may in part have helped to inspire or to support the direction of many of Lega's later works—freely brushed studies that often take as their subject a woman or group of women, sometimes accompanied by a child, who work, sew, or read out-of-doors or in an interior setting (plate 227).

Affinities between Lega and Impressionism were in fact noted by Martelli, who wrote about Lega's work of the early and mid-1880s that it bore "a great resemblance to the serene gaiety of the French Impressionists."[19] However, the broad painterly style of Lega's late work, which contributes so much to this effect, was not

and synthetic method to several French works of the same period, such as Claude Monet's *Déjeuner sur l'herbe* (plate 24), or Frédéric Bazille's *The Artist's Family* (which shows his family on the terrace of their home near Montpellier; plate 225). Despite differences in technique, it is arguably in the work of the Italian painter that one finds at this early date a more convincing thematic and luminary integration of the figures into their outdoor setting, as well as a greater dependence upon that setting and its light, to establish the mood and atmospheric unity of the picture as a whole.

Artists such as Lega and Fattori, who rarely left their Tuscan homes, had no contact with the work of the emerging French Impressionists until 1879, when the Florentine critic and writer Diego Martelli returned to Italy after a year's sojourn in the French capital.[13] Martelli was a long-time friend and early supporter of the Macchiaioli, and his seaside estate at Castiglioncello, on the western coast near Livorno, was a favorite site where many of them gathered to paint from nature in the 1860s and 1870s. Given access to the Impressionist circle in Paris by such Italian expatriate artists as Federico Zandomeneghi and Giuseppe De Nittis and by the French engraver Marcellin Desboutin, who had lived in Flo-

ITALIAN PAINTING DURING THE IMPRESSIONIST ERA

227. SILVESTRO LEGA. *Signora Eleonora Tommasi Cecchini with Franca and Maria Cecchini in a Meadow.* 1885. Oil on wood, 9⅝ × 14⅛″. Private collection

228. SILVESTRO LEGA. *Angiolo Tommasi Painting in a Garden.* c.1885. Oil on canvas, 14¾ × 10¾″. Private collection

consciously sought after or welcomed by the artist, who had been suffering from an eye disease since the early 1870s. By the mid-1880s, Lega's steadily deteriorating eyesight had reduced him to seeing only in broad masses and general tonalities, causing him in his later years great anguish and frustration over not being able to finish his works with as much descriptive detail as he had once been able to do—over not being able to carry them, in essence, much beyond the stage of the initial *bozzetto d'impressione* from nature.[20] Lega's work and his *all'aperto* painting practice were nevertheless an inspiration to several young artists for whom he acted as a mentor during these years. Among them was Angiolo Tommasi, whom Lega sketched in the act of painting a landscape in the garden of the Tommasi villa at Bellariva in 1885 (plate 228). In this quickly painted study, Lega captures the sparkling accents of warm sunlight that filter through the dense foliage surrounding the garden path and that bounce off the large umbrella shielding Tommasi and his canvas from the sun's glare.

Lega's continuing ability during his later years to organize his compositions into broad masses as well as his sensitivity to natural light is reflected in the work of Giulia Bandini, who was one of the most talented of Lega's pupils (although very little of her work is now known).[21] Bandini's *Landscape* (plate 229) was probably painted in the late 1880s, during a period when Lega was a frequent guest at her parents' villa in the hilly Gabbro region around Livorno. Distinguished by the clarity of its planar organization and by its brushwork, which is both delicate and precise, this little study is remarkable both for the strength of its compositional patterning and for its atmospheric evocation of the sun-filled and rugged terrain of the Gabbro region, which was Bandini's home.

Telemaco Signorini (1835–1901) was far more cosmopolitan and international in outlook than either Fattori or Lega. A native Florentine, he traveled abroad frequently in search of new experiences, contacts, and markets for his work (he went to Paris in 1861, 1868, 1873–1874, 1878, 1881, 1883, and 1884; and to London in 1873–1874, 1881, 1883, and 1884).[22] As early as 1862, he declared himself in support of a new, revitalized, Italian art that could rival both the splendors of the Italian past and the contemporary art of Belgium, France, and England.[23] Signorini was far more open to shifts in international taste and style than were many of his friends; but he always maintained his cultural identification with his Italian heritage, a heritage that marks and informs the best of his work.

An early polemical spokesman for the Macchiaioli, Signorini was among the first of the artists in this circle to experiment, in the late 1850s, with the "violent chiaroscuro" and the expressive effects of natural light studied out-of-doors that characterized the initial group activity of these artists. Quickly abandoning the *macchia* in its original form, Signorini was attracted in the 1860s by the concept of the social mission of art, as expounded in the writings of the French social philosopher, Pierre-Joseph Proudhon (1809–1865).[24] Perhaps

229. GIULIA BANDINI. *Landscape.* c.1887–1890. Oil on wood, 8¼ × 6¾". Galleria d'Arte Moderna, Palazzo Pitti, Florence

230. TELEMACO SIGNORINI. *The Ward of the Madwomen at S. Bonifazio in Florence.* 1865. Oil on canvas, 26 × 23¼". Galleria Internazionale d'Arte Moderna di Ca'Pesaro, Venice

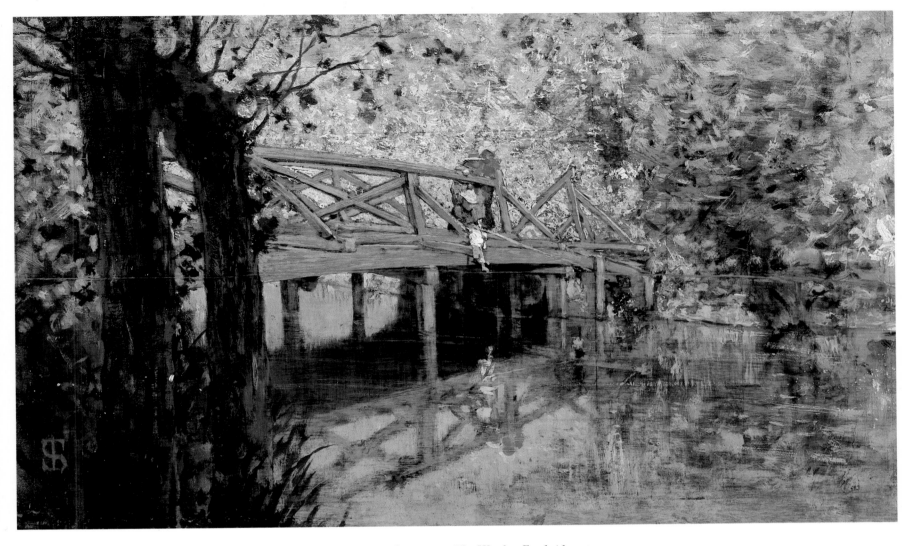

231. TELEMACO SIGNORINI. *The Wooden Footbridge at Combes-la-Ville*. 1873. Oil on wood, 6½ × 10⅜″. Collection Piero Dini

232. TELEMACO SIGNORINI. *Via delle Torricelle*. 1874. Oil on canvas, 18½ × 15″. Private collection

inspired as well by international currents in Realism and literary Naturalism, he painted his powerful and evocative *The Ward of the Madwomen at S. Bonifazio in Florence* (plate 230), dated 1865, a picture that depends on vivid backlighting and a tensely exaggerated perspective space for its emotive impact. The French artist Edgar Degas was reportedly greatly impressed with this painting when he saw it on a visit to Florence in 1875,[25] and he clearly shared Signorini's thematic taste for social realism.

Degas had strong personal ties to Italy. In his youth, he had made frequent trips there to visit his family in Naples and Florence and to study the art of the Renaissance, a tradition in which his art, like that of the Macchiaioli, would always remain strongly rooted. A lengthy stay in Florence, from August 1858 through March 1859, had put him into contact with the artists who gathered at the Caffè Michelangiolo. Their preoccupation with Barbizon painting during these years would have provided no revelations for Degas; but their intense interest in photography and in caricature may have stimulated in the young Frenchman an early interest in these visual forms, which would remain with him

throughout his career. Degas returned briefly to Florence for a visit in the spring of 1860 and may have been the agent for Giovanni Fattori's precocious exposure to Japanese prints, at a time when these would not otherwise have been known in Italy. Although Degas appears to have enjoyed a close friendship with Fattori in his youth (a portrait drawing of Degas by Fattori survives from this period), there is no evidence of later contact between them. Other early contacts made by Degas in Florence, however, most notably with Signorini and Martelli, were renewed and extended in later years when these and other Italians visited Paris.[26]

Among Signorini's friends in Paris in addition to Degas were the Italian expatriate painters Giuseppe De Nittis and Giovanni Boldini. In 1873–1874, Signorini stayed with De Nittis in Paris and traveled with him to London. In the summer of 1873, Signorini painted from nature for several months alongside his friend Boldini at Combes-La-Ville in the countryside some twenty miles southwest of Paris. Landscape studies such as *The Wooden Footbridge at Combes-la-Ville* (plate 231) are among the works that Signorini painted there. With its dappled and painterly brushwork and its diffused handling of the mellow French sunlight, the study is painted in a manner that suggests a precocious familiarity on Signorini's part with the work of the French Impressionist landscape painters. Although theirs was a manner that continued to surface upon occasion in Signorini's work, it was not, on the whole, typical of his style or of his vision.

Nor is the biting social realism of *Ward of the Madwomen* typical of the larger body of Signorini's work. Instead, his oeuvre is for the most part dominated by Italian street and market scenes. Many of these were painted with their sales potential on the international art market in mind and can therefore border, sometimes precariously, on the anecdotal and the picturesque. But this was a genre in which Signorini also did some of his finest and most innovative work. *Via delle Torricelle*, for example, of 1874 (plate 232), with its typically clear lines and strong planes, is a work of deceptive simplicity. In it, the street and buildings are presented from a very low point of view and within a radically exaggerated one-point perspective system that suggests the influence not only of the Italian Renaissance tradition but also of contemporary photography, both of which were of major importance to Signorini. (Since the 1850s, photography had been of widespread interest to artists in Florence, and the Alinari brothers had opened their photographic studio there in 1854.) The radical cropping of the architectural forms at the right and the inclusion of such hitherto marginal and ignored elements of contemporary visual experience (the graffiti, for example, scrawled inconspicuously on the wall at the far left) also attest to the impact of photography on Signorini and the extent to which his visual habits and strategies had been shaped by its characteristics and its conventions.[27]

Signorini was open to the work of the French avant-garde and shared many sources and interests in common with them. But despite his international outlook, his frequent travels abroad, and his contacts with the international art market, his own art remained demonstrably Italian. Among the other Macchiaioli, those who traveled abroad infrequently or not at all tended to be more resistant to the aesthetic, and particularly the loose brushwork, of the French Impressionists. Even Lega abandoned clear drawing and careful finish in his later works only when forced to do so by failing eyesight and not as a matter of aesthetic choice. Like the landscape painters among the French Impressionists, the Macchiaioli valued their spontaneous studies of light made outdoors because they were sincere and direct expressions of their personal responses to nature. Like the Macchiaioli, the French Impressionists also felt the need to develop and refine their initial responses to nature's light. But while for the French, the finished painting was a balance (in Monet's words) of both "observation and reflection," with a clear emphasis on the former, for the Macchiaioli, the need to conceptualize, to produce the effect of a solid and stable nature, normally outweighed the need to preserve the freshness of an immediate response. Their distinctive manner of balancing this difficult modernist equation was very much in keeping with their classicizing Tuscan heritage.

## The Italian Expatriates: Boldini, De Nittis, and Zandomeneghi

In a different category, though no less clearly Italian in their styles of painting, are the expatriates, members of a fairly large colony of Italian artists, many of whom had emigrated to Paris in the 1860s and 1870s. Attracted to Paris by its thriving art market, they hoped to take advantage of the lucrative contracts that dealers such as Goupil and Reitlinger were offering artists who could produce what their market craved—essentially Rococo costume and genre scenes. Several Italian painters achieved considerable success in this commercial realm.

The Italians, however, were at best ambivalent about the opportunities that Paris offered, lamenting on the one hand the neglect and stagnation that artists who stayed at home could expect to face but disdainful at the same time of the commercialism of the Paris art world and fearful of its corrupting influence on young and independent talents. As Diego Martelli succinctly and somewhat scornfully described the situation from the Italian point of view:

> In Italy, artistic genius has no value.... In France, instead, genius is a speculative commodity to be bought and sold; merchants of books and pictures collect young artists who can entertain the public. That is why, in Italy, genius can remain independent and untamed, while in France it is bound up with commercial interests and prostituted to public taste.[28]

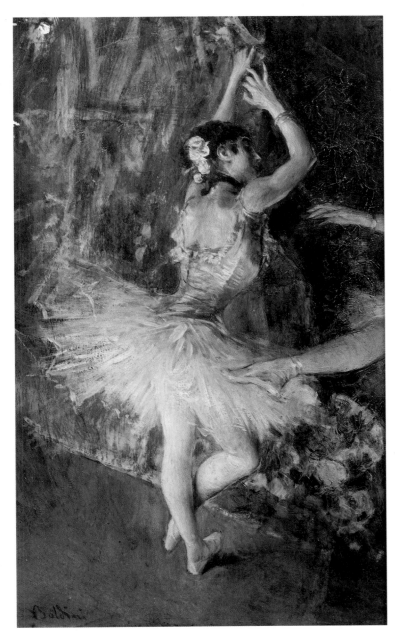

233. GIOVANNI BOLDINI. *At the Dance Class.* n.d. Oil on wood, 10¼ × 6¼". Private collection

Of the three Italian expatriates—Boldini, De Nittis, and Zandomeneghi—who emerged as significant figures in the French art world during the Impressionist era, Boldini and De Nittis were artists who achieved great international prominence in their own day as painters of and for the fashionable world of high society. It is Boldini who may be said to have fallen prey most clearly to the dangers of commercialism that Martelli described; while the prolific and immensely popular De Nittis walked such a careful and narrow line between conservative and progressive tendencies, between French taste and his own Italian sensibility, and between what was genuinely new and what was merely fashionable in the Parisian art world, that his very real stature as an independent artist still remains to be defined and reassessed. Of the three, however, it was Zandomeneghi—an artist who in his own time was neither commercially successful with dealers and collectors in Paris nor fully accepted by the independents with whom he, among all of the Italians, most fearlessly threw in his lot—who emerges not only as the most interesting and influential of the expatriates, but also as the most innovative and experimental of the Italians who worked and exhibited in the colorful shadow of "the new painting" in Paris.

In 1862 Giovanni Boldini (1842–1931) traveled from his native Ferrara to Florence to study at the academy and quickly joined the artists who gathered at the Caffè Michelangiolo.[29] Here, he soon became known for his talent as a portrait painter. In a series of small, informal portraits of his artist-friends, Boldini combined the Florentine taste for strong tonal structure with his own innate verve and painterly facility on the one hand and a personal empathy for his sitters on the other, and produced works that many regard as the strongest of his career. Also part of the Tuscan experience for Boldini was exposure to *all'aperto* painting, as it was being practiced in the 1860s by the Macchiaioli in the countryside around Florence and at the seaside estate of their supporter Diego Martelli at Castiglioncello. It was at the latter site, probably around 1869, that Boldini painted one of his rare outdoor portraits, an informal and relaxed image of the robust Martelli (plate 214), whom he portrayed not as the pensive writer and critic in his study (as both Zandomeneghi and Degas would later paint him), but in his other, very different persona, the manager of extensive rural farmlands. Dressed in his country clothes and seated casually on what appears to be a piece of farm equipment, he is seen against a background of loosely painted foliage and a sun-dappled wall.

In 1867 Boldini had briefly visited Paris to see the Exposition Universelle, and in 1871, after a successful stint as a society portrait painter in London, he was able to fulfill his ambition to return there to settle. Under contract to the picture dealer Goupil, he quickly began to turn out detailed and glittering genre pictures in the manner of Meissonier and Fortuny, pictures that featured pretty women in fashionable settings and that appealed to Goupil's largely French and American clientele. During these early years in Paris, a painting such as *Highway at Combes-la-Ville* (plate 234) is a rare reversion to the *all'aperto* tastes inculcated by Boldini's earlier Tuscan experience. Painted in the summer of 1873 at Combes-la-Ville, perhaps under the influence of Signorini, who had worked there alongside his friend during that same summer,[30] its lightened palette and blond luminosity may reflect the influence of Boldini's experiences in France; but the broad sweep of its strong, perspectival structure and its tonal clarity are thoroughly Italian.

Among the work of the Parisian avant-garde, Boldini seems to have admired most of all the figurative naturalism of Manet and Degas. He was on friendly terms with Degas, with whom he traveled to Spain in 1889. Although Boldini never exhibited with the Impressionists, he, too, was in the habit of sketching the

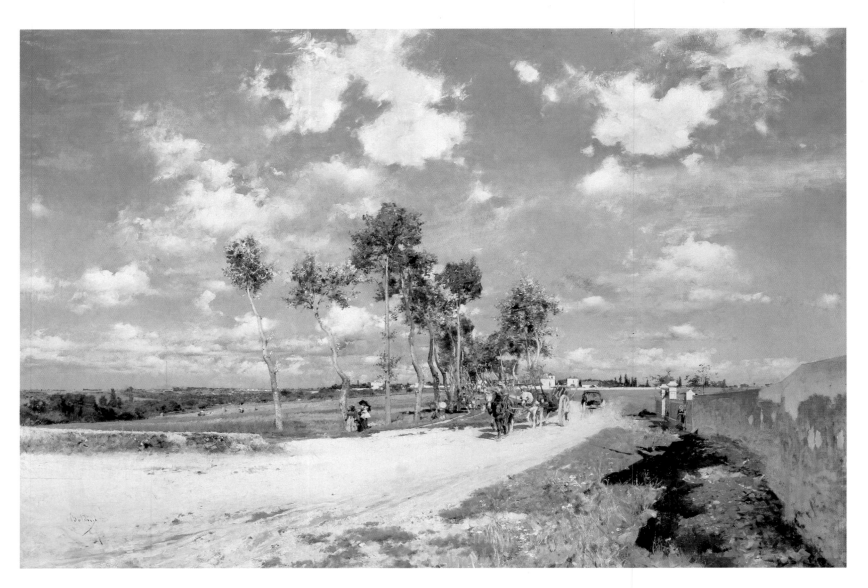

234. GIOVANNI BOLDINI. *Highway of Combes-la-Ville.* 1873.
Oil on canvas, 27½ × 40⅛″. The Philadelphia Museum of Art.
The George W. Elkins Collection

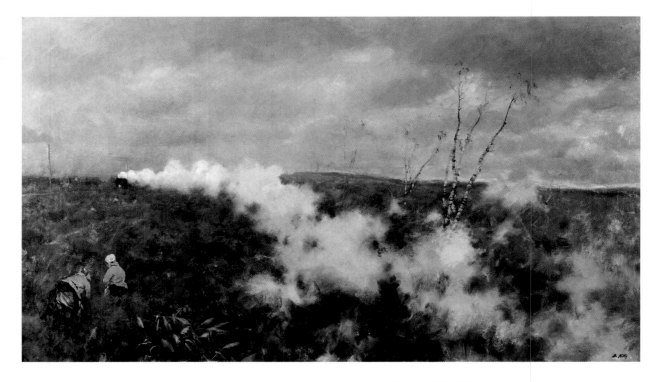

235. GIUSEPPE DE NITTIS. *The Passing Train.* 1869. Oil on
canvas, 29⅞ × 51¼″. Museo Civico, Barletta

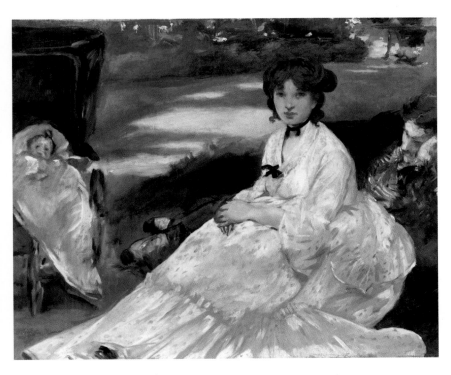

236. ÉDOUARD MANET. *In the Garden*. c.1870. Oil on canvas,
17 × 21⅝". Shelburne Museum, Shelburne, Vermont

contemporary world from the windows of his studio by
day and from theater boxes by night. However, his own
essays into the thematic realms associated with his
avant-garde friends—for example, his *At the Dance Class*
(plate 233)—reveal him to be more concerned with the
sensual display and commercial appeal of the exagger-
ated female form than with a slice-of-life, naturalist
vision of the contemporary world.

Around the turn of the century, Boldini achieved
enormous international success as a fashionable portrait
painter. His much sought-after work was characterized
by an increasing freedom of draftsmanship, carried by a
brush stroke that was swift, spontaneous, and gestural
but which never interfered with the elegant realization of
the likenesses of his high-society sitters. This late style,
which made Boldini famous for several decades, was
visually exciting and full of vigorous movement, a stun-
ning virtuoso performance in its best examples. But at its
worst, it was a technique that could lapse into stylization
and repetitive mannerisms.

Giuseppe De Nittis (1846–1884) came from Bar-
letta in the south of Italy and studied in his youth at the
academy in Naples.[31] His interest in painting landscape
and scenes of contemporary life soon prompted him to
begin working outdoors, and to this end he joined with
other local artists, including Marco di Gregorio and
Federico Rossano, to form the so-called School of Resina.
The presence in Naples, between 1864 and 1867, of the
Florentine sculptor and critic Adriano Cecioni, who
brought news of developments in Florence, greatly stim-
ulated them in this enterprise. In 1867 De Nittis visited
Florence and then Paris for several months. The follow-
ing year, he returned to Paris with the intention of

settling there. Like Boldini, he painted costume and
genre pieces for Goupil and Reitlinger and was instantly
successful in the commercial realm. He was diverted
from this path, however, by a visit early in 1870 from
Cecioni (who was highly critical of French Salon art and
of his friend's capitulation to the market[32]), as well as by
the Franco-Prussian War, which prompted his return to
Italy and to the scene of his earlier *all'aperto* experiments
from late 1870 to 1872.

Those earlier experiments, however, had not been
entirely abandoned by De Nittis even during this first
period in Paris, as his painting *The Passing Train* (plate
235) of 1869 attests. The train, leaving its prominent
swathe of dissolving steam across a field in which, by way
of contrast, two peasant women are shown at work, is a
theme of intense modernity. As a motif, it is very different
from the rural roads with horse-drawn carts and car-
riages that had provided the subjects for some of De
Nittis's earlier Neapolitan landscapes—although it is to
those earlier pictures that we must turn to find the ori-
gins of the diagonal structure of this composition and the
artist's interest in depicting vaporous atmospheric ef-
fects.[33] De Nittis was already on good terms with Degas
and Manet during these years. In 1870 Manet had vis-
ited De Nittis's summer house outside Paris in Saint-
Germain-en-Laye and may have painted there a picture
that several writers describe as Manet's first fully plein-
air work, a work for which De Nittis, his wife, and their
infant daughter have sometimes been identified as the
models (plate 236).[34]

De Nittis, who already had a reputation as a
successful Salon painter, was recruited by Degas to par-
ticipate in the first Impressionist exhibition in 1874. He
appears in the catalog of that exhibition with five works,
three of them on Italian subjects: one entitled *Road in
Italy* and two of his extraordinary atmospheric studies of
Mount Vesuvius.[35] Because of Renoir's opposition to
their inclusion, however, De Nittis's works were appar-
ently not hung until after the show opened.[36] De Nittis's
enthusiasm for the project as well as some of his ambiva-
lence are reflected in two letters he sent to Cecioni in
Florence for publication in the latter's magazine, *Il Gior-
nale Artistico*. In the first, he proudly announced his
identification with the new French group and expressed
the hope that Manet would be persuaded to exhibit with
what he called "our society."[37] The second, sent from
London before he himself had seen the exhibition, was
written as a defense of the artists and their works, al-
though he felt compelled to admit, "They are attacked,
and rightly so, for resembling each other a little too much
because they all derive from Manet; and sometimes the
pictures lack form, so dominant in them is the simple
*macchia* from nature."[38] De Nittis himself had not re-
nounced the Salon, where he was represented that year
with a painting entitled *How Cold It Is!* (plate 237), in
which a contemporary group of two fashionably dressed
Parisian ladies and a little girl, who twists and tugs
convincingly on the hand of her more simply dressed
governess, are seen braving the winter chill to walk in the

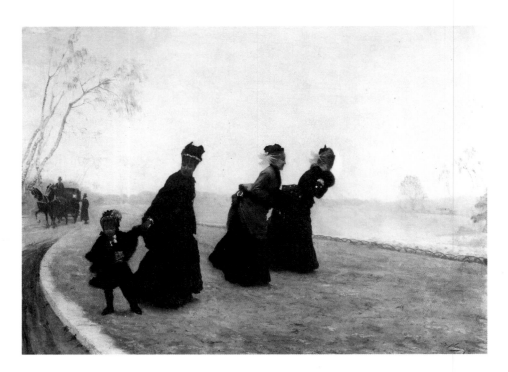

237. GIUSEPPE DE NITTIS. *How Cold It Is!* 1874. Oil on
canvas, 29⅛ × 21⅝″. Giacomo and Ida Jucker Collection

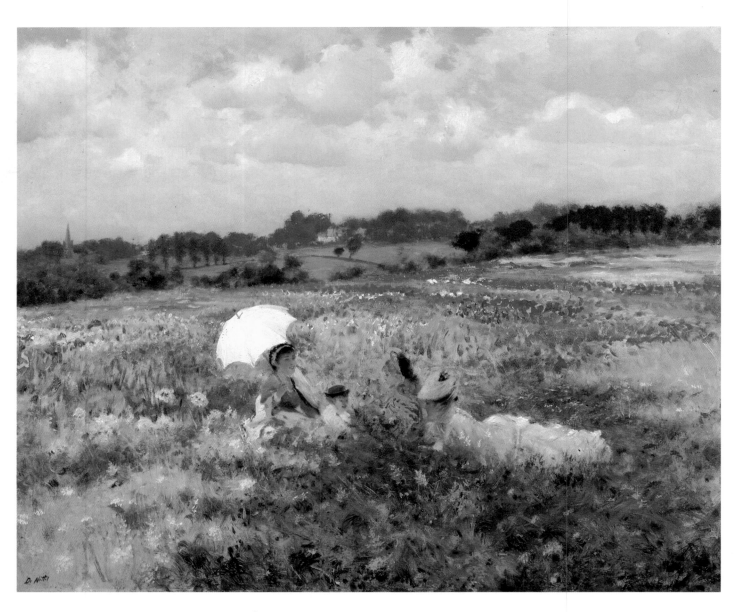

238. GIUSEPPE DE NITTIS. *In the Fields Around London.*
n.d. Oil on canvas, 17¾ × 21⅝″. Private collection

park while their carriage waits discreetly in the background. Painted with a glassy perfection of detail and a literally breathtaking atmospheric realism in the description of the barren winter landscape, the picture was an enormous public and critical success, sought after by collectors and made widely available in a popular engraved reproduction.

Perhaps because of the acclaim that this picture brought him at the Salon of 1874 or perhaps because of hostility from some of the Impressionist organizers (most notably Renoir), De Nittis never again chose to exhibit with the Impressionist group. Nevertheless, his vision was not untouched by theirs. *In the Fields Around London* (plate 238), an archetypal image of women and children sitting in a field, bathed in a mild sunlight that dissolves their forms amidst a profusion of flowers and grass, surely and skillfully rivals Renoir and Monet in their own Impressionist genre. The quickly and thinly brushed *Field of Snow* (plate 239), probably painted around 1875, is essentially a tonal study, comparable to Monet's *Impression, Sunrise* (plate 4), where large, tonally similar areas describe a pervasive atmosphere, punctuated by small color accents that suggest, in the De Nittis work, the tiny figures who walk and play along the barely perceptible paths and amidst the winter foliage in a snow-covered park. The influence upon this painting of an orientalizing aesthetic is suggested by comments from De Nittis's journal, in which he wrote in 1875, "Paris is all white with snow. . . . For me it is a vision of Japan."[39] And *Lake of the Four Cantons*, painted in 1875 (plate 240), presents the familiar Impressionist subject of a woman in a boat out on the water (in this case, Lake Lucerne, where De Nittis stopped on one of several trips he made through Switzerland on his way to or from Italy). It is painted broadly and tonally, in the manner of Manet, but with a far greater sensitivity and concern than the latter for the coloristic nuances of reflected light, light that filters into the partly enclosed interior of the boat in De Nittis's work through partially opened, diaphanous curtains and through the umbrella that the woman holds opened behind her head.

The much larger and more formally conceived *Westminster* (plate 241), painted around 1875, was one of a group of ten views of London commissioned by the English banker Kaye Knowles, who was one of De Nittis's major patrons. The painting was inspired by De Nittis's experiences in London, but also, surely, by his awareness of Monet's slightly earlier interpretations of comparable subjects (plate 242). Like Monet, De Nittis shrouds the river and suspends the buildings in the background of his picture in a veil of fog and mist, reserving the tonally darkest accents in the painting for the right-hand foreground, where the composition is anchored. But instead of the calligraphic delicacy and abstraction with which Monet treats the rectilinear wharf jutting out into the river, parallel with the picture plane, De Nittis, far more boldly and radically in this instance, uses the foreground bridge in his picture as a perspective orthogonal that pulls us—as in a Mannerist work by Tintoretto—

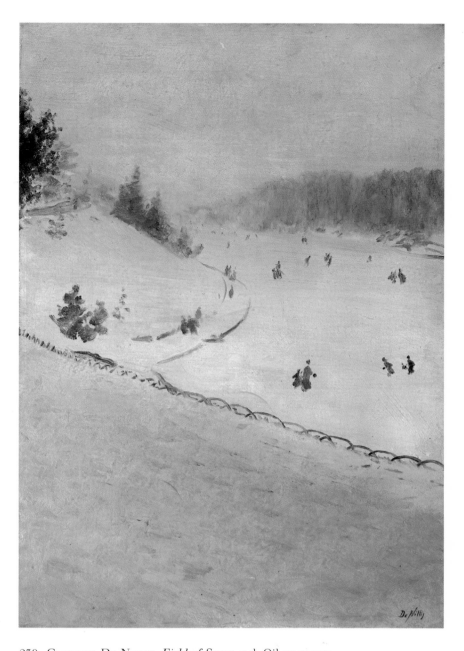

239. Giuseppe De Nittis. *Field of Snow*. n.d. Oil on canvas, 21⅝ × 15″. Private collection

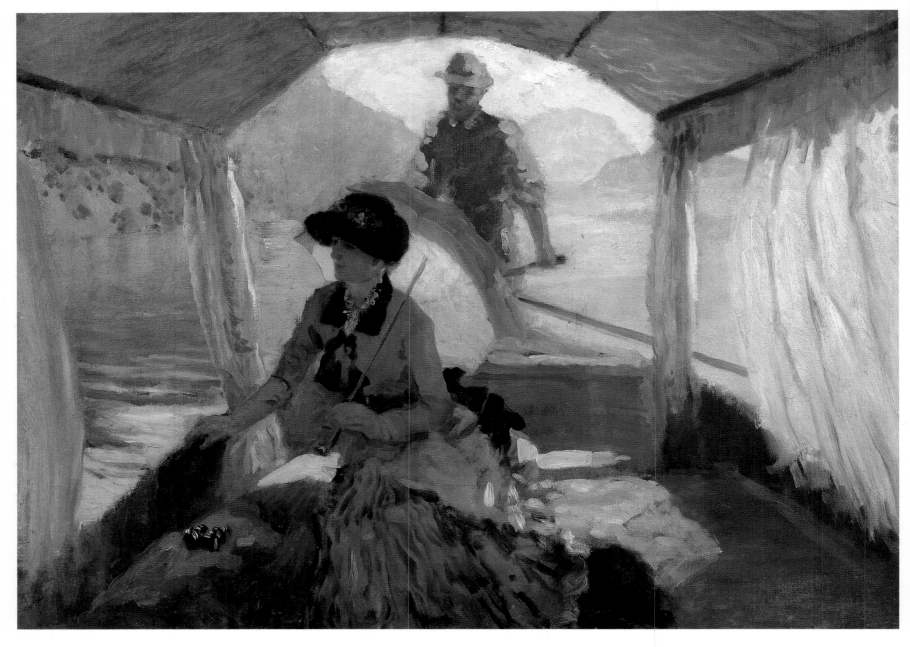

240. GIUSEPPE DE NITTIS. *Lake of the Four Cantons.* 1875. Oil on canvas, 25⅝ × 35½". Private collection

dramatically up and out of the picture space. At the same time, the figures who lean and lounge along the railing of the bridge, either to watch the passers-by or to gaze out onto the Thames, are not mere speckled touches of pigment. Though painted with economy and verve, they are clearly observed and delineated representatives of their class and of the street life of contemporary London, for which De Nittis had a keen and observant eye. Seemingly casual, but as choreographed in their movements as the figures in a Raphael fresco, their positions and glances lead us back once more into the space of the picture, where we gaze with the foreground figure out across the river at the towers of Westminster.

Side by side with works like these, which parallel or extend the Impressionist attitude, De Nittis painted large numbers of what may seem to us today to be com-

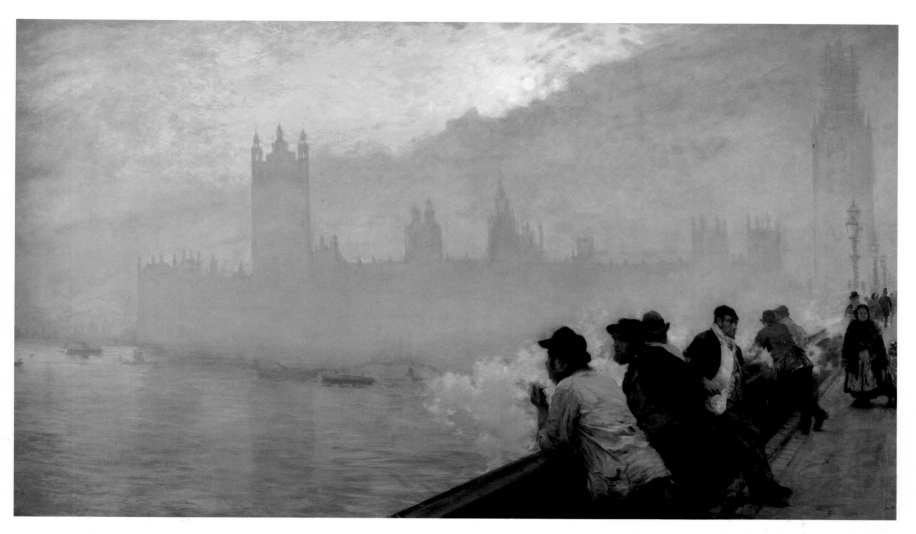

241. GIUSEPPE DE NITTIS. *Westminster.* c.1875. Oil on
canvas, 45¼ × 77½". Collection Count Umberto Marzotto

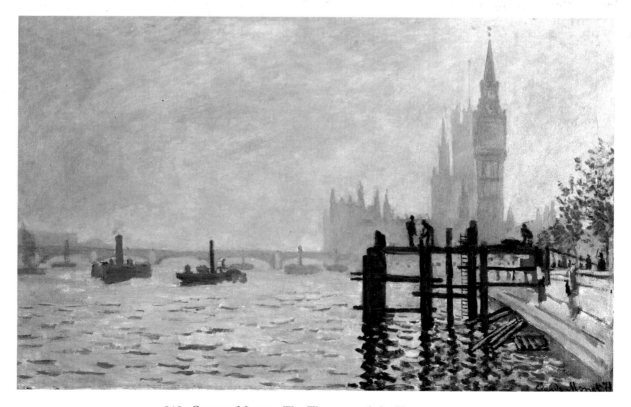

242. CLAUDE MONET. *The Thames and the Houses of
Parliament.* 1871. Oil on canvas, 18½ × 28¾". The National
Gallery, London

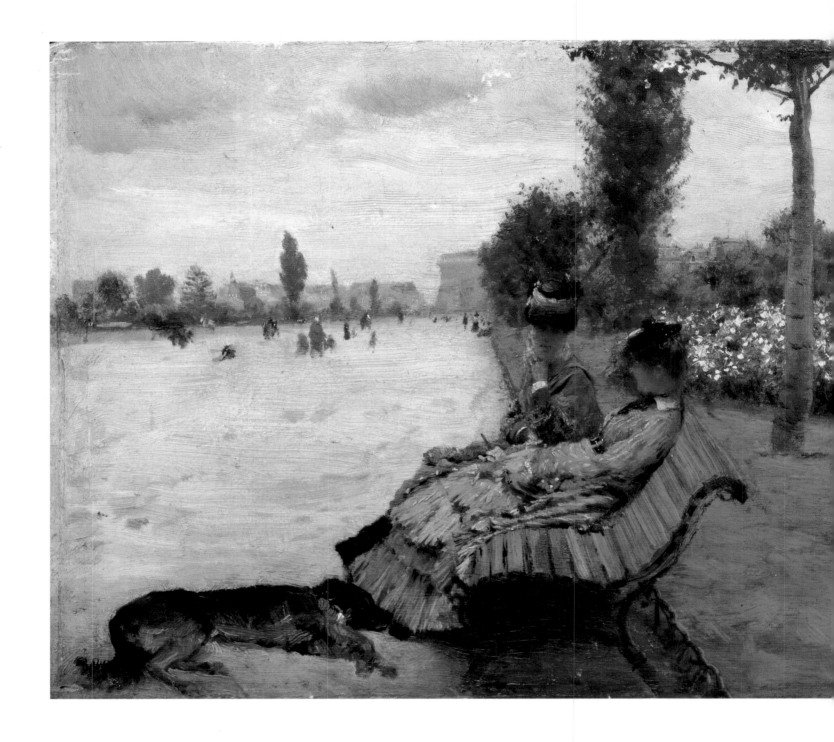

promise pictures for the market, pictures such as *On a Bench on the Champs Elysées* (plate 243), which feature pretty and fashionably dressed *Parisiennes* seen outdoors against instantly recognizable urban settings. Here, using a low point of view and a steeply angled perspective to divide the picture space diagonally, De Nittis nevertheless classically centers the women in this space, using the vertical trees that rise behind them to mark and anchor their position. Even though painted for the market, pictures like this one could be bold and complex, and their compositional strategies often depended on a mixture of elements and stimuli, from classical Italian art to Japanese prints and contemporary photography. They were admired by critics and collectors, moreover, as faithful reflections of the life, the habits, and the fashions of

ITALIAN PAINTING DURING THE IMPRESSIONIST ERA

(left) 243. GIUSEPPE DE NITTIS. *On a Bench on the Champs Elysées.* c.1874. Oil on wood, 12¼ × 17⅛″. Collection Piero Dini

(above) 244. GIUSEPPE DE NITTIS. *Place des Pyramides, Paris.* 1875. Oil on canvas, 36¼ × 29⅛″. Musée d'Orsay, Paris

contemporary Paris, and on this basis, in fact, De Nittis was praised for being the Guardi or the Canaletto of his own period.[40]

Although he did not exhibit again with the Impressionists after 1874, De Nittis, whose Saturday night soirees were renowned and well attended, remained on good social terms with Manet, Degas, and Caillebotte, and with writers such as Zola, Duranty, and Edmond de Goncourt who were associated with the Impressionists' circle.[41] With Caillebotte, he shared a taste for unexpected points of view and asymmetrical perspectives in his scenes of urban life, but unlike his friend—and for understandable reasons—he carefully avoided any implication of political radicalism in the subjects that he chose. As a foreigner, the effort to assimilate into French

life and culture was never an entirely easy or comfortable one for De Nittis, despite—or perhaps because of—the enormous critical and financial success that he enjoyed. He was resented by French artists (in 1873, a group of them complained to the dealer Goupil that it was unpatriotic for him to employ De Nittis[42]) and by Italian artists (who were angered by the extent to which De Nittis took over the Italian section at the Exposition Universelle of 1878, even though his inclusion there brought them far more attention than they might otherwise have received[43]). His sensitivity to his expatriate position and his conscious efforts to establish himself politically in France are reflected in the history behind his picture *Place des Pyramides, Paris* of 1875 (plate 244), a picture with a decidedly, almost self-consciously,

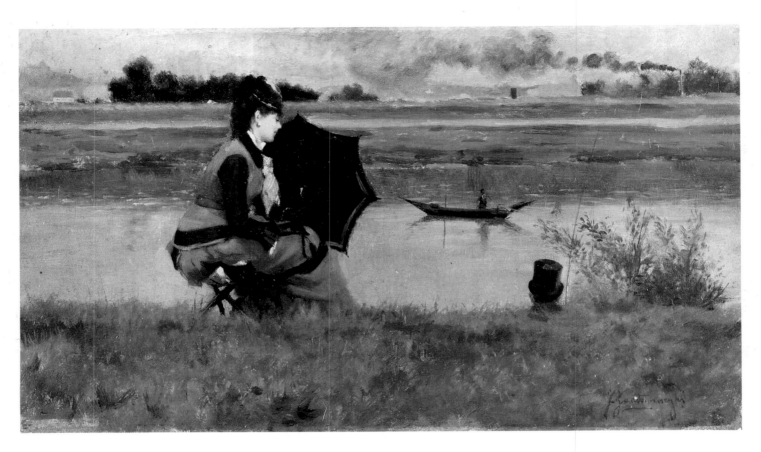

245. FEDERICO ZANDOMENEGHI. *Along the Seine.* 1878. Oil
on wood, 6¼ × 11⅜″. Galleria d'Arte Moderna, Palazzo Pitti,
Florence

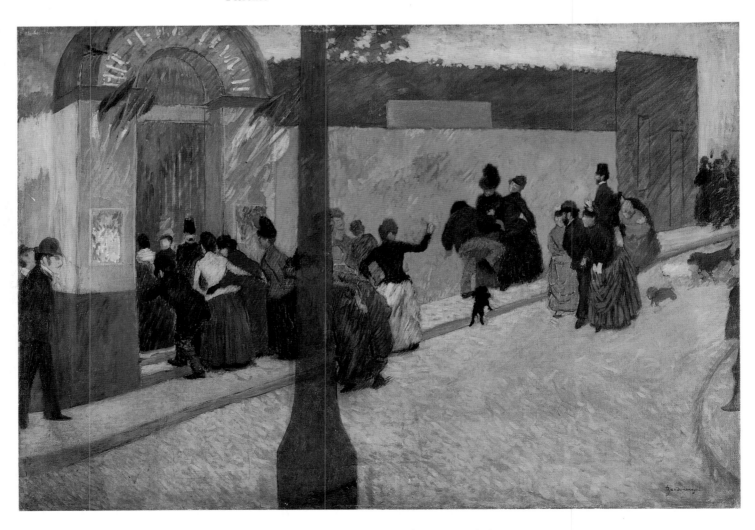

246. FEDERICO ZANDOMENEGHI. *Moulin de la Galette.*
c.1878. Oil on canvas, 31½ × 47¼″. Collection Enrico Piceni

247. FEDERICO ZANDOMENEGHI. *The Poor on the Steps of the Convent of Ara Coeli in Rome.* 1872. Oil on canvas, 30¾ × 65¾″. Galleria d'Arte Moderna, Milan

French patriotic message. In the background, the north wing of the Tuileries Palace, which had been burned a few years earlier, is under scaffolding as a reminder of the great damage that been done to the streets and monuments of Paris by the Prussians and by the Commune in 1870–1871. The scaffolding also stands as a symbol of the rebuilding of Paris after those disasters, joined here by another triumphant symbol of French nationalism, the equestrian statue of Joan of Arc by Emmanuel Frémiet, which had been installed in the Place des Pyramides in February of 1874.[44] The statue is silhouetted against a cloudy but clearing sky; and around its base flow busy, active Parisians of all classes, on foot and in carriages, from laundresses and fruit vendors to elegantly dressed ladies and gentlemen, themselves the ultimate symbol of the nation's social and economic health and resurgence. It is both telling and understandable that in 1878, upon the occasion of the Exposition Universelle, De Nittis made a point of buying this picture back from Goupil at considerable expense in order to be able to present it as his gift to the French government.[45]

De Nittis died of a stroke in August 1884, at the age of thirty-eight. In his last years, although he continued to paint successfully both for the market and for himself, these public and private worlds grew somewhat closer together as public taste began to shift in response to Impressionism. His *Luncheon in the Garden* (Museo Civico, Barletta), Impressionist in its plein-air theme and technique, was exhibited at the Salon of 1884, the year in which he died. Perhaps had he lived longer a definitive choice between the conservative and the pro-

gressive (a choice he had always skillfully avoided) would have been easier for him to make, in a world where the "intransigents" would gradually begin to experience some of the financial and, eventually, institutional success that De Nittis craved and had not been able to forego. His own work, certainly, had played an important role in mediating the transition of taste for the public in this respect, and his association with Impressionism may have made aspects of that mode more palatable for many French critics and the public at large. The very great extent to which he was associated with the movement in the public mind is clearly reflected in an adulatory article written by Émile Bergerat, director of the journal *La Vie Moderne*, at the time of the artist's death, an article entitled "*La Mort de De Nittis et la fin de l'Impressionnisme.*"[46]

Born in Venice and trained at its academy, Federico Zandomeneghi (1841–1917) lived in political exile in Florence from 1862 to 1866 as a result of his participation in Garibaldi's invasion of Sicily in 1860.[47] He was able to return to Venice when it became part of the Kingdom of Italy in 1866, and in 1874, he emigrated to Paris, where he lived for the remainder of his life. Unlike De Nittis, Zandomeneghi was not financially successful as an artist in Paris; and it may have been in part for lack of money that he never again returned to Italy. His early years in Florence had placed him in close contact with the artists at the Caffè Michelangiolo, and friendships formed there, especially with Fattori, Signorini, and Martelli, were ongoing ones. Although he was introduced to outdoor painting at Castiglioncello, his preference was for figure compositions rather than land-

scapes, and a taste for social realism, which emerges in a major and powerful work of his Italian period, *The Poor on the Steps of the Convent of Ara Coeli in Rome* of 1872 (plate 247), may owe something to similar tendencies in the work of Signorini (see above, plate 230).

Zandomeneghi's tastes and interests during his first years in Paris, as revealed in the letters that he wrote to friends in Italy, ran in the direction of artists such as Corot, Courbet, and Bastien-Lepage, whose *Portrait of His Grandfather* at the Salon of 1874 Zandomeneghi judged to be "perhaps the most wholesome" work in the entire exhibition; while Manet, at the same exhibition, he said, "takes the position of one who despises tradition in order to make himself appear original, but all he has that is original is a point of view that is ugly and disgusting."[48] His reports on the third Impressionist exhibition in 1877 were on the whole unsympathetic. "Degas," he wrote to Martelli, "exhibits some rather beautiful and individual things"; but of Monet, Pissarro, Caillebotte, and Renoir, he complained, "No foundation of knowledge sustains them, and what makes them really unbearable is the similarity of strengths and weaknesses that exists among them. The painting of one can easily be mistaken for that of another."[49] Despite these negative early reports from Zandomeneghi, Martelli admired the Impressionists for their rebellious spirit, and his enthusiasm for them and their art grew rapidly during the year he spent in Paris, from April 1878 to April 1879. It was at this time, probably as a result of Martelli's encouragement and influence, that Zandomeneghi grew closer to the Impressionists. Recruited by Degas, he exhibited with the Impressionists for the first time in the fourth group show in 1879, and his art underwent extensive and rapid changes.

*Along the Seine* (plate 245), a tiny panel, which was painted in 1878 and acquired by Martelli, can be regarded as a transitional work in this respect. It is both an audacious and an awkward picture, and its qualities perfectly exemplify the tension that existed in Zandomeneghi's art between his Italian roots and his French milieu, a tension that defined his personal brand of Impressionism and that is almost always at the heart of his most interesting and innovative work. If one imagines this painting with its figures removed, the panel becomes a freshly painted slice of the landscape, very close in its horizontal format and its tonal harmonies to the landscape studies painted out-of-doors by the Macchiaioli. Only the smoke that billows from the stack at the upper right identifies this as a more urbanized and industrialized landscape than those normally painted by the Italians. With the addition of the studio-painted figures, the scene does indeed become one of urban leisure of the sort made familiar not only by the Impressionists but by countless popular illustrators of the period. Its modernity is marked by the odd angle of vision that Zandomeneghi has adopted and that makes visible only the top hat and the fishing pole of the man who sits below us on the river bank at the right. This unusual viewpoint, however, does not interfere with the horizon-

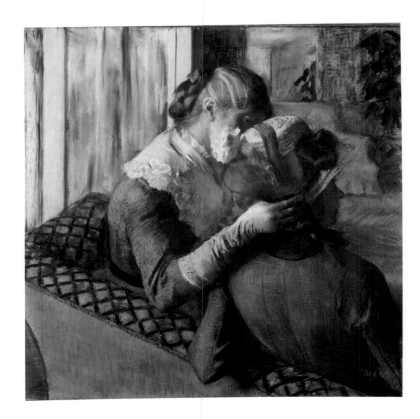

248. EDGAR DEGAS. *At the Milliner's.* c.1881. Pastel on paper, 27¼ × 27¼". Collection Mr. and Mrs. Walter Annenberg

tal orientation and friezelike formality of the composition as a whole, an Italianate taste that is heightened by the clearly silhouetted and triangularized form of the fashionably dressed woman seated in profile at the left.

In a letter dated 13 September 1878, Martelli wrote to Fattori about "a painting of the Moulin de la Galette," which he says that Zandomeneghi had just completed. The painting, he continued, "is not liked by those of our countrymen who have seen it; and as a result, he is crestfallen. Nevertheless, it is a good painting . . . and it is in certain ways part of a whole new mode of painting, the idea and intention of which those who come from home cannot understand."[50] The painting in question is thought to be Zandomeneghi's undated *Moulin de la Galette* (plate 246), which, when compared with Renoir's 1876 painting done at the same site (plate 2), is a most unusual and prophetic work for its period. It depicts the patrons of this well-known, open-air dance hall in Montmartre as they arrive at its entrance in lively groups, their faces and figures generalized and exaggerated—almost caricatured—in ways that suggest Zandomeneghi's interest in popular prints and graphic illustration in general and perhaps the current work of Jean-Louis Forain in particular. The influence of Japanese prints, ubiquitous in Paris at this time, helps to explain the Post-Impressionist look of the painting, with its steep perspective, flattened and silhouetted forms, and the superimposed vertical of the street lamp (apparently an afterthought, since the background figures are still visible beneath it), which further flattens the space

ITALIAN PAINTING DURING THE IMPRESSIONIST ERA

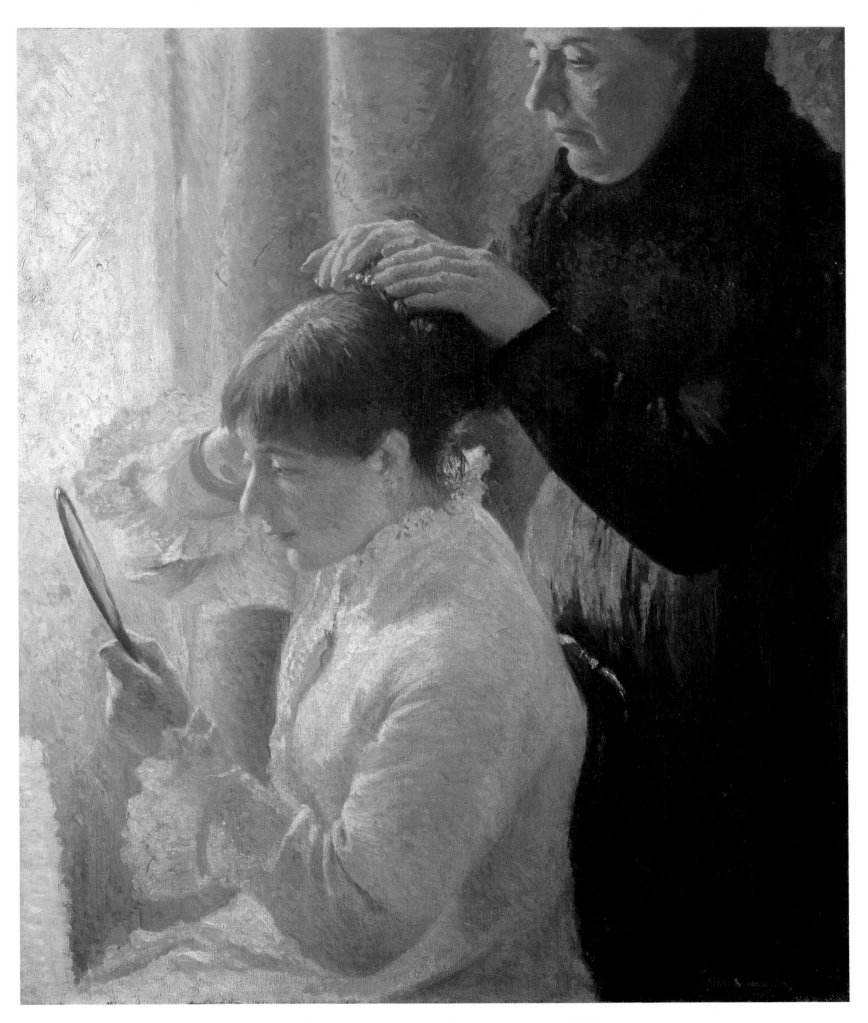

249. FEDERICO ZANDOMENEGHI. *Mother and Daughter.* 1879.
Oil on canvas, 24⅜ × 20½″. Private collection

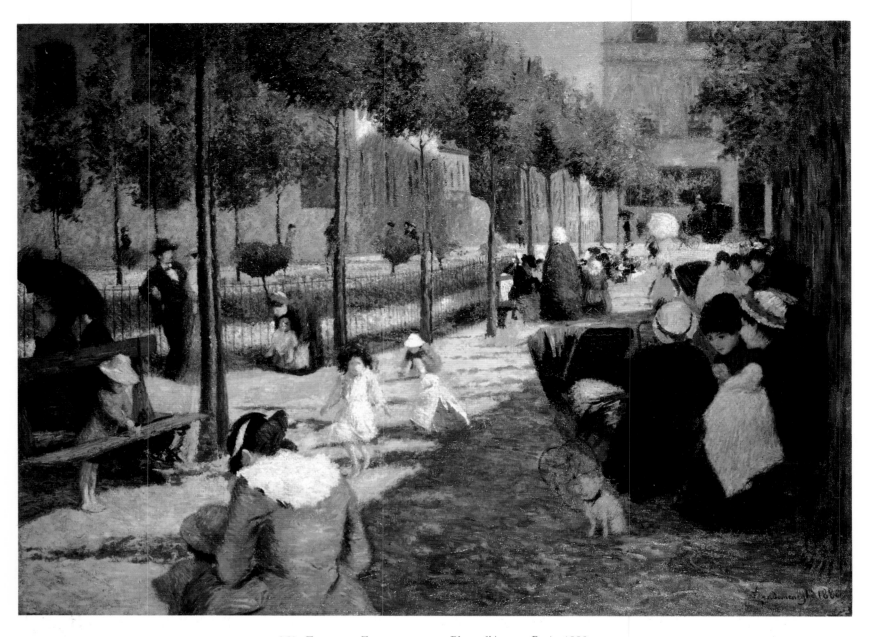

250. FEDERICO ZANDOMENEGHI. *Place d'Anvers, Paris.* 1880.
Oil on canvas, 39⅜ × 53⅛″. Galleria d'Arte Moderna Ricci
Oddi, Piacenza

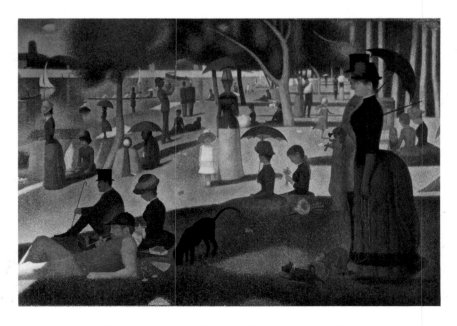

251. GEORGES SEURAT. *Sunday Afternoon on the Island of
La Grande-Jatte.* 1884–1886. Oil on canvas, 81¾ × 121⅜″.
Helen Birch Bartlett Memorial Collection, 1926.224. © 1990
The Art Institute of Chicago. All Rights Reserved

252. FEDERICO ZANDOMENEGHI. *At the Café de la Nouvelle Athènes.* 1885. Oil on canvas, 35½ × 27½″. Collection Piero Dini

and divides it asymmetrically. The surprising resemblance between later work by Henri de Toulouse-Lautrec and this precocious painting by Zandò (as he was called by his friends) has often been observed and is not accidental, as the painter François Gauzi confirmed. In the 1880s Gauzi occupied a studio in the rue Tourlaque, in the same building where Zandò lived and where Toulouse-Lautrec would also move in 1884. Gauzi reported: "Lautrec came under his influence, and Zandò was the first painter who introduced him to Impressionism. Lautrec immediately adopted his theories, and, like him, attached enormous importance to the choice of the visual angle, to the original placement of forms on the page, and to the extension of the subject beyond the painting, with the figures cut by the frame."[51]

In 1879, when Zandomeneghi joined the Impressionists for the first time at their fourth group show, he did not exhibit experimental works like *Moulin de la Galette*. Instead, anxious to establish himself, he chose a group of relatively conservative paintings that included his *Portrait of Diego Martelli*[52] (whose portrait by Degas appeared at the same show) and a female fashion portrait entitled *Winter Violets*,[53] paintings that led one critic to refer to him as "a most transigent Intransigent."[54] But at the fifth group show in 1880, he was represented by a more original and characteristic work, *Mother and Daughter* (plate 249), which he had painted in 1879, probably using his own mother, Anna, and his sister Antonietta (who were then visiting him in Paris), as his models.[55] This is a compositionally daring picture, which focuses upon the two women in an intimate close-up (the figure of the mother is cut by the frame on three sides, and her face above her eyes disappears at the upper frame). The golden light that filters through the curtained window at the left and the broken brushwork and crumbled touches of pigment that carry the colored reflections of that light throughout the work remind us of Zandomeneghi's Venetian origins and are typical of his thoroughly Italian version of Impressionism—giving deeper art historical meaning to Degas's affectionate nickname for his friend, "*le Vénitien*."

As a toilette scene, moreover, *Mother and Daughter* is very different from those essayed by most of Zandomeneghi's French colleagues because of the gentle poetry of its mood, the realism and specificity of the figures' characterizations, and the tenderness and touching humanity of their interaction, aspects of the work that favorably impressed contemporary critics who saw and commented on Zandò's picture at the Impressionist exhibition in the spring of 1880.[56] These aspects of the work may also have made a strong impression on Edgar Degas. His pastel of 1881, now known as *At the Milliner's* (plate 248) but originally entitled "A Corner of the Salon,"[57] features two similarly dressed women of the same class, one of whom reaches over, with a gesture of tender affection, to adjust the hat of the other, who is seated next to her on a couch. Atypical of works in the milliners series—and most atypical of Degas's work in general, where figures almost never touch or interact

with direct solicitude and affection—this picture is a rare and enigmatic one in Degas's oeuvre, one that is perhaps best explained as an experimental response on his part to the temperamentally very different work of his friend Zandomeneghi.

*Place d'Anvers* (plate 250), painted in 1880, was Zandomeneghi's major offering at the sixth Impressionist exhibition in 1881.[58] A typically Impressionist subject of women and children (most of them wet nurses with their young charges) in a parklike urban setting, the picture's careful structure and the frozen movement of its figures clearly depart from and contradict the effects of casual spontaneity that we associate with this genre. The picture, in fact, seems in many ways to be an uncanny prefiguration of Georges Seurat's slightly later *Sunday Afternoon on the Island of La Grande-Jatte* (plate 251), shown at the eighth and last Impressionist exhibition in 1886.[59] Among the elements in Zandomeneghi's work that suggest such an analogy are the picture's high horizon line; its rapidly diminishing perspective, carried by a row of evenly aligned vertical trees with their carefully pruned crowns of foliage and trunks that have been simplified into clean cylindrical shapes; the simplified drawing of figures and objects, which emphasizes among other things the semicircular forms of umbrellas and nursemaids' bonnets, repeated across the picture plane in a way that subtly unifies surface and depicted space; and the artist's increasingly regular application of his colors, quite apparent here, in parallel strokes and dabs of pigment. It is certainly possible that Seurat saw Zandomeneghi's picture at the Impressionist exhibition of 1881 (he had just returned to Paris in November 1880 after a year of military service), or he may well have had access to the work over the next few years through Pissarro or other mutual friends. But what is at stake here, it seems to me, is not so much an issue of influence, but rather a taste for the classical that was shared by these two artists (in conversation, Seurat likened the contemporary figures in his paintings to those on the Parthenon frieze[60]). This taste is one that would be self-consciously superimposed by Seurat on Impressionism in order to change and "improve" on it; while in Zandomeneghi's case, it was part of the heritage and sensibility that, as an Italian, he brought directly to his participation in the Impressionist movement. In the *Place d'Anvers*, in other words, Zandomeneghi was not so much purposefully trying to move the Impressionist style to a different place (as Seurat would do a few years later); rather, it would be more accurate for us to say that in 1880, as an Italian, he was interpreting the style individually, from a position of ethnic and cultural difference.

Zandomeneghi was represented in the catalog of the eighth and last Impressionist exhibition of 1886 by fourteen works, all of which are too generically titled to be identified.[61] A painting that may characterize his interests and his personal style for us during this period, however, is *At the Café de la Nouvelle-Athènes*, dated 1885 (plate 252), in which he took up the formal problem of complex mirror reflections, one that had already been

ITALIAN PAINTING DURING THE IMPRESSIONIST ERA

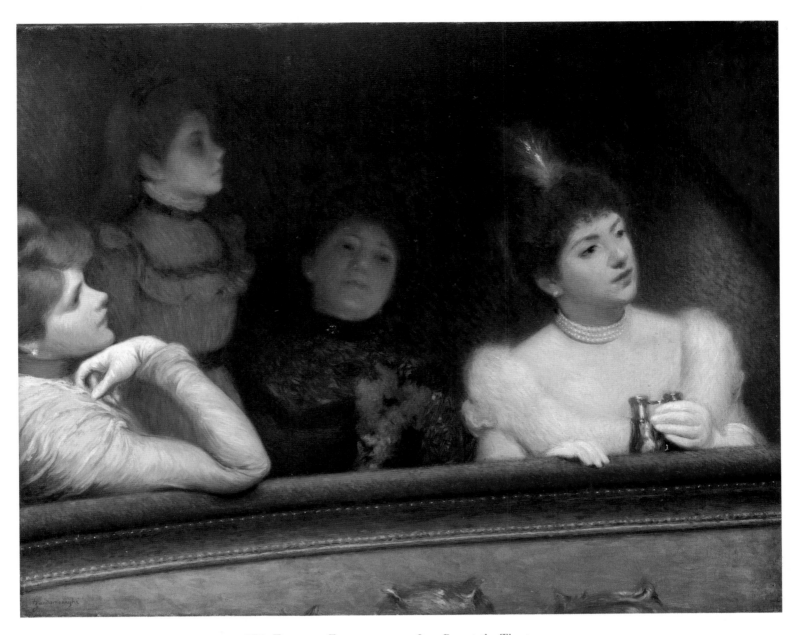

253. Federico Zandomeneghi. *In a Box at the Theater.*
c.1890–1895. Oil on canvas, 28 × 34⅝″. Private collection

dealt with experimentally in the backgrounds of theater and café scenes by a number of his colleagues, including Cassatt (*Lydia in a Loge*, 1879; plate 31), Caillebotte (*In a Café*, 1880; Musée des Beaux-Arts, Rouen), and, of course, Manet (*Bar at the Folies-Bergère*, 1881–1882; Courtauld Institute, London). Far more than they, however, Zandò concerned himself here with effects of coloristic and atmospheric diffusion, as he worked to capture the warm, smoky quality of the gaslights that illuminate the scene. These lights are viewed by us indirectly as reflections in the mirrored wall behind the couple (sometimes identified as a self-portrait of the artist with his friend and model, the painter Suzanne Valadon), who sit opposite one another in conversation at the foreground table. The diffused effect of that light in the room is expressed by streams of short, distinct brush strokes that flow over the forms, more or less following their contours in the foreground but turning into confettilike dots of

pigment in the background to support the illusion of the blurred mirror reflection. The character of the indoor illumination as well as the brushwork and the rectilinear organization of space again seem to look forward to the emerging Post-Impressionist sensibility of Georges Seurat (e.g., *Le Chahut*, 1889–1890; Rijksmuseum Kröller-Müller, Otterlo). But the warmth and naturalness of the human interaction depicted here is not found in Seurat's work; nor—with the exception of Cassatt and Morisot—is it to be found quite to this extent in the contemporary work of any of Zandomeneghi's Impressionist colleagues.

Despite his many friendships in Paris (including a long-lasting but not uncomplicated one with Degas), Zandomeneghi's letters to his friends back in Italy reflect the loneliness and isolation that he felt as a foreigner living in France.[62] His life there was also one of financial hardship. For even though Durand-Ruel became Zan-

domeneghi's dealer after he began to exhibit with the Impressionists, he appears to have done little to promote Zandomeneghi's work until the 1890s, when he gave the artist two one-person shows in Paris (1893 and 1898) and encouraged him to produce works for the increasingly lucrative American market, where figure compositions in the manner of Degas and Renoir were much in demand.[63] This support had the beneficial effect of finally freeing Zandomeneghi from what he considered to be the demoralizing and compromising work that he had been forced to do in order to survive in Paris since his earliest days there, work as a free-lance fashion illustrator for newspapers and women's magazines. But it also had the effect of stifling a great deal of his earlier originality. *In a Box at the Theater* (plate 253), probably done in the 1890s,[64] is typical of Zandomeneghi's strengths and weaknesses at this time. Working with a theme made familiar by Cassatt and Renoir, Zandò brought to it his own highly developed interest in human types and individual characterizations (indeed, the four women in this theater box might be said to represent four distinct "ages of woman"). But the picture lacks the compositional wit and complexity of its predecessors, and the theater box seems but a weak excuse for the depiction, in horizontal alignment, of these four women in evening dress. The stylized "Gibson-girl" quality of the figure at the left, moreover, strikes a particularly discordant note within the whole and suggests the lingering effects of Zandomeneghi's commercial fashion work on his art. These elements intrude more and more frequently in Zandomeneghi's later work, which is often derivative in form and sentimental in expression, offering little to rival or match his influential work of the late 1870s and 1880s, when this artist had been one of the most daring and original of the Impressionists in Paris.

## Art in the North of Italy: The Scapigliati and the Divisionisti

In the 1860s and 1870s, there emerged in Lombardy a style of loose and atmospheric painting that offers startling visual similarities to French Impressionism but which is based entirely on Italian sources and traditions. This is the style of the so-called Scapigliati, represented principally in painting by Tranquillo Cremona (1837–1878) and Daniele Ranzoni (1843–1889).

Precedents for this style in earlier nineteenth-century northern Italian painting can be found in the work of Antonio Fontanesi (1818–1882), a Piedmontese landscape painter who traveled abroad extensively (plate 173). In the 1850s Fontanesi's fluid and atmospheric style was influenced by the work of the Swiss painter Alexandre Calame (plate 401) and by the tonal poetry of the Barbizon painters; and in the 1860s, he was affected by the art of Turner.[65] A more direct and immediate influence on the Scapigliati was the work of Giovanni Carnovali (1804–1873), who was nicknamed and is often referred to in the Italian literature as "Il Piccio"

254. Giovanni Carnovali. *The Bather*. 1869. Oil on canvas, 24¾ × 17". Galleria d'Arte Moderna, Milan

(local dialect for *il piccolo*, "the small one"). Carnovali was an exceptional artist, who was in some ways to the Milanese Scapigliati what Delacroix was to the Parisian Impressionists. He is known for his portraits, his *bozzetti* dealing with mythological and religious subjects, and for his landscapes. Painted in the studio but inspired by nature, the latter are luminous and loosely brushed images, featuring broad horizons and masses of trees against amorphous, light-filled skies. Though romantic in mood and expression, the subtle colorism and painterly technique of Carnovali's work owe much to his studies of Lombard and Venetian painting of the sixteenth and seventeenth centuries. *The Bather* of 1869, for example (plate 254), is a work positioned ambiguously between mythology and the contemporary imagination. It is painted with a light-flecked, broken brushwork inspired by Titian and Correggio and a Leonardesque *sfumato* that Carnovali imbibed principally from his enthusiastic studies of the work of Bernardo Luini, a sixteenth-century follower of Leonardo in Milan. As a

ITALIAN PAINTING DURING THE IMPRESSIONIST ERA

rapid notation of color and light, *The Bather* is typical of the work by Carnovali that would influence the artists of the next generation in Lombardy, the Scapigliati.[66]

The Scapigliatura movement, which emerged in Milan between 1860 and 1880, was at its inception a literary movement, and its adherents were writers, poets, musicians, and philosophers as well as visual artists. In addition to the painters Cremona and Ranzoni, the architect Camillo Boito and the sculptor Guiseppe Grandi were also associated with this group. Their aesthetic philosophy, akin to the contemporary Wagnerian ideal of the *Gesamtkunstwerke*, was based on the ideal of unity and fusion among the arts (hence, for example, the musical allusions that one often finds in the works of the painters and the pictorial qualities that characterize the sculpture of these Scapigliati). But their group philosophy also had a strong social basis, one that reflected the eventual discontent and disillusionment of the postunification years in Italy, when unfulfilled promises of social and economic restructuring and the threat of new wars led many to reject the patriotic ideals of the Risorgimento. Those involved with the Scapigliatura circle took an anticonformist stance of revolt against the entire social, political, and cultural state of things in the new Italy, and their outlook was proclaimed by the name that was given to them. Derived from the title of a novel by Carlo Righetti, one of the members of the group, "scapigliati" means, literally, "the disheveled ones," or bohemians. Many of these writers and artists did in fact affect bohemian life-styles; several died young as a result of alcoholism, disease, or as suicides. And in general, they expressed their disaffection and dissent by opting out of a life of social or political commitment.[67]

This disillusioned withdrawal from contemporary political life, often into an ivory-tower aestheticism, is reflected by the subjects to which the painters in this circle gravitated, mostly portraits of well-to-do sitters and sentimentalized scenes of the good life among the upper classes. Cremona's *High Life* (plate 255), a watercolor painted in 1877 (one year before he died of blood poisoning from his pigments), reflects in color range and mood something of his early training in Venice. It presents a social gathering of pretty, well-dressed young women and is a good example of these upper-class, drawing-room subjects. His *Laughing Woman* of about 1874 (plate 256) is a portraitlike study in which he uses color, light, and atmosphere to convey an emotional affect that is fleeting and ephemeral (analogous to the efforts of poets in this circle, such as Bazzero and Praga, to evoke similar psychological and emotional states through formal means[68]). In style, both works share a dependence upon vibrations of color and light to create a mood by blurring the distinction between a form and its surrounding space. Like Fontanesi and Carnovali before him, Cremona's technique is a painterly one that fuses solids and voids beneath a barrage of light-flecked accents and fluid stains of color.

In the work of Daniele Ranzoni, who shared similar stylistic sources, conventional drawing is again eliminated in favor of a broken and impastoed brushwork and a coloristic evocation of the forms, which emerge from behind veils and broken touches of pigment. Ranzoni's work consists primarily of portraits, as well as some landscape studies that were done in the 1870s, when Ranzoni served as tutor to the children of the Russian Prince and Princess Troubetzkoy and lived with them (from 1873 to 1877) in their villa at Intra on Lago Maggiore. Ranzoni's portrait of the princess (an American, née Ada Winans, who became an active supporter of the arts in Lombardy[69]) dates from this period (private collection). In its chromatic brilliance and painterly verve, it is a picture that epitomizes the Scapigliatura spirit; but its vivacity represents only one side of Ranzoni's expressive range. In his *Portrait of Princess Antonietta Tzikos di St. Léger* (plate 257), dated 1885/1886, Ranzoni steps back from his sitter, whose relatively smaller size and lower position in relation to the field help to create a mood that is at once intimate and remote. He also uses cooler color, a closer range of tonal values, and smaller, finer brushwork to present a much lower-keyed, more poetic, and more introspective interpretation of his sitter (she was a daughter of Czar Alexander II, had been a student of Franz Liszt, and was known to have taken a serious interest in music, art, and the study of science[70]). The meditative qualities of this late portrait reflect not only the character of the sitter but also the state of mind of the artist. Always a more complicated personality than his friend Cremona, Ranzoni suffered from bouts of melancholia and depression that increased in severity after he returned to Italy in September of 1878 from an unhappy stay in England (where he had gone in 1877 on a portrait commission and where his work was rejected for exhibition at the Royal Academy). In 1887 he was briefly hospitalized for these psychiatric disorders and worked only intermittently during his last years.[71]

While general histories of art often relate the sculpture of Medardo Rosso (1858–1928) to that of Rodin and will explain and validate the Italian artist's work in terms of the French Impressionist movement, the roots and origins of Rosso's revolutionary style of sculpture are to be found in his northern Italian background and specifically in the circle of the Scapigliati, whose work he knew in Milan in the early 1880s. It was the Scapigliati's belief in the concept of unity among the arts that provided him early on with the impetus to merge the qualities of sculpture and painting in his own work, to attempt to give visual expression to fleeting and subjective moods, and to develop a style that would promote a fluid interchange between forms and the spaces surrounding them (compare, for example, the style and themes of Rosso's mature works with earlier paintings by Cremona; plates 258–259 and 255–256). And in the sculptural work of the Scapigliato Giuseppe Grandi (1845–1894), Rosso found an important precedent and model for his own style of broken and undulating surfaces, surfaces that suggestively catch and reflect light.[72] This style was already fully formed in Rosso's *La por-*

255. TRANQUILLO CREMONA. *High Life.* 1877. Watercolor on paper, 19⅞ × 13¾". Galleria d'Arte Moderna, Milan

256. TRANQUILLO CREMONA. *Laughing Woman.* c.1874. Oil on canvas, 23¼ × 17¼". Giacomo and Ida Jucker Collection

*tinaia* of 1883 (Gallery of Modern Art in Ca Pesaro, Venice), completed one year before the Italian artist's first trip to Paris.

The Italian Divisionist movement, which had its origins in Lombardy in the late 1880s, was also long considered to be a derivative offshoot of French Impressionist and Neo-Impressionist styles.[73] Yet members of the first generation of Divisionist painters in Italy appear to have had no direct contact with the art of either French group. They did share with the Neo-Impressionists an intense interest in optical science, and, independently, members of both groups read and based their theories on many of the same optical treatises.[74] But the Italians traced the origins of their thinking back to Leonardo,[75] and they evolved their styles for the most part out of the work of their Lombard predecessors, Cremona and Ranzoni (many of the future Divisionists were in fact students at the Brera, where, as part of the curriculum,

the painter Giuseppe Bertini had his classes copy the late works of Cremona[76]). The Italians, like the French, wanted to render light in all of its forms and to increase the luminosity of their colors; and to this end, they too were guided by the optical principles set forth by Ogden Rood (*Modern Chromatics* of 1879, translated into Italian in 1882), who advocated the juxtaposition and optical fusion of "divided" colors, as opposed to colors mixed on the palette.[77] But unlike the French, the Italians did not apply their pigments uniformly in "dots" or "points," but favored instead individual variants on a technique advocated by John Mile (as reported by Rood), which involved the parallel placement of long, thin lines or filaments of contrasting color.[78]

The guiding spirit of the Italian Divisionist movement was Vittore Grubicy de Dragon (1851–1920), who, with his brother Alberto, cofounded in Milan in 1879 the Grubicy Gallery, a gallery that actively sup-

257. DANIELE RANZONI. *Portrait of Princess Antonietta
Tzikos di St. Léger.* 1885–1886. Oil on canvas, 39⅜ × 27".
Giacomo and Ida Jucker Collection

(above right) 258. MEDARDO ROSSO. *Conversation in a Garden.*
1893. Wax over plaster, 17" high. Museo di Barzio, Como

(right) 259. MEDARDO ROSSO. *Large Laughing Figure.* 1891.
Wax over plaster, 10" high. Galleria d'Arte Moderna, Milan

260. Giovanni Segantini. *Girl Knitting*. 1888. Oil on canvas, 23⅝ × 39⅜". Kunsthaus, Zurich

ported and promoted the work of the Scapigliati and the Divisionisti in the 1880s and 1890s. In addition to being an art dealer, Grubicy was also an influential critic and an artist who himself painted in the Divisionist manner. He was an important proselytizer for the technique and was responsible for introducing several of the artists to it. He lived in Holland from 1882 to 1885 (he began painting there in 1884 under the tutelage of Anton Mauve), was in Belgium early in 1886 (too early to have seen French Neo-Impressionist works exhibited at Les XX), and remained conversant, at a distance, with avant-garde activity in Belgium during the next decade. Although his travels took him to France, his knowledge of French Neo-Impressionism seems to have depended entirely on Belgian sources, principally the articles (unillustrated) by Félix Fénéon that appeared in 1886 and 1887 in *L'Art Moderne*.[79]

Giovanni Segantini (1858–1899) is said to have used divided color for the first time in the fall of 1886, when, at the urging of Grubicy, he painted a second version of his *Ave Maria at Trasbordo* in this manner (Otto Fischbacher Foundation, St. Gallen).[80] Although trained at the Brera in the late 1870s, Segantini, who became the most internationally acclaimed of the Italian Divisionists, spent much of his career living and painting high in the Swiss Alps. His early works, like *Girl Knit-*

*ting* of 1888, follow in the naturalist tradition of Millet and Bastien-Lepage, and deal largely with the theme of peasants in nature (plate 260). Though drawn with clear contours and painted without consistent adherence to a scientific theory of color, the luminary clarity of these works derives from the artist's technique of applying his colors by means of short, "strawlike" brush strokes, whose directional placement helps to model the forms. In later works, such as *Love at the Source of Life or the Fountain of Youth* of 1896 (Civica Galleria d'Arte Moderna, Milan), Segantini attempted to integrate literary themes into natural alpine settings and was strongly influenced by Pre-Raphaelite art and by the international Symbolist movement.

In the 1890s Symbolism also increasingly affected the thematic choices of Gaetano Previati (1852–1920), another artist who studied at the Brera in Milan. His painting of 1889–1890 *In the Meadow* (plate 261) displays all the components of what today would be regarded as a typically Impressionist scene of a woman and children enjoying the sunshine out-of-doors (see Monet, plate 1). But the stiff and iconic placement of these almost disembodied and starkly illuminated figures around a central tree that dominates the space announces the artist's Symbolist intent. Throughout the work, Previati, who wrote three treatises on optical theory and the Divi-

IMPRESSIONISM IN BELGIUM AND HOLLAND

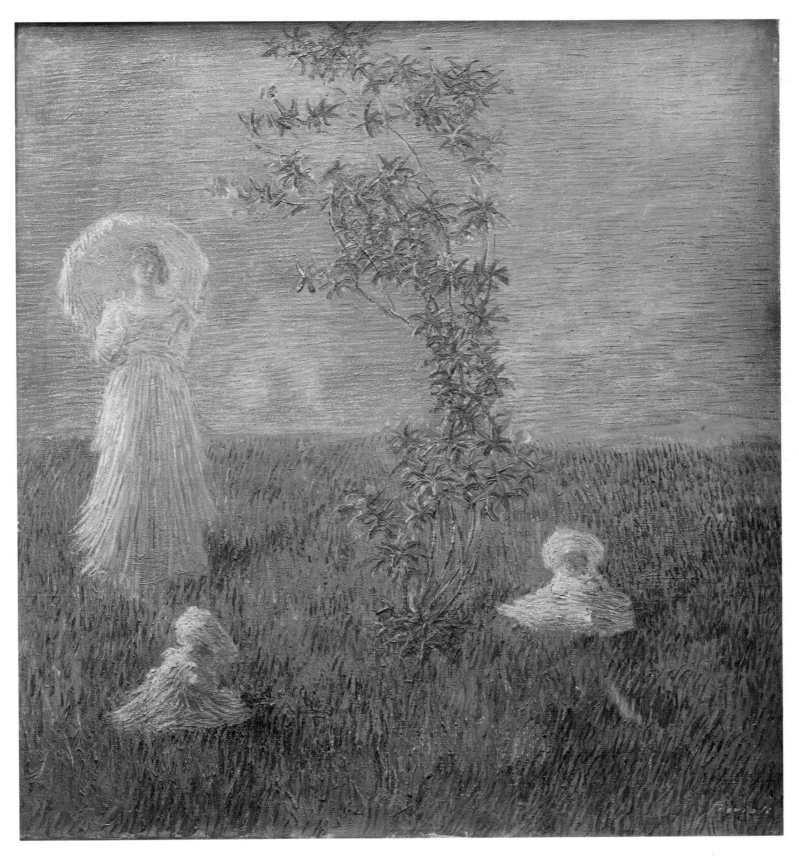

261. GAETANO PREVIATI. *In the Meadow.* 1889–1890. Oil on canvas, 24⅜ × 22¼″. Galleria d'Arte Moderna, Palazzo Pitti, Florence

262. PLINIO NOMELLINI. *The Call to Work.* 1893. Oil on
canvas, 23⅝ × 43¼". Private collection

sionist technique, employs complementary contrasts of
red and green, applied in thin, parallel brush strokes,
which are predominantly horizontal in the area of the sky
and vertical in the grass, to support, respectively, the
expression of rest versus activity.[81]

A second center of Divisionist painting developed
in the 1890s in Tuscany. There, one of Giovanni Fattori's
students, Alfredo Müller (1869–1948), who had re-
cently returned from a sojourn in Paris, influenced a
group of his fellow students to begin painting in a late
Impressionist manner—with "blue shadow and orange-
blossom light," as their dismayed teacher put it, in de-
scribing what he considered to be the mannered and
unnatural efforts of these young artists, in servile imita-
tion, he said, of Pissarro and Manet (artists whose works
had been exhibited in Florence and who were therefore
probably the only "avant-garde" French painters with
whom Fattori would have been at all familiar at this
time).[82] Critical reaction to the paintings exhibited at
the Florentine *Promotrici* from 1890 to 1892 by Müller
and his friends, however, suggests that they were painted
to some extent with divided colors that were self-
consciously superimposed rather than mixed, earning
for this short-lived Tuscan group the name
"Vibrationists."[83]

An empirical mixture of Impressionist and Divi-
sionist techniques is in fact typical of the work of Plinio
Nomellini (1866–1943), who was among the artists in
this "Vibrationist" group, and whose socialist beliefs and
themes placed him in contact and in sympathy with
several of the Lombard Divisionists. His 1893 painting

*The Call to Work* (plate 262) recalls a tradition of social
realism in Tuscan and Italian art that can be seen in
earlier paintings by Signorini and Zandomeneghi (plates
230 and 247 above). Inspired by workers at the Sampier-
darena shipyards near Genoa (where Nomellini had
moved in 1890), it is an image of the working class that is
at once heroic and grim, inspired by the artist's own, very
deeply held socialist convictions (in 1894, Nomellini was
himself among a group suspected of taking part in an
anarchist plot, for which he was arrested and brought to
trial in Genoa).

The 1890s was a decade of economic crisis and
social unrest throughout Italy, marked by the rise of labor
unions and other working-class movements (the Italian
Socialist Party was founded in 1892) and by their often
violent repression at the hands of the government. Moti-
vated by egalitarian and humanitarian concerns, all of
the Divisionists believed to some extent in the social
mission of their art.[84] In many of his paintings, the
Lombard Divisionist Alessandro Morbelli (1853–1919)
presents the lives of the aged and the destitute in public
institutions in Milan. His painting of 1895 *For Eighty
Cents* (Civico Museo Antonio Borgogna, Vercelli) depicts
the back-breaking toil of women workers in the rice fields
of northern Italy. But perhaps the most politically
charged of all of these Divisionist works is a painting
completed in 1901 by Giuseppe Pellizza da Volpedo
(1868–1907) entitled *The Fourth Estate* (Civica Galleria
d'Arte Moderna, Milan). Begun in 1898, the year of a
bloody massacre of rioting workers in Milan by the mili-
tary, this large and impressive painting (some nine feet

ITALIAN PAINTING DURING THE IMPRESSIONIST ERA

high and seventeen feet wide) is an image that proclaims the inevitable triumph of the working class. It is the culmination of a compositional type and a motif—a phalanx of workers striding forward toward the viewer—that Pellizza had been experimenting with since the early nineties, inspired by the work of his friend Nomellini.[85]

Pellizza, who had studied at the Brera Academy from 1883 to 1887, was guided in the development of his Divisionist technique first by Nomellini and then by Morbelli, with whom he corresponded after 1894. His works are diverse in subject matter, exhibiting Symbolist and pantheist tendencies as well as themes with direct social relevance. His *Rising Sun* of 1903–1904 (National Gallery of Modern Art, Rome), and the study for it (plate 263) are part of a series of works by him that deals with the phenomenon of light, a fascination that was central to the art and to the aspirations of these painters, who believed, in the words of Grubicy, that "light is life."[86]

The obvious relationship between Pellizza's pan-

theist image of the sun as a source of luminous energy and Giacomo Balla's famous *Street Lamp* of 1909 (The Museum of Modern Art, New York City), which uses similar formal methods to attribute an even greater dynamism and power to the artificial light of the modern city, is not accidental. The early work of the Futurists depended in large measure on that of the Scapigliati and the Divisionisti who had come before them. For Balla and Boccioni, who scorned (at least theoretically) so much of the Italian tradition, the Italian Divisionists were admired predecessors, artists who for the first time had sought to develop a pictorial language that was appropriate to the modern era and for whom the depiction of light had been a quintessentially modern subject.[87] It was thus through Italy's own painters—and not the art of contemporary France—that the emerging Futurists first received the Positivist legacy of the nineteenth-century, with its emphasis on modernity and its linkage of science and progress with art.[88]

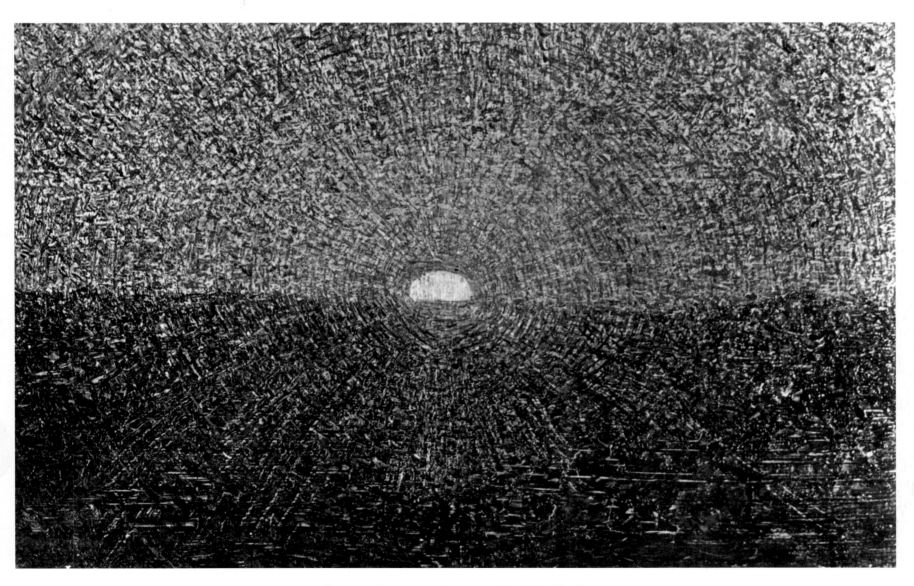

263. GIUSEPPE PELLIZZA DA VOLPEDO. Study for *The Rising Sun*. c.1903–1904. Oil on wood, 4×6″. Private collection

# THE LURE OF IMPRESSIONISM IN SPAIN AND LATIN AMERICA

*Eleanor Tufts*

264. JOAQUÍN SOROLLA. *Sewing the Sail.* 1896. Oil on canvas, 86⅝ × 118⅞″. Gallería Internazionale d'Arte Moderna di Ca'Pesaro, Venice

THE QUINTESSENTIAL HALLMARK of Spain—even in the twentieth century—is its regional diversity. This diversity is evident in many ways, including dialects, topography, dress, music, dance, art, and architecture. If Spain's provinces were not bound together by their shared physical isolation on the Iberian peninsula, there might have been a fragmentation of the nation; in fact, the Basques and the Catalans (both of whom have their own languages) in the north, closest to France, do maintain strong separatist movements. The varying terrains, from the precipitous cliffs of Asturias along the Bay of Biscay to the dry plains of La Mancha and from the snow-capped mountain ranges of Castile to the palm trees of Cádiz and the Costa del Sol on the Mediterranean, make Spain a country of rich, colorful contrasts and ever-changing panoramas.

It is no surprise that the works of the leading Spanish Impressionist painters reflect these regional differences. Aureliano de Beruete celebrated the Manzanares River in paintings of his native city of Madrid and the surrounding Castilian countryside, including the Tagus River in Toledo. Darío Regoyos is best known for portraying the dramatic mountainous landscapes and northern seaport towns of Asturias. Joaquín Sorolla's name is synonymous with scenes of dazzling sunlight on the beaches of his native Valencia in the south. Seville, in the southern province of Andalucia, spawned Luis Jiménez, who applied his pigments in a sensuous, thick manner, and Catalonia produced Ramón Casas and Joaquín Mir, who created a good number of Impressionistic masterpieces before becoming affiliated with Barcelona's Art Nouveau movement, "Els Quatre Gats" (named for a café frequented by artists and writers).

Far from being provincial, three other Spanish Impressionists traveled around Europe so much that they swept aside the confines of regionalism and must be called internationalists. The Madrid-born Martín Rico, after study in Paris, spent many years in Italy and ended his long career in Venice, where he was enchanted with the changing light on the canals. Mariano Fortuny as a student at the Academy of Fine Arts in Barcelona won the much-coveted Prix de Rome, which entitled him to four years of study in Rome, and thereafter spent much of his career living in Italy.[1] The expatriate Raimundo de Madrazo, named an Officer of the Legion of Honor by the French government, died at his home in Versailles after a long and productive artistic career.

What these Spanish painters had in common was a desire to paint directly from nature. They all emerged from a Realist tradition that was deeply rooted in the paintings of Velázquez and other seventeenth-century artists and was perpetuated in the much-admired work of Goya in the eighteenth century. Early nineteenth-century Spanish painters of genre scenes and of landscape continued in this style until a few avant-garde artists began to shed it to varying degrees. Beruete, concentrating exclusively on landscapes, showed a fascination with the changing colors of the different seasons—fall foliage, snowy mountain peaks, bright greens of spring, and dry summers—whereas Madrazo, like Manet, continued to paint many genre subjects set in domestic interiors. In search of the newest mode of expression, many Spanish artists journeyed to Paris: Rico in 1859, Fortuny in 1866, Regoyos in 1879, Casas in 1882. Luis Jiménez, who took up residence there in 1876, became a French citizen and died in Pontoise in 1928. Of all these painters Regoyos became the most Impressionistic in his technique. He completely adopted the juxtaposed staccato strokes of pure colors for his shore scenes, for the steam of trains and boats, and for dappled sunlight. In his nocturnal views, he used short lavender strokes for shadows, dabs of yellow for lamplight filtered through the trees, and violet for clouds set in a deep blue sky, as in *La Concha at Night* (plate 265).

Another factor common to all the Spanish Impressionists was the artists' admiration for Goya and Velázquez. Fortuny, for example, in 1867 went to the Prado Museum to copy Velázquez and became awed by Goya's paintings there. He first made studies of *The Family of Charles IV* (1800) and continued making copies of individual sitters, such as Goya's late *Portrait of Pedro Mocarte* (c.1806; The Hispanic Society of America, New York City).[2] Aureliano de Beruete actually owned Goya's very late *Portrait of Ramón Satué* (1823; Rijksmuseum, Amsterdam),[3] and he even wrote a monograph on Velázquez (published in Paris in 1898).[4] In his late work, Goya loosened up his pigment; instead of using the precise contour lines characteristic of his early work, he began to suggest form through generously applied dabs of color and a thick impasto. There is specific evidence that Fortuny copied Velázquez's *Portrait of Pope Innocent X* while he was in Rome[5] and that both Ramón Casas and Joaquín Mir copied Velázquez's paintings in the Prado.[6] This didactic interest in Velázquez mirrors the earlier example of Manet's admiration for the Spanish painter. We clearly see in Joaquín Sorolla's *Portrait of Aureliano de Beruete* (plate 268) the Velázqueña influence that also inspired Manet.[7] Both Manet and Sorolla exploited the subtlety of gray on gray. There are in fact three grays in Sorolla's portrait of Beruete: a light one in the hat, a medium one in the jacket, and the darkest in the coat. The tranquil figure stands before a Velázquez-like neutral background of ocher mixed with gray, and the telltale slashes of brush strokes at the lower right are very similar to Velázquez's penchant for drying his brushes on the canvas.[8] It seems that a special fire was ignited in *both* France and Spain when the Impressionist painters' fascination with Velázquez and Goya was united with plein-air methods.

Of all the Spanish Impressionists Sorolla became the most facile painter and the one most consumed by luminosity. His unmatched virtuosity in capturing the effect of light on sails is seen in his almost infinite succession of seashore paintings. His skill in depicting light and shadows on white cloth extended to his many portraits, such as *Mariá Painting at El Pardo* (plate 266) and *Raimundo de Madrazo in his Paris Garden* (plate

THE LURE OF IMPRESSIONISM IN SPAIN AND LATIN AMERICA

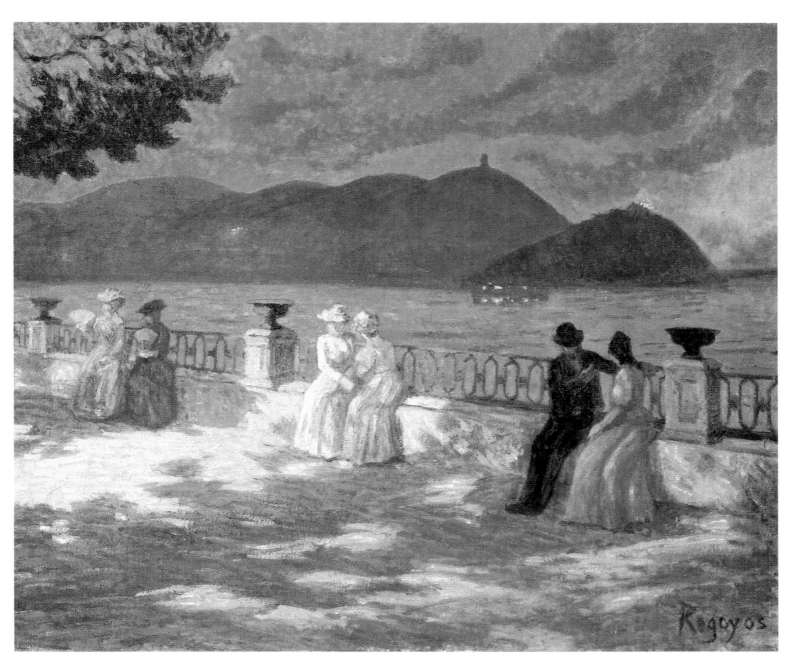

265. Darío de Regoyos. *La Concha at Night.* 1906. Oil on canvas, 24¼ × 25⅝″. Private collection

267). In the former, the white dress of Sorolla's daughter María is defined by bold slashes of white, green, apricot yellow, and pale blue; and in the latter, pink, ocher, and blue hues animate Madrazo's gray jacket, while generous broad brush strokes in the foreground provide a lively counterpoint to the shorter ones depicting the red and orange flowers in the garden behind.

In summary, the regional diversity that traditionally characterized Spanish painting was continued by artists in the late nineteenth century only with respect to their choice of subject matter; as far as style is concerned, the major Spanish painters of this period brought back to their country a dedication to plein-airism derived from their studies in Paris or in Italy. Many of the artists experimented briefly with Impressionism, grafting the new style upon their Realistic predilection, while others fully adopted the new mode as the best means for capturing outdoor phenomena.

Carlos de Haes (1826–1898) deserves credit for initiating plein-air painting in Spain. As professor of landscape painting at the Fine Arts Academy of San Fernando in Madrid, he introduced his students, among whom were Martín Rico, Aureliano de Beruete, and Darío Regoyos, to lengthy painting excursions into the countryside, which enabled them to make oil sketches that formed the basis for more ambitious canvases executed later in their studios. This Brussels-born painter had been brought to Spain in his youth when his father established a business in Málaga. For artistic training he went to Belgium in 1850 to study with the landscape painter Joseph Quinaux (1822–1895). After his return to Spain he entered his paintings in Madrid's first *Na-*

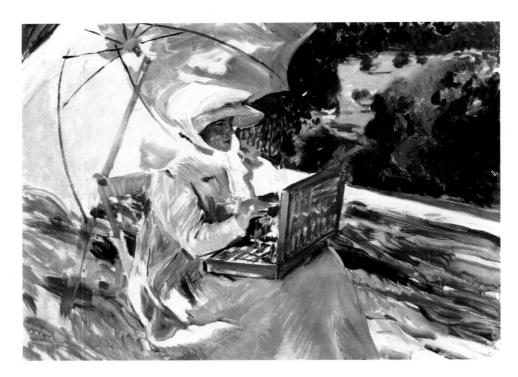

266. JOAQUÍN SOROLLA. *María Painting at El Pardo.* 1907.
Oil on canvas, 32¼ × 41¾″. Private collection

267. JOAQUÍN SOROLLA. *Raimundo de Madrazo in His Paris
Garden.* 1906. Oil on canvas, 37¾ × 44½″. Courtesy of The
Hispanic Society of America, New York City

268. Joaquín Sorolla. *Portrait of Aureliano de Beruete.* 1908. Oil on canvas, 44⅞ × 30½″. Courtesy of The Hispanic Society of America, New York City

However, the door to plein-air painting had literally been opened by Haes, and Rico, the earliest of Haes's pupils to sketch directly from nature, received his first award in the 1858 *National Exhibition* for a landscape painting of the Guadarrama Mountains.[10] The following year Rico won the academy's scholarship for landscape painting, and with his painter-friend Raimundo de Madrazo he left for Paris. In 1862, after on-site sketching of French rivers and one summer in the Swiss Alps, Rico, preceding the French Impressionists, journeyed to London to see the experimental paintings of J. M. W. Turner. Landscapes especially interested Rico, and in his sketchbooks he copied seven Turner paintings that were hanging in the National Gallery.[11] Back in France, he devoted his time entirely to landscape painting and spent one summer (apparently in 1865) working with Pissarro at La Varenne-St. Maur (about fifteen miles outside Paris); a painting from this period is *Washerwomen in La Varenne* (shipped to Spain by Rico in 1867 and now exhibited at the Casón del Buen Retiro).[12] Mariano Fortuny, who had been living in Rome, visited Paris in 1866, bearing a letter of introduction to Rico. The two painters became friends, and at the outbreak of the Franco-Prussian War they both took refuge in their native country. Rico and his wife stayed at first with her family in Madrid, but after two months Fortuny persuaded Rico to join him in Andalucia, where the abundant sunlight stimulated their flow of work. In Rico's *Gathering Oranges, Granada* (plate 270), the verdancy of the foreground is contrasted with fleecy white clouds floating above a heavily pigmented skyline of the city's towers and church dome. Populating the orange grove are three donkeys with panniers, a dog, a man and boy gathering fruit, and two women seated near a white and blue fountain, all rendered in minuscule color notations. In both this painting and the *Washerwomen in La Varenne* Rico shows his attentive observation of natural phenomena, which are reproduced in soft, realistic terms: over 50 percent of the canvas is devoted to the sky in the Granada painting, and a great swath of reflective water dominates the *Washerwomen* painting.

Rico's visit in 1872 to Fortuny's studio in Rome was the turning point in his life; once Rico had traveled through Italy and discovered the luminosity of Venice, he had found the subject matter for which he would become famous. Painting from his gondola, he moved about the city, sometimes choosing the Grand Canal, other days turning to the maze of smaller canals. His popularity with American collectors for his Venetian scenes was so great that every year he would arrive in the city with more commissions than he really wished to fulfill because he hoped that his Spanish and French scenes would also attract buyers. Awards for his canvases were also forthcoming; for example, *The Market of the Avenue Josephine, Paris* (now in the Corcoran Gallery of Art, Washington, D.C.) won a prize at the Exposition Universelle of 1878 and resulted in his being accorded the Cross of the Legion of Honor.

*tional Exhibition of Fine Arts* in 1856, and the next year he competed successfully for the position of teacher of landscape painting at the academy. His arrival brought fresh air to the classrooms as he substituted outdoor painting trips for academic copying. The Spanish art historian Gaya Nuño has heralded Haes as "the discoverer of our landscape."[9] Haes's tall, vertical painting *Los Picos de Europa* (plate 269) is typical of the kind of composition that grew out of his on-the-spot oil sketches; from such studies, made directly from nature in the Cantabrian Mountains of northern Spain, he constructed this scene of strong greens in the foreground near the twisted trees and of engulfing clouds that dilute the blue of a distant peak. Although a realistic painting, such works by Haes were important precursors to Impressionism in Spain, and shortly after Haes's death, when the National Museum of Modern Art opened in Madrid in 1900, a large room was devoted to the art of this pioneering painter.

When Martín Rico (1833–1908) began his training at the Academy of San Fernando in Madrid, landscape painting was taught by Genaro Pérez Villaamil, who worked in the Romantic tradition and in-

269. CARLOS DE HAES. *Los Picos de Europa.* 1876. Oil on canvas, 66⅛ × 48⅜″. Casón del Buen Retiro, Museo del Prado, Madrid

*Grand Canal* (plate 271) is typical of Rico's mature work: reflections in the water of shadows cast by the boats and white buildings, a limpid blue sky (he always painted Venice on clear days), and a jagged skyline produced by the different structures of this city—in this case the red brick tower of Saint Mark's and the whitish dome of Santa Maria della Salute. Such views of Venice were so highly treasured by nineteenth-century collectors that almost every museum in America owns at least one (some museums have deaccessioned their surplus so that one finds a brisk art market for them today).[13]

Rico died in this city of his adoption in his seventy-fifth year. His Venice paintings, which considerably predate Monet's visit to the city, differ from the later French painter's work in their more detailed depiction of buildings. Whereas Monet tended to blend his buildings with the water by applying the same colors in juxtaposed strokes throughout the composition, Rico dichotomized: he Impressionistically conveyed the canals with many reflective colors, yet maintained rather linearly painted churches and houses. Perhaps his verisimilitude explains his popularity—these city views served as nostalgic souvenirs for travelers to Venice.

Rico's friend Mariano Fortuny (1838–1874) en-

joyed similar success but not equal longevity. This Catalan artist, who had studied in Barcelona and Rome, had painted in Morocco in 1860 and 1862 before meeting Rico in Paris. The conjunction of events in 1866 in Paris bore more far-reaching implications for Fortuny: he met at that time Federico de Madrazo, director of the Prado Museum, whose daughter he married the next year, and he also visited the art dealer Goupil, with whom he signed a contract two years later. Upon marrying Cecilia de Madrazo, Fortuny returned with his wife to Rome, where he had maintained a studio since his student years.

Fortuny's painting technique differed from Rico's. He created a frostier quality with thickly applied pigments, as opposed to Rico's lucid tones. In *The Children of the Painter in the Japanese Room* (plate 272) the lushness of Fortuny's palette can be seen in the decorative fabric draped across his nude son Mariano, in the luminous white dress of his daughter María Luisa and the fan held in her right hand, in the decorative cushion against which she reclines, and in the plants and flowers at the left side of the room.

Fortuny's *Bullring* of 1869 (Casón del Buen Retiro, Barcelona) evokes memories of Manet's 1864 *Bullfight* (Frick Collection, New York City). In each case the painter has isolated one segment of the ring and its action, capturing a vignette in the same way a photographer might. But although both artists have recorded a single spontaneous moment, their brushwork differs. The outlines of the figures are much more distinct in Manet's painting, and the line of shadow cutting across the wall of the bullring is much sharper; in Fortuny's painting the figures are blurred, and the demarcation between *sol* and *sombra* is raggedly indicated.

International attention focused on Fortuny at the time of his 1870 exhibition at Goupil's in Paris. Théophile Gautier's enthusiastic review of May 19 in *Journal officiel* begins: "The name which has been most often pronounced for several months in the world of art is that of Fortuny. . . . Everyone asks, 'Have you seen the pictures of Fortuny,' because Fortuny is a painter of marvelous originality. . . ." Of his painting *The Spanish Marriage*, Gautier continued, "It is like a sketch of Goya . . . retouched by Meissonier. One finds here in effect all the fantastic liberty of a Spanish painter and all the scrupulous truth of a French painter; it is necessary to add the individuality of Fortuny who makes vibrate the note between the two influences which do not dominate it. What harmonious colors in their boldness which do not fear to borrow tones from the Japanese palette, exotically rare tones, reanimating pearly grays and neutral browns!"[14] Gautier in his encomium not only substantiated the popularity of Fortuny's work but also noted appreciatively the Japanese influence on the Spanish painter's style.

When the Fortuny family returned to Rome in 1872, they sought new quarters and the following year installed themselves in the Villa Martinori, which the painter, a passionate collector, converted into a museum

that attracted artists and antiquarians.[15] Photographs of the rooms correspond to the sumptuousness seen in Fortuny's paintings, such as *The Children of the Painter in the Japanese Room* (plate 272). In addition, Fortuny shared with the French Impressionists a keen interest in Japanese prints; he even wished to visit Japan and to paint there, but the cost of such a long trip proved prohibitive.[16]

While on a family holiday in 1874 at the seashore south of Naples, Fortuny painted the small study *Nude on the Beach at Portici* (plate 273). Dramatically, Fortuny concentrated exclusively on the child's skin as it reflected the sun tones and contrasted with the surrounding grayish blue wet sand. Scarcely had the family returned to Rome that fall than Fortuny, at age thirty-six, lost his life to malaria. Although more of a realistic plein-air painter than a divided-color Impressionist, Fortuny's bright Mediterranean palette did have international repercussions. His 1870 exhibition at Goupil's in Paris caused several French painters to brighten their palettes and to deemphasize shadows as well as to consider festive events for their subject matter. A group of these young artists (Jehan-Georges Vilert, Jules Ferdinand Jacquemart, Gustave Doré, and Charles Edouard de Beaumont), living together at Montmorency, even changed from painting in oils to watercolors to achieve more effectively a luminosity in their work. In 1878 they formed the Société d'Aquarellistes Français.[17]

Fortuny's *Garden of Fortuny's House* (plate 274), although joyous in color, is, alas, a collaborative piece perforce finished by Fortuny's brother-in-law, Raimundo de Madrazo (1841–1920). After the death of Fortuny, Madrazo added the figure of his sister to the sunlit path, framing her head with a red parasol, and also added a napping dog in the shadowy foreground.

Madrazo had been a pupil of his illustrious grandfather José de Madrazo, court painter to Carlos IV, and of his prominent father, Federico de Madrazo, a painter who became director of both the Academy of San Fernando and of the Prado Museum. In 1861 Raimundo enrolled at the École des Beaux-Arts in Paris as a student of Léon Cogniet and from then on made his home in France, taking occasional trips to Italy, Spain, and the United States, where his fame had spread as a portraitist.[18] His Realist style of portraiture most closely approximates Manet's and Fantin-Latour's—in which a single figure is set against a simple background that is animated through lively brush strokes. Madrazo's subject matter also included genre and landscape scenes.

His *Women at a Window* (plate 275) appears to carry anecdotal content, for the young woman seated at the left, still attired in her morning camisole, holds binoculars in her left hand, and both she and her visitor, who wears a hat decorated with pink flowers and blue feathers, gaze affectionately upon an unshown object of attention below, perhaps a child at play. Light is picked up in impasto passages, such as on the sleeve of the morning robe, in the red bow in the hostess's hair, and in her blue earring; the shadow on her right hand is rendered in

270. Martín Rico. *Gathering Oranges, Granada.* c.1871. Oil on canvas 16½ × 29½". Walters Art Gallery, Baltimore

271. Martín Rico. *Grand Canal.* n.d. Oil on canvas, 18⅛ × 28". Private collection

272. MARIANO FORTUNY. *The Children of the Painter in the Japanese Room.* c.1874. Oil on canvas, 17¼ × 36⅝". Casón del Buen Retiro, Museo del Prado, Madrid

273. MARIANO FORTUNY. *Nude on the Beach at Portici.* 1874. Oil on canvas, 5⅛ × 7½". Casón del Buen Retiro, Museo del Prado, Madrid

274. Mariano Fortuny and Raimundo Madrazo. *Garden of Fortuny's House.* c.1874. Oil on canvas, 15¾ × 10⅝″. Casón del Buen Retiro, Museo del Prado, Madrid

green. As a foil to the white camisole there is the visitor's dark dress with bluish gray pigment defining its contours. Additional sprightly notes of color are provided by the pink and violet flowers of the plant in the pot at the lower right and by the green vine and green window shutter at the left. Stylistically Madrazo is well on his way to Impressionism in this painting. A parallel can be seen in Mary Cassatt's early work at the beginning of the 1870s, such as her painting *On the Balcony* (Philadelphia Museum of Art), in which three half-length figures are depicted close to the picture surface. One woman peers down toward the street, while a man and another woman exchange flirtatious smiles. The major difference is that Madrazo, in keeping with a Spanish tendency toward serious miens, maintains more ruminative demeanors. (The Madrazo painting entered New York's Metropolitan Museum of Art as early as 1887, during a fifty-year period of American enthusiasm for Spanish painting that began with William Hood Stewart's collecting in 1867 and climaxed with Archer Milton Huntington's commissioning Sorolla to paint the provinces of Spain in the 1910s.)

A more Impressionistically dabbed scene is *Pool in the Alcázar of Seville* (plate 276), probably painted in 1872 when Madrazo visited Fortuny, who was in southern Spain avoiding the Franco-Prussian War.[19] Preoccupied with the dazzling light on the water, Madrazo summarily sketched in the bystanders, one of whom seems to poke her parasol playfully at the nearest white swan. A bronze fountain at the right balances the action, while between these two points of focus the water is enlivened with reflections. Both Madrazo and Fortuny brightened their palettes and softened their delineation of forms when they worked in the blazing sun of Andalucia, and there they approached more closely the style of their French Impressionist contemporaries.

Success came early to Madrazo in the form of a gold medal at the Paris Exposition Universelle of 1878, a special room of fourteen paintings in the Salon International of 1884, and a gold medal at the Exposition Universelle of 1889, when he was also elevated from Chevalier to Officer of the Legion of Honor. In addition to these awards, Madrazo became a highly sought-after society portraitist, famous for his dignified likenesses of wealthy Europeans and Americans who sat for him principally in his Paris studio or during a trip he took to the United States.

Although the three expatriate Spaniards Rico, Fortuny, and Madrazo experimented with plein-air painting, they never went to the extreme of dissolving form in an enthusiasm for divided dabs of pure color. Their palettes did become lush and often even pasty, but their contour lines remained intact. Their work appealed to patrons who liked to see and buy realistic representations of life.

Beruete, Regoyos, and Sorolla have been called the essential tripod of Spanish Impressionism,[20] and without question Aureliano de Beruete (1845–1912), a prolific painter of landscapes, was the earliest Spaniard

working consistently throughout his long career as an Impressionist. Coming from an aristocratic family, Beruete at first enrolled in a more conventional field of study, law, despite his youthful proclivity toward art and his experimental copying of old masters in the Prado. After graduating from the University of Madrid with a doctorate in Law in 1867 and serving as a member of parliament in 1871–1872, he gave up politics for art and became a student of Carlos de Haes's at the Academy of San Fernando, participating actively in Haes's sketching excursions into the countryside.[21] If the ardor of his devotion to his newfound career can be measured by output, we should note that, when a retrospective exhibition of his landscapes was held after his death in 1912, six hundred and sixty-six of his two thousand paintings were assembled.[22]

Beruete's *Shipwreck of the 'Cabo Mayor' on the Cantabrian Coast* (1886; private collection) has affinities with some of Manet's early paintings, particularly *The Battle of the Kearsarge and the Alabama* (1864; Philadelphia Museum of Art): a steamship, split in two by some navigational mishap, flounders on a horizontal sweep of calm sea; agitation in the water around the sinking ship helps to convey the calamitous moment.

His native region of Castile also provided Beruete with endless, appealing scenery, seen first in his *The Banks of the Manzanares* (Casón del Buen Retiro, Madrid),[23] which won a prize in the *National Exhibition* of 1878, and continuing through a variety of different views he painted of Madrid's wide river. In *The Manzanares* (plate 277), we are led beyond the ocher mud flats in the foreground through white reflections on the water to the red tile roofs of the opposite shore, where the skyline is punctuated by the royal palace at the left and the dome of San Francisco El Grande at the right. Beruete also followed his paragon Goya in choosing the meadow of San Isidro as a subject, and a comparison of their two paintings proves instructive (plates 278 and 279). The most obvious difference is in Goya's greater interest in people. Goya devoted fully half of his composition to the Madrileños celebrating the feast day of their patron saint Isidro: they are seen chatting under parasols at the left; one pours wine from a bottle at the right, and others arrive by horse-drawn carriages along the flat terrain. The extent of Goya's interest in the human element can be seen in his inclusion of the distant figures silhouetted against the blue water. Beruete, on the other hand, concentrated on the continuous flow of the landscape back into space, climaxing with the white buildings of the city, and he barely jotted in tiny figures in the unfolding field. Nevertheless, in homage to his hero, Beruete painted *The House of the Deaf Man* (1907; Casón del Buen Retiro, Madrid),[24] the house on the Manzanares that Goya bought in 1819 and that later assumed enormous historic importance because Goya covered its interior walls with the Black Paintings. The work exudes spontaneity with its rapidly executed trees, chimneys emoting smoke, and abbreviated white brush strokes denoting the far-off royal palace.

275. RAIMUNDO MADRAZO. *Women at a Window.* n.d. Oil on
canvas, 28⅝ × 23½". The Metropolitan Museum of Art, New
York City. Bequest of Catharine Lorillard Wolfe, 1887.
Catharine Lorillard Wolfe Collection (87.15131)

276. RAIMUNDO MADRAZO. *Pool in the Alcázar of Seville.*
c.1872. Oil on canvas, 23⅝ × 35½". Casón del Buen Retiro,
Museo del Prado, Madrid

277. Aurelio de Beruete. *The Manzanares, Madrid.* 1908.
Oil on canvas, 22⅝ × 31⅞″. Casón del Buen Retiro, Museo del
Prado, Madrid

278. Francisco Goya. *The Meadow of San Isidro.* 1788. Oil
on canvas, 17¼ × 37″. Casón del Buen Retiro, Museo del Prado,
Madrid

279. Aurelio de Beruete. *The Meadow of San Isidro.*
1909. Oil on canvas, 24⅝ × 40½″. Casón del Buen Retiro,
Museo del Prado, Madrid

280. Aurelio de Beruete. *View of Toledo from the Olive
Groves.* 1906. Oil on canvas, 26⅜ × 39⅜″. Private collection

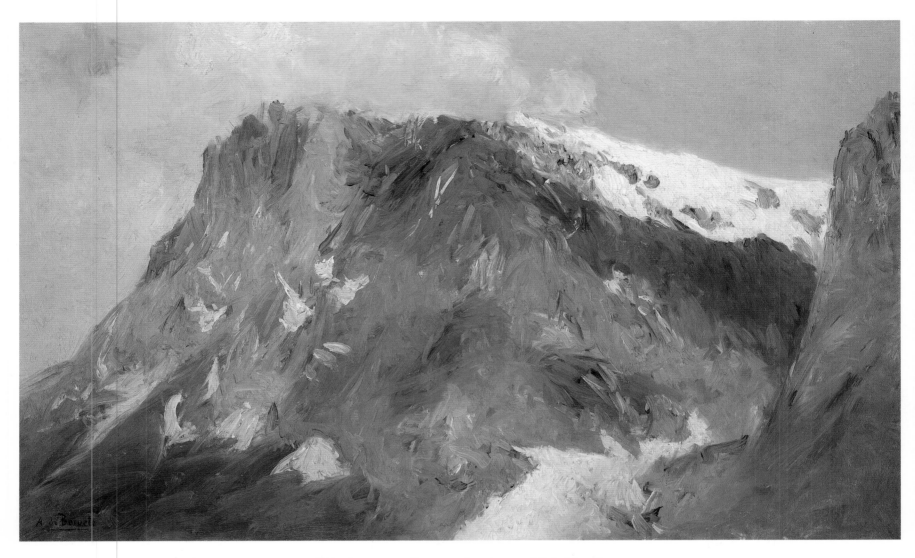

281. AURELIO DE BERUETE. *Landscape of Grindelwald.*
1906. Oil on canvas, 18⅞ × 31¾″. Private collection

282. AURELIO DE BERUETE. *Segovia from the Boceguillas Road.* 1908. Oil on canvas, 26 × 39⅛″. Courtesy of The Hispanic Society of America, New York City

The ancient Castilian city of Toledo, another popular subject for Beruete, was painted by him from many different vantage points. In 1905 he chose a prospect high above the Tagus River gorge;[25] another view is of the old Alcántara Bridge,[26] painted in the Impressionist manner of alternating dabs of raw, direct colors that mix in the beholder's eye. In 1906 he viewed the city from one of its surrounding olive groves (plate 280). From a high perspective the painter looked across at the Gothic cathedral and the four-turreted Alcázar. Through loosely applied brush strokes of blue and green in the foreground he has conveyed the idea of a rocky ground interspersed with occasional foliage before the swath of red soil that nourishes the olive orchard. Paler reds and blues define the distant city. An overall grayish tonality, similar to the unifying gray that is characteristic of many of Pissarro's paintings, mutes the colors—as so often happens in the warm atmosphere of a summer day.

Beruete also painted the nearby cities of Segovia and Ávila, showing their famous landmarks with the adjacent countryside. In *Segovia from the Boceguillas Road* (plate 282), a garden of vegetables is so Impressionistically rendered that one can only guess its con-

tents' identity as cabbages, buildings cast pale blue shadows, red roofs are insinuated with ochers and white, and little figures are barely discernible on the road at the left. The sky, composed of blue and pink, is painted with the same values as the Roman aqueduct to convey distance. Beruete characteristically captures the moment with a combination of brilliant and limpid tints.[27]

Beruete's trip to Switzerland from 1905 to 1907 produced spectacular views of the Jungfrau and the other mountains seen from Grindelwald. In *Landscape of Grindelwald* (plate 281) the pure white of the snow is differentiated from the white of the clouds, enshrouding the blue and green peaks through the addition of pale blue and yellow to the clouds. A dark green in the lower left indicates a shadow cast by a passing cloud. In this version the colors of the rocks shine in the sun, whereas a stormier day is represented in *Summits in the Berner Oberland* (1906; private collection),[28] in which the mountain peaks are hidden by floating mists and forms and atmosphere unite in a final blooming of late Impressionism.

Beruete differed from the expatriate Spaniards by being a landscape painter in the true Impressionist style, whereas Fortuny, Rico, and Madrazo retained realistic, linear forms and only in their loose brushwork and bright hues emulated the new avant-garde mode. After Beruete's death on January 5, 1912, the enormous retrospective exhibition of his landscapes was held at the studio of his friend Joaquín Sorolla. Before we examine the other two legs of the Spanish Impressionist "tripod," Regoyos and Sorolla, masterpieces by some lesser-known yet talented artists deserve interpolation.

Vicente Palmaroli González (1834–1896), who was born in Zarzalejo, a village in the Guadarrama Mountains, studied painting at the Academy of San Fernando and then continued his training in Italy (where his father, a lithographer, had been born). When he visited Paris for the Exposition Universelle of 1867 and became acquainted with the new French way of painting directly from nature, he modified his early style of painting sharply defined figures in interior settings. Back in Madrid, he was elected a member of the Academy of Fine Arts, but again an opportunity in Italy called him, this time the directorship of the Spanish Academy in Rome. It was during this Italian period of 1883–1895 that the genre painting *Confession* (plate 283) was made. Not only did Palmaroli focus on an intimate moment, but he magnificently contrasted the delicately dressed young woman—in mauve and blue—with the black-suited young man, who leans forward eagerly to confess his love. The enigmatic, overturned chair suggests something beyond this one tête-à-tête, and indeed this scene was the centerpiece of a seashore triptych, the two wings of which have been lost (but not before they were photographed[29]). In each wing there appears the figure of a woman absorbed in her private thoughts. A pervasive gray blends the delicious colors and implies an overcast day. Other Impressionist paintings by Palmaroli are of ballet dancers and a portrait of his wife in a translucent

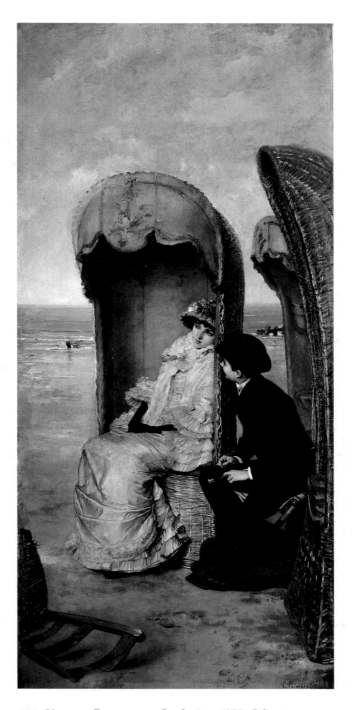

283. VICENTE PALMAROLI. *Confession*. 1883. Oil on canvas, 54 × 25″. Casón del Buen Retiro, Museo del Prado, Madrid

284. Luis Jiménez Aranda. *Portrait of a Woman in a Mantilla*. 1873. Oil on canvas, 30½ × 22⅞″. Private collection

(right) 285. Luis Jiménez Aranda. *A Lady at the Paris Exposition*. 1889. Oil on canvas, 47½ × 27⅞″. Algur H. Meadows Collection, Meadows Museum, Southern Methodist University, Dallas, Texas. Accession Number 69.24

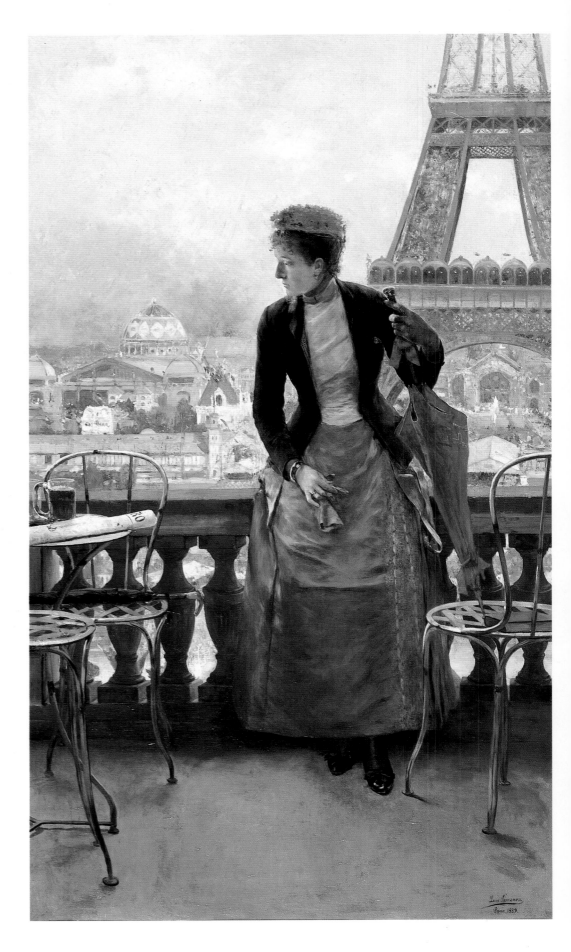

white mantilla. Perhaps the most surprising painting is *In the Studio* (early 1880s; Museum of Contemporary Art, Madrid), which interestingly has another beach setting;[30] this time the painter working at an easel is a woman. Her hat is wonderfully silhouetted against a blue sky and surrounded by halo-like white clouds.

Although the plein-air painter in Palmaroli's picture is nameless, a few Spanish women artists of the late nineteenth century can at least be identified. Marcelina Poncela Ontoria (1867–1917), born in Valladolid, received a scholarship in 1885 to study with Carlos de Haes at the Academy of San Fernando and stayed on in Madrid, participating in almost every *National Exhibition* from 1894 to 1915. Her portraits and landscapes bordered on that close axis of Realism-Impressionism (as in *Seashore Neighborhood* of 1891 and *My Children* of 1904).[31] In *Flowers of the Greenhouse*[32] she combined the two styles, giving rather substantial form to a woman in a straw hat and painting the flowers Impressionistically. One understands easily today, when admiring a geranium in the sunlight, the excitement these late nineteenth-century artists felt in their ability to differentiate between red petals glowing in the sun and the less lustrous green leaves hidden in the shade. Such a study in contrasts is visible in Poncela's painting of potted flowers on a window ledge (*Flowers*, undated; private collection, Madrid[33]). In 1895 Poncela married a journalist from Zaragoza. Their son, who became a famous playwright, wrote of his mother's commitment to her career as a painter and of his accompanying her to painters' studios and to the Prado.[34] One of her favorite places was the little Zaragozan town of Quinto de Ebro, where the family vacationed and where Poncela spent entire days painting out-of-doors. Her activity was cut short when she died of cancer in Quinto de Ebro at age fifty.

Luisa Vidal (1876–1918), who was given a solo exhibition in the *sala gran* of Els Quatre Gats, was the only woman in Barcelona to succeed as an artist at the beginning of the twentieth century. Her painting *First Communion*[35] brilliantly captures a shift from light to shadow with the façade of the church illuminated in a full glare and the celebrating family depicted in shade in the foreground. Within the family group there is a range of color values, from the white impasto of the girl's commation dress to the widowed mother's black dress. Vidal's principal subject was the human figure, as best indicated in a spread of illustrations published in the famous Catalan arts magazine *Pèl y Ploma:* a realistic 1903 depiction of a schoolgirl standing in a doorway reading a book and being watched intently by a cat; a more loosely painted portrait of an acolyte in his white surplice swinging an incense burner in a church interior; a view of a woman holding up a dish of apples, rendered in a style evocative of Manet; and another of two children whose clothes catch the light as they walk through the countryside.[36]

According to George Harvey's biography of Henry Clay Frick, Luis Jiménez's *In the Louvre* of 1881 (Frick Foundation, Pittsburgh) was the first purchase the distinguished art collector made. The painting, which still hangs in Clayton House, the Frick family home in Pittsburgh, shows a mother and daughter walking through a gallery of classical sculpture. The mother gently but decisively pulls along her daughter, who stands transfixed before a male nude statue. Just behind them a man concentratedly studies the label on a partially nude female sculpture and another appreciative man shields his eyes to see better the marmorean image. The figures in this comedy of manners are set off against a deep red background. In his early work, Jiménez (1845–1928) painted in ways similar to Fortuny and Madrazo, using a rich diversity of jewellike hues. The mother wears a red and black patterned dress with a yellow shawl and a lavender hat. Her daughter is dressed in a light gray frock, trimmed with pink flowers near the hem, a green and yellow lace stole, and a light gray hat.[37] The man reading the label is attired in pink, the other man in gray.

Prior to becoming a French citizen, the Seville-born Jiménez worked in Rome from 1867 to 1876. *Portrait of a Woman in a Mantilla* of 1873 (plate 284) is from this period. While it is essentially an objective depiction of a passively posed woman holding a fan, there is excitement in the lively surfaces of the painted fabrics. The painting is very close in style and mood to Renoir's *Lise in a White Shawl*, (1872; Dallas Museum of Art) and to Mary Cassatt's *Spanish Dancer Wearing a Lace Mantilla* (1873; National Museum of American Art, Washington, D.C.).

Luis Jiménez's search for the environment most suitable to him ended with his discovery of Pontoise at the time that Pissarro and Cézanne were also painting there. This village outside Paris, with its view of the Oise River, gave the artists a variety of open-air subjects, and Jiménez's brushwork began to loosen up and more closely approximate Impressionism. He began to move from painting figures in an interior setting to scenes that included landscape. One of his most arresting paintings is *A Lady at the Paris Exposition* (plate 285), in which the artist shows his versatility by alternating between the clear delineation of the woman leaning against a balustrade and the softer articulation of the Eiffel Tower and the world's-fair pavilions behind. Jiménez catches a fleeting moment as the pensive woman seems to await a man whose temporary absence is implied by the gentleman's umbrella resting on the chair, the newspaper (*Le Figaro*), and the drained beer mug to the left of an almost full mug. The viewpoint of the scene is from the old Trocadéro, erected for the Exposition Universelle of 1878, looking toward the 1889 Exposition Universelle and the tower just completed by Eiffel to commemorate the one-hundredth anniversary of the French Revolution.

Jiménez won a medal of honor at the 1889 Exposition Universelle for *The Visit to the Hospital* (Museum of Fine Arts, Seville) as well as many more awards at the national exhibitions in Madrid and at the Columbian Exposition of 1893 in Chicago, where he showed two genre paintings: *Old Clothes Market at the Temple,*

*Paris* and *The Lovers*.[38] During the first two decades of the twentieth century he showed oils and watercolors he had painted in Pontoise, Auvers, and Spain of landscapes, waterways, and villages.

The topic of Spanish Impressionism has only recently been singled out for study, and one of the rare books on the subject prominently features the Valencian painter Ignacio Pinazo Camarlench (1849–1916), in addition to the acknowledged pivotal three.[39] After attending drawing classes at the Academy of San Carlos in Valencia and selling enough paintings to finance a trip to Italy, Pinazo departed with two artist-friends in 1873 for Venice, Rome, and Naples. Later in 1876 he received an official scholarship to study in Rome, where he concentrated on landscapes and history paintings. On his return to his native city, he bought a house in the village of Godella, just north of Valencia, and his work dichotomized quite naturally into paintings of the seashore and of his family. *The Luncheon* (plate 286), a depiction of a cheerful event along the Mediterranean, centers upon a group of three seated at a table. In the middle distance two women dance together, and farther back festive flags flutter in the breeze. Splashes of joyous color corresponding to the hues of the women's dresses create a vivacious cloud pattern in the sky. The dissolution of contour lines and the bright bursts of color suffusing the entire composition signal Pinazo's conversion to Impressionism.

In a series of paintings of rocky beaches Pinazo recorded changes in moonlight from twilight to late evening.[40] These sketchily rendered studies have stylistic affinities with French Impressionism (which was by now familiar to most Spaniards); for example, to Eugene Boudin's shore scenes as well as conceptually to Monet's interest in observing haystacks at different times of the day.

Pinazo continued to express his fascination with natural phenomena in *At the Edge of the Water Basin* (plate 287), in which the forms of the swans and the bystanders have become so dematerialized by the saturation of the sun that their bodies are flattened, blending with the leafy trees to become one overall mosaiclike design.

The second major figure in the formation of a school of Spanish Impressionism, Darío Regoyos (1857–1913), began his career in 1878 as a student of Haes's at the Academy of San Fernando. Regoyos accepted an invitation in 1879 to visit Brussels, where his friend Isaac Albéniz, the composer whose musical depictions of Spain present an Impressionist parallel to his painter coevals, was finishing his courses at the Brussels Conservatory. Regoyos resumed his own studies, this time with the Belgian painter Joseph Quinaux, who had trained Haes. Regoyos's friends in Brussels were the young avant-garde artists who decided in 1881 to form a group called "L'Essor" and to organize their own exhibitions. In 1882 Regoyos and his friends Théo van Rysselberghe, Maximilien Luce, and Constantin Meunier traveled together to Spain, and after their return to Belgium, having

286. Ignacio Pinazo. *The Luncheon*. 1891. Oil on canvas, 7½ × 12⅝″. Museo de Bellas Artes, Valencia

stopped en route to see examples of modernist developments in Paris, they created their own avant-garde group, "Les Vingt," in 1884. Among the twenty founding members were Van Rysselberghe, Regoyos, James Ensor, Fernand Khnopff, and three sculptors. Other artists, including Morisot, Monet, Renoir, Sisley, Luce, Whistler, Rodin, Cassatt, Seurat, Signac, and Van Gogh, were invited to join them in their annual exhibitions. After ten years of such exhilarating activity in Belgium, Regoyos resettled in his native land and married a resident of Bilbao.

The sunnier climate of Spain seems to have effected a change in Regoyos's paintings. Although his Belgian landscapes showed his interest in light and atmosphere, he often depicted scenes with overcast skies. But when his subject matter changed to the villages along his homeland's north coast and their bright seaside light, he became a full-fledged Impressionist. From rocky bluffs he could look down upon colors reflected in the water—as he recorded them, for example, in *A Bullfight in the Town* (plate 289). At the left of this painting the inlet is made up of alternating dabs of blue, violet, and green, and then the pinks and yellows of the reflected buildings take over. A boat with its passengers and the Spanish flag are mirrored in the water at the right. Tiny figures indicate the bullfight that is taking place in the town's plaza before a bunting-draped municipal building. The town might even be Ribadesella, where Regoyos was born, since it has a similar harbor and lies on an estuary.

Regoyos was intrigued by the vaporous fumes of boats and trains, and in *The Rainbow* (plate 288) he was additionally challenged by the sudden appearance of a rainbow after a downpour. With subdued and variegated colors he laid out the first plane of shadow; then with yellow and purple he depicted sunlight striking the shore; a green boat defines the opposite shore in front of the bluish mountain range. Above the horizon line,

287. IGNACIO PINAZO. *At the Edge of the Water Basin.* n.d.
Oil on canvas, 7¾ × 16⅛". Casón del Buen Retiro, Museo del
Prado, Madrid

288. DARÍO DE REGOYOS. *The Rainbow.* c.1900. Oil on
canvas, 29½ × 35⅜". Museu d'Art Modern, Barcelona

289. Darío de Regoyos. *A Bullfight in the Town.* 1900. Oil on canvas, 24 × 19⅝". Museo de Bellas Artes, Bilbao

290. Darío de Regoyos. *Plaza of Irún, Sheep Market.* 1902. Oil on canvas, 23⅝ × 23⅝". Private collection

yellow and gray smoke belches forth from a steamship and clouds hover close to the mountains, while a four-color rainbow arcs gloriously over the scene.

In Regoyos's *Plaza of Irún, Sheep Market* (plate 290), we see clusters of chatting Basque farmers in their typical blue coats and berets, tree-cast shadows in purple, and tree leaves of juxtaposed dots of green and yellow. Some of Regoyos's urban landscapes recall Pissarro's work; for instance, the flickering treatment of the leaves in this painting. The dissolving of contour lines (of human figures and buildings) in Regoyos's *Street of Alcalá, Madrid* (1892; private collection),[41] is similar to Pissarro's paintings of Paris boulevards in the late 1890s.

Regoyos lived in various cities along Spain's northern coast and also for a while in Irún on the French frontier. For a short time he lived across the border in southwestern France, where he painted the spectacularly atmospheric *Snow and Thaw, Dax* (1900; private collection). His last years were spent in Barcelona, where he painted matutinal and crepuscular views of the broad, tree-lined streets (the *Ramblas*) and exhibited at the Parés Gallery and at Els Quatre Gats. Poor health unfortunately cut his life short two days before his fifty-sixth birthday.

Because we so rarely have the opportunity of hearing an artist's own words, let us conclude with Regoyos's answer to the question of which artists he admired, "The old masters whose work most pleased me are Sánchez Coello, Goya, Velázquez, and El Greco." As for his own times, he said, "I adore Corot, Manet, Monet, Renoir, and the impressionistic harmonies."[42]

"All inspired painters are impressionists, even though it be true that some impressionists are not inspired."

Sorolla[43]

VALENCIA PRODUCED BOTH the accomplished painter Cecilio Pla (1860–1934) and the giant among Spanish Impressionists, Joaquín Sorolla. One of Pla's best works is *La Mosca* (plate 291). A coquettish woman, dressed entirely in black from her hat and gloves to her long skirt, peers theatrically between two white diaphanous curtains she has parted. The woman's face, framed by auburn hair and by the lacy, Impressionistic curtains, is illuminated by a winning smile. She is humorously named "*La Mosca*"; although the word literally means "the fly" in Spanish, it has the additional connotation of "the impertinent intruder." Another infectious painting, entitled *Youth* (1915; Málaga Museum of Fine Arts),[44] is of Pla's daughter. Nothing intervenes between the viewer and the almost photographic, smiling face of the sitter, behind whom sun-drenched flowers are cursorily suggested.

Joaquín Sorolla (1863–1923) not only took Spain and the rest of Europe by storm but another continent as well, America. In one month in 1909 more than one hundred and fifty thousand people braved New York's winter snows to stand in long lines for a Sorolla exhibition at The Hispanic Society of America.[45] The New York *Evening Post* of March 8, 1909, reported that this was "probably the largest number of visitors ever recorded at a similar exhibit in this city."[46] *The Philadelphia Inquirer* described the exhibition as "the sensation of the hour in the art world of New York" and went on to cite two large canvases bought by The Metropolitan Museum of Art for its permanent collection.[47] The art critic of *The Cincinnati Times Star* went even further, calling Sorolla one of the most "successful painters the world has ever seen" and the exhibition "one of the most important events in our entire art history. . . . The nation should rise *en masse*, purchase the entire collection . . . and persuade Señor Sorolla that he could find a congenial working home in America"; this critic, Paul K. M. Thomas, concluded, "Sorolla is indeed an impressionist, and a fine one, too."[48]

The young Sorolla trained in Valencia's Arts and Crafts School and the School of Fine Arts. In 1881, when three of his seascapes were accepted in the *National Exhibition*, he traveled to Madrid and visited the Prado. He seized the opportunity to make copies of Velázquez and Ribera's paintings. Later he mentioned specifically having studied *Las Meninas* with a magnifying glass,[49] and in one of his early works he clearly shows a familiarity with Goya's painting *The Second of May, 1808,* which he must have studied in the Prado before painting his own large canvas (thirteen feet three inches by nineteen feet nine inches) of the identical subject. In his *The*

291. CECILIO PLA. *La Mosca.* n.d. Oil on canvas,
53⅛ × 30¼″. Museo de Bellas Artes, Valencia

292. JOAQUÍN SOROLLA. *Self-Portrait.* 1900. Oil on canvas,
36 × 28½″. Museo Sorolla, Madrid

293. View of Sorolla's studio.

*Second of May* of 1884, Sorolla, painting the episode from the War of Independence in almost as the same dimensions as Goya had used in 1814, also composed the mass of bodies in ways very similar. The significant difference between the two painters' actual execution of the scene was pointed out by Sorolla himself when he described how he worked outdoors:

> I think it is one of the first compositions to have been painted in Spain out-of-doors, if not the very first. I was worried until I found a suitable place, as I didn't want to be shut up in a studio. By good fortune I was allowed to work in the bullring of Valencia, and that is where I painted the picture.[50]

In a Valencian competition Sorolla won a scholarship to Rome, and he left for Italy on January 3, 1885. With the exception of the spring and summer of 1885, when he visited Paris, he spent the next four years mainly in Rome (and Assisi). Although he was chiefly involved with new ways of painting natural light, he stopped long enough to learn one more lesson from Velázquez by copying his *Portrait of Innocent X* in Rome's Doria Gallery; this copy can be seen in Sorolla's Madrid studio, now the impressive Museo Sorolla (plate 293).

In *Sewing the Sail* (plate 264), a huge painting, we see Sorolla's new interests combined with his respect for the old masters. Overall the effect is that of filtered sunlight, especially on the great spread of plunging white sail but also on the faces of two women at the left, on the pink sleeves of another woman, on the yellow sombrero of the man at the right, and on the greenish yellow leaves. He also assiduously recorded shadows on the sail sheets as well as those of the geraniums on the wall at the left. On the other hand, the complex composition itself may have been inspired by Velázquez's *Las Hilanderas* (c.1644–1648; Prado Museum)—of the very same height and approximately same width—in which women spinners at work appear in the foreground, uncarded wool and a ladder line the walls in a similar tunnel-shaped receding space, and some figures stand in the background silhouetted against a luminous backdrop.[51]

Even though Sorolla and his wife had taken up residence in Madrid in 1890, they continued to spend most summers at the seashore. Typical of his many beach scenes is *The White Boat* (plate 294), in which extraneous matters have been eliminated as the painter concentrated on two nude boy swimmers, the ripples on the water, and the boat—white in sunlight and lavender in the shade. Sorolla, who once worked for a photographer in Valencia (and whose daughter he married), excerpted the vignette much in the manner of a snapshot. William Starkweather, a painter, described watching Sorolla at work on the Valencia beach:

> Once, after a tremendous day, at five o'clock in the afternoon, Sorolla began on another study of a little girl entering the sea. To make his picture

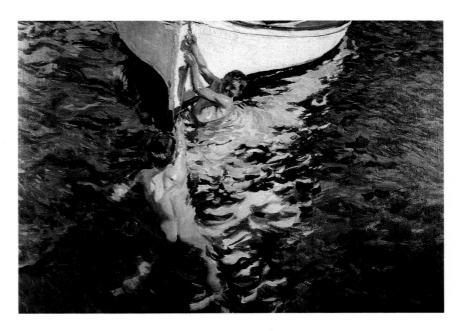

294. JOAQUÍN SOROLLA. *The White Boat.* 1905. Oil on canvas, 41⅜ × 59″. De Heeren Collection, Palm Beach

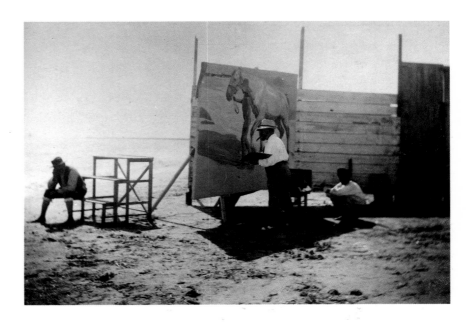

295. Photograph of Sorolla painting on the beach.

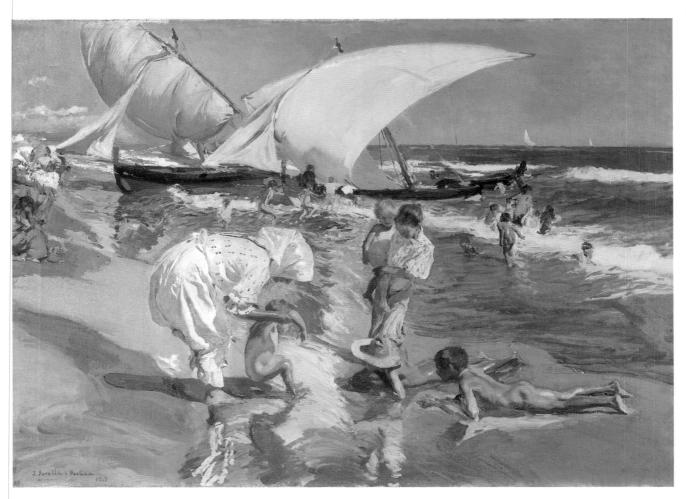

296. JOAQUÍN SOROLLA. *Beach of Valencia by Morning Light.*
1908. Oil on canvas, 29⅞ × 41½". Courtesy of The Hispanic
Society of America, New York City

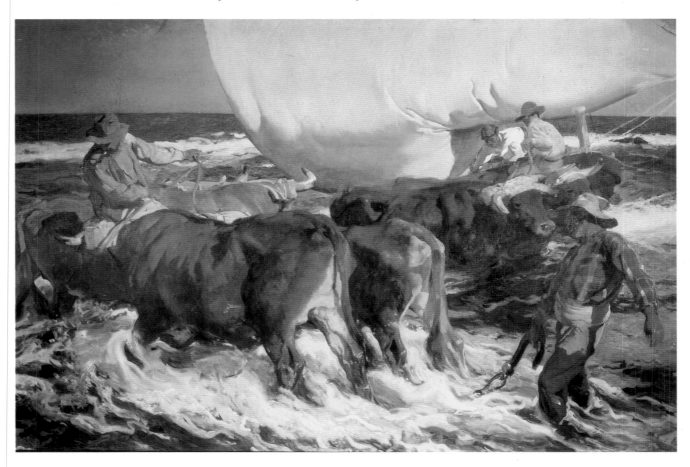

297. JOAQUÍN SOROLLA. *Beaching the Boat (Afternoon Sun).*
1903. Oil on canvas, 115¾ × 171¼". Courtesy of The Hispanic
Society of America, New York City

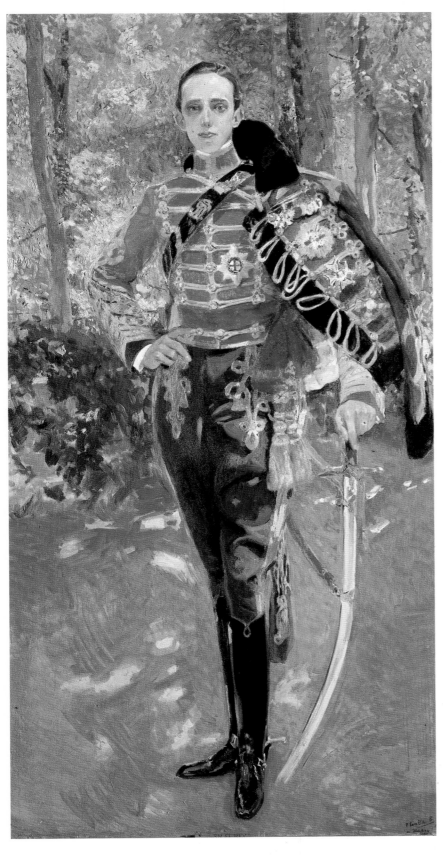

298. JOAQUÍN SOROLLA. *Portrait of Don Alfonso XIII.* 1907.
Oil on canvas, 81⅞ × 42½". Palacio Real, Madrid

less a figure study, he decided to put three little children in the sea. Two little girls and a boy waded into the water hand in hand, laughing, making no particular effort to stand still. They were, indeed, washed here and there by the waves. Sorolla painted the three wet figures, gleaming in the gold of the setting sun, in fifteen minutes. It was a marvelous display of master painting.[52]

Photographs document Sorolla's standing on the beach, painting figures (plate 295).

By the first decade of the twentieth century Sorolla was well acquainted with Impressionism through his trips to Paris and through the example of his compatriot Beruete, and in typical Impressionistic manner Sorolla consciously settled on a theme—the seaside—to paint at different times of the day. Objects glitter with color in the morning as we see in *Beach of Valencia by Morning Light* (plate 296) with its yellow impasto light in the center foreground and its orange reflections of the two nudes lying in the shallow water. The sea is painted in stripes of mauve, blue, and pink. Sometimes the brightness of an afternoon sun blanches local colors; thus in *Beaching the Boat (Afternoon Sun)* (plate 297) the yellow of the sail is a little duller than in the glistening morning light. The blue trousers of the man at the right are dark up to his thighs to indicate wetness. There are mildly brighter tones in the pink yoke of the pair of oxen at the right and the lavender pants of the seated man. In both paintings Sorolla proves to be especially adept at conveying movement in water.

During the summer of 1907, when Sorolla and his family were living in San Ildefonso, he painted the portraits of the Spanish king and queen, who were residing in the royal palace of La Granja. Once again, despite the official nature of the commission, the painting was done out-of-doors as Sorolla validated the use of Impressionism by attaching it to the long Spanish custom of royal portraiture. Alfonso XIII (plate 298), dressed in a hussar's uniform, is posed with unsheathed sword in the park of this eighteenth-century palace, which had been built by his Bourbon ancestors in imitation of Versailles. Light and shadows play across the scintillating colors of his uniform, while the background dissolves in Impressionistically rendered foliage. As one of the French critics, Louis de Vauxcelles, wrote after Sorolla's exhibition of 497 works at the Galeries Georges Petit in 1906, "A brilliant colorist, sensual and enthusiastic, Sorolla is a master of open-air portraiture."[53]

The oldest child of Clotilde and Joaquín Sorolla, María, became a painter (plate 266) and also frequently served as a model for her father. In a tour-de-force painting *María in the Gardens of La Granja* (plate 300), Sorolla marvelously caught light and shadow in mauves and yellow on the dresses and heads of María and her small hoop-holding charge, and then with vibrating brush strokes of yellow, lavender, and green he animated a pool that reflects all the colors of the park perceived by the artist on that particular day.

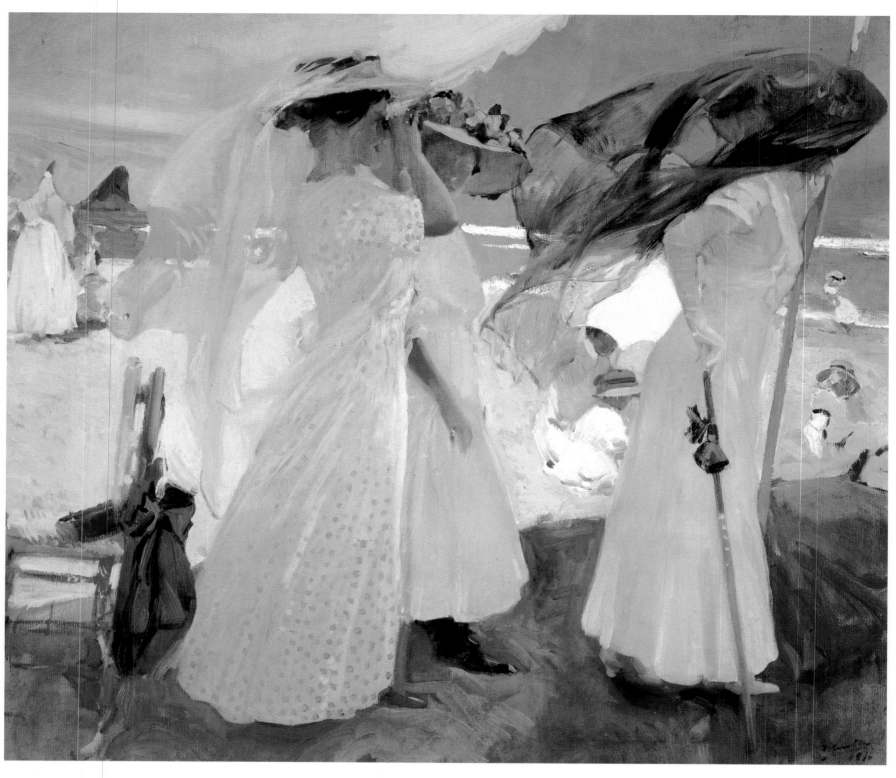

299. JOAQUÍN SOROLLA. *Under the Awning (Zarauz)*. 1910.
Oil on canvas, 39 × 45″. The Saint Louis Art Museum.
Museum Purchase

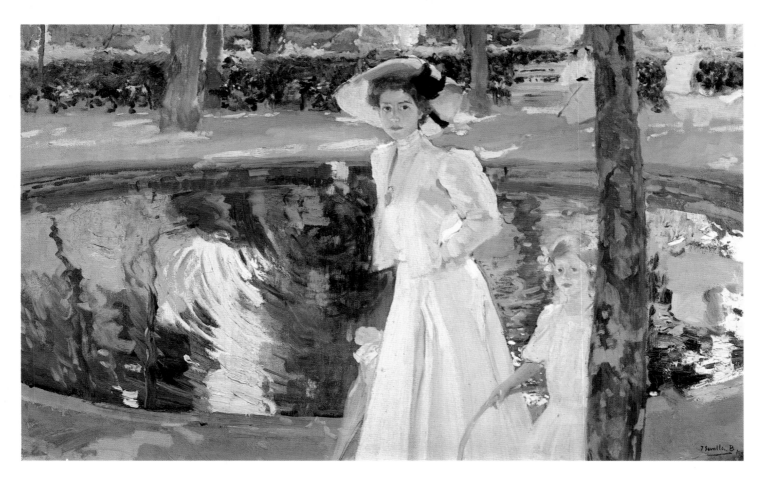

300. Joaquín Sorolla. *María in the Gardens of La Granja.*
1907. Oil on canvas, 22 × 35″. Museo Sorolla, Madrid

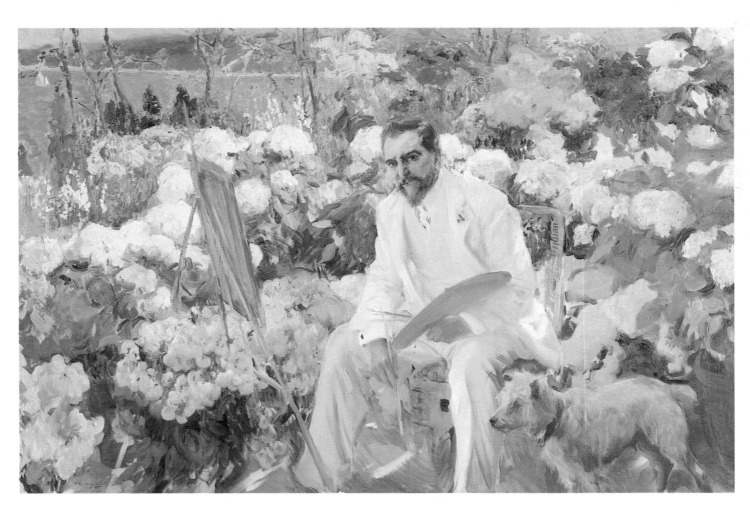

301. Joaquín Sorolla. *Louis Comfort Tiffany.* 1911. Oil on
canvas, 61 × 88¾″. Courtesy of The Hispanic Society of
America, New York City

302. Joaquín Sorolla. *Elche.* 1918. Oil on canvas, 137¾ × 91″. Courtesy of The Hispanic Society of America, New York City

303. Joaquín Sorolla. *Ayamonte.* 1919. Oil on canvas, 137⅜ × 191″. Courtesy of The Hispanic Society of America, New York City

From February through May 1907, 280 of Sorolla's works were shown at Grafton Galleries in London, where Archer M. Huntington, founder of The Hispanic Society of America, met the artist and proposed the blockbuster exhibition that opened in New York in 1909 and traveled subsequently to Buffalo and Boston. This tour was so successful that The Hispanic Society proposed a second exhibition, which was shown two years later at the Art Institute of Chicago and the Saint Louis Art Museum. In a stunning painting from this later exhibition, *Under the Awning* (plate 299), Sorolla delighted in showing the effects of the wind on the ladies' veils in addition to such subtle transparencies as the passages of the white veil over the violet and white dress at the left and the fluttering green veil against the white beach umbrella at the right. Typically Sorolla distinguished between the sunlit portions of the beach and the shaded area, using short brush strokes of reds, blues, and ochers for the latter. Even the pinkish sand is brighter in broad sunlight at the left than under the awning at the right. The setting is Zarauz on the northern coast, near fashionable San Sebastián, where the family could well afford to spend the summer, thanks to Sorolla's bustling painting sales.[54]

Sorolla visited the United States in conjunction with both of his American exhibitions. One of the buyers at his 1909 exhibition, who may have been struck by Sorolla's portrait of Madrazo in his Paris garden (plate 267), was the American artist Louis Comfort Tiffany, who commissioned Sorolla to paint his portrait. During Sorolla's next visit of 1911 he fulfilled the request by creating one of his most breathtaking paintings (plate 301), in which Tiffany is surrounded by an eruption of color in his garden at Oyster Bay on Long Island as he sits among flowers so Impressionistically rendered that identification of species defies the viewer. Tiffany's white suit is a symphony of reflected colors, further enlivened by patches of sunlight in white impasto and shadows in green tones. His dog, Funny, barely squeezes in between the chair and the potted plants.

In 1911 Archer Huntington gave Sorolla a commission to paint oil-on-canvas murals of the provinces of Spain for The Hispanic Society of America—a final major undertaking that consumed Sorolla's late years. This "Vision of Spain," as Sorolla called the project, covers the walls of a large room in the society's museum today and pictorially conveys the diversity of the country in fourteen paintings, each over eleven feet high. To represent the southwestern province of Alicante, Sorolla chose the old city of Elche, a place noted since Phoenician times for its palm forest (plate 302). In his mural, sunlight filters through the palm trees onto the scene of the women and men sorting the yellow dates from the green. Sorolla worked on site for each of his paintings—in this case from a house that overlooked the orchard.

For the last painting in the series, *Ayamonte* (plate 303), of 1919 his makeshift studio was in a tuna factory (the owners partitioned off space near the door to isolate him from the noise and odors). While Sorolla painted, he

THE LURE OF IMPRESSIONISM IN SPAIN AND LATIN AMERICA

304. RAMÓN CASAS. *In the Open Air.* c.1890–1891. Oil on
canvas, 20⅛ × 26″. Museu d'Art Modern, Barcelona

had water poured over the fish to preserve their colors longer—the dark blue of their backs and the iridescent pink of their undersides.[55] The familiar Sorolla repertoire is present: white (sailor) suits, a yellow canvas awning overhead that provides shade yet at the same time admits streaks of sunlight, action among the participants, and glistening light on the water. The location this time is the Guadiana River, which separates Portugal from Spain; on the distant shore stands a Portuguese castle. The fishermen at this Spanish port of Ayamonte (in the province of Huelva) obtain their catch from the Gulf of Cádiz and are depicted pulling their haul up the slippery incline. At the left a group of Portuguese women in their distinctive regional dress listen to an accordionist while they wait for their menfolk to finish the unloading.

By the time he finished the series, Sorolla began to feel his health failing. He returned to his family in Madrid and was able to make one more trip (to the Balearic Islands) before a stroke paralyzed him in 1920, denying him the pleasure of painting the remaining three years of his life.

Early in his career Sorolla had begun receiving prizes, including a gold medal at the Exposition Universelle of 1900 in Paris. He was named a Knight of the Great Cross of the Order of Isabella the Catholic in 1899 and a Chevalier of the French Legion of Honor in 1901 (later promoted to Officer). There has never been any doubt about his success as an artist. Sometimes, however, the question has been raised as to whether or not he was an Impressionist. Ramiro de Maeztu in his review of Sorolla's London exhibition for *La Prensa* in 1908 had no doubt: "Impressionism?" he wrote, "The word might have been expressly invented to describe Sorolla's painting,"[56] and the art historian Bernardino de Pantorba echoed this conviction in his Sorolla monograph of 1953.[57] Florencio de Santa-Ana, curator of the Museo Sorolla, has more recently asserted that three early biographers of Sorolla did not call him an Impressionist and that Sorolla spent little of his formative period in Paris. On the other hand, Santa-Ana characterizes Sorolla as closest in artistry to Aureliano de Beruete, whom he considers to be "one of the few and authentic impressionistic painters of Spain,"[58] and he concludes by calling Sorolla a "luminist" because of Sorolla's clear preoccupation with light.

Sorolla's plein-air paintings have an affinity with some of the nineteenth-century Scandinavian paintings of natural light by such artists as Anders Zorn and Peder Severin Krøyer, whom Sorolla may have met when they were all included in the Exposition Universelle of 1900. Krøyer's *Summer Evening on Skagen Beach* (plate 355), was admired by Sorolla and may have influenced the younger Spaniard's paintings of figures on the seashore.[59]

Certainly Sorolla's Impressionism developed quite naturally from his initial insistence on painting outdoors, even when creating a historical painting such as *The Second of May* in 1884, and was abetted by the brilliant Mediterranean light of his native Valencia. Sorolla called himself an Impressionist on occasion, referring to his desire to render the momentary.[60] He talked about "nature, the sun itself," producing color effects instantaneously. "The impression of these evanescent visions is what we make desperate attempts to catch and fix by means at hand. . . . No, mes amis, impressionism is not charlatanry, nor a formula, nor a school. I should say rather it is the bold resolve to throw all those things overboard."[61] An American art critic in 1909 described Sorolla's style as follows: "He employs the divisional *taches* of Monet, spots, cross-hatchings, big, saberlike strokes *à la* John Sargent, indulges in smooth sinuous silhouettes, or huge splotches, refulgent patches, explosions, vibrating surfaces; surfaces that are smooth and oily, surfaces, as in his waters, that are exquisitely translucent."[62]

Throughout his career Sorolla was in the habit of making small oil sketches, and from the beginning his style in these was a loose application of pure pigments—short brush strokes of different colors that suggested an outdoor setting. This liberating experience on a small scale may very well have encouraged him to continue his experiments on his large canvases, thus contributing to his evolution as a famous Impressionist artist to whom many painters (Manuel Benedito, José Mongrell, and Tuset and Tomás Murillo) gravitated in the hope of perfecting their luminist endeavors.[63]

Because of Barcelona's usual cultural orientation toward Paris, it is not surprising that the eyes of Ramón Casas (1866–1932) were directed north. In 1882, the year of the seventh Impressionist exhibition, Casas went to Paris to study with Carolus Duran. On his return to Spain during the summer of 1883 he visited Madrid and spent much time copying from the masters in the Prado Museum. One of the surviving copies he made is of the Infanta Margarita from Velázquez's *Las Meninas*.[64] The first important painting he exhibited at the Parés Gallery in Barcelona in 1884, *The Bullfight*, was criticized for its Impressionist style.[65] Casas and the painter Santiago Rusiñol toured Catalonia in a cart in 1889 and then the next year moved to Paris, where they shared an apartment above the celebrated Moulin de la Galette in Montmartre. This dance hall within a windmill looms in the background of Casas's atmospheric painting *In the Open Air* (plate 304). On a misty evening the attention of a woman, seated alone at a café table, is riveted on the solitary figure of a man who stands with his back to her near the lighted entranceway. Casas's painting entitled *La Madeleine* (1892; Museum of Montserrat, Barcelona)[66] of a single woman seated at a table under a mirror, which reflects both the crowd in the café and a chandelier, evokes the memory of Manet's *Bar at the Folies-Bergère* (1882; Courtauld Institute, London); but instead of being a self-contained composition Casas's work offers an air of expectancy as the woman looks fixedly to the left for an *unseen* interlocutor.

In 1894 Casas settled in Barcelona, where the subjects of some of his earliest paintings were the danc-

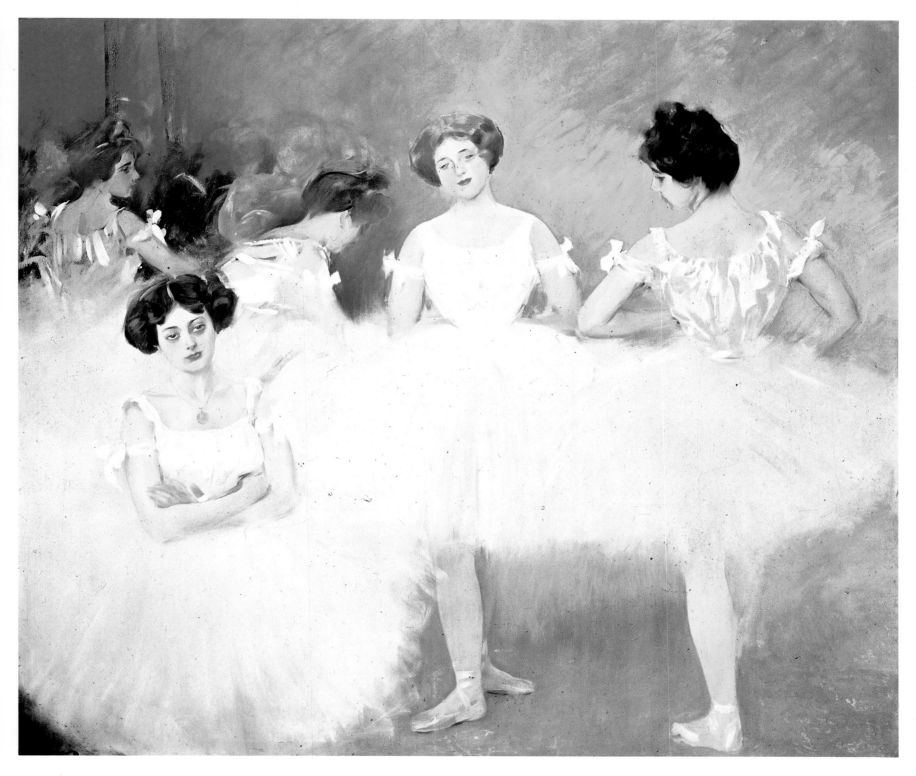

305. Ramón Casas. *Ballet Corps.* n.d. Oil on canvas,
57½ × 66½″. Círculo del Liceo, Barcelona

ers and the spectators at the Círculo del Liceo. The Impressionistically rendered tutus of the dancers in *Ballet Corps* (plate 305) recall Degas's predilection for this subject and may have been inspired by the French painter's precedent. Casas has set the white dresses dramatically before a bright orange wall. In another painting of the Liceo (c.1898–1902; Liceo Theater, Barcelona)[67] his focus is on two women in the loge who are highlighted against tiny dots of people scattered through the rest of the opera house, a scene reminiscent of Cassatt and Renoir.

A. G. Temple, an early twentieth-century writer on the topic of modern Spanish painting, called Casas an "Impressionist, . . . one of the foremost exponents that Spain possesses."[68] Indeed, Casas was an Impressionist for the first two decades of his career, but this phase turned out to be a transitory period. A few years after his return to Barcelona, he and his artistic friends, who gathered at Els Quatre Gats, began articulating ideas for a new movement that came to be called "*Modernismo.*" The two fundamental components of the new style developed by Casas and Rusiñol are Naturalism and Symbolism.[69] A motivating reason that contributed to the change was an economic upheaval in the industrial city of Barcelona that caused Casas to begin a series of town scenes reflecting the ensuing social unrest; a naturalistic representation was more explicit than an Impressionist rendition. In addition, the artists and writers of Barcelona were experiencing a surge of regional pride and began publishing a journal in the Catalan language entitled *Quatre Gats.*

Meeting with these avant-garde artists was Joaquín Mir (1873–1940) who, like Casas, came to the group after working in Impressionist-style painting, specifically in landscape. In *The Orchard of the Hermitage* (1890s; Casón del Buen Retiro, Madrid) a pervasive gray tonality to the greens and blues of the foreground indicates shade, while a late afternoon sun strikes the tops of distant cypress trees, a church steeple, and a faraway hill. A handsome web of autumn colors unites the different depths of the landscape in his *Waters of Moguda* (plate 306). The ivy-covered trees of the immediate shore interweave with the water reflections and the trees of the opposite bank, creating an enchanting tapestry, which won a first prize at the 1917 *National Exhibition* in Madrid.

Mir lived for a few years in the coastal city of Tarragona before settling in nearby Villanueva y Geltrú. He clearly reveled in the orange—tinged with golden brown—colors of the medieval church, which is the subject of his painting *The Lantern, Tarragona Cathedral* (plate 307). The cathedral, erected on the highest point of the city, where the Roman Temple of Jupiter originally stood, was begun in the twelfth century and continued in the Gothic period. Mir's view is of the Gothic octagonal lantern, the north transept with a rose window, and the top of the bell tower. The walls on this narrow street are painted in varying degrees of orange and accentuated with a vertical passage of bright yellow at the center,

306. JOAQUÍN MIR. *Waters of Moguda.* 1917. Oil on canvas, 45¼ × 59½". Casón del Buen Retiro, Museo del Prado, Madrid

307. JOAQUÍN MIR. *The Lantern, Tarragona Cathedral.* 1928. Oil on canvas, 39⅛ × 33½". Courtesy of The Hispanic Society of America, New York City

indicating rays of sunlight. Opposing these warm colors are green shadows on the church and a bright blue sky with wisps of clouds. Pedestrians are sketchily suggested in the street: a woman in red accompanied by a child in light blue and white, a woman in dark clothes, and mere blurs of figures farther back. Mir has successfully caught the atmosphere of this old quarter of the city, giving permanence to the strong lines of the centuries-old cathedral and treating in a transitory manner the ephemeral pedestrians.

With these nostalgic views of Catalonia by Casas and Mir at the turn of the century, Impressionism in Spain yielded to the modernism of the twentieth century. The torch passed at Els Quatre Gats from Casas, within whom the metamorphosis occurred, to younger artists, who were forging the next link in history's artistic chain. Spain, with its bright colors and its strong Mediterranean light so magnificently captured by the Impressionists, would continue to be depicted by powerful palettes, but space and forms within paintings were about to be fractured by the new Cubist ideas of Pablo Picasso and Juan Gris.

## Latin America

The importers of Impressionism to Latin America were those Latin American painters who had gone to Spain for their artistic training and who then returned to their homelands with an enthusiasm for Impressionism. Among these converts were Francisco Oller of Puerto Rico, Joaquín Clausell of Mexico, Martín Malharro of Argentina, Belmiro de Almeida from Brazil, and Armando Reverón of Venezuela. Others returned with a short-lived passion for the new style, and before long their liberated colors began to define more substantial forms—as can be seen in the paintings of Andrés de Santa María from Colombia and Pedro Blanes from Uruguay. It would appear that for many of these artists the stimulus of having been in Europe overshadowed any impact that their indigenous heritage might otherwise have exerted. Hence we find no allusions to Pre-Columbian art in the work of these artists, who were eager to be sophisticatedly European in the eyes of their colleagues and patrons.

A natural bridge between Spain and Latin America's art was provided by Francisco Oller (1833–1917), who was born in the Spanish colony of Puerto Rico and studied from 1851 to 1853 at Madrid's Academy of San Fernando, where Palmaroli was a classmate.[70] Oller often visited the Velázquez galleries in the Prado Museum. The next step in the making of this Impressionist was a period of study in Gleyre's Paris studio—where Renoir, Monet, and Sisley would also work—and a summer of painting in 1859 at La Roche-Guyon on the Seine with Pissarro, a fellow Caribbean by birth. Two works by Oller were accepted in the 1865 Salon, which exhibited Manet's *Olympia*, before he returned to San Juan for an eight-year period, during which time he established an academy of drawing and painting. Letters from his Parisian friends Pissarro and Cézanne urged him to return to the center of action, and when he did in 1874, he had the satisfaction of selling a painting entitled *The Student* to Dr. Paul Gachet, who was becoming an important collector of Impressionism and would later be the subject of Van Gogh's brush.

Before taking up residence in Madrid in 1877, Oller traveled to Italy and southern France. *The Basilica at Lourdes* (plate 309) is typical of his new, unconstricted brushwork and use of pure colors directly applied to the canvas. For his seven-year stay in the Spanish capital he set up a studio and offered classes. Both he and one of his students, Doña Serapia Olleda Cruz, had paintings accepted in the *National Exhibition* of 1881.[71] Two years later seventy-two paintings by Oller were shown in a solo exhibition, which drew good reviews from the press and was almost a complete sellout. Among the buyers was King Alfonso XII, whose patronage further enhanced the artist's stature.

A triumphant Oller journeyed home to Puerto Rico, bringing a full-bloom Impressionistic style with him. In 1893 he received a gold medal when he exhibited forty-six paintings at the Exposición de Puerto Rico. The next year he left for France, renewing his friendship with Pissarro but experiencing a falling out with Cézanne, who had invited him to his home in Aix-en-Provence. Because of their argument Oller had to stay at the hotel in Aix![72]

*French Landscape II* (1895; Instituto de Cultura Puertoriqueña), with its striations of light and shadow executed in characteristic short brush strokes, clearly depicts a specific moment in nature: two artists have deserted their easels, which have been set out in rolling countryside. Their palette and brushes have been temporarily left on camp stools. Perhaps the frilly, closed umbrella lying on the grass and the sunbonnet belong to a woman artist, and the umbrella already opened up, posed as we have seen it used by Monet, may indicate a male companion. The art historian Haydee Venegas has suggested that Oller might have been paying tribute to two recently deceased friends, Berthe Morisot and Édouard Manet.[73]

In 1896 Oller made his last transatlantic voyage and finally resettled for good in San Juan. He opened a drawing academy in 1901 and continued to apply his modern techniques to paintings of the Puerto Rican landscape. Oller is not only credited with transporting the new style to Latin America but is regarded as a pioneer of Impressionism in Spain.[74]

Mexico had had forty-four years of independence when Joaquín Clausell (1866–1935), who was to become the country's most Impressionistic painter, was born. A lawyer by training, he spent a year in Europe from 1892 to 1893, thus obtaining his first exposure to European Impressionism, specifically the work of Monet. On returning home he completed his legal studies in 1896 and took a position in the Department of Justice. After marrying in 1898 he and his wife moved

308. Joaquín Clausell. *Clouds over the Harvest.* 1920. Oil
on canvas, 26 × 45″. National Institute of Fine Arts, Mexico
City

309. Francisco Oller. *The Basilica at Lourdes.* c.1876–
1877. Oil on canvas, 9⅝ × 12″. Museum of History,
Anthropology, and Art, University of Puerto Rico, Rio Piedras

into a house in the center of Mexico City that had ample space for his painting studio and that today serves as the Museum of the City of Mexico, preserving intact the murals that he painted on his studio walls. This self-taught painter then traveled extensively throughout Mexico, recording a wide variety of landscapes. *Clouds over the Harvest* (plate 308) consists of bright yellow haystacks under vigorous cloud formations. In contrast to the open sky in this painting, the density of blue and green trees in the *Canal of Santa Anita* (undated; Museo Nacional de Arte, Mexico City) blocks out the sky, and the action resides instead in the many soft colors of the currents in the canal.

Other works by Clausell offer various motives in Impressionistic techniques; for example, the painting *Trees in Huipulco*[75] has a crisscrossing assortment of colors in the many tree trunks, running from blue to green to purple to pale green and finally to blue and red combined. In *Ixtacalco*[76] most of the canvas is devoted to water, which is composed of alternating blue and lavender strokes at the right and yellow and blue at the left where more sunlight hits the canal. As his biographer writes, "Anachronistically, outside of time, contrary to time . . . Clausell became in all his work an impressionist painter of the 19th century in the 20th century."[77]

The Colombian Andrés de Santa María (1860–1945) and the Argentinian Martín Malharro (1865–1911) both experimented with Impressionism but turned more toward Expressionism in their later painting. Santa María studied in France and Spain, and in an early painting such as *The Tea* (1890)[78] he captured a social moment similar to the gathering around a table in Renoir's *Boating Party* (1881; Phillips Collection, Washington, D.C.): three women and a man are outdoors under a red and yellow striped awning; the teapot reflects many colors; flowers are Impressionistically rendered; and behind, playing badminton, are two women whose white dresses and straw hats catch passages of bright sunlight.

Malharro began studying light and landscape in Argentina and eventually won a travel grant to Europe, where he quickly adopted Impressionism.[79] On returning to Buenos Aires, he exhibited his new paintings in 1902. Like Clausell, he followed Monet's example in painting haystacks and other scenes of nature with prismatic variations.

Of Brazilian painters, Belmiro de Almeida (1858–1935) was closest to the Impressionists. His first visit to Paris, introducing him to Impressionism, occurred in 1884. In *Portrait of Palmyra de Almeida* (1892; private collection, São Paulo)[80] the pinkish white tones of his mother's jacket and the pale blue of her skirt are echoed through juxtaposed short strokes in both the floor and the wall behind the sitter. But after 1900 his work became more Neo-Impressionistic. The forms in *Landscape in Dampierre (France)* (1918; private collection, Rio de Janeiro)[81] are totally Pointillistic.

Impressionism, late arriving in South America,

was embraced for the most part by rebellious artists, for example the Venezuelan Armando Reverón (1889–1954), as a challenge to stale academic traditions.[82] After study at the Academy of Fine Arts in Caracas and one year in Barcelona, Reverón returned to Caracas and joined the heterodoxical Círculo de Bellas Artes, which was open to the new sensibility of giving primacy in painting to scenes of Venezuelan nature.[83] He was preceded by the expatriate Impressionist Emilio Boggio (1857–1920), who spent most of his painting career in Europe. In 1921 Reverón isolated himself in a little house that he built on the beach at Macuto and began an "impressionism" of his own.[84] His new style divides into two phases: blue Impressionism followed by white. *The Cave* (1920; Collection Inversiones Sawas C. A.)[85] of two partially nude women, their bodies vaguely defined in a blue haze, is representative of his first period and *Landscape* (1929; Museum of Fine Arts, Caracas)[86] of the second. In the latter the contours of the trees are dissolved by the blazing light of the Caribbean Sea. Reverón apparently was an eccentric,[87] known for such bizarre habits as talking to life-size dolls he had made of rags and straw and then painted; his style later evolved into Expressionism.

One of the most successful Latin American painters was the Uruguayan Pedro Blanes Viale (1879–1926). He moved with his entire family to Spain in order to study at the Academy of San Fernando, and he was among the young artists who frequented Sorolla's studio. A trip to Mallorca in 1899 produced many lush tropical landscapes and probably the painting entitled *Las Manolas* (plate 310). Two Spanish women, elegantly wrapped in shawls of very different designs, stand by a flower-laden trellis that opens onto a view of a distant church, which looks to this author very much like Palma de Mallorca's tall Gothic cathedral with its prominent buttresses. Flowers unite the different planes of the composition from the plants in the foreground to the pattern of red flowers on one shawl to those on the bower overhead. A purple shadow leads the viewer into the foreground center where a black cat plays with a pink blossom.

On Blanes's return to Montevideo his attention focused on landscapes in South America, for example the awesome waterfalls that he painted in *Cataracts of the Iguazú* (plate 311). The freedom of the liberated Impressionist brushwork made it possible for Blanes to attempt encompassing these wide falls that are composed of twenty cataracts, averaging two hundred feet in height.

The magnetic attraction of Impressionism is evident when we see how the style extended as far as these waterfalls in southern Brazil. The appeal of this technique to artists desirous of capturing natural beauty, whether in humans or in wild phenomena, is understandable. The wonder is that the ramifications of the new movement that began in Paris were felt this remotely, up and down the South American continent.

310. PEDRO BLANES. *Las Manolas.* n.d. Oil on canvas,
91⅜ × 82¾″. Museo Juan Manuel Blanes, Montevideo

311. PEDRO BLANES. *Cataracts of the Iguazú*. n.d. Oil on canvas, 38⅝ × 31⅛″. Collection Jorge Castillo, Galeria Sur, Punta del Este, Uruguay

# MUSSELS AND WINDMILLS: IMPRESSIONISM IN BELGIUM AND HOLLAND

*Brooks Adams*

"THERE IS A school—I believe—of Impressionists, but I know very little about it," wrote Vincent van Gogh from Holland to his brother Theo in Paris in 1885.[1] Just three years later, from the south of France, Van Gogh could recommend to the young Belgian painter Eugène Boch that he study Impressionism: "I told him that it was the best thing he could do, even though he might lose two years in delaying his originality, but finally I said to him, it is as necessary to pass through Impressionism now as it used to be to pass through a Parisian atelier."[2]

Impressionism in Belgium and Holland was a natural consequence of the concern with light that has always characterized Dutch painting. Ever since the sun-drenched landscapes of Dutch painting in the so-called golden age of the seventeenth century, Dutch light has assumed an almost metaphysical importance in Western art.[3] In the late nineteenth century in The Hague, a group of painters convened to emulate and in some cases even shamelessly appropriate their seventeenth-century predecessors. Out of this situation, in which modern Dutch artists were looking at landscape partly through the filters of the golden age, grew the early work of both Van Gogh and Piet Mondrian.

A case could be made that Impressionism comes from the Lowlands, through the seventeenth-century plein-air tradition of Rembrandt and Ruysdael that was taken up by the French Barbizon painters and led directly to Monet and Manet.[4] Similarly, the art of bravura brushwork as practiced by a seventeenth-century master such as Frans Hals was consciously revived in the 1860s, when Hals was rediscovered.[5] Furthermore, the vogue for Holland as a tourist attraction, a place that was visited for its windmills and canals, its *polders* (reclaimed land) and ever-changing northern skies, as well as for its art museums (the Hals Museum, for example, opened in Haarlem in 1862), gained in popularity during the nineteenth century.[6] By 1900 artists of all nationalities visited Holland as an essential stop on the grand tour, and the history of Impressionism might thus be seen as one offshoot of this Dutch revival.

In Belgium, the most industrialized country on the Continent in the late nineteenth century, Impressionists were concerned with miners' strikes and industrial motifs seen in the Black Country, or Borinage. Indeed, it was at the ardently socialist artists' collective known as "Les XX," that French Impressionist works were shown in Belgium in the 1880s. Yet many Belgian painters, inspired by the Barbizon group, instead pursued a bucolic dream of Flemish forests and farmland, recalling the landscapes of Brueghel and Rubens, a world nowhere more threatened by the Industrial Revolution than in Belgium.

As the nearest stop for French political exiles in the nineteenth century, Belgium boasted a thriving Francophile population. At the same time, it was justly proud of its Flemish heritage, and the art centers of Antwerp, Ghent, and Bruges were popular tourist attrac-

312. ÉMILE CLAUS. *Portrait of Anna de Weert.* 1899. Oil on canvas, 47¼×51⁹⁄₁₆″. Museum of Fine Arts, Ghent

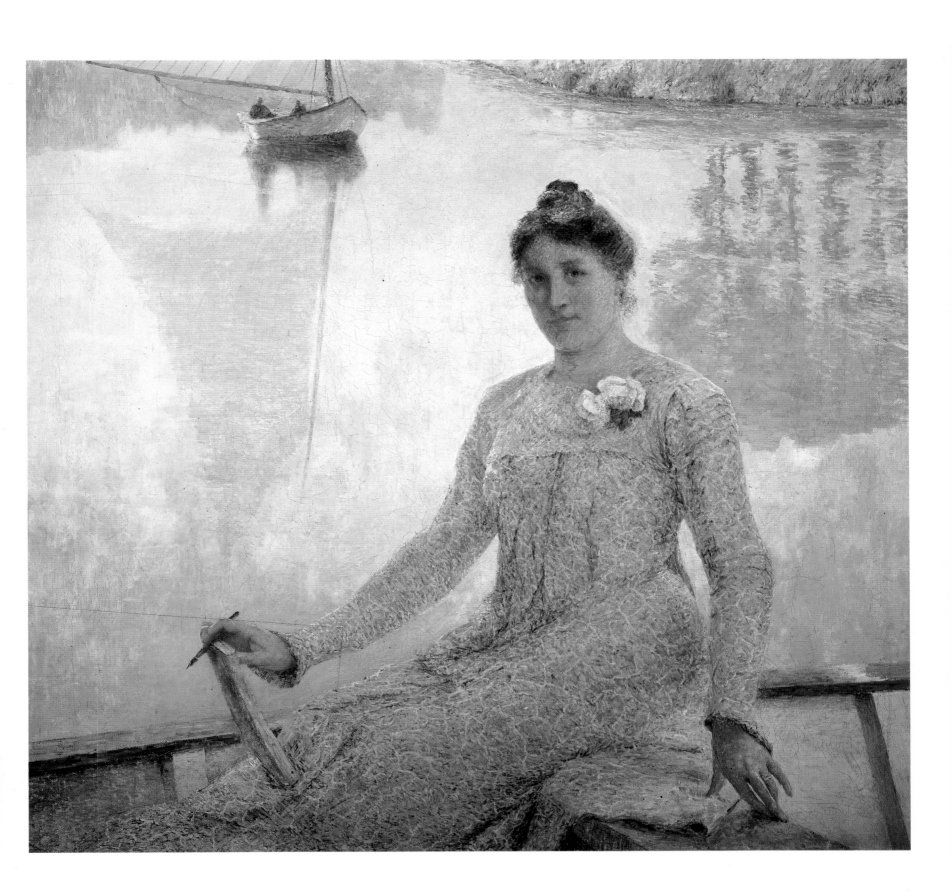

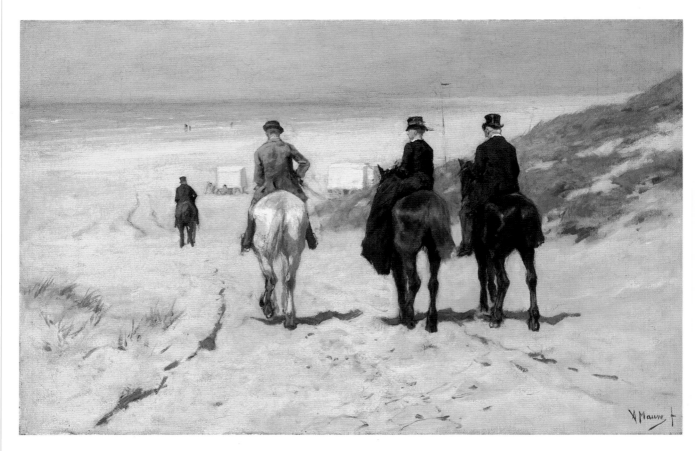

313. ANTON MAUVE. *Riders on the Beach at Scheveningen.* 1876. Oil on canvas, 15¾ × 27½″. Rijksmuseum, Amsterdam

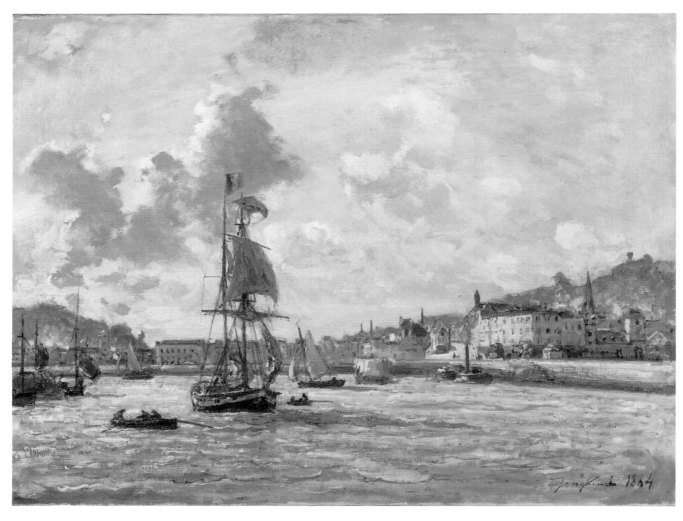

314. JOHAN BARTHOLD JONGKIND. *Entrance to the Port of Honfleur (Windy Day).* 1864. Oil on canvas, 16⅝ × 22⅛″. Louise B. and Frank H. Woods Purchase Fund (in honor of The Art Institute of Chicago's Diamond Jubilee), 1968.614. © 1990 The Art Institute of Chicago. All Rights Reserved

tions of the day. By the late nineteenth century, Belgian artists were producing the obligatory commercial views of twilight canals and brooding *beguinages* (nunneries), as well as sun-blasted visions of young girls in communion dresses (Belgium is a Catholic country) and peasants with hardy Flemish physiognomies. The visionary tradition in Flemish art, which dates back to Bosch and Van Eyck and sees in every crowd scene a carnival of souls and in each *kermesse* (village fair) a foreboding of the Last Judgment, was also actively revived in the 1880s in the art of James Ensor, whose paintings of masks are at once hallucinatory and naturalistic. Other artists, such as Constant Permeke, followed Ensor's lead and developed a gritty form of Expressionism, or "brown painting," out of Post-Impressionism. Thus, as Philippe Roberts-Jones has remarked, "For many painters in Belgium, and undoubtedly for the most authentic creators, Impressionism—the study of variations of light and its effects—was only a step, a state of transition, towards another end generally called Expressionism."[7]

## Holland

The reception of French Impressionism in Holland was bound up with the many links between Barbizon painting and The Hague School.[8] Jozef Israëls (1824–1911), the most famous Dutch artist of the nineteenth century, had studied in Paris in the 1840s and was much taken with Millet; Israëls's dark peasant scenes were, in turn, emulated by Van Gogh in *The Potato Eaters* (1885; National Museum Vincent van Gogh, Amsterdam). Conversely, the Barbizon painters Charles Daubigny and Constant Troyon had been influenced by the example of the seventeenth-century Dutch animal painters Albert Cuyp and Paulus Potter. In the 1880s paintings from the Barbizon school became extremely popular in The Hague, and the independently wealthy artist H. W. Mesdag amassed the largest collection of Barbizon paintings outside France (which can still be seen in his house museum today).

The heyday of The Hague School in the 1870s and 1880s can be seen as an indigenous form of Dutch Impressionism. "But," as Ronald de Leeuw has pointed out, "Hague Impressionism never became a hymn to color, a glorification of light or the encapsulation of a split second of nature. The Hague artists sought to convey the enchantment of subtle tones, the hazy atmosphere of their own *polders* and the peace of a single moment."[9]

Later works by Hague School artists testify to a lightening up of the dominant gray palette and to more open brushwork. Van Gogh's teacher and cousin Anton Mauve (1838–1888) was a leader in this respect: his *Riders on the Beach at Scheveningen* (plate 313), considered to be his masterpiece, captures the fashionable aspects of seaside life, and the bathing machines in the distance point to Scheveningen's rising popularity as a resort near to The Hague. Mauve's painting is singular because it is not a scene of generic fisherfolk or of con-

tented peasants: it is quite pointedly a bright review of modern life, complete with an *amazone* and three men, one of them distinctly older, indulging in a bit of morning exercise. This type of scene was to prove popular with the German painter Max Liebermann, who spent summers in Holland during the 1870s and 1880s and befriended Mauve, Jozef Israëls, and his son, the child prodigy painter Isaac Israëls, later to be one of the leading Amsterdam Impressionists. Through Liebermann, artists of The Hague School became major figures in the Munich and Berlin secessions.

The so-called Gray School of The Hague painters in the 1870s became a kind of Black Impressionism in the hands of the Amsterdam painters of the 1880s. The tone and subject matter of Dutch Impressionism shifted with Georg Hendrick Breitner and Isaac Israëls in the late 1880s from the bucolic pastorals of The Hague School to gritty scenes of urban realism. Breitner, in particular, became obsessed with the changing face of modern Amsterdam, as opposed to the eternal verities of Dutch golden-age art, and began to practice a marvelously dark and dingy version of street painting—effectively capturing Amsterdamers scurrying like patches of soot along dimly lit canals in the snow.

For foreign artists, Holland was tremendously popular during the late nineteenth century. German, American, French, Swedish, and Italian artists flocked there during the summer months, reveling in its picturesque scenery and its collections of seventeenth-century masters. Dutch scenes were frequent in the French and German Salons; Jozef Israëls and Mauve exhibited extensively there, and the Dutch painter Johan Barthold Jongkind (1819–1891), then living in France, was obliged to return to his native country regularly in the 1870s to paint scenes of moonlit windmills, for these sold extremely well in France—considerably better than his French port scenes and Parisian cityscapes.

Jongkind is, in fact, one of the most important figures in early Impressionism. Not only was he friendly with all the Barbizon painters during the 1850s, when he lived in Paris, but he also painted alongside the young Impressionists at the Auberge de Saint-Siméon on the coast of Normandy in the early 1860s. His own early 1860s port scenes are remarkably fresh and sparkling—Impressionist in all but name (plate 314). According to the painter Signac, Jongkind was fifteen years ahead of Sisley and Pissarro in his use of broken color, and he became famous for his "Jongkind blue"—for painting houses as a single stroke of blue paint, much as Van Gogh was to do some twenty-five years later. His work was also Pointillist in the 1870s, a good ten years before Seurat. As Monet remembered in 1900: "Jongkind showed me his sketches, invited me to his house and explained to me the whys and wherefores of his approach to his work. He amplified what I had already learned from Boudin, but from that moment it was Jongkind who was my real teacher. I owe the crucial training of my eye to him."[10]

Jongkind's example also probably inspired Monet to live in Holland for five months in 1871 during the

Franco-Prussian War. The French master stayed mostly in the small town of Zaandam and later painted cityscapes of Amsterdam. The pastel-colored houses and dreamy canals of Zaandam seem to have provided him with a vision of Cathay; Holland's many links through trade with the Orient supported this fantasy. In his book *Amsterdam et Venise* (1876), Henry Havard, the French merchant-turned-art historian and traveling companion to Monet who wrote several books on Dutch art and Holland, described the river Zaan as "wide, calm and full to the brim, it flows between two banks covered with trees and flowers, among which nestle a multitude of houses, belvederes, kiosks constructed of wood and painted in the most diverse and strangest of colors. The tall trees and absurd houses are mirrored in the river, which also reflects the blue sky with its big white clouds. Picture this to yourself for a moment and you will fancy yourself instantly transported to China, Japan, perhaps the Indies."[11] This mood of sparkling, almost eighteenth-century orientalism is reflected in Monet's Dutch paintings, which, like so much of early Impressionism in France, can be seen as a form of rococo revival, here clearly associated with chinoiserie.

The Barbizon painter Daubigny, probably under Jongkind's influence, exhibited a series of Dutch windmill paintings at the Paris Salon of 1872, having visited the Lowlands in 1871. "We are in blond Holland," he wrote. "As blond as Rubens's women. What an enchanting country. We have hired a boat, and we're going along the Maas in it to do the windmills of Dordrecht."[12] Eugène Boudin also followed Jongkind's example and visited Holland several times in the 1870s, having lived in Brussels during the Franco-Prussian War. In 1884 Boudin did a series of paintings on the windmills of Dordrecht, and in 1886 Monet returned to paint the tulip fields. American Impressionists such as John Henry Twachtman and William Merritt Chase also spent time in Holland; Twachtman visited Mauve's studio to show him his work, and Chase conducted a summer school for painting in Haarlem, in proximity to the Hals Museum.

The rise of Impressionism coincided with the rediscovery in France of Frans Hals in the 1860s. Championed principally by the critic Théophile Thoré-Bürger, who also rediscovered Vermeer, Hals paintings brought record prices at auction, were assiduously copied by artists such as Courbet, and provided a springboard, along with other seventeenth-century Dutch masterpieces, for much of Manet's early imagery. Hals's spontaneous and open brushwork was a major inspiration for many artists at this time; Van Gogh praised his "twenty-seven shades of black," and we feel the influence of Hals in Breitner's Black Impressionism. Thoré-Bürger might almost have been heralding the new generation of Impressionists when he wrote of Hals in 1868: "These Dutch paintings representing the contemporary life of the artists naturally make one dream of the art of our own time. . . . What is to prevent one from making a masterpiece of a meeting of diplomats seated around a table . . . of an

315. MATHIJS MARIS. *Quarry at Montmartre.* c.1871. Oil on canvas, 21⅝ × 18⅛". Collection Haags Gemeentemuseum, The Hague

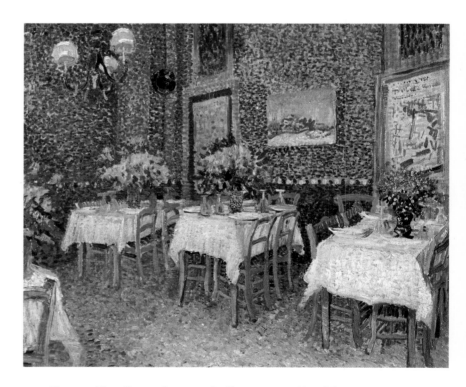

316. VINCENT VAN GOGH. *Interior of a Restaurant.* 1887. Oil on canvas, 18 × 22¼". Collection State Museum Kröller-Müller, Otterlo

orator at the rostrum of the Chamber of Deputies, a professor surrounded by young people; a scene from the races, a departure from the opera, a stroll down the Champs-Elysées; or just with men working at anything, or women amusing themselves with anything?"[13]

In the late nineteenth century, there does not seem to have been much of a market for French Impressionist painting in The Hague, at least not in the 1880s. We know that the French firm of Goupil, when it opened a branch in The Hague, could not sell the French Impressionists in 1888.[14] Yet by the 1880s, when the center of avant-garde activity shifted from The Hague to Amsterdam, French prototypes must have been available. Breitner, after befriending Van Gogh in The Hague in 1882, spent six months in Cormon's atelier in Paris in 1884, where he met Toulouse-Lautrec and Émile Bernard. The young Israëls was surrounded by a cosmopolitan flood of foreign visitors to his father's house, and the family traveled extensively. Today, there are no large public collections of French Impressionism in Holland, and although there are great French pictures such as Renoir's *The Clown* (1868) and Seurat's *Le Chahut* (1890) in the Rijksmuseum Kröller-Müller (Otterlo, The Netherlands) these were twentieth-century acquisitions.

Other painters of The Hague School, which in fact comprises four generations of artists, worked in various styles. The art of painter Jan Hendrick Weissenbruch (1824–1903), a founding member of The Hague artists' society, the Pulchri Studio, which was formed in 1847, evolved from late Romanticism to Impressionism in the course of his sixty-year career. Yet the subject matter of his works—plein-air landscapes and peasant scenes, basically remained static and traditional. There is the fascinating case of Mathijs Maris (1839–1917), the least known of the three Maris brothers, whose various works include such Impressionist works as *Quarry at Montmartre* (plate 315), painted when he was living in Paris. Mathijs then went on to become a painter of weird fairy-tale subjects—a Dutch Symbolist living in London late in the century. Also unique in the history of The Hague School is the painted panorama built by the painter H. W. Mesdag in 1880–1881 (and still a popular tourist attraction in The Hague today). It deals with a quintessential Impressionist subject—the village and beach at Scheveningen—in terms that seem subtly nostalgic. Mesdag, who lived in Brussels before moving back to The Hague, painted the seaside village as he remembered it; thus he was protesting the commercial development of the dunes—a phenomenon we see beginning in Mauve's work. Although it was not a success at first, the panorama is perhaps the only Dutch Impressionist landscape in the round. And it is noteworthy that the young painter Breitner, recently expelled from The Hague Academy for misconduct, worked on the panorama, painting the cavalry sections and the townscape of Scheveningen.

The bright quality of later Hague School imagery is best exemplified by Paul Gabriel's *In the Month of July* (1889; Rijksmuseum, Amsterdam)—a thoroughly bal-

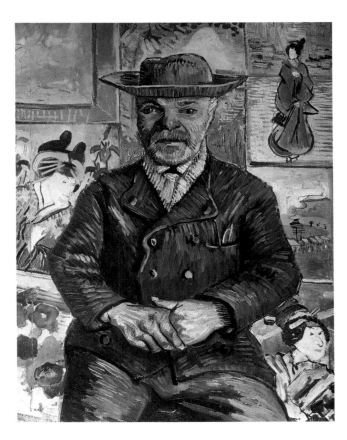

317. VINCENT VAN GOGH. *Portrait of Père Tanguy.* 1887. Oil on canvas, 36¼ × 28¾". Private collection

318. VINCENT VAN GOGH. *Peach Trees in Blossom "Souvenir of Mauve."* 1888. Oil on canvas, 28¾ × 23½". Collection State Museum Kröller-Müller, Otterlo

anced, placid image of a windmill and its reflection that pointedly recalls the gusty skies of Rembrandt's landscapes. Gabriel's painting of a windmill also inspired the young Piet Mondrian, who copied it in the Rijksmuseum in 1895, thus providing a prototype for Mondrian's obsessive exploration of windmill imagery in a Pointillist style early in the twentieth century. Gabriel attempted to combat the clichés of grayness that beset The Hague School. His painting is pointedly sunny, with a bright blue sky. Although nominally a member of The Hague School, Gabriel lived the early part of his life in Brussels, and the young Van Gogh even thought he was Belgian. Indeed, Gabriel was associated with the Belgian seascapist Louis Artan, who also lived in Brussels, and whose turbulent works form a kind of prelude to Impressionism in that country.

Van Gogh's own assimilation of Impressionism when he came to Paris in 1886 was intense and complete; his brother Theo dealt in Impressionist pictures and quickly introduced Vincent into the orbit of Impressionists and Neo-Impressionists. His *Interior of a Restaurant* (plate 316), painted more than a year after his arrival in Paris, shows him fully mastering the Neo-Impressionist style of his friend Signac. Depicting a suburban eatery in Asnières at that hour just before dinner when the flowers are on the table and the places are set with glasses turned down, Van Gogh renders a strangely cool and objective account of the place, as if submitting himself to the rigors of an alien discipline. During that summer he also painted the landscape around Montmartre with its vegetable gardens and

windmills, as if in memory of Rembrandt and Ruysdael—only now in a new, broken, and various Impressionist style, reminiscent of Matthijs Maris's *Quarry at Montmartre*, that leavens the strictures of divisionism with longer and more mixed strokes.

By the time he painted his friend, the Parisian arts supplier Père Tanguy in autumn 1887 (plate 317), Van Gogh was tackling *japonisme*. His portrait of the old communard (one of three versions) surrounded by Japanese prints is remarkable, not so much for its appropriation of a portrait format used by Manet and Degas as for the originality with which he animates the prints, so that they seem like living presences, pressing in upon the smiling old man (who often traded supplies for art). At Tanguy's store Van Gogh would have seen Pissarro, Cézanne, and Gauguin, as well as their works.

Only when Van Gogh went to Arles in February 1888 did he truly blossom as an Impressionist in the classic sense—as a painter of brilliant color working outdoors. For him, the south of France, with its life-giving sun—so different from the rainy climes of the Lowlands—was as exotic as Japan, and in the spring he painted flowering trees as if he were witnessing a cherry blossom festival. *Peach Trees in Blossom "Souvenir of Mauve"* (plate 318) was painted in March 1888 and signed after he received news that his cousin and teacher from The Hague, the painter Anton Mauve had died. This extraordinary portrait of a tree, with its blossoms seemingly flying upward in long drawn-out strokes of pink and red that merge with the broken cloudlets in the sky, gives a new centrifugal force to the lessons of Im-

319. GEORG HENDRIK BREITNER. *Evening on the Dam in Amsterdam.* c.1890. Oil on canvas, 36⅝ × 70″. The Antwerp Royal Museum of Fine Arts

(right) 320. GEORG HENDRIK BREITNER. Photograph of man and woman walking along a street.

IMPRESSIONISM IN BELGIUM AND HOLLAND

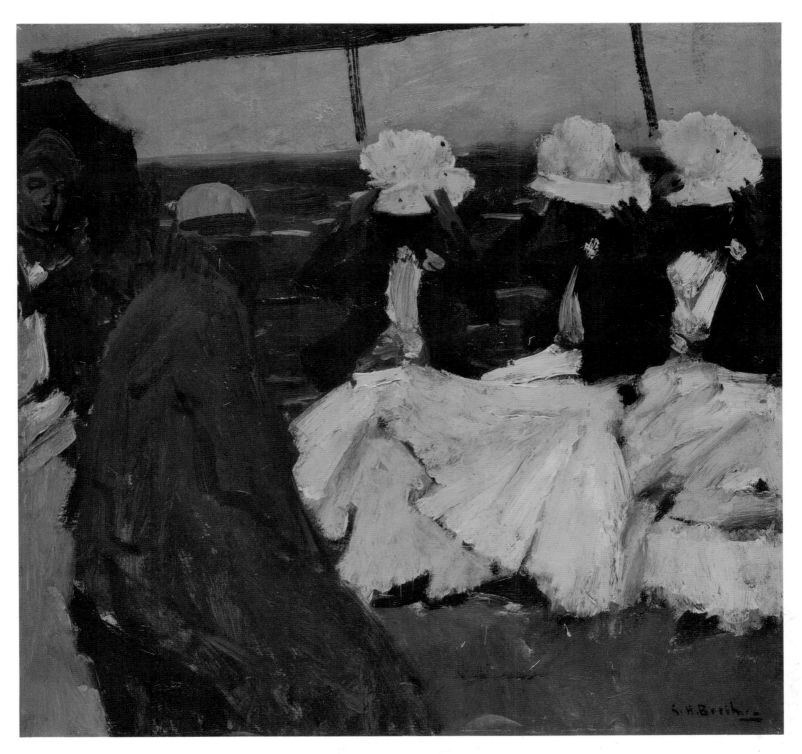

321. GEORG HENDRIK BREITNER. *Three Women on Board.*
c.1897. Oil on canvas, 22⁷/₁₆ × 19¹¹/₁₆″. Stedelijk Museum,
Amsterdam

322. Georg Hendrik Breitner. *Girl in Red Kimono*.
c.1893. Oil on canvas, 19¹¹/₁₆ × 27⁹/₁₆″. Stedelijk Museum,
Amsterdam

pressionism and Neo-Impressionism. Strokes on the ground radiate out from the tree, as if it were the center of the earth. Bright red trickles down from the fence like daubs of blood. Clearly the identity of this tree is associated in Van Gogh's mind with his own blossoming as an artist in the south of France.[15] It was Mauve who had told him to "blossom" six years before, and Van Gogh sent the painting as a gesture of his condolences to Mauve's widow.

During the same years in Holland, Breitner was developing a dark Impressionist style that earned him the nickname "the Zola of Amsterdam." His *Evening on the Dam in Amsterdam* (plate 319) has the weird flickering quality of Whistler's Nocturnes. Figures dart across the wide-open square as patches of lurid color: the woman with her two wards, pursued by yapping dogs, is an effective indication of the evening's enticements. In Breitner's world we get a new sense of Amsterdam as a city in modern flux—here lit by an artificial illumination that casts a sepulchral glow.

More than any other Impressionist in Holland, Breitner captured the quality of movement in his paintings and photographs. His *Three Women on Board* (plate 321), with its subtle harmonies of gray and yellow, has a marvelously windswept animation and was possibly inspired by a trip to London that year. All three ladies hold their hats to keep them from being blown away, and the sketchy male figure at the left is a kind of witness figure to these modern Three Graces.

Breitner's numerous photographs of the Amsterdam streets (plate 320) qualify as Impressionist works of art in their own right and often served as the direct inspiration for his paintings. With their raking angles, cropped views, and blurry close-ups, they document the comings and goings of children, maids, and businessmen—often with an eye to the possible sexual encounter. They also record the demolition of old houses to make way for new streets and buildings, such as Berlage's famous Stock Exchange. Breitner's photographs of construction sites, where the walls of standing buildings

IMPRESSIONISM IN BELGIUM AND HOLLAND

323. Isaac Israëls. *Amsterdam Serving Girls on the Gracht.*
1894. Oil on canvas, 16⅛ × 22¹⁄₁₆″. Rijksmuseum, Amsterdam

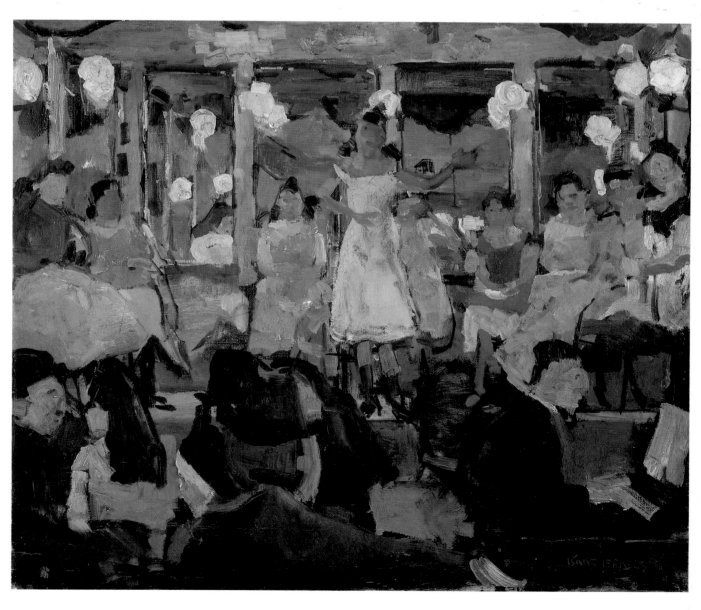

324. Isaac Israëls. *Café-Chantant in a Popular Quarter in
Amsterdam.* c.1893. Oil on canvas, 35½ × 41¼″. Collection
State Museum Kröller-Müller, Otterlo

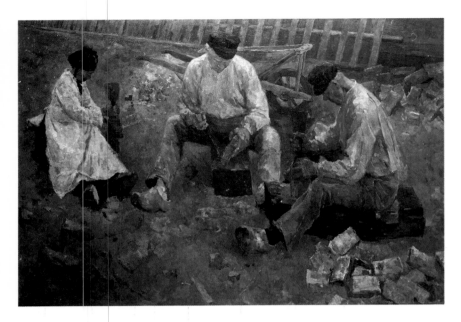

325. FLORIS VERSTER. *Stonebreakers.* 1887. Oil on canvas, 66½ × 98″. Collection State Museum Kröller-Müller, Otterlo

326. FLORIS VERSTER. *Bottles.* 1892. Oil on canvas, 14½ × 21½″. Collection State Museum Kröller-Müller, Otterlo

become Impressionist patches, denoting rooms in houses that no longer exist, are among his most affecting. In their deadpan candor, they summon up the very forces of change that shaped the modern city, and in his unflinching portraits of old workhorses, Breitner not only harks back to his early cavalry paintings but also finds a new and peculiarly touching symbol of late nineteenth-century *vanitas.*

Breitner's art also has its moments of contemplative stillness: in his sumptuous Whistlerian series of a girl reclining in a kimono (c.1893), based on photographic studies of the model, Breitner finds his own vision of the latter-day odalisque (plate 322). The model was a young girl named Geesje Kwak, who came from the popular quarter of the Jordaan. Swathed in a lurid red kimono and fondling a souvenir vase (replaced by a bunch of flowers in the painted version), the pubescent girl bespeaks a kind of gutteral *japonisme* that might have appealed to his friend Van Gogh, had he lived to see it. Yet as late as 1892, when Jan Toorop organized the first Van Gogh retrospective in The Hague, Breitner dismissed Van Gogh's painting as "art for the eskimos, coarse and crass, without the least distinction, and, moreover, all of it also stuff stolen from Millet and others."[16]

Breitner also fought with his colleague Isaac Israëls, who was perhaps the first artist actually to get a city permit in the 1890s to paint in the streets of Amsterdam. In 1894 Israëls first used his permit, which had been granted to him by the burgomaster and aldermen of the city in 1891. He and Breitner had studios for a time in the same building opposite the newly developed Oosterpark. Both made a specialty of painting the chambermaids of Amsterdam out on their morning rounds—catching the flurry of primly starched aprons and caps in patchy Impressionistic strokes. Israëls (who may have even influenced his father, Jozef) went on to paint bustling interiors of cabarets and fashion houses. His *Café-Chantant in a Popular Quarter in Amsterdam* (plate 324) captures some of the raunchy atmosphere of the lowlife dives he loved to frequent: the women sitting on the raised stage might almost be prostitutes on view in one of the city's public bordellos. The men and women in the audience seem oblivious to the singer, who looks as if she is wearing a slip. Israëls's *Amsterdam Serving Girls on the Gracht* (plate 323) is even more painterly and abstract: there are strange moments of almost Cubist *passage.* The sleeve edge of the maid on the right lines up with the tree edge on the opposite bank, and there is a masklike blankness to the women's faces.

Israëls increasingly turned to more fashionable scenes, as he began to tire of the street life in Amsterdam. With his friend Max Liebermann, he had painted outdoors at Scheveningen since childhood. Now he became well known for his slightly saccharine scenes of children riding donkeys on the beach at Scheveningen, which evoke the resort as a somewhat spoiled tourist attraction. He later lived in Paris, painting seamstresses and clients at the couture house of Pacquin as well as portraying

venerable Impressionist sites such as the Moulin de la Galette. In London at the outbreak of the war, he did Hyde Park scenes and finally returned to The Hague, where, among other things, he executed a full-length portrait of Mata Hari.[17] In the 1920s he painted plein-air portraits of royalty in Java—an indication of just how geographically widespread the Dutch Impressionist style had become.

Several other painters in the Netherlands are traditionally grouped under the heading of Amsterdam Impressionists. Willem Witsen (1860–1923) painted many of the same street scenes as Breitner and Israëls, opting for a dominant brown tone that gives his winter cityscapes a continuity with The Hague School. Suze Robertson (1855–1922), from a Hague family of Scottish origin, painted in a rough-and-ready, dark manner reminiscent of Frans Hals and of Van Gogh's *Potato Eaters*. Her work has also been compared to Paula Modersohn-Becker and Käthe Kollwitz for its expressionistic visions of women. Later she would evolve a more highly finished style of portraiture on gold leaf, often based on Flemish primitives. Similarly, Floris Verster (1861–1927) studied under Breitner and started painting Impressionistic worker's scenes in the 1880s; his *Stonebreakers* (plate 325) recalls the tradition of Courbet's *Stonebreakers* (and Mathijs Maris's *Windmill with Quarry*), with the noteworthy exception that one of Verster's workers is an old woman. Centered in Leiden, Verster gradually became known as a painter of still lifes; his *Bottles* (plate 326) is reminiscent of Ensor's *The Oyster Eater*, only Verster's studies in multiple transparency are darker and more haunting; Verster was playing on the *vanitas* tradition in Dutch painting in a new way. Early in the twentieth century, Verster developed his own style of tightly finished still life inspired by Vermeer, in which a bowl of eggs or a pair of dead birds assumes a quasi-mystical fixity.

## Belgium

The situation in Belgium was somewhat different. By 1900 the country was second in industrial power only to Great Britain, was on an economic par with the United States, and had rich colonial holdings in the Congo. Belgium was also a young nation, founded only in 1830, when the Flemish and Walloon provinces seceded from Dutch rule, and was drastically divided by language differences—with Flemish (or regional Dutch) being spoken in its northern parts, and French in the south, where the capital, Brussels, is. In the 1880s Belgium was divided by the rise of a Flemish nationalist movement, which gained a majority in Parliament in 1884. The Catholic Church encouraged the use of Flemish language and culture, Flemish was established as the official language of the courts, and a Flemish university was founded at Ghent. At this point the Belgian currency began to be printed in both languages, and the small country became officially bilingual.[18]

Belgium, like Holland, has a glorious artistic past: it is the homeland of Van Eyck, Bosch, Brueghel, and Rubens (and in the 1820s the French Neoclassicist Jacques-Louis David had died there in exile). Following twenty years of Belgian Neoclassicism by David's students, a Romantic phase led by the Belgian painter Gustave Wappers, and then a Realist movement (Courbet's *Stonebreakers* was shown at the Brussels Salon in 1852), Belgian art of the 1860s and 1870s was deeply influenced by Barbizon paintings, which could be seen at the Belgian Salon or on trips to neighboring France.

The Belgian art historian Serge Goyens de Heusch has argued that there is an "autochthonous" school of Belgian Impressionism. "With Ensor," he wrote, "Belgian Impressionism was thus born in the subdued light of interiors, a bit like in France, about twenty years earlier with Manet and Degas. Without claiming to break with a certain realist vision, the poetics of light led to a treatment of painterly substance in a transparent and unbound manner; Ensor revived the beautiful craft of Rubens."[19]

Although clearly affected by events in France, Belgian artists also developed an indigenous school of plein-air painting that is distinctive. In Belgium the tradition of painters working alfresco dates back to Rubens at least. Louis Artan (1837–1890), who painted at Barbizon and whose seascapes and beach scenes were inspired by trips to the Belgian coast as well as to Brittany, is usually considered to be a precursor to Belgian Impressionism. Louis Dubois (1830–1880) painted eccentric large *animalier* pictures with surprisingly fresh landscape backgrounds. Dubois also collaborated with Felicien Rops on an autumnal painting of figures in a forest around 1860 that seems to anticipate the figurative groupings in Monet's *Déjeuner sur l'herbe* (plate 24).[20] Hippolyte Boulenger (1837–1874) became well known for founding an informal school of plein-air painting at Tervueren outside Brussels and for his stormy seascapes, full of Expressionist incident, before his early death at the age of thirty-seven. The long-lived artist Adrien-Joseph Heymans (1839–1921) spent time in Paris in the 1870s, began painting in the Barbizon mode, and did atmospheric Flemish *polder* scenes. Heymans then banished gray from his palette in the 1880s and painted fully Pointillist industrial landscapes as well as Luminist tone poems. He exhibited with Les XX in 1884 and helped to found the Luminist group "Vie et Lumiere" in 1904. A native of Antwerp, Heymans was an early teacher of Henry van de Velde, who called him "the initiator of luminous landscape in Belgium."

James Ensor (1860–1949), born of a Belgian mother and an English father, spent most of his life in the provincial coast town of Ostend, where travelers still catch the ferry for England. Ensor's fantasies, often inspired by the masks sold in his mother's souvenir shop, could not be tied down to mere Impressionism, although he mastered the style early on—a good four years before it was shown at the salons of Les XX (of which he was a founding member). Instead Ensor sought to embrace the

salty Flemish tradition of verbal and pictorial slang that runs so deeply in Belgium; his work is often evocative of the puppet shows, carnival celebrations, and *zwanze* humor that are a staple of Belgian life. *Zwanze* means humor in Brussels dialect, and there was a salon of "*L'Art zwanze*" to which Ensor contributed in 1887. *Zwanze* humor was also associated with anarchy, and Ensor's early friends and patrons were known to be sympathetic to anarchist ideals.[21]

Ensor began painting in a heavily impastoed, naturalistic style, the so-called Gray School that characterizes much Barbizon-inspired work. By the end of the 1880s, he had developed a personal style of expressionism that owes as much to Rembrandt's etchings as it does to French Impressionism. In the early 1880s artists such as Willy Finch, Jan Toorop, and older artists such as Guillaume Vogels gathered around him, and in the early exhibitions of Les XX he was considered to be a leader of the new *tachiste,* abstract and spotty style. Yet Ensor increasingly showed himself true to the hallucinatory tradition of Bosch, although from the late 1880s on, he imbued it with a bright, Impressionist palette and rich Flemish painterly substance.

The formation of Les XX was particularly important for the history of vanguard painting in Belgium. It was essentially the brainchild of two lawyers, Edmond Picard and Octave Maus, who were also writers—the editors of the journal *L'Art Moderne* and Maecenases of the arts. Les XX started out as a dissident salon, in sympathy with the anarchist movement and in opposition to the official Salon, which was held alternately in Brussels, Ghent, and Antwerp. All kinds of new art, including Impressionism and Symbolism, were exhibited at Les XX, and foreign artists such as Whistler, Redon, Gauguin, Breitner, Isaac Israëls, and Van Gogh were invited. Beginning in 1886, the works of Monet and Renoir were seen there (although Monet had exhibited in Belgium as early as 1872), and in 1887 Seurat's *Sunday Afternoon on the Island of La Grande-Jatte* (plate 251) was exhibited at Les XX; thus Impressionism and Neo-Impressionism were discovered almost simultaneously in Belgium.

Younger artists such as Willy Finch and Henry van de Velde, who had been working in an Impressionist mode, were most enthusiastic about the new Pointillist technique, perhaps because it corresponded to the silvery, hazy quality of Belgian light or perhaps because it corresponded nicely to nascent theories of Symbolism and to what the art historian Goyens de Heusch has called "the poetics of light." Seurat and Signac's Neo-Impressionism also must have seemed to offer a bracing new order—one with revolutionary and anarchist implications. Socialism played a strong role in Les XX: Picard for one was an ardent member of the party and saw art as his banner of protest. For Picard, Impressionism was "the last turn of the wheel in this vast mesh, always in movement, that no human force can hinder the functioning of, that it is as childish to attack as it is absurd to deny."[22]

In the 1890s a second, more conservative wave of Impressionism swept through Belgium. Led by the artist Émile Claus (1849–1924), a group of Belgian Luminist painters (including Heymans and Ensor), whose paintings were devoted to the study of light, banded together and formed the group Vie et Lumière in 1904. Claus, who never joined Les XX, practiced a fairly traditional form of academic naturalism in the 1880s, but after three winters in Paris he became a confirmed Impressionist, and through the 1890s and well on into the twentieth century his paintings became Belgian paeans to Monet and influenced artists such as Anna Boch (1848–1933), who frequently returned to Brittany to paint some of the same motifs at Etretat as Monet. The poet and critic Émile Verhaeren wrote of Claus in 1901: "His art is sure, clear and ceaselessly in search of air, light and life. It commands respect in this country as the art of a master."[23] This second wave of Impressionism can thus be seen as representing a deliberately Francophile element in Belgian art. By the turn of the century, an international colony of Impressionists had developed around Claus at Astène outside Ghent, and artists came from as far away as Japan and America to study with "the pope of Astène."

Among the precursors of Impressionism in Belgium, even such a phantasmagoric artist as Felicien Rops (1833–1898) occasionally had his day in the sun, as we see in an oil study *The Beach* (plate 327), painted at the Belgian seaside resort of Blankenberghe, where he often worked with Artan. Such a direct slice of life seems totally unlike the satanic illustrator beloved by Baudelaire; yet Rops, who wintered in Paris from 1874 onwards and was on friendly terms with Manet and Degas, frequently returned to Belgium in the summer to paint *en plein air.* Rops's freshly observed *morceau,* similar in feeling to the work of Mauve, also testifies to the growing popularity of the Belgian beach resorts at Ostend, Blankenberghe, and Knokke in the late nineteenth century. Modeled on their French and English neighbors, the Belgian resorts were popular with King Leopold I, as well as with the bourgeoisie, who could take day trips there by train. Rops's slice of seaside life shows a rumble-tumble vision of flaneurs on the promenade as well as workers in the dunes probably engaged in some kind of building (the exploitation of the dunes was something that Rops had decried since the 1850s).[24] The beach scene might seem totally at odds with Rops's ideal vision of the Eternal Feminine, yet both could be incorporated into the worldview of the artist, who once wrote to a friend: "Ah the North Sea! She who comes from Iceland rolling the moiré sands in the changing satins of her dress! She is a bit my beloved mistress. When I arrive, after long absences, I open my nostrils to smell the scents of Her! Her underarms all spiced with seaweed, salt, shells and the algae of her shores. It seems to me, and it's by mysterious atavisms that make my heart exult, that she has loved me and caressed me as a child, and that very often I have fallen asleep rocked by her songs."[25]

Such a salty mix of femininity, kitchen meta-

327. Felicien Rops. *The Beach.* c.1878. Oil on canvas,
16⅛ × 23″. Royal Museums of Belgian Fine Arts, Brussels

phors, and seaside memories can also be glimpsed in James Ensor's monumental still-life painting *The Oyster Eater* (plate 328). This indigenous Impressionist work was rejected by the Antwerp Salon and an artists' collective in Brussels called L'Essor and exhibited at Les XX only in 1884. Ensor, who lived year round in the seaside resort of Ostend, was no stranger to the pleasures of Belgian shellfish; the mussel is, in fact, a kind of national symbol of his country. Yet Ensor's large painting, so ambitious for an artist of only twenty-two, also seems to have been a direct riposte to contemporary French Impressionism. A generation younger than Rops, Ensor had not yet been to Paris for an extended stay, yet *The Oyster Eater* suggests that he was au courant with Manet and Monet at this time; in fact, Manet's *Bar at the Folies-Bergère* (1881; Courtauld Institute, London) was exhibited at the Antwerp Salon in 1882. Of course, it could be pointed out that Ensor's encyclopedic rendition of bottles and glassware has precedents in seventeenth-century Dutch and Flemish still life—and is clearly related to Verster's still life *Bottles*—yet the marvelously loose brushwork of the white tablecloth, the tart yellow accent

of the lemon, and the slightly claustrophobic heavy wood hutch with its fragmentary mirror reflection make us think of Manet, himself inspired by Dutch and Flemish still life. The woman in *The Oyster Eater,* modeled by Ensor's sister, seems absorbed with her meal, though someone else clearly has just left the table—perhaps the artist himself getting up to return to his easel. Thus a game of illusion and reality is suggested, a game that in Ensor's 1880s bourgeois interiors becomes increasingly visionary, as monsters and creatures in masks begin to appear in the rooms and in the furniture. Yet at the time it must have been the boldness of *The Oyster Eater*'s aggressively open brushwork and unmodeled tints that shocked Ensor's conservative contemporaries.

A quality of apocalyptic hallucination is captured in Ensor's landscapes, which often verge on the radically abstract. His *Fireworks* (plate 329) takes the most ephemeral Impressionist manifestation of light and makes of it a brilliant arabesque, a pure painterly spectacle. The fireworks fill the canvas in a nearly symmetrical fan shape, set off against a cobalt sky and a narrow slice of water below, while tiny figures scurry like ants across the

328. JAMES ENSOR. *The Oyster Eater.* 1882. Oil on canvas,
81½ × 59¹⁄₁₆". The Antwerp Royal Museum of Fine Arts

beach. This nighttime performance suggests Van Gogh's
*Starry Night*, painted two years later at Saint-Rémy. Yet
Ensor's explosion of pure chromatics may also have a
nationalistic subtext: the painting might have been in-
spired by the celebrations of the Belgian state, feting its
fiftieth birthday in 1880.

Ensor's masterpiece *The Entry of Christ into
Brussels in 1889* (plate 330) might be considered a specif-
ically Belgian retort to the cool French classicism of
Seurat's *La Grande-Jatte*, seen at Les XX the year before.
Even bigger than Seurat's painting, Ensor's raucous car-
nival scene, with its cacophony of red and green, might
be thought of as an Impressionist street scene gone ber-
serk or a modern epic painting in disguise. It clearly
reflects Ernest Renan's writings about Christ as a histor-
ical figure, as well as the sentimental treatments of re-
ligious subjects in painting of the 1880s, such as Fritz
von Uhde's "*Come Jesus, Be Our Guest*," a scene of Christ
appearing to modern peasants that was a popular sub-
mission to the Paris Salon of 1885.[26] Ensor's painting
also portrays the celebrations that occur in Belgium dur-
ing carnival time (and has many parallels with Impres-
sionist flag-waving scenes by Monet and Childe
Hassam), but there is an apocalyptic urgency to his art
demonstrated by the inclusion of the Belgian Socialist
party's "*Vive la Sociale*" banner and the portrait of anar-
chist Émile Littré as the bandleader. The parade is sus-
piciously like a demonstration, even a riot. The crowd of
masks at left may include quotations of African masks in
King Leopold's private collection of booty from the
Congo. And typical of Ensor's *zwanze* humor, the figures
thin out to little dots at the top edge of the canvas as if in
parody of Seurat's Pointillism. Such a conglomeration of
discordant references and complementary colors was evi-
dently too much even for Les XX, for the work seems to
have been taken off view from the exhibition and re-
mained unseen until the 1920s, except by visitors to
Ensor's house in Ostend. There, hanging over the harmo-
nium, it became a kind of Belgian *gesamtkunstwerk*,
animated by the artist's music and even by the occasional
dramas he composed. In such a heady Symbolist setting,
the Impressionism of the painting was only one feature of
the work, but it nevertheless gave *The Entry of Christ* a
pictorial realism, which is one of the reasons it is still
such a confrontational work today.[27]

The more polite assimilation of Impressionism by
Ensor's peers is suggested by several works that use a
kind of allover, open brushwork to much less radical
effect. Even so decided a Symbolist as Fernand Khnopff
(1858–1921), painter of sphinxes and androgynes, was
influenced by the Naturalist movement, for not only did
he belong to the Gray School (his early works look star-
tlingly like Ensor's), but he also did perfectly straightfor-
ward landscapes of his beloved countryside in the
Ardennes. In his portraiture of children, he succumbed
to the influence of Whistler, who exhibited with Les XX.
Khnopff learned from Whistler how to render youthful
subjects in an appropriately dewy and fresh manner. In
*Mlle Van der Hecht* (plate 332), a little girl stares us down
with unflinching candor. The portrait still has a kind of
Flemish primitive fixity, though the contours of the fo-
liage behind her are blurred. Likewise Jan Toorop's *Trio
Fleuri* (plate 331), painted when the Dutch artist was
living in Brussels and exhibiting with Les XX, is a
naturalistically painted family grouping—one that is
nevertheless rife with Symbolist overtones. A portrait of
the three Hall sisters from England (the one on the left,
Annie Hall, would become Toorop's wife), the painting
combines Impressionist freshness with an air of ineffable
sadness and mystery; the sister in the middle, Meggy,
seems almost possessed. Toorop (1868–1928) later ex-
perimented with Neo-Impressionism, painting a small
scene of a wounded worker's family on the move (*After the
Strike*: c.1888; Rijksmuseum Kröller-Müller, Otterlo)
that is one of the more explicit renderings of social pro-
test in a Pointillist style.[28] In the 1890s he moved back to
Holland, worked in an elaborate Symbolist whiplash
style, and became one of the most committed advocates
of modern art in Holland, organizing the first Van

329. JAMES ENSOR. *Fireworks.* 1887. Oil and encaustic on
canvas, 40¼ × 44¼″. Albright-Knox Art Gallery, Buffalo, New
York. George B. and Jenny R. Mathews Fund, 1970

330. JAMES ENSOR. *The Entry of Christ into Brussels in
1889.* 1888. Oil on canvas, 102½ × 169½″. The J. Paul Getty
Museum, Malibu

331. Jan Toorop. *Trio Fleuri*. 1885–1886. Oil on canvas,
43⁵/₁₆ × 37⅝″. Collection Haags Gemeentemuseum, The Hague

332. FERNAND KHNOPFF. *Mlle Van de Hecht.* 1883. Oil on canvas, 14½ × 11⅜″. Royal Museums of Belgian Fine Arts, Brussels

333. CONSTANTIN MEUNIER. *The Smokestack.* c.1880s. Oil on canvas, 31½ × 19¾″. Royal Museums of Belgian Fine Arts, Brussels

334. GUILLAUME VOGELS. *Snow, Evening.* 1886. Oil on canvas, 41⅜ × 60⅝″. Royal Museums of Belgian Fine Arts, Brussels

Gogh retrospective in The Hague in 1892. Toorop's later Pointillist works would also influence the young Mondrian.

In the realm of landscape painting, one of the first Belgian artists to be considered an Impressionist by a Belgian critic was Guillaume Vogels (1836–1896).[29] A generation older than Ensor, Vogels had been a decorative painter, had probably encountered the Barbizon painters in Paris, and had been part of the original circle of plein-air painters at Tervueren. *Snow, Evening* (plate 333), shown at Les XX in 1886, is a low-lit, crepuscular scene that exhibits late Barbizon stylization in the palette-knife manipulation of its pink and gray tones. Vogels (1836–1896) is memorable because he imbued this conventional style with new *tachiste* Expressionism; the critic in *La Gazette* called him "poetic in the midst of his savagery." He became well known for wintry scenes, and there is a charming image of his friend, the Greek painter Pericles Pantazis painting in the snow.[30] Pantazis (1849–1884), also known for his Impressionist scenes of the Belgian coast, died prematurely at age thirty-five.

Landscape as a medium for essays with a social conscience are common in Belgian art of the 1880s—a decade that saw social unrest in the country and the burgeoning power of the Socialist party. Constantin Meunier's winter scene *The Smokestack* (plate 334) was painted in the Black Country—a heavily industrialized coal-mining section of Belgium where Zola found inspiration for his searing novel *Germinal* (1885) and where Van Gogh tried to preach to the miners from 1878–1880. Meunier, most famous for his later sculptures of heroic workers, started out as a painter, and his study of a smokestack on a dreary winter's day owes much to the proto-Impressionist late style of Jean-François Millet, whose powerful paintings of peasants also inspired Jozef Israëls and Van Gogh. Yet in the

335. Émile Claus. *The Picnic*. 1887. Oil on canvas,
50¾ × 78″. Royal Collections, Belgium

336. Guillaume Van Strydonck. *The Rowers*. 1889. Oil on
canvas, 33¼ × 79½″. Musée des Beaux-Arts, Tournai

337. HENRY VAN DE VELDE. *Beach at Blankenberghe with Cabanas.* 1888. Oil on canvas, 28 × 39⅝″. Kunsthaus, Zürich

338. ALFRED WILLIAM FINCH. *The Race Track at Ostend.* 1888. Oil on canvas, 19½ × 23¼″. The Art Museum of the Ateneum, Helsinki

unsentimental depiction of the chimney, which spreads black smoke into the white landscape, Meunier hit upon a vein of inspiration that would carry over into remarkably rich black-and-white drawings of worker's conditions in the 1880s and 1890s.

Émile Claus's *The Picnic* (plate 335) states the issues even more clearly: there are haves and have-nots separated by an unbridgeable gap of river, not unlike a feudal moat. A wealthy party of picnickers is seen in the distance through the screen of workers in the foreground—many of them figures viewed from the back. The range in ages among the workers (at least three generations are present) suggests a parable of courtship, marriage, childrearing, and old age—one in which the workers' struggle will be perpetuated. As for the typically Impressionist subject of leisure on the opposite bank, it, too, has its moralizing quality: note the presence of lovers disappearing into the fields at left and the tender sapling trees that echo the children playing under them. Claus, hardly an avant-gardist, never exhibited with Les XX, although he was invited to, and his work in the 1880s has much in common with the moralizing naturalism of an American painter such as Eastman Johnson (whose works were exhibited in Europe and could have been known to Claus). Later landscapes of Claus's painted along the river Lys would sacrifice rhetorical sentiment for a pure investigation of light, although Claus's images of workers always retain a certain nobility.

A successful mix of Impressionist freshness for the background and conventional Realist rhetoric for the foreground figures is conveyed by Guillaume van Strydonck's *The Rowers* (plate 336), a monumental canvas of 1889. The subject of rowers is an eminently Impressionist one, treated by Caillebotte, Monet, and others. Yet Van Strydonck (1861–1937), an original member of Les XX who collaborated on at least one painting with Ensor,[31] had recently returned from an extended visit to Florida, where he painted the "crackers," or poor white residents, in a loose, naturalistic style. One wonders if he could have seen or heard about Thomas Eakins's paintings of sculling on that trip. The rowers in Van Strydonck's paintings have marvelously observed Flemish physiognomies; the one in front, in particular, is a study in meditative melancholia. The painting has an undercurrent of Symbolist foreboding, for the subject of water as a primal element inviting introspection (or immersion) was a popular one for Symbolist poets and painters alike. Van Strydonck seems to be trying to catch that moment of intense concentration just before a race, and the crowd on the opposite bank, where other rowers can be glimpsed getting into their boats, suggests that the stakes are high.

More than Impressionism, it was Seurat who inspired a number of artists to start painting Neo-Impressionist works in Belgium. Ostensibly the first to do so was Willy Finch (1854–1930), born in Brussels of English parents and a friend of Ensor's who also spent his childhood in Ostend. Finch's painting *The Race Track at Ostend* (plate 338) captures some of the excitement of Seurat's style, not so much in its Pointillist brush

339. GEORGES LEMMEN. *View of the Thames.* c.1892. Oil
on canvas, 24×34". Museum of Art, Rhode Island School of
Design, Providence

340. THEO VAN RYSSELBERGHE. *Family in an Orchard.* 1890.
Oil on canvas, 45½×64⅜". Collection State Museum Kröller-
Müller, Otterlo

strokes as in the jaunty diagonal cut of the red fence across the lower-left corner of the canvas. The red fence becomes a kind of emblem of modernity, giving a radical edge to the racetrack, a quintessential Impressionist subject also painted by Degas and Manet. Finch, a founding member of Les XX, who would later work in ceramics and move to Finland, shows himself here to be a precocious adept of the new painting technique.

Similarly, the young Belgian painter Henry van de Velde (1863–1957) inflected his *Beach at Blankenberghe with Cabanas* (plate 337) with a diagonal thrust of Symbolist shadow play. Here, in a beach scene that suggests how much the resort of Blankenberghe had grown up in the ten years since Rops painted it, we see the lessons of Seurat applied quite literally. The painting is bespeckled in the secondary colors of violet and orange in an almost obsessively measured composition that looks as if it was constructed according to the golden section. From Van de Velde, who spent the summer of 1888 painting in his family's cabana at Blankenberghe while trying to recover from the shock of his mother's death, such a study of light and shadow takes on an almost metaphysical quality. We also know that this was the summer he was much influenced by a circle of socialist friends, including the poet Max Elskamp. Neo-Impressionism had been associated since its inception with the anarchistic ideas of Signac and Pissarro, and the Pointillist style may have seemed like a radical plot to hatch in one's family beach cabana. Van de Velde's utopian bent would take him away from painting and into Art Nouveau design and architecture in 1892, when, under the influence of William Morris, he became involved with the socially committed Arts and Crafts Movement. Before the war he would be best known as the director of the Weimar Kunstgewerbeschule, later to become the first Bauhaus. Yet Neo-Impressionism remained an important aspect of his evolution, and he advocated it strongly in Germany.

In Georges Lemmen's *View of the Thames* (plate 339), a factory rises out of the water like an apparition. The remarkable stillness of this scene, the pure silhouetting of darkened forms against the sky, and the hazy view of more smokestacks in the distance recall the similar scenes of the Borinage painted by Meunier, but now both factories and men have been subjected to a new, more rigorous sense of pictorial order. The little figures marching up the slip of an island conform to the eurhythmic verticals of the pylons above. Another smaller vertical marker divides the canvas in two, and in conjunction with another line of smokestacks downriver, forms an almost musical notation of spatial recession across the canvas. From Lemmen (1865–1916), also known for his exquisite Pointillist portrait drawings and decorative work, such a vision of industrial twilight is exceptional. Later in life Lemmen returned to a more orthodox Impressionist style. Yet for Lemmen, Finch, and Van de Velde, commitment to Neo-Impressionism and decorative work was intimately bound up with a utopian desire to improve the life of the worker. Thus the subject matter

of this industrial scene may reflect concern for the social conditions of the working class.[32]

A more art-for-art's sake approach to Neo-Impressionism was advocated by Theo van Rysselberghe (1862–1926), who was one of the first Belgian artists to see Seurat's *La Grande-Jatte* in Paris. Having gone through a Whistlerian phase in his portrait of Octave Maus (1885) and having recently returned from Morocco, where he practiced a kind of orientalist Impressionism, Van Rysselberghe supposedly broke his cane in fury before Seurat's chilly, robotic painting at the Paris Salon. Yet he became the most steady convert to the Neo-Impressionist style in Belgium, making divisionist portraits and landscapes in particular his speciality. Van Rysselberghe tended to use Impressionist cropped poses for his models. The portrait of his student Anna Boch (1889; Museum of Fine Arts, Springfield) standing with brush and palette in hand with a Japanese print behind her is a particularly strong example of the way Pointillist technique could be applied to an Impressionist format. The still life at upper left, in which a violin bow nudges a paint can full of brushes, which in turn seem to tickle the man in the Japanese print, is a tour de force of subtle humor, rendered in so many tiny touches.

One of Van Rysselberghe's specialties was the large salon *machine* in a divisionist style. In his *Family in an Orchard* (plate 340), we see strange and sometimes abrupt truncations of figures, not to mention an amusing variety of portable seating furniture. Here Van Rysselberghe is still under the spell of *La Grande-Jatte:* note the woman in the rattan chair radically truncated by the tree at right, the children in the distance, and the down-turned faces of the principal seated women, a pose which effectively conceals their identities (the one on the left is Van Rysselberghe's new wife, and the bare-headed woman at right is Maria Sethe, later to become Van de Velde's wife). Like Toorop's *Trio Fleuri*, Van Rysselberghe imbues the family group with an air of almost devout Symbolist mystery. He creates a mood of wrapt concentration that would carry over into his late monumental Pointillist canvas *The Reading* (1904; Museum of Fine Arts, Ghent), in which the poet Émile Verhaeren presides over a group of friends and worthies, including Maurice Maeterlinck and André Gide.

The rare quality of charm on a muralist's scale can be seen in the work of Henri Evenepoel (1872–1899), the precocious Belgian painter who was a close friend of Henri Matisse's in Gustave Moreau's Parisian studio. Evenepoel's *Sunday in the Bois de Boulogne* (plate 342) shows a rough sketch of the subject, possibly worked on *en plein air*. By the end of the decade, Evenepoel had enlarged and developed this scene into the extraordinary *Sunday Promenade at Saint-Cloud* (plate 341)—a canvas on the scale of *La Grande-Jatte* but now composed of a radically empty center, a panoply of pictorial incidents pushed to the canvas's edges, and rich glowing patches of color. Note what has become of the figures of the father and his two children between the sketch stage and the mural. In the sketch he is an ambling worker striding

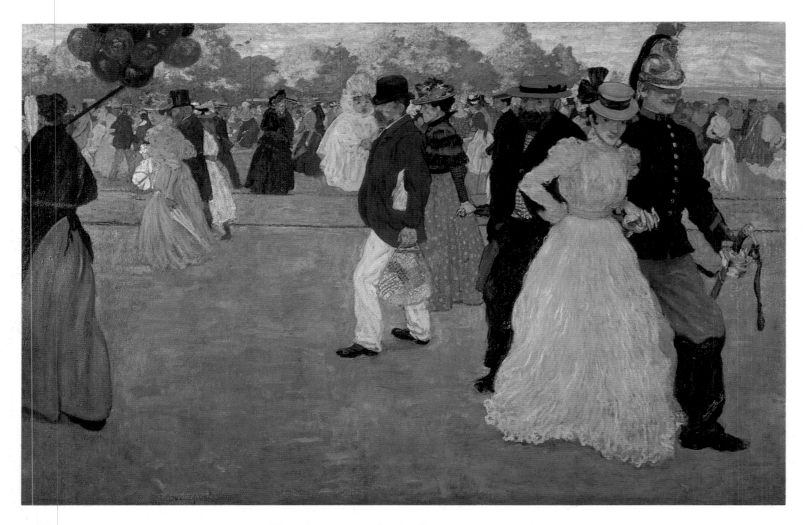

341. HENRI EVENEPOEL. *Sunday Promenade at Saint-Cloud.*
1899. Oil on canvas, 75¼ × 118½″. Musée d'Art Moderne,
Liège

342. HENRI EVENEPOEL. *Sunday in the Bois de Boulogne.*
1891. Oil on canvas, 23¼ × 35½″. The Antwerp Royal Museum
of Fine Arts

into the composition almost frontally, whereas in the later canvas he is in strict profile, with one child held magically aloft. His other arm is now occupied by an openwork baby bag, no doubt full of diapers. The older child is a slip of paint with a comically extended arm, clenched by the mother who looks none too happy. The sense of all the walkers' different speeds is palpable—the girl in a glorious pink dress rushing off with her soldier at right, the old balloon seller slowly making her exit at left, the fetching woman in blue smiling at us, with her older companion and a young girl (her daughter?) skating steadily along in tow. Evenepoel's treatment of the ground itself bespeaks a certain Flemish earthiness: loosely brushed, full of visible pentimenti, and occupying a large part of the canvas with a warm, pinkish brown color, it epitomizes the emphatically down-to-earth quality of his art. All the more tragic, then, that this brilliant young painter whom Matisse called "one of the best things in my life" was carried away by typhoid fever at the age of twenty-seven.[33]

Well into the twentieth century, the legacy of Impressionism in Belgium and Holland depended, in no small part, on the agency of patrons such as Anna Boch. Boch, independently wealthy from a family of porcelain makers in the Black Country, joined Les XX in 1885 and was famous for her musical "at home" evenings. It was

IMPRESSIONISM IN BELGIUM AND HOLLAND

343. ÉMILE CLAUS. *Tree in the Sun*. 1900. Oil on canvas,
72⁷/₁₆ × 60¼″. Museum of Fine Arts, Ghent

there that so-called Impressionist music by Debussy, Faure, Chausson, and Franck was often heard for the first time. (The first concert exclusively devoted to Debussy's music was held in 1894 in the exhibition rooms of La Libre Esthétique, an artists' society that succeeded Les XX.) Boch was also the only person to buy a painting from Van Gogh in his lifetime (*The Red Vineyard*, now in the Pushkin Museum in Moscow) and was on the verge of buying a second one from Père Tanguy, when Van Gogh died in 1890. She also amassed a splendid collection of Gauguins and other French artists that was one of the mainstays of the huge retrospective of French Impressionism at La Libre Esthétique in 1904.

At their best, Anna Boch's own paintings offer a no-nonsense approach. *Dunes in the Sun* (1903; Musée Communal d'Ixelles), probably painted on the Belgian coast, belongs to the same tradition as Mauve and Rops's straightforward views of the beach: it is simply a close-up of sand, now uninhabited (as if to make a stronger case for conservation) and captured in subtly contrasting blues and yellows with a flurry of more organized, Neo-Impressionist brushwork along the high horizon. Boch, who traveled extensively in France, Morocco, and Italy, often painted the same sites as Monet at Etretat. She is also one of the reasons that there are such great public collections of French Impressionist and Post-Impressionist art in Belgium today. Her brother, the painter Eugène Boch (1855–1941), whom Van Gogh met in the south of France and whom he depicted as *The Poet* (1888; Musée d'Orsay, Paris), seems to have followed Van Gogh's advice about "passing through Impressionism." Boch made three prolonged trips back to his native Black Country, where he painted industrial scenes.

Under the guidance of Claus, whose later works become full-blown syntheses of Symbolism and Impressionism, many painters of all nationalities devoted themselves to the study of light. Working on the banks of the Lys and at his Astène villa, Zonneschijn (Sunshine), Claus developed a school of Belgian Luminism, counting the affluent Ghent women artists Jenny Montigny, Anna de Weert, and Yvonne Serruys among his students. Not only did Claus depict de Weert and Montigny painting in the fields (in scenes that have strong affinities with the work of William Merrit Chase in the Hamptons), but he also painted Anna de Weert sketching in a boat (plate 312). This charming portrait suggests just how entrenched certain aqueous reversals of Symbolist imagery have become in nominally naturalistic portraits. The sailboat seen entering the picture from the top is so radically cropped that its full form is only visible as a reflection in the still water. The arc of the sail plays off the arched silhouette of the sketching pad she is holding, just as her pen subtly rhymes with the pinpoint sliver of the reflected mast. The figure of De Weert seems almost aqueous in color, while her head, strangely vegetal in its sloe-eyed glance, is formally related to the blur of trees reflected in the water nearby. Here, too, is an echo of Monet's paintings of poplars, which have also been seen as Symbolist evocations.

344. Piet Mondrian. *Mill by Sunlight.* 1908. Oil on canvas, 41 × 34¼". Collection Haags Gemeentemuseum, The Hague

Nowhere is the line between Symbolism and Impressionism more blurred than in Claus's monumental *Tree in the Sun* (plate 343). Here, in what amounts to a transcendental portrait of an autumnal tree seemingly eminating light from deep within its trunk, Claus finds a delicacy of line and an empathy with living forms that recall Odilon Redon. Redon had been well represented in the exhibitions of Les XX, and his many links with Belgium are traditionally ascribed to the rise of Symbolism in the Lowlands. Yet Redon's powers of naturalistic observation may have had their influence, too, and the coloristic éclat of his later works has parallels with the glowin complementary oranges, yellows, and violets sprinkled across Claus's canvas in long, commalike notations.

Working under Claus's influence, the paintings of several women Luminists deserve further attention. Jenny Montigny (1875–1937) is best known as a painter of schoolchildren playing outside in the sun. She remained unmarried and painted with Claus in London during World War I, where she did scenes of Hyde Park. Yvonne Serruys (1873–1953) was the author of *Mane Becube*, a memorable Pointillist portrait of an old Flemish peasant woman carrying a child on her back.[34] Serruys later became a sculptor in the manner of Aristide Maillol. Anna de Weert (1867–1950) was already noticed in 1898 when *L'Art Moderne* wrote, with implicit sexism, that "most of her canvases could pass as studies of the landscapist of Astène."[35] She later traveled extensively but still preferred what she called "the opaline light of our Flanders, that plays in the mists, that makes the skies and water iridescent, right up to the figures."[36]

The clichéd imagery of melancholy Belgian canals would be seized upon by artists of many nationalities, among them the young Mexican Diego Rivera, who painted nocturnal scenes of Bruges in 1909.[37] Among local artists, Albert Baertsoen's *Ghent at Night* (1903; Royal Museums of Belgian Fine Arts, Brussels), with its *l'heure bleue* vision of moored boats and reflections in the water, is typical of the genre. Baertsoen (1866–1922), a Ghent painter who later worked in Sargent's atelier in London during World War I, was reviled by Ensor for his insipid art: "Always probing and patient, he stirs the vases and fetid mud so dear to Ghent's smell, and stingily draws the academic arabesque of the canals in Maeterlinck's city, where academic ducks swim—crowned in palms. A melancholy vision of an overworked sewerman with typhus."[38]

Claus's influence extended even to his detractors—a radical group of younger artists who banded together in the nearby village of Laethem-Saint-Martin (outside of Ghent) in the early twentieth century. They formed a school of mystical Neo-Primitives that preached a higher reality than mere visual sensation, and Claus at nearby Astène became the brunt of their antagonism. The younger painters were particularly enthralled by the huge 1902 show of Flemish primitives at Bruges. Yet many of these upstarts, especially Valerius de Saedeleer (1867–1941), best known for his later Brueghelesque landscapes, went through an Impressionist phase. Saedeleer's *View of the Lys at Laethem-Saint-Martin* (or *The Cloud*: 1903; Museum J. Dhondt-Dhaenens) brings us full circle from the boating scenes of Van Strydonck and Claus, for now the boat in the foreground is empty and the cloud has become the protagonist. Saedeleer later spurned this loose, Impressionistic treatment and developed a more airless, old masterish finish in line with his return to Catholicism. Yet, this early work bespeaks a pantheistic presence that can also be noted in Mondrian's early paintings, such as *The Red Cloud* (1907–1909; Haags Gemeentemuseum, The Hague), where a cloud once again becomes the protagonist, this time of pure Fauve color.

Mondrian's coloristic effulgence, after his long and relatively dreary apprenticeship in The Hague School landscape painting, cannot be ascribed to Impressionism alone. In Amsterdam he was in contact with other Dutch painters, such as Leo Gestel (1881–1941) and Jan Sluyters (1881–1957), who had been to Paris and were practicing a mix of Neo-Impressionism and Fauvism they called Luminism. There is, too, in this period Mondrian's growing involvement with spiritualism; he joined the Netherlands Theosophical Society in 1909, which may have affected his all-embracing attitude towards nature. Yet no one who sees Mondrian's *Mill by Sunlight* (plate 344) can neglect the role that Impressionism has played in its conception. The startling yellow and blue Pointillist sky and broadly dabbed blades of red and yellow grass, not to mention the red and purple of the mill itself, are the legacy not only of Van Gogh, but of the whole group of Belgians and Dutchmen we have been discussing. Mondrian's windmill is a veritable portrait of the preindustrial workhorse, as phantasmic as Lemmen's factory and as phallic as Meunier's smokestack. It is also as strident a manifesto of Dutchness as Ensor's *Entry of Christ into Brussels* is of Flemishness. Mondrian took the calm, placid vision of Maris and Gabriel's windmills and made of them something monstrous and defiantly modern. He also pointed the way towards an increasing process of abstraction, which, like Van Gogh's blossoming at Arles, constitutes one of the central myths of modern art. Mondrian's mill seems to stand in front of the sun, blocking the light in a defiant way (just as his red cloud ostensibly has the sun behind it). This, then, is a new kind of retort to the sun worship that pervades Van Gogh's French work—a declaration that this intense kind of colorism can happen on Lowland soil. In the rough cross-hatching across the bottom part of the mill, we see an implicit gridding that leads inexorably to the plus-and-minus drawings of the 1910s as well as to the more radically abstract, De Stijl works that followed. Indeed, although it sounds farfetched to call Mondrian an Impressionist, his last great American work, *Broadway Boogie-Woogie* (1942–1943; The Museum of Modern Art, New York City), reminds us, in its primary-colored mosaic pattern, of the Neo-Impressionist fever that swept through Belgium and Holland.

# Nordic Luminism and The Scandinavian Recasting of Impressionism

*Alessandra Comini*

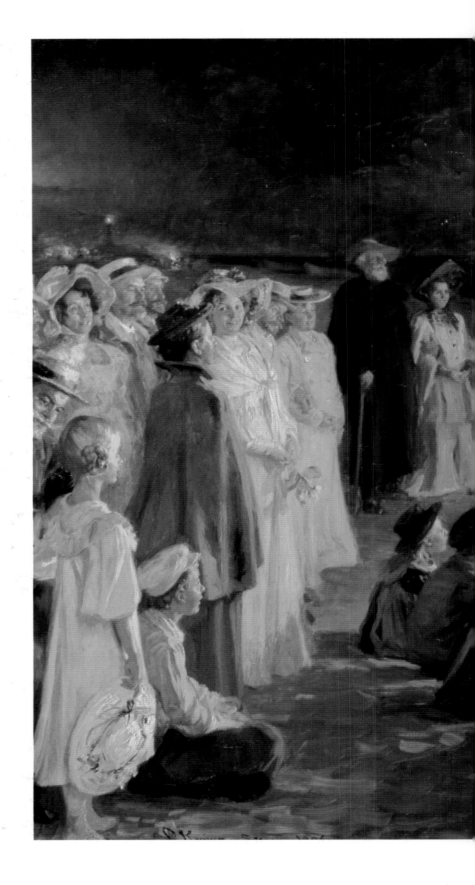

345. Peder Severin Krøyer. *Saint John's Bonfire on the Beach at the Skaw.* 1906. Oil on canvas, 59$\frac{1}{16}$ × 101$\frac{3}{16}$".
Skagens Museum/The Skaw Museum, Denmark

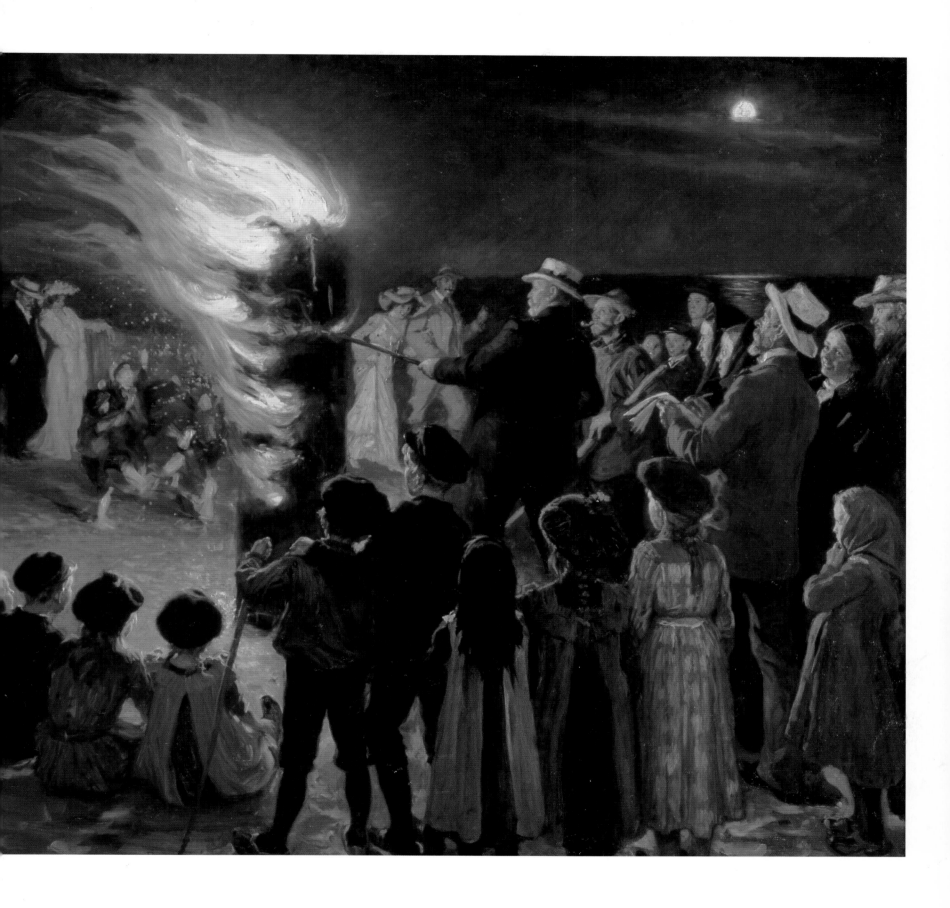

Is it possible to be an Impressionist in the shadow of the sixtieth parallel? Is it in fact desirable? These questions—in this order—were asked by the many artists from Denmark, Norway, Sweden, and Finland who in the late 1870s and early 1880s went to Paris to drink directly at the fountain of modern art.

In the year 1880 over thirty Scandinavian artists exhibited in the Paris Salon. But when they began returning to their home countries in the late 1880s and early 1890s, the plein-air Naturalist and Impressionist techniques these artists had mastered seemed inappropriate to the indigenous motifs and intense moods that, increasingly, constituted the subject matter of their canvases. The caressing, modulating, limpid blond light of the French countryside with its silvery mists was undeniably different from the sharp contrasts and dissonances of light in the rarefied, transparent air of northern latitudes.

Even the ultimate Impressionist, Claude Monet, seemed to have strained the limits of *tachisme* when, on a painting trip in Norway during the first four months of 1895, he tackled the pristinely etched vistas of icy fjords and snow-laden mountains. Compare Monet's broadly brushed, virtuosic, yet strangely inadequate rendering of Mount Kolsaas (plate 346) with Jens Ferdinand Willumsen's overwhelming portrayal of *Sun over Södern's Mountain* (plate 347) of seven years later. French Impressionism's propensity for dissolving form runs counter to the monumentality germane to this landscape, which is irradiated with such phenomenological insistence in the Scandinavian version—a version that seems to have solidified water, earth, and air into palpable registers and beams of frozen light.

Such crystallization of Impressionist optics is but one—and extreme—form of what in the context of a book on world Impressionism may be called Nordic Luminism. For a fascination with light, sparked by the open-air painting and perceptual investigations of the French, characterizes the work of all the Scandinavian painters who made the pilgrimage to Paris. Of the twenty-eight artists touched upon in this chapter, all but one (Gustav Fjaestad, who went instead to America) spent important parts of their formative years in France. The deliberate recasting of Impressionism that occurred in Scandinavia during the final two decades of the nineteenth century and the opening decade of the twentieth century has been labeled many things by critics desirous of seeing a Nordic progression from Naturalism to Symbolism that would parallel events in France. When combined with blue "mood" painting (*stemning* in Danish and Norwegian, *stämning* in Swedish) or expressly Nordic motifs, such modified Naturalism or incipient Symbolism has been termed "New," or "Mystical," or "National" Romanticism by Scandinavian scholars.

But there is ample justification for recognizing the lingering impact of Manet and Monet's Impressionist revolution, as borrowed from and transmitted by lesser lights on the French academic scene, in proposing the term "Nordic Luminism" for much of the art created in Scandinavia during the 1880s and 1890s. In spite of the fact that the Scandinavians in Paris tended to study with conservative Realists or Naturalists such as Jean-Léon Gérôme, Léon Bonnat, and Jules Bastien-Lepage rather than approach the avant-garde Impressionists (who taught only informally, if at all), it was the radical coloristic innovations of the latter that engaged their thoughts. "Impressionism confirms me and my beliefs,"[1] said the Norwegian painter Harriet Backer, who in 1878 began her ten-year study sojourn in the French capital after earlier extended training in Germany.

*The Impressionist* (*Impressionisten*) was the feisty (for Norway) name chosen by the indomitable Hans Jaeger, atheist-anarchist, free-love advocate of Christiana's (Oslo's) bohemian world, for a new review (nine issues were circulated between 1886 and 1890) that he edited from the prison cell where he was serving a sixty-day sentence for having published the "immoral" impressionistic novel *From the Christiania Bohème* (*Fra Kristiania-Bohemen*) of 1885. Along with leading Francophile critics such as Andreas Aubert, who rhapsodized over Monet's "*mélange optique*,"[2] Jaeger was determined to open skeptical Norwegian eyes to the emotional and subjective possibilities of what he saw in Impressionism's search for truth to nature. It was this sort of "radicalized Impressionism"[3]—combining French plein-air methods with Nordic emotion—that galvanized and at the same time differentiated Scandinavian Luminism from French Impressionism and Neo-Impressionism. So different in the long run was Nordic Luminism, in its intense association of perceived form with sensed, affective content, from the spontaneous, apparent neutrality of French Impressionism that it could, like Ibsen's psychological illuminism, be impatiently dismissed by the French with the catch phrase "*c'est de la Norderie*"—Sarah Bernhardt's dismissive explanation when asked as to why she had not yet played Ibsen.[4]

The young Scandinavian artists who came down from the raw North to inhale the refined city air of the French capital in the early 1880s would have agreed with the negative connotations of Bernhardt's "*Norderie*." They wished to escape the provincialism, limited cultural resources, and above all conservatism of their respective homelands (the combined population of which was under fourteen million, as compared to almost forty million souls in France).

The sense of purpose and joyous expectation animating those who arrived and set up studios in Paris are wonderfully captured in a compelling, life-size portrait by the Danish artist Bertha Wegmann (1847–1926) of the Swedish painter Jeanna Bauck (1840–1926), proudly signed and inscribed "Paris 1881" (plate 348). The artists had met while studying in Munich in the 1860s, where Wegmann worked for thirteen years eking out a meager living. When news of the Impressionist achievements finally penetrated Germany, Paris replaced Düsseldorf and Munich as the mecca for Scandinavian artists, and by 1880 both Wegmann and Bauck had settled in Paris. Wegmann shows the forty-one-

year-old artist seated on a bench in her atelier, her loaded palette and brushes laid to the side temporarily while she looks directly at the beholder, one finger keeping her place in the book she has just closed. The openness of her steady gaze and partial smile is engaging and invites further scrutiny. There is a deft contrast between the elegant black silk dress and the sunlight from the back window glancing off the young green ivy leaves, the book, and the palette and blazing through Bauck's frizzy blonde hair in a compositional tour de force. Wegmann called her portraits "situation pictures," and the quiet drama of professionalism and confident self-sufficiency in this portrait of a fellow artist certainly echoes Wegmann's own ambitious state of mind. In this same year Wegmann got up the courage to exhibit in the Paris Salon, where she received an honorable mention. The following year, 1882, she participated again, entering a portrait of her sister, and was awarded a gold medal—the first of many international honors she would garner through her long life. Although, like many of her generation, she did not adopt a full-fledged Impressionism, the brightening of her dark, German-derived palette and her attention to natural light effects were the direct results of studying plein-air techniques in an Impressionist-conscious Paris. She had worked with Bonnat, Gérôme, and Bastien-Lepage—those favorite academic choices of the Nordic artists—and even visited Manet, whose personality she admired more than his technique. For Wegmann and the other "first-wave" Scandinavian artists who came to Paris, the embracing of plein-air painting—*friluftsmaleri* in Danish—was its own reward, for it meant freedom from traditional academic constraint, emancipation from the murky tones of Realism, and a more vibrant immediacy.

Another member of the first generation to come to Paris was the genial Finn Albert Edelfelt (1854–1905). So successful was he in absorbing French finish and finesse in equal measure—he had studied history painting with Gérôme, the advocate of slick surfaces, and greatly admired Bastien-Lepage's propensity for rendering solidly palpable subjects projected against indistinct plein-air backgrounds—that it was not Bonnat's but rather his portrait of Louis Pasteur (plate 349) that the French government acquired from the Salon of 1886. Edelfelt's international reputation was established with this work, in which the sixty-three-year-old scientist is shown examining a piece of a dog's spinal cord by the light of a window in his laboratory. The drawing is tight and the brushwork precise; only in the farthest reaches of the room are objects slightly blurred by the sunlight that filters in through the curtained windows. That Edelfelt did not share the Impressionists' delight in optical aberrations can be seen from this complaint in a letter he wrote to his mother: "The portrait of Pasteur ought to be good, but the light is very poor since the laboratory is surrounded by big chestnut trees that throw the strangest green reflections on the face of my old man."[5] (A green face was out of the question for this Northerner!) Back in Finland in 1891, he continued to use the plein-air ap-

346. CLAUDE MONET. *Mount Kolsaas, Norway.* 1895. Oil on canvas, 25 × 39″. Private collection

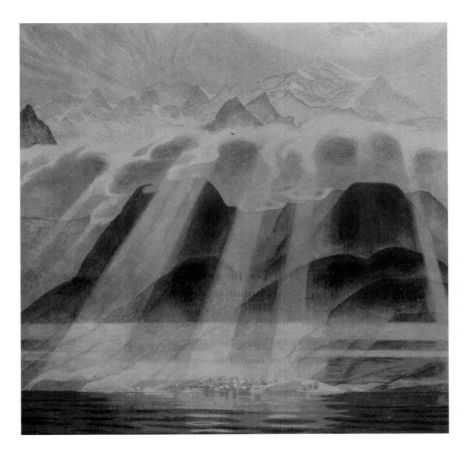

347. JENS FERDINAND WILLUMSEN. *Sun Over Södern's Mountain.* 1902. Oil on canvas, 82¼ × 81⅞″. Thielska Galleriet, Stockholm

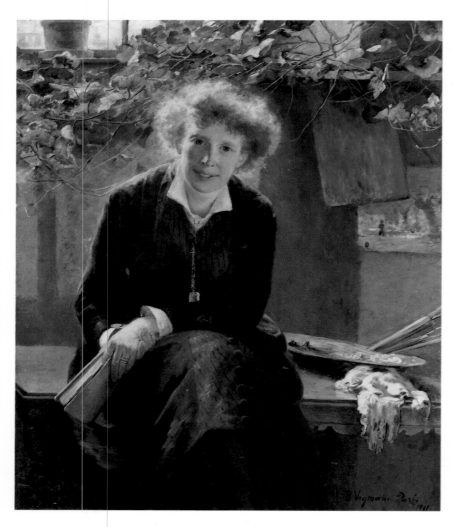

348. BERTHA WEGMANN. *Portrait of the Swedish Painter Jeanna Bauck*. 1881. Oil on canvas, 41¾ × 33½". Nationalmuseum, Stockholm

349. ALBERT EDELFELT. *Portrait of Louis Pasteur*. 1885. Oil on canvas, 62¼ × 51¼". Musée National du Chateau de Versailles

proach, but not Impressionist optics, to heighten the moods of his luminous depictions of Finnish lakes and forests. A friend of Sibelius's (who would compose the music for Edelfelt's funeral in 1905), the painter shared the musician's passion for giving artistic voice to Finnish national motifs and feeling.

The most cosmopolitan of the Scandinavian artists to have a successful Paris Salon career was the multifaceted Swede Anders Zorn (1860–1920), who was equally at home working in sculpture, watercolor, etching, and oils. In steady demand as a society portraitist, he visited America six times, held forth in London, traveled widely around Europe, and ran a fashionable studio in Paris from 1888 to 1896. His etched portrait of Rodin (plate 350) reveals, in its bravura rainstorm of strokes and bold, summary technique, a clear indebtedness to Impressionist light effects. We shall return to Zorn as an effective articulator of national identity through the medium of Luminism—Impressionism recast—in a separate discussion of the four Scandinavian countries as we follow the Nordic migration to and from Paris.

## Denmark and the Artists' Colony at Skagen

"You needle the Danes, I'll needle the Norwegians!" urged Ibsen after meeting the radical Danish-Jewish critic Georg Brandes (1842–1927) for the first time in 1871.[6] Both men shared the opinion that Scandinavia was culturally backwards, content to doze in the comfort of its isolation. As writers, both men would collide with and reshape contemporary thought. More far-reaching in influence and impact than Norway's gadfly Hans Jaeger, Brandes, through provocative books and university lectures, introduced European thought to Scandinavia and interpreted Northern literature and art for Southern admirers. In the summer of 1883 he made his way to the northernmost tip of Denmark, the Cape of Skagen—the Skaw (plate 351)—to visit the Norwegian artist Christian Krohg (1852–1925), who had met and portrayed him in Berlin. What Brandes saw and experienced at Skagen gave him hope for the future of Scandinavian art.

350. Anders Zorn. *Portrait of Auguste Rodin.* 1906. Etching, 8⅜ × 6⅛″. Nationalmuseum, Stockholm

351. Aerial view of the fishing village and artists' colony at the Cape of Skagen on the northern tip of Denmark.

Here at the top of Denmark, where two seas—the Skagerak on the west and the Kattegat on the east—continuously crash into each other, giving off a particularly intense and blinding light, was assembled a group of Danish, Norwegian, and Swedish artists who had trained in Paris, were familiar with Realist and Naturalist developments in art and in literature, and were plying their sophisticated tools of plein-airism in the construction of a singularly Nordic vision. Brandes was enchanted by the loneliness and magnificence of the flat Jutland scenery, the shimmering white coastline of the cape, the wild, tangled heaths, and the soft rows of dunes and sea grass. "The leading figures in Skagen are the air and the sea," he wrote. "A dissimilar and yet harmonious pair, which is changeable and at the same time a still image, reddens and at the same time darkens, becomes angry and storms."[7] Four artists began portraits of Brandes that summer,[8] and the stimulation and admiration were mutual.

The enchanted world of Skagen had already been discovered—appropriately—by Hans Christian Andersen, who, after visiting the cape in August of 1859, published this enthusiastic appeal to artists: "Are you a painter? Then make your way up here, for there are motifs enough for you, here is scenery for poetry; here in the Danish landscape you will find an aspect of nature which will give you a picture of Africa's desert, of the ash heaps of Pompeii and of sandbanks in the great ocean above which birds soar. Skagen is worthy of a visit."[9]

But it could also rain in Skagen. For days, weeks even. The return of the sun was a welcome occasion for celebration, and it was just such a merry artists' party, complete with champagne, that Peder Severin Krøyer (1851–1909) immortalized in what is one of Scandinavia's best-loved paintings, the *Hip, Hip, Hurrah!* of 1884–1888 (plate 352). Under a lush green arbor dappled by sunlight, eleven animated persons, including a little girl, are gathered around a long table spread with a white cloth and laden with champagne bottles and glasses. It is the moment of the toast, and the men rise to clink their glasses lustily while the women raise theirs from their seats. The colors and light-filled wandering shadows are those of French Impressionism, the illumination and brushwork, while not broken, is elegant, buoyant, and scintillating. How different from the carefully controlled soupçon of light in Edelfelt's *Louis Pasteur* or Wegmann's *Jeanna Bauck*—admittedly indoor—portraits.

Whence this seeming Impressionism? Who was Peder Severin Krøyer (he called and signed himself Søren Krøyer) and what was the impact of his presence in Skagen? The child of an unwed mother, he was born in a Norwegian fishing village but brought up in Copenhagen by his uncle, a prominent zoologist whose scientific texts the precocious Søren deftly illustrated at the age of ten. After studying—and winning a gold medal—at the Royal Academy of Art in Copenhagen he traveled to Germany, Austria, Switzerland, Holland, and Belgium, arriving in Paris in 1877. He worked in Bon-

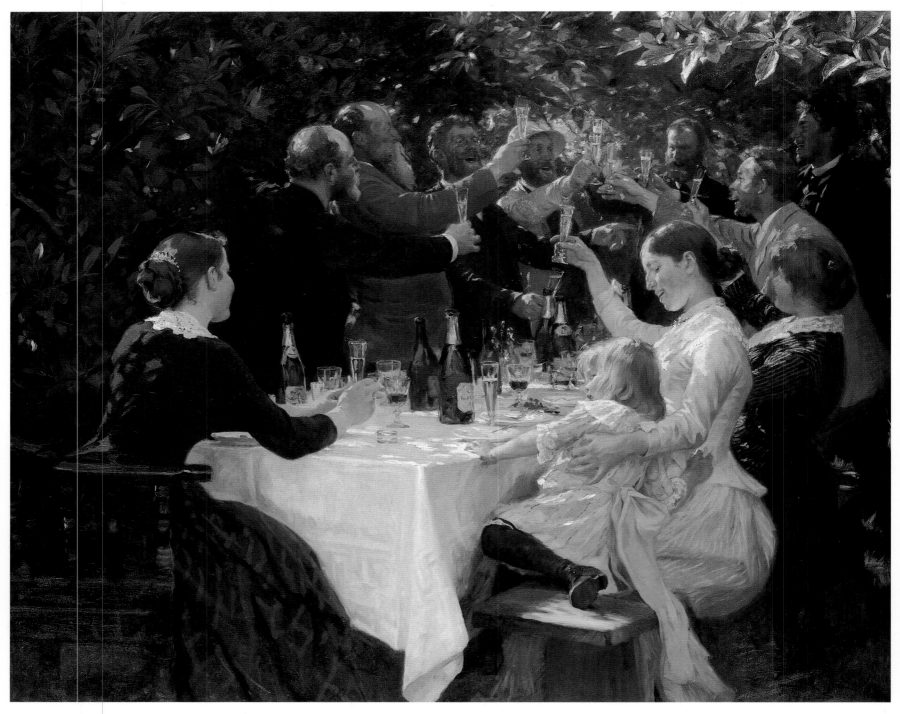

352. PEDER SEVERIN KRØYER. *Hip, Hip, Hurrah! Artists'
Party at Skagen.* 1884–1888. Oil on canvas, 52¹⁵⁄₁₆ × 65⅛".
Göteborgs Konstmuseum, Sweden

353. PEDER SEVERIN KRØYER. *Roses. Garden in Skagen.*
1883. Oil on canvas, 26¾ × 29¹⁵/₁₆″. Private collection

354. PEDER SEVERIN KRØYER. *Fishermen on the Skagen Beach.* 1883. Oil on canvas, 58 × 80⅛″. Statens Museum for Kunst, Copenhagen

nat's studio for two years. In 1879 he toured Italy, Spain, and France, and joined plein-air artists' colonies in Brittany and outside Barbizon. The earnest Realism of his earlier years became correspondingly less dogmatic and more receptive to Impressionist influences. His new loosened style and virtuoso compositions attracted the admiring interest of two eminent Danes, George Brandes, whom he first met in Paris, and the Copenhagen tobacco manufacturer and collector Heinrich Hirschsprung (like Brandes, of Jewish descent), who provided him financial support.

By chance, while visiting the World Exposition in Vienna in 1882, the peripatetic Krøyer met two Danish painters who lived and worked in Skagen, the husband-and-wife team of Michael and Anna (née Brøndum) Ancher. Krøyer mentioned that he had read about

Skagen and would like to go there, and an invitation was promptly issued. He arrived in July of that year for what would become almost annual sojourns for the next quarter century. On his first visit, he stayed in the Brøndum Hotel, owned by Anna Ancher's father, which was already a natural focus for musicians, artists, and writers (Hans Christian Andersen had lodged there in 1859): over the years its dining room was transformed into an "Artists' Room," hung with over eighty paintings, most of them profile portraits of the changing members of the Skagen colony. (Carefully matched in size and format, these portraits and their original paneled setting, based on something Krøyer had seen at Fontainebleau, can be seen today in a recreation of the Brøndum dining room at the Skagen Museum.)

*Hip, Hip, Hurrah!* was inspired by a festive artists'

355. PEDER SEVERIN KRØYER. *Summer Evening on the Skagen Beach: The Artist and His Wife.* 1899. Oil on canvas, 53⅛ × 73⅝″. The Hirschsprung Collection, Copenhagen

luncheon held in 1884 in the garden of a house on the Markvej that Michael and Anna Ancher had just bought. Krøyer based the complicated composition on an actual photograph taken during the party, but the execution took much longer than one summer to complete since, in the best plein-air tradition, the artist insisted on making his studies for the painting on the actual site and, in the best Skagen tradition, the sun was not always out. Krøyer became obsessed with the idea of capturing the sunlight's changing play on tree leaves, faces, and clothing. The gray-dappled tablecloth with and without bottles and glasses necessitated separate studies. During the four years it took to complete the work some of the participants were subtracted, other friends added, and the little girl (Anna and Michael Ancher's daughter

Helga) changed from a year-old baby in her mother's lap to the five-year-old bundle of energy at the lower right. Next to her is her mother, the painter Anna Ancher, with her distinctive broken-nose profile. Continuing counter-clockwise, we see the organist of the Skagen church, Helene Christensen, who was on intimate terms with Krøyer. Next to her, rising from his seat, is the Danish artist Thorwald Niss, then the tall Swedish painter Oscar Björck, and at the head of the table facing us, the proud host, Michael Ancher. To his right, in the canvas hat, is Michael's brother-in-law Degn Brøndum, then the euphoric Krøyer himself, with pince-nez, laughing and pointing a finger at Niss. Next to Krøyer is the bearded Norwegian Christian Krohg and finally the Danish painter Viggo Johansen. Anchoring the near end of the

table is his wife and Anna Ancher's cousin, Martha Møller Johansen. The exuberance of the toast is matched and perpetuated by the sonorous color chord that begins with the scarlet red of Helga's stocking, moves through her pink-and-white striped dress and pink sash, continues in the yellow tonalities of her mother's dress and the tablecloth, is picked up by the blues, creams, blacks, and olives of the men's suits, and comes to rest again in the rippling red plaid of Martha Johansen's blue skirt—all under a shimmering canopy of viridity that ranges from forest green to lemon yellow.

No wonder Krøyer was admired by his peers, and no wonder that their Skagen canvases began to partake of the same lighter "French" touch and illumination. The Skagen artists would also follow Krøyer's lead when he shifted his attention from daytime sunlight to the evening sea light. Two paintings by Krøyer, painted ten years apart, document what would be a fruitful oscillation between the two times of day for the artist. The later work, of 1893, *Roses. Garden in Skagen* (plate 353), is coloristically and stylistically related to *Hip, Hip, Hurrah!*, while the earlier canvas, *Fishermen on the Skagen Beach* (plate 354) of 1883, with its prevailing black, blue, and cream tonalities and twinkling points of light on the horizon, is an early instance of the Scandinavian response to a uniquely Nordic phenomenon—the so-called blue hour, formed in the atmosphere by the lingering twilight of the long midsummer evenings. Although not yet partaking of the lilac blue palette that would be so favored in the 1890s, Krøyer's canvas addresses the suspended sense of time and action common to the "blue painting" that would characterize that decade in Denmark. The reclining, exhausted fishermen lie immobile, like breakwater rocks, on the still-warm sand. As with *Roses* and *Hip, Hip, Hurrah!*, our eyes are guided into the picture's depth by a large mass posited at the front of a powerful diagonal sweep into space. The *stemning* is replete with suggestions of eternal repetitions, limitless horizons, unexpressed desires.

Pondering just such intangibles, Krøyer created one of the most memorable icons of Nordic Luminism—the *Summer Evening on the Skagen Beach* (plate 355) of 1899—ten years after his marriage to the young and strikingly beautiful artist Marie Triepcke (1867–1940), whose dark beauty had been portrayed by Bertha Wegmann in 1884. Sixteen years Søren's junior, Marie had briefly been his student at a small private school in Copenhagen while still a teenager, but she was not really noticed by him until a chance meeting in Paris in 1888, where she had gone to continue her studies. They married the following year, to the pretended jealousy of their mutual friend Georg Brandes, and traveled to Italy for their honeymoon before settling down to creating two homes, one a stately villa in Copenhagen, the other a summer "dream house" in Skagen. Marie worked with the architect Ulrich Plesner and made designs for the carved wood decor that graced both houses. In 1895 their daughter Vibeke was born, very much more the image of her red-haired father than her dark-haired mother.

*Summer Evening on the Skagen Beach* is thus not only an irresistibly romantic portrayal of a couple in nature but also a revelatory reflection on ten years of the artist's marriage.

All the ingredients for presenting human harmony are in this picture: a benign nature bathed by the late summer sun, privacy, leisure time, and intimate physical proximity. There is apparent like-mindedness concerning mode of dress—a hint of financial well-being is actually suggested by Søren's prominent gold watch fob—and even the faithful hunting dog Rap (*rap* is the Danish word for "quick") accompanies the elegant pair on their slow-paced walk along the smooth shoreline that is rhythmically lapped by gentle waves. The imagery projects the quintessence of oneness—union with nature, union with one another. Krøyer's picture is often paired as "happy" foil to Edvard Munch's later troubled seaside scenes of sexual distress, where even the moon acquires phalliclike distension in its watery reflection. Not so here. Or are things other than what they seem? This is the blue hour, the time of unrequited longing. Observe the two protagonists closely. They do not look at each other, but rather out towards the sea and distant boats, neither of which they really see. Their eyes are fixed on different inner visions. Søren's arm is linked lightly but insistently through Marie's; her arms hang leadenly, unresponsively at her sides. Søren's facial expression is tense, Marie's is remote, self-absorbed, and melancholy. A study and a posed photograph for the painting bear out this interpretation[10]—but more important evidence is the history of their life together. For Peder Severin Krøyer did not inform his young bride when they married that he had contracted a chronic venereal disease. From 1895 on, his manic-depressive attacks plagued their marriage. In the spring of 1900 the forty-nine-year-old artist was finally forced to have himself temporarily admitted to a mental hospital, where he was diagnosed as having dementia paralytica—a manifestation of the final and deadly stage of syphilis.

The dawning brutal realization of all this can be augured in the small but extraordinarily riveting *Double Portrait* of 1890 (plate 357) in which each artist portrayed the other. Their faces are side by side against a neutral background and almost on the same level. Both stare out frontally with serious, fixed expressions. Søren's tender portrayal of Marie, whose shoulder overlaps his, revels in the lovely symmetry of a face that so enchanted him. Marie's handling of Søren's physiognomy is slightly less assured but more objective: the broad nose, pointed ears, and even splotchy complexion of her husband are all rendered faithfully, and the intensity of his personality is convincingly registered. Possessively, only Søren's initials claim authorship of this partnered presentation. Twelve years after this hopeful bid on the part of Søren for permanence, Marie would ask for a divorce.

Krøyer may well have rejoiced in the depiction of what he considered to be a happy marriage of three decades when he painted the large portrait *Edvard Grieg*

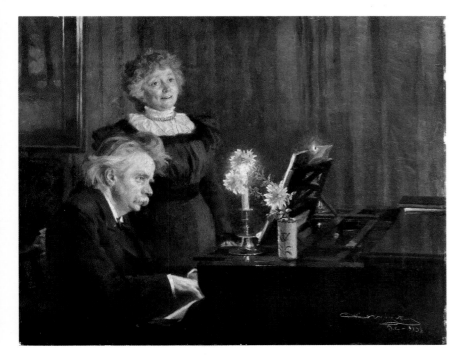

356. PEDER SEVERIN KRØYER. *Edvard Grieg Accompanying His Wife Nina Grieg.* 1898. Oil on canvas, 23 × 28¾″. Nationalmuseum, Stockholm

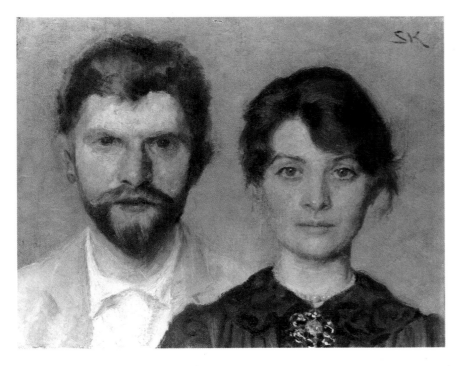

357. PEDER SEVERIN KRØYER AND MARIE TRIEPCKE KRØYER. *Double Portrait* (each artist has portrayed the other). 1898. Oil on canvas, 5⅞ × 7½″. Skagens Museum/The Skaw Museum, Denmark

*Accompanying His Wife, Nina Grieg* (plate 356) in 1898. Two candles, their flames partially shielded by yellow flowers and the open music volume, illuminate the intimate setting. The scene takes place not in Norway but in Krøyer's recently completed (1897) Copenhagen villa at Bergensgade 10. There, during their winter stays in Denmark, the Griegs were cherished guests at the many musical soirees held by Krøyer, who was himself an ardent musician. The great Norwegian composer sits at his host's Erard grand piano[11] and accompanies his wife, who although she no longer sang in public was still considered the best interpreter of his many songs. Bathing the room in glowing soft greens, Krøyer poignantly captures the characteristic attitudes of the performers—the fragile Edvard, the transported Nina— while the stepped progression from vase to flowers to candle gently leads us to the apex—Nina's head—of the composition. The crafted simplicity of Krøyer's conception complements the guileless sincerity of the musical moment.

If Krøyer could fine-tune his warm color harmonies to produce the intimate luminosity appropriate to candlelight interiors, he could also orchestrate the realm of daytime outdoor shade into pedal points of cool blue and white luminism. This he did in an appealing 1902 *Portrait of Holger Drachmann* (plate 360), the Danish poet (1846–1908), some of whose verses Grieg set to music in 1889. Drachmann was also a trained amateur painter whose passion for marine scenes brought him to Skagen as a frequent visitor (eventually he became a permanent dweller) as early as 1871. Wearing a blue jacket and cocked hat, with a fringed blue shawl thrown over his crossed knees, Skagen's prominent resident sits deep in thought on a rustic wooden settee under the shade of a tree in Krøyer's garden, a pencil poised above his notebook. Using his familiar compositional device to draw the eye into the picture, Krøyer places the elegant ballast of Drachmann's comfortably extended figure on the lower right, while bench and tree limbs pull diagonally towards a sun-flooded green opening between the trees in the left background. With great panache the artist whips up the canvas surface using little circular strokes of white, blue, green, and yellow. This is the closest he or any Scandinavian artist will come to the broken color application of French Impressionism, and the effect is opulent—fully up to the abundant self-esteem of Drachmann, whose sentimental verses and popular tales of the "sand region's" fisherfolk had made his name synonymous with Skagen.

In his younger years Drachmann had been part of the bohemian circle around Munch and Strindberg in Berlin. "He is a wonderful person," Grieg wrote of Drachmann in 1886 after taking a walking tour with him of the high mountains in Norway's Jotunheim district. "There is something of the troubadour or 'minnesinger' . . . about him and he stands out so comically against the sickly realism of our times, it seems to me."[12] Something of the suppressed rivalry Drachmann appears to have felt towards Krøyer, Skagen's other re-

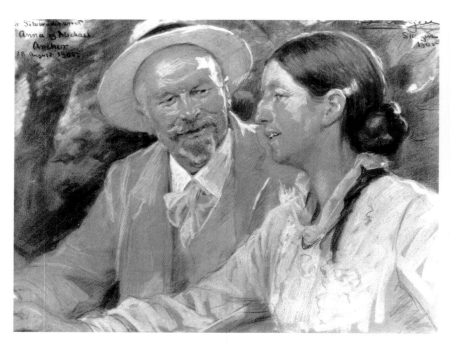

358. HOLGER DRACHMANN. *The Beach at Grenen.* 1907. Oil on canvas, 13 × 18⅞″. Skagens Museum/The Skaw Museum, Denmark

359. PEDER SEVERIN KRØYER. *Double Portrait of the Painters Michael and Anna Ancher.* 1905. Pastel, 21⅝ × 29½″. Collection Michael and Anna Ancher House, Skagen, Denmark

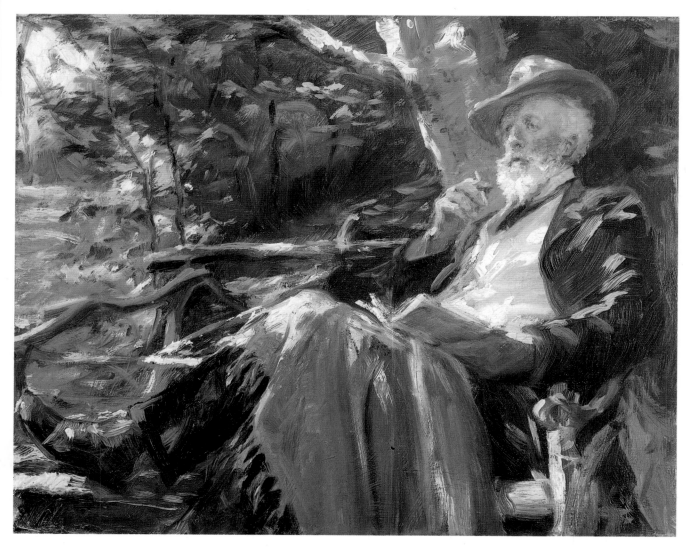

360. PEDER SEVERIN KRØYER. *Portrait of Holger Drachmann.* 1902. Oil on canvas, 12¾ × 18⅞″. The Hirschsprung Collection, Copenhagen

nowned depictor, comes out in the birthday verse he wrote for the artist in the year of Krøyer's portrait of him:

Here you sit, Søren, happy and content
With a smile in your eyes—and with one-and-
    fifty [years]
On your back.
To brood on life, to ponder and reason—
From where and how, when and whence
Was never your track.[13]

The following year the fifty-seven-year-old Drachmann married, as Krøyer had done, a very young wife and installed her in an old country house restored to his own design with a large painting studio at one end. Here he finished off pale blue, brown, and white seascapes of the Skagen area such as *The Beach at Grenen* (plate 358) of 1907, all of them rendered in a sketchy, vitalistic manner but without the punch of Krøyer and his professional colleagues.

Without doubt Drachmann's best depictions of Skagen were his literary tableaux, and it is of them we are invited to think when examining Krøyer's huge summation picture of 1906—three years before his death—*Saint John's Bonfire on the Beach at The Skaw* (plate 345). The ambitious work—there are over forty figures in it, most of them identifiable and derived from countless preparatory drawings, pastels, and oil studies—presents the high point of a Skagen summer, the annual June 24 celebration of the feast day of Saint John, with a dramatic bonfire (*St. Hans blus*) on the beach. Coming just two nights after the summer solstice, elements of pagan ritual are invoked, as in the effigy of a witch being set afire and supposedly seen flying away to the sky. In Krøyer's moon- and fire-lit nocturnal beach scene a circle of expectant children and adults watch as the venerable captain of Skagen's marine rescue brigade solemnly ignites the spooky effigy. On the far right, holding his sketchbook aloft, the Danish painter Laurits Tuxen (who had studied alongside Krøyer under Bonnat) draws the scene while his wife, Frederikke, looks on; to the far left, wrapped against the cool night air in a blue cloak, stands another painter, Anna Ancher, with Michael Ancher behind her, and watching the scene with approval in the center left is the black-cloaked Holger Drachmann with his young wife, Soffy, at his side. Krøyer's blazing brush skips across the canvas, adding flickering highlights to the faces, clothes, and sand. Drachmann's *Sante Hans* lines flare up: ". . . on the beach we will light the fire on the grave mounds of our forefathers. Each town has its witch, and each county its trolls. These we will keep away from us with a fire of happiness."[14]

Krøyer's nocturnal masterpiece not only celebrates Saint John's bonfire, it also commemorates the milestones of his private life with an almost masochistic insistence. His eleven-year-old daughter, Vibeke, is shown watching the spectacle to the extreme left, dressed in a white summer frock, her hair in circular braids over her ears. Directly in the diagonal line of her gaze, however, to the right of the Drachmann pair, leaning against a boat, stands the mother who in 1904 had abandoned her and Krøyer for another man. As if to rub salt into the wound, Krøyer even paints in his rival, the Swedish violinist and composer Hugo Alfvén (1872–1960), who stands next to Marie, his hands thrust in his pockets. Remote from the other onlookers, they gaze downwards morosely, neither of them really watching the festivities,[15] and set up an ironic contrast to the animated couple hurrying past the other side of the bonfire. All the requisites for an Ibsen or Strindberg psychological drama lurk in this theatrical ensemble; by 1906, Marie had given birth to a second daughter, by Hugo, and was living with him as his common-law wife.[16] Munch's posterlike *Dance of Life*, painted six years earlier, was not, in the final analysis, to be the only Scandinavian statement on the sexual imperative. The hidden drama of Krøyer's midsummer's night, however, has eluded modern audiences partly because of a lack of familiarity with the artist's biography but also because of the—by 1906—old-fashioned plein-air style.

Krøyer seems to have taken comfort in depicting couples who, like the Griegs, seemed to enjoy intact marriages, and his 1905 silver wedding gift to Anna and Michael Ancher took the form of a handsome pastel double portrait of the two artists (plate 359). Illuminated by sun-filtered beige and blond tonalities, the couple is shown outdoors under garden trees. Michael glances affectionately at Anna, who seems to concentrate on an off-scene work in progress, her hand raised to easel height.

Of all the Skagen painters, Anna Brøndum Ancher (1859–1935) was the most constantly praised for her subtlety in using the colors of the spectrum. She was also the only native-born of the "Skagen" painters. Her birth, local lore records with pride, was precipitated by the excitement caused at Hans Christian Andersen's arrival at the Brøndom Hotel. She grew up observing the summer painters who stayed at her father's hotel and, showing talent herself, she was allowed to study drawing for four years in the winters of 1875 to 1878 at Vilhelm Kyhn's school for women artists in Copenhagen. But she learned more about color from observing the paintings laid out to dry on the sand dunes and in the grass around her father's hotel by the summer guests, including, from 1874, Michael Ancher, and from 1879, Christian Krohg. In 1880, to no one's surprise, the twenty-one-year-old Anna married the abundantly talented Michael, ten years her senior. It was Krøyer who first took Anna Ancher's painting gifts seriously, and he was followed by Georg Brandes who, in return for one of her works, gave her the manuscript for his 1877 book on Kierkegaard. In the winter of 1888–1889 she visited Paris with Michael and again studied drawing—her weak suit—for six months at the school of Puvis de Chavannes, an artist whose unprecedented simplification of the pictorial surface, color, and composition would impress many Scandinavian painters. Nevertheless it was her exposure to the atomization of light and color practiced by the Impres-

sionists that took root in her own art. Possessed by what she professed to see "only as color,"[17] she began to paint small interior scenes, punctuated by windows or reflections from windows, in which the two worlds of outdoors and indoors were addressed through their exchange of light.

An example of this type of luminism is Anna Ancher's *Sunshine in the Blue Room* (plate 361) of 1891. Ancher's eight-year-old daughter, Helga, whom we met in *Hip, Hip, Hurrah!*, sits knitting in her grandmother's Blue Room at the Brøndum Hotel. But she is not the subject of the painting—her back is to us. She, like the reflecting glass on the framed pictures above her, is a carrier for colored light. The sunlight from the tall window on the far right rakes across her blue apron and yellow mop of hair to fall on the striped carpet below, and daylight from the second window glides in to fall in lambent squares on the adjacent wall, resonating in its blued whiteness with the light orange curtains, pinkish red tablecloth, and purple dress of Helga. In true Impressionist fashion, Ancher has not mixed her colors on the palette but applied them directly, stroke next to stroke, onto the canvas. The artist's 1903 portrait of Michael Ancher and his eager hunting dog, *Breakfast Before the Hunt* (plate 362), might correspondingly be called "Sunshine in the Orange Room," so saturated with orange and yellow tonalities (and their complementary hues) are the objects in the light-flooded room—the south and sunniest room in the Ancher house.[18] Like Michael's breakfast, Anna Ancher's color is so full and juicy that, as in Oscar Björck's admiring characterization, one could enjoy it "like a ripe fruit."[19]

While Anna Ancher was becoming the Vermeer of Skagen with her refulgent indoor translations of Impressionism, her husband, Michael Ancher (1849–1927), led the way in discovering and zealously recording the picturesqueness of Skagen villagers at their work outdoors. Born and raised on the island of Bornholm, he had studied at the Copenhagen Academy from 1871 to 1875, but was mostly self-taught, following the examples of his heroes in art, Raphael, Velázquez, Frans Hals, and Rembrandt. His initial "heroic" Realist style was used to convey the arduous life of the fisherfolk, but in the 1890s, following Krøyer's example, he began to incorporate mood and light effects into his pictures and expanded his subject matter to include scenes of domesticity and leisure. His delicate *Promenade on Skagen Beach* (plate 363) of 1896, set out with broad, luminous tones, is a beautiful example of this new interest in Luminism. The great diagonal expanse of white Skagen sand, raked by yellow and lavender shadows in the paling sunlight, is equated with the long rectangle of the canvas. On this magic Northern carpet promenade five young women— the dark-haired daughters of the local judge, and a blonde guest. The youngest sister walks alone in front, pensively clasping her arms behind her and gazing at her violet shadow; the guest, unused to the ocean chill, muffles her arms and neck in her yellow striped shawl and converses with one of her hostesses, who is dressed in a

(opposite) 361. ANNA ANCHER. *Sunshine in the Blue Room.* 1891. Oil on canvas, 25⅝ × 23¼″. Skagens Museum/The Skaw Museum, Denmark

(right) 362. ANNA ANCHER. *Breakfast Before the Hunt.* 1903. Oil on canvas, 19⅛ × 22½″. Skagens Museum/The Skaw Museum, Denmark

(below) 363. MICHAEL ANCHER. *Promenade on Skagen Beach.* 1896. Oil on canvas, 27³/₁₆ × 63⅜″. Skagens Museum/ The Skaw Museum, Denmark

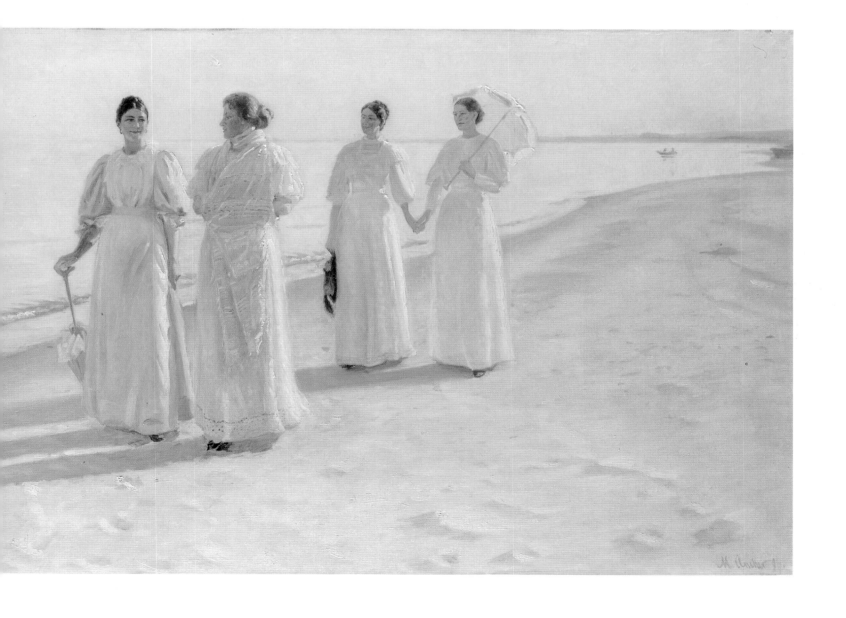

light pink dress, while two other sisters, dressed in white, join hands and bring up the rear. That is all, the rest is *stemning*. With such a tour de force to his credit it is surprising to learn that Michael Ancher suffered from bouts of self-doubt and had to conquer his envy of Krøyer's greater technical élan. He could have rested easy. The appeal of a picture such as this is unending and eloquently parallels Drachmann's verse reduction of Skagen to "sea and beach, first and last."[20]

## Norway and the Cult of the North

If Denmark has its Skagen—a flat, barren opposite pole to Paris—Norway has its stave churches, fjords, and high mountains. But in the first eager exodus of young Norwegian artists to avail themselves of European culture "down below," the country's native magnificence and indigenous charms were ignored. Some of the artists who trained in Paris were never moved to feature specifically Norwegian motifs; others, plying the same Impressionist-conscious techniques, applied themselves to isolating and exalting them. The differing examples of two of Norway's most incisive talents are cases in point: Asta Nørregaard (1853–1933) and Harriet Backer (1845–1932). They partook of the same artistic training in Norway and abroad, but their painterly goals became increasingly disparate. Their backgrounds are perhaps partially accountable: Nørregaard's parents (members of the civil service) died when she was quite young, and she had to fend off poverty—a lesson that inclined her toward middle-of-the-roadism in art and inspired her to use her formidable photographic portrait ability to penetrate high society; Backer was the second of four daughters born to a wealthy shipping magnate who gave his children every educational advantage (the third daughter, Agathe, was to become one of Norway's leading pianists and Grieg's favorite interpreter of his piano concerto), hence Backer possessed the self-confidence and the means to brave unpopular avant-garde trends. Both studied at Knut Bergslien's painting academy in Christiania in the mid-1870s, and both were in Munich by 1875, where they moved in Ibsen's circle. Being women they were not allowed to study at the academy but visited and copied in the galleries and found an encouraging teacher in their young fellow Norwegian Eilif Peterssen. By 1879 they had both separately relocated to Paris and at the somewhat erratic school of Madame Trélot de Lavignes and elsewhere studied with the mandatory triumvirate of Gérôme, Bonnat, and Bastien-Lepage. Nørregaard remained in Paris for six years, until 1885, and Backer for ten, returning permanently to Norway in 1889. The final divergence of their interests is confirmed when we consider that the former concluded her career by painting the portrait of Norway's King Hakon VII, while the latter devoted herself to church interiors and still lifes.

Two works by Nørregaard reveal her promise and her flowering to greatest advantage. The 1883 *Self-Portrait in Her Paris Studio* (plate 364) with the artist's name and location clearly printed on the lower right, is an intriguing compendium of credentials. Dressed for work, her colors laid out in conventional fashion on a large palette, the artist stands facing her latest and largest commissioned work—an altarpiece—in a modest but well-equipped studio. While a nascent Impressionism peeks in at the window, all else bespeaks the old masters and an academic training. On the wall behind the artist, couched in blues, whites, and reds, is an example of what she could copy for a potential customer from the Louvre's storehouse of masterpieces, in this instance Titian's *Madonna and Child with Saint Catherine and a Rabbit* of c.1530. (It is amusing to note that our Norwegian has instinctively made Titian's mountains a little higher.) In a dazzling feat of foreshortening and raking light, the artist's altarpiece for a church in the Norwegian town of Gjovik is reproduced in its entirety, while the repoussoir agent of open paintbox with upturned mirror reflecting the tree leaves outside attests to her considerable abilities in still life painting. And finally, behind the artist in the back right-hand corner, an invitation to portraiture is concretely symbolized by the elegant armchair and textured back cloth. This visual letter of recommendation combines the best of tradition with a hint of avant-garde dissolving of form. Which way will the artist go?

The answer is provided in Nørregaard's stunning life-size pastel *Portrait of Elisabeth Fearnley* (plate 365) of 1892. Nothing is dissolved here; the subject is firmly drawn and treated for itself, not for its tones. Bonnat and his masterful example of texture and costume have carried the day. And yet there are subtle nods to modernist nuances—the Whistlerian device of the oriental screen, for example, and the audacious pairing of pinks with lavenders, in the bulging vase of wisteria and in the polar bear's open muzzle, on either side of the sheer black chiffon dress of the sitter. Nørregaard's elegant portrait style remained, by choice, poised on the brink of modernism but anchored in the honorable, uncontroversial past. One of Norway's great portraitists, she declined participation in the Nordic recapitulation of Impressionism yet benefited from the new horizons of light and coloristic verve that were the legacy of that movement.

Nine years earlier in Paris, Harriet Backer had created another interior, this one titled simply *Blue Interior* (plate 366). Asta Nørregaard is the obliging model who sits at her sewing, her back to the fireplace, and facing a heavily curtained window that is cut off from view. The blue velvet draperies are opened enough to allow the winter sunlight a color-igniting access to the room and a gemlike brightness radiates from the flourishing green plant at the window, the upholstered blue chair seats, curtain, and rug, and the red orange desk against the wall. These colors are picked up and reflected in the red blooms of the plant on the mantelpiece and its mirror image, the green ottoman on the floor, and the limpid blue of the framed (Norwegian?) marine view on the wall over the desk. Backer had just seen a large Monet exhibition, the luminosity of which had greatly affected

(left) 364. Asta Nørregaard. *Self-Portrait in Her Paris Studio*. 1883. Oil on canvas, 25⅜ × 18⅞″. Private collection.

(above) 365. Asta Nørregaard. *Portrait of Elisabeth Fearnley*. 1892. Pastel, 78¾ × 45¼″. From the collection of Thomas N. Fearnley

her as she reported to Eilif Peterssen: "They are impressionistic landscapes and still lives. I really think that Monet is the master within the style of such light and distance and decorative effect. . . . From there I went directly to Luxembourg, and there was no color in a single canvas afterwards."[21] Backer's response was the atmospheric *Blue Interior*. This reworking of Impressionism with its extended chromatic palette to suit her own sensibilities began what would be a lifelong engagement with something she called plein-air interiors, in which light would create forms. Andreas Aubert reviewed *Blue Interior* with enthusiasm in *Aftenposten* as a fine and fresh painting "where each atom is color."[22] In

366. Harriet Backer. *Blue Interior.* 1883. Oil on canvas,
33 1/16 × 26″. Nasjonalgalleriet, Oslo

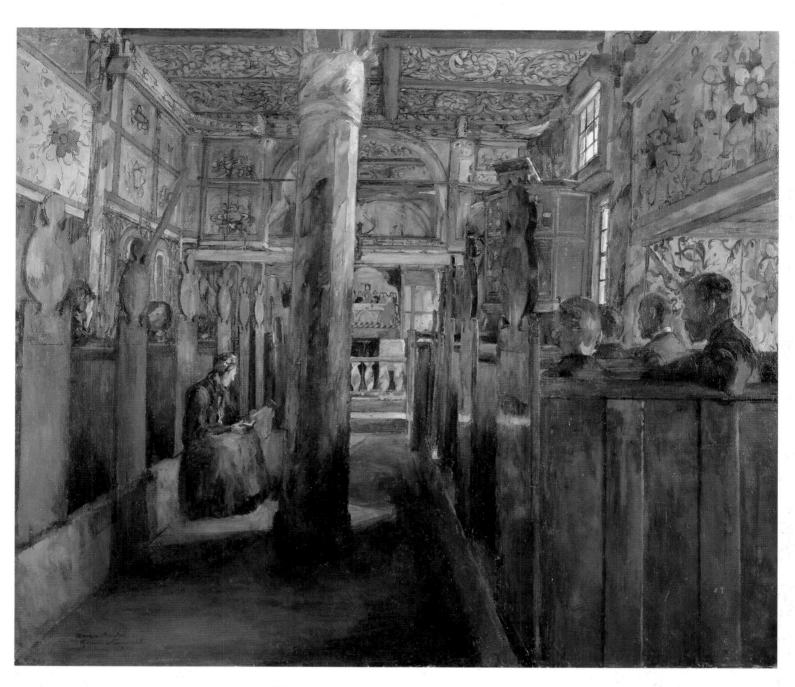

367. Harriet Backer. *Uvdal Stave Church.* 1909. Oil on canvas, 45⅛ × 53⅛″. Rasmus Meyers Collection, Bergen, Norway

368. Eilif Peterssen. *Bas Meudon Landscape.* 1884. Oil on
canvas, 15⅛ × 18¼″. Nationalmuseum, Stockholm

369. Kitty Kielland. *Summer Night.* 1886. Oil on canvas,
39½ × 53⅜″. Nasjonalgalleriet, Oslo

370. FRITS THAULOW. *The Lysaker River in Summer*. 1887.
Oil on canvas, 27⅜ × 23½″. Amell's Fine Art, Stockholm

with chair legs. As soon as I enter a place where there are blue and red colors on farm furniture, or on glossy painted walls where the light throws in a reflection from trees and sky outside through window or open door, then I soon stand before a canvas . . . and say to myself: 'There you go again.'"[24] The loving attention Backer gave each "color fleck" (her term) shows that she had taken to heart her teacher Bastien-Lepage's admonition to handle every object like a portrait. Considering that Backer was sixty-four years old when she completed the Udval church interior, and that she had for several years braved the fall chill to get the "best" light, her dedication to plein-air Luminism for the celebration of national character is remarkable.

It was not that the Norwegian Paris-trained artists were technically incapable of painting French Impressionist–type scenes. Nørregaard's and Backer's colleague Eilif Peterssen (1852–1928) had executed sparkling, sophisticated countryside vistas that could certainly pass for "French" products: see his sun- and shadow-bathed *Bas Meudon Landscape* (plate 368) of 1884, for instance. But what appealed increasingly to Peterssen and his like-minded colleagues far more than cultivated French picturesqueness under a midday sun was the solemn quality of their homeland's own natural scenery, where the long summer twilight was perceived as something unique, something essentially Nordic.

The idea of going back to original sources was pervasive in Norwegian thinking at this time. Grieg invoked frequently the beautiful features of Norwegian nature: "The blue inland seas, the waterfalls, the sky, the mountains and woods in all their pristine beauty,"[25] and Ibsen would say: "Anyone who wishes to understand me fully must know Norway. The spectacular but severe landscape . . . the lonely, shut-off life . . . so that [people] become reflective and serious, they brood and doubt and often despair."[26] And Grieg again, thinking of the cultural isolation and poverty of his country: "Yes, Norway! Norway! . . . Good Lord, anybody can be rich and practical; but not everyone can be *serious* and *introspective!*"[27]

Those very qualities of seriousness and introspection are what rose to the surface when in the summer of 1886 a group of five Norwegian artists, fresh from their studies on the Continent, responded to the invitation of fellow-artist Christian Skredsvig to join him on his wife's farm, Fleskum, by Lake Daelivannet in Baerum, an area on the Christiania Fjord near Christiania. Backer, Eilif Peterssen, Kitty Kielland, Eric Werenskiold, and Gerhard Munthe formed that summer what could be called Norway's answer to the Skagen colony (although it lasted only a few years). Nina and Edvard Grieg were occasional visitors. Like the composer, these painters had absorbed what Munich, Rome, and Paris had to offer and were now ready to translate their cosmopolitan techniques into the native dialect.

Kitty Kielland (1843–1914), in large canvases such as *Summer Night* (plate 369), concentrated on communicating mood. Choosing the edge of a secluded lake undisturbed by bathers or boaters and waiting for her

her autobiography Backer's own evaluation of her Paris encounter with Impressionism and its morphosed presence in her works was as follows: "Only through Impressionism can the color motifs of my paintings be found. Only through strict and disciplined work, each fleck of paint in its right place. The flecks of color should stand in an immovable constellation, like the stars in the sky, shining to each other."[23]

Like her Danish counterpart Anna Ancher, Harriet Backer would be judged as one of her nation's greatest colorists. She would also respond to her country's keenness for a national identity, a Nordic essence in art. It was the critic Aubert who directed Backer's painterly attention to the country church at Udval (plate 367), typically Norwegian in its richly decorated blue, white, red, and green interior. Each pew has its carved green end post, every inch of wall and flat ceiling is subdivided into red-framed panels for *rosemaling*—a traditional embellishment of roseate design. Another painter in search of "Norseness" might have done the quaint stave exterior, but Backer was irresistibly drawn to the challenge of her "interior plein-air" mission. Of this drive she had written: "It is no good that I have sworn not to paint more interiors, torture myself with lines of perspective, labor

371. ODA KROHG. *A Subscriber to the "Aftenposten."* 1887. Oil on canvas, 18½ × 21⅝". Private collection

372. ERIK WERENSKIOLD. *Portrait of Henrik Ibsen.* 1895. Oil on canvas (grisaille), 47⅞ × 28⅛". Nasjonalgalleriet, Oslo

motif to be lit by evening rather than morning light, she worked at giving deep sonority to her tonalities, at muting the effects of light, and at enhancing the stillness and silence of her subject. Although still utilizing the French mandate of responding to sense impressions, she harnessed the abundance of color and detail in her pictures—and corresponding brush strokes—to a profounder and broader rendering of organic form. The atmospheric unity, ranging from pale lavender and pink to greeny black, along with its evocative mood, became the goal. It was during the long hours of the Northern twilight that nature's forms—no longer subdivided into a thousand dissimilar and distracting manifestations under the sun's magnifying glass—seemed to return to their quintessential oneness.

Having found her "justification" (her term) as a painter—Luminism in the expression of an introspective Nordic identity—Kielland dedicated herself to depicting the calm Jaeren plain south of her native Stavanger on the southwestern coast of Norway. By the time of the 1889 Exposition Universelle in Paris, where she won a silver medal for a plein-air Jaeren landscape, which was bought by the French government, she could write in triumph that Norwegian art had at last produced something that could stand up to the great competition from Europe.[28] It is noteworthy that both Kielland and Backer, who for years shared lodgings[29] if not motifs in France and Norway, both practiced a methodical and even stubborn plein-air site painting, the one on the Jaeren plain, the other in the interiors of Norwegian churches. Like their friend Grieg, whose music *means* Norway in the popular mind, Kielland's and Backer's images also served to canonize Norwegian essence as something "serious and introspective."

Whereas lakes were Kielland's forte, rushing rivers were the domain of Frits Thaulow (1847–1906). His pastel view of *The Lysaker River in Summer* (plate 370) of 1887 is an admirable example of this Norwegian's ability to mix (he had first trained as a pharmacist, his father's profession[30]) the Realism he had learned studying marine painting at the academies in Copenhagen and Karlsruhe with the chromatic innovations and on-site open-air observations of Impressionism. But unlike Kielland, Backer, and Peterssen, there was no nationalistic program in his approach to motif, and although during his extended returns to Norway in the 1880s he participated prominently in organizing artists' activities, he did not feel a compulsion to have each and every Norwegian scene he recorded enshrine Norwegianism. (Even Grieg lost patience with his *Peer Gynt* composing, writing about the Hall of the Old Man of the Dovre section: "I literally can't bear to listen to it, it is so full of cow-turds, Norse-Norsehood, and Be-to-thyself-enoughness!"[31]) A personal friend of Monet's, it was Thaulow who persuaded the French Impressionist to undertake the painting of snow scenes with him during the winter of 1895, and by that time the Norwegian, who had taken up permanent residence in France, could complain about the Norwegian air, which was "so trans-

parent that one could count the needles on the fir trees."[32] Thaulow's eyes were first opened to Impressionism at the Salon of 1879 and by contact with Gauguin, his brother-in-law, who was working in an Impressionist style when Thaulow saw him in Paris. He had visited Skagen with Holger Drachmann (with whom he shared a studio in Copenhagen) in 1872, and he returned there with his fellow Norwegian Christian Krohg in the summer of 1879, fascinated by the unique light of the strand. His adoption of open-air painting at that time made him one of Norway's first artists to bring the technique home (he also guided and defended his precocious young cousin Edvard Munch), and he was instrumental in preparing the Norwegian public for painterly chromaticism. Nevertheless, despite genuine fondness for his native land, Thaulow was one artist who concluded that one could simply not be an Impressionist in the shadow of the sixtieth parallel, and rather than change his style he changed his country.

Another Norwegian artist who drank enthusiastically of the Impressionist elixir with bracing results was Oda Krohg (née Lasson; 1860–1935). Famous in Christiania as the "madonna-prostitute-muse" of the bohemian circle around Hans Jaeger—she was part of his shared love-triangle experiment with Christian Krohg (an experiment that failed when Oda decided to marry Christian in 1888)—and refugee from an early marriage that had produced two children, she began studying with Krohg in 1884 and made her debut two years later with two paintings in the Norwegian autumn salon. Her close-focus, boldly conceived picture of 1887, *A Subscriber to the "Aftenposten"* (plate 371), shows why Krohg took her seriously. Using a lively, streaking application of white and blue, with highlighting strokes of pink and yellow, the painter instantly conveys the humor and homeyness of the scene: a little blonde "subscriber" of three or four appreciates *The Evening News* in her own way, cutting right through the inviting front page with a large pair of scissors. As she crops so does the artist, in the best Degas fashion. (This *before* she lived with Christian Krohg for an extended period—c.1895 to 1907—in Paris.) As impulsive and restless an artist as she was a person, Oda Krohg worked in several different ways simultaneously: a Romantic-Symbolist manner, a somewhat stark portraiture style, and the intuitive Impressionism represented here.

One of the six Norwegian artists who had taken part in the pivotal Fleskum summer of 1886, Erik Werenskiold (1855–1938) had assimilated modern French painting techniques during two prolonged study sojourns in Paris, beginning in 1881 for two years and returning in 1888 to work with Bonnat. He admired the Impressionists, even writing an article about them in 1882, and he also followed developments at Pont Aven with interest. It was Norway's "other" great writer, Bjørnstjerne Bjørnson, who urged him to return to Norway to create a national art (the mere mention of Bjørnson's name, according to Georg Brandes, was like hoisting the Norwegian national flag). Werenskiold was

373. EDVARD MUNCH. *Flowering Meadow at Veierland.* 1887. Oil on paper, 26³/₁₆ × 17⁵/₁₆″. Nasjonalgalleriet, Oslo

not hard to persuade: "Love of nature must of necessity lead artists back to their own land," he stated.[33] Not only was Werenskiold at home painting the particular and impressive landscapes of his homeland in a muted vibrato style derived from his observations of Impressionism, as well as providing illustrations for Norwegian fairy tales, he also applied himself as an able portraitist, commemorating the human landmarks of Norwegian culture. His large grisaille (intended as a study for an oil, never undertaken) portrait of Ibsen (plate 372) unabashedly equates the majesty of Ibsen's mighty forehead with a Norwegian mountain peak, in homage to the nation's double treasure of playwright and nature. One of six portraits done in 1895 by Werenskiold of the great dramatist's "terrain of the face" (Ibsen's phrase, approvingly noted by the artist), it owes its riveting characterization to Ibsen's indefatigability as a model who could stand "still as a pillar . . . happily for a couple of hours on end, he was so strong," Werenskiold explained.[34]

How different is this adamantine "pillar," who had achieved international renown for pillorying the foibles and hypocracies of Norwegian society, from the young dreamer with soft, smooth cheeks and bulging Adam's apple in Asta Nørregaard's large 1885 pastel portrait of the twenty-two-year-old Edvard Munch (Munch Museet, Oslo).[35] Munch's exposure to—and ultimate rejection of—Impressionism was formed during three study trips to Paris on state scholarships, the first in 1885—the year of Nørregaard's portrait of him—the second in 1889, when he enrolled briefly in Bonnat's studio, and the third in 1891. Christian Krohg, reviewing the young artist's work in 1889, labeled Munch "an impressionist" and "our only one so far."[36] This was in regard to vibrantly brushed landscapes such as *Flowering Meadow in Veierland* (plate 373) of 1887. However, the compliment Krohg intended addressed not the style in which Munch's views of nature were couched but rather the sensed *emotion*—as opposed to the quiet *stemning* of the Fleskum painters—emanating from the canvas. It was this sort of, to Krohg at least, emotionally charged, "subjective impressionism"[37] that differentiated Munch, as the leading member of the "third" and coming generation, from Krohg and his mood-evoking colleagues. Sadly Krohg concluded: "We, this generation of Norwegian painters to which I belong, we are not impressionists—so much the worse for us. We can only stand atop the mountain [ubiquitous Norwegian metaphor!] and look into the promised land."[38] Henceforth mood was not to be supplied by nature but by the artist, and nature would lie in the mood of the artist.[39] And henceforth Edvard Munch would no longer employ Impressionism, turning instead to the Symbolist-Expressionist language of his great image-making decade, the 1890s.

After building his dream house *Troldhaugen* ("troll hill") outside Bergen in 1885, Grieg became convinced that there were good trolls and evil trolls.[40] If we compare Theodor Kittelsen's (1857–1914) scary but benign country troll (plate 374) who wanders down Chris-

374. THEODOR KITTELSEN. *Troll in the Karl Johan Street.* 1893. Drawing (dimensions unknown). Private collection

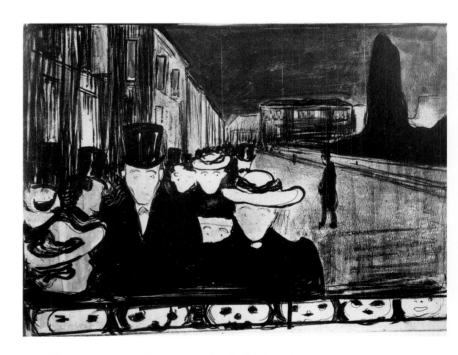

375. EDVARD MUNCH. *Evening on the Karl Johan Street.* 1896. Lithograph, 21¹/₁₆ × 27".

376. GERHARD MUNTHE. *Antechamber in the Artist's Home.* 1902. Watercolor, 13⅝ × 16⅝". Nasjonalgalleriet, Oslo

tiania's main thoroughfare, the Karl Johan Street, flustering everyone (except the unflappable Ibsen on the far lower right) with the spectral march of all those "trolls" who constitute the "other" in Munch's (plate 375) plunging view of the same street, we can understand that Munch was not only no longer an Impressionist but that he was also no longer a specifically and self-consciously Norwegian artist. His personal experience of alienation can stand as a universal expression of emotion.

This was not to be the course of mainstream Norwegian art, which at the turn of the century was concerned with reinforcing aspects of national identity in a common cult of the North. Some of the artists we have considered intensified their activities as illustrators of Nordic legends and sagas, taking time out from regular painting activities to add to the national reservoir of fanciful Norwegian images. In doing so they usually changed their style from an Impressionism recast to one of great decorative flair. This was the case with Gerhard Munthe (1849–1929), who proudly shared with the public the charming "country Norwegian" decoration of an idyllic retreat he had built in Lysaker outside Christiania in 1899 (plate 376). (Carl Larsson of Sweden would also render "intensely Swedish" views of domestic moments in his country house for an adoring public.)

One of the charter Fleskum colony members, Munthe had emerged with an almost moral commitment to creating a typically Norwegian art. Christian Krohg's large 1885 portrait of Munthe (plate 378) situates him in Ibsen's Grand Café, about to join the company of other Christiania artists (the cigar-puffing profile of the ma-

rine painter Reinholdt Frederik Bøll is seen to the left). The "Parisian" suaveness of Krohg's atmospheric presentation was something that Munthe too could muster in his light-and-atmosphere sensitive landscapes. He especially delighted in summer yellows and greens (see his Fleskum views) and winter oranges and whites, as in the engaging slice of life scene *Throwing Snowballs* (plate 377) of 1885, the year of his first visit to Paris. He could also be monumental in scope, encompassing a broad panorama with broad, loose strokes and restricting his palette to a few restrained and balanced colors, such as the 1889 view *From Drøbak* (plate 379), south of Christiania. In his Norwegian nature scenes Munthe was a hair-splitting perfectionist, saying that grass should be painted so that one could tell what time of year it was and also whether it grew on the mountains or in the lowland—only thus could the uniquely Norwegian character be fully brought to life.

The Norwegian national anthem begins with the words "*Ja, vi elsker dette landet, som det stiger frem*" ("Yes, we love the land that rises"). Perhaps the most enthusiastic and the most unusual purveyor of the majesty that is Norway was not a Norwegian at all but the painter with whom we compared Monet's Norwegian mountain painting, the Dane Jens Ferdinand Willumsen (1863–1958). Trained as an architect, sculptor, and craftsman as well as a painter in Copenhagen, he went to Paris in 1888 and returned for four years in 1890, when he met and became friends with Gauguin. Stung by Danish reviews saying he had plagiarized the French artist, Willumsen disassociated himself from the Pont Aven school and sought inspiration first in Courbet's Jura mountain range and then in Norway, where his 1892 encounter with the Jotunheim—the giant mountains—inspired a new plein-air "solidified" Impressionism and an eschatological philosophy. Having met an alien nature that was brutal and uninhabitable for human beings, he

377. GERHARD MUNTHE. *Throwing Snowballs.* 1885. Oil on canvas, 26⅝ × 40⅛". Nasjonalgalleriet, Oslo

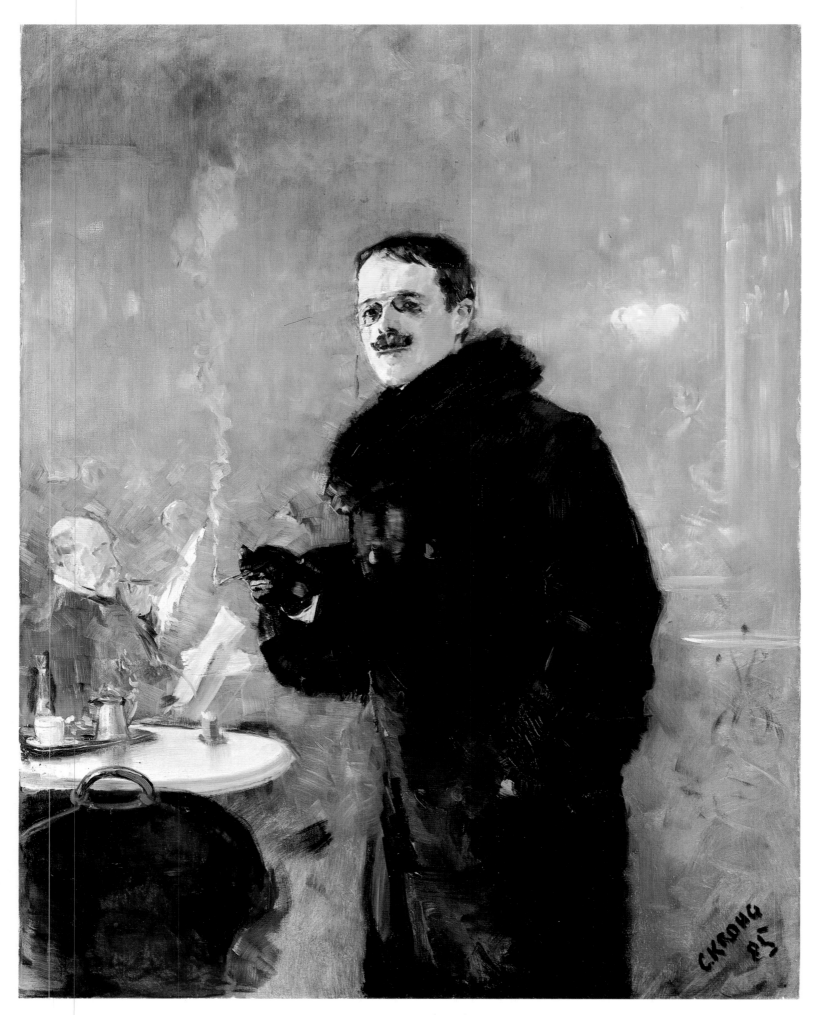

378. Christian Krohg. *Portrait of the Norwegian Painter
Gerhard Munthe.* 1885. Oil on canvas, 59¹/₁₆ × 45¼".
Nasjonalgalleriet, Oslo

379. Gerhard Munthe. *From Drøback*. 1889. Pastel,
8⅝ × 13⅛". Private collection

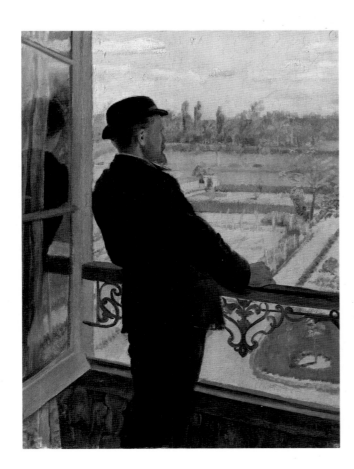

380. Christian Krohg. *Portrait of the Swedish Painter Karl
Nordström*. 1882. Oil on canvas, 24¼ × 18¼". Nasjonalgalleriet,
Oslo

came to see the ice fields as a gigantic symbol for nature's sublime indifference. Nature was destructive and creative at the same time, like human beings. *Sun over Södern's Mountain* (plate 347) is a spectacular embodiment of these thoughts. Potential destruction inhabits the upper blue-and-white zone—the heavy snow is overwhelming and unpredictable, and huge threatening clouds billow above the lower brown mountain peaks. But falling in pale blue rays through all this is the equally powerful light of the sun, and where the sun meets the glowing orange ground, a city springs up, poised on the inky blue water's edge and lapped by great, regular waves. Human creativity and natural destruction are held in perpetual equilibrium. This, for Willumsen at least, is Norway. *"C'est de la Norderie"* vindicated!

## Sweden: Luminism and the Mystical Union with Nature

Like their Norwegian colleagues, the young Swedish painters of the 1880s were not interested in taking the Troll King's advice to Peer Gynt: "To thyself be enough." Eager to abandon what they considered a "land without motifs" (a famous complaint voiced by the Swedish painter and critic Richard Bergh), they descended on Paris and the French countryside to acquire the sophistication and inspiration lacking at home. The ubiquitous Christian Krohg's *Portrait of the Swedish Painter Karl Nordström* (plate 380), painted in Grez, near Fontainebleau, during the summer of 1882, suggests the North-South dichotomy facing expatriate Scandinavian artists: their works, when redolent of French artistic ideas, were approved by the Parisian press, but the same skills and palette struck the public back home as affected and peculiar. Like the iron railing separating Nordström from the French scene below, the very fact of being a Scandinavian adept in French techniques acted as a barrier. The plein-air provincialism learned at Grez by Nordström (he returned in 1884 for two years) was set into perspective when he and other Impressionist "assimilated" Swedish artists found themselves overshadowed at the 1889 Exposition Universelle in Paris by the triumph of the Norwegians, whose emphasis on Nordic motifs and *stemning* gave them a distinctive identity as an emerging new school. Inspired, Nordström returned to wrest a similar *stämning* from Swedish nature—perhaps not so bereft of motifs, after all, if the imported French spectacles were removed. Reasoning that the French painted only what they saw, he began painting what he *knew*—the barren granite skerries and cliffs of his native province of Bohuslän on Sweden's west coast. "Here is silence—an absolute silence. Not a single sound. A paradise for nerves grown lax. No sunshine—a soul-refreshing violet tone," he wrote.[41] In 1893 he joined Richard Bergh and others in the ancient coastal town of Varberg, situated in the neighboring southern province of Halland, initiating what would become an

381. KARL NORDSTRÖM. *Kyrkesund.* 1911. Oil on duck,
48 × 74″. Nationalmuseum, Stockholm

382. CARL WILHELMSON. *On the Rocks at Fiskebäckskil.*
1905–1906. Oil on canvas, 49⅝ × 59⁷/₁₆″. Göteborgs
Konstmuseum, Sweden

important artists' colony. Rearranging his Impressionist palette to favor blues and reds, and applying streaky brush strokes to capture the extreme, pellucid clarity of the Swedish atmosphere, Nordström addressed the monumental nature and hushed mood of his homeland for the next three decades, creating in his final years a limpid heroic style (plate 381) that addressed the age-old Bohuslän trinity of ocean, ships, and rocks.

Carl Wilhelmson (1866–1928) was, like Nordström, a native of Bohuslän. He studied briefly with Carl Larsson in Sweden and then spent the early 1890s in France, working at the Académie Julian in Paris and painting in Brittany. In 1896 he returned to Sweden's rocky west coast—his country's equivalent to Brittany—and began to paint the life of the fisherfolk in the village where he had been born, Fiskebäckskil. For him the union with nature was not so much mystical as it was natural. The quiet, dignified people in his pictures exhibit the same craggy features as their landscape, and over the years Wilhelmson's plein-air style became progressively monumental, with dry pigments pinning down the Northern lights on large, coarse canvases. Compare his iconic *On the Rocks at Fiskebäckskil* (plate 383) of 1905–1906 with Krøyer's more immediate *Fishermen on the Skagen Beach.* The earlier picture, closer to Impressionist impulses, is diffused and dampy, the later image, more hieratic in conception, is stony and sharply defined, its blue lavender luminism almost petrified. Both paintings feature men of the North gazing out to sea, men who make their living from that sea. The moral quality is implicit: nature is enough; nature is all.

A Swedish nationalism of another, less mystical, more material sort was fashioned by Nordström's Grez colleague Carl Larsson (1853–1919), who from 1877 on had made many visits to France. His vaporous, sun-bleached *In the Kitchen Garden* watercolor of 1883 (plate 383), stemming from a two-year stay in Grez (1882–1884), exhibits his easy grasp of French tonal refinements and atmospheric subtleties. The Swedish National Museum bought this image of Grez the same year Larsson created it, and back in Sweden critics fought with each other as to whether the picture's blanching sunlight was really authentic, some saying no, others saying yes, pointing out that in Sweden the light is very sharp but that in France the light is mild and soft, and that shadows therefore were not dark but translucent and bright.

When Larsson returned home permanently in 1885, he and his wife Karin—a fine decorative artist in her own right—elected to live primarily in the village of Sundborn in his native province of Dalarna—especially rich in folk tradition—in the heartland of Sweden. The following year, with the sly good humor so characteristic of him (the great Swedish collector Ernst Thiel wrote to him: "I love your art which gives me nuts to crack."[42]), Larsson painted a white-carpeted vignette of Nordic plein-airism that he exhibited in the Paris Salon that summer under the laconic title *In Sweden* (plate 384). What a contrast to the sweltering kitchen garden at Grez!

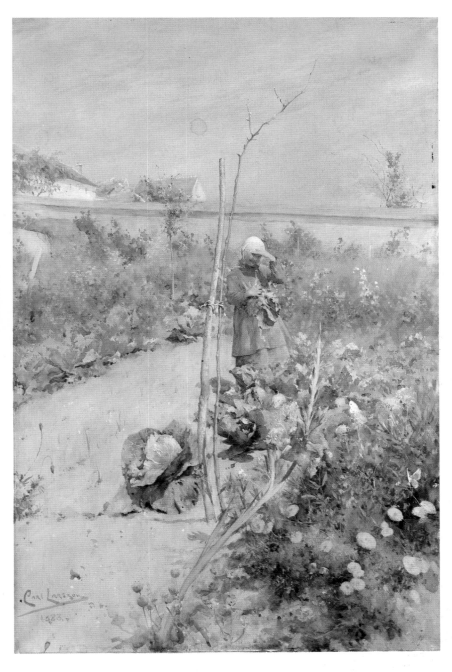

383. CARL LARSSON. *In the Kitchen Garden.* 1883. Watercolor, 36⅝ × 24″. Nationalmuseum, Stockholm

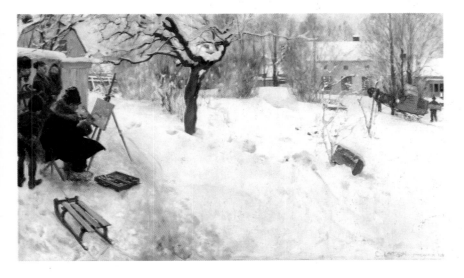

384. CARL LARSSON. *The Open-Air Painter in Sweden.* 1886. Oil on canvas, 46⅞ × 82¼″. Nationalmuseum, Stockholm

But this is what outdoor artists must endure if they are to remain true to their calling. (Frits Thaulow had his oil paints especially treated against coagulation in freezing winter temperatures.) The long expanse of canvas and snow was painted just outside Larsson's house in Stockholm, and in a drawing of the same scene the artist gave an identification (for the mystified Thiel perhaps?) of the elements placed in such a "Japanese" manner at the picture's peripheries: "A. A Swedish 'pleinair'ist' in fur coat and rush shoes. B. A curious boy with sled. C. A carpenter who is curious. [We can see the carpenter's plane.] D. A woman with a screaming child. E. A sausage factory. F. House and red wagon. G. A not-flowering apple tree. H. Footprints. I. J. K. L. M. Snow or Kremnitz white. That's all."[43]

Perhaps the outdoor cold was too much even for Carl Larsson. Beginning in 1894 he switched locales and styles to create the series of twenty-six line-drawing watercolors on which his international fame rests—the enchanting vignettes of utopian rustic domesticity (based on his family's life at their Arts-and-Crafts–furnished Sundborn country house) that came to be synonymous with Swedish national character and decor when published as the book *A Home* in 1899.

The eminently successful and prolific Larsson was Anders Zorn's greatest rival, and it is time to consider Dalarna's other great son from the perspective of Scandinavia's recasting of Impressionism. We have observed Zorn at his virtuosic best as a master who could pull the sap and warmth out of drawing on copper in the etched portrait of his friend Rodin. After eight years' residence in Paris he too succumbed to a longing for his homeland and returned to Sweden in the spring of 1896. He began construction of a comfortable country house (today a museum), filled with treasures from his international travels in the village where he had grown up under humble circumstances, Mora, in the heart of Dalarna. Zorn returned to this, the most "Swedish" of provinces with the richest preserved folk customs, out of sentiment, but also because he firmly believed in its regenerative powers (his own ailing mother had regained her health in Mora). The retirement to Mora of Sweden's most cosmopolitan artist echoes Nordström's flight to Bohuslän for restorative reasons: "It seems that it will be the wilderness which will preserve our health and strength,"[44] Nordström had written in 1892.

The thirty-six-year-old Zorn brought back with him from Paris a large oil self-portrait (plate 385) he had painted that winter (Stockholm's National Museum obligingly bought it the following year to celebrate the return of the country's most famous painter). It is a brilliant tour de force, stylistically combining veneration for Rembrandt and Titian with homage to Impressionist illumination and cropping. The artist, his ample figure positing a large scalene triangle in the lower left foreground, is thematically related to but distanced by the receding parquet floor from the smaller obtuse triangle formed by the lolling nude model in the shadowy upper-right background. On his palette Zorn displays the four

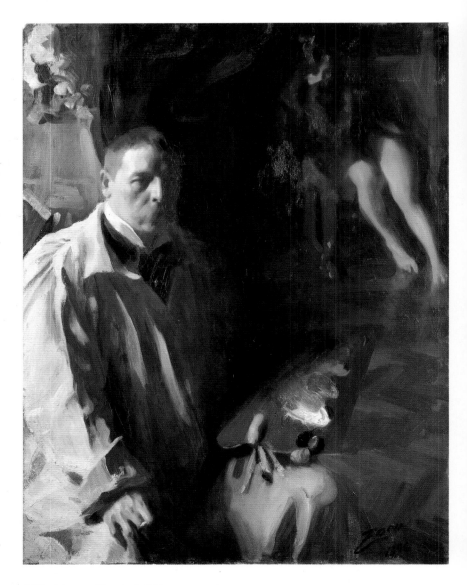

385. ANDERS ZORN. *Self-Portrait with Model.* 1896. Oil on canvas, 46 × 37″. Nationalmuseum, Stockholm

basic colors—white, ocher, vermilion, and black—used to conjure up this theatrical vision of the artist before his model (the cigarette in Zorn's right hand was a constant accompaniment to his work, as one can see from the thousand small burn marks on the floor of his Mora painting cabin). From the unseen window on the left, sunlight picks up the shimmering white of the artist's smock and collar and turns his exposed ear into a filter for pink light. The model, her legs gleaming in the darkness, wraps herself in her long red brown hair. Zorn's frank, swashbuckling love of sensuous forms and shifting lights thrilled his Swedish audiences (Thiel disliked him personally and thought him amoral, but nevertheless adored and collected his art) and brought a welcome new element into the Scandinavian spectrum.

It is entirely in character that Zorn's greatest expression of Swedish mystical union with nature included the union of the sexes. His motif, *Midsummer Dance* (plate 386) of 1897, was "discovered" in the company of

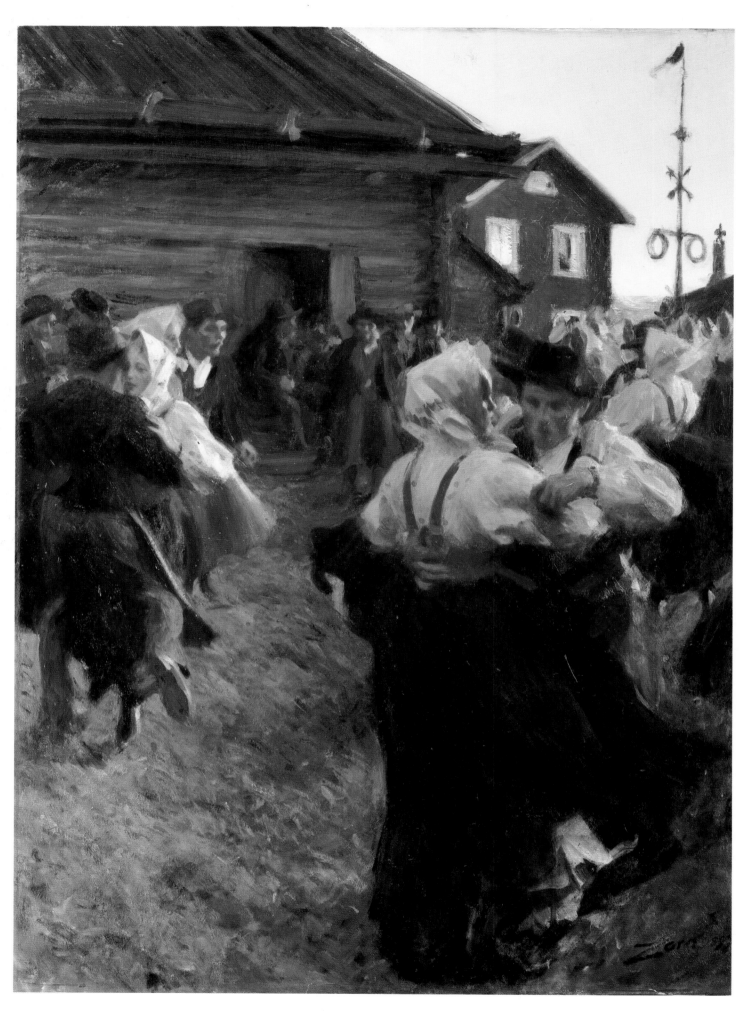

386. ANDERS ZORN. *Midsummer Dance*. 1897. Oil on canvas,
55⅛ × 38⅝″. Nationalmuseum, Stockholm

387. Bruno Liljefors. *Jays.* 1886. Oil on canvas,
21⅝ × 27⁹/₁₆″. Nationalmuseum, Stockholm

388. Gustaf Fjaestad. *Hoar-Frost on the Ice.* 1901. Oil on
canvas, 59¹/₁₆ × 79¾″. Thielska Galleriet, Stockholm

Sweden's aristocrat painter, Prince Eugen (1865–1947), a sometime visitor to Nordström's Varberg colony and a sensitive depictor of Swedish *stämning*.[45] So enchanted was the prince by the spectacle of a spontaneous peasant dance he witnessed while out riding with Zorn that, the artist recorded in his autobiography, he insisted Zorn paint it, persisting until he got Zorn's handshake on it. "The painting was done in June and part of July after sunset, and now I'm glad I did it," Zorn wrote, pronouncing it to be the work which "gives my innermost most completely."[46] What a contrast Zorn's joie-de-vivre celebration of boisterous energy and surging eroticism makes to Krøyer's well-behaved Danish midsummer beach bonfire. The whirling couples, dressed in traditional costume, are locked in tight embrace as the men spin their partners with ever-increasing speed and audacity. A momentarily empty wedge of iridescent green and red ground—Zorn's favorite colors for representing the earth's fecundity—leads our eyes into the picture, inviting us to participate in the mad stamping, and to the right a freshly erected maypole, decorated with greenery, reigns with pagan potency against the luminous night sky. What Zorn would glorify in paint, Strindberg would invoke on stage (the sexual tensions of *Miss Julie* explode specifically on Midsummer Night's Eve) and Alfvén (of Marie Krøyer imbroglio fame) would extol in highly colored orchestral music (the *Midsummer Vigil* of 1903).

The union with nature preached by Zorn in his sometimes kitschy paintings (like Renoir, he was fond of populating his palpitating outdoor scenes with roseate female nudes communing with the elements) was also approached in a practical way by the painter, who put his considerable energies and prestige into the creation at Mora of an extensive open-air museum with traditional Dalarna farm buildings from all over the province (we can note one on the left in *Midsummer Dance*).

Still a different oneness with nature—on a literal and metaphorical level—was projected by the Uppsala-born artist Bruno Liljefors (1860–1939), one of Sweden's most original and unusual artists. A friend of both Zorn's and Larsson's—he briefly stayed with the latter in Grèz during the summer of 1884—he depicted neither the exuberant dancing peasants of Zorn nor the checked gingham-curtained interiors of Larsson, but quite another realm and yet one as distinctly Swedish. Liljefors's world was that of the birds and animals of the wild. Trained in Stockholm and Düsseldorf, with two sojourns in Paris (1883–1884; 1886), where he was intrigued by Impressionist lighting and compositional systems, he withdrew to his native province of Uppland to saturate himself in a Walden-like communion with its wooded hills, meadows, and fir forests. His *Jays* (plate 387) of 1886 displays his part-hunter's, part–natural scientist's comprehension of the integration of wildlife with its environment. So well camouflaged is the large yellow squawking jay in the left foreground that we almost hear it before we see it perched in the lemon leaves. Liljefors combined the novelties of Impressionist and Japanese

asymmetrical viewpoint and steep perspective with his own acute observations of fauna and flora. His pictures address the unsullied world of nature and its denizens. Like Monet, the artist studied his subjects at all hours and in all seasons. His ducks, geese, owls, foxes, and rabbits epitomize an expression of something—some natural accord—lost to humankind. Liljefors learned their language and translated their message of consonance into a Swedish national treasure.

A Swedish artist who, in exception to the general rule, did not go to Paris to study and yet who might be called the "Monet of Sweden" for his numerous water studies with their close focus and seemingly tipped-up surfaces is Gustav Fjaestad (1868–1948). The transfixed Impressionism of his haunting 1901 picture *Hoar-Frost on the Ice* (plate 388) combines a flat, sculpted effect with a patterned and precise decorative touch and conveys a majestic grandeur through its gently undulating rhythms and almost monochromatic color scheme of white, gray, and mauve, punctuated here and there by pale blacks and oranges. Fjaestad had studied at the Swedish Academy of Fine Arts at the beginning of the 1890s and had also assisted both Larsson and Liljefors with major decorative commissions. But before he even attended the academy, Fjaestad had been to America in his youth, and a kind of American efficiency informs his artistic production (he was also a dedicated craftsman). The astonishing verisimilitude of his nature scenes, for example, was achieved through a special technique he developed: instead of drawing the motif on the canvas, he prepared the canvas with a photosensitive coating on to which he then projected photographs (American know-how!) of the subject he wished to paint—subjects that were often woven into tapestries by his wife, Maja, herself an artist.[47] In 1897 Fjaestad left Stockholm in search of the lake and river motifs that would become his hallmark. These he found in abundance in western Sweden in the inland province of Värmland—the snows and storms of which had already been romanticized into national legend by Selma Lagerlöf in her 1891 novel *The Saga of Gösta Berling*. Bergh's complaint that Sweden was a land without motifs had been proven wrong. Fjaestad spent the rest of his life rendering the snowy splendor of Värmland and no doubt agreed with the words of the famous old folk tune *Song of Värmland:*

> Oh Värmland, you beautiful, you delightful land,
> You crown of Swedish lands!
> And if ever I should come to the Promised Land,
> To Värmland I would return, yes.

The ever-present phenomenon of human habitations surrounded by water in Sweden provided some artists with city motifs in which a mystical union with the elements is made more puissant by contrasting the urban center with its natural surroundings. Visitors to Scandinavia have always commented upon the startling

389. EUGÈNE JANSSON. *The Riddarfjord in Stockholm.* 1898.
Oil on duck, 59 × 53⅛″. Nationalmuseum, Stockholm

distant horizon to welcome the sky and become part of the natural cosmos. A strange and singular painter, Jansson bordered on Expressionism with his subjective Impressionism.

"Imitate nature almost . . . and especially the way in which nature creates!" With this injunction August Strindberg (1849–1912) ended his 1894 essay "On New Art, or Chance in Artistic Production." The great portrayer's other stage was painting—an outlet to which he turned for short intense periods in times of spiritual need, notably in the years 1892–1894, 1901–1902, 1903, and 1905. Always a highly visual writer, he had taken careful note of Impressionism, freely confessing in his preface to *Miss Julie* (1888) that "with regard to the scenery, I have borrowed from impressionistic painting in its asymmetry, its terse and pregnant concision. . . ."[48] However, while he appreciated Impressionist methods, he, like Munch, had little use for frivolous subject matter or blanching sunlight (Sisley appeared like an "albino" to him). In a large rectangular oil panel entitled simply *The City* (plate 390) of about 1903, Strindberg followed his own admonition to paint *like* nature, rather than after nature. His desire to create like nature, incorporating chance, brought him to the edge of abstraction: fully three quarters of the canvas are taken up by a stormy sky, buttered on with palette-knife helpings of black, gray, blue, and white. The menacing clouds dwarf the gleaming narrow strip of city on the low horizon line below (a glistening cupola suggests not Stockholm but Venice, and Strindberg's admitted hero Turner), and a black ocean swells towards it from the foreground rocks. Far more furious in execution and raw in mood than Jansson's city view, the impastoed image suggests the turbulence Strindberg seems to have precipitated so frequently in his private life. In the essay entitled "Alone," which he wrote to prepare himself for final separation from his third wife, Harriet Bosse, in 1903—the probable date of this painting—Strindberg spoke of making nature serve as a "backdrop" to his character.[49]

Christian Krohg appreciated and added this "backdrop" dimension of nature to his 1893 portrait of Strindberg (plate 391)—a very large, commanding image bought by the playwright's greatest rival, Ibsen, for the wall of his study. "He is my mortal enemy, and shall hang there and watch while I write," mischievously explained the Norwegian bard.[50] The leafy screen background in Krohg's picture is a reminder of the frottage painting experiments with leaves and flowers conducted by Strindberg in Paris during the 1890s.

Strindberg's experience of oneness with nature as knife-stroked onto his own canvases was literally elemental. He restricted his vision to the only things that mattered—sky and sea, or land and trees—motifs he frequently studied through his telescope. The same favored blue black sky hovers over the brilliant orange and yellow trees of *Allée* (plate 392) of 1903, the only work Strindberg ever signed and dated directly on the front. "My heart soars off in that direction [towards the trees],

proximity, even eruption of nature within city limits, be it granite outcrop or threading fjord. For the reclusive artist Eugène Jansson (1862–1915), the spectacle of Stockholm scattered on her islands was haunting and compelling. From his high apartment on the south side of the Riddarfjärden bay, looking across at the tall steepled Riddarholm Church on its own island and the Gamla Stan (Old Town) island behind it, Jansson studied his city at different times of the day and night. Like Monet, he observed the changing light effects as sun and moon moved across the sky, but unlike the French Impressionists (whom he only saw on a first trip to Paris in 1900), Jansson did not paint the impression made on his senses but rather—and from memory—the impress left on his soul. *The Riddarfjord in Stockholm* (plate 389) of 1898 is a stark panoramic nocturnal view bathed in a deep blue light and rendered with a variety of undulating brush strokes. White city lights, near and far, swirl or sparkle with hypnotic intensity, and a thin thread of red horizon marks off the dark blue city silhouette with its Riddarholm steeple from the agitated blue sky above. Water—its movement, its reflections—is the dominating element. The city is a shadowy phantom as, robbed of its corporeality by the intense night light, it merges with the

390. AUGUST STRINDBERG. *The City.* c.1903. Oil on canvas,
37³/₁₆ × 20⁷/₈″. Nationalmuseum, Stockholm

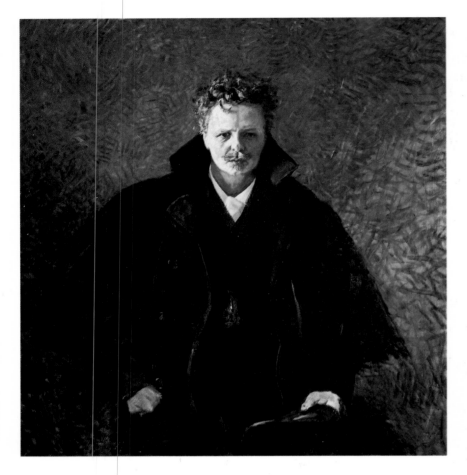

391. CHRISTIAN KROHG. *Portrait of August Strindberg.* 1893. Oil on canvas, 49⅝ × 50″. The Norwegian Folk Museum, Oslo

for I know that the sea lies somewhere behind the woods," the recluse of *Alone* had written,[51] commenting in real life to Carl Larsson triumphantly that Ernst Thiel had just bought three of his paintings, including the *Allée* with the "great unknown [*stora okända*] in the background."[52] The "unknown" for Strindberg, and for all Swedes held in the thrall of nature mysticism, was just that—the inexplicable magnet that demanded and offered union with the elements.

## *Finlandia: Internationalism Versus Finnophilia*

"Others mix you cocktails. I come with pure cold water," was the metaphor Jean Sibelius (1865–1957) chose to explain to Westerners the particular quality of his music.[53] It was just such a bewildering choice—European assimilation versus exploration of Finnish identity—that competed for the allegiance of Finnish artists training in the 1880s. Albert Edelfelt, of Louis Pasteur portrait fame, had brought the seductive message of French cosmopolitanism back to Finland in the early 1880s and was personally responsible for directing the footsteps of many of his younger colleagues—including the two we

392. AUGUST STRINDBERG. *Allée.* 1903. Oil on canvas, 37 × 20⅞″. Thielska Galleriet, Stockholm

393. Helene Schjerfbeck. *Drying Laundry.* 1883. Oil on duckboard, 15⅜ × 21¼". Private collection

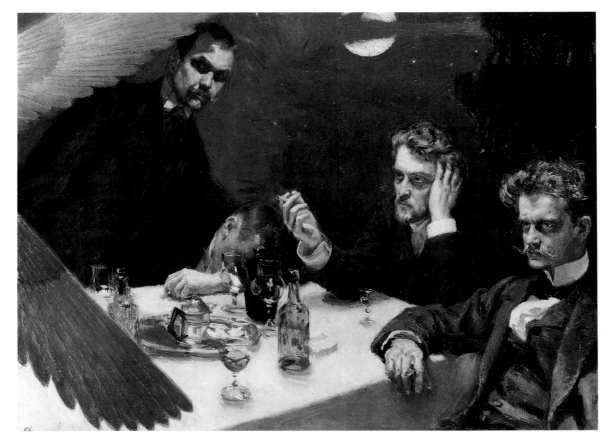

394. Akseli Gallen-Kallela. *Symposium (The Problem).* 1894. Oil on canvas, 29⅛ × 39". Private collection

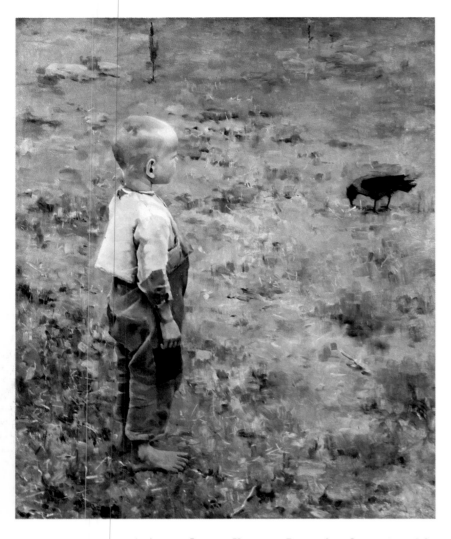

395. AKSELI GALLEN-KALLELA. *Boy with a Crow*. 1884. Oil on canvas, 34¹/₁₆ × 28½". Art Museum of the Ateneum, Helsinki

shall examine here—to France. On the other hand the rising threat of interventionism by Russia—after six hundred years of Swedish rule Finland had been annexed by Russia as a Grand Duchy in 1809—had triggered a great introspective national revival that would climax in the pro-Finlandia demonstration of 1899, the year of Sibelius's patriotic tone poem. Torn between the rival cults of internationalism and chauvinism, Finland's artists mostly made their choice in favor of the homeland, using their foreign-acquired skills to exalt the mother country in themes picturing Finland's epic past. This was the route Gallen-Kallela would ultimately take, and there would be no place for even a modified Impressionism in his linear symbolism. We shall return to Gallen's Paris decade, after first regarding the work of a coeval who shared that French decade of the 1880s and who elected to take an internationalist viewpoint in theme as well as technique.

Helene Schjerfbeck (1862–1946) displayed such precocious drawing ability as a child that she was allowed into Helsinki's Finnish Fine Arts Association's Drawing School at the age of eleven—and this partly by accident since the jury, which included Edelfelt, had no idea that the amusing illustrations they had just applauded were produced by a child. Schjerfbeck's childhood was overshadowed by two events, a fall at the age of four that fractured her hip and left her lame for life (her impecunious family, too proud to consult a physician, had allowed the hip to heal naturally), and the death of her father when she was only thirteen. During most of her adult years she was saddled with a demanding mother who placed housework ahead of art. As late as 1926 we hear Schjerfbeck complain, "A painter should not be a housewife."[54] After four years at the Drawing School and two more years of private study she received a travel stipend that enabled her to go to Paris in the fall of 1880. At the house of her friend the sculptor Walter Runeberg she met most of the leading Nordic personalities of the day, including Grieg, Bjørnson, and Strindberg. Like so many of her fellow Scandinavians she chose to study with Bonnat, Gérôme, and Bastien-Lepage, and her plein-air techniques were honed by a year's stay in Brittany (1883–1884), where, at the age of twenty-one, she painted the extraordinarily delicate yet compelling *Drying Laundry* (plate 393). The humble motif assumes a painterly magnificence as we follow the pale cream, pink, blue, yellow, and orange commentaries on the double diagonal sweep of cloth squares across the quiet green ground. A Corot-like silvery netting protects the casual spray of pink and blue blossoms that have sprouted on the right. This chance garden and its slender trees are lopped off in the best Impressionist style, and the ground-hugging vantage point excludes the horizon, adding to the apparently uncomposed slice of life—in this case slice of nature—aspect of the picture.

Back in Finland from the 1890s on, except for a few study trips abroad, Schjerfbeck moved gradually towards an Impressionism of greater simplicity and abstraction. Scholars have tended to credit this to her interest in Puvis—that same artist who had impressed so many Scandinavian artists in Paris—but as her haunting, palely lit *Yellow Roses* (private collection) of the late 1880s demonstrates, Schjerfbeck's concentration and economy, her sense of poise and balance, are also significantly Northern qualities, ones found in the music of Sibelius as well. For both, the combination of minor and major impulses could endow a work of sheerest simplicity with monumental effect. The mystical luminosity of Schjerfbeck's later works (some remarkable self-portraits from her eighty-second and eighty-third years challenge Picasso's old-age self-portraits for unmitigated reductive intensity) was her carefully won response to the modalities of Impressionism. Looking back on the outside influences she had welcomed into her painting life she concluded: "An artist can be cosmopolitan—and still be national."[55]

Quite to the contrary, Akseli Gallen-Kallela (1865–1931; who used the Swedish form Axel Gallén until 1904) desired only to apply the fruits of his cosmopolitan harvests—reaped during sojourns in London, Berlin, East Africa, Mexico, and Taos, New Mexico—to

the creation of a nationalist art. (Thereby ignoring Christian Krohg's pithy reflection that all nationalist art is bad and all good art is national.) The soul-searching problems and sudden revelations involved in such an undertaking, one subscribed to by Finnish composers and writers as well, were to be symbolized by Gallen-Kallela after his return from studies in Paris in an artists' banquet picture of 1894, *The Problem* (the title was later changed to *Symposium;* plate 394). He shows himself as a Mephistophelian figure standing to the left of three fellow members of the nationalistic "Young Finland" movement who sit around a dinner table in various stages of reaction to heavy thinking and heavy drinking: the composer-pianist Oskar Merikanto with his face and arm on the table, the composer-conductor Robert Kajanus (who would present Sibelius's First Symphony to the world at the 1900 Paris Exposition Universelle), and, to the far right, a slightly under-the-weather Jean Sibelius. To the far left a spread-winged apparition signifying artistic creation unfolds itself to the mesmerized view of those Young Finlandians who can still focus. This deeply serious but unintentionally humorous ensemble (compare it with Krøyer's happy, sun-dappled champagne drinkers in *Hip, Hip, Hurrah!*) would address itself to a Finnish Renaissance in the arts and would take for subject matter episodes from Finnish mythology, especially the national folk epic, the *Kalevala.*[56]

This ardent nationalist who wished to place his art at the service of his country's identity-affirming aspirations had begun, even before his 1884 study trip to Paris, as an impressive depictor of Finnish subjects in the current pale plein-air style. He was inspired by Bastien-Lepage's example (reproductions of the French painter's work were eagerly studied in Helsinki) of siphoning off the blurred backgrounds and blonder tonalities of Impressionist landscapes as settings for distinct, close-focus figures. Gallen-Kallela's amusing *Boy with a Crow* (plate 395) of 1884 was completed in Finland a few months before he left for Paris and almost outdoes the Bastien-Lepage paradigm with its emphasis on equating boy and environment—achieved by using the same white, brown, and pinkish gray color for both. The painter had managed to have the little farm boy stand quite still by telling him that he could catch the crow if he could manage to lure it near enough to put salt on its tail. As with Schjerfbeck's *Drying Laundry,* there is no horizon line: it is the earth that fills the picture space, knitting together two natural inhabitants of the Finnish soil—the black crow who pecks for food and the barefooted, motionless boy whose two black and gray trouser patches match and bond him to the crow's colors. This picture, at once so Finnish and so French, was enthusiastically received in Paris.

Another Nordic identity-asserting motif completed by Gallen-Kallela just before relocating to Paris, and one prescient of the artist's later emphasis on morbid episodes from the *Kalevala,* is the canvas-filling *Rotten Fish* (plate 396) of September 1884. Washed up on the shore, the agonies of its last gasp still very much evident,

396. AKSELI GALLEN-KALLELA. *Rotten Fish.* 1884. Oil on canvas, 17⁵⁄₁₆ × 14⁹⁄₁₆″. Art Museum of the Ateneum, Helsinki

a once agile predator, now only a colorful rotting carcass, nevertheless displays the powerful animus—the Finnish word would be *sisu*—that so recently propelled it through Finland's "pure cold" water. A stunning image in spite of its repellent state (Gallen-Kallela found it "divinely beautiful"[57]), it pungently conveys the artist's primitivistic nature philosophy in which the great questions of life and death are everywhere to be found, in the most minor as well as the most majestic phenomena.

WE HAVE SEEN in this appraisal of the Scandinavian recasting of Impressionism that in the shadow of the sixtieth parallel the combination of plein-airism and Northern light produced a new Luminism: sometimes gentle, as with the Danes, more often moody or mystical, and full of transfixed atmosphere, as with the Norwegians and the Swedes, even at times laconically concentrated, as with the Finns, but always in the service of defining those timeless qualities found in nature that for the Scandinavians are the alpha and omega of the Nordic world.

F. BOCION 1877

EVERY WRITER ON Swiss art has confronted
the problem of defining the scope of Swiss
culture. Books and exhibitions concerning
the topic invariably start with the statement
that until the first decades of the twentieth
century a national Swiss identity did not exist. There
usually follows a discussion of specific national charac-
teristic features, such as the influence of the Alps upon
daily life or the effects of popular traditions on the few
Swiss artists known outside the country. In comparison
with other European countries, specifically France or the
German principalities, Switzerland lacked fine arts cen-
ters, academies, or even local traditions. Before 1800—
and also during much of the nineteenth century—
Switzerland was a very provincial country without the
centers of enlightenment or a class of interested bour-
geoisie that existed elsewhere in Europe. There are a few
exceptions to this general rule. In Zurich there developed
in the mid-eighteenth century a thriving circle of schol-
ars and artists that congregated around Salomon Gess-
ner, Johann Jakob Bodmer, and Johann Kaspar Lavater.
But the small-town qualities of Zurich and the inertia of
the moneyed aristocracy limited the movement consider-
ably. Johann Heinrich Pestalozzi and Henry Fuseli
(1741–1825) went through this experience; char-
acteristically both left Zurich, the latter to pursue his
well-known career in England. Another city with a
sophisticated standard of culture was the center of
French-speaking Switzerland, Geneva. Housing the
only—and modest—academy of art in Switzerland since
1751, Geneva had a substantial strata of educated citizens
that provided a favorable climate for artistic creation.

The life of painters and sculptors was difficult in
nineteenth-century Switzerland. Opportunities to ex-
hibit and sell their products were limited to traveling
exhibitions—the *Turnus*—where newly founded local art
societies tried to promote works of art. The exhibiting
artists, logically and understandably, tried to please the
tastes of buyers and created pleasant views of well-
known and picturesque landscapes. In private letters
artists complained that if they could not sell one or two
paintings at the *Turnus*, they would not know how to
survive financially the following year. The paintings for
sale were based on studies and oil sketches that were
never exhibited, but which served as the bases for other
similar "finished" paintings. In German-speaking
Switzerland, reviews of the official exhibitions always
reproached artists for neglecting the painted details.
Johann Jakob Ulrich and his pupil Rudolf Koller, as a
result, never exhibited their studies. Ulrich's beautiful
small landscapes of France and Italy (plate 398) only
came to light in an exhibition after his death in 1878 and
did not meet with success. Koller was convinced by col-
leagues to show his landscape oil sketches in 1900 in a
retrospective exhibition on his seventieth birthday. By
that time, the taste of the public had changed, and Koller
sold, to his own surprise, nearly all his smaller paintings
to a new class of bourgeois collectors. In Geneva, the
influential academy teacher Barthélemy Menn, who had

# PLEIN-AIR PAINTING IN SWITZERLAND

*Hans A. Lüthy*

397. FRANÇOIS BOCION. *Fishermen Mending Their Fishing
Nets.* 1877. Oil on canvas, 15⅜ × 19¾″. The Oskar Reinhart
Foundation, Winterthur

turned to painting simple landscapes around Geneva after his return from Italy, never exhibited any canvases at local or national exhibitions.

Thus the plein-air works we see in Swiss museums today show almost incompatible tendencies in style. For example, the small-size oil sketch—always regarded as a preliminary work—was never developed into an independent category. Placed in an international context, the style of many Swiss landscape paintings in the nineteenth century, however, took an important step towards Impressionism; but the final gap between the direct approach to the atmospheric landscape and the Impressionistic technique of the fragmented stroke was never closed.

DURING THE EIGHTEENTH century, landscape painting was more commonly practiced in Switzerland than elsewhere in Europe. After 1655, when the Dutch government commissioned Jan Hackaert (1629–c.1700) to find the area where the Rhine begins, Swiss artists in general became interested in the unique topographical views of their country. Between 1660 and 1670 the Swiss painter and engraver Conrad Meyer, a companion of Hackaert's on his journey to Switzerland, painted the first landscapes of the Zurich lake during different seasons.[1]

The growing interest in topography sparked further joint ventures between Switzerland and Holland. In 1785 the Swiss editor Rudolf Henzi published forty-two prints in a folio entitled *Vues remarquables tirées des montagnes de la Suisse* in Amsterdam. They were partially based upon earlier editions of similar views by Caspar Wolf (1735–1783).[2] These outline etchings and colored aquatints enjoyed a limited success among Swiss natives and English tourists; however, the international edition greatly increased awareness of the country's picturesque Alpine peaks and glaciers.

Wolf began his career as a painter of altarpieces, tapestries, and fire screens. After a brief period in Germany and Paris he toured the lower Alps in 1774 and painted several small tempera studies on paper that served as models for finished paintings completed in his studio. Wolf often returned to the site of his subjects, correcting mistakes and enriching his landscapes with small details. More than 170 different sketches by Wolf of the lower and higher Alps are extant in Swiss collections, and they form the first ensemble of professional plein-air landscapes.

During the eighteenth and nineteenth centuries, Swiss painting can be described as being like parts of a jigsaw puzzle. The eastern, German-speaking portion of Switzerland was mainly influenced by German and Austrian culture, while one third of the nation—which was politically unified in 1815—spoke French and was more familiar with France and especially Paris than with its German-speaking neighbors. Typically, young artists from Neuchâtel, the cantons of Vaud, and Geneva developed their artistic skills in Parisian academies after a short preliminary training at the local art school in Geneva. Their Zurich, Bern, and Basel colleagues, often

without any previous professional training, studied in Munich, Düsseldorf, or Berlin. Familial and practical relationships narrowed these gaps during the course of the nineteenth century and the pattern does not apply to some more important artists. However, some of these incompatibilities between the segments of Swiss society exist even today.

By comparison with France, where landscape painting usually followed the strict rules of academic theory, the Swiss approach to nature was much more direct and not at all influenced by former traditions. The first decades of the nineteenth century were marked by a desire to discover firsthand the beauties of the native landscape. Responding to the demand of the growing tourist industry, hundreds of minor talents provided the market after 1820 with unpretentious views of Swiss lakes and mountains, mostly in the form of aquatints, etchings, and lithographs. Even Ferdinand Hodler manufactured little views of the lake of Thun in a clumsy oil technique before beginning his professional training in Geneva with Barthélemy Menn.

The paintings of the German-born Geneva landscape and genre painter Wolfgang-Adam Toepffer (1766–1847) parallel contemporary French landscape painting in terms of the structure of their compositions and the carefully balanced distribution of light and shade (plate 399). Toepffer excelled in applying Neoclassical qualities to gentle descriptions of the natives of the Geneva region.[3] His landscapes often display a multitude of sharply scrutinized peasants attending popular feasts or otherwise at leisure. Harking back to Dutch traditions the artist bridged the passing of eighteenth-century Swiss folklore and the beginning of the modern Realist movement. Geneva, a city steeped in Calvinism, provided the austere spiritual background for a Realist approach to its surrounding landscape of charming valleys and softly carved hills. One unusual view of the Geneva shore and port executed in about 1790 deserves to be mentioned. The artist was the little-known François Ferrière (1752–1839), who enjoyed a brilliant career as a portrait painter in London, Leningrad, and Moscow.[4] His humble view of Geneva is one of the first Realist cityscapes in European nineteenth-century painting, in effect anticipating one of the Impressionists' most innovative areas.

About 1800 landscape painting in German Switzerland assumed a different course. After a rich cultural life during the eighteenth century, art and literature declined precipitously, and Zurich artists lost the ability to paint well in the oil technique. Unlike Geneva, where artists thrived despite political turmoil, in Zurich art was restricted to engravings and prints of picturesque views destined for the few visitors. A young aristocrat, sent by his father to Paris to become a banker, transformed this situation in a most unconformist manner. Johann Jakob Ulrich (1798–1877) decided after his banking experience to begin a career as a painter.[5] He became a copupil of Corot's in the studio of Jean-Victor Bertin and first exhibited his painting *Vue de la côte de*

398. Johann Jakob Ulrich. *Clouds over the Sea.* c.1840s.
Oil on paper on board, 12⅝ × 17⅜″. Private collection

399. Wolfgang Adam Toepffer. *Landscape near Geneva.*
n.d. Oil on paper over board, 10¼ × 12″. Private collection

400. FRANÇOIS DIDAY. *The Small Lake at Sièrre.* n.d. Oil on paper on canvas, 10½ × 14½". Private collection

*Dieppe* at the 1824 Salon. In 1828 Ulrich traveled to Italy, characteristically not to Rome but to Naples, where he stayed for nearly three years. The bright Mediterranean light and the colorful daily life was conducive to plein-air painting, and Ulrich returned to Paris with a series of vivid studies of intimate views of Naples and other southern Italian landscapes. The Ulrich family still preserves a business card of Johann Jakob that he used upon his return to Paris on which he called himself "*peintre de paysage.*"

Ulrich exhibited again several times at the Salon, choosing for his motifs primarily views of the coastline of the English Channel from France, Holland, and England. His specialty was wide bodies of water and cloudy skies—without human figures but with the occasional sailing boat or early steamer added to balance the unbounded infinity of nature. Like many landscape painters in the first half of the nineteenth century, Ulrich started from the vantage of the seventeenth-century Dutch painters. The main distinction between the seventeenth-century forerunners and the plein-air painter lies in the treatment of light in the landscape. Dutch artists (Salomon van Ruysdael or Jan van Goyen, for example) also used a low horizon line and similar compositional outlines. On the other hand, Dutch landscapes describe the main elements of nature in an organic fashion: one can feel the thickness of a trunk or hear the rasping sound of grass. Ulrich, on the other hand, did not emphasize this materiality in his land- and seascapes. The different elements of water, sand, and gravel, as well as the cloudy skies, are painted in an immaterial but unified atmosphere. Weather and climate are given much more importance than before and characterize the general mood of the infinite space.

In 1837 Ulrich returned to Zurich where he ex-

ecuted a lithograph for the members of the Zurich Art Society. His presentation drawing was rejected because his view of an Italian bay lacked any human presence. Ulrich yielded to the provincial demands and submitted a conventionally animated scene. After this experience with the conservative artistic climate in his hometown he led a rather dull life as a teacher and illustrator of topographical albums with scenes of Swiss views. In Switzerland he never resumed the inspired and direct interpretations of nature he managed to paint in his youth. In German-speaking Switzerland Ulrich can be considered a precursor. His foreign experiences and travels had an influence during the middle of the century on pupils such as Rudolf Koller (born in 1828).

The development of plein-air painting was much more continuous in French Switzerland. After Toepffer it is marked by two names: François Diday and Alexandre Calame.[6] Diday, born in Geneva in 1802, was the first native artist to exploit the various atmospheric changes in the Alps (plate 400). Paralleling Caspar David Friedrich's landscapes in northern Europe, Diday's work invested virgin nature with sentiment. His pupil Alexandre Calame (1810–1864) from Vevey, then a small village on Lake Geneva, soon overtook his teacher. Both Diday and Calame visited Paris during the 1820s; Calame went to Düsseldorf in 1838, where he incorporated aspects of the French and the German landscape schools and painted savagely romantic Alpine valleys with cataracts, plunging cliffs, and weather-beaten pines and spruces (plate 401). In the 1840s Calame became one of the most sought-after painters of Europe. The courts of Russia and Great Britain purchased his large views of the Bernese Oberland. While painting countless repetitions of the latter motifs, Calame also proved that he could create small, unpretentious landscapes of the Swiss midlands, the populated flatter area between the Alps and the Jura, in which he realized a new conception of an intimate and peaceful landscape with villages and peasants depicted in harmony with their environment.

The Swiss landscapes by Toepffer, Diday, and Calame also contain political overtones. After the creation of the Swiss confederation in 1815, when the cantons of Geneva and Neuchâtel and the Valais joined the other cantons, the German Swiss desired more knowledge of their new neighbors. Paralleling nineteenth-century American landscape painters who explored new terrains with pencil and brush to convince new settlers of the beauties of the unknown landscape, the Swiss bridged the gaps between the new groups of citizens by demonstrating similarities in the domesticity of their surroundings.[7]

One of the most influential figures in Swiss landscape painting is Barthélemy Menn from Geneva (1815–1893), son of a confectioner from the Grisons and a peasant's daughter from the canton of Vaud.[8] After a short period at the local academy of art, Menn went to Paris, entered Ingres's studio, and then followed the French master to Rome in 1834. Menn returned to Paris in 1838 and became associated with Corot and other

401. ALEXANDRE CALAME. *The Rhône Valley at Bex with a View to the Lake of Geneva.* 1833–1838. Oil on paper on canvas, 11⅝ × 17". The Oskar Reinhart Foundation, Winterthur

402. BARTHÉLEMY MENN. *The Mont d'Orge near Sion.* c.1860. Oil on paper on canvas, 11¼ × 16⅝". The Oskar Reinhart Foundation, Winterthur

Barbizon school painters, changing his style and subject matter from Ingres's rigid classicism to intrinsic but carefully composed landscapes of the surroundings of Geneva. He spent the rest of his life as a highly regarded and qualified private teacher. Menn had a special gift in developing the talents of his pupils. Among his protégés were the distinguished Swiss landscape painters of the second half of the nineteenth century, including Pierre Pignolat, Édouard Castres, and Ferdinand Hodler. Menn excelled in the *paysage intime*, the representation of unpretentious landscapes. In opposition to Calame's ambitious and dramatic mountain views, Menn's simple scenes (plate 402) consist of meadows, fruit trees, thickets, and small pools and are close in spirit to the down-to-earth views of a regular citizen enjoying a walk in nature. At first sight, Menn's landscapes appear to be similar to Corot's; however, Menn never renounced his classical education and he maintained a rationally imposed distance from the poetic aspects of nature. He also had a special appreciation for hidden tectonics in his landscapes; each painting or study contains an intelligent structure in itself, one of the most overlooked but essential qualities of Impressionism in France.

Calame's counterpart in eastern Switzerland was Johann Gottfried Steffan (1815–1905), who was born in Wädenswil on the shore of the Zurich lake.[9] He started his career as a lithographer and later studied painting in Munich, where he admired Carl Rottmann's Italian landscapes. Steffan specialized in Bavarian and Swiss mountain views, especially scenes depicting the famous lakes of Chiemsee, Starnbergersee, Walensee, and the Lake of Zurich (plate 403). The latter, hemmed in by steep mountains and cliffs, was a beloved motif for painters in eastern Switzerland, and Steffan often sojourned there in the summer months with two artist-friends, the Zurich-born Rudolf Koller and Robert Zünd from Lucerne. Steffan's generation, which reached artistic maturity around mid-century, produced full-scale landscapes divided into two distinct categories. First, there were studio works, destined for the yearly national exhibition of paintings and sculptures in various Swiss cities or elsewhere in Europe. These "official" works provided for the living costs and expenses of the artists and their families. They were expensive and sold to a growing class of entrepreneurs in Zurich, Berne, and Basel to decorate their homes. Also an unusual lottery system was created and combined with the entrance ticket for the national exhibitions that allowed any common visitor to win an important painting. Local societies for fine arts also bought lottery tickets, accounting for several large canvases by Steffan and his contemporaries that found their way into the newly founded local museums. Second, there were numerous studies made for the latter paintings and considered by the artists as tools for the official works. These were never exhibited and often appeared only after the death of the artist, when his studio was put up for auction (a traditional practice in France as well).

Steffan's studies show a delicate talent for direct observation of nature and its different aspects. In some

403. Johann Gottfried Steffan. *Evening Twilight at the Lake of Zurich*. 1846. Oil on paper on canvas, 8¼ × 13¼".
Private collection

sense they belong to the early Realist movement, where freshness and sensibility took precedence over academic training. The conventional and smooth manner of the finished paintings that established the reputation of the nineteenth-century artist gave way to a greater appreciation of the studies among the art public. However, Swiss collectors only gradually developed this new taste. The decisive step was undertaken by the Winterthur collector Oskar Reinhart (1885–1965), who started to form his collection (now the Oskar Reinhart Foundation in Winterthur) after 1906, the year of a large survey exhibition of German nineteenth-century painters in Berlin, the so-called *Exhibition of the Century*.

One of Steffan's more ephemeral disciples was Arnold Böcklin (1827–1901), probably the best-known nineteenth-century Swiss artist.[10] Born in Basel, he spent the years from 1850 to 1857 in Rome after short periods of training in Düsseldorf with Wilhelm Schirmer in Belgium and in Geneva with Alexandre Calame. Böcklin was one of the last European masters to populate his bucolic landscapes with figures. And he moved increasingly in a mythological direction. At the beginning of this unique, antimodernist adventure in art, which

made him one of the most famous artists of his time, Böcklin encountered the environs of Rome, where he explored the southern light of the Campagna and the Alban mountains. In 1868 Böcklin wrote to his friend R. Schick: "For a Northerner the scenic attractions of Italy are the luscious vegetation, the beauty of the simple buildings, the plateaus, the frugality of green, and the splendid formations of the rocks." If Böcklin's name today brings to mind fauns, satyrs, nymphs, dryads, sirens, and sea-maidens, his masterful treatment of their landscape surroundings must not be forgotten. Böcklin's success is in large part due to the blending of a Realist landscape with fantastic and mythological figures. In his time Böcklin was considered the absolute antithesis to Impressionism. Such paintings as *The Island of Death*, where the landscape almost seems to emanate human feelings and emotions and to have a general mood of perpetuity, negate common tenets of Realism. The well-known German art critic Julius Meier-Graefe, one of the propagandists of Impressionism in Germany, slandered Böcklin as the Antichrist of art in a 1905 pamphlet entitled "*Der Fall Böcklin und die Lehre von den Einheiten.*" He accused Böcklin of reducing painting to

an affair of the mind and not of the brush. Yet today Böcklin's affinities with Impressionism are more apparent than they were to such nineteenth-century aesthetes. The Impressionists' works are not deprived of feeling, and Böcklin could paint a landscape as brilliantly as his French contemporaries (plate 404).

If Böcklin was the visionary of an idealistic kingdom, François Bocion (1828–1890) can be called the interpreter of a paradise on earth, Lake Geneva. Born in Lausanne, the capital of the canton of Vaud,[11] Bocion spent three years in Paris, from 1847 to 1849, studying in part with Charles Gleyre, a native of Vaud and the teacher of Sisley, Monet, Bazille, and Renoir in the 1860s. Upon his return to Lausanne, Bocion devoted himself to depicting Lake Geneva under every atmospheric condition (plates 405 and 406). He made virtually hundreds of studies of the environs, which he then transformed into completed studio works. Marked by the luminous effects of the various times of the day and the seasons, these landscapes contrast the vast area of water between Switzerland and France with the distant peaks and crests of the Swiss and French Alps. Bocion is considered to be the Swiss Impressionist *par excellence.* Yet the art historian William Hauptman, recently analyzing the relationship between Bocion and his French contemporaries of the 1870s, points out that Bocion's art is more closely related to Bazille's than to Monet's: "While Bocion's paintings retain the fresh luminosity of plein-air observation, his works are decidedly more structured and controlled with regard to composition, framing and perspectival axes, and thus more aligned with a classical tradition."[12]

In Bocion's works, there still remain traces of classical influence.[13] The Swiss were decidedly one of the most conservative publics in Europe. This was particularly true in Zurich, influenced by the Protestant reformer Ulrich Zwingli, and in Geneva, the home of John Calvin. Swiss painters such as Menn and Bocion could survive only by teaching, not by selling their art, and many artists, including Steffan and Böcklin, left Switzerland to pursue their careers in foreign countries. The brushwork and the surface of the paintings submitted to the national "salons" were required to be tight and smooth. Studies were not allowed, with the exception of an occasional watercolor for buyers of modest means. Although the results of summer sojourns to picturesque sites were numerous, these products remained private material for finished compositions. The prerequisite for entry was the elimination of disharmonious elements and a convenient variegation to animate nature.

Acceptable and suitable painting consisted of depicting people working or at leisure. The reticence to paint landscapes without a civilizing presence harks back to the classical principles of the seventeenth century and the still-prevailing order of rank in the categories of works of art: the highest rank being history painting, then genre, and finally landscapes. Many critics in the nineteenth century based their judgments on the relationship between figures or animals and the landscape

404. Arnold Böcklin. *Wall of Rock in the Albanian Mountains.* 1851. Oil on canvas, 24¼ × 29½". Kunstmuseum, St. Gallen

itself. Swiss painters followed those rules during the entire period, a phenomenon that was also true of other national schools of the nineteenth century.

Thus, the numerous paintings of the Swiss lakes always depicted boats; Lake Geneva being immediately recognizable by the characteristic crossed sails of its fishing boats and transportation vessels. Other possibilities included the depiction of cattle and domestic animals. The Zurich artist and animal painter Rudolf Koller (1828–1905) specialized in this genre.[14] We are exceptionally well-informed about Koller and his career through his prolific correspondence with his contemporaries in Zurich. Koller first trained in Zurich with Ulrich. In 1846 he went, on the advice of his teacher, to Düsseldorf, where he befriended Böcklin. Both artists traveled together to Belgium and Paris. Koller, again upon Ulrich's recommendation, greatly benefited from his visit to the French animal painter Raymond Brascassat, who kept a special atelier full of dogs, horses, and cattle. Koller decided to pursue a career as an animal painter himself and bought in 1862 a house at the Zürichhorn, near Zurich, where he owned several species of animals, including cows, hens, sheep, and goats. Unlike Brascassat, Koller painted his animals outdoors, and in order to paint correct positions and weather conditions he always placed several easels in his garden.

Koller's view of Richisau in the canton of Glaris (plate 407)—even without animals—is typical of Swiss painting in mid-century. The late summer landscape of the Alpine pasture expands and recedes from a very detailed foreground to the distant summits. Both the soil

405. François Bocion. *Sunset at the Lake of Geneva.* n.d.
Oil on canvas, 10⅛ × 17¼″. Private collection

406. François Bocion. *The Artist with His Family Fishing
at the Lake of Geneva.* 1877. Oil on panel, 12⅝ × 19⅛″.
Musée Cantonal des Beaux-Arts, Lausanne

and air appear to soak in the sun, which reflects on the water and leaves. Koller's landscapes illustrate to near perfection Castagnary's abstract concept of translating immediate visual sensations into art.[15]

Almost all of the artists we have encountered spent their lives in Switzerland after some travels abroad. With the exception of Böcklin, they represented their native country in fresh, direct fashion with only slight indications of their academic training in Paris or in Germany. Only one artist forced his way through this scheme and combined a bohemian life with modern ideas of the arts. Franz Buchser (1828–1890), born in the small village of Feldbrunnen near Solothurn, joined the Swiss Guard in Rome in 1848 and decided simultaneously to become an artist.[16] Self-taught, he traveled widely in the 1850s in France, Belgium, Spain, and England. After an engagement as a soldier in Morocco, life in Switzerland became rather dull, and he emigrated in 1866 for five years to America, where he painted primarily landscapes and scenes of everyday life of Native Americans and African-Americans.[17] Buchser liked life in Virginia and even changed his first name to Frank. In 1867 he spent time in the Shenandoah Valley and filled his sketchbooks with scenes of Woodstock, Virginia, a once prosperous village that had been ravaged by the Civil War (plate 408). His plein-air oil studies show the qualities of a gifted but untamed traveling painter who tried to translate his intuitive sensations directly onto canvas in a modern style.

Buchser is an excellent example of a provincial painter, although the painter himself was anything but provincial. As a Swiss artist he belongs to an eccentric category without a school or a sustaining circle. His works extend from conservative portraits to Impressionistic landscapes without a traditional chronological development or much self-imposed discipline. Whereas artists in centers such as Paris, Düsseldorf, Munich, or Rome were part of an enlightened elite composed of fellow colleagues, enemies, and the public, in Switzerland this group was much smaller and could rarely provide the single artist with a sufficient support system. The much-admired advantages of such a provincial setting were its familiar ties and traditional roots, but these vanished quickly if the inner circle could not understand an artist working outside of standard conventions. One of the most talented contemporaries of Buchser, Albert Anker (1831–1910), born in the village of Ins near Berne, confronted these issues.[18] His father, a veterinarian, induced his son to study theology. After several semesters in Germany, Anker changed his mind and entered Gleyre's studio in Paris in 1854. Driven his entire life by a profound sense of morality, he decided to take up the career of a history and genre painter. He split his life between Paris, where he spent winters, and his native Ins, where he kept a summer studio. Even today Anker serves as a nostalgic ideal for conservative politicians and enjoys considerable popularity in Switzerland. Without question, Anker was one of the most talented Swiss painters of the nineteenth century, and he could have

407. Rudolph Koller. *The Richisau.* 1858. Oil on canvas, 32¼ × 39¾″. The Oskar Reinhart Foundation, Winterthur

408. Frank Buchser. *Village Street in Woodstock, Virginia.* 1867. Oil on canvas, 9½ × 13″. The Oskar Reinhart Foundation, Winterthur

409. ALBERT ANKER. *Market in Murten*. 1876. Oil on board,
8 × 10″. The Oskar Reinhart Foundation, Winterthur

achieved international fame in a different climate. His
letters, however, demonstrate the profound and tearing
conflict in his personality. The decision to be an artist
itself seems to have eaten up Anker's courage to take risks
in life, and he chose to pursue his career in the most
promising way to financial security.

Perfectly intimate with the contemporary Im-
pressionist movement and its financial drawbacks, Anker
preferred to sell his Realist genre scenes for compara-
tively modest prices to the French dealer of the Realists,
Goupil, and he was associated in the 1870s with the
American George A. Lucas, a well-known agent for
American collectors. Later Anker complained about his
lack of training in landscape painting; nevertheless, he
produced some of the most vivid and Impressionistic
landscapes in Swiss art. On several trips to Italy, he
traveled with sketchbooks, in which he executed a series
of beautiful watercolors of Italian cities and sites.[19]

Anker's oil sketch of a market day in Murten
(plate 409), a small medieval city in the canton of Berne,
was painted in lieu of a historical subject. The study
stands today as a work of art in its own right and demon-
strates Anker's capabilities in landscape painting. The
imprint of the sun-filled main street, the sparkling colors
of the people, and the carefully arranged values in the
adorned walls make this painting a rural companion to
some of Pissarro's cityscapes of the 1870s. In his genre
paintings, Anker belongs in the wider context of the
French Realist movement. He traveled outside Switzer-
land only to neighboring countries and called himself
more craftsman than artist.

Another painter whose work had Impressionistic
tendencies was Édouard Castres (1838–1902) from Ge-
neva.[20] Like many Swiss artists, he was trained first as a
watch designer and enameler. He then worked as a
painter in Geneva and Paris, where he later volunteered

PLEIN-AIR PAINTING IN SWITZERLAND

410. EDOUARD CASTRES. *Snowed up Street in Paris*. 1872.
Oil on canvas, 23⅜ × 17½″. The Oskar Reinhart Foundation,
Winterthur

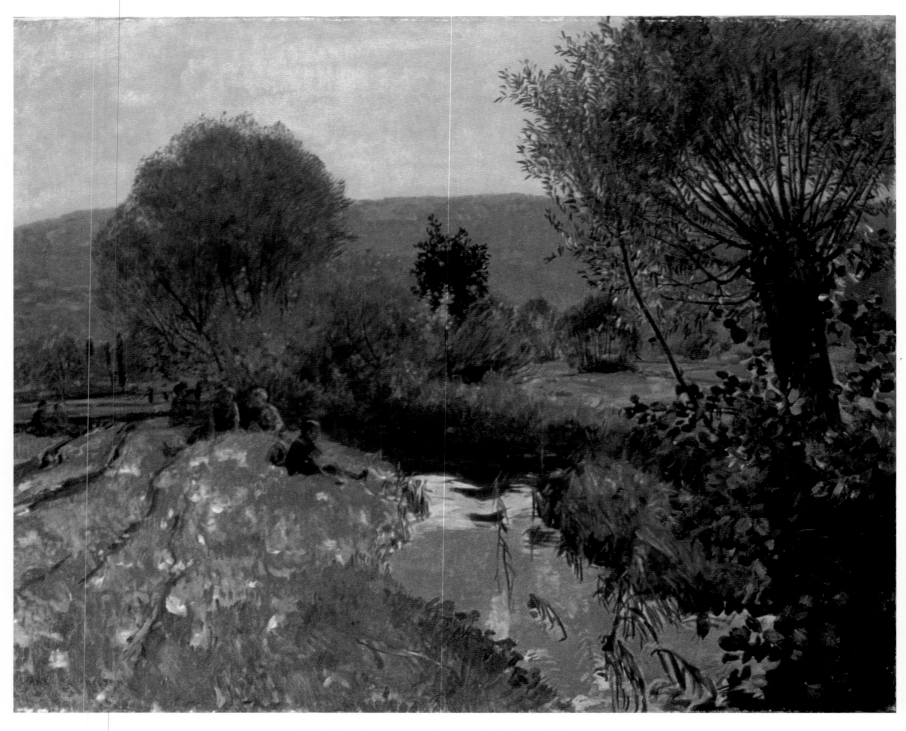

411. Hans Sandreuter. *Autumn in the Leime Valley*. 1892.
Oil on canvas, 47⅝ × 59½″. The Oskar Reinhart Foundation,
Winterthur

412. Otto Fröhlicher. *Landscape with Loam Pit.* 1869. Oil on canvas, 18½ × 26⅜″. The Oskar Reinhart Foundation, Winterthur

to drive Red Cross ambulances during the Franco-Prussian War. He fled with General Bourbaki and his unfortunate French army through the Franche-Comté in 1871 and was at the French surrender to the Swiss at La Verrière. These adventures made Castres a painter of outdoor military scenes, a métier that he mastered with growing success. After these experiences, his specialty became dainty and transparent winter landscapes (plate 410). The omnipresence of snow scenes in Swiss painting should be emphasized; snow in its various stages of growing and melting during the winter is an important element of daily life in Switzerland. By contrast, in Paris, where snow falls infrequently and often unexpectedly, French artists have always depicted snowy landscapes as an unusual phenomenon, celebration for the eyes of an urban population unaccustomed to the transformations of nature.

The *paysage intime*, the selective choice of unpretentious nature, has already been mentioned as one of the attractions of Barthélemy Menn's art.[21] With the advance of Realism, landscape paintings became less glamorous, and the artists looked primarily for hitherto unnoticed motifs, where they discovered hidden beauties. A Swiss artist who befriended the second generation

of the Barbizon school, Otto Frölicher (1840–1890), born in Solothurn, illustrates this trend.[22] He was a pupil of Johann Gottfried Steffan's in Munich and also had spent time in the ateliers of Andreas and Oswald Achenbach in Düsseldorf. In the 1870s Frölicher visited Paris and Barbizon. He returned to Munich, where he avoided the dramatic landscape of the Bavarian woods and lakes in favor of simple, unaffected topics (plate 412). Anker, Castres, and Frölicher all faced early on in their careers the overwhelming impression of Diday's and Calame's exploitation of the Swiss Alpine landscape, and the *paysage intime* was their answer to the commercial use of the touristic Swiss scenery. In Switzerland during the latter half of the nineteenth century there had indeed been a transformation of nature. Everywhere the growing railroad network made new regions accessible and changed the visage of the familiar landscape. Torrents in the Alps were tamed and bridged, while new canals between lakes were dug, destroying the sinuous creeks and the irregular pattern of pools. Yet there is no negative commentary on these alterations of nature in contemporary Swiss art. Indeed, sometimes the railroad, never considered a threat, was a welcome and even picturesque element enriching plains or valleys. Nineteenth-century Swiss landscape painting mirrored, in general, Swiss life as peaceful and prosperous.

Thus, the general development of Swiss landscape painting started in the seventeenth and eighteenth centuries, beginning with artistic conquests of the native country. Romanticism in the first half of the nineteenth century gave birth to the sublime Swiss landscape of multiple cataracts, sunrises or sunsets over the Alps, and plunging views of lakes and valleys. The third step—a reaction to the former level—described the modest and simple beauties of nature to be found in the country's lower regions. Yet the introduction of modern life in painting, such as the progress of technique and technology as expressed in French Realist paintings of industrialization by François Bonhommé or Impressionistic landscapes with railway stations and bridges by Monet and Pissarro, did not become a subject for Swiss artists until the end of the century.

These observations are well illustrated by the generation of painters born in the first years of the 1850s, including Hans Sandreuter (1850–1901) from Basel, Léo-Paul Robert (1851–1923) from Biel, and Frédéric Dufaux (1852–1943) from Geneva.[23] Sandreuter was one of Böcklin's outstanding pupils, and he dedicated his life to painting idealistic frescoes and figure compositions. Visits to Italy and France induced him to paint landscapes. One of his most important works was painted near Basel in the Leimental (plate 411) and has been praised as the finest of his landscapes. The motif is unpretentious but represents the charming richness of a bright summer's day. Sandreuter's approach is similar to Léo-Paul Robert's treatment of the landscape, as shown for example in his view of Nidau near Biel in the canton of Berne (plate 412). Robert was the nephew of Louis-Léopold Robert from Neuchâtel, who at the 1831 Paris

413. Léo-Paul Robert. *Landscape near St. Raphael.* 1881.
Oil on canvas, 10⅝ × 14″. Kunstmuseum, Solothurn

414. Léo-Paul Robert. *A View at Nidau.* 1889. Oil on
canvas over board, 8 × 11″. The Oskar Reinhart Foundation,
Winterthur

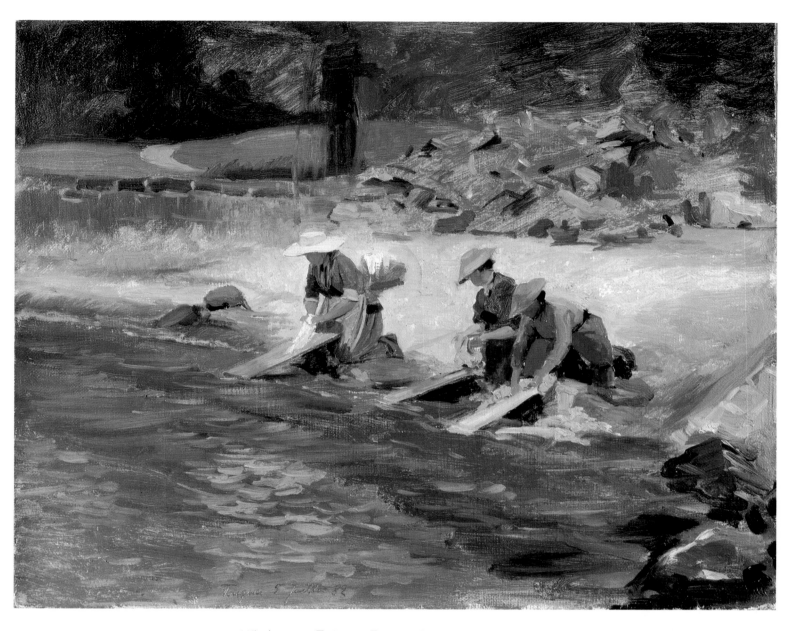

415. AUGUSTE FRÉDÉRIC DUFAUX. *Laundresses.* 1882. Oil on canvas, 12¾ × 15¾″. The Oskar Reinhart Foundation, Winterthur

416. AUGUSTE FRÉDÉRIC DUFAUX. *A View of Tréport.* 1883. Oil on canvas, 8½ × 15⅝″. The Oskar Reinhart Foundation, Winterthur

Salon had a large public following and became famous for his melancholic groups of Roman brigands. Léo-Paul Robert was trained in Munich, Florence, and Paris, under Jean-Léon Gérôme. He is primarily known for his monumental frescoes in the Museum of Fine Arts in Neuchâtel, but like Sandreuter he executed landscapes during periods of relaxation (plate 413).

Frédéric Dufaux seems to have been the most gifted of the so-called Geneva school of landscape painters, all of them pupils of Barthélemy Menn. Dufaux lived from 1876 to 1891 in Paris, afterwards in Geneva. We do not know the details of his life and friends during his stay in Paris, only that he suffered the same fate as many other Swiss painters who demonstrated promising beginnings but returned to their native country only to lapse into oblivion. Dufaux, with his bright and sparkling palette, was close in spirit to the French Impressionists, and he often painted brilliant and witty genre scenes, as in a small painting of washerwomen who blend perfectly into the pleasant banks of the Geneva lake (plates 415 and 416).

In 1980 the Museum of Fine Arts in Berne, the Swiss capital, reconstructed an exhibition of the year 1890, the so-called *Nationale*. Due to Frank Buchser's lobbying, the state had decided in 1887 officially to support the visual arts, including the revival of national exhibitions. But the results of the *Nationale* in 1890 were disappointing, and contemporary reviews found no innovative trends present. The reconstruction in 1980 also confirmed the limited work of the *chefs d'école*.[24]

One painter, however, captivated the critics with a bold and new style: Ferdinand Hodler (1853–1918), who was born in Berne and resided in Geneva.[25] Hodler also studied with Barthélemy Menn and had already achieved a certain reputation in Geneva. In 1891 he tried to exhibit locally his Symbolist composition *The Night*, (1890; Kunstmuseum Berne), but it was expelled from the exhibition by the mayor of Geneva because of its supposedly pornographic subject. Hodler showed the huge painting in a leased exhibition room in Geneva—like Courbet in 1855, who showed his rejected masterpieces in a separate pavilion in Paris—and engineered a considerable public success. The earnings enabled him to send *The Night* to Paris, where it was admitted by the jury of the Salon du Champs-de-Mars in the spring of 1891. In Berne in 1890, three works by Hodler were shown: two figure paintings, one with a pageant of Swiss wrestlers and the other of an enormous warrior. The third canvas was an Alpine landscape. One reviewer compared Hodler's work with modern French art but considered this comparison not to be a recommendation. Only the principles of plein-air painting made the works by Hodler worth mentioning, stated the critic, demonstrating the outdated attitude of the Bernese public toward the new development of taste in France. The critic expressed what a majority of the visitors felt: Hodler's landscapes and figures were conceived in a radically different spirit from Swiss and even European art. Yet Hodler's successful reception in Paris at the Champs-de-

417. FERDINAND HODLER. *A Street in Madrid*. 1878–1879. Oil on board, 8¾ × 5¼″. Private collection

Mars and at the Salon of the Rosicrucians was noted in his homeland, especially in the French-influenced city of Geneva. And in 1897, after his surprising success in winning the competition to decorate the walls of the new Museum of National Heritage in Zurich—an award that provoked the most heated debate about art ever held in Switzerland—he was in a position to change the direction of art in his country.

Trained in the Geneva "tradition" of open-air landscape painting, particularly the work of Menn, Hodler discovered southern light during a longer stay in Madrid in 1878 (plate 417). Without any knowledge of contemporary Impressionist art he developed his own vision of nature; first hesitantly and still relying on Menn's teaching, but after 1880 in his own unmistak-

418. FERDINAND HODLER. *The Beech Forest.* 1885. Oil on
canvas, 40⅛ × 51⅝″. Kunstmuseum, Solothurn

able style. Hodler tried to combine intuitive first impressions of nature with a personal reinterpretation of the individual elements. This attempt resulted in a theoretical concept he called "Parallelism"—of nature and the human mind. In 1897 Hodler gave an important lecture in Fribourg, where he delivered his theory of the artist's mission: "Entering a forest I can see ahead of me, to the right and to the left, the innumerable columns formed by the tree trunks. I am surrounded by the same vertical line an infinite number of times."[26] As early as 1885 he had painted *The Beech Forest* (plate 418), which represents the beginning of his artistic efforts to meet this theory.[27] Through the Geneva poet Louis Duchosal, Hodler became familiar with French Symbolist tenden-

cies and visited Paris several times. By the late 1880s he was specializing in large Symbolist figure paintings with titles such as *View into Eternity* or *Dialogue with Nature*.

Hodler neglected landscape painting until he became interested again in nature after the turn of the century. In *Lake Geneva from St-Prex*, painted in 1901 (plate 419), the artist rejected the traditional conception of landscape painting in favor of a new vision. He amalgamated two aspects that seem at first incompatible: a detailed lifelike description of nature and an artificial rhythm connecting the four horizontal layers of meadow, lake, mountain, and sky. The panicles in the foreground, the tiny trees in the middle ground, and the stylized clouds dominate the natural impression without violat-

419. Ferdinand Hodler. *Lake Geneva from St. Prex.* 1901.
Oil on canvas, $28\frac{1}{8} \times 42\frac{1}{8}$". Private collection

ing reality. The striking contrast in color between the yellow green soil and the different blues in the upper half of the landscape gives the painting an expressive power that has been compared with the vision of an intimate and sweet dream.[28]

One of the important motifs in the first decade of the twentieth century was forest interiors, often with water in the form of small streams and cascades. At a large exhibition of Hodler's works, organized by the Vienna Secession in 1904, one example was shown under the title *Song of the Forest*, recalling similar motifs by Nordic artists such as Âxel Gallen-Kallela and Edvard Munch.[29] Basically the small details have the same metaphorical weight as the open landscape of the Geneva lake. Nature encompasses not only different aspects of water, rocks, pebbles, soil, moss, undergrowth, trunks, and leaves but also the miracle of divine creation. Hodler

was strongly influenced by pantheism, and his *Forest Interior near Reichenbach* (plate 420) seems to be filled with whispering voices of supernatural beings. If Impressionism is often named a banquet for the eyes, Hodler's forest piece could be called a meal for the soul.

Hodler's impact also altered the budding influence of French Impressionism in Switzerland. The new generation of young and gifted Swiss painters, who otherwise would have absorbed the tenets of Impressionism, looked to Hodler to learn the direction of the new avant-garde spirit of the fin de siècle. Thus, because of Hodler's catalytic role, the style of French Impressionism of the 1870s was bypassed in favor of Post-Impressionism. Young Swiss artists such as Cuno Amiet went to Pont-Aven and discovered there the transformation of landscape into a transcendental vehicle for the soul of the artist.

420. FERDINAND HODLER. *The Forest Interior near Reichenbach*. 1903. Oil on canvas, 43¾ × 33⅞". Private collection

# IMPRESSIONISM IN AUSTRIA AND GERMANY

*Horst Uhr*

IMPRESSIONISM IN AUSTRIAN painting began to flourish in the early 1880s, its rise, ironically, coinciding with the completion of Vienna's Ringstrasse, an imposing array of buildings—both public and private—constructed in various historicizing styles. The modest landscapes of the Austrian Impressionists had no place in such an environment. These buildings called for a program of interior decoration in which painting joined architecture and sculpture in an appropriately splendid *Gesamtkunstwerk.* While the task of achieving this fell to such skillful imitators of the Baroque as Hans Makart (1840–1884) and his disciples, the Impressionists painted on the outskirts of the city and in the small market towns and villages along the Danube, in the Salzkammergut and the plain of the Hungarian Puszta. They nonetheless managed to exhibit their paintings with considerable success not only in Vienna, but in London, Paris, Berlin, Munich, and Düsseldorf, winning critical praise as well as more tangible rewards in the form of medals, prizes, and other distinctions.

German Impressionism developed much later, about 1900, a quarter century after the first group exhibition of the French Impressionists and long after the French pioneers of the movement, such as Renoir, Monet, and Pissarro, had abandoned Impressionism in its original form. The center of German Impressionism was Berlin. More specifically, this style of painting came to be identified with the Berlin Secession, an association founded in May 1898, of painters, sculptors, and graphic artists recruited from all over the country for the purposes of organizing exhibitions independent of the academy-sponsored shows at the Berlin Glass Palace and promoting closer contacts with artists from abroad. Unlike the Société Anonyme—the collective name by which the French Impressionists had first introduced themselves—the Berlin Secession was an immediate success. Supported by enlightened bankers and industrialists, the association had its own exhibition building and was closely connected with dealers who supported the secessionist cause. From 1900 on the Berlin Secession regularly exhibited works by leading foreign painters, including the French Impressionists as well as artists representing more recent trends. The Berlin Secession itself was not a homogeneous group, for it included Realists such as Hans Baluschek (1870–1935), the Symbolist- and Jugendstil-inspired Ludwig von Hofmann (1861–1945) and Walter Leistikow (1865–1908), and the Pointillists Curt Herrmann (1854–c. 1920) and Paul Baum (1859–1932). However, the secession's three most important members, Max Liebermann (1847–1935), Max Slevogt (1868–1932), and Lovis Corinth (1858–1925), were Impressionists. In recognition of their leadership, the Berlin dealer Paul Cassirer conferred on them the designation "triumvirate of German Impressionism."[1]

A shrewd businessman, Cassirer was keenly aware of the marketing value of the Impressionist label, although his description distorted the true nature of the

422. CARL BLECHEN. *View of Rooftops and Gardens.* c.1828–1829. Oil on canvas, 7⅞ × 10¼″. Staatliche Museen Preussischer Kulturbesitz, Nationalgalerie, Berlin (West)

three painters' contribution. The "triumvirate" part of the designation, on the other hand, was a felicitous choice, for the Berlin Secession stood in opposition not only to the Berlin Academy and its director Anton von Werner (1843–1915) but also to the aesthetic precepts espoused by many conservative groups and even the imperial court. Kaiser Wilhelm II himself took more than a passing interest in such matters. Believing that under his reign the arts should prosper, he was at once conservative and chauvinistic and delighted in any artistic effort that celebrated the house of Brandenburg-Prussia. He also liked to foster the illusion that Germany was the special guardian of Western civilization. "For us Germans the great ideals which are more or less lost to other peoples have become permanent possessions," he boasted in the speech on September 18, 1901, that celebrated the opening of the Siegesallee, the broad new avenue traversing the Tiergarten to the Brandenburg Gate.[2] Already in 1897 the conservative newspaper *Re-*

*ichsbote* expressed the fear that the "ridiculous fad for the foreign" was corrupting German art and the German art market, insisting that the "wealthy, educated circles in Germany" had to understand that they owed it to their country "to favor German art and thus spur it on to great achievements."[3] Conservative resentment continued to center on the international role the Berlin Secession had begun to play, as well as on the foreign influence that seemed to be reflected in the work of the German Impressionists.[4]

There is no question that German artists benefited from contact with French painting throughout the nineteenth century and possibly profited even more from modern Dutch painting. Yet Impressionism in both German and Austrian painting has so much a character of its own, and its real origins are so entirely indigenous, that to transfer the term "Impressionism" from French developments is useful only in a general way. In its Austrian or German context it at best describes a sketchlike tech-

IMPRESSIONISM IN AUSTRIA AND GERMANY

nique. There Impressionists were far less concerned than the French with the juxtaposition of bright colors and colored shadows; nor were they as preoccupied with rendering minute nuances of light and atmosphere. Series such as Monet's views of Waterloo Bridge, Rouen Cathedral, or his grain stacks are unknown in the German and Austrian schools. Instead of breaking up their images into many brush strokes, painters of both countries tended to respect the material integrity of nature and adhered to a greater cohesion of tones. At the same time, they viewed nature subjectively, projecting their sentiments into what they saw so as to communicate some of their innermost feelings. For some, moreover, typically Impressionist subjects only complemented a pervasive preoccupation with more conventional themes. As a consequence, Impressionism in Austria and Germany represents a much less drastic departure from earlier tradition than is the case with French Impressionism and thus is more accurately defined as the culmination of nineteenth-century Naturalism, albeit in a more painterly form. Impressionism in Germany and Austria is, in fact, really not any more "impressionistic" than the brushwork of Velázquez and Frans Hals, to which the term is also often applied in a generalized way. Especially with regard to painting out-of-doors, it is difficult to draw sharp distinctions between the different stages of what was a fairly continuous development. Indeed, well before the French critic Louis Leroy in 1874 referred to the French painters as "Impressionists," German and Austrian painters could look back on a long tradition of *Freilichtmalerei* of their own. The sources of their Impressionism are found there.

The German Romantic painter Philipp Otto Runge (1777–1810) anticipated the development as early as 1802, when he wrote: "In our time . . . something is about to die . . . everything is becoming more airy and light than before, everything gravitates toward landscape."[5] Runge himself never shared in this trend, although the rendering of natural light was for him, too, a major interest. In the course of a short career he produced a subjective art, culminating in emblematic compositions incorporating both Christian and cosmic references intended to reveal the workings of God in nature and in man's soul. This conflict between sensory experience and the need to rise above it was to surface repeatedly throughout the 1800s and is an essential feature also of German Impressionism.

Concerns for both optical sensations and intellectual significance in a work of art already motivated Albrecht Dürer (1471–1528), and since Dürer's time artists painted out-of-doors and many more did drawings from nature. In the context of German and Austrian Impressionism there is no need, however, to trace these developments back any further than the early nineteenth century. A small anonymous German picture of that period, now in the Neue Pinakothek in Munich, depicts a painter in the countryside seated on a cart ingeniously equipped with a box to hold easel and painting utensils and with a bench to make working in the open more comfortable.[6] Yet, since plein-air painting was not as yet widely accepted, such an artist would have felt compelled in his public works to subordinate the freshness of his original visual impressions to artificial studio tones and a romanticized conception.

In German-speaking Europe the distinction of having been among the first, if not *the* first, nineteenth-century artist to have considered that oil sketches executed in the open air could be entirely independent and complete works belongs to Johann Georg von Dillis (1759–1841).[7] Among his best-known works are the views of Rome (Schack-Galerie, Munich) that he painted in 1818 at the Villa Malta while accompanying the Bavarian crown prince (and future king) Ludwig to Italy. As early as 1790 Dillis had painted landscapes in the Bavarian countryside and soon thereafter turned his attention to the environment of Munich. In Dillis's oil sketches emphasis is entirely on optical experience. Nature is not described in detail, but suggested broadly. Each stroke of the brush is an autonomous pictorial expression; light and atmosphere are a function of color. Even the human figures have been depersonalized. They are mere splashes of pigment and not the carrier of some anecdotal content.

Elsewhere in Germany early plein-air painting flourished in various regions. Georg Wilhelm Issel (1785–1870), a native of Darmstadt, worked directly from nature around 1814 or perhaps even earlier. Three Hamburg painters, Friedrich Wasmann (1805–1886), Christian Morgenstern (1805–1867), and Johann Jacob Gensler (1808–1845) painted out-of-doors in the 1830s and 1840s. The Norwegian Johan Christian Clausen Dahl (1788–1857) left his mark on artists in Dresden, where he taught at the academy from 1824 on. Dahl painted two kinds of landscapes: Romantic mood scenes reminiscent of the work of his friend Caspar David Friedrich (1774–1840) and small plein-air landscapes that testify to his keen powers of observation. The topographical sites of many of his oil sketches can be identified. Dahl also painted meteorological phenomena, such as clouds, as did Carl Gustav Carus (1789–1869), another member of Friedrich's circle.

In Berlin, artists were heading toward an objective representation of the material world already at the turn of the century, which led to a public debate in 1802 between the poet and dramatist Goethe and the sculptor Johann Gottfried Schadow (1764–1850) on the respective merits of idealism and realism. By the 1830s Johann Erdmann Hummel (1769–1852) and Eduard Gärtner (1801–1877) produced panoramic portraits of the city that are of almost photographic clarity and precision. But only with Carl Blechen (1798–1840) was true plein-air painting introduced in Berlin. Blechen, who had befriended both Friedrich and Dahl in Dresden in 1823, started out as a painter of landscapes that communicate mood in a Romantic manner. A thirteen-month period of study in Italy, beginning in the autumn of 1828, enabled him to see nature in terms of more purely pictorial qualities. While a freer painterly handling—already no-

ticeable prior to his departure for the south—may have been encouraged by his contact with Dahl, light as a predominant feature first entered Blechen's landscapes in Italy. His Italian landscapes have a close affinity to those of Corot and indeed were painted immediately after the French painter's first visit to Rome. Like Corot, Blechen rendered light and atmosphere in terms of tonal values, evolving his imagery from a rich tactile impasto. Upon his return to Berlin, he translated these sketches into larger and more finished works, opting for a tighter compositional structure and a more disciplined handling of the paint. Blechen's small plein-air picture of Berlin rooftops and backyards (plate 422) is undated but was painted either just before his trip to Italy or soon thereafter.[8] The choice of the unpretentious subject is as bold as the abbreviated execution, the image having been rendered entirely through color applied in brush strokes of varying sizes and shapes.

When Blechen exhibited several of his Italian landscapes at the Berlin Academy in 1832, his bold technique and sincere conception met with little understanding. Only in 1835 did an anonymous critic—who was no doubt thinking of Corot—compare Blechen's works favorably with those of contemporary French painters. Although Blechen was elected in the same year to membership in the Royal Academy, he had little influence on the further development of Berlin painting. Already the following year he was forced to suspend his teaching activities due to the onset of an incurable mental illness. He died insane on July 23, 1840, six days before his forty-second birthday.

Blechen's picture precedes by only a little more than a decade the similarly prosaic early subjects of Adolph von Menzel (1815–1905), considered by modern critics to be Berlin's greatest nineteenth-century painter. Menzel's are small-scale works, painted between the mid-1840s and the mid-1850s, of subjects taken from his immediate environment and observed in both natural and artificial light. While reminiscent of the open-window motif of the Romantic tradition and many a Biedermeier interior, *The Balcony Room* (plate 423), one of several paintings of Menzel's family apartment in Berlin, is devoid of anecdotal content. The room is only sparsely furnished, as if someone were in the process of moving in or moving out. As with similar effects in photography, the seemingly accidental cropping of the composition on all sides accentuates the feeling of emptiness still further. Yet this impression is calculated so as to enhance the real subject of the painting: light, which enters the room through the billowing curtains and is reflected off the mirror, the chairs, and the shiny floor. The pigments have been applied broadly, simplifying the forms they describe.

Whether the young Menzel knew of Blechen's work is uncertain; he never mentioned him in his correspondence. But Menzel was aware of developments in France. As early as 1836 he defended "the materialism of today's Frenchmen," by which he meant their tactile paint application, referring specifically to the marine

423. ADOLPH VON MENZEL. *The Balcony Room*. 1845. Oil on paper, 15¾ × 12½″. Staatliche Museen Preussischer Kulturbesitz, Nationalgalerie, Berlin (West)

painter Théodore Gudin.[9] Gudin, whose work was influenced by John Constable and Eugène Isabey, eventually visited Berlin in 1844, establishing contact with several local artists. The proto-Impressionist spontaneity and abbreviated forms of Menzel's landscapes from the 1840s are similar to Constable's oil sketches. This is true also for Menzel's study of clouds (plate 424), although in this painting he was most likely indebted to the indigenous German tradition, especially the cloud studies of Dahl, which he may have known from two trips he undertook to Dresden in 1840 and 1850. In his cloud study, Menzel was, again, a dispassionate observer, motivated by curiosity about meteorological phenomena rather than a pantheistic yearning for the infinite. He most likely observed this subject from his window and executed it directly from nature. The pigments are applied on a brownish ground that is visible along the line of treetops at the lower margin. This ground also functions coloristically, describing the character of the early evening sky.

In October 1855 Menzel traveled to Paris to see the Exposition Universelle, the first in the French capital's series of world's fairs. Patterned on the successful International Exposition held in London in 1851, the Paris exposition celebrated the most recent technological

424. ADOLPH VON MENZEL. *Study of Clouds.* 1851. Oil on
canvas, 11 × 15¾″. Staatliche Museen Preussischer Kulturbesitz,
Nationalgalerie, Berlin (West)

425. ADOLPH VON MENZEL. *Afternoon in the Tuileries
Garden.* 1867. Oil on canvas, 19¼ × 27⁹⁄₁₆″. Staatliche
Kunstsammlungen, Gemäldegalerie Neue Meister, Dresden

achievements, but also included the 1855 Salon, which opened on May 15 as an important part of the exhibition program. Although we know little about Menzel's trip, the opportunity must have allowed him an in-depth look at contemporary French painting. Perhaps he also saw the one-man show that Courbet had independently set up in a pavilion in the Avenue Montaigne. Menzel returned to Paris in 1867, and this time he certainly visited Courbet's pavilion at the Place de l'Alma and apparently also saw another independent exhibition that Manet had organized nearby. That Manet left an impression on him is indicated by *Afternoon in the Tuileries Garden* (plate 425), which Menzel painted soon after his return to Berlin. Yet the differences between Menzel's picture and Manet's 1862 *Music in the Tuileries* (plate 000), which was included in the painter's 1867 one-man show, are substantial. Whereas Manet subordinated the individual figures to the unity of the picture plane, Menzel was less concerned with the concept of the painting as a whole than with making palpable all the things *in* the painting. On the basis of many preliminary pencil drawings executed in Paris, he depicted a scene rich in narrative details, and his bourgeois milieu is made up of various social classes and generations. Each figure in the foreground is characterized in terms of actions, gestures, and physiognomy. There is also considerable reliance on local color; only in the far distance do the figures and colors weave together.

Thus, by 1867 Menzel had long abandoned the technique of his earlier oil sketches and begun to introduce many intermediary steps between the initial conception and final execution of a painting. During his second visit to Paris he was far less interested in Courbet and the young painters around Manet than in more established artists such as Ernest Meissonier, whom he befriended and visited at his studio in Poissy. Menzel's early oil sketches, meanwhile, lay hidden away in his studio. Indeed, in his old age, believing genius to be synonymous with diligence, Menzel dismissed the spontaneous manner of the French Impressionists as mere "laziness."[10]

In the career of the Bavarian Franz von Lenbach (1836–1904), who by 1856 painted refreshingly simple plein-air landscapes and genre scenes in the vicinity of his native Schrobenhausen and developed a keen interest in natural light during his first journey to Rome in 1858, a potentially Impressionistic conception was similarly limited to the early years of his development. Lenbach not only possessed well-developed powers of observation, he was also unusually sensitive to the manifestation of light as color. In *The Red Umbrella* (plate 426), for example, a harvest landscape painted in 1861, the summer's heat is not depicted in terms of conventional anecdotal details but rather through the contrast between the golden yellow tones of the fields and the magnificent red of the large umbrella shielding a young girl and an infant asleep in a cart. As in Menzel's oil sketches, the individual forms are not dissolved but instead are blocked out in terms of broad areas of juxtaposed pigments. Six years

after completing this picture Lenbach turned away from plein-air painting and devoted his attention exclusively to portraits, in which he employed a stereotyped chiaroscuro borrowed from sixteenth- and seventeenth-century masters. His clients included such luminaries as Richard Wagner, Bismarck, and Pope Leo XIII, assuring Lenbach of a stunningly successful career and a sumptuous life-style that earned him the title "prince of painters."

The development of *Freilichtmalerei* in Austria during the first half of the nineteenth century was equally sporadic. Adalbert Stifter (1805–1868), novelist and amateur painter, produced nature studies of an Impressionistic directness comparable to the sketches of Blechen and the young Menzel. The first great landscapist to turn his attention to the sunlit Austrian countryside was Ferdinand Georg Waldmüller (1793–1865). In 1829 he was named keeper of the Vienna picture gallery and professor at the academy, but shortly thereafter began to jeopardize both appointments by advocating the study of nature in opposition to conventional academic teaching. Waldmüller once confessed that a patron's request for a perfect likeness had been a revelation for him and made him recognize that true art must be based on a thorough understanding of nature. In 1831 he traveled for the first time to the Salzkammergut and upon his return exhibited the paintings he had executed there, adding to the various titles the annotation "study after nature" so as to underscore his disavowal of any idealist conception.[11] Waldmüller's continued advocacy of the study of nature eventually led to his forced retirement in 1857. His landscapes possess a sunlit clarity, but he never developed a pictorial solution with which to communicate the transitory effects of light and atmosphere. The extent to which the corporeal substance of the individual forms of nature remained for him more important than purely optical phenomena can be seen in his view of Mödling, a small picturesque town nestled in the hills of the Vienna Woods (plate 427). The details of the landscape have been reproduced faithfully throughout. Light etches rather than dissolves the forms and extends across the smooth picture surface like a unifying film. Waldmüller had many students, but only a few followers who overcame the still popular convention of *vedute* painting. The Alpine landscapes of Franz Steinfeld (1787–1869) and his son Wilhelm Steinfeld (1816–1854) are closely related to Waldmüller's works, as are the Prater landscapes of Matthias Rudolf Thoma (1792–1869), many of which have been attributed to Waldmüller himself.

Whereas plein-air painting in the first half of the nineteenth century in Austria and Germany resulted from individual efforts, sometimes—as in the case of Blechen and Lenbach—encouraged by travel in Italy, contact with developments in France helped shape the collective experience of many painters from the middle of the century onward. Several young men from Frankfurt were among the first to encounter the art of Courbet and the Barbizon school. This group included Victor Müller (1830–1871), Angilbert Göpel (1821–1882), Jules

426. FRANZ VON LENBACH. *The Red Umbrella.* c.1860. Oil on
paper on cardboard, 10⅝ × 13⅝″. Hamburger Kunsthalle,
Hamburg

427. FERDINAND GEORG WALDMÜLLER. *View of Mödling.*
1848. Oil on canvas, 22 × 27³⁄₁₆″. Collections of the Prince of
Liechtenstein, Vaduz Castle

Lunteschütz (1822–1893), and Otto Scholderer (1834–1902). Müller, the group's driving force, lived in Paris from 1851 to 1858. He studied with Thomas Couture, but also found himself drawn to Courbet, whom he met in 1852. Although Müller's own art remained close to Couture's, he became one of Courbet's strongest supporters in Germany. In 1852, 1855, and 1858 he organized exhibitions of Courbet's works in Frankfurt and in conjunction with the last show invited the French painter to visit the city, where the two shared a studio for about half a year.[12]

Göpel, Lunteschütz, and Scholderer were introduced to Courbet's paintings in Frankfurt. Scholderer subsequently deepened his understanding of French painting in Paris, first in the winter of 1857–1858 and then intermittently throughout the 1860s. He befriended Henri Fantin-Latour and joined the circle of Manet at the Café Guerbois in the Grande rue des Batignolles. Fantin-Latour depicted Scholderer and Manet along with several other members of "le groupe des Batignolles" in *Le Toast*, a picture he submitted to the Salon of 1865 but subsequently destroyed. In 1870 Fantin-Latour completed another group portrait, *A Studio in the Batignolles Quarter* (plate 21), depicting Scholderer, Renoir, Monet, Zacharie Astruc, Émile Zola, Edmond Maître, and Frédéric Bazille grouped around Manet. Scholderer surely knew of the French painters' plans to organize an exhibition independent of the juried exhibitions at the Salon. Already in 1867 Bazille had communicated these plans to his family, although at the time the exhibition could not be realized due to lack of funds. New plans were made in 1869, evidently initiated by the Batignolles group, only to be thwarted again, this time by the outbreak of the Franco-Prussian War.[13]

Scholderer's attractive still life of pansies and cherries (plate 428), painted around 1870, perhaps while he was still in Paris, recalls the still lifes of Fantin-Latour, especially in the tightly rendered textures of the objects and in the decorative arrangement before a neutral ground, while the more freely brushed tablecloth is technically closer to still lifes by Bazille, Renoir, and Monet from the 1860s. Another Frankfurt painter, Louis Eysen (1843–1899), made his way to Paris in 1869, where he studied with Léon Bonnat and Scholderer. Hans Thoma (1839–1924), a native of the Black Forest hamlet of Bernau, spent several weeks with Scholderer in the French capital in 1868, at which time he met Courbet and was profoundly impressed by his art.

German awareness of contemporary French painting intensified as a consequence of the important international exhibition held in Munich in 1869. Victor Müller, who had settled in the Bavarian capital four years earlier, and the landscape painter Eduard Schleich the Elder (1812–1874), who had first visited Paris in 1851 where he found inspiration in the Barbizon school, were among the organizers of the exhibition and saw to it that Gustave Courbet and the Barbizon painters were amply represented: Courbet, who sent seven works, including his 1849 *The Stonebreakers* (formerly Staatliche

428. OTTO SCHOLDERER. *Still Life with Pansies.* c.1870. Oil on canvas, 15 × 18⅛". Collection Dr. Georg Schäfer, Schloss Obbach, Euerbach

429. WILHELM LEIBL. *Portrait of Mina Gedon.* 1868–1869. Oil on canvas, 47 × 37⅝". Bayerische Staatsgemäldesammlungen, Neue Pinakothek, Munich

Gemäldesammlungen, Dresden), received an entire room for himself. Manet exhibited two paintings, *Spanish Singer* (or *Guitarrero*) of 1860 (The Metropolitan Museum of Art, New York) and *Philosopher with Cap* of 1865 (Art Institute of Chicago). When Courbet visited Munich in October 1869 to see the exhibition, he had much praise for "the young people" he encountered there, who—as he wrote to his parents—painted exactly the way he did.[14] Among the "young people" whom Courbet met at this time were Theodor Alt (1846–1937), Karl Haider (1846–1912), Rudolf Hirth du Frênes (1846–1916), Wilhelm Leibl (1844–1900), Johann Sperl (1840–1914), and Wilhelm Trübner (1851–1917), and probably the Hungarian Pál Szinyei-Merse (1845–1920), all of whom were still students at the Munich Academy. Courbet demonstrated for his new friends his technique by painting two pictures, a female nude and a landscape, the latter executed in the course of two hours.[15] The young Germans were impressed by Courbet's *alla prima* method, his lively paint application, careful distinction of tonal values, and summary treatment of form. The young Wilhelm Leibl, whose *Portrait of Mina Gedon* (plate 429) was included in the 1869 exhibition, had already developed a similar approach on his own, and when Courbet wrote to his parents, he no doubt was thinking of this painter. Indeed, Courbet considered Leibl's portrait the highlight of the exhibition.[16] This painting—executed in a broad, fluid manner, with the figure displayed against a shallow neutral ground— is actually closer to Manet's paintings from the 1860s than to Courbet's, but it is the result of Leibl's entirely independent study of seventeenth-century masters. Manet had learned from Velázquez; Leibl was indebted to Rembrandt.

Victor Müller, who also served on the jury of the 1869 exhibition, saw to it that both Courbet and Corot received the Order of Saint Michael First Class, the highest distinction the Bavarian government could bestow, and he recommended that Leibl's portrait, too, be given an award. The nomination for a gold medal, however, was withdrawn after Arthur von Ramberg (1819–1875), one of Leibl's teachers, argued that Leibl was still a student and thus possibly had not worked independently on the portrait.[17] In October 1869, when Leibl accepted the invitation of the French painter Henriette Browne (Sophie de Saux) to come to Paris, he took the portrait of Mina Gedon with him and exhibited it at the 1870 Salon. The picture was well received, and the young painter was awarded the gold medal that had eluded him the year before.

Leibl remained in the French capital for eight months. During this time he frequently met with Courbet and the two Frankfurt painters Scholderer and Eysen. He probably also got to know Manet, whose simplified brush strokes and restrained palette he emulated in several of his Paris paintings. Unfortunately, the outbreak of the Franco-Prussian War cut short Leibl's stay in France in July 1870. Upon his return to Munich he encountered much hostility, for not only had he been honored by the enemy, he was also seen as the principal promoter of French influence on German painting. Henceforth Leibl painted in the villages of the Bavarian countryside, often in the company of like-minded friends. Trübner, the Karlsruhe painter Albert Lang (1847–1933), and the Viennese Carl Schuch (1846–1903) joined him in 1871 in Bernried at the Starnberger See, often painting the same motifs as the French Impressionists were doing at this time along the Seine at Argenteuil and in Louveciennes. Thoma, Scholderer, Eysen, and Hirth du Frênes also maintained contact with Leibl. After 1878 Leibl and Johann Sperl worked and lived together. The Austrian Fritz Schider (1846–1907), who had married Leibl's niece Lina Kirchdorffer in 1877, occasionally came to visit.[18]

Common to the development of these artists was the experience of French pre-Impressionist painting: the Barbizon school, Courbet, and Manet's works from the 1860s. Even if they knew paintings by the young French Impressionists, as was the case with Scholderer, their works, too, would also have been indebted to the Barbizon tradition. Hans Thoma's panoramic Rhine river landscape near Säckingen (plate 430), for instance, recalls paintings by Daubigny, except that the tonality is more unified and emphasizes to a far greater extent the mood rather than the purely visual character of the landscape. Another idyllic touch is provided by the human figures, painted in clear, local colors, and even at a distance legible enough to register the solicitous concern of the peasant woman seeking to steady her child on the back of a donkey. Louis Eysen's *Summer Landscape* (plate 431), painted near Kronberg in the foothills of the Taunus mountains sometime between 1875 and 1877, is devoid of such anecdotal elements and consequently appears more distinctly French. Both Monet and Renoir had painted such flower-strewn meadows a few years earlier, although the atmospheric character of Eysen's landscape, an effect achieved through slight intervals between color values, recalls more specifically the example of Corot.

Wilhelm Trübner took Leibl's *alla prima* technique as his point of departure, but developed from it an independent solution to the problem of plein-air painting (plate 432) by organizing his brush strokes into a system of regular patches that lend the surface texture of his pictures a strong element of design. There are no truly atmospheric effects; near and distant objects generally possess the same clarity. Trübner's technique, in short, is intellectual rather than truly optical in nature, and as a result his landscapes have a decorative character, reinforced by a narrow color scale that is dominated by delicate shades of green gravitating toward gray.

Carl Schuch evolved a systematic kind of brushwork of similar aesthetic appeal. In his case the concern for formal rather than primarily descriptive considerations eventually led to a remarkable emancipation of the pictorial means. Especially in the still lifes he painted in Paris between 1882 and 1891 there is less emphasis on the objects than on the independent life of the colors.

430. Hans Thoma. *The Rhine Near Säckingen.* 1873. Oil on
canvas, 25 × 40⅜″. Staatliche Museen Preussischer Kulturbesitz,
Nationalgalerie, Berlin (West)

Schuch was at the time fully aware of the French Impressionists. He understood that local color is modified by light and atmosphere, and he spoke of such Impressionist methods as the juxtaposition of primary hues to be blended by the human eye. He even used the term *Impressionismus.* Nonetheless, he remained sceptical of the French Impressionists' achievement. He considered their "seemingly unselfconscious technique . . . another form of self-consciousness," an interesting but one-sided "absurdity." As for Monet, he admitted that his paintings were of a pervasive airiness but thought that in the end "nothing much happened."[19] His still life of asparagus (plate 421), which he painted, like all his Paris still lifes, in a small gloomy studio in the rue St. Honoré, recalls Manet's two earlier asparagus still lifes of 1880 (Wallraf-Richartz Museum, Cologne; Musée d'Orsay, Paris). But light in Schuch's painting, as in works by the seventeenth-century masters Schuch so admired, manifests itself only as a consequence of the surrounding darkness. The colors glow against a dark ground, and the brush strokes communicate a sense of urgency that is very different from the typical Impressionist way of seeing.

There are a few works from the Leibl circle that parallel—at least conceptually, though not always technically—paintings by the French Impressionists. Among these is Rudolf Hirth du Frênes's 1875 picture of Leibl and Sperl sailing on the Ammersee near Unterschondorf (plate 434). Only a year earlier Manet had painted his two great boating pictures at Argenteuil (plate 26). Like the Frenchman, Hirth was preoccupied with the momentary impression of the outing rather than with conventional verisimilitude. Yet he was far less interested than Manet in conveying nuances of light and atmosphere, applying instead opaque, weighty pigments and summarizing the individual forms in a broad, simplified manner. Fritz Schider, perhaps the finest colorist of the Leibl circle, had by the early 1870s developed a similarly abbreviated style. And like the French Impressionists, he had a penchant for bourgeois themes: men and women enjoying picnics in the countryside or the pleasures of an urban park. Unlike Menzel's anecdotal painting of 1867 (plate 425), Schider's picture of the Chinese tower in the English Garden in Munich (plate 433) conveys the impression of an informal gathering in a broader and more fluid manner that—in a way that is

IMPRESSIONISM IN AUSTRIA AND GERMANY

431. LOUIS EYSEN. *Summer Landscape.* 1875–1877. Oil on canvas, 19½ × 26⁹⁄₁₆″. Städelsches Kunstinstitut und Städtische Galerie, Frankfurt

432. WILHELM TRÜBNER. *Utility Buildings on the Herreninsel in the Chiemsee II.* 1874. Oil on canvas, 24⅜ × 30⅜″. Bayerische Staatsgemäldesammlungen, Neue Pinakothek, Munich

433. FRITZ SCHIDER. *The Chinese Tower.* c.1873. Oil on
canvas, 55⅛ × 43¾″. Öffentliche Kunstsammlung, Basel

434. RUDOLF HIRTH DU FRÊNES. *The Painters Leibl and Sperl in a Sailboat.* 1875. Oil on canvas, 30⅞ × 25¼″. Staatliche Kunsthalle, Karlsruhe

435. WILHELM LEIBL. *The Veterinarian Dr. Reindl in the Arbor.* c.1890. Oil on wood, 10⅛ × 7¾″. Städtische Galerie im Lenbachhaus, Munich

similar to Manet's *Music in the Tuileries* (plate 23)—subordinates the details to a generalized treatment. This is even more evident in Schider's preliminary oil sketches for the painting, which were done out-of-doors, whereas the final version was executed in the studio. Among the painters of his circle Leibl himself ultimately produced the most pronounced *Pleinairismus*. Although he usually avoided the use of broken brush strokes and unmodulated pigments, in the early 1890s he did several open-air paintings that are fairly pure examples of Impressionism. In the small panel depicting the veterinarian Doctor Reindl (plate 435), figure and space are unified by outdoor light, and the flickering brush strokes break up the forms into a myriad of colors.

Closely related to Schider's painting is the well-known 1873 *Picnic in May* (Magyar Nemzeti Galéria, Budapest) by Pál Szinyei-Merse. Szinyei-Merse too, as in *Drying Laundry* (1869; Magyar Nemzeti Galéria, Budapest), made astonishingly free studies directly from nature, but in his finished works he subordinated his painterly technique to a more controlled rendering. Indeed, *Picnic in May* was executed in Szinyei-Merse's Munich studio during the winter 1872–1873 in memory of a pleasant spring day spent in the Hungarian countryside. When the canvas was exhibited in Budapest soon thereafter, both the lively character and modern subject

met with such hostile criticism that Szinyei-Merse withdrew to his estate at Jernye, painting little for the next twenty years.

Despite a strong indigenous artistic tradition, Austria in the nineteenth century lost some of her most promising painters to Munich. Moritz von Schwind (1804–1871) settled in the Bavarian capital in 1828; Arthur von Ramberg followed in 1849; both Hans Makart and Franz von Defregger (1835–1921) studied at the Munich Academy in the 1860s. Schwind, Ramberg, and Defregger also taught at the Munich Academy, attracting still other Austrian painters to the city. Schuch and Schider have already been mentioned; two other Austrian painters who belonged to the larger Leibl circle were the genre and portrait painter Carl Mayr-Graz (1850–1929) and the Viennese still life painter Ludwig Eibl (1842–1918).

Austrian pre-Impressionists who remained active in their native country transformed the tradition of

436. Jakob Emil Schindler. *Peasant Garden at Goisern.*
1883. Oil on wood, 10¼ × 13½″. Collection Dr. Georg Schäfer,
Schloss Obbach, Euerbach

Waldmüller into a more convincingly atmospheric type
of landscape painting. Some, including Ludwig
Halauska (1827–1882), with whom Carl Schuch studied
in the late 1860s, achieved this independently through
close observation of nature. For others, such as August
von Pettenkofen (1822–1889), who traveled to Paris in
1852 and 1855, further decisive influences came from
the Barbizon school. In 1870 landscapes by the Barbizon
painters were also well represented at the international
exhibition inaugurating the new building of the Associa-
tion of Viennese Artists. Even for Eugen Jettel (1845–
1901) and Rudolf Ribarz (1848–1904), who both lived
in Paris for many years, from the early 1870s to the early
1890s, the experience of Barbizon Naturalism was more
important than French Impressionism. Their

IMPRESSIONISM IN AUSTRIA AND GERMANY

437. Olga Wisinger-Florian. *Falling Leaves.* 1899. Oil on canvas, 36⅝ × 50⅜″. Österreichische Galerie, Vienna

landscapes—painted in veiled, broken tones, not in bright colors—convey a gentle, slightly melancholic mood.

Jakob Emil Schindler (1842–1892), Austria's most influential landscape painter in the second half of the century, first got to know works of the Barbizon school at the 1873 Vienna World Exposition and in 1881 visited Paris, drawing further inspiration from Rousseau, Daubigny, Dupré, and Corot. Already in the 1860s Schindler had painted landscapes of a similarly elegiac mood. In the 1880s he adopted a lighter palette and a more effervescent treatment of light and atmosphere, yet as his handsome garden pictures from Goisern in the Salzkammergut illustrate (plate 436), he neither subordinated nature to a more summary treatment, nor did he

entirely abandon the romanticizing conception of his earlier years, a tendency that has earned him the epithet "*Stimmungsimpressionist.*"[20]

Schindler was a gifted teacher. His students in the 1880s, who often accompanied him on extended study trips in the Austrian countryside, included Olga Wisinger-Florian (1844–1926), Maria (or Marie) Egner (1850–1940), and Carl Moll (1861–1945). Egner and Wisinger-Florian continued in Schindler's manner (plate 437). Since so many of Wisinger-Florian's landscapes are of the autumnal countryside, she was called "the Mistress of Autumn."[21] Moll, who also became Schindler's devoted friend, sharing his home in Vienna and Plankenberg for eleven years, later married Schindler's widow (his stepdaughter, Alma Maria Schindler, married the composer Gustav Mahler in 1902) and in 1897 became a cofounder of the Vienna Secession. Moll developed Schindler's naturalism into a somber Symbolist style of landscape painting before adopting a more intense colorism in the early 1900s. Theodor von Hörmann (1840–1895), too, was briefly associated with Schindler. In 1886 he studied in Paris with the academic figure painter Raphaël Collin and also came into contact with French Impressionism, an experience that led him to use a more pronounced colorism. Under Schindler's influence Hörmann adopted a neutral palette as well as a more subjective approach.

In 1873 Schindler had also befriended Tina Blau (1845–1916). Blau was at the time already a mature artist, having studied initially with Anton (Antal) Hanély (c.1820–after 1887), a little-known pupil of Waldmüller's, and later at the Vienna Academy with August Schaefer von Wienwald (1833–1916), who encouraged her to paint directly out-of-doors. Her first exhibition at the Vienna Art Association in 1869 resulted in the sale of a painting that enabled her to go to Munich, where she studied with Wilhelm von Lindenschmidt the Younger (1829–1895). Having painted in the vicinity of Munich, Blau returned to Vienna in 1873. Schindler encouraged her at this time to turn her attention to the Viennese countryside. In 1873 Blau also first visited the small market town of Szolnok in the Hungarian Puszta, where Pettenkofen was also still active at this time. The following year she shared a studio with Schindler and also traveled with him to Holland.

Blau's first big success came with the 1882 exhibition in Vienna of *Spring in the Prater* (plate 438). Although this panoramic landscape has been praised by some as "the first Impressionist painting in Austria,"[22] both the detailed rendering and the transparent luminosity of this picture are reminiscent of Waldmüller. When Blau exhibited the painting at the Paris Salon in 1883, it was awarded a "*mention honorable.*" Tina Blau visited the French capital that year. Unfortunately, there are no letters or diaries that would give further information on her visit, in particular on whether she got to see any French Impressionist works. That her visit to Paris had a profound effect on her technical development is seen from a series of small oil sketches on wood panels

painted in the Tuileries Gardens. Color, juxtaposed in broad planes, dominates these sketches, although the pigments have been applied in mixed, not broken, hues, resulting in depictions of such opposite moods as *Sunny Day* (plate 439) and *Dark Day* (1883; Österreichische Galerie, Vienna).

Following her marriage in 1883 to Heinrich Lang (1838–1891), a painter of horse and battle pictures, Blau settled in Munich. In 1894, soon after her husband's death, she returned to her native Vienna. In her works from the 1890s she placed greater emphasis on pictorial structure, even to the point of scratching contour lines directly into the wet paint. In her later works she often subordinated her lively colorism to darker tones. Having been active as a teacher in Munich, in 1897 Blau also became the cofounder of the Vienna Art School for Women and Girls, the so-called Ladies' Academy, where she led the classes for still life and landscape painting until 1915. For years the painter Hugo Darnaut (1851–1937) tried unsuccessfully on her behalf to change the statutes of the Vienna Künstlerhaus, which prohibited membership by women artists. Financial rewards, on the other hand, did not elude her. According to Tina Blau's own records of her sales, she achieved good prices. Kaiser Franz Joseph rarely missed her exhibitions, and even the prince regent of Bavaria on a visit to Vienna paid a visit to her Prater studio. Above all, her "yearning to work in God's nature," as she put it,[23] never abated. Even in her sixties Tina Blau could still be seen in the Prater, wheeling a baby carriage laden with canvas and painting utensils to a site where she might work directly from the motif out-of-doors.

In the larger political and geographical context of the dual monarchy of Austria-Hungaria, which after 1867 was constituted by the Austrian Empire— including, besides the Germans of Austria and Bohemia, Slovenes, Czechs, Poles, Ruthenians, and even a few Italians—and the kingdom of Hungary—which, in turn, encompassed Slovaks, Croats, Serbs, and Transylvanians—the most interesting developments toward an Impressionist type of painting were initiated by young Hungarians, although, in the end, they rarely ventured beyond the poetic conception of the Barbizon school.

Mihály Munkacsy (1844–1909), descendant of an old Bavarian family by the name of Lieb who had taken the name of his birthplace to give expression to his yearning for national identity, originally studied at the academies in Budapest and Vienna and in 1865 visited Munich, where he got to know Wilhelm Leibl. In 1867 he first traveled to Paris, where he came under the influence of Courbet and the painters at Barbizon, especially Millet. Munkacsy settled in Paris in 1872 and two years later—during the heyday of French Impressionism— met Manet. He nonetheless resisted plein-air painting and devoted himself, except for occasional landscapes executed in the Barbizon manner, to realistic genre pieces taken from the working life of the common people. These paintings, which very much impressed the young

438. TINA BLAU. *Spring in the Prater.* 1882. Oil on canvas,
84¼ × 114½″. Österreichische Galerie, Vienna

439. TINA BLAU. *In the Tuileries Gardens (Sunny Day).*
1883. Oil on canvas, 7⅛ × 10⅝″. Österreichische Galerie,
Vienna

Max Liebermann, established Munkacsy's reputation throughout Europe.

László Mednyánsky (1852–1919), who also spent time in Paris in the 1870s and afterwards during travels in both Hungary and Italy produced landscape studies of an increasingly brighter colorism and fluid execution, continued to follow in his more finished works a delicately poetic conception. Simon Hollósy (1857–1918), too, practiced a lyrical sort of Naturalism. In 1886 he founded a private art school in Munich, where he was soon joined by other young Hungarians, including Károly Ferenczy (1862–1917), István Reti (1872–1945), and Janós Thorma (1870–1937). In 1896 Hollósy moved his school to the small Hungarian town of Nagybána (since 1920 the town belongs to Rumania and is now called Baia Mare). Opposed to the conventional academic program, the Nagybána school marked the beginning of modern painting in Hungary and even induced Pál Szinyei-Merse to start painting again after twenty years. Although Hollósy's own later works occasionally come close to Impressionism, his conception remained fundamentally introspective, like the nature lyricism that was pursued at the end of the century in such German artists' colonies as Die Scholle and Neu-Dachau. Károly Ferenczy in the late 1890s actually painted religious subjects set in the landscape around Nagybána.

Throughout these years paintings by the French Impressionists were apparently unknown to those who stayed in Austria or Germany. Even as late as 1893, in the first exhibition of the Munich Secession, there was not a single French Impressionist picture, but a considerable number of the older masters from Barbizon were represented. Similarly, the fifth exhibition of the Vienna Secession in the autumn of 1899 featured only modern French graphics, by Carrière, Renoir, Pissarro, Vallotton, and Puvis de Chavannes. Not until the sixteenth exhibition of the Vienna Secession, in 1903, was the Austrian public introduced to a representative selection of French Impressionist works. In Germany the reasons for the tardy reception of French Impressionism were largely political. Speculation as to what direction German painting might have taken without the Franco-Prussian War are futile, but for the French the memory of their country's defeat was long-lasting and discouraged personal contacts between nationals of the two countries for many years. German painters resumed their visits to France, but it was a one-way street. Once in Paris they discovered that the camaraderie enjoyed by Scholderer at the Café Guerbois and by Leibl and his friends in the circle of Courbet was a thing of the past.

The experiences of Liebermann and Corinth were not unusual in this regard. Liebermann, who lived in Paris and Barbizon from 1873 to 1878, had a studio in Montmartre in the same building in which the Viscount Ludovic-Napoléon Lepic—perhaps best known from the picture Degas painted of him and his two daughters in 1873—also had an atelier. Lepic wanted to introduce Liebermann to several French painters, including

440. MAX LIEBERMANN. *Garden at the Old Men's Home in Amsterdam.* 1881. Oil on canvas, 21¾ × 29⅝". Collection Dr. Georg Schäfer, Schloss Obbach, Berlin

Manet, but was forced to abandon his plans when the mere suggestion that they might have to share a café table with the German met with adamant resistance.[24] Liebermann had arrived in Paris with two letters of introduction, one addressed to the Belgian painter Alfred Stevens, the other to Léon Bonnat. Bonnat first received him coolly and on a second visit was only slightly more gracious, giving him the blunt advice: "Make the small sacrifice of having yourself naturalized, and you will be one of us."[25] Ignoring the suggestion, Liebermann nonetheless managed to exhibit at the Salon from 1874 onward, even though a critic that year commented angrily that in return for the privilege the painter should have relinquished his German citizenship. The same critic concluded: "It is a crime to perform Richard Wagner in France and to admit Prussians to our exhibitions."[26] Even as late as 1882, having joined the "Cercle des XV," an exhibiting group of artists organized by Bastien-Lepage and Alfred Stevens, Liebermann, whose work was highly praised by such critics as Paul Leroi and Ernest Hoschedé and exhibited at the 1882 Salon, avoided the group's weekly meetings so as not to provoke hostile sentiments. When Corinth arrived in Paris in the autumn of 1884 to study at the Académie Julian, he thought it wise to keep his Prussian background a secret. Since he had previously attended the Munich Academy, he let his French fellow students believe he came from Bavaria, a more acceptable if not entirely redeeming place of origin. A few days after classes began, his caricature in the uniform of a Bavarian soldier with bloody hands against a red background was sketched on the studio wall. An inscription underneath read, "Quand même."[27] This pithy "in spite of everything" unequivocally indicated that he was still considered a German.

441. Max Liebermann. *Beer Garden in Munich*. 1884. Oil
on canvas, 37¼ × 27″. Bayerische Staatsgemäldesammlungen,
Neue Pinakothek, Munich

French hostility, more than anything else, it seems, precluded the inclusion of German artists in the inner circle of the Impressionists, although Liebermann must have known about them, especially since Lepic participated in the historic first exhibition at Paul Nadar's in 1874 as well as in the second Impressionist exhibition in 1876. Instead, Liebermann's closest friends in Paris were the Austrians Jettel and Ribartz. Corinth kept company with other young painters from Prussia, Bavaria, and Switzerland. At no time during the entire period he spent in Paris—from the autumn of 1884 to the spring of 1887—did he come into contact with works by the French Impressionists. He arrived too late to have seen the memorial exhibition of Manet at the École des Beaux-Arts, although he was in time for the next exhibition, the large retrospective that was held in 1885 for Jules Bastien-Lepage, whose pseudo-Impressionist brush strokes and diluted colors may have embodied for him the latest word in French modernism. Corinth apparently encountered Impressionism only in the extreme form of Neo-Impressionism; in December 1884, seemingly by chance, he walked into the *Salon des Indépendants*, where he saw works by Signac, Guillaumin, Cross, and others, including Seurat's *A Bathing Place* (National Gallery, London) and a landscape sketch of the island of La Grande-Jatte, a study for the large painting on which Seurat was then working.

German painters were thus more or less fated to develop Impressionism on their own, relying on their indigenous tradition as well as on some of the same sources the French painters had explored as well: the Barbizon school and seventeenth-century Dutch painting. In addition, they learned from contemporary painters in Holland. Already between 1855 and 1870 a "Dutch Barbizon" flourished in the vicinity of Osterbeck; thereafter the school's center shifted to The Hague, attracting painters such as Jozef Israëls and Anton Mauve, who both were similarly dependent on the Barbizon school and the indigenous Dutch landscape tradition of the seventeenth century. Israëls and Mauve painted scenes from the life of fishermen and simple rural themes, all in a unifying and mood-inducing grayish tonality encouraged by the peculiar Dutch weather and atmosphere.

Liebermann's development conveniently typifies the gradual steps German painters took toward Impressionism. His own early preference was for working-class themes and peasant subjects in the manner of the Barbizon school. He greatly admired Millet and in the Louvre learned from the Dutch masters, copying Frans Hals's *Young Gypsy Woman*, fascinated, as Courbet and Manet had been earlier, by this painter's fluid style. Liebermann deepened his understanding of Frans Hals by repeatedly traveling to Holland. He copied figures from Hals's large group portraits in Haarlem, and in Scheveningen and Zandvoort he painted landscapes and working-class interiors that are close in technique and conception to paintings of The Hague School. Liebermann met Israëls in the summer of 1881 in The Hague; in 1884 he met Anton Mauve in Laren.[28] Liebermann was also deeply impressed by the continuing commitment of the Dutch to charitable institutions, such as orphanages and homes for the aged. In 1880 his chance discovery of the sunlit courtyard of an old men's home in Amsterdam resulted in a painting in which he faced for the first time the challenge of outdoor light, although he painted only the preliminary sketch directly from nature, completing the final version of the picture (plate 440) in the studio. Liebermann was reluctant to sacrifice the picture's anecdotal content to the illusion of figures enveloped by light and atmosphere. The faces of the men, especially those in the foreground, are sufficiently specified to allow the viewer to empathize with their solitude and introspective reflection.

That Liebermann's primary interest was not the pursuit of purely optical reality is confirmed by the even more anecdotal *Beer Garden in Munich* (plate 441), painted in 1884. This picture, too, was executed in the studio on the basis of several preliminary detail sketches and drawings. The canvas is filled with sunlight, but the light has no unifying role. Instead, each figure possesses great visual clarity and is given distinct characterization in terms of gestures and facial expressions. Unlike Schider's painting of more than a decade earlier (plate 433), Liebermann's chronicles a great variety of human actions and sentiments in a manner reminiscent of Menzel's *Afternoon in the Tuileries Garden* (plate 425).[29]

A greater concern for content in a work of art than for pictorial problems remained typical not only of Liebermann but of German painters in general. In several works from the 1880s devoted to themes of both individual and communal labor, Liebermann actually abandoned the light palette of his early Dutch paintings in favor of Jozef Israëls's drab tonality. In *The Netmenders* (1887–1889; Hamburger Kunsthalle) and *Woman with Goats* (Neue Pinakothek, Munich) he heightened the meaning still further by emphasizing through eloquent postures the drama of human endurance in the context of a harsh rural life.

Modern Dutch painting and the Dutch environment had an important influence on other German painters as well. Dutch painters exhibited regularly at the Munich Glass Palace from 1879 on, and German artists visited hospitable Holland in growing numbers. Gotthard Kuehl (1850–1911), who established contact with The Hague School after 1878, traveled to Holland—like Liebermann—from Paris, and Fritz von Uhde (1848–1911) first went to Holland in 1882 on Liebermann's advice. Both painted subjects of Dutch village life and developed great mastery in the depiction of light and atmosphere, as may be seen in the remarkable subtlety of the backlighting in Kuehl's *Sunday Afternoon in Holland* (plate 442), but they always underscored the quaintness of the Dutch rural milieu by careful attention to folk costumes and such obligatory accessories as clay pipes and wooden clogs. Lovis Corinth first encountered modern Dutch painting at the 1883 international exhibition in Munich, at which time

442. GOTTHARD KUEHL. *Sunday Afternoon in Holland.* 1891.
Oil on canvas, 32¼ × 24″. Bayerische
Staatsgemäldesammlungen, Neue Pinakothek, Munich

443. LOVIS CORINTH. *The Artist's Father on His Sickbed.*
1888. Oil on canvas, 24 × 27½″. Städelsches Kunstinstitut und
Städtische Galerie, Frankfurt

Jozef Israëls's painting *The Widower* (1880; Rijks-museum H. W. Mesdag, The Hague) impressed him deeply. He still remembered the picture five years later when he painted his sick father asleep in a sunlit interior (plate 443), although he replaced Israëls's melancholy chiaroscuro with an objective description of the room. Sunlight casts reflections on the furniture and enlivens the still life of medicine bottles, glasses, and fresh flowers set out on a chair beside the bed. One small carnation has fallen from the water glass, a poignant reminder of the picture's true meaning.

During the 1890s many German artists sought to reinvigorate traditional subjects within the context of empirical truth. In 1889 the Swiss Arnold Böcklin showed seventeen paintings at the Munich Glass Palace, including his fierce 1873 canvas *Battle of Centaurs* (Öffentliche Kunstsammlung Basel, Kunstmuseum). Böcklin's strikingly Naturalistic depiction of these as well such other mythological hybrids as nymphs, satyrs, and fauns was so successful that he was soon compared to Goethe, Beethoven, Rembrandt, and Phidias, and even hailed as the "Shakespeare of painting."[30] Böcklin satisfied a bourgeoning need for a "heightened" reality that was part of a general antiscientific movement in both art and philosophy. Already in 1884 the French novelist and critic Joris-Karl Huysmans had expressed his disdain for Naturalism. Two years later Jean Moréas's manifesto *Le Symbolisme* criticized writers such as Émile Zola, while in Germany the novelist and playwright Hermann Bahr announced in 1891 that "the rule of Naturalism" was over, "its magic dispelled."[31] German critics, too, called for an art of thematic content, for "allegory, the stories of the Bible, Homer," to serve as guides in "a world of greater beauty and lofty thought."[32] In French painting the rejection of Naturalism was also the rejection of Impressionism. In Germany some artists began to stylize forms of nature in a process that was to culminate in Jugendstil, the German version of the international Art Nouveau movement, while others—such as Böcklin— followed the new vogue for the meaningful theme but presented their ideal subject matter in Naturalistic form.

As early as 1879 Liebermann had painted an uncompromisingly Naturalistic picture of the twelve-year-old Jesus in the Temple. In 1884 Uhde, too, began to turn to religious paintings, placing biblical figures in a contemporary working-class milieu, usually sunlit interiors painted in the light-toned, muted colors of The Hague School. In 1891 he similarly transformed an archetypal subject in German Romantic painting: the solitary figure, seen from the back, gazing out of an open window (plate 444). Caspar David Friedrich and Moritz von Schwind had painted this subject to convey a sense of communion with nature and the infinite. In Uhde's picture the curiosity of the seamstress seems to have been aroused by nothing more than an unspecified commotion on the street.

Corinth, too, reinterpreted Romantic subjects in a more prosaic way. In addition to landscapes in the Barbizon manner, he painted open-window views as well as

444. FRITZ VON UHDE. *Young Woman at the Window.* c.1891. Oil on canvas, 31¾ × 25½". Städelsches Kunstinstitut und Städtische Galerie, Frankfurt

the haunting *Fishermen's Cemetery at Nidden* (plate 445). The mournful character of this picture not only derives from the motif but is also a consequence of the pictorial elements. Purplish tones dominate the variegated colors of the sandy soil, and most of the gravemarkers are painted in somber shades of blue and brown. There is a strange, almost anthropomorphic, quality about these crosses, seemingly gazing out toward the sea. They direct the viewer's thoughts toward the open water, where sailboats—poignant reminders of transience— glide smoothly along the shore. Corinth's *Self-Portrait with a Skeleton* (plate 446), painted in 1896, derives from the famous 1872 self-portrait by Böcklin (Staatlichemuseen Preussischer Kulturbesitz, Nationalgalerie, Berlin). In Böcklin's self-portrait the painter, palette and paintbrush in hand, listens to Death as if to an inspiring muse. Death, playing the fiddle, is shown as an animated counterpart to the painter, whereas in Corinth's picture the apparition has been replaced by a studio prop, suspended from an iron stand. Bright daylight enters through the large window, beyond which lies an urban landscape dominated in the distance by church steeples and smoking chimneys.

These subjective works differ greatly from the unaffected paintings of the French Impressionists. Yet French Impressionism had by this time found cham-

pions among German collectors and museum officials and was beginning to modify German painting as well. The center of this transformation was Berlin. In 1882 the lawyer Carl Bernstein and his wife, Felicie, admirers of modern French art and literature, had settled there. During their earlier residence in Paris the couple had acquired a small but exquisite collection of French Impressionist paintings, assembled with the help of their cousin Charles Ephrussi, a friend of Renoir's.[33] They owned four Manets, including the well-known *Folkestone Boat* (1869; Philadelphia Museum of Art), landscapes by Monet, Pissarro, and Sisley, and portraits by Berthe Morisot and Eva Gonzalez.[34] Berlin artists soon had an opportunity to view the collection at the Bernsteins' home. According to the Danish writer Georg Brandes, these paintings were a great novelty, though reactions to them were not entirely positive. Menzel in particular was critical. While he expressed some approval of Manet's *Folkestone Boat* and declared that one of the woman painters might one day amount to something provided she discarded her "crude and repugnant technical details," he wondered whether the Bernsteins had actually paid good money for "that mess."[35] When Menzel noticed that the Bernsteins were embarrassed by his remark, he tried to apologize in his inimitable manner: "I am very sorry to have spoken so impolitely of your collection, but it happens to be my sincere opinion. Your pictures are dreadful."[36] In October 1883 the Berlin dealer Fritz Gurlitt exhibited the Bernstein collection at his gallery and shortly afterwards mounted a second exhibition of works of Pissarro, Renoir, and Degas sponsored by the Parisian dealer Paul Durand-Ruel. These exhibitions inspired the young French Symbolist poet and critic Jules Laforgue, who worked in Berlin from 1881 to 1886 as a reader to the German Empress Augusta, to write one of the earliest and most incisive analyses of Impressionism.[37]

Max Liebermann first saw the Bernstein collection in 1885 or 1886. Hugo von Tschudi, who in 1896 was made director of the National Gallery, apparently also became acquainted with French Impressionist paintings in the Bernstein home. Soon after his appointment to the National Gallery post he traveled with Liebermann to Paris to see paintings by Manet at Durand-Ruel's, an experience that made him decide to add works by the French Impressionists to the museum's permanent collection. However, since state funds could be used only to purchase German works, Tschudi was forced to persuade wealthy patrons to provide the necessary money or to donate the paintings directly to the museum. Manet's *In the Conservatory* (1879) was the first picture so acquired. Tschudi's gambit so aroused the animosity of Anton von Werner, that in 1898 he managed to have a rule enacted requiring that all new works intended for the National Gallery must first be shown to the kaiser for his approval.

In 1892 Max Liebermann apparently acquired a painting for himself by Manet, an 1881 still life of flow-

445. Lovis Corinth. *Fishermen's Cemetery at Nidden*. 1893.
Oil on canvas, 44⅛ × 58¼". Bayerische
Staatsgemäldesammlungen, Neue Pinakothek, Munich

446. Lovis Corinth. *Self-Portrait with a Skeleton*. 1896. Oil
on canvas, 26 × 33⅞". Städtische Galerie im Lenbachhaus,
Munich

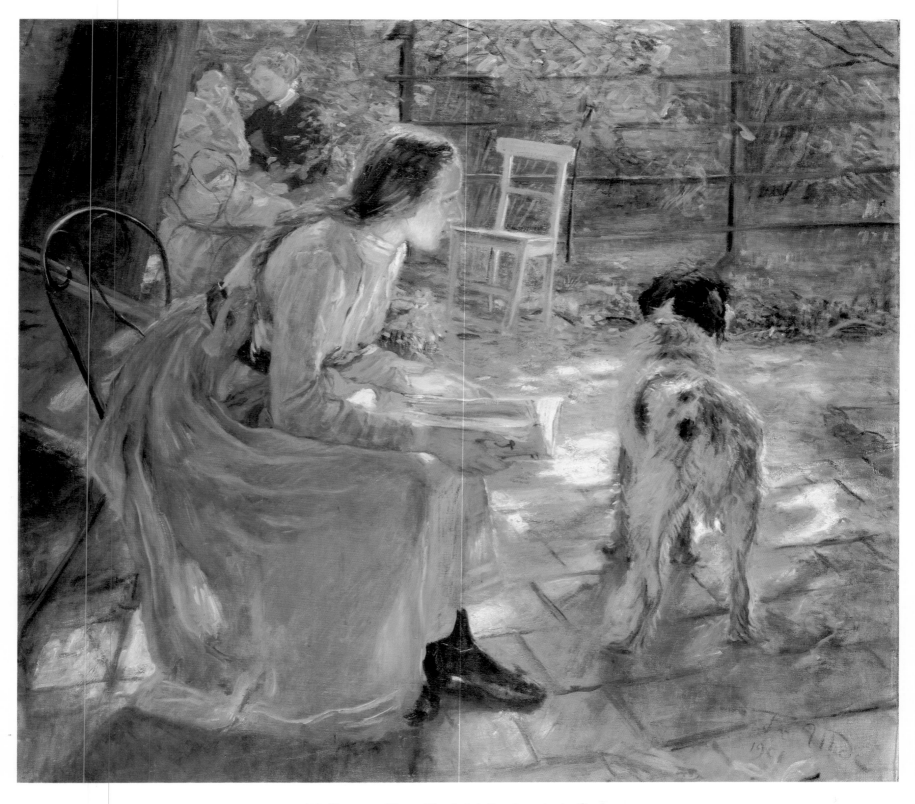

447. FRITZ VON UHDE. *The Artist's Daughters in the Garden.*
1901. Oil on wood, 54 × 59⅝″. Städelsches Kunstinstitut und
Städtische Galerie, Frankfurt

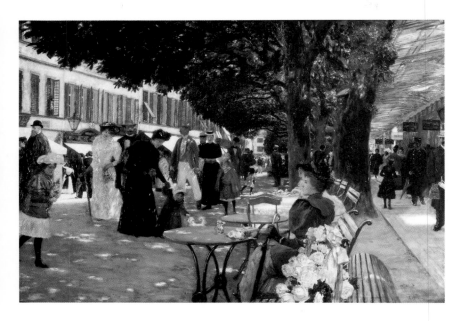

448. FRANZ SKARBINA. *Promenade in Karlsbad.* c.1899–1900. Oil on canvas, 38¼ × 57½″. Bezirksamt Charlottenburg, Berlin (West)

ers. In 1898, when he failed to obtain Manet's portrait of George Moore (1879; The Metropolitan Museum of Art, New York City), he decided to make a copy of the painting. Eventually his own collection of French paintings encompassed three Monets, two each by Cézanne and Toulouse-Lautrec, one Pissarro, an early Renoir, five works by Degas, and no less than seventeen Manets. Liebermann met Degas in 1899 at the home of Edmund Duranty, the editor of the *Gazette des Beaux-Arts.* He also published essays on both Degas (1896) and Manet (1905), deepening his understanding of the two French painters through further intellectual reflection.

After the founding of the Berlin Secession in May 1898, Liebermann—who served as the association's president—vigorously championed French Impressionist painting in Berlin. Already the secession's second exhibition, in May 1900, featured no less than forty-four foreigners, among them Pissarro, Monet, and Renoir. In 1901 the French Impressionists were again well represented; the exhibition also included paintings by Van Gogh. Works by Manet were shown the following year. Toulouse-Lautrec and Cézanne dominated the exhibition in 1903. In its efforts to introduce modern French art to Berlin the secession had the energetic support of Bruno and Paul Cassirer, who jointly operated a gallery of their own, owned a publishing firm, and also looked after the secession's business affairs. As early as October 1899 the two cousins, who had good connections with French dealers, mounted an exhibition of paintings by Degas. After 1901, when Paul Cassirer assumed sole responsibility for the gallery, he organized on the average six major exhibitions a year, featuring members of the Berlin Secession while reinforcing the association's international outlook by including works of foreign artists. In 1903 he again showed paintings by Degas, as well as works by Monet, Edvard Munch, Édouard Vuillard, and

Paul Bonnard. In the spring of 1904 he held a major exhibition of oils and watercolors by Cézanne. In 1906 he displayed twenty-four paintings by Manet from the collection of the singer Jean-Baptiste Faure. Early in 1910 he joined Durand-Ruel and Bernheim-Jeune in acquiring the collection of the margarine manufacturer August Pellerin, which again included many Manets.[38] Cassirer remained for years Germany's leading dealer of modern art and the principal supplier of French Impressionist and Post-Impressionist works to museums, galleries, and private collectors in central Europe.

Not surprisingly, by the turn of the century typical Impressionist subjects, such as street and café scenes, were no longer uncommon in German painting (plate 448). Even Fritz von Uhde turned his attention from biblical themes to the environment of his sunny garden (plate 447). Manet played a major role in these developments, since he appealed to the Germans in a number of ways. He rarely dissolved the imagery of his pictures as his younger friends Renoir and Monet did; he also retained the sensuous touch of the old masters. Furthermore, his figures continued to convey profoundly human sentiments. In essence, the Germans discovered in Manet a kindred spirit: a methodical artist who was ultimately more interested in finding a pictorial equivalent for an ideal vision than in rendering purely optical truth. For Liebermann a second source of inspiration was Degas, another artist who like Manet had remained on the periphery of French Impressionism. Liebermann admired Degas's draftsmanship and learned to appreciate the way in which the painter subordinated the human figure to the exigencies of the pictorial structure.

By the late 1890s Liebermann had begun to turn away from working-class subjects in favor of themes of leisure. His picture of bathing youths (plate 449) illustrates the direction his art was now taking. He began the painting in the autumn of 1895 and the following year exhibited it at the Paris Salon. Degas saw it there and was favorably impressed. Liebermann subsequently kept reworking the canvas until 1898, overpainting some figures and adding others. The composition breaks with conventional norms in that the figures are distributed asymmetrically, with emphasis on the group at the extreme right. And while there is still concern for anatomical clarity, the figures have been depersonalized, which greatly diminishes the anecdotal content of the picture. The muted colors, however, are still as opaque as in Liebermann's earlier paintings from Holland. In several subsequent paintings depicting human figures in greater motion—tennis and polo players and riders at the beach—Liebermann achieved greater fluency without abandoning his interest in the individual forms. He also diminished the viewer's sense of depth by allowing the background to rise more closely parallel to the picture plane. Technically this brought Liebermann closer to Manet. That he recognized in the French painter the standard by which he wished to be judged is suggested by the fact that in 1906 he exhibited his own paintings at

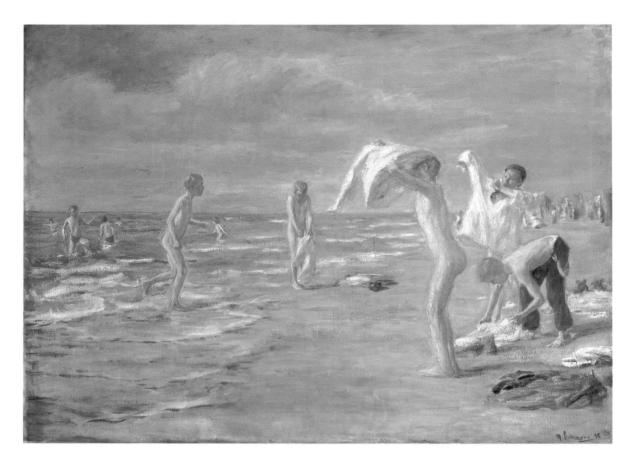

449. MAX LIEBERMANN. *Bathing Youths.* 1898. Oil on canvas,
48 × 59½″. Bayerische Staatsgemäldesammlungen, Neue
Pinakothek, Munich

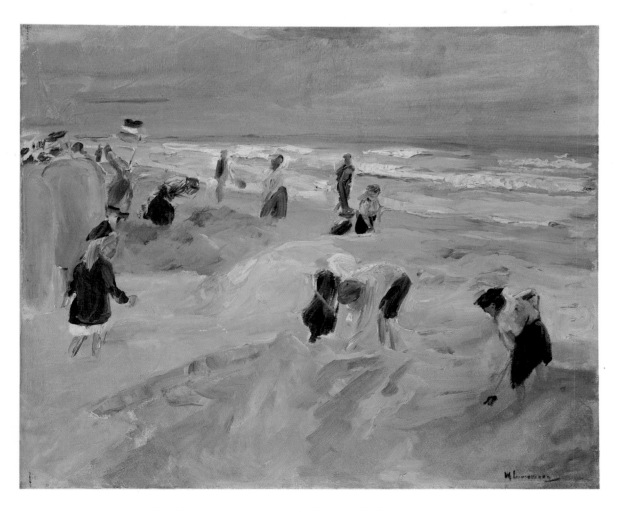

450. MAX LIEBERMANN. *Beach Scene at Nordwijk.* 1908. Oil
on canvas, 26 × 32¼″. Niedersächsisches Landesmuseum,
Hannover

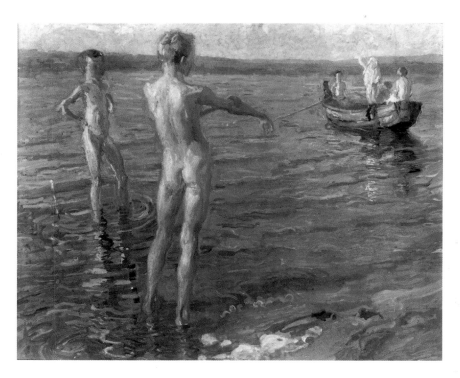

451. CHRISTIAN LANDENBERGER. *Summer Evening at the Lake.* 1904. Oil on canvas, 45¼ × 55½″. Bayerische Staatsgemäldesammlungen, Neue Pinakothek, Munich

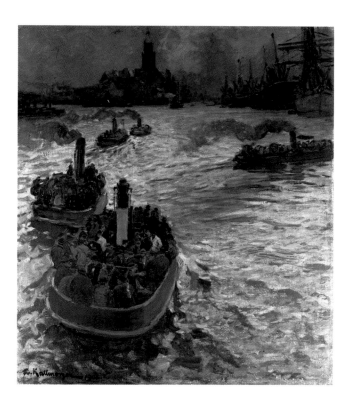

452. FRIEDRICH KALLMORGEN. *Workers' Boats in Hamburg Harbor.* 1900. Oil on canvas, 30 × 25½″. Museum Folkwang, Essen

Cassirer's alongside the Manets from the Faure collection. Two years earlier he had already stated his position in a manner seemingly in harmony with the concept of *l'art pour l'art.* "The specifically painterly content of a picture is greater," he declared in an essay first published in *Die neue Rundschau* in 1904, "the less interest there is in the picture's subject matter; the more the content of a painting has been subordinated to the pictorial form, the greater the painter." Throughout the essay Liebermann is concerned with painterly technique, yet while he emphasizes sensory perception as the basis of the artistic process, purely optical values were for him only relative, as is evident from the many ways in which he qualifies his remarks: "What good are the most correct draftsmanship, the most accomplished execution, the most brilliant color, if these . . . qualities are devoid of feeling! The picture remains—a painted piece of canvas." Painting does not consist, he explains, "of the invention of thought" but of the "invention of the visible form for thought." And quoting his first teacher, the Berlin painter Carl Steffeck (1818–1890), he adds succinctly: "What one cannot paint from memory, one cannot paint at all."[39] Which is to say that Liebermann was concerned with finding a pictorial equivalent not only for *what* he saw, but also for *how* he saw it. This subjective attitude explains why even his most Impressionistic paintings (plate 450) vary a great deal in mood. His brushwork is alternately dynamic and lyrical, and a predominant tonality generally reinforces the character of a given work.

This conflict between optical truth and the need to rise above it is an essential feature of German Impressionism. German painters concerned merely with optical phenomena are in fact the exception rather than the rule. For Friedrich Kallmorgen (1856–1924), for instance, the environment of Hamburg harbor was not primarily a subject of changing atmospheric effects, but also a drab social setting, with masses of workers being ferried to the newly created industrial plants (plate 452). In his pictures of bathers by the sea (plate 451) Christian Landenberger (1862–1927) recorded not merely a leisure activity, but accentuated the idyllic mood of the picture so as to evoke the kind of utopia the young Expressionists were to render in a primitivizing—and thus in their view more "natural"—style only a few years later. In his many streets scenes of Berlin, Lesser Ury (1861–1931) intensified the colors to the point of stridency so as to convey not only the glitter and speed, but also the decadence of the modern metropolis (plate 453).

This subjective tendency of German Impressionism is also amply documented in the work of Max Slevogt and even more so in Corinth's, the two painters who after the turn of the century joined Liebermann in the "triumvirate" of German Impressionism. Both were members of the Berlin Secession and under the influence of French Impressionism turned to lighter colors and a more vibrant technique. Yet neither was exclusively a plein-air painter. The picture Slevogt sent to the first exhibition of the Berlin Secession in 1899 was a large

both painters created a convincing likeness, they also conveyed something of the character of the role. Seen against the backdrop of the scenery, Francesco d'Andrade, in particular, does not simply pose in his costume, he *is* Don Giovanni, confronting the viewer with the audacious nonchalance that has made Mozart's hero one of the more endearing scoundrels in the operatic repertoire. In the painting of his wife at the vine trellis (plate 458) Slevogt again departed from conventional Impressionism. The firm brush strokes emphasize the figure and the pensive face. The woman's association with the grape arbor is also clearly intended to be symbolic, her poignant introspection conjuring up a mood of autumnal lassitude that is reinforced by the picture's predominantly golden tonality.

Corinth occasionally painted pictures that are close to French Impressionism. When he depicted his wife in the process of getting dressed after a swim in a pond (plate 459), he even painted, in typical Impressionist fashion, while seated in a boat. Yet like Slevogt's picture this is also, even intrinsically so, a quintessential painting of the season. The colors dash across the canvas, now ebbing, now flowing, in bursts of resurgent energy. That the problem of plein-air painting was for Corinth only relative is even more evident in his view of Hamburg across the basin of the Alster River (plate 460) in which emphasis is still less on description than on mood. Unlike Kallmorgen (plate 452), Corinth painted a festive side of the seaport during the visit of the German emperor in late August 1911. The flags hoisted to celebrate the occasion are so large, they have no plausible relationship to the structures they surmount and dwarf even most of the church towers visible in the far distance. As boats scurry along the river wrapped in a grayish blue light, the entire city is aflutter with excitement.

In his later paintings Corinth sought to depict nature still more vividly in terms of observations that are both physical and psychological in origin. With advancing age (and after suffering a stroke in December 1911) triptych depicting episodes from the parable of the Prodigal Son. Slevogt's interest in literary subjects continued throughout his life; he was also a gifted musician and illustrator. Corinth, too, painted subjects from the Bible, mythology, history, and literature throughout his career, and he illustrated many books. Thus both were predisposed toward a more imaginative treatment.

In his most typically Impressionist subjects, such as the 1901 pictures from the Frankfurt Zoo (plate 454), Slevogt maintained the objective distance of Manet, whose coloristic sophistication and lush technique he successfully emulated. In the garden pictures (plate 455) he painted in 1912 at the Neu-Cladow estate of his patron, the collector Johannes Guthmann, he also adopted colored shadows and followed a more conventional Impressionistic technique. Slevogt's portrait of the Portuguese baritone Francesco d'Andrade as Don Giovanni (plate 456) is most likely also indebted to Manet's example — the portrait of Jean-Baptiste Faure in the role of Ambroise Thomas's *Hamlet* (plate 457). While

453. LESSER URY. *Nollendorf Square at Night.* 1925. Oil on canvas, 28½ × 21½". Staatliche Museen zu Berlin, Nationalgalerie, Berlin (East)

454. MAX SLEVOGT. *Girl at Lion Cage.* 1901. Oil on canvas, 21½ × 32⅛". Niedersächsisches Landesmuseum, Hannover

455. Max Slevogt. *Flower Garden in Neu-Cladow*. 1912.
Oil on canvas, 25¼ × 31⅞″. Westfälisches Landesmuseum für
Kunst und Kulturgeschichte, Münster

456. MAX SLEVOGT. *Francisco d'Andrade as Don Giovanni
(The White d'Andrade)*. 1902. Oil on canvas, 84⅝ × 63″.
Staatsgalerie, Stuttgart

(left) 457. ÉDOUARD MANET. *Jean-Baptiste Faure in the Role
of Hamlet*. 1877. Oil on canvas, 77⅛ × 51¼″. Museum
Folkwang, Essen

(above) 458. MAX SLEVOGT. *Nini at the Vine Trellis*. 1911.
Oil on canvas, 78¾ × 41¾″. Landesmuseum, Mainz

459. Lovis Corinth. *After the Bath.* 1906. Oil on canvas, 31½ × 23⅝". Hamburger Kunsthalle, Hamburg

460. Lovis Corinth. *Emperor's Day in Hamburg.* 1911. Oil on canvas, 27¾ × 35½". Wallraf-Richartz-Museum, Cologne

461. LOVIS CORINTH. *Wilhelmine with Flowers.* 1920. Oil on canvas, 43¾ × 59″. Öffentliche Kunstsammlung, Basel

462. MAX LIEBERMANN. *The Artist's Garden at the Wannsee.* 1918. Oil on canvas, 27½ × 35½″. Hamburger Kunsthalle, Hamburg

(right) 463. MAX SLEVOGT. *Wine Harvest in Leinsweil Valley.* 1916. Oil on canvas, 34⅞ × 26⅜″. Museum Folkwang, Essen

464. MAX SLEVOGT. *Sunny Garden Corner in Neukastel.*
1921. Oil on canvas, 35½ × 43¼″. Bayerische
Staatsgemäldesammlungen, Neue Pinakothek, Munich

465. LOVIS CORINTH. *Walchensee, View of the Wetterstein.*
1921. Oil on canvas, 35½ × 46⅞″. Saarland Museum,
Saarbrücken

466. LOVIS CORINTH. *The Walchensee in Moonlight.* 1920.
Oil on wood, 7⅛ × 10¼″. Pfalzgalerie, Kaiserslautern

the awareness of his own mortality informed virtually every subject he painted. Even the picture of his eleven-year-old daughter (plate 461) is a poignant metaphor of transience. The asymmetrical composition, with the sitter at the far right and most of the picture space devoted to still life, is reminiscent of Degas's *A Woman with Chrysanthemums* (1865; The Metropolitan Museum of Art, New York City). And as in Degas's famous painting, there is a mood of profound melancholy. Except for the large showy amaryllis, the flowers are for the most part appropriate to the girl's own stage of life. Yet all the blossoms appear as if dissolved from within, as patches of black paint push through the variegated colors. The girl's body and face have been accommodated both coloristically and texturally to the flowers as if to emphasize their common fate.

Landscape painting dominated the output of all three leading German Impressionists in their later years. During World War I Liebermann turned to the tranquil surroundings of his country home at the Wannsee on the outskirts of Berlin, painting garden pictures that evoke a sense of timeless order (plate 462). Slevogt, who had known the horrors of war on the western front, painted the vineyards of the Palatinate from his hilltop house near Neukastel (plate 463) and the secluded corners of his enclosed garden (plate 464). The enduring cycle of the seasons is the real subject of these landscapes—summer in its fullest bloom, the autumnal plenty of the fields, and the rest of winter. Corinth painted most of his late landscapes from the terrace of his vacation home in Urfeld at the Walchensee, Germany's largest and deepest mountain lake. He, too, painted the surrounding countryside during all seasons and at all times of the day, from dawn to dusk, even at night when the moon stood high above the mountains, less motivated by the actual appearance of the mountain landscape than by the desire to project his innermost sensations into it. In these paintings form becomes elusive, not just in the Impressionist sense but also independent of optical perception. Even at their most splendid there is something tragic about these landscapes. Often seen as if from the window of a speeding train (plate 465), they suggest a sense of irrevocable loss, as if nature in all her impermanence could be arrested for only one intoxicating, fleeting moment. In his nocturnes of the Walchensee Corinth discovered what is probably the lake's most haunting view (plate 466). To these he brought particularly intense feelings, as is related by Corinth's wife, the painter Charlotte Berend (1880–1967), who has vividly described the silence and tension to which he succumbed prior to painting such a view, the passionate intensity with which he set to work translating into pictorial form an image he had been carrying in his imagination all day long, and the physical

and emotional exhaustion that followed upon its ultimate realization.[40] Corinth's late works are often included in discussions of German Expressionism. But there is no convenient label for his late style. It exemplifies a form of Expressionism only in the very general sense and—like the late style of Rembrandt and Frans Hals, the two artists Corinth admired most—is more accurately defined as *Altersstil*, the logical and final evolution of an art that demanded the experience of a lifetime to be transformed from an avowal of the senses to an expression of deep feeling.[41]

Late in March 1925, a few months before his death, Corinth disavowed his association with a purely representative art when he wrote in his diary: "I have discovered something new. True art means seeking to capture the unreal. This is the highest goal!"[42] Three years later Slevogt, commenting on Liebermann's 1904 essay, expressed a similar view, though couched in less philosophical language:

> The eye is not an instrument like a mirror. The eye is a living conduit to our entire being. It is always self-conscious, always conditioned by some purpose—it is a sieve that allows many things to filter through in the process of seeing. The eye looks, it searches, and whatever it does not understand it does not see. A hunter does not see like a sailor. Somebody who never hunts cannot see a rabbit even if it is sitting right next to him. The eye sees with much imagination, music, rhythm, and intoxication.[43]

These words are hardly those of conventional Impressionists, but rather are deeply rooted in the German Romantic tradition. As Caspar David Friedrich had counseled in one of his famous aphorisms: "A painter should not merely paint what he sees in front of him, he ought to paint what he sees within himself."[44]

That the belated encounter with French Impressionism affected the development of German painting at the turn of the century is indisputable. Yet French Impressionism was not able to overcome the subjective approach so indigenous to the German tradition. Indeed, some painters, including Christian Rohlfs (1849–1938) and Max Beckmann (1884–1950), found their way quickly from Impressionism to Expressionism. Not surprisingly, historians have recognized the inadequacy of the designation "Impressionism" in the context of German developments, preferring instead to qualify the label by speaking of "so-called" German Impressionism or setting the term "German Impressionism" within quotation marks.

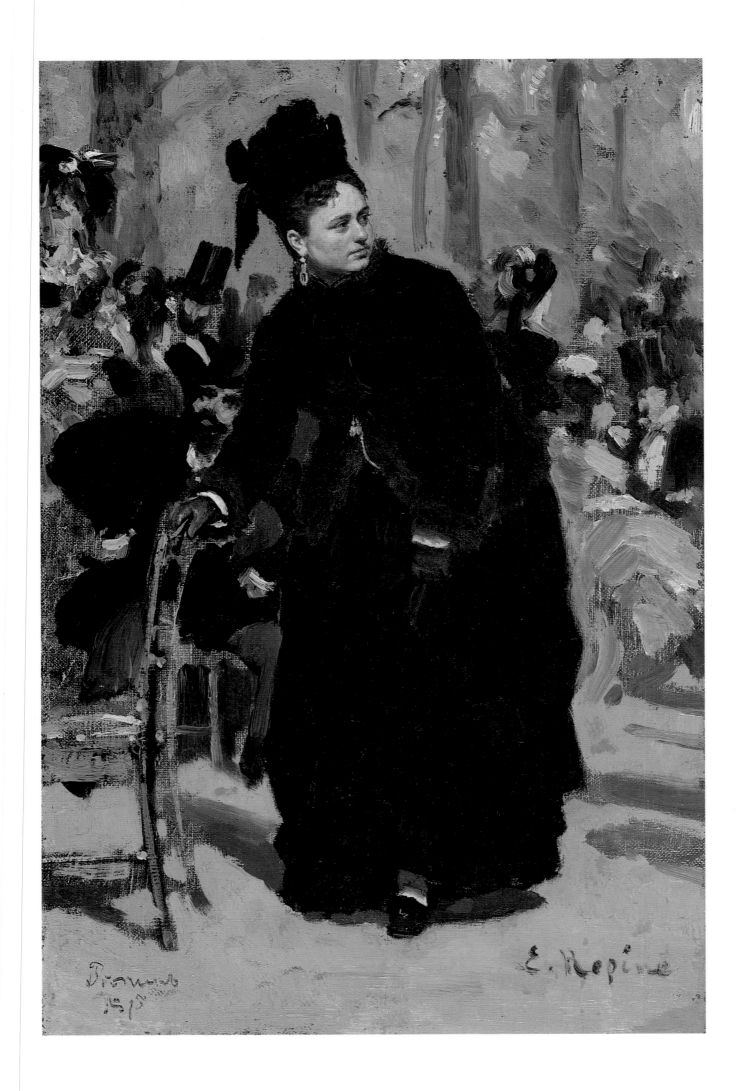

"WE NEED LIGHT—more that is joyous and light": a note penciled in a sketchbook sums up the search that led to Russian adaptations of Impressionism, which began in the 1870s and extended into this century.[1] Two scenes painted by artists who were friends and colleagues show how an early contact with French Impressionism acted as a catalyst for change. *The Rooks Have Arrived* (plate 468) by Aleksei Savrasov (1830–1897) and *Moscow Yard* (plate 469) by Vasilii Polenov (1844–1927) share the bell towers and gilt domes of Russian churches in typical landscape settings. Both depict real scenes without idealization, and they fit firmly within the category of Realism, as it was understood in Russia in the 1860s and 1870s. The Russian Realist movement, chiefly identified with a group of independent artists known as the Peredvizhniki, to which both Savrasov and Polenov belonged, emphasized a philosophical commitment to truth, to depicting subjects from real life, rather than any stylistic tendency. Alike in subject, but quite different in theme, intention, and visual effect, these works show the stylistic range of the Realist landscape.

Savrasov's painting employs the grayish white tones of melting snow and overcast sky, of whitewashed masonry and birch trunks, to convey the monotony of the landscape. Spiky textures of rooks' nests, church domes, and fluttering birds offer both visual contrast and a symbolic promise of spring's return. The trees tie together the foreground, the architecture, and the distant horizon and metaphorically anchor the church, symbol of national and spiritual identity, to the natural reminders of the cycles of nature. Polenov's scene sparkles with light and with flecks of white, green, yellow, blue, and red against the softer earth tones. The space is limited, bounded by prosaic fences and outbuildings. The cupolas and tent-shaped bell tower are normal features in this still rural corner of Moscow. Both artists emphasize seasonal and atmospheric effects; Savrasov does so to underscore the vastness and continuity of Russia, but Polenov seeks to convey the sight and feeling of bright sun in a familiar backyard.

Savrasov's work, while based on direct study of nature, reflects the contemplative attitude characteristic of early nineteenth-century landscape painting; Polenov's, also carefully studied on the spot, seems more spontaneous and direct. The works do not represent opposing schools of thought, rather both contain, in differing degrees, elements that remain essential in Russian art: acute observation of nature and communication of an idea or feeling. However, Polenov's painting, one of the first to show the effects of French Impressionism, signals a shift away from contemplative and symbolic painting toward specific visual observation. Polenov's students Isaak Levitan (1860–1900), Konstantin Korovin (1861–1939), and others would take this path farther and eventually find new subjective qualities in their Russian landscapes.

# THE IMPRESSIONIST VISION IN RUSSIA AND EASTERN EUROPE

*Alison Hilton*

467. ILIA EFIMOVICH REPIN. *Woman Leaning on the Back of a Chair* (study for *Paris Café*). 1875. Oil on canvas, 15⅞ × 10½". State Russian Museum, Leningrad

"A period of transition" is how one Russian described artistic life in Paris in the mid-1870s.[2] The same could be said of life in Saint Petersburg and Moscow, as Russia underwent major social and political changes and had increasing cultural contacts with the West. Artists of three generations, who began their careers in the early 1870s, in the 1880s, or at the end of the century, experienced transitional situations in distinct ways; for each group, contact with art abroad contributed to a process of reexamining their own training and national traditions. Vasilii Polenov, Ilia Repin (1844–1930), and other graduates of the Saint Petersburg Academy of Arts received grants for study in Europe to conclude their training. Like artists from other countries, many Russians went to Paris, and some became well-informed about current art. Some were attracted by the innovations and the antiacademic stance of the French Impressionist group, partly because they saw parallels between it and a recently formed group of Russian Realists that took shape in the 1860s and 1870s. But the philosophy of Russian Realism was so strongly tied to national and social concerns that few Russians could accept the spontaneity and visual bravura of modern French art. Even artists attuned to the new painting, such as Repin and Polenov, did not reject tradition but rather reaffirmed the need for a strong Russian school based on the great traditions of the past. Though they painted studies *en plein air*, they adhered to academic standards for finished works. It was only several years later that their students, Valentin Serov (1865–1911), Korovin, and Levitan, vehemently rejected the moral emphasis of Realism and instead sought light and joy in painting.

Distinctive Impressionist styles in portraiture, genre, and above all landscape began to appear in Russia in the late 1880s. The favorite motifs were similar to those of the French artists: glimpses of figures outdoors or in light-filled rooms, poised momentarily or absorbed in work or social activity; views from balconies, from porches, or along paths; the qualities of light, shade, air, and water at varying locations, times, and seasons. But it was not just a matter of adapting Impressionist devices to Russian settings. Russian Impressionism grew out of an artistic environment based on different values from those of French Impressionism. For Russian artists and critics from the 1860s until the end of the century, content outweighed style as a criterion for evaluating art; therefore innovations that seemed mainly stylistic were often dismissed as superficial. Even the artists most closely identified with Impressionism, Korovin and Levitan, sought to express not only feeling but also spiritual truth in their work.

Russians made their first essays in Impressionist painting in direct response to the first two Impressionist group exhibitions in Paris in 1874 and 1876; other productive points of contact occurred from about 1889 to 1895, when many younger artists went to Paris, and again at the turn of the century, when new artists' groups and art publications and increasing participation in international exhibitions brought Russia into the sphere of European art. What Russians and other foreigners expected of the new art in France—and what they found and considered valuable—changed from one set of encounters to the next. Artistic intentions changed, along with the visual aspects of the work, but the continuing regard for spiritual truth suggests why Impressionism, essentially an outgrowth of Realism in Russia, was so important for the development of both formal and philosophical aspects of nonrepresentational art in the early twentieth century.

## The Russian Landscape Tradition and Early Impressionism

The practice of painting in the open air was well established by the early nineteenth century. Russians Fedor Matveev (1758–1826) and Silvester Shchedrin (1791–1830) worked in Italy, around Naples, Sorrento, and Capri, where artists from many countries sought to capture the qualities of Mediterranean light. Shchedrin was among the first to paint directly from nature; he avoided classical motifs in favor of simple genre scenes and concentrated on the varied light effects of sky and sea. His work was popular, an alternative to the Saint Petersburg Academy's emphasis on classical sculpture and posed models. In the same period, an indigenous school of landscape painting was started by Aleksei Venetsianov (1780–1847), who, after training at the academy, retired to Tver province, where he painted peasants and landscapes. He opened an art school for local youngsters on his estate and taught them to rely on direct observation of nature rather than imitating other artists. His early *Threshing Barn* (1821–1823; Russian Museum, Leningrad) offered proof of his principles: he had most of one wall of a barn cut away in order to paint the interior scene in natural light.

Classes in landscape painting were held at the Moscow School of Painting and Sculpture, which opened in 1842 as the Moscow Nature Class. The Moscow School was under the administrative supervision of the Saint Petersburg Academy and was inferior in status, accredited to award only silver and not gold medals to graduates, but it was considered more liberal in its teaching practices, especially in the categories of genre and landscape painting. Savrasov taught there beginning in 1852; later Polenov and Levitan headed the landscape studio. Direct study from nature, encouraged at the school, was in sharp contrast to the practice at the academy, as Repin learned in the 1860s. When he met with the academy's rector, Fedor Bruni, to go over a study for an assigned piece, he was taken aback by the professor's displeasure at the details from nature. "These are just ordinary bushes that grow on Petrovskii Island," Bruni complained. "The stones, too—all this is gratuitous . . . for an historical scene it is of no use at all. Go to the Hermitage, choose a work by Poussin and copy some part of it that will be suitable for your picture. In an historical painting the landscape, too, should be historical."[3] The

468. ALEKSEI KONDRATEVICH SAVRASOV. *The Rooks Have Arrived.* 1871. Oil on canvas, 24⅜ × 19⅛″. State Tretiakov Gallery, Moscow

(right) 469. VASILII DMITREVICH POLENOV. *Moscow Yard.* 1877. Oil on canvas, 19⅝ × 15⅛″. State Tretiakov Gallery, Moscow

young artist rejected this advice and soon found support among like-minded students and members of the Saint Petersburg Artists' Artel.

The Artists' Artel was formed in 1863, conceived as dramatically as the Paris Salon des Refusés that same year. With no knowledge of the events in Paris but infected by a spirit of reform in Russia, senior students at the Saint Petersburg Academy demanded the right to choose meaningful themes for the final gold-medal competition. When the administration rejected their petition and assigned a theme from German mythology, they left the academy in protest and organized a cooperative studio, the Artists' Artel. The leader of the group and of the new Realist movement, Ivan Kramskoi (1837–1887), believed that art must be free of administrative control in order to fulfill a moral obligation to present true pictures of life. He was influenced by the writings of social philosophers Pierre-Joseph Proudhon, Hippolyte Taine,

Dmitrii Pisarev, and Nikolai Chernyshevskii. The eminent critic Vladimir Stasov, already known for his advocacy of the Russian national school in music, became an adviser and spokesman for the Realist artists, and Pavel Tretiakov, a Moscow merchant who collected Russian art, became their main patron. Tretiakov's support was crucial in the decision of the artel members to join forces with a group of Moscow artists to organize annual exhibitions that would open in Saint Petersburg, travel to Moscow, and then to several provincial cities, so that the art could be seen by a broad public. The Association of Traveling Art Exhibitions (*Tovarishchestvo Peredvyzhnykh Khudozhestvennykh Vystavok*, hence the name "Peredvizhniki" for its members) received an official charter in November 1871. This independent organization undermined the authority of the academy while strengthening the Realist presence in Russian art. However, except for a lack of mythological themes, the major-

470. Mariia Konstantinovna Bashkirtseva. *Autumn.* 1883.
Oil on canvas, 38⅛ × 46″. State Russian Museum, Leningrad

471. Aleksei Petrovich Bogoliubov. *Seacoast at Veules,
Normandy.* c.1870s. Oil on canvas (dimensions unknown).
State Russian Museum, Leningrad

472. ILIA EFIMOVICH REPIN. *Barge Haulers on the Volga.*
1870–1871. Oil on canvas, 51¾ × 110⅝". State Russian
Museum, Leningrad

ity of works shown—landscapes, portraits, and "scenes from life"—differed little from those at the academy.[4] The Realists were the vanguard of their time, not for any stylistic experimentation but for their independent stance and their determination to paint subjects from life in Russia.

In the minds of many artists and writers, commitment to Russian subjects and rejection of the academy's authority meant rejection of European art. The sense of opposition between Russian and European characteristics went back to the reforms of Peter the Great in the late seventeenth century, and the conflict between Slavophiles and Westernizers was a major issue in the nineteenth century. Despite the ambivalence about Europe, Russians had access to a broad range of European art, from antiquities and old masters to contemporaries, especially in Saint Petersburg. The Hermitage opened to the public in 1852; the collection of Count Kushelev-Bezborodko, rich in French landscape paintings, including works by the Barbizon school, was the foundation of the academy's study collection; and the Hermitage, academy, and Saint Petersburg Public Library had fine collections of engravings.[5] In Moscow, students could see European art collected by Sergei Tretiakov, brother of Pavel, who favored nineteenth-century French painting: Ingres, Cabanel, and other Salon artists, as well as the Barbizon painters, Rousseau, Dupré, Daubigny, Troyon, Corot, and Millet. The best-known work, the favorite of almost all Russian painters, was Jules Bastien-Lepage's *Village Love*.[6] Familiarity with Barbizon painting may have inclined Russians to pursue interests in rustic landscapes and changing weather, but the influence of the native landscape tradition, exemplified by Savrasov and the brilliant but short career of Fedor Vasiliev (1850–1873), was more profound. The early appearance of Impressionist qualities in Russian art came not from sudden access to new ideas, but through a strong indigenous plein-air tradition that prepared artists to respond to new stimuli.

Besides those who went to France as students and returned with Impressionist ideas, some Russians who stayed in France were also influential in the development of Impressionism. Mariia Bashkirtseva (1859–1884) arrived in France in 1872, enrolled in the Académie Julian in 1877, and achieved notable success before her death from tuberculosis. She was known for genre and portraits, in a style compared, sometimes favorably, with that of Bastien-Lepage,[7] but her landscape *Autumn* (plate 470) has effects of light and weather close to those of Pissarro or Sisley. Aleksei Bogoliubov (1824–1896), a landscape professor at the academy, settled in Paris in the 1870s and became an adviser to the academy pensioners who studied there. He encouraged them to make a habit of sketching vignettes of Parisian life. In the summers he went to the Normandy coast, often to Veules, a fishing village between Etretat and Dieppe, which became a Russian art colony. *Seacoast at Veules* (plate 471) is one of several works by Bogoliubov showing Boudin-like gatherings of summer visitors, painters as well as bathers. Under Bogoliubov's influence, Polenov and Repin painted the beach, cliffs, and village scenes in 1874, as did Korovin nearly two decades later.

The academy pensioners naturally expected to benefit from contact with French art, but they did not

absorb French influence naively or uncritically. Having completed their studies, Repin and Polenov began their term in France with solid successes, including academic medals, to their credit; Repin stopped in Vienna on his way to Paris and enjoyed seeing his first independent work, *Barge Haulers on the Volga* (plate 472), at the *International Exhibition*.[8] Arriving in Paris in the autumn of 1873, the two Russians were awed at first by all the exhibitions and distractions in the city, but they took advantage of every new experience and began to feel at home. They found studios in Montmartre "with a wonderful view, all Paris beneath our feet,"[9] and began a program of sketching and visiting the Louvre, other exhibitions, and art dealers; they spent evenings reading aloud (Polenov was fluent in French). The correspondence of Henri Regnault, a painter killed in the Franco-Prussian War, and for many young men the model of the heroic artist, was a favorite; Polenov paid Repin the compliment of comparing his artistic talent to Regnault's.[10] Others who won praise were the Neapolitan Domenico Morelli[11] and the Spaniard Mariano Fortuny, whose posthumous exhibition Polenov called "the apogee of pure art."[12] But no contemporaries could equal the great painters of Italy, Spain, and Holland: "even the genius Regnault is only an imitator of Velázquez," Repin wrote.[13] In reports to the academy and in informal letters to friends, they stressed the value of Michelangelo and Raphael, Titian and Veronese, Velázquez and Murillo, Rembrandt and Van Dyck.[14] They said modern artists relied on "virtuosity" and "mannerism" instead of on immediacy and feeling.[15]

When Repin learned of the Independents' exhibition in April 1874, he recognized something of interest. "Among the French a new realist tendency has just appeared," he wrote to Stasov. "Or rather, a *caricature* of one . . . but there is something there." In contrast to the "mannered, routine, boring" work in the Salon, he said, "only the realists are an exception, but they are young, foolish, and scandalous. In the future they will have many chances, and I now have faith only in them, but unfortunately they are shortsighted, like all the French, silly and capricious, like children."[16] In a similar vein, he wrote to Tretiakov of his scorn for Corot's "toylike nymphs" and Cabanel's "conventional sleekness," and asserted that Russians cared about "individuality, intimacy, depth of content, and truth." He hinted at an answer to those needs:

> The remarkable phenomenon here is the appearance of the realists: so far they are rejected, and so they are scarcely to be seen at the Salon, but only in another, small exhibition [i.e., at Nadar's studio]. But they have a positive future, and now the best things can be definitely ascribed to this same realist school.[17]

Repin began a large-scale painting of a sidewalk café, a motif that would let him depict "the chief types of Paris in their most typical setting."[18] Stasov and

473. ILIA EFIMOVICH REPIN. *Portrait of Vera Repina*. 1874. Oil on canvas, 28¾ × 25⅝". State Tretiakov Gallery, Moscow

474. VASILII DMITREVICH POLENOV. *Fishing Boat, Etretat*. 1874. Oil on wood, 4⅛ × 7⅛". Fiala Collection, Prague

THE IMPRESSIONIST VISION IN RUSSIA

Kramskoi warned him not to forget his Russian heritage by becoming too French, but he ignored them and sent *Paris Café* (1875; private collection) along with several studies, such as *Woman Leaning on the Back of a Chair* (plate 467), to the Salon of 1875.[19] Unlike the more spontaneous studies, the finished work was carefully planned to demonstrate a variety of poses and gestures; the figures were not candidly observed habitués but models and acquaintances. The choice of subject and Repin's decision to exhibit the painting was his declaration of independence from his mentors. In answer to a remark that there was nothing artistic in contemporary costume, Polenov defended his friend, saying that figures in frock coats and vests were worth painting as long as they were not done in "an academic, routine manner."[20]

Comments like this show that not only did the friends talk about the new art but that they also followed discussion in the press, in particular the writing of Émile Zola. Zola's influential reviews were published in the Saint Petersburg journal *Messager de l'Europe* from March 1875 to December 1880, before their publication in French.[21] Polenov and Repin met Zola at a reception organized by Ivan Turgenev in April 1876, and they were familiar with his ideas about the place of Manet in the history of art. Zola's Russian readers, naturally, related his articles about the opposing sides in French art to events at home and to the efforts of the Peredvizhniki.

Although Repin had arrived in Paris too late for the opening of the 1873 Salon des Refusés, he attended the first Impressionist exhibition and the auction sale at the Hôtel Drouot. He understood the issues, sided with the Independents, and wrote indignantly about the unfairness of the jury system. "They accept so many trifles, while they refuse so many good things!!! Here one depends on protection and contacts. And the Salon des Refusés . . . of course many artists do not want to spoil their good name there, what is there speaks eloquently of the jury's lack of conscience."[22] The following year he complained of the "mediocrity" of the jury, which again refused Manet. He went to Manet's studio exhibition in April 1875 and commented, "*Canoers [at Argenteuil]* is not bad, and it was certainly wrong to reject it; it would have added some interest to the Salon."[23]

Repin praised Manet's direct painting as a way of avoiding academic clichés and expressing individuality. "I admire this as I admire all the expressionalists, who are winning more and more recognition here," he wrote in 1876,[24] using one of several variant terms (Russian phonetic transcriptions) for the Impressionists. To Kramskoi he admitted that the works "at first seemed senseless and empty," but he now understood that apparent senselessness as a basic trait of "the empressionists Manet, Monet and others, with their freedom and childlike truth." He stressed the need for experimentation, a key idea throughout his career: "the language everyone uses is of little interest. But an original language is noted quickly, and here is a splendid example—Manet and all the impressionists."[25]

Kramskoi, still the spokesman for the Peredvizhniki, responded cautiously: "In French painting . . . originality, independent views and subjectivity (most precious in an artist) are completely lacking—except for a small band (about fifteen), the so-called 'empressionalists.' But so far, their things have not gone beyond the realm of experiments."[26] A month later, having read Zola's review, he still had doubts; he did not see how Impressionism differed from all the "stylish and eccentric gimmicks" clamoring for attention. The genuine value of study from nature was obscured by the insistence on "effect," which he thought "shortsighted," in every sense of the word.[27] Like some of Zola's other readers, Kramskoi noted that even the foremost champion of the new art tempered his defense of Manet and the Impressionists by regretting their emphasis on "technique" at the expense of "thought."

Repin was fascinated by Impressionist technique, and he saw the large, brisk brush strokes and absence of finely worked detail as the keys to immediacy. Among his early essays was a portrait of his child perched stiffly on a high, brocade chair (plate 473). "I have done a portrait of Vera (*à la Manet*) in the course of two hours," he wrote triumphantly.[28] Polenov and Repin worked together in the open air in their Montmartre neighborhood and at Veules with Bogoliubov's Russian "colony."[29] Repin painted an old mill and some villagers as well as seascapes at low and high tide. Some of Polenov's scenes recall Corot, but studies of cliffs near Etretat (plate 474) were much bolder, emphasizing vivid contrasts of color at twilight and effects of weather. The quantity of paintings (Polenov made some forty studies of beach and cliffs) and the enthusiastic letters show the artists' growing self-confidence. They felt comfortable in Normandy, as if they were painting scenes of their homeland.[30]

More than any of Repin's French works, *On the Turf Bench* (plate 475), done just after his return to Russia, embodies the results of his plein-air studies. The subject, members of Repin's family and a dog relaxing beneath shade trees at a dacha near Saint Petersburg, recalls intimate scenes of figures in gardens painted by Berthe Morisot and Claude Monet, which Repin would have seen at the Impressionist exhibitions of 1874 and 1876. The similarity in style is even more significant. In contrast to the imitative *Paris Café*, it does not rely on modern fashion and implied narrative, but achieves a sensation of ease and familiarity by means of a light palette, brisk brush strokes, and a lack of painstaking detail. It shows Repin's assimilation of the "new language" he picked up from Manet and the Impressionists. In the next few years he painted landscapes in the north and around his childhood village Chuguev in the Ukraine, as well as informal figure studies, such as *Girl with a Bouquet* (plate 477), in which light took precedence over detail.

Polenov also painted familiar landscapes in an Impressionist manner. *The Polenov House at Imochentsi* (plate 476) is an apparently unplanned sketch of a slop-

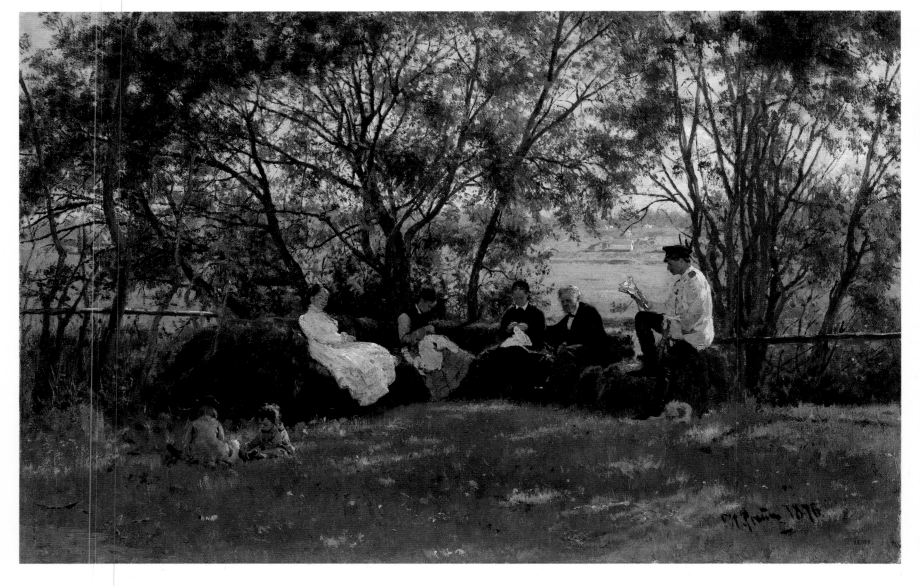

475. Ilia Efimovich Repin. *On the Turf Bench.* 1876. Oil on canvas, 14⅛ × 21⅞". State Russian Museum, Leningrad

476. Vasilii Dmitrevich Polenov. *Polenov House at Imochentsi.* 1876. Oil on cardboard, 8⅞ × 12⅝". Vasilii Dmitrevich Polenov Estate-Museum, Polenovo, Tula Region

ing lawn studded with trees, which partly mask the gabled house. Oblique sunlight on the lawn and one wing of the house contrasts with flatly painted, dark shadows. *Moscow Yard* (plate 469), done the following year, exhibits the same effects of bright sunlight on white and gray buildings and varicolored foliage. Polenov often painted plein-air landscapes not only in Russia but in Bulgaria, when he volunteered in 1877 to fight for the liberation of Bulgaria from Turkey, and he made many small studies of the countryside around the war zone. In 1881 he traveled to Palestine, in preparation for an ambitious historical painting, *Christ and the Woman Taken in Adultery* (1884–1887; Russian Museum). The studies (plate 478) are full of intense light and strong blue and purple shadows, wholly different from the brilliantly colored but overfinished painting. The same differences can be seen in Repin's work, between studies that are Impressionist in treatment of light, color, and handling of paint and finished works with national and social themes.

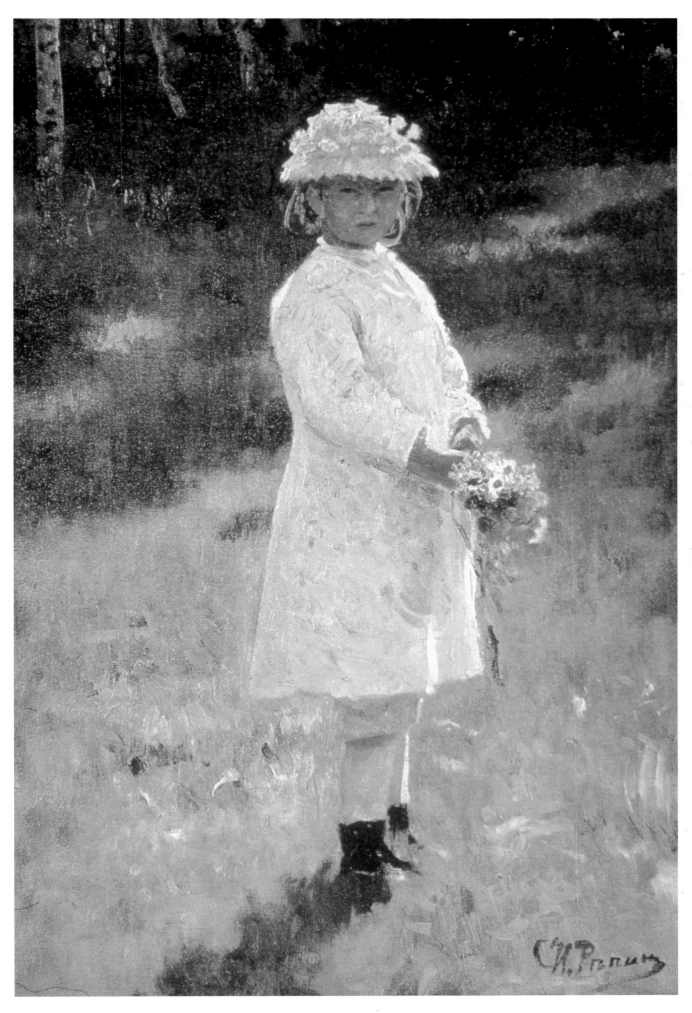

477. Ilia Efimovich Repin. *Girl with a Bouquet (Vera, the Artist's Daughter)*. 1878. Oil on canvas, 24⅝ × 19⅛". Brodskii Museum-Apartment, Leningrad

478. Vasilii Dmitrevich Polenov. *Temple in Palestine.*
c.1881–1882. Oil on canvas (dimensions unknown). State
Russian Museum, Leningrad

479. Arkhip Ivanovich Kuindzhi. *Birch Grove.* 1879. Oil on
canvas (dimensions unknown). State Russian Museum,
Leningrad

The abrupt change of styles, an apparent loss of spontaneity when the artists turned from studies of figures outdoors and landscapes to major paintings, involved more than a demarcation between sketch and finished work. The moral outlook of the Russian Realist movement was the crucial factor in preventing them from fully accepting or continuing to develop Impressionist styles. When he had been in Paris nearly a year, Repin wrote to Kramskoi about the differences between French and Russian attitudes:

> I have now completely forgotten how to judge, and I do not regret the loss of this faculty, which consumed me. I would prefer that it never returned, but I sense that back within the boundaries of our beloved homeland it will again exert its rights over me! May God preserve Russian art from corrosive analysis! When will it push its way out of this fog?[31]

Repin argued against art that limited itself to depicting conditions that plagued civilization; he could already see other possibilities. The letter shows Repin's reluctance to return to the "corrosive analysis" that afflicted the Peredvizhniki's critical Realism and his enthusiasm for the new spirit in France: "This is a period of transition: among the younger generation there is a vital response, which is producing things full of life, strength and harmony."[32] For both Repin and Polenov, however, the return to Russia meant the resumption of moral responsibilities.

If Repin and Polenov retreated from the possibilities of Impressionism, they were more open to new ideas than most of their colleagues. Kramskoi's brief visit to Paris had little effect on his work. Viktor Vasnetsov (1848–1926) spent some time in Paris in 1876, mainly sketching street performers. He used plein-air painting in studies for major works and in landscapes such as *Akhtyrka* (1879; Polenov Estate Museum, Polenovo), a view from a terrace down some steps to a lawn surrounded by bushes; the same kind of domestic vista that Repin and Polenov painted at the time. However, an artist who achieved striking effects of light and shade was the self-taught Arkhip Kuindzhi (1842?–1910), who had traveled throughout Europe in 1873. His studies of a *Birch Grove* (plate 479) emphasized more extreme tonal and textural contrasts than any of Repin's or Polenov's works.

Several artists from Czechoslovakia, Rumania, and other Eastern European countries were in Paris during the Impressionist years, but there seems to have been little contact between them and artists from Russia. Perhaps because they did not experience the early struggles of the Peredvizhniki, these artists had no reason to identify with the young Russians' concern with independence and were more interested in assimilating the motifs and styles they saw in recent French painting. The Czech Antonín Chittossi (1847–1891) studied in Paris in 1879 and painted Impressionist cityscapes featuring quais and railway stations as well as peaceful landscapes

such as *The Eure at Acquigny* (National Gallery, Prague). He adapted this style to landscapes of southern Bohemia and led younger Czech artists toward Impressionist styles. The Rumanian Nicolae Grigorescu (1838–1907) studied in France in the 1860s and painted in Fontainebleau and Normandy with the Barbizon group. His tonal, sometimes apparently "unfinished" work influenced Ion Andreescu (1850–1882), who went to France in 1879 and used strong colors and compositions focused on a single motif. Artists from the Austro-Hungarian Empire who were in Paris during the 1870s included Mihály Munkacsy (1844–1909), who worked in Vienna, Munich, and Düsseldorf before spending twenty-five years in Paris, and Lászlo Mednyánszky (1852–1919), a landscape painter; both remained stylistically closer to the Barbizon school than to the Impressionists.

Polish art in the 1870s was virtually dominated by Jan Matejko (1838–1893), an internationally renowned painter of historical scenes and the most influential teacher at the Polish Academy in Cracow. Hendryk Siemiradzki (1834–1902), born in the Ukraine, studied at the Saint Petersburg Academy before moving on to Munich, Rome, and Paris, where his sumptuous, if slightly revolting, *Human Torches of Nero* (1876; National Museum, Cracow) won a gold medal at the Salon of 1878. But some Polish artists were either influenced by the French Impressionists or worked along parallel lines. Jozef Chelmonski (1849–1914) studied in Warsaw and Munich, before going to Paris in 1875. He lived there until 1887, developed a successful blend of rustic genre and Impressionist brushwork, and continued to work in this style after his return to Poland. Aleksandr Gierymski (1850–1902) was more original. After study in Warsaw and Munich, he went to Italy in 1871 and stayed mainly in Rome until 1888; he lived in Paris from 1890 to 1893 and again from 1898 to 1899. Like Repin and Polenov in his regard for the old masters, he also used plein-air effects to give veracity to genre scenes. His striking and unprecedented *Study II to Summerhouse (with a Top Hat)* (plate 480), done before he went to France, may show the influence of his years in Italy. The token subject, a corner of a gazebo with a hint of narrative in the empty bench and abandoned hat, is submerged in the extraordinary play of light through the vine-covered latticework and the nearly abstract patterns of shadow. These effects anticipate the Post-Impressionist works by the Russian Igor Grabar and the Czech Ludvík Kuba.

## The New Generation and the Pursuit of Light

In Russia, the transitional stage heralded by Repin required several intermediate steps. Contact with French art was the starting point, but the crucial second step, assimilation and internal development, took place under new conditions and was taken mainly by Serov, Korovin,

480. ALEKSANDER GIERYMSKI. *Study II to Summerhouse (with a Top Hat)*. 1876–1880. Oil on canvas, 22⅞ × 16⅛". National Museum, Warsaw

Levitan, and others born in the 1860s, who studied with Polenov and Repin and were introduced by them to Impressionism.

Polenov's "drawing evenings" and Sunday morning watercolor sessions attracted not only students and former students—including Elena Polenova (1850–1898; Polenov's younger sister), Ilia Ostroukhov (1858–1929), Sergei Ivanov (1864–1910), Mikhail Nesterov (1862–1942), Avram Arkhipov (1862–1930), Leonid Pasternak (1862–1945), the nucleus of the "Polenov circle"—but also such visitors as Vasnetsov, Repin, Serov, and Mikhail Vrubel (1856–1910). All were frequent guests of the railway magnate and art patron Savva Mamontov at his Moscow house or at Abramtsevo, his estate northeast of Moscow, which became a major art colony. Its members and surroundings appeared in a number of paintings, including Serov's *Girl with Peaches* (plate 481), the work that most fully embodied the younger artists' striving for freshness.

Korovin recalled with gratitude that Polenov recognized his students' inclination toward Impressionism and told them about the movement;[33] Polenov urged them to look at works by Bastien-Lepage, Menzel, Breton, Fortuny, and other European painters in Sergei Tretiakov's collection and at the Barbizon landscapes in the Kushelev Gallery at the academy and to make studies *en plein air*. Korovin said that painting scenery for Mamontov's private theater alongside Levitan and Polenov helped him to understand the distinction between copying nature literally and creating a natural effect using "incomplete drawing" and "vanishing patches" of contrasting colors.[34] Soon after Polenov took over the Moscow School landscape class from Savrasov, he invited Korovin to his studio to see studies for *Christ and the Woman Taken in Adultery*. Korovin was uninterested in the subject but pleased by the landscape elements because they were "painted as if directly from nature," though he preferred Polenov's Russian scenes, painted for their own sake rather than to support a theme.[35] Korovin later admitted that when he saw Polenov's studies of Palestine, "I saw the blue shadows, too, but I was afraid to take them [for my work] because everyone found them too bright."[36] But within a few months Korovin himself was juxtaposing vivid colors so effectively that Polenov suggested working together from a model so that his pupil might coach him: "I mix colors in a conventional and routine way. Please, help me get away from this."[37]

Korovin had already rejected most of the conventions of academic painting as well as the didacticism of Realism. In his memoirs he claimed that his first independent work, *Portrait of a Chorus Girl* (plate 482), was the first Russian portrait done as a picture only, without the intention of conveying the character of the subject. He deliberately chose a commonplace, unattractive model and left the setting, a public park, only vaguely defined. Korovin's interest was in the relationships of simple, clear colors and patches of light on the figure. The broad brush strokes, the absence of defining contours, and the disregard of anatomical harmony for the

THE IMPRESSIONIST VISION IN RUSSIA

481. VALENTIN ALEKSANDROVICH SEROV. *Girl with Peaches.*
1887. Oil on canvas, 35⅞ × 33½". State Tretiakov Gallery,
Moscow

sake of visual harmony daringly repudiated the traditional canons of portraiture. Mamontov showed the canvas to Repin, who leapt to his own conclusion about the artist and exclaimed: "A Spaniard! That is obvious. Splendid! It is painting for the sake of painting. A Spaniard, with temperament."[38]

Korovin claimed to be the inventor of the plein-air portrait as Serov had not yet painted anything like this. According to his own account, Korovin had neither seen nor heard of French Impressionism in 1883.[39] He first went to Europe in the spring of 1885, spending time in Spain before going to Paris. *Spanish Tavern* (1885; Tretiakov Gallery, Moscow) and *On the Balcony. Spanish Women Leonora and Ampara* (1885; Tretiakov Gallery), begun in Barcelona and finished in Paris, echoed the fascination with Spanish motifs that Manet had felt twenty years earlier. In Paris, he sought out the works Polenov had described.[40] The effects of this trip, a trip to Italy in the winter of 1887 with Mamontov, and shorter visits to Paris in 1886 and 1888 only gradually worked their way into his painting. *Chorus Girl* was not the beginning of a series of Impressionist portraits but a spontaneous attempt to capture a single effect, an experiment that aroused wonder but not real understanding. Renewed contact with the Abramtsevo circle and especially with Serov brought Korovin to the point of connecting his experience abroad with his earlier, intuitive treatment of a figure in sunlight and enabled him to explore the consequences of *Chorus Girl*.

Korovin and Serov, who had met at Abramtsevo in 1886, became such close friends that people called them Korov and Serovin.[41] Serov's portrait of Korovin (plate 483) conveys the artist's easygoing nature, his sloppy dress and uncombed hair, and his casual posture. The sketches pinned to the wall in the background are like many Korovin did in France and show his quick, effortless technique. Serov was a quieter, more intense person, who took great pains in his work though he strove for an illusion of spontaneity. It is no wonder that Serov's first plein-air figure paintings, *Girl with Peaches* and *Girl in Sunlight* (1888; Tretiakov Gallery), took longer than Korovin's to achieve and came after a series of landscape studies.

Serov began his training in Europe as a child; his mother, the composer Valentina Serova, had taken him to Munich, where he studied drawing with Karl Koepping, and then to Paris, where he studied with Repin in 1874–1875. He accompanied Repin to exhibitions and events in the Russian circle, but as a nine-year-old boy he would not have had independent contact with the Parisian art world. Returning to Russia, he lived at Abramtsevo, as part of the Mamontov family, and continued to work with Repin until he entered the Saint Petersburg Academy. He left in 1885 to travel abroad and to see the works of Rembrandt, Velázquez, and the Italian Renaissance and Baroque masters. In Venice, he was struck by a sudden revelation of the excitement and joy he missed in Russian art, and, "in a somewhat intoxicated condition," he wrote home:

482. Konstantin Alekseevich Korovin. *Portrait of a Chorus Girl*. 1883. Oil on canvas, 21 × 16¼". State Tretiakov Gallery, Moscow

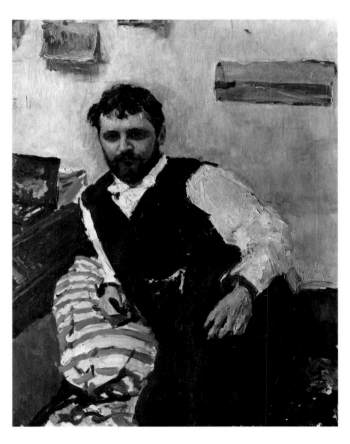

483. Valentin Aleksandrovich Serov. *Portrait of Konstantin Korovin*. 1891. Oil on canvas, 44⅛ × 35". State Tretiakov Gallery, Moscow

484. VALENTIN ALEKSANDROVICH SEROV. *Riva degli Schiavoni in Venice*. 1887. Oil on canvas, 8⅞ × 12⅜". State Tretiakov Gallery, Moscow

I am certain that everything done here by the mind and hand of an artist was done in a state of near intoxication. Therefore they were good, those masters of the sixteenth-century Renaissance. They lived easily, without care. I want to be the same—carefree. In the present century artists paint only what is serious, nothing joyous. I want, I want the joyous and will paint only the joyous.[42]

Serov's wish was not to copy the styles of the Bellinis, Carpaccio, Veronese, Tintoretto, and Titian but to paint as freshly and joyously in his own way as they had in theirs.[43] He painted little in Venice: a sketch from his hotel window, *Riva degli Schiavoni* (plate 484), and one of Saint Mark's (1887; Tretiakov Gallery). But these studies of fluid, silvery tones of water, air, and pavements, accented with irregular strokes of black, brown, and dark blue to mark figures, windows, and shadows, show his interest in capturing effects rather than in describing details. In contrast to Polenov's use of plein-air studies to give his paintings accuracy and permanence, Serov's studies and similar ones of Florence by Korovin represent an integration of observation and subjective response to a visual sensation.

Serov went back to Abramtsevo and to Domotkanovo, an estate in Tver province owned by his friend, the artist Vladimir Derviz. He found in these pleasant settings and in the people he saw daily subjects that perfectly answered his wish for "the joyous." *Girl with Peaches*, portraying the Mamontovs' twelve-year-old daughter Verusha, was painted with the immediacy and directness he admired in Venetian painting. He later told his friend Igor Grabar:

All that I achieved was freshness, that special freshness which you always feel in nature and do not see in painting. I worked on it more than a month and wore her out, poor girl. But still I wanted to preserve that freshness of touch along with complete finish—just as the old masters did. I thought of Repin . . . of the old masters—my trip to Italy was very telling at the time—but most of all I thought of that freshness. I had never thought of it so intensely.[44]

The girl, at the center of the composition, leans forward in her chair, with arms resting on the table, so that her momentary pose picks up the oblique edge of the table and the irregularly spaced verticals of the doorjamb and the frame of the window behind her. The striking treatment of light from behind the figure, edging the contours of the girl, chairs, and peaches with white and bringing out the deeper russet and rosy tones, warrants comparison with effects achieved by Degas and Renoir, although Serov did not yet have a firsthand knowledge of Impressionism. Probably Repin's treatment of light on figures in the late 1870s had some influence, as Serov's letter suggests. Next to *Girl with Peaches*, Korovin's earlier *Chorus Girl* seems simple, sketchy, and unresolved. Serov's work was praised for the apparently effortless accomplishment of using white on white and for his pastel color harmonies; it won first prize at the 1887 *Exhibition of the Moscow Society of Lovers of Art*.[45]

Serov said that *Girl with Peaches* was not a traditional portrait but a picture.[46] Without denying the personality of his models, most of them his friends, Serov picked out a special coloration that was part of the relationship between figure and setting. His outdoor counterpart to *Girl with Peaches* was *Girl in Sunlight*, again not a portrait but an experiment in translating shifting patches of sunlight on skin and fabric into adjacent and interacting pastel tones. The model, his cousin Mariia Simonovich, was a sculpture student who understood the artist's aim "to achieve likeness and along with this the play of light on the face."[47] Most colleagues and some critics applauded the originality of this "daring attempt to translate onto canvas all the varying reflections and tones falling on the figure."[48] Tretiakov bought the painting, despite a warning from a conservative artist that exposing the unusual sun-flecked skin would be as pernicious as "innoculating the gallery with syphilis."[49]

Serov, unlike Korovin, was not deliberately iconoclastic. He respected the traditions of landscape and figure painting, but his concern for freshness along with complete finish led him to more subtle and far-reaching stylistic innovations. He used tones, textures, and the space around figures not as foils but as equally important elements that conveyed a specific emotional character. The titles of *Girl with Peaches* and *Girl with Sunlight* underline Serov's interest in creating complete pictorial environments through the unity of figures and landscape.

Korovin, too, treated landscape as an expressive

485. KONSTANTIN ALEKSEEVICH KOROVIN. *Nasturtiums.*
c.1887–1888. Oil on canvas, 11¾ × 17¾". Vasilii Dmitrevich
Polenov Estate-Museum, Polenovo, Tula Region

486. KONSTANTIN ALEKSEEVICH KOROVIN. *In the Rowboat.*
1887. Oil on canvas, 20⅞ × 17". State Tretiakov Gallery,
Moscow

counterpart to figures. On his return from Europe he
tried to relate his experience abroad to the special atmo-
sphere he found at Abramtsevo in *Northern Idyll* (1886;
Russian Museum). Though painted *en plein air*, the folk
costumes, reflecting the Abramtsevo circle's interest in
national culture, gave the work a staged, nostalgic air.
Paintings done at Abramtsevo by Vasnetsov that were
based on Russian folklore and by Nesterov, who placed
religious images in carefully observed local landscapes,
showed the same difficulty in reconciling plein-air
painting techniques with literary themes emphasizing
Russian cultural identity. The dilemma, recalling the
conflict of Slavophiles and Westernizers, was reinforced
by official cultural policy promoting national subjects in
painting and "neo-Russian" styles in architecture and
decorative arts. Though not inhibited by the moral im-
peratives of critical Realism, as Polenov and Repin had
been in the early 1880s, these artists could not wholly
accept an Impressionist approach to painting—one that
operated equally for subject and technique. Korovin and
Serov were the first to break away from the Realists'
preoccupation with theme at the expense of style and to
equate subject with style.

Korovin took part in the dispute over idea and
style at the Moscow School in the 1880s. Polenov's stu-
dents in the landscape class, he later recalled, had con-
stantly to defend themselves against attacks by the pupils
of the more conservative Peredvizhniki in the genre stu-
dio. The genrists held that landscape painting was easy
but pointless: "Landscape has no subject. Any fool can
paint a landscape. But genre cannot exist without an
idea. Genre demands thought." This assertion echoed
the ideological rhetoric of the 1870s, although the politi-
cal and social conditions, which had demanded analysis,
moral judgment, and true pictures of life, had changed.
The key to the debate, Korovin said, was that the genrists
still believed that "*what* you paint is important," but the
landscapists answered, "What is important is *how* you
paint."[50]

Serov's *Girl with Peaches* and *Girl in Sunlight* had
counterparts in Korovin's paintings of the Polenovs and
their friends at Zhukovko, a dacha not far from Moscow.
*Nasturtiums* (plate 485) shows a corner of a flower-
covered veranda, a woman in a light dress at the bottom
of the steps looking back at a man who stands in shade on
the porch. The bright grass and the flowers and leaves
with touches of white at the edges recall Monet's paint-
ings of lawns and flowerbeds of the early 1870s. *At the
Tea Table* (1888; Polenov Museum) shows four friends
around a table set on the open porch. The angle of the
table, the backlighting through masses of late summer
foliage, and the play of light on the surfaces are almost
quotations from *Girl with Peaches*. But Korovin's work is
less firmly composed. Attention shifts from one figure to
another, to the still life, and to the outdoor light. *In the
Rowboat* (plate 486), a third painting in the Zhukovko
cycle, has only two figures, Korovin and the artist Mariia
Iakunchikova (1870–1902), seated in a boat which
seems to be drifting under branches at the edge of a

THE IMPRESSIONIST VISION IN RUSSIA

pond. It is carefully arranged; everything supports the flattening effect of the unusual viewing angle. Attention is drawn to the surface of the canvas by the wedge of the boat's prow, echoed by the poses of the man bending forward over a book and the woman leaning slightly to the right, the color contrast of light blouse, shirt cuffs, book, and the seats, oars, and gunwhales of the boat against the brownish green water and green leaves, the flat brush strokes on the garments, wood surfaces, and leaves, and finally, the absence of a horizon or setting. As in *Nasturtiums*, the seemingly accidental glimpse of figures unaware of a viewer was a device Korovin learned from his encounter with French Impressionism, but one that he made his own. Like some works by Manet and Degas, the painting emphasizes qualities of paint, color, and contour even more than the effects of air and light. It also contains a laconic personal content: not narrative, but the states of reading and listening. Korovin did not take this kind of psychological expression much further. Instead he worked with ways of conveying mood through landscapes.

"We need paintings which are close to the heart, which call forth a response of the soul. We need light— more that is joyous and light," Korovin wrote in a sketchbook in 1891.[51] He expanded this idea in another entry in the sketchbook:

> Landscape should not be painted without a goal, for the sake of beauty alone, but rather so that through the landscape something significant may be reached, something close to the spirit of nature. Within it should be the story of the soul. It should resonate to a deep, sincere feeling. This is hard to express in words, it is so close to music.[52]

This aspect of landscape was to become still more important when Korovin and Serov each did a series of paintings of the far north for Savva Mamontov in 1894. Some of these pictures resemble works by the Scandinavians Nils Kreuger, Fritz Thaulow, Prince Eugen, and Anders Zorn (whom Korovin knew well); more important, the Russians' connection of "impression" with mood and feeling is similar to the idea of evoking feeling through nature in Nordic *stamning* painting.[53]

Levitan, unlike his friends, painted landscapes exclusively; most included signs of human presence— houses, monasteries, footpaths, boats, haystacks, or farm animals—but no genre or portrait elements. As a child and young man he lived in extreme poverty, but he was able to attend the Moscow School with the help of grants.[54] He was just gaining recognition at student exhibitions when his life was made more difficult by a government edict of 1879 (a reaction to anarchist activities) forbidding Jews to live in Moscow; Levitan moved to an outlying village, commuted by railway, and for a time even slept in one of the school's empty studios. He persevered and completed *Autumn Day, Sokolniki* (1879; Tretiakov Gallery), which Tretiakov bought. A path lined with trees leads the eye into the middle distance, and a wedge of overcast sky echoes the shape of the path. It is a simple composition characteristic of his later work. A figure, added by his friend Mikhail Chekhov, lends an introspective, autumnal mood; after this, Levitan dispensed with figures, but he still sought to evoke emotional responses with his landscapes. He traveled around Russia, to the Crimea and along the Volga. In a village where the river makes a broad loop, he painted *After Rain, Plës* (1889; Tretiakov Gallery), showing the returning light and clearing clouds after a rainstorm; this and many companion works render temporary effects of weather much as did Monet's coastal landscapes of the late 1860s, but Levitan did not know Impressionism until he visited Paris in 1890. During the next years, Levitan continued to paint on the Volga and in other parts of Russia. He began working in a style distinct from that of Savrasov or Polenov, using open compositions, with large areas of sky.

Among the works that sum up the process of bringing Impressionist ideas about light, color, and atmosphere into Russian landscapes are a group painted by Korovin, Serov, and Levitan in the mid-1890s that focus on precise seasonal effects: Korovin's *Winter* (plate 487), Serov's *October, Domotkanovo* (plate 488), and Levitan's *March* (plate 489)—itself almost a mirror image of *Winter*—and *Golden Autumn* (plate 490). They continue Polenov's objective approach to light and atmosphere. Yet they also contain emotional effects, which may be compared to descriptions in the writing of Chekhov: often prosaic in detail but with undercurrents of feeling.

"It is impossible to describe nature without pathos, without enthusiasm," Chekhov said in 1895, thinking of Levitan.[55] The "pathos" in Levitan's work was not a matter of conveying a human emotion in a symbolic manner but of subordinating momentary personal feelings to a spiritual identification with nature. Levitan, who suffered from heart disease and frequent bouts of depression (to the point of attempted suicide), did not let his melancholia intrude on his interpretations of landscapes. He wrote about this to Sergei Diaghilev: "Whole days I lie in the forest reading Schopenhauer. You are surprised. You think that henceforth my landscapes will be permeated with pessimism? Don't worry—I love nature too much."[56]

Levitan's goal was to find the visual means to express the character of a landscape. He could use heavy impasto in the tiny and delicate *Birch Grove* (plate 491) or thin washes of almost monochromatic paint in *Silence* (plate 492), using pastels and watercolors more inventively than most of his colleagues. Some of his late works submerge the landscape into a coloristic or textural effect, most striking in *Twilight, Haystacks* (1899; Tretiakov Gallery). Korovin's paintings of Scandinavia and northern Russia and the studies he and Serov did together in 1894, also play down description in favor of stylization. Having developed the process begun by Polenov of freeing landscape from conventional thematic associations by distilling the purely visual elements of a landscape, these artists were beginning to allow visual

effect and painting style to give rise to subjective associations.

Levitan, Korovin, and Serov never went as far in the direction of stylization as did Polenova or Iakunchikova. Polenova painted small studies of nature, roadside flowers silhouetted against dark pine trees or framed by a low fence, and adapted these forms to applied art designs. Iakunchikova often used landscape motifs as vehicles for contrasting closeness and distance, as in *From the Window of an Old House, Vvedenskoe* (plate 493), and she used heavily outlined contours of pine boughs, plants, or birds as the basis for abstract patterns. This tendency, related to Art Nouveau, called "*modern*" in Russia, led to a new and final reworking of Impressionism at the turn of the century. Regardless of stylistic preference, artists of the "transitional" period beginning in the mid-1880s were conscious of the need for a spiritual element in art—quite different from the "idea" emphasized by the Peredvizhniki—and of the requirement that the means of expression, or style, be appropriate to the underlying spiritual content.

By the mid-1890s the definition of Impressionism had become too fluid to be understood in the same way by everyone. Korovin, the only one who courted comparison with the French, did not mind the publicity when Tsar Alexander III, at the 1891 *Traveling Exhibition*, stopped by Korovin's work to remark, "That is from the Impressionist School," adding, "*Mais ça laisse beaucoup à désirer.*"[57] The views of boulevards and sidewalk cafés, like *Paris Café* (plate 494), which he brought back from a recent trip and showed at the Moscow Society of Artists' exhibition in 1894, excited controversy: could these really count as Russian works? Nikolai Dosekin (1863–1935), a member of the society who also painted views of Paris streets, devoted part of a review to this question:

> Korovin follows the difficult path of lyricism in painting, of the imprinting of subjective moods, which sometimes make our ordinary surroundings unrecognizable. . . . People have stated that Korovin's paintings are imitations of the latest French Impressionists. . . . Without question, depictions of . . . French models cannot avoid having a French character. But if we examine the aspect in which, regardless of subject, the artist expresses individual traits, we see that the similarity is superficial. Coloration, harmony of tones, precisely the aspects upon which Korovin bases his style, differ totally from contemporary French Impressionism. The latter is characterized by light and a rather bright spectrum of colors. Korovin's painting is distinguished by a dark, barely colored spectrum, entirely his own.[58]

Using Korovin's works to introduce the concept of "lyricism," Dosekin pointed out that the subject was immaterial; the special task of art was the "fixation of that first moment when that poetic mood appears in the

487. KONSTANTIN ALEKSEEVICH KOROVIN. *Winter.* 1894. Oil on canvas mounted on cardboard, 14⅝ × 20⅝". State Tretiakov Gallery, Moscow

488. VALENTIN ALEKSANDROVICH SEROV. *October, Domotkanovo.* 1895. Oil on canvas, 19⅛ × 27⅞". State Tretiakov Gallery, Moscow

THE IMPRESSIONIST VISION IN RUSSIA

489. Isaac Ilich Levitan. *March*. 1895. Oil on canvas,
23⅝ × 29½″. State Tretiakov Gallery, Moscow

490. Isaac Ilich Levitan. *Golden Autumn*. 1895. Oil on
canvas, 32¼ × 49⅝″. State Tretiakov Gallery, Moscow

491. Isaac Ilich Levitan. *Birch Grove.* 1885–1889. Oil on paper on canvas, 11¼ × 19¾". State Tretiakov Gallery, Moscow

492. Isaac Ilich Levitan. *Silence.* 1898. Oil on canvas, 37¾ × 50⅜". State Russian Museum, Leningrad

493. Mariia Vasilievna Iakunchikova. *From the Window of
an Old House, Vvedenskoe.* 1897. Oil on canvas, 34¾ × 42".
State Tretiakov Gallery, Moscow

494. Konstantin Alekseevich Korovin. *Paris Café.* 1890s.
Oil on canvas, 24 × 19¾". State Tretiakov Gallery, Moscow

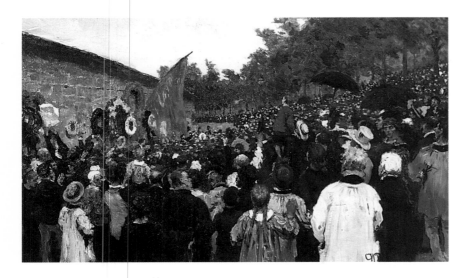

495. Ilia Efimovich Repin. *Annual Memorial Meeting at the Wall of the Communards, Père Lachaise Cemetery in Paris.* 1883. Oil on canvas, 14½ × 23½". State Tretiakov Gallery, Moscow

496. Ilia Efimovich Repin. *Nevskii Prospekt.* 1877. Italian pencil on paper, 11⅝ × 16⅛". State Russian Museum, Leningrad

artist's soul." The artist had to find an external form to convey that internal mood; because there were no objective forms to correspond precisely with each feeling, the viewer should not expect to understand a "lyrical" painting immediately but should try to grasp the artist's form of expression. A Parisian street, the objective content of Korovin's work, was still permeated with "the poeticism of subjective content, in other words, mood."[59] This formulation absolved Korovin of the charge of duplicating French Impressionism and instead drew attention to the "current of Russian poetry" and the means of expressing it visually.

The new approaches of Serov, Korovin, and Levitan helped other young artists and also some of the older artists to find new goals. Just as Polenov asked Korovin to help him use colors more freshly, Repin learned from his students and obviously admired Korovin's handling of paint. When Repin revisited Paris in 1883, he could look at the art with eyes attuned to the perceptions of his younger colleagues. His stay revived his interest in Impressionism, but he was scornful of the "imitations" at the Salon. The early Impressionists, he said, had conscientiously worked out particular problems, and had "attained strength and authority," but soon the critics announced that "incompleteness" was the mark of genius. "And now what happens? Everyone has started to affect virtuosity and incompleteness!"[60]

The painting *Annual Memorial Meeting at the Wall of the Communards, Père Lachaise Cemetery in Paris* (plate 495) shows Repin's renewed interest in Impressionism. He had joined a crowd of about ten thousand people carrying wreaths to the graves of Blanqui and other communards executed in 1871; in a pencil sketch and in the small painting done at his hotel, he tried to capture the "tremendous furor" of the event; the red banner, bright sky, and the masses of people shouting "*Vive la Revolution sociale!!*"[61] The choice of technique was inspired both by the revolutionary nature of the subject, which reminded him of his excitement at living in Montmartre and seeing signs of the commune on his first visit, and by his presence once again in the midst of the Parisian art world. Repin, characteristically, adapted style to both subject and mood. At this point, he decided to use Impressionist devices in a much more ambitious work, *They Did Not Expect Him* (1883–1888; Tretiakov Gallery), which shows a newly released political exile in order to reinforce the contemporaneity of the scene. But it was mainly for nonideological genre subjects and portraits that he used a markedly Impressionist manner. In his drawings of Saint Petersburg for *Scribner's Magazine* (plate 496), he left large areas empty and used quick pencil notations to indicate anonymous figures hurrying about their affairs, including just a few topographical details, shop signs, and advertising posters to establish the settings. Compared with *Paris Café*, the drawings show a fuller understanding of the Impressionist vocabulary appropriate for rendering a slice of city life. Paintings of the late 1880s and early 1890s also demonstrate Repin's Impressionist leanings. *Doctor Pavlov in the Op-*

497. Ilia Efimovich Repin. *Doctor Pavlov in the Operating Room*. 1888. Oil on cardboard, 11 × 15⅞″. State Tretiakov Gallery, Moscow

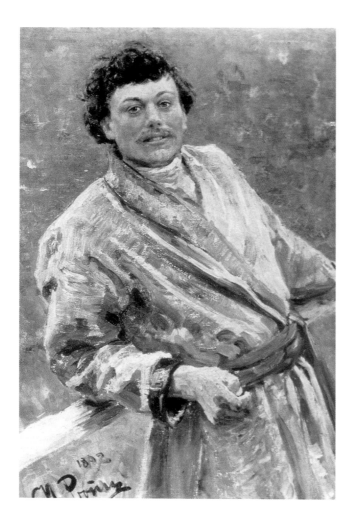

498. Ilia Efimovich Repin. *White Russian*. 1892. Oil on canvas, 40⅛ × 28⅛″. State Russian Museum, Leningrad

*erating Room* (plate 497) shows the surgeon almost hidden by assistants, raising a mallet to begin an operation. It is hardly a portrait, but rather an essay in contrasts; the drama of the operation altered by the bright, clear light and cool ambience. Despite its small size, it was not a study, but "a painting from nature, complete and firm," Repin told Tretiakov.[62] With the remarkable modulations of light over the white towels and smocks, it was probably meant to outshine both the Impressionists and the young Russians. Perhaps inspired by Serov and Korovin, he painted his daughter Vera in a field with a bunch of wildflowers in *Autumn Bouquet* (1892; Tretiakov Gallery) and *White Russian* (plate 498), showing a smiling young man in a gray robe with a pink shirt and a green sash leaning against the top rail of a fence. Neither work has the complex interaction of figure and setting found in Serov's paintings; the background of *White Russian* is only blurred patches of green with touches of rose, the brush strokes very broad like those on the robe, and the effect is much like that of Korovin's *Chorus Girl*.

By the early 1890s Repin was distancing himself from philosophy, the "disease" of Russian art. "Our salvation is in form," he claimed, "in the living beauty of nature."[63] He directed his ambitions for Russian art toward the younger generation and its search for the joyous:

> I am certain that the following generation . . . will free itself from the search for ideas, and will breathe freely, will look upon God's world with love and joy, and will relax in the unquenchable richness of forms and harmony of tones.[64]

Repin and Polenov championed the younger artists when the Peredvizhniki, twenty years after the group's founding, grew increasingly conservative and seemed, Polenov said, to "regard with a kind of hatred all that is young and fresh."[65] Repin served on a commission to reform the academy's curriculum, and in 1893 he joined the teaching staff, while Polenov remained at the Moscow School.[66] Repin said that his chief principle was "inviolability of the artistic individuality of the students."[67] He discouraged imitation and advocated study from nature and careful rendering of what the eye perceived; he told his students that "the sketch is the most essential aspect of an artist's work."[68] Besides holding drawing sessions every week, like Polenov, he took students to Vyshnyi Volochek in Tver province (between Moscow and Saint Petersburg) to let them study landscape and figures in the open air. *At the Academic Dacha* (plate 499) records one outing in a deliberately sketchlike technique. As part of his efforts to help young artists, he organized the *Exhibition of Experiments in Creative Art*, which was intended to include work in all media "unfinished in the academic sense" and to give artists and the public a chance to examine the creative process.[69]

Meanwhile, beginning in 1889 and 1890, many younger artists went to Paris, with the encouragement of Repin and Polenov, to make their acquaintance with the

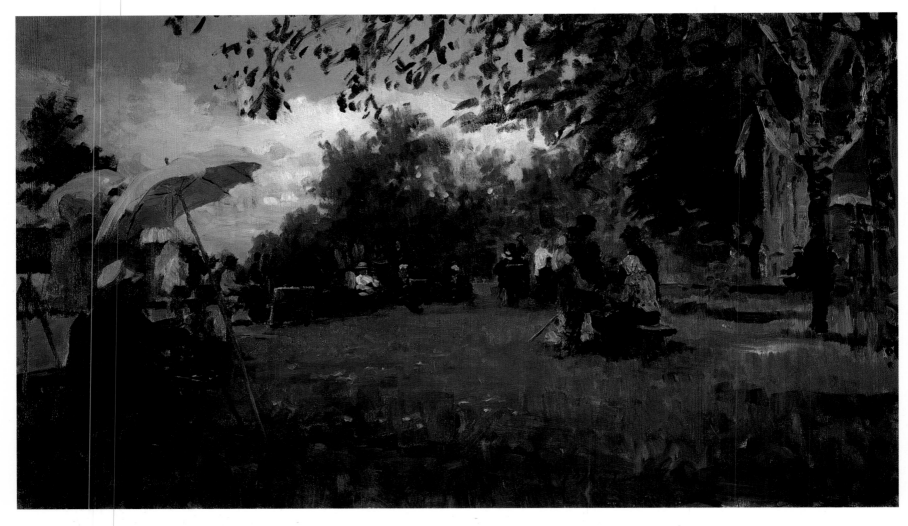

499. Ilia Efimovich Repin. *At the Academic Dacha.* 1898.
Oil on canvas, 25¼ × 41¾". State Russian Museum, Leningrad

center of the art world, to visit the Exposition Universelle, and to see firsthand the works they had heard about from their teachers. They also wanted the stimulation of seeing "something new and inspiring" and working among people "who live a strong artistic life."[70] Most saw what they expected. Serov wrote: "I was wholeheartedly glad to see Bastien le Page [*sic*]—a fine artist, indeed the only one of whom I still have a good and pleasant memory. This may be because I gave twice as much attention to him."[71] Polenova and Nesterov singled out *Jeanne d'Arc Listening to Voices* (1879; The Metropolitan Museum of Art) as the highlight of their visit.[72] They were drawn to Bastien-Lepage not only because they liked *Village Love;* his work succeeded, where other French painting did not, in creating harmony and mood through landscape and its tonalities.[73] The distinction was important in discussions of Russian art, especially Korovin's, in relation to the differences between French and Russian Impressionism.

Artists interested in genre made less use of Impressionism than landscapists, but some stylistic differences in some artists' treatments of genre subjects resulted from exposure to French Impressionism. Pol-

500. Elena Dmitrievna Polenova. *Laundress,* (study for *Guests*). 1891. Oil on canvas, 17¾ × 28¾". Private collection

The Impressionist Vision in Russia

501. Avram Efimovich Arkhipov. *Laundresses.* c.1890. Oil
on canvas, 35½ × 27½". State Russian Museum, Leningrad

enova painted both landscapes and scenes of humble urban life. Soon after returning to Russia she completed a more ambitious work, *Guests*, originally called *Laundress* (1891; Tretiakov Gallery), showing a servant ironing while two peasant boys eat bread and tea, a subject typical of Realist genre. Its unusual strength, evident in a study (plate 500), comes from the brilliant light silhouetting the figure and the shadows and reflections on surfaces. These traits could be related to *Girl with Peaches*, but it is possible that Polenova also saw some of Degas's laundress paintings at Durand-Ruel's and that his unusual treatment of laboring figures inspired her to begin similar studies immediately after her return. Lack of evidence makes such speculation useless,[74] but at least one point can be drawn from the work of Polenova and her friends Ivanov and Arkhipov. A painting expressing sympathy for the poor no longer had to follow the norms of 1860s Realism.

At the end of the decade, Arkhipov painted *Laundresses* (plate 501), in a way that showed the physical strain of their work directly, without telling a story. He visited the laundry room at the Smolenskii market in Moscow to study the scene and then called the women to his studio and had them pose in the corner close to the window, so the light would be like that in the basement laundry.[75] Using silvery tones of gray and tan and contrasting pale red and dark gray and handling his paint with broad strokes of a palette knife or with light streaks of an almost dry brush, Arkhipov achieved the effects of pale daylight haloing the women's hair and shoulders, refracting through the rising steam, and reflecting almost blindingly from the condensing moisture on the floor. This was unlike anything he had done before, though he was always a strong plein-air painter. In *Laundresses*, Arkhipov found his mature style, and, in many paintings of northern villages done between 1902 and 1914, he studied the possibilities of silvery, oblique light or the effects of intensely contrasting light and shadows on the brilliant reds, pinks, and yellows of peasant garments.

Ivanov used a striking new way of expressing his social concern in *Execution. The Year 1905* (plate 502). He depicted the horrifying massacre of unarmed citizens by Imperial troops on "Bloody Sunday," but without blood or drama. There is a large, open square bounded by a row of buildings across the upper part of the canvas, two crumpled figures in the lower right, a small crowd with a red banner on the far right edge, and on the other side a blur of white and dark gray indicating the mounted soldiers firing; nothing else, except for a small dog running crazily across the open space. The only dark tones are in the shadowed façades and the black trousers of the fallen figures, silhouetted against the stark white ground. The surprising treatment of space and light seems to have more in common with experiments in landscape and cityscape painting than with the normal emphasis on human figures in genre and historical scenes. Perhaps influenced by French Impressionism indirectly, since he did not record his inter-

502. SERGEI VASILEVICH IVANOV. *Execution. The Year 1905.* 1905. Oil on canvas (dimensions unknown). Central Museum of the Revolution, Moscow

est in any specific French work, Ivanov found new visual devices to make the shock of the event immediate for the viewer. The aesthetic values proclaimed in the 1880s by Serov and Korovin were clearly meaningful even for genre painters and other artists who continued to deal with Realist subjects—peasants, the urban poor, and victims of famines and repression. Their works could communicate sympathy or outrage immediately through visual contrasts in place of the narrative or thematic juxtapositions employed in earlier Realist art.

Other artists rejuvenated the traditional landscape of mood with new visual ideas. Stanislav Zhukovskii (1873–1944), trained in Warsaw and Moscow, devoted much of his work to interiors and exteriors. Around 1905 he painted highly structured landscapes viewed through windows or from a porch. Igor Grabar (1871–1960) took up the idea of using architecture as a framework for color, textural, and spatial relationships in *September Snow* (plate 503). With its deep recession and contrasting flatness of paint and its brilliant effects of white snow and porch columns and roof punctuated by patches of yellow, orange, rose and blue, the work seems to acknowledge Iakunchikova's compositional structure and Serov's tour-de-force handling of light. Grabar, born in Budapest, moved as a child to the Moscow district; he studied at the academy under Repin and then went to Munich in 1896 to enter Anton Azbé's studio, where he joined several Russians, including Vasilii Kandinskii

503. Igor Emanuilovich Grabar. *September Snow.* 1903. Oil on canvas, 31 × 35″. State Tretiakov Gallery, Moscow

(1866–1944). By the time he returned to Russia in 1901, he had traveled widely in Europe and studied at the Académie Julian in Paris, where he also saw as many Impressionist paintings and locales as possible.[76] *September Snow* was the culmination of his years of absorbing an unusually wide range of artistic experience:

> *September Snow* was a real breakthrough for me. Falling somewhere between my former *plein air* and my new impressionistic aims. . . . The painting of the snow—its lightness and apparent whiteness in the face of deep tonalities—was achieved with the help of unmixed colors, that is, ultimately by way of a moderated divisionism.[77]

## Russian Impressionism in an International Art World

While many artists traveled in the 1890s, organizations at home responded to new demands by sponsoring exhibitions and lectures of international scope, among them two shows of French painting, in 1891 and 1896, a Scandinavian section of the Nizhnii Novgorod Trade Fair in 1896 and a major exhibition in Saint Petersburg organized by Diaghilev in 1897, an exhibition of over 250 Japanese paintings and prints from a private collec-

tion in 1896, an exhibition of English and Belgian art in 1898, and Diaghilev's *International Exhibition of Paintings* in 1899. This last exhibition marked the debut of the group Mir iskusstva ("World of Art") and a turning point in the relationship of Russian and European art.[78] Even artists such as Serov and Levitan, after many exhibitions in Europe, were glad to see their works "in such distinguished company."[79]

But the expectations of those who went to Paris as to "a promised land, which from Russia seemed to light up the world"[80] were doomed to disappointment. Levitan, in 1890, found a Parisian art scene that bore little resemblance to what Polenov had described. He wrote to Chekhov that there were "masses of wonderful things in art" but also masses of extremely "psychopathic" elements and called the adulation of Puvis de Chavannes a bizarre "abomination."[81] Ivanov, though apparently open to some Impressionist ideas, found the Symbolist art he saw in 1894 incomprehensible; even Iakunchikova, who had been at the Académie Julian since 1892, was ambivalent when she took Ivanov around the galleries. Early in her stay, she had written about "the sick direction of contemporary art—the search for amplification of all feelings, which they call decadence."[82] Reporting on the Symbolist art at Champ de Mars and the Rose + Croix exhibitions, she dismissed the "dots and nightmares" and the "horribly bright colors and crude contours" as "not genuine art, but something unhealthy, nightmarish."[83] She understood Carrière's concept of "inner visions evoked by previous impressions," but she found his works "so foggy, strange and melancholy" that they could not convey his visions to others.[84] Polenova revisited Paris in 1895 and noted the enormous changes in five years; taking a positive attitude, she said one must reevaluate previous standards in order to understand the "new powers" appearing in Paris, including Brangwyn, Thaulow, and other English, American, and Scandinavian artists.[85] As pioneers in the revival of applied arts, Polenova and Iakunchikova were more receptive than most to stylized linear forms and to Japanese prints, a stylistic source virtually ignored by other Russians.

The new elements to be seen in Paris came not only from French Symbolism but from the growing internationalism in art. On a trip through Europe in 1893, Repin was struck by the rapid succession of styles in Warsaw. "The Polish adepts of *plein airism* have already fouled it," he wrote. "A motley of violet reflections is sprinkled over all flat surfaces . . . blue shadows give a deathly chill. Under the flag of *plein airism* and impressionism, colored violet and blue, they bravely wage war against the exhausted, brown tones of the previous two centuries." He concluded, "Symbolism, allegory, search for the most improbable originality excludes any realism, any study. Impressionism enters into these paintings only in the sense of technical freedom."[86] When he reached Paris and the Champ de Mars he was horrified at "the mass of dilettantism, pseudo-artistic lack of finish." Lumping together the various trends, he drew some conclusions about the aftermath of Impressionism:

504. Leon Wyczolkowski. *Digging Beets.* c.1895. Oil on canvas, 20⅛ × 26⅜″. National Museum, Warsaw

505. Jan Stanislawski. *Cabbage Field.* c.1903. Oil on canvas, 7⅞ × 10¼″. National Museum, Warsaw

The Impressionists have degenerated, grown tired and fewer in number. Having played their part—rescuing art from the academic routine with its heavy, brown coloration and conventional compositions—they have themselves fallen into a routine of violet, blue and orange reflections. The freshness of direct impressions has gone on to the point of eccentricity, clamorous effects, contrived spotting of iridescent color.[87]

An art movement based upon the immediate rendering of impressions must be, Repin thought, a short-lived phenomenon. He hoped that the situation he observed in Europe might be avoided at home, and one of his goals in teaching was to warn students against imitation of novelty, technical virtuosity, eccentricity, and mannerism.

The increasing range of styles also affected artists from Eastern Europe. Leon Wyczolkowski (1852–1936) studied in Warsaw, Munich, and Cracow before going to Paris in 1878 and again in 1889; he exhibited abroad, and he was a founding member of the Polish artists' group *Sztuka* ("Art"). Known as an Impressionist painter of landscape and rural genre, he used divided brush strokes and prismatic color to render sunlight in works such as *Digging Beets* (plate 504). Jan Stanislawski (1860–1907), also from the Warsaw and Cracow schools, went to Paris in the 1880s and again in 1890. A member of *Sztuka* and of international groups, he was professor of landscape at the Cracow Academy and an advocate of the plein-air approach. His views of Poland and the Ukraine, often small and apparently simple (plate 505), were admired for their poetic atmosphere. Other Poles allied with Impressionism at the end of the century included Wladyslaw Podkowinski, Jozef Pankiewicz, and Olga Boznanska (who settled in Paris). In Hungary, Károly Ferenczy (1862–1917), Simon Hollósy (1857–1918), who had worked in Munich, and a small group of younger artists, including Istvan Reti (1875–1943), began spending summers painting in northern Transylvania and founded the Nagybána art colony in 1896. Closer in his interests to contemporary French Symbolists was Jozef Rippl-Ronai (1861–1927), who went to Paris about 1890, exhibited with the Nabis, and returned to Hungary, where his semi-Impressionist, Symbolist style influenced younger artists.

The Czechoslovakian plein-air school begun by Chittussi prepared the ground for Impressionist and Post-Impressionist styles, most directly through the work of Antonín Slavicek (1870–1910). He studied in Munich and Prague and tried to found an art colony based on the Worpswede colony in northern Germany and devoted to the expression of the harmony of nature. Ludvík Kuba (1863–1956) studied at the Prague Academy, at the Académie Julian (1893–1895), and in Munich (1896–1904) under Anton Azbé; he had interests and experiences like those of Russians in Paris or Munich, and he became friends with Grabar at Azbé's studio. He often used broad strokes of broken color to unite figures and settings; in his Impressionistic *Among*

*the Roses, Breznice* (1906; National Gallery of Prague) he translated the contrast of light and shadow into small patches of dark and light green, pink, white, and tan, in places using a palette knife to give a mosaiclike or cloisonné effect.

By the mid- to late 1890s, artists and writers in Russia and other countries were attempting to distinguish between the objective and analytical qualities associated with French Impressionism and more subjective qualities, which they identified with their own schools, using such terms and phrases as "lyricism," "the imprinting of subjective moods," and "the poeticization of nature." Obvious Impressionist traits—"sketchiness," "patches of color," and "incomplete drawing"—often cited by critics were still thought insufficient as a basis for art.[88] Increasingly, these aspects were downplayed in favor of the more fundamental requirements. "We need paintings that call forth a response of the soul," Korovin had written in a sketchbook. The landscapes of northern Russia by Korovin, Levitan, Serov, Arkhipov, and others, with their muted silvery tones punctuated by glints of oblique light, filled the need for a spiritual element in painting. Mikhail Nesterov, who painted the same landscapes but rarely used Impressionist techniques, was afraid that his works, with their Russian symbols, might be less successful abroad than those of his friends. But after attending the 1898 Munich Secession and seeing Russian and German paintings together, he wrote that the old categories of art were losing their meaning and that the way was opening for a new, broadly based, outlook: "One might formulate the *new* art thus: a search for a *living spirit, living forms, living beauty*, in nature, in thoughts, in the heart and everywhere."[89]

The shift away from French-inspired Impressionism in Russia was part of a broad pattern of work by artists of many countries searching for alternative views of artistic truth. Impressionism initially signified technique, the means of painting that would convey, as directly as possible, an effect perceived by the artist. A change in emphasis from technique toward the meaning of the final work (understood in terms of internal vision or allegory)—from "subjectivity of perception" to "expressive synthesis"—was characteristic of late nineteenth-century art.[90] This shift occurred in the work of Repin, who was a key figure in the evolution of Realism and Impressionism; in that of Korovin, Serov, Levitan, and others who began their careers with styles and goals based on Impressionism; and in the work of artists such as Grabar and those connected with the Saint Petersburg Mir iskusstva group, whose formative experiences took place in the 1890s within an international artistic environment.

The art journal *Mir iskusstva*, first published in November 1898, reflected the group's role in organizing exhibitions, including the *Scandinavian Exhibition* of 1897 and the *International Exhibition* of 1899. Extremely significant for artists, these exhibitions were also denounced by conservatives as "decadent" in the same way the Impressionists' exhibitions were first mocked.[91]

506. Isaac Ilich Levitan. *Haymaking.* 1900. Oil on paper
on cardboard, 3⅜ × 6⅞″. State Russian Museum, Leningrad

Diaghilev said that a new kind of exhibiting group should send art abroad and take its place among the "brillant and forceful" Munich Secession, the Parisian Champ de Mars, and the London New Gallery. Because Russian art was "in the transitional state," it was especially urgent to find a forum for exposure of a broad range of styles.[92] These ideas guided the choice of subjects discussed and illustrated in the journal; the unifying theme was the belief in an all-inclusive "world of art," without geographical or historical boundaries. The Mir iskusstva exhibitions and journal consolidated the tendencies that had begun in the 1870s, with the first independent exhibiting association and the first encounters with Impressionism.

Moscow artists received extensive coverage. Diaghilev believed that the lyrical, intuitive Moscow landscape painting was a major manifestation of the "new era" in Russian art, and that Korovin, Serov, and Levitan were its strongest representatives.[93] Some features of the artists' late work, though clearly part of their internal development, might also be related to their contact with Mir iskusstva. A tendency to pare down color schemes to a few related tones and to simplify compositions can be seen in *Silence*, with its almost monochrome dark tones, and in *Haymaking* (plate 506), one of Levitan's last works, which has a very bright yellowish green as its color theme and a horizontal composition. Serov's *Horses by the Seashore* (1905; Russian Museum), like many of his

later works, is also based on a limited range of grayish blue, tan, and russet tones, and a structure based on horizontal bands of sand and sea. *The Children. Shasha and Iura Serov* (plate 507), shown at the second Mir iskusstva exhibition, has the same tonalities and the same setting on the Gulf of Finland, but a more complex composition contrasting the boys' angular stances, reinforced by the bars of the boardwalk railing, with the flatness of the beach, water, and sky. Korovin was pursuing several interests at the same time. His plein-air landscapes of northern Russia, such as *Country Village* (plate 508) became bolder through emphasis on bright, directional light, perhaps influenced by his work in the Crimea and on the French Riviera. Urban scenes, such as *Paris, 14th of July* (plate 509), recalling Monet's flag paintings, became a motif for concentrated work. He experimented with effects of artificial lighting in *Paris. Boulevard des Capucines* (plate 510), a dramatic picture with its grays and blues enlivened by a patch of intense yellow orange—the light from a restaurant spilling out onto the street in thick, curving strokes. The bold application of paint and the striking, unnatural colors also show the influence of Korovin's work on stage designs for Diaghilev's ballet.

Aleksandr Benua (Benois; 1870–1960) and Grabar were largely responsible for interpreting for the public the art of the previous quarter century and of their own time. The role of art criticism in *Mir iskusstva* was

THE IMPRESSIONIST VISION IN RUSSIA

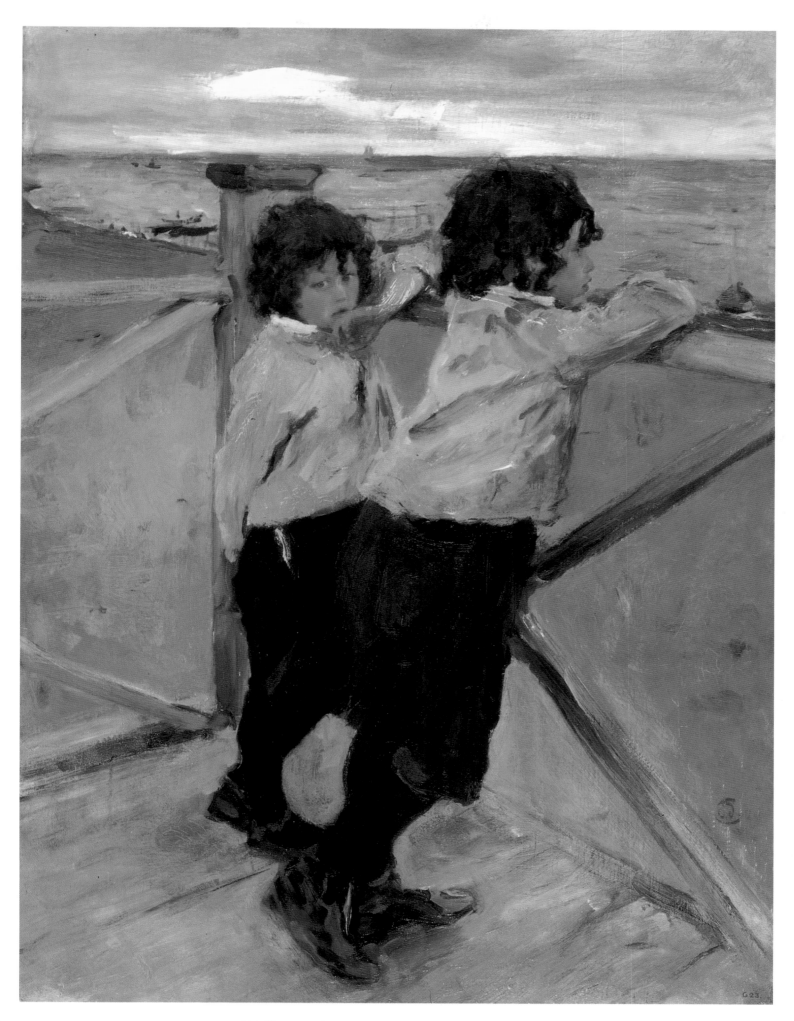

507. VALENTIN ALEKSANDROVICH SEROV. *The Children,*
*Shasha and Iura Serov.* 1899. Oil on canvas, 28 × 21¼″. State
Russian Museum, Leningrad

508. Konstantin Alekseevich Korovin. *Country Village.*
1919. Oil on canvas (dimensions unknown). State Russian
Museum, Leningrad

(left) 509. KONSTANTIN ALEKSEEVICH KOROVIN. *Paris, 14th of July.* n.d. Oil on canvas (dimensions unknown). State Russian Museum, Leningrad

(above) 510. KONSTANTIN ALEKSEEVICH KOROVIN. *Paris. Boulevard des Capucines.* 1906. Oil on canvas, 28⅞ × 25⅝". State Tretiakov Gallery, Moscow

twofold: an "Artistic Chronicle" section in each issue covered exhibitions in Paris, Munich, and other centers and longer feature articles followed Russian and European art. According to Benua, the group became aware of French Impressionism through Zola's *L'Oeuvre*, which appeared in Russian translation in 1886, soon after its publication in Paris. But since the novel was about "theories and principles," they had to wait until Richard Muther's history of nineteenth-century painting appeared in 1893 to see reproductions of the works.[94] Grabar went to Paris in 1897 and enjoyed the "unexpected plus" of seeing "some 25 Manets and 40 Degases."[95] Benua saw Impressionist paintings in the original only in 1899, at the Georges Petit Gallery. Writing for *Mir iskusstva*, he criticized the pursuit of "clinical" objectivity and the resulting lack of "poetry" in Monet's work,[96] a distinction that recalls criticisms of Korovin's work a few years earlier. Manet, Monet, and

Degas received credit for their pioneering role, but the *Mir iskusstva* artists felt less affinity for them than for artists whose work held more "poetic" content.[97] They admired Whistler, Sargent, Zorn, and Liebermann for their bold styles; they called Ludwig Dill and Hans Thoma, Giovanni Segantini, Fritz Thaulow, Vaino Blomstedt, and Kaspar Jaernefelt the heirs of the Barbizon tradition.[98]

As an artist, Grabar showed the same directness and "sincerity of feeling" that he stressed in his writing about art. He wrote about the "poetry of vision, as music is the poetry of sound" in reference to Whistler,[99] but he could have applied it to his favorite Russian art and to his own work. *A White Winter, Rooks' Nests* (1904; Tretiakov Gallery) translated Savrasov's motif into a poetic but not nostalgic study of decorative, silhouetted branches against a white ground. *Winter* (plate 511), *February Azure* (1905; Tretiakov Gallery), and *March Snow*

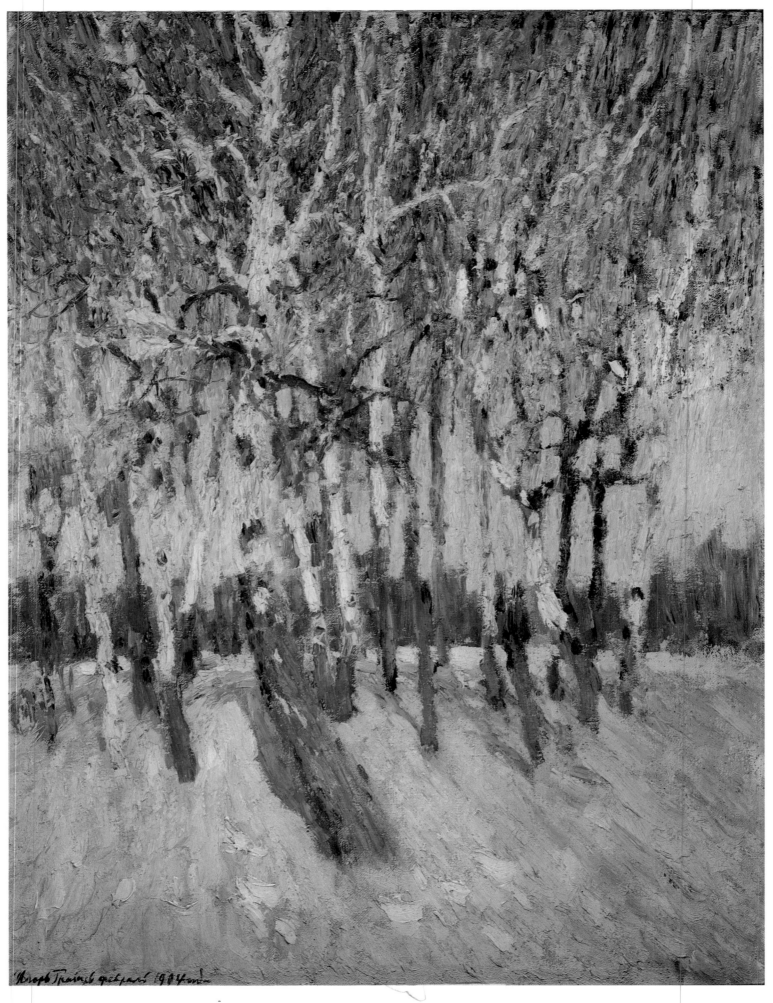

511. IGOR EMANUILOVICH GRABAR. *Winter.* 1904. Oil on canvas (dimensions unknown). State Russian Museum, Leningrad

512. Igor Emanuilovich Grabar. *The Uncleared Table.*
1907. Oil on canvas, 39⅜ × 37¾″. State Tretiakov Gallery,
Moscow

(1906; Tretiakov Gallery), painted outdoors at the dacha
at Dugino where Levitan had once worked, formed a
series of color studies of the almost blinding effects of
bright sunlight on snow. Grabar used a combination of
long, fluid brush strokes and unmixed colors, a variation
of his "divisionism," as a way of getting onto canvas
phenomena that were, he felt, more than visual. Color
was the key not to copying landscape but to finding the
essential harmony of a scene. In his study of color,
Grabar turned to still life, a genre also favored by
Korovin in which the artist could purposely arrange the
color, texture, and structure. *The Uncleared Table* (plate
512), displays an array of plates, dessert dishes, liqueur
glasses, carafe, compotes, and flowers on a rumpled
cloth. The way the table is tilted toward the picture plane,
with the chair aligned along its edge and the patterned
wallpaper filling the rest of the picture space, shows the
result of careful study of Cézanne and Matisse.[100] This
work and its variants, in which only the patterned cloth
and artfully placed fruits and dishes appear, no longer
embodied the spontaneous qualities of Impressionism.
The deliberation of Grabar's use of still life is comparable
to Korovin's late return to the urban vista motif: almost
contrived subjects were vehicles for new approaches to
formal problems.

By the turn of the century, conventional stylistic
boundaries had indeed broken down. Impressionism no

longer signified a specific movement or style. The readily
identified broad brush strokes and patches of color, first
employed as means of capturing visual sensations and
later regarded as trademarks of modernism, once again
returned to the status of technical tools. Equally valid
techniques included Whistler-like monochromes (used
by Serov and Levitan), cloisonné contours with flat color
(developed by Iakunchikova), and Pointillism (modified
by Grabar). It was the lyrical quality, more than the
sketchlike technique, that remained important.

The final permutation of Russian Impressionism
was effected by artists loosely associated with Mir isk-
usstva, who went on to work in different directions. Kan-
dinskii, Grabar's friend in Azbé's studio and a writer of
brief notes for *Mir iskusstva*,[101] used an Impressionist
style in his early works that perhaps owed as much to a
broad familiarity with contemporary art as to his revela-
tory first sighting of Monet's grain-stack painting at a
Moscow exhibition in 1896.[102] Mikhail Larionov
(1881–1964) and Natalia Goncharova (1881–1962)
were invited by Diaghilev to participate in the final
exhibitions of the Mir iskusstva group in Saint Pe-
tersburg and Paris in 1906. They had studied in Moscow
with Korovin, and their early landscapes, Larionov's *Cor-
ner of a Garden* (plate 513) and Goncharova's *Rowan
Tree, "Panino" near Viazma* (1908; Tretiakov Gallery),
also hint at Grabar's influence with their use of long
brush strokes and divisionist color. Even Neoprimitivist
works, such as Goncharova's *Grain Harvest* (1908; Rus-
sian Museum) and Larionov's *Bathing Soldiers* (1911;
Tretiakov Gallery), show the value of plein-air painting,
vibrant colors, and vigorous brush strokes. Kazimir Ma-
levich (1878–1935) went through an Impressionist stage
between 1904 and 1908. *Apple Blossoms* (plate 514),
done while he was studying at the Moscow school, shows
the influence of Impressionism; *Morning in the Village
after Snow* (1912; Guggenheim Museum, New York
City) is closely related to Grabar's *March Snow* in both its
motif and its analytical nature. These works were points
of departure for radically different directions: by the end
of the decade, the Impressionism of the Moscow School
and the visual ideas based on the international styles of
the Mir iskusstva group were no longer valid for an avant-
garde. Instead, many artists and writers began to use the
term "Impressionism" both to describe the iconoclastic
attitudes and formalist experiments of the Russian Neo-
primitivists and Cubo-Futurists and to announce a "new
vision" in all spheres of art. Amateur painter, critic, and
theoretician Nikolai Kulbin (1868–1917) organized an
"Impressionist" group in 1908 in order to liberate art,
music, and literature through an "intuitive principle"
comparable in some ways to his friend Kandinskii's
"principle of inner necessity."[103] For the artists and
writers who declared the work of art self-sufficient and
form independent of content, Impressionism was no
longer a development of nineteenth-century Realism but
rather the forerunner of the new art forms of the twen-
tieth century, in particular the subjective abstraction
developed by Kandinskii and Malevich within the de-

cade. Ironically, when formalism and abstraction were suppressed during the height of Socialist Realism in the 1940s and 1950s, Impressionist landscape filled an unexpected new role as an outlet for artists who wanted to explore formal problems but had to make sure that their work expressed a national spirit.

There are several reasons why Impressionism did not become a defined movement in Russia, despite the attraction and real value it had for artists of widely divergent interests. Historical factors as well as visual perceptions were important. As Repin astutely noted in 1894, Impressionism was by its very nature "a short-lived phenomenon," not meant to become an established school.[104] The spontaneity, vitality, and iconoclasm of the early Impressionist exhibitions in Paris and the early essays by Russian artists in the 1870s could not be sustained once the modern themes, the novel technical devices, and the professed goal of conveying optical reality were widely accepted.

But the effect of Impressionism was ultimately more substantial. By affirming the value of the immediate, visual effect, by using the sketch to enhance spontaneity, and by showing that a spiritual element could be communicated directly, without narrative, commentary, or symbolism, Impressionism served as a catalyst for experimentation and discovery. The philosophical or moral element that had been so crucial to Russian Realism that it actually hindered acceptance of Impressionism in the 1870s and early 1880s was modified but not entirely replaced by the goal of expressing the lyricism of nature and the subjective moods of the artist. The moral imperative prevented Russian artists from being satisfied for long with purely formal investigations. Korovin, Levitan, Serov, and Grabar were conscious of the differences between the primarily optical emphasis of French Impressionism and the inner responses that they hoped to arouse through the "poeticization of nature" and the "poetry of vision" in their art. Kandinskii made a comparable distinction between the inner and outer elements of a work of art: the inner was "the emotion of the artist's soul," which evoked a corresponding emotional vibration in the viewer through a specific means of expression, the outer element or the material form. His discussion of the essential unity of inner and outer elements and his assertion that art is "produced by the inner need, which springs from the soul" recall the vocabulary of Korovin, Dosekin, and others who defined lyrical Impressionism.[105] Even Malevich, recounting the evolution of Suprematism, relied on a fairly traditional distinction between imitation of nature and the expression of "intuitive feeling," which could make a painted surface "a real, living form." Malevich explained intuition as a new (nonutilitarian) form of reason capable of creating new forms: the square, the "creation of intuitive reason" was "the face of the new art."[106] Suprematism as the expression of a new, nonobjective, and pure world of art was, paradoxically, not a rejection but an affirmation of both the painted surface of a picture and an inner dimension of spiritual meaning still pervasive in Russian art.

513. MIKHAIL FEDOROVICH LARIONOV. *Corner of a Garden.* c.1904. Oil on canvas (dimensions unknown). State Russian Museum, Leningrad

514. KASIMIR SERGEEVICH MALEVICH. *Apple Blossoms.* 1904. Oil on canvas, 21⅝ × 27½". State Russian Museum, Leningrad

## A WORLD IN LIGHT

**1.** Christian Brinton, *Impressions of the Art at the Panama-Pacific Exposition, with a Chapter on the San Diego Exposition and an Introductory Essay on the Modern Spirit in Contemporary Painting* (New York: John Lane Co., 1916), pp. 15–16; as quoted in William H. Gerdts, *American Impressionism* (New York: Abbeville Press, 1984), p. 302. Brinton (1870–1942) helped to arrange several international exhibitions of contemporary art, including an American painting show in Berlin in 1910, a Scandinavian show brought to the United States in 1912, and a Swedish art show at the Toledo (Ohio) Museum of Art in 1916 (Gerdts, p. 302). He wrote exhibition catalogs on the art of the Belgian Constantin Meunier and the Russian Ilya Repin (1921), among others, and in 1932 he organized for The Hispanic Society of America a show of works by Cesárea Bernaldo de Quirós, *Paintings of Gaucho Life in Argentina 1850–1870*. On Brinton's efforts to promote Russian art in the United States, see Robert C. Williams, *Russian Art and American Money* (Cambridge, Massachusetts: Harvard University Press, 1980), pp. 83–110. **2.** Fritz Novotny, *Painting and Sculpture in Europe 1780–1880* (Baltimore: Penguin Books, 1960), p. 179. **3.** This evaluation and the terms quoted are from a surprisingly recent and revisionist source, Kathleen Adler, *Unknown Impressionists* (Oxford: Phaidon Press, 1988), p. 11. **4.** *The New Painting: Impressionism 1874–1886*, exhibition organized by Charles S. Moffett, with the assistance of Ruth Berson, at The Fine Arts Museums of San Francisco and The National Gallery of Art, Washington, D.C., 1986. Catalog published by The Fine Arts Museums of San Francisco. **5.** Edmond Duranty, *La nouvelle peinture: à propos du groupe d'artistes qui expose dans les galeries Durand-Ruel* (Paris: Dentu, 1876). Duranty's text is reprinted in the exhibition catalog, *The New Painting: Impressionism 1874–1886*, in English translation (pp. 37–47) and in the original French (pp. 477–484). **6.** See Stephen F. Eisenman, "The Intransigent Artist or How the Impressionists Got Their Name," in *The New Painting: Impressionism 1874–1886* (San Francisco: The Fine Arts Museums of San Francisco, 1986), pp. 51–59. **7.** Diego Martelli, "Gli Impressionisti" (lecture of 1879; first published in Pisa in 1880), in *Scritti d'arte di Diego Martelli*, ed. Antonio Boschetto (Florence: Sansoni, 1952), p. 106. **8.** Théodore Duret, *Les peintres impressionnistes* (Paris: Librairie Parisienne, 1878), p. 12; translated as *Manet and the French Impressionists* (Philadelphia: J.B. Lippincott Co., 1910). **9.** For a different view, see Paul Tucker, "Monet's *Impression, Sunrise* and the First Impressionist Exhibition: A Tale of Timing, Commerce, and Patriotism," *Art History* 7 (December 1984), pp. 465–476. **10.** Georges Rivière, "L'exposition des impressionnistes," *L'Impressionniste* 1 (April 6, 1877), pp. 2–6, in *Les Archives de l'Impressionnisme*, ed. Lionello Venturi (Paris and New York: Durand-Ruel, 1939). **11.** *Ibid.*, vol. II, p. 311. **12.** Jules Castagnary, "L'exposition du boulevard des Capucines: les impressionnistes," *Le Siècle*, April 29, 1874. This argument is further developed in my unpublished manuscript, *Impressionism and the Romantic Tradition* (1981). The "subjectivity of Impressionism" has been explored by Richard Shiff, "The End of Impressionism: A Study in Theories of Artistic Expression," *The Art Quarterly* 1 (Autumn 1978), pp. 338–378; revised and reprinted in Shiff, *Cézanne and the End of Impressionism* (Chicago and London: University of Chicago Press, 1984), pp. 3–52, and in *The New Painting: Impressionism 1874–1886* (1986), pp. 61–89. **13.** Duranty, *La nouvelle peinture*, in *The New Painting: Impressionism 1874–1886*, p. 44. **14.** On Caillebotte, see J. Kirk T. Varnedoe and Thomas P. Lee, *Gustave Caillebotte: A Retrospective Exhibition* (Houston: Museum of Fine Arts, 1976); and Marie Berhaut, *Caillebotte, sa vie et son oeuvre: Catalogue raisonné des peintures et pastels* (Paris: La Bibliothèque des Arts, 1978). **15.** On Haussmann's projects, see Howard Saalman, *Haussmann: Paris Transformed* (New York: George Braziller, Inc., 1971); and T.J. Clark, *The Painting of Modern Life: Paris in the Art of Manet and His Followers* (New York: Alfred A. Knopf, 1984), pp. 23–78. **16.** Caillebotte's friendship with De Nittis appears to predate his contacts with the Impressionist group, and it may well have been De Nittis who introduced him into the Impressionists' circle. For the letter from De Nittis to his wife, which establishes the friendship as of spring 1874, see Enrico Piceni, *Giuseppe De Nittis* (Milan: Mondadori, 1934), p. 41. For more on the relationship, see Varnedoe, *Gustave Caillebotte: A Retrospective Exhibition*, pp. 34 and 44, n. 10. In 1872 Caillebotte traveled to Naples and the south of Italy at a time when De Nittis was in residence there. It is not known if they were in contact at that time. However, Caillebotte's *A Road Near Naples* of 1873 (reproduced in Varnedoe, cat. no. 4, p. 79) is closely related in subject and structure to many of De Nittis's Italian works. **17.** Varnedoe, *Gustave Caillebotte: A Retrospective Exhibition*, pp. 149–150. **18.** Meyer

Schapiro, "The Nature of Abstract Art," *The Marxist Quarterly* I (January–March 1937), pp. 77–98; reprinted in Schapiro, *Modern Art: The Nineteenth and Twentieth Centuries* (New York: George Braziller, Inc., 1978), pp. 185–211 and especially pp. 192–193. **19.** Linda Nochlin, "Morisot's *Wet Nurse:* The Construction of Work and Leisure in Impressionist Painting," in Nochlin, *Women, Art, and Power, and Other Essays* (New York: Harper and Row, 1988), pp. 41–44. **20.** *Ibid.*, pp. 41–44. On Morisot, see also Charles F. Stuckey, William P. Scott, and Suzanne Lindsay, *Berthe Morisot: Impressionist* (Washington, D.C.: National Gallery of Art, 1987); and Kathleen Adler and Tamar Garb, *Berthe Morisot* (Ithaca, New York: Cornell University Press, 1987). **21.** *The New Painting: Impressionism 1874–1886*, nos. 85 and 86, pp. 316–317. See also, Jean-Paul Bouillon, "Marie Bracquemond," *Women's Art Journal* 5 (Fall 1984–Winter 1985), pp. 21–27. **22.** See, for example, the opinion of Philippe de Chennevières in the *Gazette des beaux-arts*, July 1, 1880, as quoted by George Heard Hamilton, in *Manet and His Critics* (New Haven: Yale University Press, 1954), p. 235. **23.** See Charles Baudelaire, "Le Peintre de la vie moderne" (1863), in *The Painter of Modern Life and Other Essays*, trans. Jonathan Mayne (London: Phaidon Press, 1964), p. 13; and Theodore Reff, "Manet and the Paris of Haussmann and Baudelaire," in *Manet and Modern Paris* (Washington, D.C.: National Gallery of Art, 1982), pp. 13–28. **24.** On Manet and Japanese prints, see Jacques Dufwa, *Winds from the East: A Study in the Art of Manet, Degas, Monet and Whistler, 1856–1886* (Stockholm and Atlantic Highlands, New Jersey: Almquist and Wiksell International and Humanities Press, 1981). **25.** Antonin Proust, *Edouard Manet: Souvenirs* (Paris: 1913), p. 42, as cited by Reff, *Manet and Modern Paris*, p. 14. **26.** In addition to the small-scale study reproduced here, two fragments of the final canvas now survive, one in the Musée d'Orsay and the other in a private collection in Paris. An oil sketch from nature, showing Bazille and Camille, is in the collection of The National Gallery of Art, Washington, D.C. See Daniel Wildenstein, *Monet, biographie et catalogue raisonné*, 4 vols. (Lausanne and Paris: Bibliothèque des Arts, 1974–1985); vol. I, nos. 63a, 63b, and 61. For an extended analysis of the project and its remains, see Joel Isaacson, *Monet: Le Déjeuner sur l'herbe* (New York: Viking Press, 1972). **27.** Lilla Cabot Perry, "Reminiscences of Claude Monet from 1889–1909," *American Magazine of Art* 18 (March 1927), pp. 119–125; reprinted in *Impressionism and Post-Impressionism 1874–1904*, ed. Linda Nochlin (Englewood Cliffs, N.J.: Prentice-Hall, 1966), pp. 35–36. **28.** On Monet's working methods, see John House, *Monet: Nature into Art* (New Haven and London: Yale University Press, 1986); also Grace Seiberling, "The Evolution of an Impressionist," in *Paintings by Monet*, ed. Susan Wise (Chicago: The Art Institute of Chicago, 1975); and Robert Herbert, "Method and Meaning in Monet," *Art in America*, September 1979, pp. 90–108. **29.** In a letter to Durand-Ruel from Giverny on July 22, 1883, Monet wrote: "The weather has been very bad for several days and I am taking advantage of it to work indoors and finish as many canvases as possible for you" (Daniel Wildenstein, *Monet, biographie et catalogue raisonné*, vol. II, letter 366, p. 230; letter cited by Seiberling, "*Evolution*," p. 21). **30.** Cited and translated by Seiberling, "The Evolution of an Impressionist," p. 22. **31.** On Bastien-Lepage, see Kenneth McConkey, "The Bouguereau of the Naturalists: Bastien-Lepage and British Art," *Art History* I (September 1978), pp. 371–382; and W. S. Feldman, *The Life and Work of Jules Bastien-Lepage (1848–1884)*, Ph.D. thesis, New York University, 1973. **32.** Examples are cited throughout this volume. See, also, *Catalogues of the Paris Salon*, facsimile edition, ed. H.W. Janson (New York: Garland Publishing Co., 1977). **33.** On the taste for Dutch art among collectors in nineteenth-century France, see Gerald Reitlinger, *The Economics of Taste* (London: Barrie and Rockliff, 1961–1970), vol. 1, pp. 138–139; and Albert Boime, "Entrepreneurial Patronage in Nineteenth-Century France," in *Enterprise and Entrepreneurs in Nineteenth- and Twentieth-Century France*, eds. Edward C. Carter II, Robert Forster, and Joseph N. Moody (Baltimore and London: The Johns Hopkins University Press, 1976), pp. 140–144. **34.** Alan Bowness, *The Impressionists in London* (London: The Arts Council of Great Britain, 1973). **35.** For the influence of Spanish painting in France, see. I. H. Lipschutz, *Spanish Painting and the French Romantics* (Cambridge, Massachusetts: Harvard University Press, 1972); and Joel Isaacson, *Manet and Spain* (Ann Arbor: University of Michigan Museum of Art, 1969). **36.** See, among others, Gabriel P. Weisberg, *"Japonisme": Japanese Influence on French Art, 1854–1910* (Cleveland: Cleveland Museum of Art, 1975); Klaus Berger, *Japonismus in der westlichen Malerei, 1860–1920* (Munich: Prestel Verlag, 1980); and Yamada, Chisaburoh, ed., *Japonisme in Art: An International Symposium* (Tokyo: Kodansha International, 1980). **37.** On this

phenomenon, see Harrison C. White and Cynthia A. White, *Canvases and Careers: Institutional Change in the French Painting World* (New York: John Wiley and Sons, 1965), especially pp. 124–154; Boime, "Entrepreneurial Patronage in Nineteenth-Century France," pp. 165–173; Linda Whiteley, "Art et commerce d'art en France avant l'époque impressionniste," *Romantisme* 4 (1983), pp. 65–75; and Nicholas Green, "Dealing in Temperaments: Economic Transformations of the Artistic Field in France During the Second Half of the Nineteenth Century," *Art History* 10 (1987), pp. 59–78. The primary source for the history of the Durand-Ruel Gallery is "Mémoires de Paul Durand-Ruel," in Venturi, *Les Archives de l'Impressionnisme*, vol. II, pp. 141–220. **38.** On the Paris expositions, see Patricia Mainardi, *Art and Politics of the Second Empire: The Universal Expositions of 1855 and 1867* (New Haven and London: Yale University Press, 1987); and Shane Adler Davis, "Fine Cloths on the Altar: The Commodification of Late-Nineteenth-Century France," *Art Journal* 48 (Spring 1989), pp. 85–89. **39.** Boime, "Entrepreneurial Patronage in Nineteenth-Century France," pp. 137–207, especially pp. 154ff, 181ff. **40.** For example, on patterns of collecting in Scandinavia, see Tone Skedsmo, "Patronage and Patrimony," in *Northern Light: Realism and Symbolism in Scandinavian Painting, 1880–1910* (New York: The Brooklyn Museum, 1982), pp. 43–51. **41.** On the history and effects of the feminist movement in France, see, among others, Claire Goldberg Moses, *French Feminism in the Nineteenth Century* (Albany, New York: State University of New York Press, 1984); and Patrick Kay Bidelman, *Pariahs Stand Up! The Founding of the Liberal Feminist Movement in France, 1858–1889* (Westport, Connecticut, and London: Greenwood Press, 1982). **42.** See Charlotte Yeldham, *Women Artists in Nineteenth-Century France and England; Their Art Education, Exhibition Opportunities and Membership of Exhibiting Societies and Academies, with an Assessment of the Subject Matter of Their Work and Summary Biographies*, 2 vols. (New York and London: Garland Publishing Co., 1984). **43.** See Carol Duncan, "Virility and Domination in Early Twentieth-Century Vanguard Painting," *Artforum*, December 1973, pp. 30–39; revised and reprinted in *Feminism and Art History: Questioning the Litany*, eds. Norma Broude and Mary D. Garrard (New York: Harper and Row, 1982), pp. 293–513. On the late nineteenth-century view of Impressionism as a "feminine" style, see Kathleen Adler and Tamar Garb, introduction to *Berthe Morisot, Correspondence*, ed. Denis Rouart (Mt. Kisco, New York: Moyer Bell Limited, 1987), pp. 6–8.

## Impressionism in the United States

**1.** "The Fine Arts—The French Impressionists," *The Critic* 120 (April 17, 1886), pp. 195–196. **2.** Bernice Kramer Leader, *The Boston Lady as a Work of Art: Paintings by the Boston School at the Turn of the Century* (Ann Arbor: University Microfilms International, 1980); Bernice Kramer Leader, "Antifeminism in the Paintings of the Boston School," *Arts Magazine* 56 (January 1982), pp. 112–119. **3.** See, for instance, Henry James, "The Grosvenor Gallery and the Royal Academy," *Nation* 24 (May 31, 1877), pp. 320–321; Mariana Griswold van Rensselaer, "The New York Water Color Exhibition," *Lippincott's Magazine* 1 (April 1887), p. 417; and two articles by Archibald Gordon in *The Studio and Musical Review*: "The Impressionist Pictures," 1 (April 9, 1881), pp. 162–167; and "The Impressionists," 2 (April 16, 1881), pp. 178–179. **4.** Lucy H. Hooper, "Art Notes from Paris," *Art Journal* (New York) 6 (1880), pp. 188–190. **5.** The standard study of Cassatt is Adelyn D. Breeskin, *Mary Cassatt: A Catalogue Raisonné of the Oils, Pastels, Water-Colors, and Drawings* (Washington, D.C.: Smithsonian Institution Press, 1970.) See also, Nancy Mowll Mathews, *Cassatt and Her Circle: Selected Letters* (New York: Abbeville Press, 1984). Of the many recent biographical studies, the most perceptive is Griselda Pollock, *Mary Cassatt* (New York: Harper and Row, 1979). **6.** The identification of Cassatt's sister, Lydia, is traditional, but recently it has been suggested that the subject of the painting appears younger than other contemporary images of Lydia by Cassatt and does not suggest the suffering and ill health that would terminate her life in 1882. **7.** "Art in Paris," *The New York Times*, April 27, 1879, p. 2. **8.** John Moran, "The American Water-Colour Society's Exhibition," *Art Journal* (New York) 4 (1878), p. 92; "The Old Cabinet," *Century* 15 (April 1878), pp. 888–889. **9.** Hans Huth, "Impressionism Comes to America," *Gazette des Beaux-Arts* 6 (April 29, 1946), pp. 225–252. **10.** William H. Gerdts, "The Arch-Apostle of the Dab-and-Spot School: John Singer Sargent as an Impressionist," in *John Singer Sargent* (New York: Whitney Museum of American Art, 1986). **11.** "The Royal Academy Exhibition," *Art Journal* (London) 26 (June 1887), p. 248. **12.** René Gimpel, *Diary of an Art Dealer* (New York: Farrar, Straus and Giroux, 1966), p. 75; the incident was first mentioned by Gimpel in "At Giverny with Claude Monet," *Art in America* 15 (June 1927), p. 172. **13.** R. H. Ives Gammell, *Dennis Miller Bunker* (New York: Coward McCann, 1953); Charles B. Ferguson, *Dennis Miller Bunker (1861–1890) Rediscovered* (New Britain, Connecticut: New Britain Museum of American Art, 1978). **14.** There are several slightly disparate accounts of the arrival and constituents of the first American group to work in Giverny. Probably the two most useful are: Edward Breck, "Something More of Giverny," *Boston Evening Transcript*, March 9, 1895, p. 13; Dawson Dawson-Watson, "The Real Story of Giverny," appendix to Eliot C. Clark, *Theodore Robinson: His Life and Art* (Chicago: R. H. Love Galleries, 1979), pp. 65–67. **15.** Hamlin Garland, *Roadside Meetings* (New York: Macmillan Press, 1930), pp. 30–31. **16.** Kathryn Corbin, "John Leslie Breck, American Impressionist," *Antiques* 134 (November 1988),

pp. 1142–1149. **17.** *Lilla Cabot Perry: A Retrospective Exhibition*, Stuart P. Feld, ed. (New York: Hirschl & Adler Galleries, 1969); Lilla Cabot Perry, "Reminiscences of Claude Monet from 1889 to 1909," *American Magazine of Art* 18 (March 1927), pp. 119–125. **18.** John I. H. Baur, *Theodore Robinson, 1852–1896* (Brooklyn: The Brooklyn Museum, 1946); Sona Johnston, *Theodore Robinson, 1852–1896* (Baltimore: Baltimore Museum of Art, 1973). **19.** Robinson's unpublished diaries from March 1892 to March 1896 are on deposit at the Frick Art Reference Library in New York. **20.** Eliot Clark, *John H. Twachtman* (New York: privately printed, 1924); John Douglass Hale, "The Life and Creative Development of John H. Twachtman," Ph.D. thesis, Ohio State University, 1957; Richard J. Boyle, *John Twachtman* (New York: Watson-Guptill Publications, 1979). **21.** W. Mackay Laffan, "The Material of American Landscape," *American Art Review* 1 (1880), p. 32. **22.** Deborah Chotner, Lisa Peters, and Kathleen A. Pyne, *John Twachtman: Connecticut Landscapes* (Washington, D.C.: National Gallery of Art, 1989); "An Art School at Cos Cob," *Art Interchange* 43 (September 1899), pp. 56–57. **23.** See, for instance, the reference to Twachtman in "Ten American Painters," *Independent* 56 (April 17, 1904), p. 853; "Twachtman's Painted Poems," *The New York Times*, January, 10, 1905, p. 6. **24.** Duncan Phillips, Emil Carlsen, Royal Cortissoz, Childe Hassam, J. B. Millet, H. De Rassloff, Augustus Vincent Tack, and Charles Erskine S. Wood, *Julian Alden Weir: An Appreciation of His Life and Works* (New York: E. P. Dutton and Company, 1922); Dorothy Weir Young, *The Life and Letters of J. Alden Weir* (New Haven: Yale University Press, 1960); Doreen Bolger Burke, *J. Alden Weir, An American Impressionist* (Newark, Delaware: 1983). **25.** Young, *J. Alden Weir*, p. 123. **26.** May Brawley Hill, "Robert William Vonnoh (1858–1933)," unpublished paper, City University Graduate School, September 1982. **27.** Adeline Adams, *Childe Hassam* (New York: American Academy of Arts and Letters, 1938); Donelson Hoopes, *Childe Hassam* (New York: Watson-Guptill Publications, 1979). **28.** Jennifer A. Martin Bienenstock, "Childe Hassam's Early Boston Cityscapes," *Arts Magazine* 55 (November 1980), pp. 169–170. **29.** Critic of the *Boston Evening Transcript*, reviewing exhibition of 1887 at Noyes, Cobb & Co.: clipping preserved among the Hassam archival material at the American Academy of Arts and Letters. **30.** A. E. Ives, "Mr. Childe Hassam on Painting Street Scenes," *Art Amateur* 27 (October 1892), pp. 116–117; William Henry Howe and George Torrey Robinson, "Childe Hassam," *Art Interchange* 34 (May 1895), p. 133. **31.** Israel L. White, "Childe Hassam—A Puritan," *International Studio* 45 (December 1911), pp. xxix–xxxvi; Frederic Newlin Price, "Childe Hassam—Puritan," *International Studio* 77 (April 1923), pp. 3–7. **32.** For Hassam in Old Lyme, see Kathleen M. Burnside, *Childe Hassam in Connecticut* (Old Greenwich, Connecticut: Greenwich Civic Center, 1987). The literature on the Old Lyme art colony is extensive; see especially Jeffrey W. Andersen, "The Art Colony at Old Lyme," in *Connecticut and American Impressionism* (Old Lyme, Connecticut: Lyme Historical Society, 1980). **33.** The definitive study here is Ilene Susan Fort, *The Flag Paintings of Childe Hassam* (Los Angeles: Los Angeles County Museum of Art, 1988). **34.** See, for instance, "Impressionism and Impressions," *Collector* 4 (May 15, 1893), p. 213. **35.** Hamlin Garland, "Impressionism," in *Crumbling Idols: Twelve Essays on Art* (Chicago and Cambridge: Stone and Kimball, 1894), pp. 121–141. **36.** William H. Gerdts, et al. *Ten American Painters*, (New York: Spanierman Gallery, 1990). See also: Kenneth Coy Haley, "The Ten American Painters: Definition and Reassessment," Ph.D. thesis, State University of New York at Binghamton, 1975; Patricia Jobe Pierce, *The Ten* (Concord, New Hampshire: Rumford Press, 1976). **37.** Elizabeth de Veer and Richard J. Boyle, *Sunlight and Shadow, The Life and Art of Willard L. Metcalf* (New York: Abbeville Press, 1987). **38.** Royal Cortissoz, *In Summertime: Paintings by Robert Reid* (New York: R. H. Russell, 1900); Stanley Stoner, *Some Recollections of Robert Reid* (Colorado Springs: Dentan Printing Company, 1934); Helene Barbara Weinberg, "Robert Reid: Academic Impressionist," *Archives of American Art Journal* 15 (1975), pp. 2–11. **39.** Patricia Jobe Pierce, *Edmund C. Tarbell and The Boston School of Painting 1889–1980* (Hingham, Massachusetts: Pierce Galleries, Inc., 1980). But see also Bonnie Burnham, "Edmund C. Tarbell: Recognition Brings Confusion," and Virgilia Heimsath Pancoast, "Edmund C. Tarbell Forgeries Identified by IFAR," both in *Art Research News* (Fall 1984), pp. 3–5. **40.** Guy Pène du Bois, "The Boston Group of Painters: An Essay on Nationalism in Art," *Arts and Decoration* 5 (October 1915), pp. 457–460. **41.** Carol Lowrey, *Philip Leslie Hale, A. N. A. (1865–1931)*, (Boston: Vose Galleries of Boston, Inc., 1988). **42.** The "Tarbellites" were first identified as such by Sadakichi Hartmann, "The Tarbellites," *Art News* (March 1, 1897), pp. 3–4. **43.** John Wilmerding, Sheila Dugan, and William H. Gerdts, *Frank W. Benson The Impressionist Years* (New York: Spanierman Gallery, 1988). **44.** Bernice Kramer Leader, "The Boston School and Vermeer," *Arts Magazine* 55 (November 1980), pp. 172–176. **45.** [Philip Hale], *Vermeer* (Boston: Bates & Guild Company, 1904), pp. 213–252; Philip L. Hale, *Jan Vermeer of Delft* (Boston: Small, Maynard and Company, 1913). **46.** Lee W. Court, ed., *Joseph De Camp, An Appreciation* (Boston: State Normal Art School, 1924). **47.** Bernice Kramer Leader, *The Boston Lady as a Work of Art: Paintings by the Boston School at the Turn of the Century* (Ann Arbor: University Microfilms International, 1980); Bernice Kramer Leader, "Antifeminism in the Paintings of the Boston School," *Arts Magazine* 56 (January 1982), pp. 112–119. For the Boston painters generally, see also: R. H. Ives Gammell, *The Boston Painters 1900–1930* (Orleans, Massachusetts: Parnassus Imprints, 1986). **48.** The standard study of Chase is Ronald G. Pisano, *A Leading Spirit in American Art: William Merritt*

Chase 1849–1916 (Seattle: University of Washington Press, 1983). See also the early volume: Katherine Metcalf Roof, *The Life and Art of William Merritt Chase* (New York: Charles Scribner's Sons, 1917). For Chase's election to replace Twachtman, see "American Art at Society's Show," *The World* (New York), April 16, 1905, p. 4. **49.** Kenyon Cox, "William M. Chase, Painter," *Harper's New Monthly Magazine* 78 (March 1889), pp. 549–557; Charles de Kay, "Mr. Chase and Central Park," *Harper's Weekly* 35 (May 2, 1891), pp. 327–328. **50.** John Gilmer Speed, "An Artist's Summer Vacation," *Harper's New Monthly Magazine* 87 (June 1893), p. 3. **51.** The contemporary literature on the Shinnecock school is extensive; in addition to Speed, see "Summer Art at Shinnecock," *New York Herald*, August 2, 1891, p. 24; Philip Poindexter, "The Shinnecock Art School," *Frank Leslie's Weekly* 75 (September 29, 1892), pp. 224, 230; Rosina H. Emmet, "The Shinnecock Hills Art School," *Art Interchange* 31 (October 1893), pp. 89–90; Marguerite Tracy, "A Foreground Figure," *The Quarterly Illustrator for 1894* 2, pp. 407–413; Elizabeth W. Champney, *Witch Winnie at Shinnecock* (New York: Dodd, Mead & Company, 1894); Lillian Baynes, "Summer School at Shinnecock Hills," *Art Amateur* 31 (October 1894), pp. 91–92; "A School in the Sands," *Brooklyn Daily Eagle*, October 14, 1894, p. 9; Jessie B. Jones, "Where the Bay-Berry Grows: Sketches at Mr. Chase's Summer School," *Modern Art* 3 (Autumn 1895), pp. 109–114; Mary Clara Sherwood, "Shinnecock Hills School of Art," *The Arts* 4 (December 1895), pp. 171–73. **52.** William H. Gerdts, "The Teaching of Painting Out-of-Doors in America in the Late Nineteenth Century," in *In Nature's Ways: American Landscape Painting of the Late Nineteenth Century* (West Palm Beach, Florida: West Palm Beach Galleries, 1987), pp. 25–41. **53.** "Our Summer Art Schools," *Art Interchange* 33 (July 1894), p. 21. **54.** Allen S. Weller, *Frederick Frieseke, 1874–1939* (New York: Hirschl & Adler Galleries, 1966); Moussa M. Domit, *Frederick Frieseke, 1874–1939*, (Savannah, Georgia: Telfair Academy of Arts and Sciences, 1974); Ben L. Summerford and Frances Frieseke Kilmer, *A Retrospective Exhibition of the Work of F. C. Frieseke* (San Francisco: Maxwell Galleries, 1982). **55.** Clara T. MacChesney, "Frieseke Tells Some of the Secrets of His Art," *The New York Sunday Times*, June 7, 1914, p. 7. **56.** Robert Ball and Max W. Gottschalk, *Richard E. Miller, N. A.: An Impression and Appreciation* (Saint Louis: Longmire Fund, 1968). **57.** Mabel Urmy Seares, "Richard Miller in a California Garden," *California Southland* 38 (February 1923), pp. 10–11.

## British Impressionism

**1.** George Moore, "The Salon of 1888," *Hawk*, May 8, 1888, p. 257. **2.** John Ruskin, *Flors Clavigera* (London, July 2, 1877). **3.** See Sidney Starr, "Personal Recollections of Whistler," *Atlantic Monthly* 1001 (1908), p. 535. **4.** H. Vivian, "Mr. Walter Sickert on Impressionist Art," *Sun*, September 8, 1889. **5.** Walter Sickert, "Impressionism," in *The London Impressionists* (London: Goupil Gallery, 1889), p. 3. **6.** *Ibid.*, p. 5. **7.** E.J. Spence, "Jimmy's Show (concluded)," *Artist and Journal of Home Culture*, July 1, 1887, p. 217. **8.** W.P. Frith, "Crazes in Art: Pre-Raphaelitism and Impressionism," *Magazine of Art* XI (November 1887–October 1888), p. 187. **9.** "The Gospel of Impressionism: A Conversation between Two Impressionists and a Philistine," *Pall Mall Gazette*, July 21, 1890. **10.** See Anna Gruetzner Robins, "Degas and Sickert: Notes on Their Friendship," *Burlington Magazine* CXXX (March 1988), p. 225. **11.** *Pall Mall Gazette*, July 21, 1890. **12.** *Ibid.* **13.** Anon. (D.S. MacColl), "The New English Art Club," *Spectator*, April 18, 1891. **14.** Sickert, "The Whirlwind Diploma Gallery of Modern Pictures," *Whirlwind*, July 26, 1890, p. 67. **15.** Philip Wilson Steer, "Mr. P. Wilson Steer on Impressionism in Art," in D.S. MacColl, *The Life, Work and Setting of Philip Wilson Steer* (London, 1945), p. 177. **16.** F. Wedmore, *Some of the Moderns* (London, 1909), pp. 25–26. **17.** Wilson Steer, "Mr. p. Wilson Steer on Impressionism in Art," p. 177. It is not clear whether Steer was deliberately paraphrasing Émile Zola. Certainly he could have been told about the French author's views by his friend George Moore, who knew Zola. **18.** D.S.M. (MacColl), "The New English Art Club," *Spectator* 5 (December 1891). **19.** A. Symons, "The Decadent Movement in Literature," *Harper's Monthly Magazine* (European edition) 87 (November 1893), p. 861. **20.** P. G. Hamerton, *Landscape* (London, 1885), p. 333. **21.** George Clausen, "Some Remarks on Impressionism," *Art Journal* (January 1893), p. 104. **22.** Edward Stott, *Art Journal*, January 1893, p. 104. **23.** L. Housman, "Mr. Edward Stott, Painter of the Field and of the Twilight," *Magazine of Art*, 1900, p. 531. **24.** Wilson Steer, "Mr. P. Wilson Steer on Impressionism in Art," p. 178. **25.** F. Wedmore, *Constable: Lucas: With a Descriptive Catalogue of the Prints They Did Between Them* (London, 1904), p. 12. **26.** C.J. Holmes, *Constable and his Influence on Landscape Painting* (London, 1902). **27.** See Sickert, "The Royal Academy," *Sun*, February 17, 1897. **28.** F. Brown, "Winifred Matthews," *Quarto* 11 (1896), p. 14. **29.** D.S.M. (MacColl), "The New English Art Club and the Meissonier Exhibition," *Spectator*, April 22, 1893. **30.** W. Dewhurst, *Impressionist Painting. Its Genesis and Development*, (London, 1904). **31.** D. S. MacColl, *Nineteenth Century Art* (London, 1902), p. 6.

## Impressionism in Canada

**1.** "Studio Notes: Impressionism," *Arion* 1 (September 1881), pp. 89–90. For a brief discussion of this article see Carol Lowrey, "Arcadia and Canadian Art," *Vanguard* 15 (April–May 1986), p. 20. **2.** This is *Temps Passé*, now in the collection of the Owens Art Gallery, Mount Allison University, Sackville, New Brunswick. **3.** Joan Murray, ed., *Letters Home: 1859–1906, The Letters of William Blair Bruce* (Moonbeam, Ontario: Penumbra Press, 1982), p. 122. **4.** *Ibid.*, p. 123. **5.** See William H. Gerdts, *American Impressionism* (Seattle: The Henry Art Gallery, University of Washington, 1980), pp. 51–52. **6.** Greta, "Boston Art and Artists," *The Art Amateur* 17 (October 1887), p. 95; cited in Gerdts, p. 30. **7.** *Pleasant Moments*, in the collection of the Art Gallery of Hamilton, Hamilton, Ontario. **8.** In the collection of the Art Gallery of Hamilton, Hamilton, Ontario. **9.** Lowrey, "Arcadia and Canadian Art," p. 22. **10.** "The Impressionists," *Arcadia* 1 (December 15, 1892), p. 325. **11.** "Impressionism, The Subject of a Lecture by Raffaëlli, the Noted French Artist," *The Gazette*, May 3, 1895. **12.** "Re Impressionism. What It Is and in What It Differs From Other Schools, By Mr. W. Brymner, R.C.A.," *The Gazette*, March 12, 1896. **13.** "Nos Artistes à Paris," *Courier du Canada*, January 22, 1891: "M. Cullen penche plutôt vers l'école impressionniste et ce n'est pas certes pas un reproche que nous lui ferons car cette tendance prouve chez cet artiste une horreur de la banalité que nous ne saurions trop encourager. C'est dans cette note qu'il vient de terminer deux paysages de sa composition qui sont exposés en ce moment à l'American student association, boulevard Montparnasse; ce sont là deux oeuvres très personelles et qui promettent beaucoup." **14.** *The Gazette*, January 24, 1896. **15.** "An artistic trend," *The Herald*, December 1, 1896. **16.** "Chronique du Lundi," *La Patrie*, April 12, 1897: "Un impressionniste consciencieux de l'école moderne française que M. Cullen. Je ne pourrais jamais vous rendre l'effet extraordinaire de ses tableaux. Les scènes d'hiver sont d'une puissance de coloris étonnante; on sent qu'il peint ce qu'il voit et comme il le voit, avec le seul souci de rendre sincèrment la nature." **17.** "Sale of Paintings," *Montreal Star*, December 21, 1897. **18.** Letter of January 12, 1897, Edmund Morris correspondence, E. P. Taylor Reference Library, Art Gallery of Ontario, Toronto. **19.** "Le salon de 1899," *La Revue des deux Frances* 503 (June 1899): "Du bon impressionnisme, fait sans recherche mais consciencieux et qui veut bien dire ce qu'il veut." **20.** *Old Friends* (London: Chatto & Windus, 1956), p. 156. **21.** "The Master Impressionists (Chapter VII)," *The Fine Arts Journal* 28 (1913), p. 347. **22.** Albert Laberge, "A la Galerie des arts, brillante ouverture de l'Exposition annuelle de peinture," *La Presse*, March 20, 1905; "les effets de lumière a travers le feuillage dénotent un maitre." **23.** *Montreal Witness*, February 13, 1906. **24.** The paintings, both entitled *Composing His Serenade*, are in the Confederation Art Gallery and Museum, Charlottetown, Prince Edward Island. **25.** *A Painter's Country, The Autobiography of A.Y. Jackson* (Toronto: Clarke, Irwin & Company Limited, 1967), p. 17. **26.** Letter of November 12, 1906, Archives of Canadian Art, McCord Museum, Montreal, cited in Nancy Boas, *The Society of Six: California Colorists* (San Francisco: Bedford Arts, 1988), p. 46. **27.** Reproduced before it was cut down, in H. H. Boyesen, "Boyhood and Girlhood," *The Monthly Illustrator* 4 (April 1895). Robert Stacey kindly brought this to my attention. **28.** "Art at the Ontario Society of Artists' Exhibition," *Massey's Magazine* 1 (1896), pp. 412–416.

## The Sunny South: Australian Impressionism

**1.** See Jane Clark, "The *9×5 Exhibition*, 1889," in Jane Clark and Bridget Whitelaw, *Golden Summers, Heidelberg and Beyond* (Sydney: National Gallery of Victoria, Art Gallery of New South Wales, 1985–1986), p. 113. Ironically they headed their statement with a quotation from the arch-enemy of the French Impressionists, Gérome. **2.** *Table Talk* (Melbourne), August 23, 1889. **3.** "The bush" signifies uncultivated land; it is loosely used to signify "nature," or even "the countryside." **4.** The Australian seasons are the reverse of those in the northern hemisphere, thus a Melbourne summer runs from November to March. **5.** Quoted by Bridget Whitelaw, "Plein-air painting": the early artists' camps around Melbourne in Clark and Whitelaw, *Golden Summers*, p. 61. "Jackies," "laughing jackasses," or kookaburras are native-birds with raucous laughter. **6.** See, for example, Whitelaw, "Plein-air painting," p. 64. She finds Roberts's concept of Impressionism "closer to . . . . the juste milieu" as defined by Alfred Boime in *The Salon and French Painting in the Nineteenth Century* (London: Phaidon, 1971). For a counter-argument, see Bernard Smith, "New Light on Old Light: Impressionism and the Golden Summers Exhibition," *The Age Monthly Review* (Melbourne), December–January 1985–1986. **7.** D.S. MacColl, *The Work and Setting of Philip Wilson Steer* (London: Faber and Faber, 1945, 20–2): on the Impressionist exhibitions in London, see Douglas Cooper, *The Courtauld Collection* (London: The Athlone Press, University of London, 1954), pp. 21–25. **8.** R.H. Croll, ed., *Smike to Bulldog: Letters from Sir Arthur Streeton to Tom Roberts* (Sydney: Robertson and Mullens, 1946), p. 134. **9.** John Russell to Tom Roberts, undated, 1885 (Tom Roberts's Papers, Mitchell Library, Sydney), vol. III, p. 12. **10.** Terry Smith, "The Most Australian of Our Artists, Tom Roberts, Impressionism and Cultural Construction," *The Age Monthly Review* (Melbourne) February 1986, pp. 17–18. **11.** See *Argus* (Melbourne), March 25, 1882 (about A.J. Daplyn's work); *Argus*, March 3, 1883 (about Julian Ashton). **12.** *Argus*, March 13, 16, and 20, 1883. In the 1880s there was considerable speculation about the influence of Australia's climate on its culture. **13.** Charles Nalsh (an ex-art student from England), *Argus*, Juy 31, 1885; "A Landscape Painter," *Argus*, July 4, 1885. **14.** Charles Baudelaire, "Le Peintre de la vie moderne," Paris

1863, in *Oeuvres complètes* (Paris: Gallimard, 1964), p. 1163. **15.** Tom Roberts, Charles Conder, and Arthur Streeton, "Concerning Impressions in Painting," *Argus*, September 3, 1889. **16.** Editorial in *Argus*, September 4, 1889. **17.** Roberts and Humphrey worked as photographers; Streeton was an apprentice photographer; Roberts did illustrations for the *Picturesque Atlas of Australia*. **18.** In *An Autumn Morning, Milsons Point* (Sydney: Art Gallery of New South Wales, 1888); *The Age*, April 30, 1888, p. 6. **19.** Streeton to Roberts, c.1890, in Croll, *Smike to Bulldog*, p. 6. **20.** Terry Smith ("Landscapes with Feeling," *The Age Monthly Review* [Melbourne] August 1986, p. 22), discusses the painting in terms of the discourse of fashion—and suggests the relationship of the reclining figure to a shop dummy. **21.** Contemporary journals record the other trappings of modish Japonisme in the decor of studios. Ron Radford (in *Creating Australia, Two Hundreds Years of Arts 1788–1988*, ed. D. Thomas [Adelaide: International Cultural Corporation of Australia and Art Gallery of South Australia, 1988], p. 122) suggests that the two foreground figures were painted in the studio (there is an oil-sketch for the woman). Given the group's commitment to open-air painting and direct verification of sense impressions, I see no evidence for this—the tonal contrasts between figures and beachscape can be explained by the absence of "the atmospheric veil." **22.** See T.J. Clark, "The Environs of Paris," in *The Painting of Modern Life. Paris in the Art of Manet and His Followers* (Princeton, New Jersey: Princeton University Press, 1984), pp. 147–204. **23.** The phrase is Tom Roberts's, in a letter to the editor, *The Argus*, June 28, 1890. **24.** Anita Callaway, *The Babes in the Wood: Ways of Seeing Lost Children*. Fourth Year Honours thesis, Fine Arts Department, University of Sydney, 1984. **25.** A watercolour by Abrahams (*Golden Summers*, p. 60), shows a picture at least five feet high being painted *en plein air*. **26.** Undated letter to Roberts, c. 1888–1889, cited in Croll, *Smike to Bulldog*, p. 6. **27.** Jeannette Hoorn, "The Idea of the Pastoral in Australian Painting 1788–1940," Ph.D. thesis, University of Melbourne, 1988, pp. 153–154. **28.** *Argus*, May 26, 1892. **29.** *Argus*, September 11, 1888. **30.** *The Age*, May 28, 1891. **31.** *Argus*, June 1, 1896. **32.** *Argus*, October 25, 1894. **33.** Conder to Roberts, August 20, 1890, in Croll, *Smike to Bulldog*, p. 128; Streeton to Roberts, 1890, in Croll, *Smike to Bulldog*, p. 14. **34.** Streeton to McCubbin, 1891, in Croll, *Smike to Bulldog*, pp. 20–21. **35.** *Table Talk*, May 10, 1889, p. 6; *Melbourne University Review*, May 1890. **36.** Terry Smith, "Teaching Art History—A Tutorial In Arthur Streeton's *Still glides the stream*—1800," *Creativity in Art Education Conference Papers* (Sydney: Art Education Society, 1982). **37.** Unsigned letter to Roberts, March 1887, (Tom Roberts's papers, Mitchell Library, Sydney, vol. III), p. 33. **38.** A corroboree is "an Aboriginal assembly of sacred, festive or warlike character" (*Macquarie Dictionary*).

## The Impressionist Impulse in Japan and the Far East

**1.** Collin (1850–1916) was already famous as a painter of nudes in a sort of academic Impressionist manner. He was later to receive important state commissions from the French government, including murals for the Hôtel de Ville in Paris and the ceiling of the famous Théatre de l'Odéon. His work there was replaced in recent years with a new Chagall ceiling. **2.** Such journals began to appear around the turn of the century, and in the aggregate they provide an exciting picture of general developments in modern painting and sculpture. Many of these publications combined art reproductions and critical commentary with texts of contemporary Japanese and foreign literature in translation as well. Among the most influential were such publications as *Myōjō* ("Morning Star"), founded in 1900; *Hototogisu* ("Cuckoo"), which began in 1897; *Hōsun* ("An Inch Square"), founded in 1907; *Bijutsu shinpō* ("Art News"), which began in 1902; and, in particular, the famous *Shirakaba* ("White Birch") magazine that began publishing in 1910 and provided highly stimulating coverage of the newest trends in art and literature to a receptive public for over a decade. **3.** The first collection of Western painting to be permanently on display to the public was first shown in the Ohara Museum in 1921. The museum, however, was rather inaccessible, located as it was in the town of Kurashiki, several hours by train from the city of Osaka. The collection, much augmented since, remains one of the finest in Japan today. **4.** Shimazaki Tōson, "Parii dayori," in *Tōson zenshū* (Tokyo: Chikuma shobō, 1967), vol. 6, p. 399. **5.** Takamura Kōtarō, *Geijustsuronshū* (Tokyo: Iwanami bunko, 1982), p. 82. **6.** Umehara Ryūzaburō, *Runoaru no tsuioku* (Tokyo: Yotokusha, 1944)

## Italian Painting During the Impressionist Era

**1.** See Roberto Longhi, "Il Impressionismo e il gusto degli italiani," published as the introduction to the Italian edition of John Rewald, *Storia dell'Impressionismo*, trans. Antonio Boschetto (Florence: Sansoni, 1949), pp. vii–xxix. Vittorio Pica's writings include an article on Claude Monet, *Emporium* XXVI (1907), and a book, *Gli Impressionisti francesi*, published in 1908. For a summary of artists whose works were shown at the exhibitions in Venice between 1895 and 1912, see *Post-Impressionism: Cross-Currents in European Painting*, eds. John House and MaryAnne Stevens (London: Royal Academy of Arts, 1980), pp. 287–297. **2.** Quoted by Edgar Holt, *The Making of Italy, 1815–1870* (New York and London: Atheneum, 1971), p. 258. **3.** Adriano Cecioni, "Telemaco Signorini," *La Domenica Letteraria* (Rome), vol. 3, August 2, 1884, in Cecioni, *Opere e scritti*, ed. Enrico Somarè (Milan: Edizioni dell'Esame,

1932), p. 157. This and all other translations, unless otherwise indicated, are my own. **4.** Instrumental in establishing this critical position was Longhi; see "Il Impressionismo e il gusto degli italiani." **5.** See, for example, the point of view expressed by Luciano Berti in the preface to *I Macchiaioli nella cultura toscana dell'Ottocento* (Florence: Forte di Belvedere, 1976), pp. 5–6. **6.** More than two hundred of Filippo Palizzi's outdoor studies were bequeathed by the artist to the National Gallery of Modern Art in Rome. On the Palizzi brothers, see Paolo Ricci, *I Fratelli Palizzi* (Busto Arsizio: Bramante Editrice, 1960); and on the School of Posillipo, see Raffaello Causa, *La Scuola di Posillipo* (Milan: Fratelli Fabbri Editori, 1967). **7.** Vittorio Imbriani, *La Quinta Promotrice* (Naples, 1868), in Vittorio Imbriani, *Critica d'arte e prose narrative*, ed. Gino Doria (Bari: Laterza, 1937), pp. 1–168; these quotes, pp. 45 and 49. On Imbriani's theory of the *macchia* and its relation to the concept that was influential in Florence in the late 1850s, see Norma Broude, "The Macchiaioli: Academicism and Modernism in Nineteenth-Century Italian Painting," Ph.D. thesis, Columbia University, 1967, pp. 78–84. **8.** For more on the Macchiaioli, see Norma Broude, *The Macchiaioli: Italian Painters of the Nineteenth Century* (New Haven and London: Yale University Press, 1987), and Dario Durbè, *The Macchiaioli* (Rome: De Luca Editore, 1978). **9.** On Abbati, see, Piero Dini, *Giuseppe Abbati, l'opera completa* (Turin: Umberto Allemandi & C., 1987); and Broude, *The Macchiaioli* (1987), pp. 80–82 and 123–136. **10.** On Fattori, see Broude, *The Macchiaioli* (1987), pp. 185–265. For a catalog of his paintings, see Giovanni Malesci, *Catalogazione illustrata della pittura ad olio di Giovanni Fattori* (Novara: Istituto Geografico de Agostini, 1961); and for the prints, see Andrea Baboni, *Giovanni Fattori: l'opera incisa* (Milan: Over, 1983). **11.** The pioneering work on the importance of Japanese prints for the Macchiaioli is by Nancy Jane Gray Troyer, "The Macchiaioli: Effects of Modern Color Theory, Photography, and Japanese Prints on a Group of Italian Painters," Ph.D. thesis, Northwestern University, 1978; see, also, her "Telemaco Signorini and Macchiaioli *Giapponismo*," *The Art Bulletin* 66 (March 1984), pp. 136–145. **12.** On Lega, see Dario Durbè and Cristina Bonagura, *Silvestro Lega (1826–1895)* (Bologna: Edizioni Alfa, 1973); and Broude, *The Macchiaioli* (1987), pp. 151–184. **13.** The standard biography is by Piero Dini (with the collaboration of Alba del Soldato), *Diego Martelli* (Florence: Edizioni Il Torchio, 1978); on Martelli's four trips to Paris (of which this was the last), see pp. 125–156. **14.** Ludovic R. Pissarro and Lionello Venturi, *Camille Pissarro, son art, son oeuvre* (Paris: P. Rosenberg, 1939): no. 405, *Paysage, Environs de Pontoise* (dated 1877), and no. 451, *Dans le Jardin Potager* (dated 1878). **15.** Broude, *The Macchiaioli* (1987), pp. 272 ff. and note 47. **16.** Diego Martelli, "Gli Impressionisti" (lecture of 1879; Pisa, 1880), in *Scritti d'arte di Diego Martelli*, ed. Antonio Boschetto (Florence: Sansoni, 1952), pp. 98–110. **17.** See the letters to Martelli from Francesco Gioli and Telemaco Signorini, in Dini, *Diego Martelli*, pp. 140–141 and 142–143; see also, Broude, *The Macchiaioli* (1987), p. 276. **18.** *Ibid.* **19.** Diego Martelli, "Rident memoria luget," *La Commedia Umana*, October 25, 1885, in Durbè and Bonagura, *Lega*, pp. lxxix–lxxxi; this quote p. lxxxi. **20.** See comments made by the artist and his friends (Signorini, Martelli, and Giulia Bandini), quoted in Broude, *The Macchiaioli* (1987), pp. 171, 174, 175. **21.** On Bandini and other women artists in the circle of the Macchiaioli, see Broude, *The Macchiaioli* (1987), pp. 118–23. **22.** Telemaco Signorini, "Cronologia autobiografica," in Enrico Somarè, *Signorini* (Milan: Edizioni dell'Esame, 1926), pp. 267–271; and Cecioni, "Telemaco Signorini," pp. 163–164. On Signorini, see also Lara-Vinca Masini, *Telemaco Signorini* (Florence: Edizioni d'Arte il Fiorino, 1985); and Broude *The Macchiaioli* (1987), pp. 136–151. **23.** "X" (Telemaco Signorini), "Alcune parole sulla Esposizione Artistica nelle sale della Società Promotrice," *La Nuova Europa* 2 (October 19, 1862), in Mario Borgiotti and Emilio Cecchi, *The "Macchiaioli," The First "Europeans" in Tuscany* (Florence: Olschki, 1963), pp. 25, 27. **24.** See Broude, *The Macchiaioli* (1987), p. 298, note 86. **25.** Letter to Signorini from Marcellin Desboutin, dated April 16, 1875, in Somarè, *Signorini*, p. 36. **26.** On Degas and Italy, see R. Raimondi, *Degas e la sua famiglia in Napoli, 1793–1917* (Naples, 1958); Jean Sutherland Boggs, "Edgar Degas and the Bellellis," *The Art Bulletin* 37 (1955), pp. 127–136; Boggs, "Edgar Degas and Naples," *The Burlington Magazine* 105 (June 1963), pp. 273–276; Lamberto Vitali, "Three Italian Friends of Degas," *The Burlington Magazine* 105 (June 1963), pp. 266–272; and Broude, *The Macchiaioli* (1987), pp. 248–265. **27.** On the impact of photography on the work of the Macchiaioli in general and Signorini in particular, see Lamberto Vitali, *La fotografia e i pittori* (Florence: Edizioni Sansoni Antiquariato, 1960); and Troyer, "The Macchiaioli" (1978). **28.** Diego Martelli, "Giuseppe De Nittis," *Fieramosca*, September 13, 1884, in Boschetto, *Scritti d'arte di Diego Martelli*, pp. 125–126. **29.** On Boldini, see Carlo Ragghianti and E. Camesaca, *L'opera completa di Boldini* (Milan: Rizzoli, 1970); and *Three Italian Friends of the Impressionists: Boldini, De Nittis, Zandomeneghi*, with an introduction by Dario Durbè, essays on the artists by Enrico Piceni, and catalog entries by Giuliano Matteucci and Paul Nicholls (New York: Stair Sainty Matthiesen, 1984), pp. 17–30. **30.** Giuliano Matteucci, *The Macchiaioli: Tuscan Painters of the Sunlight*, with an introduction by Erich Steingräber (New York: Stair Sainty Matthiesen, 1984), p. 62. **31.** On De Nittis, see Giuseppe De Nittis, *Notes et souvenirs du peintre Joseph de Nittis* (Paris, 1895), Italian edition: *Taccuino, 1870/1884*, with a preface by Emilio Cecchi, trans. from the French and notes by Enzo Mazzoccolo and Nelly Rettmeyer (Bari: Leonardo da Vinci, 1964); Vittorio Pica, *Giuseppe De Nittis: l'uomo e l'artista* (Milan: Alfieri & Lacroix, 1914); Enrico Piceni, *Giuseppe De Nittis* (Milan: Mondadori,

1934); Mary Pittaluga and Enrico Piceni, *De Nittis* (Milan: Bramante Editrice, 1963); Michele Cassandro, *De Nittis* (Bari, 1971); Enrico Piceni, *De Nittis, l'uomo e l'opera*, with a general catalog of the works (Busto Arsizio: Bramante Editrice, 1979–1982); "Giuseppe De Nittis," in Durbé, *Three Italian Friends of the Impressionists*, pp. 33–40. **32.** For Cecioni's views on the French art world, see his letter to Signorini from Paris, July 24, 1870, in *Opere e scritti*, pp. 273–275. **33.** For example, *Il Passaggio degli Appennini* of 1867 (Piceni, *De Nittis*, 1934, pl. III; and Piceni, *De Nittis*, 1979–1982, vol. I, pl. 4). **34.** For a discussion of this painting, see Charles S. Moffett and Françoise Cachin, *Manet, 1832–1883* (Paris and New York: Grand Palais and The Metropolitan Museum of Art, 1983), pp. 318–320. **35.** For reproductions of several of the Mount Vesuvius studies, see Piceni, *De Nittis* (1934), pls. XIV–XVIII; and Piceni, *De Nittis* (1979–1982), vol. I, pls. 20–21. **36.** Durbé, *Three Italian Friends of the Impressionists*, p. 10. **37.** Letter from Paris dated April 5, 1874, in *Il Giornale Artistico* (Florence), vol. I, no. 24, April 16, 1874, pp. 190–191. Modern edition, with critical note by Fernando Tempesti (Florence: S.P.E.S., n.d.). **38.** Letter from London dated June 10, 1874, *Il Giornale Artistico* (Florence), vol. II, no. 4, July 1, 1874, pp. 25–26. **39.** De Nittis, *Taccuino, 1870/1884*, p. 115. **40.** The comment, by the French critic Jules Claretie, is cited by Pica, *De Nittis*, p. 121, and by Matteucci, *Three Italian Friends of the Impressionists*, p. 38. **41.** See Martelli's description of a dinner party he attended at the De Nittis home in 1878, in "Giuseppe De Nittis," *Scritti d'arte di Diego Martelli*, pp. 127–128. The passage is quoted and translated in Broude, *The Macchiaioli* (1987), p. 272. **42.** *Three Italian Friends of the Impressionists*, p. 11. **43.** Martelli pointed this benefit out to Fattori in a letter of April 13, 1878. See Piero Dini, ed., *Giovanni Fattori, Lettere a Diego* (Florence: Edizioni Il Torchio, 1983), p. 65. **44.** On Frémiet's statue, see *L'Univers Illustré*, February 28, 1874, p. 132; June 10, 1874, pp. 18–19. As cited by Paul Tucker, "The First Impressionist Exhibition in Context," in *The New Painting: Impressionism 1874–1886*, ed. Charles S. Moffett (Washington, D.C.: National Gallery of Art, 1986), pp. 98–99. **45.** Durbé, *Three Italian Friends of the Impressionists*, p. 35. **46.** Cited by Piceni (1934),*De Nittis*, p. 61. **47.** On Zandomeneghi, see Enrico Piceni, *Zandomeneghi* (Milan: Mondadori, 1952); Mia Cinotti, *Zandomeneghi* (Busto Arsizio: Bramante Editrice, 1960); Enrico Piceni, *Zandomeneghi, l'uomo e l'opera* (Milan: Bramante Editrice, 1979). **48.** Letter to Signorini, dated August 6, 1874, in Lamberto Vitali, ed., *Lettere dei Macchiaioli* (Turin: Einaudi, 1953), pp. 282–285; these quotes, pp. 283–284. **49.** Letter from Zandomeneghi, quoted by Martelli in notes for a lecture of 1877, in *Scritti d'arte di Diego Martelli*, p. 49. See, also, his letter to Fattori, May 26, 1877, in Vitali, *Lettere*, pp. 293–294. **50.** Vitali, *Lettere*, p. 300, note 5. **51.** François Gauzi, *Lautrec et son temps* (Paris, 1954), pp. 130–132; reprinted in Cinotti, *Zandomeneghi*, pp. 83–84, this quote, p. 83. **52.** Dated 1879. Florence, Galleria d'art moderna (Martelli Bequest); reproduced in Moffett, *The New Painting*, p. 289, pl. 84. **53.** Dated 1879. Crema, Paolo Stramezzi Collection; reproduced in Cinotti, *Zandomeneghi*, pl. 16. **54.** Paul Sébillot, *La Plume* (May 15, 1879), quoted in *The New Painting*, p. 289; see also p. 271 for the list of Zandomeneghi's works in this exhibition. **55.** *Three Italian Friends of the Impressionists*, p. 46. **56.** The comments, for example, of Joris-Karl Huysmans are quoted in *The New Painting*, p. 333. **57.** On Degas's work, see Colin B. Bailey in *Masterpieces of Impressionism and Post-Impressionism from the Annenberg Collection* (Philadelphia: Philadelphia Museum of Art, 1989), pp. 19–21. **58.** He sent five works to this show. See *The New Painting*, p. 356. **59.** Observed in Norma Broude, "Will the Real Impressionists Please Stand Up?" *Art News*, vol. 85, no. 5 (May 1986), p. 87; Kathleen Adler, *Unknown Impressionists* (Oxford: Phaidon Press, 1988), p. 96; and Mary Mathews Gedo, "The 'Grand-Jatte' as the Icon of a New Religion: A Psycho-Iconographic Interpretation," *The Art Institute of Chicago Museum Studies*, vol. 14, no. 2 (1989), p. 229. **60.** As reported by Gustave Kahn (1888), in Norma Broude, ed., *Seurat in Perspective* (Englewood Cliffs, N.J.: Prentice-Hall, 1978), p. 20. **61.** The catalog entries are reproduced in facsimile in *The New Painting*, p. 447. **62.** See, for example, his letter of 1888 to Martelli, in Vitali, *Lettere*, p. 296. **63.** See Zandomeneghi's analysis of this change in his fortunes, in a letter of 1894 to Martelli, in Vitali, *Lettere*, pp. 301 ff. **64.** Here I follow and agree with the dating of Cinotti, *Zandomeneghi*, pl. 66. Matteucci argues instead for a date in the mid-1880s (*Three Italian Friends of the Impressionists*), p. 50. **65.** On Fontanesi, see Andreina Griseri, *Il Paesaggio nella pittura piemontese dell'Ottocento* (Milan: Fratelli Fabbri Editori, 1967); and Broude, *The Macchiaioli* (1987), pp. 94 and 292, note 99. **66.** On Carnovali, see C. Caversazzi, *Giovanni Carnovali, il Piccio* (Bergamo, 1946); M. Valsecchi, *Giovanni Carnovali, il Piccio* (Varese, 1952); A. Locatelli Milesi, *Il Piccio* (Bergamo, 1952); and Gustavo Predaval, *Pittura Lombarda dal Romanticismo alla Scapigliatura* (Milan: Fratelli Fabbri Editori, 1967). **67.** For a useful discussion in English of the political and literary background, see the essay by John Wetenhall, "Milan and Venice," in *Italian Paintings 1850–1910 from Collections in the Northeastern United States* (Williamstown: Clark Art Institute, 1982), pp. 41–63. **68.** Marisa Emiliani Dalai and Gabriella Mercandino Jucker, eds., *Pittura Italiana dell'Ottocento nella raccolta Giacomo Jucker* (Milan: Raccolta Jucker, 1968), commentary on pl. 62. **69.** See the biographical notes by one of her sons, Luigi Troubetzkoy, in *Paolo Troubetzkoy nel Museo di Pallanza* (Milan: Edizioni Alfieri, 1952), p. 36; and Norma Broude, "The Troubetzkoy Collection and the Influence of Decamps on the Macchiaioli," *The Art Bulletin*, vol. 62, no. 3 (September 1980), p. 405. **70.** Dalai and Mercandino Jucker, eds., *Pittura Italiana dell'Ottocento nella raccolta Giacomo Jucker*, commen-

tary on pl. 78. **71.** On Ranzoni and Cremona, see A.M. Brizio, L. Caramel, and E. Malagoli, *Mostra della Scapigliatura* (Milan: Palazzo della Permanente, 1966); and Enrico Piceni and Mario Monteverdi, *Pittura Lombarda dell'Ottocento* (Milan: Cassa di Risparmio delle Provincie Lombarde, 1969). A useful early discussion of Cremona is provided by Ashton Rollins Willard, *History of Modern Italian Art* (New York: Longmans, 1900), pp. 469–471 and 623–628. **72.** On Grandi and for examples of his work, see Emilio Lavagnino, *L'Arte moderna dai neoclassici ai contemporanei* (Turin: Unione Tipografico-Editrice, 1961), vol. II, pp. 741, 743, 744–748; Carlo Pirovani, *Scultura Italiana dal neoclassicismo alle correnti contemporanie* (Milan: Electa, 1968), pls. 35–37 and pp. 16–17; also, Willard, *History of Modern Italian Art*, 229–231. **73.** On Italian Divisionism, see Fortunato Bellonzi, *Il Divisionismo nella Pittura Italiana* (Milan: Fratelli Fabbri Editori, 1967); Teresa Fiori, ed., *Archivi del Divisionismo*, with an introduction by Fortunato Bellonzi (Rome: Officina Edizioni, 1969); E. Bairati et al., *Mostra del Divisionismo Italiano* (Milan: Palazzo Permanente, 1970); and Annie Paule Quinsac, *La Peinture Divisionniste Italienne: origines et premiers développements 1880–1895* (Paris: Klincksieck, 1972). For an excellent summary of scholarship on this movement in English, see Sandra Berresford, "Divisionism: Its Origins, Its Aims and Its Relationship to French Post-Impressionist Painting," in House and Stevens, *Post-Impressionism: Cross-Currents in European Painting*, pp. 218–226. **74.** These are reviewed by Berresford, pp. 221–222. **75.** Vittore Grubicy de Dragon, "Polemiche artistiche," *Cronaca d'arte*, vol. I, no. 27 (June 21, 1891), in Fiori, *Archivi del Divisionismo*, vol. I, p. 93. **76.** Quinsac, *La Peinture Divisionniste*, p. 126. **77.** Grubicy, "Polemiche Artistiche,", pp. 92–94, identifies Rood and the Scapigliati as sources for the Divisionists. **78.** Mile was a professor at the University of Warsaw. See J. Mile, "Uber die Empfindung, welche entsteht, wenn verschiedenfarbige Lichtstrahlen auf identische Netzhautstellen fallen" (1838), in Quinsac, pp. 274–277. **79.** Berresford, "Divisionism," p. 222. **80.** On Segantini, see Maria Cristina Gozzoli and Francesco Arcangeli, *L'Opera completa di Segantini* (Milan: Rizzoli, 1973); Hans Lüthy and Corrado Maltese, *Giovanni Segantini* (Zürich, 1981); Annie Paule Quinsac, *Segantini, catalogo generale* (Milan: Electa, 1982); and Gabriella Belli, ed., *Segantini* (Milan: Electa, 1987). **81.** Previati makes these formal and expressive connections, possibly influenced by the writings of Charles Blanc and Charles Henry, in his *Principi scientifici del Divisionismo: La tecnica della pittura* (Turin, 1906), p. 224. On Previati, see also *Gaetano Previati, Mostra Antologica* (Ferrara: Palazzo dei Diamanti, 1969). **82.** Letter from Fattori to a group of students, January or February 1891, in Vitali, *Lettere*, pp. 64–65; and letter from Fattori to Plinio Nomellini, March 12, 1891, *ibid.*, p. 67. **83.** Berresford, "Divisionism," pp. 223–224. **84.** Their attitudes and statements in this regard are reviewed by Berresford, "Divisionism," p. 221. See also, *Arte e Socialità in Italia dal Realismo al Simbolismo, 1865–1915* (Milan: Palazzo Permanente, 1979). **85.** Pellizza had seen and admired a compositionally related work by Nomellini, *The Loading Square*, at the Brera Triennale of 1891 (Gianfranco Bruno, ed., *Plinio Nomellini*, [Milan: Palazzo Permanente, 1985], p. 200). On Pellizza, see also, Aurora Scotti, *Catalogo dei manoscritti di Giuseppe Pellizza da Volpedo provenienti dalla donazione Eredi Pellizza* (Tortona, 1974); and Aurora Scotti, ed. *Pellizza da Volpedo* (Milan: Electa, 1980). **86.** Vittore Grubicy de Dragon, "Tecnica e estetica divisionista," *La Triennale*, 14–15 (1896), pp. 110–112, quoted and trans. by Berresford, "Divisionism," p. 220. **87.** See Umberto Boccioni, "Gaetano Previati" (1916), in *Archivi dei Divisionismo*, vol. I, p. 57; and Guido Ballo, *Preistoria del Futurismo* (Milan, 1964). **88.** For further discussion of these issues, see Anna Maria Damigella, "Divisionism and Symbolism in Italy at the Turn of the Century," in Emily Braun, ed., *Italian Art in the 20th Century* (London: Royal Academy of Arts, 1989), pp. 33–41; and Adrian Lyttelton, "Society and Culture in the Italy of Giolitti," *ibid.*, pp. 23–31.

## THE LURE OF IMPRESSIONISM IN SPAIN AND LATIN AMERICA

**1.** At the midpoint of his grant to Rome the city of Barcelona decided that the subject of the painting he was to do for its Council Chamber should be a battle scene of the war in Morocco, so Fortuny made two trips to North Africa. "In the Footsteps of Fortuny and Regnault," *Century Magazine*, vol. 23, No. 1 (November 1881), p. 24. **2.** Aureliano de Beruete y Moret, *Goya as Portrait Painter*, trans., Selwyn Brinton. (London: Constable & Co., 1922), pp. 105–106. For an illustration of Fortuny's copy see Elizabeth Du Gué Trapier, *Catalogue of Paintings (19th and 20th Centuries)*, Vol. I (New York: Hispanic Society of America, 1932), frontispiece. For Fortuny's copy of Velázquez's *Menippus* see Joaquín de la Puente, *Catálogo de las Pinturas del Siglo XIX, Casón del Buen Retiro* (Madrid: Museo del Prado, 1985), No. 2611. Martín Rico's sketchbooks preserve his copies of two of Goya's portraits: *The Duchess of Alba* (1797) and *Isabel Cobos de Porcel* (1805); see Elizabeth Du Gué Trapier, *Martín Rico y Ortega in the Collection of The Hispanic Society of America* (New York: Hispanic Society of America, 1937), p. CCIX and p. CCLXXXIV, respectively. **3.** *Aureliano de Beruete, 1845–1912* (Madrid: Obra Cultural de la Caja de Pensiones, 1983), p. 36. **4.** Juan Antonio Gaya Nuño, *Ars Hispaniae Historia Universal del Arte Hispánico*, vol. 19, *Arte del Siglo XIX* (Madrid: Editorial Plus-Ultra, 1966), p. 383. Beruete's monograph on Velázquez was translated into English and published in London in 1906. **5.** Enrique Lafuente Ferrari, *Breve Historia de la Pintura Española*.

(Madrid: Editorial Dossat, 1946), p. 405. **6.** *Spanish Painters in Search of Light (1850–1950)*. (Madrid: U.S.–Spanish Joint Committee for Educational and Cultural Affairs, 1984), p. 106. **7.** For example, Manet's *Portrait of Duret* (1868: Petit Palais, Paris) and *Portrait of Clemenceau* (1879–1880; Musée d'Orsay, Paris). **8.** See, for example, Velázquez's *Portrait of Don Pedro de Barberana*, c.1631–1633 in the Kimbell Museum, Fort Worth. **9.** Gaya Nuño, *Ars Hispaniae*, p. 369. **10.** Trapier, *Martín Rico*, p. 3. For an illustration of this painting, which is today in the Prado's nineteenth-century museum, the Casón del Buen Retiro, see La Puente, *Catálogo de las Pinturas*, no. 4496. **11.** Trapier, *Martín Rico*, p. 6. **12.** *Ibid.*, p. 13. For an illustration see La Puente, *Catálogo de las Pinturas*, no. 4494. **13.** Taking just at random the art sales for 1899, one sees not only that the list is sprinkled with the names of Spaniards but that they commanded comparatively high prices. Fortuny's *Arab Fantasia* sold for the highest price of $7,700, while William Bouguereau's much larger canvas *The Little Pilfers* sold for $6,600 and Rosa Bonheur's *The Choice of the Flock* for $4,200. Jiménez y Aranda's *A Spanish Pharmacy* brought $1,900, Vicente Palmaroli's *Selling Antiquities* $1,440, and Martín Rico's *Scene in Venice* $1,200 in comparison with $250 for Sanford Gifford's *Venetian Fishing Boats*, $770 for Eastman Johnson's *The Reprimand*, $110 for William Merritt Chase's *A Visitor*, and $130 for Winslow Homer's *In the Garden*. Other Spaniards whose paintings were bought in New York that year were Raimundo de Madrazo, Eduardo Leon Garrido, and Eduardo Zamacoïs. See Florence N. Levy, ed., *American Art Annual 1899* (New York: The Art Interchange, 1899). When William H. Stewart died in 1897 and his estate of Spanish paintings was sold, Fortuny's *The Choice of a Model* (1874; now in the Corcoran Gallery of Art) fetched $42,000 and his *Arab Fantasia* (1867 version; now in the Walters Art Gallery) $12,000. W. R. Johnston, "W. H. Stewart, the American Patron of Mariano Fortuny," *Gazette des Beaux-Arts*, series 6, vol. 77 (March 1971), pp. 185–188. **14.** Baron Davillier, *Fortuny, Sa Vie, Son Oeuvre, Sa Correspondence* (Paris: Auguste Aubry, 1875), pp. 55–62. **15.** Marqués de Lozoya, *Mariano Fortuny* (Madrid: Fundación Universitaria Española, 1975), p. 19. **16.** Francisco Pompey, *Fortuny* (Madrid: Publicaciones Españolas, 1974), pp. 47 and 56. **17.** William R. Johnston, "Fortuny and His Circle," *Bulletin of the Walters Art Gallery*, vol. 22, no. 7 (April 1970), p. 2. **18.** A *Self-Portrait* by Madrazo, signed and dated "New York 1901," hangs today in the Meadows Museum, Southern Methodist University, Dallas. **19.** Madrazo had remained in France since the outbreak of the war in 1870, serving in the American Ambulance Corps. William R. Johnston, *The Nineteenth-Century Paintings in the Walters Art Gallery* (Baltimore: Walters Art Gallery, 1982), p. 178. **20.** Luis Figuerola-Ferretti, "Aureliano de Beruete en la Modernidad," *Goya*, nos. 175–176 (July–October 1983), p. 77. **21.** *Spanish Painters in Search of Light*, p. 97. **22.** *Aureliano de Beruete, 1845–1912*, p. 10. **23.** La Puente, *Catálogos de las Pinturas*, no. 4050. **24.** *Ibid.*, no. 4255. **25.** *Ibid.*, no. 4244. **26.** Trapier, *Catalogue of Paintings*, pl. LVIII. **27.** Essay by Joaquín de la Puente, "Beruete, Impresionista, Rigor Vidente, Retina Excepcional," in *Aureliano de Beruete, 1845–1912*, p. 30. **28.** *Ibid.*, pl. 52. **29.** The triptych is illustrated in Rosa Pérez y Morandeira, *Vicente Palmaroli* (Madrid: Instituto Diego Velázquez, 1971), pl. 37. **30.** *Ibid.*, pl. 2. **31.** Both are illustrated in Estrella de Diego, *La Mujer y la Pintura del XIX Español* (Madrid: Ediciones Cátedral, 1987), p. 270. **52.** Illustrated in José Carlos Brasas Egido, *La Pintura del Siglo XIX en Valladolid* (Valladolid: Institución Cultural Simancas, 1982), pl. LXXVI. **53.** *Ibid.*, pl. LXXVIII. **34.** *Ibid.*, p. 82. **35.** Illustrated in Francisco Serra, *Nuestros Artistas* (Barcelona: Edimar, 1954), p. 75. **36.** "Nuestros Grabados," *Pèl & Ploma*, vol. IV (1903), pp. 274–288. **57.** My thanks to the Frick Art Reference Library for its color notes on the back of this photograph. **38.** Charles M. Kurtz, ed., *Official Illustrations from the Art Gallery of the World's Columbian Exposition* (Philadelphia: George Barrie, 1893), pp. 256 and 273. **39.** Leopoldo Rodríguez Alcalde, *Los Maestros del Impresionismo Español* (Madrid: Ibérico Europea de Ediciones, 1978). **40.** *Spanish Painters in Search of Light*, nos. 24–26. A good place to see Ignacio Pinazo's paintings today is the new museum in Valencia, Instituto Valenciano de Arte Moderno. **41.** Illustrated in *Darío de Regoyos, 1857–1913* (Madrid: Fundación Caja de Pensiones, 1986), no. 45. **42.** *Ibid.*, p. 9. **43.** *Eight Essays on Joaquín Sorolla y Bastida*, vol. II (New York: Hispanic Society of America, 1909), p. 213. **44.** Luis F. Olla Gajete, *Museo de Málaga. La Pintura del Siglo XIX* (Madrid: Ministerio de Cultura, 1980), pl. LXXVII. **45.** As many as 29,461 people visited the exhibition on a single day during the February 1909 showing. See *The Painter Joaquín Sorolla y Bastida* Francisco Pons Sorolla (London: Philip Wilson Publishers, 1989), p. 24. **46.** *Eight Essays*, p. 358. **47.** *Ibid.*, pp. 310 and 321. **48.** *Ibid.*, pp. 246–247. **49.** *Ibid.*, p. 213. **50.** Pons Sorolla, in *The Painter Joaquín Sorolla y Bastida*, p. 20. **51.** In 1882 Sorolla painted a copy of the woman winding thread into a ball at the right side of *Las Hilanderas* that is in the Sorolla Museum in Madrid today. **52.** William E. B. Starkweather, "Joaquín Sorolla, The Man and his Work," in *Eight Essays*, p. 87. **53.** Carmen Garcia, in *The Painter Joaquín Sorolla y Bastida*, p. 85. **54.** *Ibid.*, pp. 246–247. In 1909 in New York 195 paintings sold for a total of $181,760, and on the second tour Sorolla was able to realize $80,000. **55.** Ruth Matilda Anderson, *Costumes Painted by Sorolla in his Provinces of Spain* (New York: Hispanic Society of America, 1957), p. 178. **56.** Carmen Garcia, in *The Painter Joaquín Sorolla y Bastida*, p. 81. **57.** Bernardino de Pantorba, *La vida y la obra de Joaquín Sorolla y Bastida* (Madrid: Mayfe, 1953), p. 72. **58.** Florencio de Santa-Ana, "Impresionism o no impresionismo en Sorolla," *Archivo Español de Arte* (1982), pp. 42–49.

**59.** Carmen Garcia, in *The Painter Joaquín Sorolla y Bastida*, p. 39. **60.** Priscilla Muller, "Sorolla in America," *American Artist* 38 (April 1974), p. 25. **61.** *Eight Essays*, p. 214. **62.** *Ibid.*, p. 297. **65.** An artist relates the story of a Spanish student who despaired of being able to emulate Sorolla's electric speed in capturing, for example, figures in the water. See Starkweather, in *Eight Essays on Sorolla*, p. 88. Among the Americans who studied with Sorolla was Jane Peterson, who at thirty-two joined him in Madrid and accompanied him to Seville for his critiques of her plein-air paintings. She had been advised by the painter F. Hopkinson Smith, who saw her painting the canals in Venice, that Sorolla, whose works he had seen in the big Paris exhibition, would be the best artist to guide her. See J. Jonathan Joseph, *Jane Peterson, An American Artist* (Boston: privately printed, 1981), p. 27. **64.** Illustrated in *Ramón Casas Exposició* (Barcelona: Ajuntament de Barcelona, 1982), p. 51. **65.** *Spanish Painters in Search of Light*, p. 106. **66.** Illustrated in *Ramón Casas Exposició*, no. 23. **67.** *Ibid.*, no. 41. **68.** A. G. Temple, *Modern Spanish Painting* (London: Arnold Fairbairns & Co. Ltd., 1908), p. 66. **69.** Marilyn McCully, *Els Quatre Gats* (Princeton: Princeton University Art Gallery, 1978), p. 14. Of Casas's early style she writes, "He experimented to a greater extent than Rusiñol with a loosened brush stroke and color, qualities which are still called 'impressionist' in Spain." [*Idem.*]. **70.** *Francisco Oller, A Realist-Impressionist* (Ponce, Puerto Rico: Museo de Arte de Ponce, 1983), p. 31. **71.** *Ibid.*, p. 135. **72.** *Ibid.*, p. 35. **73.** *Ibid.*, p. 145. **74.** Gaya Nuño, p. 580. **75.** Illustrated in Juan García Ponce, *Joaquín Clausell, Oleos y Murales* (México: Fondo Editorial de la Plástica Mexicana, 1973), p. 45. **76.** Illustrated in *Ibid.*, p. 41. **77.** *Ibid.*, p. 7. **78.** *Andrés de Santa María, 1860–1945* (Paris and Bogotá: Musée Marmottan and Museo Nacional, 1985), pl. 4. **79.** Stanton Loomis Catlin and Terence Grieder, *Art of Latin America since Independence* (New Haven: Yale University Art Gallery, and Austin: University of Texas Art Museum, 1966), p. 183. **80.** Illustrated in José Maria dos Reis Júnior, *Belmiro de Almedida, 1858–1935* (Rio de Janeiro: Pinakotheke, 1984), p. 57. **81.** *Ibid.*, p. 88. **82.** I am grateful to Mari Carmen Ramírez, curator of Contemporary Latin American Art at the Archer M. Huntington Art Gallery, University of Texas, who provided additional suggestions for my research on Latin American painters. **83.** *La Pintura en Venezuela*. Essay by Mariano Picón-Salas (Caracas: Secretaria General de la Decima Conferencia Interamericana, 1954), p. 41. **84.** Catlin and Grieder, *Art of Latin America*, p. 195. **85.** Illustrated in Lawrence Campbell, "Armando Reverón," *Art News*, vol. 55, no. 5 (September 1956), p. 16. **86.** Illustrated in Catlin and Grieder, *Art of Latin America*, pl. 68. **87.** Reverón suffered some regression in his youth from typhoid fever and was cruelly nicknamed "El Loco" by his classmates. Sharon Crockett, "Reverón," *Audio-Visual Program, Set 201* (Washington, D.C.: Museum of Modern Art of Latin America, Organization of American States, n.d.).

## MUSSELS AND WINDMILLS: IMPRESSIONISM IN BELGIUM AND HOLLAND

**1.** Mark Roskill, ed., *The Letters of Vincent van Gogh* (New York: Atheneum, 1984), p. 226. **2.** Quoted in Serge Goyens de Heusch, *L'Impressionisme et le Fauvisme en Belgique* (Antwerp: Fonds Mercator, 1988), p. 108. **3.** On the metaphysical dimension in 17th-century Dutch landscape, see R. H. Fuchs, *Dutch Painting* (London: Thames & Hudson Ltd., 1978), p. 154. **4.** See Petra Ten Doesschate Chu, *French Realism and the Dutch Masters—The Influence of Dutch Seventeenth-Century Painting on the Development of French Painting Between 1830 and 1870* (Utrecht: Haentjens Dekker and Gumbert, 1974). **5.** See Frances S. Jowell, "The Rediscovery of Frans Hals," in Seymour Slive, ed., *Frans Hals* (London: Royal Academy of Arts, 1989), pp. 61–86. **6.** See Hans Kraan, "The Vogue for Holland," in *The Hague School: Dutch Masters of the 19th Century* (London: Weidenfeld and Nicolson, 1983). **7.** Quoted in Jane Block, *Les XX and Belgian Avant-Gardism* (Ann Arbor: UMI Research Press, 1984), p. 61. **8.** See John Sillevis and Hans Kraan, eds., *L'École de Barbizon: Un Dialogue Franco-Néerlandais* (The Hague: Haags Gemeentemuseum, 1985). **9.** Ronald de Leeuw, "Introduction," in *The Hague School: Dutch Masters of the 19th Century*, p. 35. **10.** Victorine Hefting, "Introduction," in Jongkind (Tokyo: Yonkinto ten, 1982), n.p. **11.** Quoted in Boudewijn Bakker, "Monet as a Tourist," in *Monet in Holland* (Amsterdam: Rijksmuseum Vincent van Gogh, 1986), p. 31. **12.** Hans Kraan, "The Vogue for Holland," in *The Hague School: Dutch Masters of the 19th Century*, p. 116. **13.** Quoted in Jowell, "The Rediscovery of Frans Hals," p. 69. **14.** De Leeuw, *The Hague School: Dutch Masters of the 19th Century*, p. 59. **15.** This point is made by Charles Moffett in his "Vincent van Gogh and The Hague School," in *The Hague School: Dutch Masters of the 19th Century*, p. 139. **16.** Quoted by De Leeuw in "The Avant-Garde (1885–1910)," *ibid.*, p. 113, note 3. **17.** Reproduced in Anna Wagner, *Isaac Israëls* (Venlo: Uitgeverij Van Spijk B.V., 1985), p. 104. **18.** Block, *Les XX and Belgian Avant-Gardism*, p. 8. **19.** Goyens de Heusch, *L'Impressionisme et le Fauvisme en Belgique*, p. 59. **20.** *Ibid.*, p. 31. **21.** For Ensor and *zwanze* humor, see Diane Lesko, *James Ensor, The Creative Years* (Princeton: Princeton University Press, 1985) p. 50. **22.** Quoted in Goyens de Heusch, *L'Impressionisme*, p. 55. **23.** *Ibid.*, p. 218. **24.** For Rops's paintings, see Robert Hoozee, "Les artistes belges et le littoral," in *Histoires d'Eaux, Stations thermales et balnéaires en Belgique XVI–XXe siecle* (Brussels: Galerie CGER, 1987), p. 243. **25.** Quoted in Goyens de Heusch, *L'Impressionisme*, p. 33. **26.** Reproduced in Robert Rosenblum and H. W.

Janson, *Nineteenth-Century Art* (New York: Harry N. Abrams, Inc., 1984) p. 409. **27.** See my "Ensor as a 1980s Artist," *Print Collectors' Newsletter* vol. XIX, no. 1 (March–April 1988), pp. 10–12. **28.** Reproduced in *Post-Impressionism, Cross-Currents in European Painting* (London: Weidenfeld and Nicolson, 1981), p. 273. **29.** See *Belgian Art 1880–1914* (Brooklyn: the Brooklyn Museum, 1980), p. 158. **30.** Reproduced in Goyens de Heusch, *L'Impressionisme*, p. 68. **31.** *Ibid.*, p. 78. **32.** See *Belgian Art 1880–1914*, p. 119. **33.** Goyens de Heusch, *L'Impressionisme*, p. 156. **34.** *Ibid.*, p. 233. **35.** *Ibid.*, p. 226. **36.** *Ibid.* **37.** For Rivera's views of Bruges, see *Diego Rivera, A Retrospective* (New York: W. W. Norton, 1986), p. 32. **38.** Quoted in Goyens de Heusch, *L'Impressionisme*, p. 91.

## NORDIC LUMINISM AND THE SCANDINAVIAN RECASTING OF IMPRESSIONISM

**1.** Lief Østby, *Fra naturalism til nyromantik* (Oslo: Gyldendal Norsk Forlag, 1934), p. 47. All translations are mine unless otherwise indicated. **2.** For Aubert's pivotal contribution to the propagation of Impressionism in Northern countries see Henri Usselmann, "Andréas Aubert, un exégète norwégien de l'impressionnisme (1885–1884)," *Gazette des Beaux-Arts* 105 (February 1985), pp. 89–96. **3.** See Reinhold Heller's excellent discussion of what he calls the Norwegian radicalization of Impressionism in *Munch. His Life and Work* (Chicago: The University of Chicago Press, 1984), especially pp. 38–42. **4.** As reported to the painter Christian Krohg in the 1890s by Aurélien Lugné-Poe, see Michael Meyer, *Ibsen. A Biography* (Garden City, New York: Doubleday & Co., 1971), p. 570, note 44. **5.** As quoted in *Nasjonalgalleriet, 1880–årene i nordisk maleri* (Oslo: Nasjonalgalleriet, 1985), p. 78. **6.** As given in Meyer, *Ibsen*, p. 345. **7.** As cited in Neil Kent, *The Triumph of Light and Nature. Nordic Art 1740–1940* (London: Thames and Hudson, 1987), p. 108. **8.** The Danes Peter Severin Krøyer and Michael Ancher, the Swede Oscar Björck, and the Norwegian Elif Petersen (the latter two did not complete their sketches). Krøyer also made a portrait in 1883 of Björck and Petersen at work on their Brandes portraits. **9.** As given in Kent, *The Triumph of Light and Nature*, p. 105. **10.** Oil study of 1889, private collection, reproduced in Lise Svanholm, *Marie Krøyer* (Copenhagen: Herluf Stokholms Forlag, 1987), p. 31; the 1892 photograph of Marie and Søren reproduced in Ernst Mentze, *P. S. Krøyer* (Copenhagen: Det Schønbergske Forlag, 1980), p. 153. Søren, wearing a hat, stands on the right in a pose similar to that of the painting, his left hand on his hip and his right arm linked through Marie's left. The dog Rap is at their feet on the left. Marie's hair is done up in a loose bun, as in the painting, and her mournful expression with slightly parted lips is identical with that bestowed on her in the oil. Krøyer clearly used this photograph for the modeling and expression of both faces in the painting. **11.** Krøyer's Erard piano is now in the Skagen Museum. The artist played the guitar and sang Danish, French, and Italian songs in a dark husky voice. **12.** Grieg, letter to the Danish composer August Winding, as given in David Monrad-Johansen, *Edvard Grieg* (New York: Tudor Publishing Co., 1938), p. 276. **13.** As given in Mentze, *P. S. Krøyer*, p. 187. I am immeasurably grateful to Lili Jensen for help in the translation of this and many other pertinent passages in Danish, Norwegian, and Swedish. **14.** Third verse to Drachmann's song text "Vi elsker vort Land," which was written in 1885 for a fairy-tale musical comedy entitled *Once Upon a Time*. **15.** Krøyer based the figures of Marie and Hugo Alfvén on a 1903 oil study he had made of them in almost identical pose before a rowboat. The study (private collection) is reproduced in color in Svanholm, *Marie Krøyer*, p. 39, and includes the dog Rap to Hugo's right. Marie had fallen in love with Hugo in 1902, two years after Søren's first stay at a mental hospital. Rather than give her the divorce she asked for, Krøyer invited Alfvén to stay with them in their Skagen home, hoping proximity would break the spell, hence the 1903 oil study of them utilized for nostalgic inclusion in the Saint John's Bonfire picture. **16.** Marie and Hugo did not marry until 1912. Their marriage, although of longer duration, was also doomed to failure: they split apart in 1928, and a divorce was finalized in 1937. **17.** As quoted in Ole Wivel, *Anna Ancher* (Copenhagen: Herluf Stokholms Forlag, 1987), p. 10. **18.** The Michael and Anna Ancher House in Skagen was faithfully preserved by their daughter Helga with all its paintings and furnishings intact and is today a museum. **19.** As cited in Kent, *The Triumph of Light and Nature*, p. 113. **20.** From Holger Drachmann's August 1895 poem "Skagen." **21.** Letter of Easter 1883, as given in *De drogo till Paris: Nordiska Konstnärinnor på 1880-talet* (Stockholm: Liljvalchs Konsthall, 1988), p. 126. **22.** As quoted in *1880–årene i nordisk maleri*, p. 57. **23.** Else Christie Kielland, *Harriet Backer 1845–1932* (Oslo: Aschehoug, 1958), p. 96. **24.** Written by Backer for Christian Krohg's second volume featuring Norwegian painters, *Artists II* (1892); extract given in *De drogo till Paris*, p. 146. **25.** Grieg in a London interview, 1889, quoted in Monrad-Johansen, *Edvard Grieg*, p. 293. **26.** Ibsen in conversation, quoted by Felix Philippi in 1902, as given in Meyer, *Ibsen*, p. xxi. **27.** Grieg, letter of October 8, 1887, in Finn Benestad and Dag Schjelderup-Ebbe, *Edvard Grieg, The Man and the Artist* (Lincoln: University of Nebraska Press, 1988), p. 331. **28.** *De drogo till Paris*, p. 145. **29.** They lived together until Kielland's death a few days before her seventy-first birthday. Backer lived to the age of eighty-seven. Reacting to his sister's obstinate pursuit of painting, Kielland's younger brother Alexander, a noted novelist, wrote in a letter of 1879 to Edvard Brandes that she was diligent and energetic, went her own way "chasing mood and subject" but then added in a

revelatory fit of pique: "She has not 'sacrificed' greatly for art since she appears destined to remain not only unmarried, but highly unmarried; besides she's well off so her artist's life looks more like a hobby for an ugly and wealthy lady." Quoted by Anne Wichstrøm, *Kvinner ved staffeliet. Kvinnelige malere i Norge før 1900* (Oslo: Universitetsforlaget, 1983), p. 141. This unworthy tirade brings up the age-old issue of whether it was possible for a woman artist to follow a professional career if she married. Of the eight female painters treated in this chapter only three married: Anna Ancher, Marie Krøyer, and Oda Krohg. **30.** Harald Thaulow was the feisty chemist with a social conscience (he waged a ten-year war on the Christiania Steam Kitchens for neglecting the city's poor) on whom Ibsen partly based the character of Dr. Stockmann in his play *An Enemy of the People* of 1882. **31.** Letter of August 27, 1874, to Frants Beyer, quoted in John Horton, *Grieg* (London: J. M. Dent and Sons, Ltd., 1974), p. 45. **32.** As given in Roald Nasgaard, *The Mystic North. Symbolist Landscape Painting in Northern Europe and North America 1890–1940* (Toronto: University of Toronto Press, 1984), p. 40. **33.** Cited in Nasgaard, *The Mystic North*, p. 39. **34.** Quoted in Meyer, *Ibsen*, p. 733. **35.** The fact that Nørregaard has pictured Munch in front of an easel with a figure study and with a sketchbook in his lap seems to suggest the student status of the young artist—possibly briefly *her* student, although the Munch literature does not acknowledge this. **36.** As cited in Reinhold Heller, "Edvard Munch's 'Night,' The Aesthetics of Decadence, and the Content of Biography," *Arts Magazine* 53 (October1978), p. 81. **37.** Heller's useful term, *ibid.* **38.** *Ibid.* **39.** Ragna Stang's formulation in *Edvard Munch. The Man and His Art* (New York: Abbeville Press, 1979), p. 79. **40.** Letter to Frants Beyer of October 24, 1892, given in Benestad and Schjelderup-Ebbe, *Edvard Grieg*, p. 262. **41.** Description of his hometown written in 1891, a year before Nordström left Stockholm and moved with his family to the Bohuslän area, quoted in Nasgaard, *The Mystic North*, p. 38. **42.** Quoted in Ulf Linde, *Thielska Galleriet* (catalog of the collection; Stockholm: Thielska Galleriet, 1979), p. 112. **43.** As cited in *1880–årene i nordisk maleri*, p. 74. **44.** Quoted in Nasgaard, *The Mystic North*, p. 29. **45.** An active patron and collector of his fellow artists, Prince Eugen assembled an important collection of Nordic art from 1880 to 1940 at his large turn-of-the-century villa Waldemarsudde in Djurgården, just outside Stockholm. The house is now a museum. **46.** As given in *Nationalmuseum Stockholm* (catalog of the permanent collection; Höganäs: Bokförlaget Bra Böcker, 1984), p. 70. **47.** Ernst Thiel fitted Fjaestad's tapestries to the salon doors of his villa and commissioned him to design the fantastic "environmental" wooden sofa and matching table and chairs ensemble (1907–1908) still in place today in the Munch room of the Thielska Galleriet in the Djurgården. **48.** In Arvid Paulson, trans., *Strindberg's One-Act Plays* (New York: Washington Square Press, 1969), p. 46. **49.** August Strindberg, *Inferno, Alone and Other Writings* (Garden City, New York: Anchor Books, 1968), p. 377. **50.** As quoted in Meyer, *Ibsen*, p. 732. **51.** Strindberg, *Alone*, p. 385. **52.** Linde, *Thielska Galleriet*, p. 104. See also Torsten Mätte Schmidt, *Strindbergs Maleri* (Malmö: Allhems Förlag, 1972), p. 356. **53.** As cited in Wendy Hill, *Green Gold and Granite. A Background to Finland* (London: Max Parrish and Co., 1953), p. 93. **54.** Quoted in Lena Holger, *Helene Schjerfbeck. Liv och Könstnärskap* (Stockholm: Raster Förlag, 1988), p. 24. **55.** As cited in *Dreams of a Summer Night* (London: Hayward Gallery, 1986), p. 238. **56.** Sibelius was composing his *Lemminkäinen Suite* and Gallen-Kallela was completing his highly stylized conception of *Lemminkäinen's Mother* at this time. **57.** Quoted in *1880–årene i nordisk maleri*, p. 89.

## IMPRESSIONISM IN AUSTRIA AND GERMANY

**1.** Hans-Jürgen Imiela, *Max Slevogt* (Karlsruhe: G. Braun, 1968), p. 107. **2.** Werner Doede, *Berlin: Kunst und Künstler seit 1870* (Recklinghausen: Bongers, 1961), p. 82. **3.** Peter Paret, *The Berlin Secession: Modernism and Its Enemies in Imperial Germany* (Cambridge, Mass.: Harvard University Press, Belknap Press, 1980), p. 65. **4.** For more on the political role of the Berlin Secession, see Doede, *Berlin: Kunst und Künstler seit 1870*; Paret, *The Berlin Secession*; and Marion F. Deshmukh, "Art and Politics in Turn-of-the-Century Berlin: The Berlin Secession and Kaiser Wilhelm II," in *Turn of the Century: German Literature and Art, 1890–1915*, eds., Gerald Chapple and Hans H. Schulte (Bonn: Bouvier, 1981), pp. 463–475. **5.** Lorenz Eitner, ed., *Neoclassicism and Romanticism 1750–1850*, vol. I: *Enlightenment/Revolution*, Sources and Documents in the History of Art Series, ed. H. W. Janson (Englewood Cliffs, N.J.: Prentice Hall, 1970), p. 146. **6.** A sketch of a painter's box designed for working out-of-doors, drawn in Rome between 1650 and 1652 by the English traveler Richard Symonds, indicates that there were no real impediments to painting in the open countryside at least as early as the middle of the seventeenth century. On the origins of landscape paintings done out-of-doors, see Lawrence Gowing, "Nature and the Ideal in the Art of Claude," *Art Quarterly* 37 (1974), pp. 91–96; and Philip Conisbee, "Pre-Romantic Plein-Air Painting," *Art History* 2 (1979), pp. 413–428—for the analysis of Symond's sketch, see pp. 414–415. **7.** Barbara Hartwig, "Johann Georg von Dillis, Wilhelm von Kobell und die Anfänge der Münchner Schule," in the exhibition catalog *Münchner Landschaftsmalerei 1800–1850*, ed. Armin Zweite (Munich: Städtische Galerie im Lenbachhaus, 1979), pp. 58–77. **8.** For two additional and closely related views of Berlin backyards and roofs, see Irma Emmrich, *Carl Blechen* (Munich: C. H. Beck, 1989), nos. 142 and 143. **9.** Jens Christian Jensen, *Adolph von Menzel* (Cologne: DuMont Buchverlag,

1982), p. 54. **10.** *Ibid.* **11.** Heinrich Schwarz, *Salzburg und das Salzkammergut. Die künstlerische Entdeckung der Stadt und der Landschaft im 19. Jahrhundert* (Vienna and Munich: Verlag Anton Schroll & Co., 1958), p. 51. **12.** For Courbet's relationship to German artists of the period, see *Courbet und Deutschland* (Hamburg: Hamburger Kunsthalle, 1978). **13.** Paul Tucker, "The First Impressionist Exhibition in Context," in *The New Painting: Impressionism 1874–1886* (San Francisco: The Fine Arts Museums of San Francisco, 1986), p. 93; John Rewald, *The History of Impressionism* (New York: The Museum of Modern Art, 1980), pp. 172–173. **14.** See *München 1869–1958: Aufbruch zur modernen Kunst* (Munich: Haus der Kunst, 1958), p. 24. **15.** *Courbet und Deutschland*, p. 49. Of these two paintings only the female nude has been identified; this painting, known as *La Dame de Munich*, is lost. **16.** Eberhard Ruhmer, *Der Leibl-Kreis und die Reine Malerei* (Rosenheim: Rosenheimer Verlagshaus Alfred Förg, 1984), p. 353. **17.** *Ibid.* **18.** Michael Petzet, ed., *Wilhelm Leibl und sein Kreis* (Munich: Städtische Galerie im Lenbachhaus, 1974). **19.** Ruhmer, *Der Leibl-Kreis und die Reine Malerei*, pp. 63–64. See also Eberhard Ruhmer, "Wilhelm Leibl et ses amis pour et contre l'impressionisme," *Gazette des Beaux-Arts* 95 (1980), pp. 187–197. **20.** Heinrich Fuchs, *Die Österreichischen Maler des 19. Jahrhunderts*, vol. IV (Vienna: Dr. Heinrich Fuchs Selbstverlag, 1974), K19. **21.** See Helga H. Harriman, "Olga Wisinger-Florian and Tina Blau: Painters in *Fin de Siècle* Vienna," *Woman's Art Journal*, vol. 10, no. 2, p. 26, quoting from Gerbert Frodl, *Wien um 1990. Kunst und Kultur* (Vienna: C. Brandstätter, 1985), p. 552. **22.** Heinz Shony, "Zung Leben von Tina Blau," in *Tina Blau 1845–1916* (Vienna: Osterreichische Galerie im Oberen Belvedere, 1971), p. 11. **23.** Hans Aurenhammer, in *ibid.*, p. 5. **24.** Erich Hancke, *Max Liebermann. Sein Leben und seine Werke* (Berlin: Bruno Cassirer, 1923), pp. 78–79. **25.** *Ibid.*, p. 79. **26.** *Ibid.*, p. 85. **27.** Lovis Corinth, *Legenden aus dem Künstlerleben* (Berlin: Bruno Cassirer, 1918), p. 53. **28.** John Sillevis, Nini Jonker, and Margreet Mulder, *Max Liebermann en Holland* (The Hague: Haags Gemeentemuseum, 1980). **29.** For a detailed discussion of this painting and its context, see Christian Lenz, *Max Liebermann: "Münchner Biergarten"* (Munich: Hirmer, 1986). **30.** Kenworth Moffett, *Meier-Graefe as Art Critic. Studien zur Kunst des neunzehnten Jahrhunderts*, no. 19 (Munich: Prestel Verlag, 1973), p. 54. **31.** Hermann Bahr, *Die Überwindung des Naturalismus* (Dresden: E. Pierson, 1891), p. 152. **32.** Cornelius Gurlitt, *Die deutsche Kunst seit 1800: Ihre Ziele und Taten* (Berlin: Bondi, 1924), p. 402. **33.** Hans Jürgen Imiela, "Zur Rezeption des deutschen Impressionismus," *Beiträge zur Rezeption der Kunst des 19. und 20. Jahrhunderts*, Studien zur Kunst des 19. Jahrhunderts, no. 29, ed. Wulf Schadendorf (Munich: Prestel Verlag, 1975), p. 81; Peter Krieger, "Max Liebermanns Impressionisten-Sammlung und ihre Bedeutung für sein Werk," in Sigrid Achenbach and Matthias Eberle, *Max Liebermann in seiner Zeit* (Berlin: Nationalgalerie, 1979), p. 60. **34.** Krieger, "Max Liebermanns Impressionisten-Sammlung," p. 62. **35.** George Brandes, *Berlin som tysk Rigshovestadt* (Copenhagen: P. G. Philipsen, 1885), pp. 535–539; and Max Liebermann, *Die Phantasie in der Malerei: Schriften und Reden*, ed. Günter Busch (Frankfurt: S. Fischer, 1978), pp. 96–102. **36.** Liebermann, *Die Phantasie in der Malerei*, p. 98. **37.** Jules Laforgue, *Mélanges posthumes, Oeuvres completes*, vol. III (Paris: Mercure de France, 1902–1903) pp. 133–144; see also Barbara Ehrlich White, *Impressionism in Perspective* (Englewood Cliffs, New Jersey: Prentice Hall, c. 1978), pp. 33–34. **38.** See Emil Waldmann, "Édouard Manet in der Sammlung Pellerin," *Kunst und Künstler* 8 (March 1910), pp. 387–398. **39.** Liebermann, *Die Phantasie in der Malerei*, pp. 49–53. **40.** Charlotte Berend-Corinth, *Lovis* (Munich: Albert Langen and Georg Müller, 1958), pp. 43–44. **41.** See Horst Uhr, "The Late Drawings of Lovis Corinth: The Genesis of His Expressionism," *Arts Magazine* 5 (1976), pp. 106–111; and Horst Uhr, "*Pink Clouds, Walchensee*: The 'Apotheosis' of a Mountain Landscape," *Bulletin of The Detroit Institute of Arts* 55 (1977), pp. 209–215. **42.** Lovis Corinth, *Selbstbiographie* (Leipzig: S. Hirzel, 1926), p. 185. **43.** Imiela, *Max Slevogt*, p. 122. **44.** Eitner, *Restoration/Twilight of Humanism*, vol. II, p. 55.

## PLEIN-AIR PAINTING IN SWITZERLAND

**1.** G. Solar, "Conrad Meyer und Jan Hackaert," in *Kunst des 17. und 18. Jahrhundert in Zürich, Jahrbuch des Schweiz, Institutes für Kunstwissenschaft 1974–77* (Zürich, 1978), pp. 29–76; G. Solar, *Jan Hackaert, Die Schweizer Ansichten 1653–1656*, (Dietikon-Zürich: Zentralbibliothek Zürich and Schweiz. Institut für Kunstwissenschaft, 1981). **2.** W. Raeber, *Caspar Wolf 1735–1783, Sein Leben und Werk* (Aarau and Munich: Schweizerisches Institut für Kunstwissenschaft, 1979); *From Liotard to Le Corbusier, 200 Years of Swiss Painting*, ed. Swiss Institute for Art Research (Atlanta: High Museum of Art, 1988), nos. 16, 17. **3.** *Ibid.*, nos. 19, 20. **4.** F. Zelger, *Stiftung Oskar Reinhart Winterthur, Katalog der Gemälde, Bank I: Schweizer Maler des 18. und 19. Jahrhunderts* (Zurich, 1977), pp. 159–161. **5.** Hans A. Lüthy, *Der Zürcher Maler Johann Jakob Ulrich* (Zurich, 1965); *From Liotard to Le Corbusier*. **6.** A. Schreiber-Favre, *François Diday, Fondateur de l'école suisse de paysage* (Geneva, 1942); V. Anker, *Alexandre Calame, Vie et oeuvre, Catalogue raisonné de l'oeuvre peint* (Fribourg: Office du Livier, 1987). **7.** H. U. Jost, "Nation, Politics and Art," in *From Liotard to Le Corbusier*, pp. 15–21; B. B. Fortune, "Painting in America and Switzerland 1770–1870, Preliminaries for a Comparative Study," *Ibid.* pp. 23–33. **8.** J. Brüschweiler, *Barthélemy Menn, Étude critique et biographique* (Zurich, 1960). **9.** Zelger, *Stiftung Oskar Reinhart Winterthur*, pp. 329–331.

**10.** R. Andree, *Arnold Böcklin: Die Gemälde* (Basel and Munich, 1977). **11.** *Chefs-d'oeuvres du Musèe Cantonal des Beaux-Arts Laussanne* (Lausanne, 1989), pp. 94–103. **12.** "The Swiss Artist and the European Context: Some Notes on Cross-Cultural Politics," *From Liotard to Le Corbusier*, pp. 35–46 and cat. no. 34. **13.** Lüthy, *Ulrich*, p. 55. **14.** M. Fischer, *Rudolf Koller* (Zurich, 1942). **15.** G. P. Weisberg, *The Realist Tradition, French Painting and Drawing 1830–1900* (Cleveland: The Cleveland Museum of Art, 1980), p. 182. **16.** *Frank Buchser, a Retrospective* (Solothurn: Kunstmuseum der Stadt Solothurn, 1990). **17.** H. Honour, *The European Vision of America* (Cleveland: The Cleveland Museum of Art, 1976), nos. 303, 304, 320, 333–336. **18.** S. Kuthy und Hans A. Lüthy, *Albert Anker* (Zürich, 1980); *From Liotard to Le Corbusier*, nos. 40, 41. **19.** Hans A. Lüthy, *Albert Anker, Aquarelle und Zeichnungern* (Zurich, 1989). **20.** Zelgung, *Stiftung Oskar Reinhart Winterthur*, pp. 137–145. **21.** V. Huber, *Schweizer Landschaftsmaler, Das intime Landschaftsbild im 19. Jarhundert* (Zurich, 1949). **22.** *Ibid.*, 163–168. **23.** *Ibid.*, Sandreuter, pp. 301–307; Robert, pp. 281–283; Dufaux, pp. 151–157. **24.** Sandor Kuthy, *Kunstszene Schweiz 1890* (Bern: Kunstmuseum Bern, 1980). **25.** Sharon Hirsh, *Ferdinand Hodler* (New York: George Braziller, Inc., 1982); *Ferdinand Hodler, Sammlung Max Schmidheiny*, with essays by Oskar Bätschmann and Hans A. Lüthy, catalog by Marcel Baumgartner (Thurgau: Kunstmuseum des Kantons Thurgau, 1989.) **26.** An English version is in Peter Selz, *Hodler* (Berkeley, California: University Art Museum, 1973), pp. 119–125; the original French is in *Hodler et Fribourg* (Fribourg: Musée d'art et d'histoire Fribourg, 1981), pp. 35–62. **27.** See Lukas Gloor, text to cat. no. 4 and the essays by Stephen F. Eisenman and Oskar Bätschmann in *Ferdinand Hodler Landscapes* (Los Angeles: Wight Art Gallery of the University of California, Los Angeles, 1987). **28.** cf. exh. cat. Atlanta, as n. 2, cat. no. 43. **29.** See Roals Nasgaard, *The Mystic North, Symbolist Landscape Painting in Northern Europe and North America, 1890–1940* (Toronto: Art Gallery of Ontario, 1984).

## THE IMPRESSIONIST VISION IN RUSSIA AND EASTERN EUROPE

**1.** Konstantin Korovin, note in sketchbook used in June 1891, in N. Moleva, ed., *Konstantin Korovin, zhizn i tvorchestvo* (Moscow: Akademiia khudozhestv, 1963), p. 214. **2.** Repin to Ivan Kramskoi, October 16, 1874, in Isaak Brodskii, ed., *Repin. Pis'ma*, vol. I (Moscow: Iskusstvo, 1969) p. 143. **3.** Repin, *Dalekoe blizkoe* (Moscow: Iskusstvo, 1953), p. 168. On the art schools, see N. Moleva and E. Beliutin, *Russkaia khudozhestvennaia shkola* (Moscow: Iskusstvo, 1967), pp. 65–85. **4.** On the inaugural exhibition see Vladimir Stasov, "Peredvizhnaia Vystavka 1871 goda," *Izbrannoe sochineniia*, vol. 1 (Moscow, Leningrad: Iskusstvo, 1950) p. 54; Sofia N. Gol'dshtein, "Iubeleinye Vystavki," in *Peredvizhniki. K stoletiu Tovarishchestva Peredvizhnykh Khudozhestvennykh Vystavok* (Moscow: Iskusstvo, 1971), pp. 36–54. For background on the Peredvizhniki, see Alison Hilton, "Scenes from Life and Contemporary History. Russian Realism of the 1870s–1880s," in *The European Realist Tradition*, ed. Gabriel Weisberg (Bloomington: Indiana University Press, 1982), pp. 187–214; Elizabeth K. Valkenier, *Russian Realist Art. The State and Society: The Peredvizhniki and Their Tradition* (New York: Columbia University Press, 1989). For documentation, see Gol'dshtein, et al., *Tovarishchestvo Peredvizhnykh Khudozhestvennykh Vystavok 1869–1899. Pis'ma, Dokumenty* (Moscow: Iskusstvo, 1987). **5.** B. Veselovskii, *Katalog Galerei gr. N.A. Kusheleva-Bezborodko* (Saint Petersburg, 1886); Stasov, *Fotograficheskaia i fototipicheskaia kollektsii Imperatorskoi Publichnoi Biblioteki* (Saint Petersburg, 1885). **6.** Gol'dshtein, "P.M. Tretiakov i ego sobiratel'skaia deiatel'nost'," in Iakov Bruk et al., *Gosudarstvennaia Tret'iakovakaia, Galerei. Ocherki istorii 1856–1917* (Leningrad: Khudovknik RSFSR, 1981), pp. 92–93. **7.** Repin to V. Verevkina, July 26, 1894, in Igor Grabar and Ilia Zil'bershtein, *Repin. Khudozhestvennoe nasledstvo* (Moscow, Leningrad: Akademiia nauk, 1948–1949), II, p. 296. See Marie Bashkirtseff, *Le Journal de Marie Bashkirtseff* (Paris, 1887). **8.** Repin, *Dalekoe blizkoe*, p. 283, quotes praise by Friedrich Paecht (1873); Émile Duranty and Paul Mantz in *Gazette des Beaux-Arts* XVIII (1878), pp. 164, 417. **9.** Polenov, letter to family, December 8, 1873, in *V.D. Polenov, E.D. Polenova: Khronika sem'i khudozhnikov*, ed., Elena Sakharova (Moscow: Iskusstvo, 1964), p. 104; Repin's studio was at rue Veron 31, Polenov's at rue Blanche 27. Information on their years in Paris is from letters in Sakharova, *Polenov, Polenova*, pp. 103–152 and notes 713–721, and Brodskii, *Repin. Pis'ma*, vol. I, pp. 85–178; further details in Alison Hilton, *The Art of Ilia Repin* (Ph.D. thesis, Columbia University, 1979), pp. 150–179. **10.** Polenov to his mother, M.A. Polenova, February 17, 1874, *Polenov, Polenova*, p. 117. **11.** Polenov to F. Chizhov, June 24, 1874, in Sakharova, *Polenov, Polenova*, p. 137. **12.** Polenov to Kramskoi, April 1875, *Ibid.*, p. 172; Repin to Stasov, April 24, 1875, in Brodskii, *Repin. Pis'ma*, vol. I, p. 151. **13.** Repin to Kramskoi, December 16, 1873, *Ibid.*, vol. I, p. 97. **14.** Polenov to Petr Iseev, March 2, 1874, in Sakharova, *Polenov, Polenova*, p. 118; Repin to Stasov, January 8, 1874, in Brodskii, *Repin. Pis'ma*, vol. I, 106. **15.** Repin to Stasov, May 25, 1874, *Ibid.*, vol. I, p. 135. **16.** Repin to Stasov, April 13, 1874 and May 12, 1874, *Ibid.*, vol. I, pp. 127, 129–130. **17.** Repin to Tretiakov, May 23, 1874, *Ibid.*, vol. I, p. 132. **18.** Repin to Tretiakov, May 22, 1875, *Ibid.*, vol. I, p. 119. **19.** Repin to Stasov, March 20, 1875; to Kramskoi, June 1, 1875, *Ibid.*, vol. I, pp. 150, 161. **20.** Polenov to Fedor

Chizhov, June 24, 1874, in Sakharova, *Polenov, Polenova*, p. 136. **21.** Alison Hilton, *"Le Messager de l'Europe:* Zola's Art Criticism Beyond Paris," in *Émile Zola and the Arts*, ed. J.-M. Guieu and A. Hilton (Washington, D.C.: Georgetown University Press, 1988), pp. 61–72. **22.** Repin to Kramskoi, May 10, 1875, in Brodskii, *Repin. Pis'ma*, vol. I, p. 155. **23.** Repin to Stasov, April 12, 1876, *Ibid.*, vol. I, p. 178. **24.** Repin to N. Aleksandrov, March 16, 1876, *Ibid.*, vol. I, p. 175. (The Russians used roughly phonetic transcriptions into Cyrillic letters of the foreign words "expressionalists," "empressionists" and "impressionists"—apparently interchangeably. They sometimes used Latin letters, sometimes Russian, for their own and other artists' names.) **25.** Repin to Kramskoi, May 10, August 29, 1875, *Ibid.*, vol. I, pp. 154, 165. **26.** Kramskoi to Tretiakov, June 13, 1876, in Gol'shtein, ed., *I.N. Kramskoi. Pis'ma, stat'i*, vol. II (Moscow: Izobrazitel'noe iskusstvo, 1965–1966), p. 27. **27.** Kramskoi to Stasov, July 21, 1876, *Ibid.*, vol. II, pp. 45, 52–54. **28.** The statement might also refer to a portrait of his wife, Vera (1875; Russian Museum) since the letter is not securely dated; see Ilia S. Zil'bershtein, "Repin v Parizhe (novonaidennye raboty 1873–1876)" *Repin. Khudozhestvennoe nasledstvo*, vol. I, p. 147; Grigorii Sternin et al. *Ilia Repin, Zhivopis', Grafika* (Leningrad: Aurora, 1985), p. 251. **29.** Konstantin Savitskii and his wife, landscapist Alexandr Beggrov, and animal painter Dobrovolskii; accounts of the trip in letters of Repin, Polenov, and Savitskii, June–September 1874, in Brodskii, *Repin. Pis'ma*, vol. I, pp. 135–140; and Sakharova, *Polenov, Polenova*, pp. 142–150. **30.** Polenov letter to family, August 1, 1874, in Sakharova, *Polenov, Polenova*, p. 142; Repin, letters to Polenov, June 1874, and to Stasov, July 26, 1874, Brodskii, *Repin. Pis'ma*, vol. I, pp. 136, 138. **31.** Repin to Kramskoi, October 16, 1874, in Brodskii, *Repin. Pis'ma*, vol. I, p. 143. **32.** *Ibid.* **33.** Moleva, *Korovin*, p. 159. **34.** *Ibid.*, p. 155. **35.** *Ibid.*, pp. 162–163. **36.** *Ibid.*, p. 27. **37.** *Ibid.*, p. 163. **38.** *Ibid.*, p. 159. Repin's response to Korovin's *Chorus Girl* reflects his enthusiasms for Spanish painting, especially the work of Velázquez and Murillo, which he studied during a trip to Western Europe, including Spain, in May 1883. Repin's word "temperament" echoes, perhaps subconsciously, Zola's comments on Manet. **39.** *Ibid.*, p. 194. **40.** *Ibid.*, pp. 37–39. **41.** Mark Kopshitser, *Valentin Serov* (Moscow: Iskusstvo, 1967), p. 59. **42.** Serov to O. Trubnikova, May 1887, in I.S. Zil'bershtein and V.A. Samkov, *Valentin Serov v vospominaniiakh, dnevnikakh i perepiske sovremennikov*, vol. I (Leningrad: Khudozhnik RSFSR, 1971), I, pp. 275–276. **43.** Ostroukhov, quoted in *Serov v vospominaniiakh*, vol. I, p. 255. **44.** Grabar, *Valentin Aleksandrovich Serov. Zhizn' i tvorchestvo* (Moscow: Knebel, 1913), p. 74. **45.** [S. Flerov], review in *Moskovskie vedomosti*, 1888, quoted in *Serov v vospominaniiakh*, vol. I, pp. 156–157. **46.** Serov to Ostroukhov, December 6, 1888, in Moleva, *Korovin*, p. 194. **47.** Maria Simonovich-L'vova, in Samkov, *Serov v vospominaniiakh*, vol. II, p. 151. **48.** [V. Sizov], *Russkie vedomosti*, December 28, 1888, *Ibid.*, vol. II, p. 253. **49.** Vladimir Makovskii's comment reported by Grabar (1937), *Ibid.*, vol. I, p. 523. **50.** Moleva, *Korovin*, p. 160. **51.** *Ibid.*, p. 214. **52.** *Ibid.*, p. 213; note of June 24, 1891, in sketchbook in Tretiakov Gallery. **53.** On connections between Russia and Scandinavia, see T.D. Mukhina, "K voprosu o russko-skandinaviskikh khudozhestvennykh sviazakh v konste XIX–nachala XX veka," *Sovetskoe iskusstvoznanie '81* (Moscow: Sovetskii khudozhnik, 1982), pp. 266–278. **54.** A. Fedorov-Davydov, ed., *I.I. Levitan. Pis'ma, Dokumenty, Vospominaniia* (Moscow: Iskusstvo, 1956), pp. 113–114. **55.** Chekhov to A. Suvorin, January 19, 1895, in Fedorov-Davydov, *Levitan. Pis'ma*, p. 134. A. Fedorov-Davydov, *Russkii peizazh kontsa XIX–nachala XX veka. Ocherki* (Moscow: Iskusstvo, 1974), pp. 30–31 is one of many who offer this comparison. **56.** Levitan to Sergei Diaghilev, 1898, in Federov-Davydov, *Levitan. Pis'ma*, p. 207. **57.** Polenov to N. Polenova, March 7, 1891, in Sakharova, *Polenov, Polenova*, pp. 275–276; the incident was reported in all the Petersburg newspapers, in Moleva, *Korovin*, pp. 211, 502. **58.** Nikolai V. Dosekin, "Vtoraia vystavka Moskovskikh Khudozhnikov," *Artist* 37, (1894), pp. 143–44, in Moleva, *Korovin*, pp. 234–236. **59.** *Ibid.* **60.** Repin to Polenov, July 17, 1883, in Brodskii, *Repin. Pis'ma*, vol. I, p. 289. There was no Impressionist exhibition that year. **61.** *Ibid.* **62.** Repin to Tretiakov, 1892, *Ibid.*, vol. I, p. 411. **63.** Repin to Elena Antokolskaia, August 7, 1894, *Ibid.* vol. II, p. 74 **64.** *Ibid.* **65.** Polenov to N. Polenova, February 13, 1889, in Sakharova, *V.D. Polenov* (Moscow, Leningrad: Iskusstvo, 1948), pp. 249, 251. The Peredvizhniki passed new regulations in 1890 which restricted the admission of new members and made it harder for nonmembers to exhibit. **66.** On reform of the academy and the artist's roles see A.N. Savinov, "Akademiia khudozhestv i Tovarishchestvo Peredvizhnikh Khudozhestvennykh Vystavok," *Problemy razvitiia russkogo iskusstva* (Leningrad: Akademiia khudozhesty, 1972) II, pp. 42–51; letters of Polenov and Brodskii, *Repin. Pis'ma*, I, p. 375, II, p. 125; Sakharova, *Polenov, Polenova* pp. 587–595, 602–603. **67.** Repin, "V zashchitu novoi Akademiia khudozhestv" (1897) in Brodskii, *Repin—Pegagog* Moscow: Akademiia khudozhestv, 1960), p. 18. **68.** Brodskii, "Khudozhestvenno-pedagogicheskie vzgliady I. E. Repina" (Ph.D. Thesis, Academy of Arts, Leningrad, 1949), p. 43. **69.** Repin to E. Polenova, October 13 and 27, 1896, in Sakharova, *Polenov, Polenova*, pp. 853–855; see Hilton, "The Exhibition of Experiments in Saint Petersburg and the Independent Sketch," *The Art Bulletin* LXX, no. 4 (December 1988), pp. 677–698. **70.** Polenova to E. Mamontova, August 24, 1889, in Sakharova, *Polenov, Polenova*, p. 436; Levitan to A. Sredin, March 28, 1899, in *Levitan. Pis'ma*, pp. 95-96. **71.** Serov to Ostroukhov, September 16, 1889, in *Mastera iskusstva ob iskusstve*, ed. A. Guber (Moscow, Iskusstvo, 1970), vol. VII, pp. 206, 207. **72.** Polenov to E. Mamontova, September 23, 1889, in Sakharova, *Polenov, Polenova*,

p. 438; Nesterov to his family, July 22, 1889, *Nesterov, Iz pisem*,ed. A. Rusakova, (Leningrad: Iskusstvo, 1968), p. 33. Korovin, three years later, found only Bastien-Lepage and Anders Zorn worth mentioning according to his notebook from the Paris trip (1892: Tretiakov Gallery), and a letter to A. Vasnetsov, February 27, 1892, in Moleva, *Korovin*, pp. 223–224, 226–227. **73.** French critic Charles Bigot made this point in 1885 and 1888; see Richard Schiff, "The End of Impressionism," *The New Painting. Impressionism 1874–1886*, ed. Charles Moffett (San Francisco: Fine Arts Museums of San Francisco, 1986), pp. 77–78. **74.** Polenova's letters from Paris mention only Bastien-Legape and Bashkirtseva by name, Sakharova, *Polenov, Polenova*, p. 440. **75.** I. N. Barsheva, *Arkhipov* (Leningrad: Khudozhnik RSFSR, 1974), p. 24, citing Arkhipov's inscription on a study in a private collection, Leningrad. **76.** Grabar to D. Kardovskii, Paris, May 17, 1897, in, *Igor Grabar'. Pis'ma*, L. Andreeva and T. Kazhdan, eds., (Moscow: Akademiia nauk, 1974), I, p. 89. **77.** Grabar, *Moia zhizn'. Avtomonografiia* (Moscow and Leningrad: Iskusstvo, 1937), p. 197, quoted in Janet Kennedy, *The "Mir iskusstva" Group and Russian Art, 1898–1912* (New York: Garland Publishing Co., 1977), p. 331. **78.** Grigorii Sternin, *Khudozhestvennaia zhizn' Rossii na rubezhe XIX-XX vekov* (Moscow: Iskusstvo, 1970), pp. 105–106, 119, 123, 147–150, 243, 271; the 1891 French exhibition had only Salon art; the larger 1896 one allowed most space to academic painters but had a smaller section of works from the Bernheim-Jeune gallery, including canvases by Ingres, Millet, Courbet, Corot, Monet, Sisley, Renoir, and Rafaëlli. The 1897 Scandinavian exhibition included Zorn, Liliefors, Thaulow, Werenskiold, and Hammershoi; Zorn spoke at the banquet. **79.** Levitan to A. Turchaninova, January 24, 1899, in *Levitan, Pis'ma*, pp. 94–95. Among the Russian artists were Bakst, Benua, Vasnetsov, Golovin, Korovin, Levitan, Maliavin, Nesterov, Polenov, E. Polenova, Repin, Serov, Somov; foreign artists included Aman-Jean, Besnard, Blanche, Carriere, Degas, Frederic, Forain, LaTouche, Monet, Moreau, Puvis de Chavannes, Renoir, Boecklin, Dill, Lenbach, Liebermann, Boldini, Gallen-Kallela, Brangwyn, and Whistler. **80.** Sergei Ivanov to A. Kiselev, 1894, in I. Granovskii, *S. V. Ivanov. Zhizn' i tvorchestvo* (Moscow: Iskusstvo, 1962), p. 124. **81.** Levitan to Anton Chekhov, March 10, 1890, in *Levitan. Pis'ma*, p. 32. **82.** Iakunchikova to Polenova, January 11, 1892, in Sakharova, *Polenov, Polenova*, p. 478. The publication of Dmitrii Merezhkovskii's book *On the Reasons for Decline, and on New Currents in Contemporary Russian Literature* (Saint Petersburg, 1893) made the term *decadence* ubiquitous. **83.** Iakunchikova to Polenova, March 30, 1892, in Sakharova, *Polenov, Polenova*, p. 483. **84.** Iakunchikova, May 28, 1892, *Ibid.*, p. 484; she commented on Redon and other symbolist artists in other letters. **85.** Polenova to N. Polenova, May 1895, *Ibid.*, pp. 552, 534, naming Thaulow, Zorn, Sorolla, Brangwyn, Harcourt, and Harrison. **86.** Repin, "Pis'ma ob iskusstve," October 25, 1893, in Repin, *Dalekoe blizkoe*, pp. 403–404. **87.** Repin, "Pis'ma ob iskusstve," May 1894, *Ibid.*, pp. 436–438. **88.** Hilton, "The Exhibition of Experiments," pp. 694-695. **89.** Nesterov to M. Solov'ev, February 1898; to A. Turygin, July 18, 1898, in *Nesterov. Iz Pisem*, pp. 131, 133–134. **90.** See Robert Goldwater, *Symbolism* (New York: Harper and Row, 1979), pp. 2–3; Richard Schiff, *Cézanne and the End of Impressionism* (Chicago and London: University of Chicago Press, 1984), pp. 44–50. **91.** Kennedy, *The "Mir iskusstva" Group*, pp. 18–19, citing A. Benois, *Memoirs* (London: Chatto Windus, 1960–1964), II, p. 157. **92.** *Ibid.*, pp. 20–21, quoting Diaghilev's typescript (Russian Museum). **93.** *Ibid.*, pp. 58,130–131. **94.** *Ibid.*, pp. 162–163 citing Benua, *Zhizn' khudozhnika* (New York: Chekhov Publishers, 1955), II, p. 394. **95.** Grabar to Kardovskii, May 17, 1897, in *Grabar'. Pis'ma*, vol. I, 89. **96.** Kennedy, *The "Mir iskusstva" Group*, 164, citing Benua, "Ob impressionizme," *Mir iskusstva* I, no. 6 (1899), pp. 49–50. **97.** The articles on these artists were written by German contributors—Max Liebermann, Richard Muther, and Julius Meier-Graefe. See Kennedy, *The "Mir iskusstva" Group*, 149, citing *Mir iskusstva* II, nos. 21–22 and 23–24 (1899). **98.** See Kennedy, *The "Mir iskusstva" Group*, 165–177 on the group's preferences in contemporary art. **99.** Grabar, "Upadok ili vozrozhdenie?" *Niva* (1897), nos. 1–12, cited in Kennedy, *The "Mir iskusstva" Group*, 170. **100.** Kennedy, *The "Mir iskusstva" Group*, 173, notes that the group did not greatly admire Cézanne, but Grabar was one of the first to write about his work; he saw Matisse's work in Paris in 1904. **101.** Kandinskii, "Pis'ma iz Miunkhena," *Mir iskusstva*, no. 1–6 (1902), pp. 96–98, cited in Kennedy, *The "Mir iskusstva" Group*, p. 177. **102.** Kandinskii explained that seeing Monet's *Haystack* made him realize that "the subject, as an essential element of the picture, was discredited" and that painting itself was capable of developing powers like those of music, published in "Text Artista," in *Wassily Kandinsky Memorial* (New York: Solomon R. Guggenheim Foundation, 1945), p. 49. The exhibition he attended, of French painting from the Bernheim-Jeune collection, opened first in St. Petersburg, and then in Moscow in December 1896; see Sternin, *Khudozhestvennaia zhizn' Rossii*, p. 262. **103.** On the Russian interpretations of "Impressionism" in the early twentieth century, see Vladimir Markov, *Russian Futurism: A History* (London: Macgibbon & Kee, Ltd., 1968) pp. 1–28. **104.** Repin, "Pis'ma ob iskusstve," May 1894, *Dalekoe blizkoe*, p. 438. **105.** Vasilii Kandinskii, "Content and Form" (1910), in Bowlt, *Russian Art of the Avant-Garde* (New York: Viking, 1976), p. 19; Wassily Kandinsky, *Concerning the Spiritual in Art*, translated by M. T. H. Sadler (New York: Dover, 1977), p. 55. **106.** Kazimir Malevich, "From Cubism and Futurism to Suprematism: The New Painterly Realism" (1915) in *K. S. Malevich, Essays on Art 1915–1933*, ed., Treols Andersen (New York: George Wittenborn, 1968), pp. 32–33, 38–39.

# SELECTED BIBLIOGRAPHY

## A WORLD IN LIGHT

Adler, Kathleen. *Unknown Impressionists*. Oxford: Phaidon Press, 1988.

Berson, Ruth, ed. *The New Painting: Impressionism 1874–1886. Documentation*. 2 vols. San Francisco: The Fine Arts Museums of San Francisco, forthcoming.

Clark, Timothy J. *The Painting of Modern Life: Paris in the Art of Manet and His Followers*. New York: Alfred A. Knopf, 1984.

The Fine Arts Museums of San Francisco, and The National Gallery of Art. *The New Painting: Impressionism 1874–1886*. Essays by Charles S. Moffett, et al. San Francisco: The Fine Arts Museums of San Francisco, 1986.

Garb, Tamar. *Women Impressionists*. Oxford: Phaidon Press, 1986.

Grand Palais. *Centenaire de l'impressionnisme*. Essays by Anne Dayez, et al. Paris: Grand Palais, 1974.

Herbert, Robert L. *Impressionism: Art, Leisure, and Parisian Society*. New Haven and London: Yale University Press, 1988.

House, John. *Monet: Nature into Art*. New Haven and London: Yale University Press, 1986.

Isaacson, Joel. *The Crisis of Impressionism, 1878–1882*. Ann Arbor: University of Michigan Museum of Art, 1979–1980.

Los Angeles County Museum of Art; Art Institute of Chicago; Grand Palais. *A Day in the Country: Impressionism and the French Landscape*. Essays by Richard Brettell, Scott Schaeffer, et al. Los Angeles and New York: Los Angeles County Museum of Art and Harry N. Abrams, Inc., 1984.

Monneret, Sophie. *L'Impressionnisme et son époque*. 4 vols. Paris: Denoël, 1978–1981.

Reff, Theodore. *Manet and Modern Paris*. Washington, D.C.: The National Gallery of Art, 1982.

Rewald, John. *The History of Impressionism*. New York: The Museum of Modern Art, 1973 (first edition, 1946).

Shiff, Richard. *Cézanne and the End of Impressionism*. Chicago: University of Chicago Press, 1984.

University of California at Riverside Art Gallery, and Los Angeles County Museum of Art. *The Impressionists and the Salon (1874–1886)*. Riverside: University of California Press, 1974.

Venturi, Lionello, ed. *Les Archives de l'impressionnisme*. 2 vols. Paris and New York: Durand-Ruel, 1939. Reprinted, New York: Burt Franklin, 1968.

## IMPRESSIONISM IN THE UNITED STATES

Boyle, Richard J. *American Impressionism*. Boston: New York Graphic Society, 1974.

Brooklyn Museum. *Leaders of American Impressionism*. Essay by John I. H. Baur. Brooklyn: Brooklyn Museum, 1937.

Dixon Gallery and Gardens. *An International Episode: Millet, Monet and Their North American Counterparts*. Essay by Laura L. Meixner. Memphis, Tennessee: Dixon Gallery and Gardens, 1982.

Gammell, R. H. Ives. *The Boston Painters 1900–1930*. Orleans, Massachusetts: Parnassus Imprints, 1986.

Garland, Hamlin. *Crumbling Idols: Twelve Essays on Art*. Chicago and Cambridge: Stone and Kimball, 1894.

Gerdts, William H. *American Impressionism*. New York: Abbeville Press, 1984.

Haley, Kenneth. "The Ten American Painters: Definition and Reassessment." Ph.D. thesis, State University of New York at Binghamton, 1975.

Henry Art Gallery, University of Washington. *American Impressionism*. Essay by William H. Gerdts. Seattle: Henry Art Gallery, 1980.

Hoopes, Donelson. *The American Impressionists*. New York: Watson-Guptill Publications, 1972.

Leader, Bernice. *The Boston Lady as a Work of Art: Paintings by the Boston School at the Turn of the Century*. Ann Arbor, Michigan: University Microfilms International, 1980.

The Metropolitan Museum of Art. *American Impressionist and Realist Paintings and Drawings, from the Collection of Mr. and Mrs. Raymond Horowitz*. Essay by Dianne H. Pilgrim. New York: The Metropolitan Museum of Art, 1973.

Montclair Art Museum. *Down Garden Paths*. Essay by William H. Gerdts. Montclair, New Jersey: Montclair Art Museum, 1983.

The National Gallery of Art. *American Impressionist Painting*. Essay by Moussa M. Domit. Washington, D.C.: The National Gallery of Art, 1973.

Norton Gallery of Art. Weber, Bruce and Gerdts, William H. *In Nature's Ways: American Landscape Painting of the Late Nineteenth Century*. Essays by Bruce Weber and William H. Gerdts. West Palm Beach, Florida: Norton Gallery of Art, 1987.

Phoenix Art Museum. *Americans in Brittany and Normandy 1860–1910*. Essay by David Sellin. Phoenix, Arizona: Phoenix Art Museum, 1982.

Pierce, Patricia Jobe. *The Ten*. Concord, New Hampshire: Rumford Press, 1976.

## BRITISH IMPRESSIONISM

Baron, Wendy. *Sickert*. Oxford: Phaidon Press, 1973.

Billcliffe, Roger. *The Glasgow Boys*. London: Britoil, 1985.

Cartwright Hall. *Sir George Clausen R.A. 1852–1944*. Essay by Kenneth McConkey. London: Cartwright Hall, 1980.

Christie's. *The New English Art Club Centenary Exhibition*. Introduction by Anna Gruetzner Robins. London: Christie's Auctioneers, 1986.

Fitzwilliam Museum, Cambridge University. *Philip Wilson Steer 1860–1942*. Essay by Jane Munro. Cambridge: Fitzwilliam Museum, 1986.

Flint, Kate. *Impressionists in England: The Critical Reception*. London: Routledge and Kegan Paul, 1984.

Forge, Andrew. "The Slade (2): The Years of Vitality." *Motifs* (autumn 1960), p. 1631.

Gruetzner, Anna. "Two Reactions to French Painting." In *Post-Impressionism*. London: Royal Academy of Arts, 1979.

McConkey, Kenneth. "The Bouguereau of the Naturalists: Bastien Le Page and British Art." *Art History* (September 1978), pp. 3–17.

———. *British Impressionism*. Oxford: Phaidon Press, 1989.

National Gallery of Ireland. *Walter Osborne*. Essay by Jeanne Sheehy. Dublin: National Gallery of Ireland, 1983.

Norwich School of Art. *Henry Tonks and the Art of Pure Drawing*. Essay by Linda Morris. Norwich, England: Norwich School of Art, 1985.

Oldham Art Gallery. *A Painter's Harvest: Works by Henry Herbert La Thangue R.A. 1859–1929*. Essay by Kenneth McConkey. Oldham, England: Oldham Art Gallery, 1980.

Royal Academy of Arts. *Impressionism*. Essay by John House. London: Royal Academy of Arts, 1974.

## IMPRESSIONISM IN CANADA

Antoniou, Sylvia. *Maurice Cullen 1866–1934*. Kingston, Ontario: Agnes Etherington Art Centre, Queen's University, 1982.

Baker, Victoria. "Chronology." In *Marc-Aurèle de Foy Suzor-Coté, Back to Arthabaska*. Arthabaska, Québec: Musée Laurier, 1987, pp. 49–54.

Boas, Nancy. *The Society of Six: California Colorists*. San Francisco: Bedford Arts, 1988, pp. 45–51.

Boissay, René. *Clarence Gagnon*. Montreal: Héritage/Broquet, 1988.

Braide, Janet. *William Brymner, 1885–1925, A Retrospective*. Kingston, Ontario: Agnes Etherington Art Centre, Queen's University, 1979.

Cloutier, Nicole, et al. *James Wilson Morrice 1865–1924*. Montreal: The Montreal Museum of Fine Arts, 1985.

Jouvancourt, Hugues de. *Suzor-Coté*. Montreal: Editions internationales Alain Stanké Ltée, 1978.

Karpiscak, Adeline Lee. *Ernest Lawson, 1873–1939.* Tucson: University of Arizona Museum of Art, 1979.

L'Allier, Pierre. *Henri Beau, 1863–1949.* Québec: Musée du Québec, 1987.

Lamb, Robert J. *The Canadian Art Club, 1907–1915.* Edmonton, Alberta: The Edmonton Art Gallery, 1988.

Mellen, Peter. "Precedents for the Group of Seven—Montreal," in *The Group of Seven.* Toronto: McClelland and Stewart Limited, 1970, pp. 6–15.

Murray, Joan. *Impressionism in Canada 1895–1935.* Toronto: Art Gallery of Ontario, 1973.

Murray, Joan, ed. *Letters Home: 1859–1906, The Letters of William Blair Bruce.* Moonbeam, Ontario: Penumbra Press, 1982.

Ostiguy, Jean-René. *Marc-Aurèle de Foy Suzor-Coté, Winter Landscape.* Masterpieces in the National Gallery of Canada No. 12. Ottawa: The National Gallery of Canada, 1978.

Reid, Dennis. "Pre-1910: Schooling" and "1910–1913: Towards a 'Hot Mush School' in Toronto." In *The Group of Seven.* Ottawa: The National Gallery of Canada, 1970, pp. 17–65.

## The Sunny South: Australian Impressionism

Astbury, Leigh. *City Bushmen. The Heidelberg School and Rural Mythology,* Melbourne: Oxford University Press: 1985.

———. *Sunlight and Shadow, Australian Impressionist Painters 1880–1900.* Sydney: Bay Books, 1989.

Burn, Ian. "Beating about the Bush. The Landscapes of the Heidelberg School," in *Australian Art and Architecture. Essays in Honour of Bernard Smith.* Edited by Anthony Bradley and Terry Smith. Melbourne: Oxford University Press, 1980.

Clark, Jane, and Whitelaw, Bridget. *Golden Summers, Heidelberg and Beyond.* Melbourne and Sydney: National Gallery of Victoria and Art Gallery of New South Wales, 1985–86.

Croll, R.H., ed. *Smike to Bulldog. Letters from Sir Arthur Streeton to Tom Roberts.* Sydney: Robertson and Mullens, 1946.

Dysart, Dinah. *Julian Ashton.* Sydney: S. H. Erwin Museum and Art Gallery, 1981.

Galbally, Ann. *Arthur Streeton.* Melbourne: Lansdowne Press, 1979.

———. *Frederick McCubbin.* Victoria: Hutchinson, Richmond, 1981.

Hoff, Ursula. *Charles Conder.* Melbourne: Lansdowne Press, 1972.

———. "Reflections on the Heidelberg School," *Meanjin.* (Melbourne), vol. 10, no. 2, 1985.

Smith, Bernard. *Australian Painting, 1788–1970.* Melbourne: Oxford University Press, 1971.

———. "New Light on Old Light: Impressionism and the Golden Summers Exhibition," *The Age Monthly Review* (Melbourne), December–January 1985–86.

Smith, Terry. "Teaching Art History: A Tutorial in Arthur Streeton's *Still Glides the Stream. . . . 1890,*" *Creativity in Art Education Conference Papers.* Sydney: Art Education Society, August 1982.

———. "The Most Australian of Our Artists, Tom Roberts, Impressionism and Cultural Construction," *The Age Monthly Review* (Melbourne), February 1986.

Spate, Virginia. *Tom Roberts.* Melbourne: Lansdowne Press, 1972.

Thomas, Daniel, ed. *Creating Australia. Two Hundred Years of Art.* Adelaide, Sydney, and Melbourne: International Cultural Corporation of Australia and Art Gallery of South Australia, 1988.

Topliss, Helen. *The Artists' Camps. Plein-Air Painting in Melbourne, 1885–1898.* Melbourne: Monash University Gallery, 1984.

———. *Tom Roberts 1856–1931. A Catalogue Raisonné.* Melbourne: Oxford University Press, 1985.

## The Impressionist Impulse in Japan and the Far East

### China

Relatively little material is available in Western languages on modern Chinese art of the pre-Mao period. In compiling my brief remarks, I found the following most useful:

Crozier, Ralph. *Art and Revolution in Modern China, The Lingnam (Cantonese) School of Painting, 1906–1951.* Berkeley: University of California Press, 1988.

Kao Mayching, ed. *Twentieth-Century Chinese Painting.* Hong Kong: Oxford University Press, 1988.

Sullivan, Michael. *The Meeting of Eastern and Western Art.* Greenwich: New York Graphic Society, 1973; revised edition, Berkeley: University of California Press, 1989.

The above volumes contain additional bibliographic citations from Western and Chinese sources.

### Japan

The only survey in English for this period of art is the catalog for the exhibition *Paris in Japan, The Japanese Encounter with European Painting,* published by Washington University in Saint Louis and the Japan Foundation in 1987. The catalog contains detailed bibliographic citations of works in English, French, and Japanese.

In addition, the following may be of particular interest:

Harada Minoru. *Meiji Western Painting.* New York and Tokyo: Weatherhill/Shibundo, 1974.

Miyagawa Torao. *Modern Japanese Painting.* Tokyo, New York, and San Francisco: Kodansha International, 1967.

Munsterberg, Hugo. *The Art of Modern Japan.* New York: Hacker Art Books, 1978.

Rimer, J. Thomas. *Pilgrimages, Aspects of Japanese Literature and Culture.* Honolulu: University of Hawaii Press, 1988.

Yamada Chisaburoh, ed. *Dialogue in Art: Japan and the West.* Tokyo, New York, and San Francisco: Kodansha International, 1976.

## Italian Painting During the Impressionist Era

Bellonzi, Fortunato. *Il Divisionismo nella Pittura Italiana.* Milan: Fratelli Fabbri Editori, 1967.

Berresford, Sandra. "Divisionism: Its Origins, Its Aims and Its Relationship to French Post-Impressionist Painting." In *Post-Impressionism: Cross-Currents in European Painting.* Edited by John House and MaryAnne Stevens. London: Royal Academy of Arts, 1979, pp. 218–226.

Broude, Norma. *The Macchiaioli: Italian Painters of the Nineteenth Century.* New Haven and London: Yale University Press, 1987.

Cinotti, Mia. *Zandomeneghi.* Busto Arsizio: Bramante Editrice, 1960.

Clark Art Institute. *Italian Paintings 1850–1910 from Collections in the Northeastern United States.* Essays by David Cass and John Wetenhall. Williamstown: Clark Art Institute, 1982.

Dini, Piero. *Dal Caffè Michelangiolo al Caffè Nouvelle Athènes: I Macchiaioli tra Firenze e Parigi.* Turin: Umberto Allemandi & C., 1986.

Durbè, Dario. *I Macchiaioli.* Introduction by Lamberto Vitali. Rome: De Luca Editore, 1978.

Fiori, Teresa, ed. *Archivi del Divisionismo.* Introduction by Fortunato Bellonzi. 2 vols. Rome: Officina Edizioni, 1969.

Forte di Belvedere. *I Macchiaioli nella cultura toscana dell'Ottocento.* Preface by Luciano Berti and essays by Dario Durbè and Sandra Pinto. Florence: Forte di Belvedere, 1976.

The Frederick S. Wight Art Gallery, University of California. *The Macchiaioli: Painters of Italian Life, 1850–1900.* Essays by Dario Durbè, Albert Boime, Denis Mack Smith, and Piero Dini. Los Angeles: Frederick S. Wight Art Gallery, 1986.

Lavagnino, Emilio. *L'Arte Moderna dai Neoclassici ai Contemporanei.* 2 vols. Turin: Unione Tipografico-Editrice, 1961.

Longhi, Roberto. "Il Impressionismo e il gusto degli italiani." Introduction to John Rewald, *Storia dell'Impressionismo.* Italian trans. by Antonio Boschetto. Florence: Sansoni, 1949.

Monteverdi, Mario. *Storia della Pittura Italiana dell'Ottocento.* 3 vols. Milan: Bramante Editrice, 1975.

Palazzo Permanente. *Arte e Socialità in Italia dal Realismo al Simbolismo, 1865–1915.* Milan: Palazzo Permanente, 1979.

———. *Mostra della Scapigliatura.* Essays by A. M. Brizio, L. Caramel, and E. Malagoli. Milan: Palazzo Permanente, 1966.

Piceni, Enrico. *De Nittis, l'uomo e l'opera,* 2 vols. (with general catalog of the works). Busto Arsizio: Bramante Editrice, 1979–1982.

Quinsac, Annie-Paule. *La Peinture Divisionniste Italienne: origines et premiers développements 1880–1895.* Paris: Klincksieck, 1972.

Soffici, Ardengo. "L'Impressionismo e la Pittura Italiana." *La Voce* (March 1909). Reprinted in Paola Barocchi, ed., *Testimonianze e polemiche figurative in Italia dal Divisionismo al Novecento.* Messina and Florence: Casa Editrice G. D'Anna, 1974.

Stair Sainty Matthiesen Gallery. *Three Italian Friends of the Impressionists: Boldini, De Nittis, Zandomeneghi.* Introduction by Dario Durbè, essays on the artists by Enrico Piceni, and catalog entries by Giuliano Matteucci and Paul Nicholls. New York: Stair Sainty Matthiesen Gallery, 1984.

## The Lure of Impressionism in Spain and Latin America

Anderson, Ruth Matilda. *Costumes Painted by Sorolla in his Provinces of Spain.* New York: The Hispanic Society of America, 1957.

*Aureliano de Beruete, 1845–1912.* Madrid: Obra Cultural de la Caja de Pensiones, 1983.

Bereute y Moret, Aureliano. *Historia de la Pintura española en siglo XIX.* Madrid: Blass, 1926.

Catlin, Stanton Loomis, and Grieder, Terence. *Art of Latin America since Independence*. New Haven and Austin: Yale University Art Gallery and University of Texas Art Museum, 1966.

*Darío de Regoyos, 1857–1913*. Madrid: Fundación Caja de Pensiones, 1986.

*Eight Essays on Joaquín Sorolla y Bastida*, 2 vols. New York: The Hispanic Society of America, 1909.

Fernández, Justino. *El Arte del Siglo XIX en México*. México: Universidad Nacional Autónoma de México, 1983.

*Fortuny 1838–1974*. Madrid: Fundación Caja de Pensiones, 1989.

García Miñor, Antonio. *El pintor Darío de Regoyos y su época*. Oviedo: Instituto de Estudios Asturianos, 1958.

Giraldo Jaramillo, Gabriel. *La pintura en Colombia*. México: Fondo de Cultura Económica, 1948.

*Joaquín Clausell, Oleos y Murales*. México: Fondo Editorial de la Plástica Mexicana, 1973.

La Puente, Joaquín de. *Catálogo de las Pinturas del Siglo XIX. Casón del Buen Retiro*. Madrid: Museo del Prado, 1985.

Musée Marmottan. *Andrés de Santa María, 1860–1945*. Paris: Musée Marmottan, 1985.

Museo de Arte de Ponce. *Francisco Oller, A Realist-Impressionist*. Ponce, Puerto Rico: Museo de Arte de Ponce, 1983.

*The Painter Joaquín Sorolla y Bastida*. London: Philip Wilson Publishers, 1989.

Pantorba, Bernardino de. *La vida y la obra de Joaquín Sorolla*. Madrid: Editorial Mayfe, 1953.

Peluffo Linari, Gabriel. *El Modernism. Historia de la Pintura uruguaya*. Montevideo: Ediciones de la Banda Oriental, 1987.

*La Pintura en Venezuela*. Caracas: Secretaria General de la Decima Conferencia Interamericana, 1954.

Reis Júnior, José Maria dos. *Belmiro de Almeida, 1858–1935*. Rio de Janeiro: Pinakotheke, 1984.

Rodríguez Alcalde, Leopoldo. *Los Maestros del Impresionismo Español*. Madrid: Ibérico Europea de Ediciones, 1978.

Santa-Ana y Alvarez-Ossorio, Florencio. *Museo Sorolla. Catálogo de Pintura*. Madrid: Ministerio de Cultura, 1984.

Simó, Trinidad. *J. Sorolla*. Valencia: Vicent García Editores, 1980.

*Spanish Painters in Search of Light (1850–1950)*. Madrid: U.S.–Spanish Joint Committee for Educational and Cultural Affairs, 1984.

Temple, A. G. *Modern Spanish Painting*. London: Arnold Fairbairns & Co., 1908.

## MUSSELS AND WINDMILLS: IMPRESSIONISM IN BELGIUM AND HOLLAND

*Art et Société en Belgique 1848–1914*. Charleroi: Palais des Beaux-Arts de Charleroi, 1980.

*Belgian Art 1880–1914*. Brooklyn: The Brooklyn Museum, 1980.

Block, Jane. *Les XX and Belgian Avant-Gardism*. Ann Arbor: UMI Research Press, 1984.

Canning, Susan M. *A History and Critical Review of the Salons of Les Vingt: 1884-1893*. Ann Arbor: UMI Research Press, 1980.

Champa, Kermit Swiler. *Mondrian Studies*. Chicago: The University of Chicago Press, 1985.

Delevoy, Robert L., De Croes, Catherine, and Ollinger-Zinque, Gisele. *Fernand Khnopff*. Brussels: Editions Lebeer-Hossmann, 1987.

Farmer, John David. *Ensor*. New York: George Braziller, Inc., 1976.

*Fernand Khnopff, 1858–1921*. Brussels: Ministère de la Communaute Française de Belgique, 1979.

*Georg Hendrik Breitner, Gemalde, Zeichnungen, Fotografien*. Cologne: Rheinland-Verlag GmbH, 1977.

Goyens de Heusch, Serge. *L'Impressionisme et le Fauvisme en Belgique*. Antwerp: Fonds Mercator, 1988.

Hammacher, A. M. *Amsterdamsche Impressionisten en hun Kring*. Amsterdam: J. M. Meulenhoff, 1946.

Hefting, P. H., and Quarles van Ufford, C.C.G. *Breitner als fotograf*. Rotterdam: Lemniscaat, 1966.

*Henry van de Velde (1863–1957), Paintings and Drawings*. Antwerp: Ministry of the Flemish Community, 1988.

*Histoire d'Eaux, Stations thermales et balnéaires en Belgique XVIe–XXe siècle*. Brussels: Galérie La Caisse Generale d'Epargne et de Retraite, 1987.

Hyslop, Francis E. *Henri Evenpoel, Belgian Painter in Paris 1892–1899*. University Park: The Pennsylvania State University Press, 1975.

Jaffé, Hans L. C. *Piet Mondrian*. New York: Harry N. Abrams, Inc., 1985.

*Jan Toorop 1858–1928, Impressioniste, Symboliste, Pointilliste*. Paris: Institut Neerlandais, 1977.

*Le premier groupe de Laethem-Saint-Martin, 1899–1914*. Brussels. Musées Royaux des Beaux-Arts de Belgique, 1988.

Lesko, Diane. *James Ensor, The Creative Years*. Princeton: Princeton University Press, 1985.

McQuillan, Melissa. *Van Gogh*. London: Thames and Hudson, 1989.

Pickvance, Ronald. *Van Gogh in Arles*. New York: Harry N. Abrams, Inc., 1984.

Royal Academy of the Arts, *The Hague School: Dutch Masters of the 19th Century*. London: Weidenfeld and Nicolson, 1983.

*Van Gogh en Belgique*. Mons: Musée des Beaux-Arts de Mons, 1980.

Wagner, Anna. *Isaac Israels*. Venlo: Uitgerverij Van Spijk B.V., 1985.

Welsh-Ovcharov, Bogomila. *Vincent van Gogh and the Birth of Cloisonism*. Toronto: Art Gallery of Ontario, 1981.

## NORDIC LUMINISM AND THE SCANDINAVIAN RECASTING OF IMPRESSIONISM

Brooklyn Museum. *Northern Light. Realism and Symbolism in Scandinavian Painting 1880–1910*. Edited by Kirk Varnedoe. New York: Brooklyn Museum, 1982.

Hayward Gallery (Arts Council of Great Britain). *Dreams of a Summer Night*. London: Hayward Gallery, 1986.

Kent, Neil. *The Triumph of Light and Nature. Nordic Art 1740–1940*. London: Thames and Hudson, 1987.

Liljvalchs Konsthall. *De drogo till Paris: Nordiska Konstnärinnor på 1880-talet*. Edited by Louise Robbert. Stockholm: Liljvalchs Konsthall, 1988.

Nasgaard, Roald. *The Mystic North. Symbolist Landscape Painting in Northern Europe and North America 1890–1940*. Toronto: University of Toronto Press, 1984.

Nasjonalgalleriet. *1880-årene i nordsk maleri*. Essays by Pontus Grate and Nils-Göran Hökby. Oslo: Nasjonalgalleriet, 1985.

Østby, Lief. *Fra naturalism til nyromantik*. Oslo: Gyldendal Norsk Forlag, 1934.

Varnedoe, Kirk. *Northern Light. Nordic Art at the Turn of the Century*. (Expanded version of exhibition catalog *Northern Light*.) New Haven: Yale University Press, 1988.

Voss, Knud. *Skagenmålarna i Nordiskt Ljus*. (Trans. from the Danish.) Helsingborg: Skagen Museum, Schmidts Boktryckeri, 1987.

Wichström, Anne. *Kvinner ved staffeliet. Kvinnelige malere i Norge før 1900*. Oslo: Universitetsforlaget, 1983.

## IMPRESSIONISM IN AUSTRIA AND GERMANY

Finke, Ulrich. *German Painting from Romanticism to Expressionism*. London: Thames and Hudson, 1974.

Fuchs, Heinrich. *Emil Jakob Schindler*. Vienna: Dr. Heinrich Fuchs Selbstverlag, 1970.

Grimschitz, Bruno. *Österreichische Maler vom Biedermeier zur Moderne*. Vienna: Kunstverlag Wolfrum, 1963.

Hancke, Erich. *Max Liebermann. Sein Leben und seine Werke*. Berlin: Bruno Cassirer, 1923.

Imiela, Hans-Jürgen. *Max Slevogt*. Karlsruhe: G. Braun, 1968.

Jensen, Jens Christian. *Adolph Menzel*. Cologne: DuMont, 1982.

Kaiser, Konrad, ed. *Der frühe Realismus in Deutschland 1800–1850*. Schweinfurt: Sammlung Georg Schäfer, 1967.

Österreichische Galerie. *Tina Blau 1845–1916: Eine Wiener Malerin*. Vienna: Österreichische Galerie im Oberen Belvedere, 1971.

Rosenhagen, Hans. *Uhde. Des Meisters Gemälde*. Stuttgart and Leipzig: Deutsche Verlagsanstalt, 1908.

Ruhmer, Eberhard. *Der Leibl-Kreis und die reine Malerei*. Rosenheim: Rosenheimer Verlagshaus Alfred Förg GmbH & Co. AG, 1984.

Schwarz, Heinrich. *Salzburg und das Salzkammergut. Die künstlerische Entdeckung der Stadt und der Landschaft im 19. Jahrhundert*. Vienna and Munich: Verlag Anton Schroll & Co., 1926.

Stuttmann, Ferdinand. *Max Liebermann*. Hanover: Fackelträger Verlag, 1961.

Uhr, Horst. *Lovis Corinth*. Berkeley: The University of California Press, 1990.

Von der Osten, Gert. "Über den 'Deutschen Impressionismus'." *Jahresring* 56/57 (1956), pp. 117–124.

Wichmann, Siegfried. *Realismus und Impressionismus in Deutschland. Bemerkungen zur Freilichtmalerei des 19. und beginnenden 20. Jahrhunderts*. Stuttgart: Schuler Verlag GmbH, 1964.

## PLEIN-AIR PAINTING IN SWITZERLAND

*The Alps in Swiss Painting*. Edited by the Pro Helvetia Foundation Zurich. Tokyo and Zurich: Odakyu Grand Gallery and Bundner Kunstmuseum, 1977.

Bätschmann, Oskar. *Entfernung der Natur*. Cologne: Dumont, 1989.

———. *Malerei der Neuzeit* (ARS HELVETICA, vol. VI). Disentis: Desertina, 1989.

Bovy, Adrien. *La Peinture Suisse de 1600 à 1900*. Basel: Birkhäuser, 1948.

De Herdt, Anne. *Dessins genevois de Liotard a Hodler*. Geneva: Musée d'Art et d'Histoire, 1984.

Deuchler, Florens, Roethlisberger, Marcel, and Lüthy, Hans. *Swiss Painting from the Middle Ages to the Dawn of the Twentieth Century*. New York: Skira-Rizzoli, 1976.

Gantner, Joseph, and Reinle, Adolf. *Kunstgeschichte der Schweiz. Von den Anfängen bis zum Beginn des 20. Jahrhunderts*. 4 vols. Basel: Huber Frauenfeld, 1947–1968; vol. 4: Reinle, Adolf. *Die Kunst des 19. Jahrhunderts. Architektur/Malerie/Plastik*. 1962.

High Museum of Art. *From Liotard to Le Corbusier, 200 Years of Swiss Painting*. Edited by the Swiss Institute of Art Research. Atlanta: High Museum of Art, 1988.

Huber, Jörg. *Schweizer Malerei von den Anfängen bis ins 20. Jahrhundert. vol. II: Zwischen Harmonie und Aufbruch: Das 19. hahrhundert*. Glattbrugg: Beobachter AG, 1984.

Huber, Vera. *Schweizer Landschaftsmaler. Das intime Landschaftsbild im 19. Jahrhundert*. Zurich: Manesse, 1949.

Lüthy, Hans A., and Heusser, Hans-Jörg, *Kunst in der Schweiz 1890-1980*, Zürich: Orell Füssli, 1983 (also in French: Lausanne, Payot 1983).

Von Tavel, Hans Christoph. *Ein Jahrhundert Schweizer Kunst. Malerei und Plastik. Von Böcklin bis Alberto Giacometti*. Geneva: Skira, 1969.

Von Tavel, Hans Christoph, et al. *Schweiz im Bild—Bild der Schweiz*. Zurich: Helmhaus, 1974.

## THE IMPRESSIONIST VISION IN RUSSIA AND EASTERN EUROPE

Andreeva, L., and T. Kazhdan, eds. *Igor Garbar', Pis'ma*. Moscow: Nauka, 1974.

Brodskii, Isaak, ed. *Repin. Pis'ma*. Moscow: Iskusstvo, 1969.

Fedorov-Davydov, A., ed. *I. I. Levitan. Pis'ma, Dokumenty, Vospominaniia*. Moscow: Iskusstvo, 1956.

———. *Russkii peizazh kontsa XIX—nachala XX veka. Ocherki*. Moscow: Iskusstvo, 1974.

Gomberg-Verzhbinskaia, Eleonora. "Iskanie v russkoi zhivopisi 1890–1900x godov," in *Russkaia khudozhestvennaia kul'tura kontsa XIX—nachala XX veka*. Eds. A. Alekseev and Iu. Kalashnikov. Moscow: Nauka, 1969.

Hilton, Alison. "The Exhibition of Experiments in St. Petersburg and the Independent Sketch," *The Art Bulletin* LXX, no. 4, (December 1988), pp. 677–698.

Kennedy, Janet. *The "Mir iskusstva" Group and Russian Art*. New York: Garland Publishing Co., 1977.

Kopshitser, Mark. *Valentin Serov*. Moscow: Iskusstvo, 1967.

Kotalik, Jini, et al. *Tschechische Kunst 1878–1914. Auf dem Weg in die Moderne*. Darmstadt: Mathildenhöhe, 1985.

Moleva, N. *Konstantin Korovin, zhizn' i tvorchestvo*. Moscow: Akademiia Khudezhestu, 1963.

National Museum in Warsaw and National Academy of Design, New York. *Nineteenth-Century Polish Painting*. Essay by Agnieszka. Morawińska. New York: National Academy of Design, 1988.

Repin, Ilya. *Dalekoe blizkoe* (1937). Moscow: Iskusstvo, 1953.

Sakharova, Elena, ed. *V. D. Polenov, E. D. Polenova. Khronika sem'i khudozhnikov*. Moscow: Iskusstvo, 1964.

Salgo, Nicolas, et al. *Hungarian Painting. A Century 1850–1950*. Washington, D.C.: American University Press, forthcoming.

Sarab'ianov, Dmitrii. *Valentin Serov*, Leningrad, New York: Aurora, 1982.

Sternin, Grigorii. *Khudozhestvennaia zhizn' Rossii na rubezhe XIX—XX vekov*. Moscow: Iskusstvo, 1970.

Sternin, Grigorii, et al. *Ilia Repin. Zhivopis', Grafika*. Leningrad: Aurora, 1985.

Zil'bershtein, Ilia, and V. Samkov. *Valentin Serov v vospominaniakh, dnevnikakh, i perepiske sovremennikov*. Leningrad: Chudezhnik RSFSR, 1971.

# PHOTOGRAPH CREDITS